[Handwritten annotations at top: "–People want a character", "– Character Team", "– How to turn investor", "18–30 yrs old", "–Gen 2", "–What storyline does it tell Per Person"]

The International Film Business

C000060295

Examining the independent film sector as a business on an international scale, author Angus Finney addresses the specific skills and knowledge required to successfully navigate the international film business.

Finney describes and analyses the present structure of the film industry as a business, with a specific focus on the film (and entertainment) value chain and takes readers through the status of current digital technology, exploring ways in which this is changing the structure and opportunities offered by the industry in the future. The textbook provides information and advice on the different business and management skills and strategies that students and emerging practitioners will need to effectively engage with the industry in an international context. Case studies of films and TV, including *Squid Game* (2021), *Parasite* (2019), *Game of Thrones* (2011–2019) and *The Best Exotic Marigold Hotel* (2011), are supplemented by company case studies on Redbus, Renaissance, Pixar, with additional new chapters focusing on Netflix, TikTok, You Tube and the Metaverse.

This third edition of *The International Film Business* includes up-to-date information on the status of the international film industry during and post COVID-19; expanded content looking at the TV industry and streaming services; new case studies and dedicated sections on the Streaming Wars and the Chinese Film Industry and a new chapter looking at the changes in digital production in the context of the global and territorial film and TV industry.

Written for students of Film Business and emerging practitioners, this book will take readers through the successes and failures of a variety of real film companies and projects and features exclusive interviews with leading practitioners in all sectors of the industry, from production to exhibition.

Angus Finney is Cambridge University's MBA Coach on the Culture, Arts and Media Management concentration at Judge Business School, where he is a Fellow; and a senior contributor to *Variety*. In addition to Finney's executive producer responsibilities, including the upcoming Danish–German film based on Janne Teller's novel *Nothing* (released 2022), and his non-executive board responsibilities, he currently teaches, trains and mentors at a range of leading institutions. These include the National Film and Television School, the British Film Institute, Creative England, the Danish National Film School, South Africa's National Film and Video Foundation, the German Film and TV Academy Berlin, the Beijing Film Academy, Screen Ireland and Canada's Motion Producers Association, via the global consultancy Media Xchange. Finney has held four expert witness appointments since 2012, including working with HMRC and the UK's police force. He was Film London's Project Manager for the Production Finance Market for a decade (2007–2017); Managing Director of Renaissance Films (1999–2005) and a senior editor at *Screen International* during the 1990s. His previous books include: *Developing Feature Films in Europe: A Practical Guide* (1996), *The State of European Cinema: A New Dose of Reality* (1996) and *The Egos Have Landed: The Rise and Fall of Palace Pictures* (1996). He has a PhD in Management from Bayes Business School, City University London (2014), an MA in Journalism from New York University (1988) and a BA Hons in International Relations from Sussex University (1985).

The International Film Business

A Market Guide Beyond Hollywood

Third Edition

Angus Finney

Routledge
Taylor & Francis Group

LONDON AND NEW YORK

Third edition published 2022
by Routledge
4 Park Square, Milton Park, Abingdon, Oxon, OX14 4RN

and by Routledge
605 Third Avenue, New York, NY 10158

Routledge is an imprint of the Taylor & Francis Group, an informa business

© 2022 Angus Finney

First edition published by Routledge 2010
Second edition published by Routledge 2015

British Library Cataloguing-in-Publication Data
A catalogue record for this book is available from the British Library

Library of Congress Cataloging-in-Publication Data
Names: Finney, Angus, 1964- author.
Title: The international film business : a market guide beyond Hollywood / Angus Finney.
Description: Third edition. | New York, NY : Routledge, 2022. | Includes bibliographical references and index.
Identifiers: LCCN 2022000386 (print) | LCCN 2022000387 (ebook) | ISBN 9781032071763 (hardback) | ISBN 9781032071756 (paperback) | ISBN 9781003205753 (ebook)
Subjects: LCSH: Motion pictures--Marketing. | Motion pictures--Distribution. | Motion picture industry--Finance.
Classification: LCC PN1995.9.M29 F565 2022 (print) | LCC PN1995.9.M29 (ebook) | DDC 791.43068/8--dc23/eng/20220107
LC record available at https://lccn.loc.gov/2022000386
LC ebook record available at https://lccn.loc.gov/2022000387

ISBN: 978-1-032-07176-3 (hbk)
ISBN: 978-1-032-07175-6 (pbk)
ISBN: 978-1-003-20575-3 (ebk)

DOI: 10.4324/9781003205753

Typeset in Sabon
by SPi Technologies India Pvt Ltd (Straive)

For Nicky, and in memory of Nik Powell (1950–2019), film producer and entrepreneur

Contents

List of illustrations

Figures

Tables

Introduction

Success is going from failure to failure without losing enthusiasm.
(Winston Churchill)

The inspiration for this book was born out of failure, not success. I spent an earlier decade of my career in journalism, consulting and book writing during the 1990s before being presented with the opportunity to cross the commentator/practitioner divide, and work as an entrepreneur and manager at the sharp end of the business. I ran Renaissance Films, a London-based film company, over a seven-year period, the first four with my former partner Stephen Evans. Ultimately, I was forced to close that company and place it into receivership in 2005. The challenge and associated pressures of combining development, production, finance, sales, marketing and the eternal search for distribution under one umbrella, while managing the expectations of institutional investors and later completing a sole management buyout of the company, were ultimately insurmountable. On reflection, however, that exposure and experience has been instructive. So part of this book's purpose is to capture some of that acquired knowledge and share it as transparently as the libel laws will allow me.

During the process of personal and professional rehabilitation, it became clear that buried inside those years of practitioner activity was a rich seam of experience and potential case studies. Many less formal film books and lectures on the subject veer towards the anecdotal, and often focus on 'successful exceptions'. This new work also draws on my PhD doctorate (2014), which researched and analysed the impact of cognitive bias on project management – which to us mortals means how people in the film industry lie to themselves. I have aimed to use the majority of the case studies to explore the dysfunctional and often inefficient processes and people-generated problems rather than just throw a spotlight on the extraordinary and rare hits. However, success sometimes comes along when least expected, as borne out by the worldwide South Korean hit *Parasite*; *Squid Game's* meteoric impact on world-wide entertainment, and the global *Game of Thrones* phenomenon – three new case studies added to this third edition.

Given the blinding speed of change since the first two editions (2010, 2015), the process of writing this edition felt akin to starting from scratch again. This new text is aimed directly at both the specialized film student but also the broader media education sector (both undergraduate and postgraduate). It has also been designed in a way that makes much of the material relevant for practitioners – including producers,

writers, directors, agents, financiers, lawyers, and executives far across the spectrum of the international film business, from agents to acquisitions; sales to streaming, and into a gradually emerging new entertainment and media landscape.

When reviewing existing literature on the film and entertainment business, many texts seemed to focus on Hollywood and predominantly the way Hollywood studios approach production and distribution. Whilst it is understandable why academic research is drawn to the studios – who offer quantitative data and historical trends in abundance – what is left untended is the international film industry as practiced and experienced by all outside (and often connected to) the Hollywood hegemony. That hegemony has been hugely disrupted by the global surge of online content and what I refer to as "The Streaming Wars": as this book explores: the entertainment business is undergoing not just an evolution, but a revolution as we head further into the twenty-first century.

The International Film Business: A Market Guide Beyond Hollywood is divided into three main sections: 1. The film value chain; 2. Users and the changing digital market; and 3. Business, leadership and management strategies. This book has been designed by us to enable the majority of the chapters and case studies to stand alone, and to be utilized for teaching and training purposes without the need to wade through the entire 150,000-word text in one linear session.

However, the book is also aiming to be larger than just the sum of its parts, a goal not lost on many who reported back on the first and second editions. By analysing the horizontal and vertical structures that shape the film industry, along with changing patterns of user consumption and digital technology, it aims to concurrently examine the existing industry while acknowledging the high levels of restructuring currently underway. When reviewing existing literature and exploring the above themes while teaching at MBA level at Judge Business School, Cambridge University, and MA level at various academic institutions, and work with industry bodies since 2010, it has become clear that business, project and creative management skills need to be welded into any industry and market analysis of the film sector. All too often those skills are an afterthought or deemed irrelevant to the creative pool, which is deeply damaging to the industry's future. And film, although just one of a number of key creative industries, remains one of the most visible. Indeed, film is not called a 'loss-leader' for nothing.

Acknowledgements

This book first originated through discussions with Terry Ilott, Course Director at the former Cass Film Business Academy (FBA) City University London; Peter Bloore, then an associate director at the FBA and now an established academic; and Manchester University's Professor of Strategy Joe Lampel. I subsequently received research support from the former UK Film Council and later from Creative Skillset, for which I am grateful. John Woodward, along with Dan Simons and others, were extremely encouraging, and without their combined encouragement the process would have stalled. However, this new third edition is an almost entirely fresh stab at capturing and understanding the changing of the guards.

A host of generous practitioners, lecturers and students who have supported, aided and taught me much – often through engaging and enlightening Q&A's; practitioner workshops, academic classrooms and teaching/training sessions, but also through actual productions, mentoring, helpful communication and professional exchanges, deserve thanks. They include Juanaid Ahmed, Peter Armstrong, James Atherton, Chris Auty, Julie Baines, Michael Barker, Daniel Battsek, Mark Beilby, Andrew Bendel, Jonathan Berger, Emily Best, Charlie Bloye, Peter Bloore, Philippe Bober, Cristian Bortone, Simon Bosanquet, Laurence Bowen, Marc Boothe, Grant Bradley, Meredith Brett, Graham Broadbent, Paul Brett, Peter Broderick, Ben Browning, Pete Buckingham, Will Buckley, Philippe Carcasonne, Phyllis Carlyle, Abbey Caton-Packer, Leon Clarence, David Collins, Mads Egmont Cristensen, Simon Crowe, Tammy Ro Simon Crowe, Chris Curling, Hilary Davis, Ken Dearsley, Sarah Dillon, Andrew Eaton, Jake Eberts, Haley Edwards, Bernd Eichinger, Jonathan Evans, Stephen Evans, Bertrand Faivre, Richard Fletcher, Francis Foster, Sara Frain, Simon Franks, Michael Franklin, Rob Friedman, Julian Friedmann, Kate Gardiner, Jake Garriock, Ben Gibson, Sandy Gildea, Mark Gill, Terry Gilliam, Geoff Gilmore, John Giwa-Amu, Tristan Goligher, Mark Gooder, Zaheer Goodman-Byat, Tony Grisoni, Mike Gubbins, Sonia Guggenheim, Ed Guiney, Kurt Guo, Allegre Hadida, Simeon Halligan, George Hamilton, Per Damgaard Hansen, Andy Harries, Sandra Hebron, Lars Herman, David Heyman, Will Higbee, Richard Holmes, Phil Hunt, Ian Hutchinson, Anna Huth, Aparna Ilangovan, Janine Jackowski, Soren Kragh Jacobsen, Sophie Janson, Nic Jeune, Rachael Richardson Jones, Howard Kaidaish, Ralph Kamp, Stephen Kelligher, Mike Kelly, Makhosazana Khanyile, David Kosse, Peter Bille Krogh, Michael Kuhn, Neil LaBute, Pierre-Ange Le Pogam, Peter Le Tessier, Charles Lei, Kate Leys, Robin Liu, Kevin Loader, Nadine Luque, Thomas Lydholm, Alan Charles Macdonald, Andrew Mac-Donald, Helena Mackenzie, Heather Mansfield, Nick Manzi, Nick Marston, Alan

Martin, Margaret Matheson, David Max-Brown, Cameron McCracken, Teresa McGrane, Scott Meek, Roger Michell, Chris Moll, Alan Moss, Gail Mutrux, Lynda Myles, Per Neuman, Yolanda Ncokotwana, Inshaaf Nordien, Norman North, Rebecca O'Brien, Alejandro Pardo, David Parfitt, Adam Partridge, Nathan Pawley, Abigail Payne, Simone Payne, Simon Perry, Ashley Pharoah, Trine Piil, Nik Powell, Mark Prescott, John Ptak, David Puttnam, Philip Raby, Tim Richards, Tammy Romaniuk, Charles Roven, Patrick Russo, Phil Rymer, Vanessa Saal, Arjun Sablok, Deborah Sathe, James Schamus, David Shear, Anne Sheehan, James Shirras, Gisli Snaer, Tina Sorensen, Sean Steele, Bille Steen, Helena Spring, Andrew Taylor, Jeremy Thomas, Alison Thompson, Stewart Till, Paul Trijbits, Neil Watson, James K. Wight, Katrina Wood, Stephen Woolley, Adrian Wootton, Zaheer, Zixi Zhang and Jia Zhou, to thank those that I can recall. Those not listed from whom I've also learnt from – in particular during my trials and errors at Renaissance Films; the decade-long management of the Film London Production Finance market, and the lifting (and collapsing) of a range of projects as an executive producer, much gratitude is in order.

A number of leading organizations and institutions where I have worked, taught and shared over the past 17 years or so, should be thanked, including in the UK and Ireland (the British Film Institute, Creative England, Film London, Ffilm Cymru; Media Xchange, Screen Ireland, etc.), along with the New Zealand Film Commission, SPADA, the Abu Dhabi Film Commission, TwoFour54, South Africa's National Film and Video Foundation, the Saudi Arabia Film Commission, Canada's MPA, China's Beijing Film Academy; the Copenhagen Business School, Copenhagen University, University of the Arts/London College of Communication, the London Film School, the National Film and Television School, City University London, Royal Holloway College, La Sorbonne, Paris, London University, Exeter University and Cambridge University and Judge Business School specifically, have all helped shape my thinking, learning and the development of this book's enduring themes and insights.

I am grateful to Lei Ding, a Chinese scholar, for her help with research on the Chinese star system, and further checking by my colleagues Zixi Zhang and Millie Zhou. I am indebted to my research assistant Julia Henderson, who spent hours transcribing interviews, researching key subject areas and providing me with valuable feedback. Much thanks to my editor Claire Margerison and her team – in particular, my hands-on editors at Routledge, Sarah Pickles and Nick Brock (the latter was painstakingly efficient in his editing of the manuscript). All were very patient as they awaited a radically new third edition. Of course, all remaining omissions, errors and mistakes (including unreferenced late night parties) remain my responsibility.

Angus Finney, January 2022

Part I
The film value chain

1 The winds of change

> The future is already here; it's just not evenly distributed.
>
> (novelist William Gibson)
>
> I have a living room … I want to go to the theatre.
>
> (Quentin Tarantino, 2021) [1]

Changing gears

Over the past one hundred years and a few more rather lively ones of late, a multitude of challenges have threatened to kill off the film industry. Cue the headlines: World War One, the 'Spanish Flu' epidemic; the arrival of 'talkies'; World War Two; the arrival of post-war television in the living room; the invention of video in the 1970s; the explosion of the internet in the 1990s; the 2008 financial crisis; and, most recently, the onslaught of a worldwide pandemic in early 2020 that is still very much present at the time of publication. The blinding speed of change over the past five years has been predominantly driven by what I and others term "the streaming wars". Intense competition is shifting the film and content industry from natural evolution to radical revolution (and increasingly onto smaller screens, 'wherever you are, whenever you want'), thanks in part to the impact and ongoing presence of the Coronavirus epidemic. And yet despite blow after blow (real or imagined), film and moving images have proven remarkably resilient and are still coming "to a cinema near you" or, more likely today, at a screen near your eye level.

Believers argue that as the film medium and industry rises above each challenge, it becomes stronger than ever before. "What we thought was going to happen in four years, it's now happened in one", gushed one digital production specialist in the timely Future of Film report [2]. Others bemoan the closed cinema theatres of late and issue the death rattle for "cinema" as we have known it over the past (albeit ever-shifting) century. The naysayers are ignoring some key "known knowns": our collective human appetite for stories, content and meaning is insatiable, especially in times of political turmoil and insecurity about today and tomorrow, let alone the near-distant future. Millions around the globe clearly desire to escape on a daily and hourly basis; many still yearn for the shared experience of the big screen. Filmmaker and author Jon Boorstin explains: "Size is crucial. The voyeur in us must feel life encompassing the story, swallowing up the screen. We need spectacle, sweeping panorama, to convince us that the world out there is beyond the edge of the frame" [3]. Critically, people

DOI: 10.4324/9781003205753-2

around the world continue to want to be entertained; and that includes being challenged, surprised and inspired. As Nigerian award-winning novelist Ben Okri points out: "Stories are the highest technology of being" [4]. And critically, people remain subtle and yet fickle: most rarely do we know what we want to watch until we actually see it.

The overall stakes as both a worldwide industry and a global business are high. The total economic impact of the entire screen sector in 2019, just prior to the onset of COVID-19, was some $414 billion, and global expenditure on Screen Production was $177 billion (including scripted film, TV/streamed content and documentaries, but not sport, news and commercials) [5]. In a wide-ranging study by OlsbergSPI [ibid.], the writers made a convincing, heavily evidence-based case for governments around the world to embrace and support screen production as a key economic driver in the post-COVID-19 recovery. At the time of writing, the pandemic-created production pile-up resembled a line of packed Jumbo Jets tailed back on an overcrowded runway. But gradually the pace of lift-off will accelerate inexorably, given the demand for content around the world.

The three-legged chair: creativity, technology and leadership

Producer and statesman Lord Puttnam observed a decade ago: "The change is enormous yet nothing is changing" [6]. Film is an ideas-driven business: "The notion that the audience wants a satisfying emotional experience, a reconciliation and completeness, has not changed." Much of this book examines and delves into the heart of the creative responsibilities and endeavours of project managers – namely 'producers' – while noting the importance of the writer–director–producer "creative triangle" [7]. A wide range of case studies, including *Game of Thrones*, Pixar and *Parasite*, provide insights into the creative challenges facing content makers, but also bears witness to the extraordinary ability of talent to win out against the toughest tests. Filmmaking is akin to "carrying water up a hill", as one award-winning South African producer reminded me in Johannesburg during the countless pre-lockdown(s). And many of those water-carriers are not operating in the limelight, under the starry strobes of Awards seasons and prime-time attention. The majority of the professionals interviewed for this new edition (effectively a completely new book) work at the essential coal face of the business, and, in their own special ways, bring a level of creative sophistication, problem solving and cultural insights so often taken for granted or missed completely by the media and sometimes the very talent they are supporting and willing on to greater endeavours.

Technology: changing winds

To understand where we are now, we need to understand what has gone before, and the anthropological impulses that invariably act as breaks on change, whatever form(s) that may take. The generational process of ageing populations (and certain governments) deciding what's good for their offspring (and citizens) is timeless, and is normally driven by a combination of ignorance, protectiveness and fear. The process of declining acceptance of all things new as we grow older was enshrined by the writer Douglas Adams, when he came up with a set of rules in his novel *The Salmon of Doubt* [8], that pinpoints our changing reactions to technologies.

Adams' three rules are:

1. Anything that is in the world when you're born is normal and ordinary and just a natural part of the way the world works.
2. Anything that's invented between when you're 15 and 35 is new and exciting and revolutionary and you can probably get a career in it.
3. Anything invented after you are 35 is against the natural order of things.

Writing in *The Guardian*, the newspaper's technology specialist John Naughton cited Ben Thompson's work on how best to understand and analyse the advance of technology [9]. Thompson suggests that we think of the industry in terms of "epochs" – important periods or eras in the history of a field. At that point he saw three epochs in the evolution of our networked world of tech, each defined in terms of its core technology and its "killer app".

Epoch one was the PC era, kicked off in 1981 as IBM launched its personal computer. And the killer app was the spreadsheet. The film business's equivalent was the culmination of what cinema author Peter Biskind wrote so masterfully about in *Easy Riders, Raging Bulls*, at time in the 1970s when auteurs had dominated Hollywood and the theatrical box office [10]. Meanwhile the VCR had long been born, marked by VHS beating out Betamax in the mid-1970s and winning the living room tape wars (ironically won by the lowest-quality bidder).

Epoch two was the internet era, which began 14 years after the PC epoch began, in 1995. The core technology was the web browser – the tool that turned the internet into something that all of us could understand and use. The 'search' (driven by the engine) was the killer app and the dominant use came to be social networking, with market share being captured by the ubiquitous Facebook.

And the film industry's equivalent? The advent of the Digital Versatile Disc (DVD) in 1997, which further transformed the living room experience, while arming distributors with a license to print money, given the huge margins on offer. Indeed, profits from the deep well of ancillary riches was so addictive that it subsequently became hard for studios and distributors to wean themselves off those now-disappearing drugs. Meanwhile digital filmmaking and the gradual demise of 35 mm was also cutting a swathe across mainstream film production and projection.

Epoch three in Thompson's framework – the phase that we're experiencing now – is what he deems the "mobile" era. It dates from 2007 when Apple announced the iPhone and launched the smartphone revolution. Naughton suggests that the killer app is the so-called "sharing economy (which of course is nothing of the kind), and messaging of various kinds has become the dominant communications medium. But now it looks as though this smartphone epoch is reaching its peak" [ibid.].

The film industry's third epoch over the past 40 years? No doubt the start and rapid rise of streaming – driven by digital and online technology and a desire to reach audiences/users/customers/members wherever you are. And that is a key part of the fresh focus of this book: how people's habits are changing, how we make choices about our screen and leisure time, and how the fight for attention and loyalty (see Chapters 16 and 17: The Streaming Wars; and Netflix case study) is driving an explosion of content and material, not all, inevitably, impactful or as well aimed as intended. Movies, drama and ambitious series are extremely expensive gambles. "Producers … might want perfection, but they are asking themselves a much cruder question: how does

this thing need to work? What is the X factor that it must contain that will forgive a thousand blunders?" [11]. And the overriding challenge today is to not just embrace but to lead with genuine inclusion: "Audiences need to be able to see people like themselves in films, they need to be able to see people like them making films, otherwise they will just think it's not a place for them", explains Delphi Lievens [12]. Her viewpoint is supported by the vastly successful Jason Blum, who underlines the point:

> I really believe that you want the storytellers to look like the audience they're telling stories for: And that's what we've done and will continue to do.
>
> [ibid.]

Which brings us to the advent of the fourth epoch and the future landscape. In this so far phase without end, some commentators and Silicon Valley titans are heralding the arrival of the metaverse(s), comprising a mass virtual reality world where, for example, the children of tomorrow will have "friends" with a range of virtual influencers without even thinking of how they might differ to their mates living down the road. And as a writer far beyond the age of 35 (even before the first edition of this book was published in 2010), I was forced to confront my own prejudices by teaming up with digital entrepreneur James K. Wight. A curious and highly engaging 20-something whom I taught at Exeter University and the London Film School, Wight patiently talked me through the decline of Facebook, the rise of TikTok, the wider virtual world and an introduction to the metaverse(s). The result is enshrined in Chapter 20 in an effort to try to better understand the order of things now and tomorrow.

Leadership out in front

Students and academics are often guilty of assuming management and leadership amount to one of the same thing. They do not. Whilst management – a key theme analysed continuously throughout this book (including project, creative, business etc.) – is a vital skill set for the creative industries to thrive, the international film business would die on the sword without genuine leadership on the front line. Perhaps the most impressive and profound book I came across in researching this third edition did not originate from the entertainment world beyond Hollywood. Instead, Disney's Bob Iger's "*Ride of a Lifetime: Lessons in Creative Leadership…*" [13] struck home to me. Most impressive of all is his understanding of what is required to make and see through genuine change, as he reflected on the advent and auspicious rise of Disney +, and the leadership that was required to make it happen:

> Too often, we lead from a place of fear rather than courage, stubbornly trying to build a bulwark to protect new models that can't possibly survive the sea change that is underway. It's hard to look at your current models, sometimes even ones that are profitable in the moment, and make a decision to undermine them in order to face the change that's coming.
>
> [Ibid]

And so to the capture of knowledge, through collecting, analysing and utilising industry experience and practice: very much the centre of this book's overall purpose. In theory, armed with vast levels of data and digital advancements, we should be

embracing a new powerfully reflexive world of magical engagement. However, rather more home truths, feedback loops and authentic sharing would go a long way to securing an industry fit for purpose as the wind blows us into a fourth epoch, the results of which we can only wonder.

References

[1] Quentin Tarantino, quoted in the Armchair Expert podcast, *Financial Times*, 28–29/08/21.
[2] Jon Boorstin, *The Hollywood Eye*. Harper Collins, 1990.
[3] Ben Okri, *The Mystery Feast: Thoughts on Storytelling*. Clairview Books, 2015.
[4] Stolz, A., Atkinson, S. and Kennedy, H. W., *Future of Film Report*, 2021.
[5] Global Screen Production, *The Impact of Film and TV Production on Economic Recovery from COVID-19: A Study by OlsbergSPI*, 25/06/2020.
[6] Lord Puttnam was talking at the *Ffilm Cymru conference* in Cardiff, Wales, 2013.
[7] Peter Bloore, *The Screenplay Business*. Routledge, 2013.
[8] Douglas Adams, *The Salmon of Doubt*. Heinemann, 2002.
[9] John Naughton, 'PC, internet, smartphone: what's the next big technological epoch?' *The Guardian*, 11/09/2021.
[10] Peter Biskind, *Easy Riders, Raging Bulls*. Simon & Schuster, 1998.
[11] John Boorstin, *The Hollywood Eye*. Harper Collins, 1990, p. 135.
[12] Delphi Lievens, *Future of Film Report*, 2021.
[13] Bob Iger, *Ride of a Lifetime: Lessons in Creative Management from 15 years as CEO of the Walt Disney Company*. Bantam Press, 2019.

2 The film value chain

[handwritten annotations:]
Streaming Service
- Folks behind the camera become famous
- Each person, a company, like a sports athlete
- Never before seen
- Robust entertainment marketplace

> The essence of strategy is choosing what not to do.
> (Michael Porter, Harvard Business School)
>
> The independent film production and distribution sector is ... a value system business – feature films are made and delivered by a chain of companies – businesses, freelancers – all working on different elements, adding value in different ways.
> (Peter Bloore, screenwriter, author and academic) [1]

The value chain model: An introduction

The 'value chain' [2] is a model designed by Harvard academic Professor Michael Porter in 1985 that describes a series of value-adding activities connecting a company's or business sector's typical supply side (e.g. materials, logistics, production processes), with its demand side (e.g. marketing, distribution and sales), by examining the different stages and links of a sector's value chain. Managers have been about to use the model to refine and/or redesign their internal and external processes to improve efficiency and effectiveness – i.e. become more competitive. While considerable academic research and study has focused on value chain analysis, less attention has been concentrated on value chain restructuring and the impact of uncertainty and disruption on the various stages of an industry's links in the chain.

The 'value chain model was formalized by Michael Porter's book *Competitive Advantage: Creating and Sustaining Superior Performance* (ibid.). Porter subsequently summarized the value chain as "the set of activities through which a product or service is created and delivered to customers." The value chain is used to help analyze that company's competitive advantage and strategy within the marketplace. In a later article about the Internet in 2001 [3] Porter summarized the value chain as follows: "When a company competes in any industry, it performs a number of discrete but interconnected value-creating activities, such as operating a sales force, fabricating a component, or delivering products, and these activities have points of connection with the activities of suppliers, channels and customers. The value chain is a framework for identifying all these activities and analysing how they affect both a company's costs and value delivered to buyers" (ibid.).

However, many products are not created and delivered to the end user by a single company. Notably, the international film business addressed in this book offers up a

DOI: 10.4324/9781003205753-3

complex multi-player and multi-company/organization(s) landscape. The majority of practitioners, for example, working in the film and television sector are freelance – moving from project to project rather than remaining in the same company/organization. Hence, the corporation and/or studio/large company model is not necessarily a firm and relevant fit to analyse the complexity of the overall entertainment industry's architecture. Individual players (producers, writers, directors, actors, heads of departments, skilled crew members, etc.) pay critical and key roles in creating and capturing value, and small and medium enterprises (SMEs) contract and expand according to the level of production activity at any given point in time.

The shape and structure of the independent film industry

The film industry's shape, size and characteristics present a series of challenges for the researcher and practitioner alike. The global film market can be analysed from a horizontal perspective, meaning the countries (aka 'territory') covered by the content's reach. This assists us in understanding global, multinational, and territory-by-territory strategies, and the respective values and potential competitive advantages offered by scale. As such, the horizontal approach allows us a degree of "macro" analysis, taking into account global trends, key territorial distinctions and, in the rare instance of an independent film that hits worldwide, observations on the extraordinary penetration and super-returns resulting from *The King's Speech* or *Parasite*-style universal exploitation.

However, firstly, a wealth of economic data points to the fact that the film industry is a failure-driven business, not a "hit-driven" business, as practitioners tend casually to refer to it [4]. Each film released into the market is essentially an orphan, with no guarantee of successfully reaching cash-break-even let alone profitability, even when armed with star names and large marketing budgets. (Increasingly, 'star power' means less and less when it comes to anticipating streaming platform success, for example.) The inability to predict future success of a project's performance was the specific point that screenwriter William Goldman was driving at in *Adventures In The Screen Trade*: "No one knows anything" [*about what's going to work commercially before...it actually does work!*] [5]. Secondly, in a marked move away from a deep ancillary well of secondary rights exploitation global streaming platforms have effectively "flattened" out the vertical mining of rights and revenue streams, and cross-collateralizing horizontal upsides, leaving the independent filmmaking business model more vulnerable than perhaps ever before in the past century-plus of cinema.

The previous vertical perspective

The global film market can also be approached from a vertical perspective, meaning the exploitation chain, starting with the theatrical release – then historically moving through what was "video/DVD/Pay TV/Free TV" and ending in library rights. The vertical analysis enables us to analyse specific film media characteristics and their relative values and roles within the film value chain [5]. Each film product is capable of being delivered and viewed in a number of ways by the end user. Until recently, but now under direct reconstruction, was the sequentially constructed "historical window exploitation chain" (see Figure 2.1).

> Theatrical release → DVD window → Pay TV window → Free TV window

Figure 2.1 Historical window exploitation chain.

A. Finney [6]

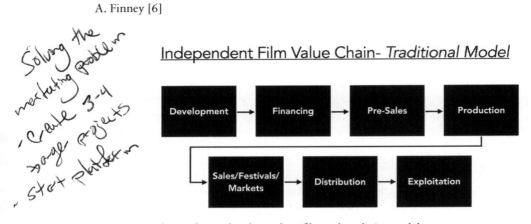

Figure 2.2 The traditional independent film value chain model.

A. Finney [ibid., 6]

It is this chain, when analysed from vertical link-to-link, that helps us towards an understanding of how the revenue streams within the film business have been generally understood on a "micro" basis. Film and small screen content exploitation remains dependent on both the vertical and horizontal aspects, but the depth of vertical value has changed significantly in the past decade. Until recently, it would be accurate to state that a film is nearly always released first in its domestic country of origin, and then subsequently exploited in additional territories. It was also accurate to state that a film has been released first theatrically (if it succeeds in being booked in cinemas), and then through a sequence of "windows", including DVD, Pay TV and Free TV, which can be referred to as the "traditional independent film value chain model (see Figure 2.2).

The film value chain is a term that applies to all the various stages of the creation, distribution and exploitation of product across the global film business. The primary products of the film industry are often described as a group or "bundle" of rights. This group of related rights that constitute a movie product can be broken down into three key parts: (1) the underlying rights; (2) newly created copyrights; and (3) exploitation rights. Before examining the broader implications of the film value chain, it is essential to understand its legal and practical framework. The underlying rights to a film normally kick off in a pre-existing book, script (original or adapted), play or other source of material that has to be acquired, along with any underlying rights that are created or used within the film, including elements such as character, image, and music etc. These rights normally belong to third parties and have to be legally acquired before they can be incorporated into a film.

Furthermore, the right to utilize and exploit the work of writers, actors, directors, designers, has to be acquired by legal contract. Writers, directors and creative artists normally are contracted through standard formatted contracts that are agreed across

the industry. Thirdly, it is often required that permissions must be sought and cleared from third parties – most notably when shooting on location. Service agreements have to be entered into for the use of studios, laboratories, visual effects houses etc. Once a film has completed production and post-production, an entirely new right is created: the film copyright. Other copyrighted elements may be included within the film, such as the soundtrack, costumes or characters. The film copyright and related copyrights are then exploited by the licensing of various sales, distribution and merchandising rights to third parties active in film sales, distribution, exhibition, home entertainment, merchandising, prequels, sequels, and other forms of ancillary exploitation.

This historical, entrenched structure has effectively withheld product from the market in a way that has suited the rights owner, licensor and creators, rather than the consumer/user. The copyright structure has also clashed with the open Internet streaming of content via predominantly free payment structures. Whilst subscription (Amazon Prime, Netflix, HBO Max, Disney + etc.) and ad-supported sites (YouTube, Facebook, TikTok etc.) are taking up the "digital dime" slack, there is a fundamental mismatch between copyright structures and free and open information systems that has yet to be fully reconciled. The now almost extinct DVD revenue income next to fast online digital revenue growth is providing an opportunity to film producers and entrepreneurs keen to move away from a business model of uncertainty to one that has a clear shot at sustainability. The overall independent model is set out in Table 2.1.

The established structure and system for distributing independent films has entered a period of growing tension and stress, further exacerbated by the onset of the 2020 Coronavirus pandemic, still very much alive at time of publication. There is rising pressure on the sales/territorial distributor relationships in the value chain, alongside escalating costs of marketing and distribution that has long enabled the Hollywood studios to dominate theatrical distribution. Advances paid to acquire and distribute non-studio films have now dwindled to near-extinction unless they are aimed at acquiring slices of rights around the $10m-plus budget level. Such films need to have significant creative elements attached and confirm a combination of track record and a clearly intended market. Without pre-saleable elements such as A-list actors, top directors or proven genre credentials (including the dominance of mainstream sequels, prequels, remakes etc.), distributors have grown increasingly shy of paying advances to secure upcoming but yet-to-be produced film product. The narrow, intensely competitive and studio-dominated theatrical window has also worked against the smaller, niche film that has traditionally struggled to find its audience in the first three weeks, let alone first three days.

The long-existing approach of attempting to sell films (which normally means license) in return for significant cash advances that in turn contribute towards repayment of the negative cost of the film or, in exceptional cases, take the film past break-even and into profit, has undergone considerable change.

The new value chain model

Now we see hundreds of films (and scripted content, documentary) being made around the world for streaming platforms exclusively, most often without a theatrical opening: so no 'shop window' is being exploited through theatres to create buzz and awareness, and no residual ancillary revenues exist beyond the 'one stop' exclusive platform so often employed by Netflix, Amazon Prime, et al. Whilst this newly

Table 2.1 The independent value chain model: from consumer to concept

Film value chain model (independent model, by activity)		
Element	Players	Support
Consumer	First time product is seen by end-user, and where true value can be assessed and realized. Time and money have been sunk at high level before this final contact with the consumer marketplace.	Media spend, press and publicity, social networking + traditional marketing tools
Exploitation	Exhibition/cinema release, DVD sales/rental, VHS sales/rental, Pay TV, video on demand, Internet, download, Free TV, Syndication Library rights: ongoing exploitation opportunities for producer, financier; distributor's licence window remake, prequel, sequel rights + library sales	Marketing by territory (distributor and separately by exhibitor)
Distributor	International sales agent; producer's rep; producer, marketing and selling distribution rights and in return receiving commission.	Marketing by sales agent and international markets
Shoot/post	Production company/producer, director, cast, crew, studio locations, labs, support services, post-production, supervision, facilities. (Director, producer and financiers normally involved in final cut and sign off of product.)	Marketing use of PR on shoot
Financing	Producer(s); production company; package, including the script, director, cast, national and international pre-sales (if available), sales estimates, co-production, co-finance. Funds/partners, national subsidy finance, national broadcaster. Finance, equity, bank, gap finance, tax financing. Executive, associate and co-producers. Talent agent, talent manager, lawyers. Completion bond. Insurance.	Lawyers, talent agents
Development	Concept, idea, underlying material, producer (creative), writer, development executive, script editor, development financier, agent, director (as developer with writer or as writer/director). Private equity rare at this stage.	Regional and national subsidy support and/or broadcaster support.

Source: Finney, A. (2015/2022)

established model is being re-examined and adapted on a regular basis (see Netflix case study, Chapter 16), the pressure on the producer's fee rather than a sharing in revenue streams on an ongoing basis has fundamentally altered the international film business model. Top worldwide A-list producers, including, for example, Andy Harries, MD of the prolific Left Bank Pictures, have gone on record to explain their concerns about recent significant realignments in the revenue-sharing agreements; while others, such as US genre guru producer Jason Blum, have pointed out that it encourages producers to increase budgets (and thereby increase fee levels), as that is all they will receive with regard to the bottom line.

The film industry's historical obsession and reliance on restricting user access, ergo the creation of scarcity of access, and hence the control of pricing, is in post-free fall.

There is a clear shift of power in the value chain. Changing technology, social media and user demands are challenging the established "windows" structure long favoured by both the studios and all independent distribution incumbents. It's not just mass-market economics on view: local audiences and communities are rising up, drawn to streaming content in part thanks to a global pandemic, but also demanding culturally specific stories that explore their own communities.

Change has initially been embraced slowly by the film industry: while studio incumbents have struggled to turn their tankers around (with the notable exception of Disney and its dramatic arrival into the streaming market via Disney+). Weaker independent players have found themselves caught at the bottom of a V shape: declining distribution advances (e.g.: minimum guarantees that have historically been used to finance independent film production), a lack of bank and appetite and lowering of expertise in lending and risk management, dwindling DVD revenues and free TV values, primarily thanks to the onslaught of Subscription Video-On-Demand (SVOD), a rising Advertising Video-On-Demand (AVOD) market and a wide and growing range of streaming customer value propositions. Some studios have benefited by tackling the challenge head-on through acquisitions and new sites (including Disney, Warner Bros, and to a lesser extent Paramount via Viacom etc.), while others have no fully-owned and controlled 'go-to' platform (Sony) to place their tentpoles, although Sony's close relationship with Netflix is making up for its slow start. By sharp contrast, independent companies typically lack the scale and volume to compete, unless they are A-list content developers, producers and talent that can be relied upon to deliver with reliability and without painstaking micro-management.

The advantages of the independent sector's film value chain rested on its design and tacit understanding between players that served to combat uncertainty in the economic and risk management "links" in the chain. Observers have argued that the value chain that connects the film producer/financier/seller/distributor exists in order to combat uncertainty:

> The Film Value Chain model depends on conventions, where action is only rational between certain practitioners and is enabled through the use of evaluative frameworks that coordinate action and enable filmmakers to operate under uncertainty. Such evaluative frameworks include budgets, financial plans, recoupment charts and sales estimates. Sales agents estimate the potential high and low prices that a film will sell for to a distributor in each territory around the world. These figures allow for coordinated action across segments of the value chain. Producers in turn depend on these estimates, combined with some pre-sales to test the commercial market appetite and pricing, alongside the 'reputation' and track record of the sales company attached. The sales company, or 'international distributor' has a historical and current understanding of what combination of prices it will attract in order to a) service the production's ability to close its finance, and b) contribute effectively to its own portfolio of product and ultimately capture value and profit for its own business operation" [6].

As the Internet starts to dominate the circulation and consumption options beyond the cinema, the context of existing evaluative frameworks can be questioned. Social media data, for example, has fundamentally changed the relationship between upcoming product, appetite and performance. Terry Ilott, former director of the Cass Business

The Restructured Film Value Chain

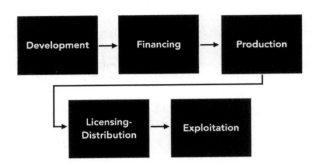

Figure 2.3 The restructured film value chain.

A. Finney [6]

School's Film Business Academy, has argued that, given this level of disruption to traditional business-to-business middlemen and gatekeepers, the film industry will become less "special" and more like other industries as larger parts of the value chain, freed from capacity and scarcity constraints and able to implement differential pricing based on a more direct relationship to the user, are thus enabled to take on so called "normal" commercial characteristics [7].

Such changes may result in more producers undertaking their own distribution arrangements, whether they are negotiating with multiple territorial distributors or nailing their own worldwide or multiple streaming deals. Both actions mean that sales are cut out of the value chain, leaving it looking more truncated (see Figure 2.3).

Convergence has placed the "user" at the heart of any emerging business models. New businesses are zeroing in on how well-informed consumers are using the functionality and content now available across the full range of devices, platforms and services that they own or receive. These new digital technologies have also concurrently shrunk and yet opened up key sections of the vertical chain model. Increasingly, films are distributed and circulated at different stages of the old value chain and move on from there.

The pressure and speed of change

The World Wide Web and the emergence of digital platforms have all been designed to connect us together, even when we cannot or are limited to travel in a time of a global pandemic, as I write. The rising level of global connectedness and integration rose exponentially during Covid-19's occurrence. Metrics published by DHL Global Connectedness Index in its 2020 report [8] showed that cities research indicated that global internet traffic shot up 48% between mid-2019 and mid-2020. "The experience of being trapped in different physical places … has left people inhabiting different mental islands, even if they seem connected by cyberspace … extreme globalization has suddenly collided with stark localization, creating a confusing mix," Tett concluded.

The overall media environment, which includes film, television, music, live events, games, virtual and augmented reality and user-generated content to name the dominant sectors, is under considerable and increasing pressure with increasing competition

for people's time, attention, money and loyalty. Stepping away from feature film and long-running drama series for a moment, it's revealing to review the growth in other key media and creative industries, and how their value chains have also been turned upside down. Take the music industry: In 1984, nearly 40 years ago, 6,000 music albums were released in the UK alone. Today, streaming services make available a similar number re volume – 55,000 new songs – every single day. Since Spotify opened for business in 2009, the number of UK songwriters has risen by 115% to 140,000 and the ranks of UK recording artists has mushroomed by 145% to 115,000. Back in the late 1990s, there were 5 UK major labels and around 24 independent distributors. In 2021 Spotify is hosting music from more than 750 suppliers [9].

Former Spotify chief economist Will Page knows his market: "There are also more genres to classify all these songs. In 2000, the music industry classified all the world's music into no more than a dozen and a half genres. In 2021, Spotify's 'every noise' acoustic map tracks 5,244 genres". Page makes the point that the music industry (and its inherent traditional value chain model) was one of the first industries to be hit by digital disruption: "Its fate shows the rest of us the future. When digitization removes barriers to entry, there is so much more of everything.". He points to other media and creative industries. 2020 also saw an uplift of new books – more than 5.5 million titles, although only 20% were new titles; podcasts (885,000 new episodes – almost two new podcasts every minute), mobile games (88,000, up 50% on 2019) and scripted original TV series (nearly 500 in the US alone) – more than one a day being produced and delivered.

The problem, well explained by Page, is that music artists are paid on a royalty basis. Just as independent producers lost out to video and DVD revenues over the past 50 years – shut out due to rising prints and advertising costs on the theatrical window and a marginal share of the most profitable exploitation windows for years, so too are today's musicians being shoved to the end of the revenue queue: "Three big labels make more than $1m an hour from streaming as artists struggle to pay rent" [ibid.].

What do these changes mean for the international film business?

The production and distribution of audio-visual content in particular has been affected in the past decade by:

- Technological change, including a considerable increase in bandwidth specifically within Western Europe and North America, but also that change is impacting first and second world regions across the globe. Now India, Africa and, operating in its own "walled garden" with increasing regulatory restrictions, China, are also key players in the social media information mass market, whether global or territorially orientated.
- Audience fragmentation and migration: Territories, communities and a growth of expats and diaspora who are keen to see their own lives and communities, values and issues reflected on the screens they watch are significant audiences.
- An increase in multi-tasking skills and multi-absorption of varying media simultaneously has taken place in viewers/customers/audiences. These viewing/clicking trends are particularly borne out by the rise of online gaming, YouTubing, Instagram, Fortnite, TikTok et al.

How to turn this into the global game?
- Between countries
- Between filmmakers

- A rise in social networking and associated user-generated content and collaboration. See above, in particular Gen-Z (see Chapter 20).
- A rise in multi-channel, interactive broadcasting, placing increasing pressure on traditional broadcasters and their licensing model or advertising supported model, given that such models are no longer "a license to print money".[1]
- An increase in populist, interactive programming involving the public as lead players and contestants. And now, social influencers, about to be supplanted by virtual influencers, have arrived.
- A change in payment/billing mechanisms. This, in turn, has had a considerable impact on subscription and advertising-supported online models moving beyond physical and digital; piracy.
- A rise in the public's ability to produce and distribute (often cost-free) their own creative endeavours, including music, words, photographs and video.
- Interchangeability between mediums, with decreasing and less clear boundaries between online networks, short films, recorded music, photos, podcasts, virtual and augmented reality etc.
- Transferability of intellectual property, franchises, story universes and talent from one component to another or a number: For example, a TikTok star on a show shifting to Netflix or Amazon; or a YouTube short being picked up adapted to a long-form scripted show etc.

[handwritten margin note: Networking w/ pros]

The effect of the above changes have not in large been driven by old-style broadcasters and filmmakers, but by a range of new companies meeting consumer demands in ways the old systems did not. This former 'supply-led' model to a 'demand-led' business trend has changed the exclusivity of existing suppliers and gatekeepers. For decades, the decision-makers, notably commissioning editors, enjoyed a tyranny of control over the selection and green lighting of content, as borne out by the TV Value Chain Model (see Figure 2.4).

While broadcasters and commissioning editors in the TV world have habitually referred to "choice", what they usually meant is a choice of content: Chosen by those decision-makers themselves! Those choices are being thrown into a new world of ubiquitous access and fickle customer loyalties. Films and programmes have long

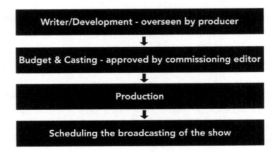

Traditional Television Value Chain - *Commissioning Editor Model*

Figure 2.4 The TV value chain model.

A. Finney 2022

tended to be prototypical, one-offs that demonstrate little indication of future success, as explained by reference earlier to William Goldman at the start of this chapter. Hence the entertainment industries, in particular independent film and television, have downplayed retail management (with the notable exception of Amazon and Amazon Prime, and to an extent Apple) and failed to deliver customer service to a level that competitive high street brands have aimed to achieve but have now lost control of due to changing behaviour. The overall emphasis and shift to the "lifetime customer value model", as explored in later chapters in this book.

Developing business models

Today's media incumbents are having considerable difficulty changing their own predispositions, assumptions and entrenched mindsets. Media companies creating, licensing and distributing intellectual property rights (IPRs and their inherent copyrights) have tended to rely on relatively complex business models, traditionally based on a mixture of advertising, subscription, licence fee (e.g. Free TV), pay-per-view, sponsorship and sub-licensing etc. None of these models necessarily placed the customer value proposition in pole position. And now the "traditional" models are starting to struggle, fail to adapt, merge, acquire businesses they don't understand, and/or go bankrupt in the process.

While there are key inherent dangers lurking in this bipolar positioning (where all sides may well fail to see and navigate the future clearly), there are also positive areas of potential advancement. Specifically, barriers to entry for smaller and independent companies are lowering, and opportunities for creative talent to develop with less sunk-cost risks associated with physical production are promising: as long as they can ultimately reach the market. The promise of a new, increasingly efficient marketplace that is responding to the needs of new users provides for new commercial opportunities, which in turn also offers potential cross-media synergies for the entertainment industry. Lastly, there is increased possibilities for interaction with other markets linked to the core product, and able to be exploited and disseminated simultaneously across new platforms and accessed (and potentially paid for) by a myriad of user-friendly systems. Ultimately, the adoption of a more holistic approach towards IPR/ copyright exploitation, in particular at the initial rights stage, and multi-platform promotion and circulation will be essential if the cost of new content is to be successfully amortized. Hardly new, given that the studios have been operating it for decades, is the much-discussed "360-degree" model. In the "future is now" multi-channel world, where the user has infinite choice, creative businesses need to compete not just against rival product, the maturing user-generated content and alternative entertainment providers, but with other non-media businesses competing for the user's "share of mind" and marginal utility. This requires early consideration and assessment of all potential forms of exploitation, adoption and promotion of film in particular if the restructuring entertainment value chain is to be mastered. How this fits with the model of a film producer who currently populates, for example, the European independent film market, begs serious commercial questions.

"The 360-degree model only really makes sense if it is matched by a focus on brand, genre, talent and/or defined audience/community", explains Terry Ilott... "Drama does not lend itself to the 360-degree approach, yet it is what nearly all UK indie producers focus on. The 360-degree model also requires volume, which in turn means flexibility

as to budgets, formats and platforms. Again, indie producers don't do volume." Ilott goes on to underline recurring weaknesses in the producer value chain, as few production companies are appropriately resourced; few have business skills to match creative skills, and rarely is the independent film producer armed with equivalent knowledge and skill in television, games and new forms of content [10].

Vertically integrated, multi-channel exploitation remains vital to the sustainability and commercial development of the independent film sector. New product has the potential to be positioned and accessed through a multiplicity of revenue channels. This strategy demands a certain level of knowledge of the market for each opportunity, but it is also possible to acquire this through a series of partnerships or joint ventures, something anathema to many SME-sized independent production-orientated outfits. By avoiding the integrated approach, such outfits are losing out on a direct relationship with their audience, and the virtuous circle created as each strand of exploitation promotes and reinforces each other.

Opportunities: the new battleground

It is clear that the early part of the film value chain will not face the same disruptive pressures that the latter parts currently have to confront. Development and the production process remain constants, although formats and transmedia storytelling will start to have an impact on the selection process of material. Finance is definitely evolving and reacting to the uncertainty of digital revenue streams and the cannibalization of what used to be separate, controlled windows and profit pools; simultaneously, distribution is facing a significant revolution. The rise of the dominant 'Super Producer' connected with the audience as well as the pipelines offered by aggregators, is already among us (see Figure 2.5 re the 'super producer model below).

The new entertainment value chain places the aggregator (e.g. Google, Amazon etc.) at the centre of financing/distribution. We should watch out for consolidation, and the emergence of "super-independent" players that are linked to aggregators – who, in turn, control platforms and content access – and are able to achieve scale and critical mass. These international distributors will have the ability to release through third parties in appropriate theatrical territories, while concurrently exploiting their digitized libraries and new product on multiple digital outlets and platforms. In turn, the aggregators will have both a considerable impact and potential control over the industry's emerging structure. Responsibilities have grown for the 'super producer', but the many routes to market (see Figure 2.6) have become rich with opportunities, including the traditional route, the streaming route and increasingly the route direct to audience, a trend we will see more of in time to come if content makers are able to hold on to their IP/copyrights.

The Super Producer Model - *How the value chain looks today*

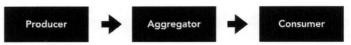

Figure 2.5 The super producer model.

A. Finney [6]

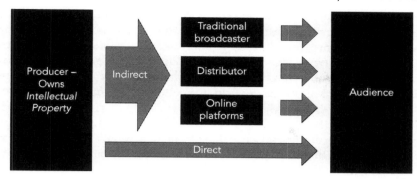

Figure 2.6 The producer's routes to the audience model. A. Finney 2022

Create a competitive marketplace *Add*

Even Super Producers suffer from one apparent and inherent problem: access to information and audience data. The newly arrived information gatekeepers – including the open model of Google and its acquired offspring YouTube and the closed applications of Apple, and the ever-private Netflix, play critical roles in determining how and if filmmakers and their consumers get access to what and, crucially, on what terms. Audience data sharing is now a far cry from the daily and weekly Variety box office reporting of old. It exists, but it's not for sharing.

Neither is the aggregator-driven model one that greatly encourages traditional film distributor options given the changing revenue stream model. "You're facing a situation where you make a film", explains Simon Franks, the successful entrepreneur and distributor, and chairman of Redbus. "Let's say it does £5m at the UK box office, which is always the hurdle to profitability in most films, and there is still a prints and advertising loss at that level. But now you need to make all your prints and advertising back and pay for the film and the profit just from one source, which is the second and now only window. … I don't like the idea of that. I don't like the idea of having to rely on just one window and one entity in order to become profitable" (see Chapter 29: Redbus Case Study).

Overall, it is the ever tightening of the film (and entertainment) value chain, whereby the producer is brought much closer to the consumer (and hence the revenue streams being recouped), that is of significant interest. Niche audiences, once able to be tapped and marketed directly, have significant value if they are able to be reached less expensively. Communities offer the potential for fan bases and, on occasion, significant commercial core audiences. As part of work published since the last two editions of this book (2010, 2015), it is instructive to see how my own former students are taking the argument forward.

Michael Franklin, a former Film Business Academy MSc student and now research fellow at St Andrews University, frames the new environment via the historical insecurity of the traditional film value chain:

> Recognising and interpreting new evaluative frameworks is becoming integral to managing uncertainty and reformulating the film value chain for the digital age. To put it simply, digital tools allow producers to react to consumer demand uncertainty in two ways. Firstly, by engaging with the potential audience earlier and to a greater degree; through interactive media and extended content producers

Didn't know I needed D-Kin

create greater demand and thus increase revenues. Secondly, in order to claim a larger share of revenues, filmmakers pro-actively pursue dis-intermediation by circumventing some segment(s) of the traditional film value chain via the Internet. The success of this second strategy often relies on the success of the first. The removal of the traditional sales agent, distributor or exhibitor, who traditionally funds and executes all marketing activities, means that their marketing role and resources must be replaced [11].

The above argument will depend on independent film producers striving to achieve a hybrid model – one that Franklin notes and this author has been using as a model when training and teaching at an MBA level and to professional trade associations. By hybrid I mean that producers and entrepreneurs in the film and scripted content space need to understand and master traditional and current tools for selling and marketing their films and shows, but concurrently start designing and working on digital and social media aspects that are growing increasingly critical to finding and winning an audience. They may also need to consider traditional "cornerstone" finance next to new pools of finance from crowdsourcing and crowdfunding, for example, or how to effectively 'knit together' streaming and traditional financing so that they achieve alignment of interest and a complimentary structure rather than assuming an either/or scenario.

Ultimately, Internet marketing and its ever-increasing growth in sophistication and specific demographic reach and targeting, will encourage end users such as cinema owners and chains, Pay-TV operators and even video/streamed game operators to enter the production market themselves, as many are now doing. Global aggregators, such as Google and Apple, are also priming the pump. A world where these players decide to buy shares in companies that commission development and feature films which, in turn, help drive their respective platforms is cutting out third party distribution completely. Such a move in strategy by players operating with global scale and reach is now bearing witness to a very different, restructured film value chain.

Note

1 The quote marks define an oft-stated view that the ITV franchise winners in the UK were effectively given "a license to print money throughout the late 20th century". That view has changed post 2000.

References

[1] Bloore, P., *The Screenplay Business: Managing Creativity and Script Development in the Film Industry*. Abingdon: Routledge, 2012.
[2] Porter, M.E., *The Competitive Advantage: Creating and Sustaining Superior Performance*. New York: Free Press/Macmillan, 1985.
[3] Porter, M.E., 'Strategy and the internet', *Harvard Business Review* (March): 63–78, p. 74. Boston: Harvard University Press, 2001.
[4] De Vany, A., *Hollywood Economics: How Extreme Uncertainty Shapes the Film Industry*. Routledge, 2004.
[5] Goldman, W., *Adventures in the Screen Trade*. Warner Books, 1983.

[6] Finney, A., 'Value chain restructuring in the film industry: the case of the independent feature film sector' (Chapter 1). In *Perspectives on Business Innovation and Disruption in Film, Video and Photography*, eds. P. Wikstrom and R. DeFellippi. Edward Elgar, 2014.

[7] Ilott, T., '50 theses on film'. Unpublished Paper, Film Business Academy, Cass Business School, 2009.

[8] Tett, G., 'Globalisation 2.0: is it time to reconsider how we connect?", *Financial Times*, 20 February 2021.

[9] Page, W., *Tarzan Economics: Eight Principles for Pivoting Through Disruption*, 18/05/2021.

[10] Ilott, T., *Film Business Academy*. City University, 2009.

[11] Franklin, M., Internet-enabled Dissemination: Managing Uncertainty in the Film Value Chain. In *Digital Disruption – Cinema Moves On-Line*, eds. D. Iordana and S. Cunningham. St Andrews, 2012.

3 Development and the producer's roles

Just write some treatments [handwritten annotation]

> I always look for a good story. That sounds very simplistic, but you'd be surprised – it is the most difficult thing to find.
>
> (Producer Kathleen Kennedy, president of Amblin Entertainment)
>
> The basic art of motion pictures is the screenplay; it is fundamental, without it there is nothing.
>
> (Raymond Chandler)

Introduction to film development

Development is the chronological starting point for all producers, writers, writer/directors and many directors who do not actually 'write' screenplays when embarking on the film process. It is the place that ideas, stories and projects start their lives: it comprises the core "material" from which all other matters pertaining to a production flow from. From here, early-stage conceptions need to be stimulated and nourished, and driven forwards through a range of different stages. As such, the development stage of a film project is the bedrock to subsequent film activities, including packaging, financing, pre-production, principal photography, post-production, sales, marketing, distribution and the subsequent film exploitation process to audiences.

When professionals refer to 'development' in most industries, they are normally making reference re 'R&D', meaning 'research and development'. This can be described as an upfront, long-term investment normally involving considerable sunk costs that are unlikely to be returned quickly, or, in many cases, not at all. Nevertheless, long-term planning and the opportunity costs associated with building a strong product and an occasional discovery are deemed critical to a healthy industrial model. However, development within the film industry – and, in particular, development outside the Hollywood Studio system – operates within a much more precarious infrastructure.

For the purposes of this book, development activity is defined as the work that surrounds the initial concept or story idea, the acquisition of that idea, the screenwriting process, the raising of development finance and the initial stage of production planning. In addition to the seeking out of either original ideas or secondary source material (meaning books, articles etc.), development is traditionally considered to encompass the writing of treatments. These are normally documents consisting of around ten pages of story outline without dialogue. A treatment is used to map out

DOI: 10.4324/9781003205753-4

a story or concept, and for potential parties to consider if that story or concept is of interest to develop further into a screenplay.

Following a treatment, some writers opt to develop a step outline, which blocks out each scene of a screenplay but does not include (normally) dialogue of the characters. This helps provide a further guide to the writer when they come to flesh out the story into a full screenplay. Indeed, some literary agents and producers find a well-developed, detailed step outline can be a better indicator of a strong project than a formal treatment. And the writer is in a good position to switch from step outline to screenplay as most of the further writing is dialogue-driven. However, the document most used to raise development support (partners and money) is the treatment, rather than a step outline.

The early stages of feature film development

The initial idea stage is a loosely structured area with a considerable number of possibilities when working with feature film concepts. An idea may take a variety of routes towards a full screenplay commission. The flow system in Figure 3.1 shows some of the different routes that are often taken.

The initial idea of a script [1] can be an idea, a treatment, or a first draft screenplay. Unsolicited scripts from unknown (or unrepresented) writers [2] will, in the majority of instances, move through to a reader first [3]. Readers are professionally employed script 'reviewers' who have to follow a set of relatively standardized rules and form-filling. These normally include: a logline; a one-page synopsis; and then a

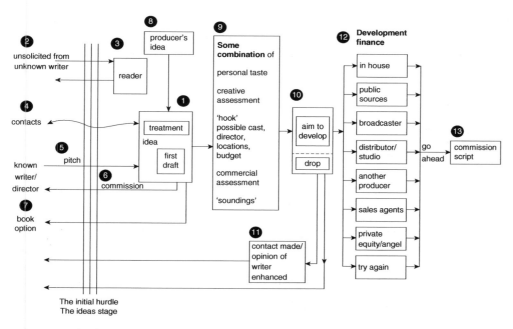

Figure 3.1 The film development process.
(Source: National Film and Television School/A. Finney)

critique of the script that includes the relative strengths and weaknesses of the story, the commercial appeal, the dialogue, the time and setting, the pace and emotional value of the script etc.

Most unsolicited screenplays will be rejected. A very small percentage will come through as an idea [1] from development. Ideas also come from contacts [4]; a pitch by [5] or commission to [6] a known/established screenplay writer; or from the buying of book option [7]. A large number of creative producers generate ideas themselves [8]. The producer will then normally assess the essential idea/concept through a combination of taste, creative assessment, 'hook', possible cast, director, locations, interiors and budget [9]. On this basis, the producer may decide to go ahead with the development, or to drop the project. His/her decision often depends on whether the producer's idea and writer can be 'set up' at a development home (in the independent market, this would include a broadcaster or subsidy player; in Hollywood, it would mean a studio or well-financed independent production company).

To develop an idea, a producer will either have access to their own finance or secure third-party finance. This can come from an in-house source, from a public development fund, a broadcaster, a private financier, a distributor or the producer themselves. It should be noted that certain independent producers prefer not to set up projects at the early stage of development, as this ties both them and the rights to a particular financier. "It's always better to see if you can either convince a writer, or find the money to kick a screenplay off, rather than depend on a third party from the outset", explains producer Andrew Macdonald. "That way you really are the producer of the screenplay."

The producer also has to make a commitment in terms of time, energy, planning and focus; often incurring considerable expense through travelling to potential partners, financiers, markets and festivals. He/she will have to put a development budget together at an early stage. In addition, another producer or potential co-financier may assist with development finance. Once the finance structure has been at least part-raised, the idea will normally move into a fully-fledged development stage. This normally includes a first and second draft, one polish and the active raising of awareness and a potential 'package' prior to formal financing.

Development as a high-risk activity

Figure 3.1 appears to provide the impression that there is a straightforward, standardized route for developing ideas into screenplays, and then on to the market. However, the fact is that feature film development is an inexact and high-risk activity. Most production companies are, by their nature, heavily involved in the development process. And most film projects that start their life in active development fail to make it to the principal photography stage. While there are many different ways and routes to move a film project towards production, one element remains consistent throughout the independent film business: development is a high-risk stage of film production. There are no guarantees of a project's successful journey from idea through to treatment and subsequent drafts, from screenplay that is signed off by a director, and on to production – then distribution and exhibition, and finally to what should be the ultimate goal: an audience.

The role of the 'bible' for TV series

While on the subject of early-stage documents, the other key piece of work normally associated with long-running drama series (or mini-series) is the 'bible'. The bible is written by the writer, and normally will require between 15 and 25 pages, headed by a Series File Card that states title, format, genre, period, producer(s) and talent attached, and tagline/log-line. It's important to pay attention to the name/title of the series as this is the start of your positioning and marketing strategy. The Card needs to specify how many episodes the first series will have, and how many potential series you're planning. While 'repeatable' series appears to have been all the rage in the 2020s to date, there is a general awareness that audiences, in particular streaming "members" as Netflix boss Reed Hastings likes to call his subscribers, are fickle and switch preferences on a monthly or bi-yearly basis – meaning that by the time a series reaches screens it may well be out of sync with the strategy that informed a 'yes' decision made so many months or years previously. What comes next may differ according to writer and producer's taste and style, but you would need the following:

- Synopsis is critical, but one page is best
- Motivation: A short statement about what inspired the series
- Ultimate objectives
- Key content themes (political, love, history, social justice, loss etc).
- Genre: What 'type' of material is it? Comedy, thriller, horror, action etc.? Don't mix genres if you can help it as it confuses the audience and will be off-putting to most commissioning editors.

Themes are independent of the genre, and potentially provide a rich range of reasons why the material is compelling, authentic and arresting – all factors that can make the difference between being read, or not read, let alone moving to the next stage. Themes play a crucial role as they help establish how the viewer will identify with and relate to the characters. Thematic schemes are directly related to the way you tell the story and why the audience is going to be hooked. Examples of classic themes include:

- Desire: *Breaking Bad*
- Morality: *Mad Men*
- Power: *Game of Thrones*
- Supernatural: *Stranger Things*
- Flawed genius: *The Queen's Gambit*
- Period romp: *Bridgerton*
- Crime thriller: *The Serpent*
- Police thriller: *Line of Duty*
- Family comedy: *Schitt's Creek*

A page on lead characters and supporting needs to be included. Indeed, given the long format, there is considerably more space to develop in-depth characters than in a feature film format. Key is descriptions of motivations, psychology, and objectives:

- What do they want? Why can they not have it?
- Some physical descriptions and ages help

All going to die one day
- Pass it on !

- Spell out the protagonist(s) and antagonist(s)
- Why do we care about them?

Empty the Scary pages

Next up is a Plot Map. This is the thematic development of the story, outlining what will happen in each episodes. Some writers design a table where you develop the main plot and add subplots, but I have seen examples which quickly become so complex that they are overwhelming and ultimately confusing. A Plot Map can be organised around characters, chronology, and placed in their order of importance. Characters and their actions tend always to be best to "drive" the plot, rather than storyline by numbers and events.

The style and aesthetics are also worthy of a page. As the writer you will have your vision/views, but the precise content will require input from your producer(s). If the show is period it will dictate certain expectations and pricing, while futuristic/sci-fi (SFX/VFX) is also critical to map carefully, making sure that you have established the rules of your storyworld's universe. What makes it different, original and attention grabbing? Does the landscape/scenery/setting play a critical role? You will need to consider who you are sharing the document with, as much depends on what stage the project is at and what your next intended steps are. A writer will work with producer and they may add further details, such as the wider creative team, CVs, cast list (intended or confirmed), locations, budget, production plan, finance plan, full treatments, scripts etc. However, it is advisable to have at least the pilot script or first episode written, edited and ready. Comparison titles (aka 'Comps') are fine, but always aim while being realistic. Much emphasis is placed on visuals, which need to be compelling and of an outstandingly high quality. Poster images or cover and photos for a bible can be really compelling, while a mood reel/ proof of concept is very important (Netflix insists on this).

List Stages and

Development of feature film projects is a relatively expensive area of risk investment. With reference to Chapter 2, The film value chain, we see how far the development activity and initial seed money is from the final end user. Not only is the development stage distanced from the exploitation stage, but it requires considerable sunk costs to even bring a project to the point of potential financing. For example, a European film with a budget of around €2–4m may cost between €50,000 and €150,000 at a minimum to develop to the point of official pre-production. By contrast, larger budget films of around €7–10m may cost as much as €300,000 to move through development and into production.

×3 – film

How to support first time filmmakers

The US independent marketplace, by contrast, tends to be more ad hoc and opportunistic: many writers and directors in the early stages of their career are more set on getting a first feature into production than following a linear, albeit limited, development structure. And with the absence of public funds and broadcaster support systems, the US independent filmmakers' entry points are, on the one hand, harder regarding the lack of financial support, but more open to the commercial whim of the open market. Within both approaches, the surrounding but strategically central elements to the scriptwriting process itself tend to be ignored or at least downplayed. These include research and acquisitions of rights for source material (often ignored or treated casually at the early stage by new writers and filmmakers, at their peril often later down the line), treatment development, the building of a 'package', the raising of

finance, the positioning of the package to the relevant part of the international market, and the costs of paying script editors or hiring additional writers.

Independent film producers have traditionally seen development costs and time spent on the process in relation to their projected return from production fees (if not forced to be part or fully deferred) and potentially retained rights. The preoccupation with production has mainly stemmed from the fact that when producers are in production, they are being paid. This approach has tended to obscure the financial and practical elements essential to a concrete and healthy development process. Crucially, it has also led the producer to take a less realistic, hard look at the projected 'value' of a project, and how to realize that value in the marketplace.

In addition to the fragmented economic model referred to previously, the European producer has also had to deal with the 'auteur' challenge. Part of Europe's idiosyncratic blind spot regarding development is an historical one, and stems from a very heavily developed 'auteur' culture, where film directors have enjoyed the majority of the power in the filmmaking process. This is particularly the case in France and French-speaking territories, and to a large extent in Spain, Italy and many smaller territories. The results of this dependence have led to feature films tending to be rescued in the cutting room by film editors rather than script editors before the main budget was spent. European writers, in particular, have tended to be marginalized by the auteur system, while producers have arguably lost out and have been seen as financial servants for the directors.

The Studio model

Most comprehensive models that offer a fully-fledged, integrated development process are generally found within the Hollywood Studio system. Nearly all independent filmmakers lack Hollywood-type studio infrastructures. The independent sector rarely attracts the capital or larger entities with which to invest and manage development in an industrial manner. Individually run companies are forced to drive their ideas and screenplays from the bottom up and the potential for a 'national' film producer to recoup the costs of a production from that one territory alone is normally unfeasible. Most individual territories, in particular in Europe, are not large enough to recoup the negative cost of a film's budget. And those international territories that are large enough to fund and recoup within – including, for example, Japan and South Korea – tend to drive highly domestic product that rarely sells or travels across the global market.

'On-the-block' development deals – where a production company is attached to a studio – hardly exist in Europe, mainly because there are no studios operating on the same scale as Hollywood. A major studio or major film production company with direct links to distribution normally treats development as a fixed cost within its overall annual budget and longer-term business plan. A portion of this expenditure is allocated to each film as an above-the-line cost. In Hollywood, the studios tend to place development costs at around 8–10 per cent of a film's total budget. Hollywood's development to production success ratio is very low, with estimates placing it at around one in twenty projects making production. By contrast, around one in five or six screenplays is placed into production with the European system.

At its simplest, hit films that go on to make a profit repay the costs of unmade screenplays and projects. Profits are then pumped back into the development

Automate The Prod Cycle (handwritten margin note)

system, and the cycle of production is continued. Estimates place the studio system's annual spend on development at more than $1bn. "That is what Europe is competing with", producer David Puttnam points out. "It is administered by very experienced executives working at an energy level almost unknown in Europe. It is fed by a very aggressive and well-run agency system at every level. The process is on a different planet."

On closer examination, the studio system and its approach to development is far from linear. A typical Hollywood development department would generally be handling around 20–30 solicited ideas and scripts from numerous sources. These ideas would emerge from movies, TV shows, books (fiction, non-fiction and biography), articles, plays and comic strips etc. Executives working within this system have their own approach to seeking out material: some are 'pitch-driven', and want a story or idea told to them during a meeting; others are material-driven, and want time to read a treatment or story outline along with background material. Some act like producers and come up with new ideas for which they then find a writer to come on board and commission.

One senior studio executive described the aspects of her job as follows:

Make it easy to love the idea (handwritten margin note)

> I spend every waking hour thinking about what might be a good movie. I talk to as many people as I can to find new ideas. People call all the time with pitches. If certain people call me with a specific movie pitch, I schedule an hour with them to hear the story … I have found over the years that there is no sense in buying something that I'm not personally invested in. We spend so much time developing these ideas into scripts and then movies, that it is important to love the idea. After buying an idea, the next step is developing a workable script. That can take months, or even years. We work closely with the screenwriter and help line up the director and key actors, as the script gets closer to completion.

The social network of contacts, friends, and the flow of information within the studio system is essential glue to this industrialized development process. But there are inherent pitfalls and dangers within this highly pressurized and competitive sector. Stay too close to the same people, and the ideas may become less fresh. Become dependent on the same teams of talent and you can run the risk of becoming tired and uninventive. "When you stick to the same collaborators for too long you may run out of creative frictions", observes director Peter Weir.

Whilst the above structures, all tightly organized around weekly development and approval meetings, appear solid and focused, there are well-documented (both formally and informally) weaknesses in the above system. By taking into account the recent history of each film's performance, and, crucially, by depending on a marketing department's assessment of a package and previous data on starts, director, genre etc., there is a pervasive tendency for development executives to either say 'no', or fire writers and hire a new one, or veer at the start of the process to distinctly homogenized fare for fear of stepping outside the wagon circle. They need, after all, to look as if they are doing something.

Independent producers close to the studio system tend to treat independent sources of finance in a similar manner to a studio, albeit at a different level of financial support. While an on-the-lot, in-house producer will normally have an office, an overhead, a 'quote' price for his/her production fee, and a development budget agreed with

a studio, an independent producer off-the-lot will seek a development fee (normally in the range of $25,000–$40,000) as they prepare to work with a financier/indie house on an agreed project. No such system operates in this manner outside the mature independent marketplace in the USA.

The writers' place in film development

The key starting point for every feature film is the 'idea'. The creative concept of what will make a potential film lies at the centre of development. In turn, the writer is at the heart of the creative development process. In many cases, he/she will either initiate an idea for an original screenplay, or suggest an adaptation of an existing book or work. The writer may develop an outline of 1–2 pages, or a more fully-fledged treatment of 10–15 pages before approaching a producer. (Sometimes the producer will write out the outline and then seek out the appropriate writer.) More experienced writers are approached by producers to adapt their ideas for a film or to work on a story for which the producer owns the adaptation rights. In contrast to the studio system, few non-Hollywood writers work on teams or even in pairs. Many writers in Europe have emerged from television or theatre, and have often written long-form literature such as novels and non-fiction books.

Above all, many writers for independent cinema are isolated and unconnected from the main arteries of the film business. Few are 'networked' into the channels that would help move their projects through development and into production. Above all, they often lack close and trusting relationships with film producers capable of stable conditions both creatively and economically. Indeed, according to the Federation of Screenwriters in Europe:

> it is often the case that writers write scripts 'on spec' (without a specific commission), and often accept low or non-existent payment for early stage development in order to try to assist projects into development. Fees paid for actual development or production rarely take into account the level of high-investment by writers into projects which often do not even go into production. In effect, writers often subsidise project development.

By way of contrast, it is relevant to compare the television fiction development process that is normally followed by the Anglo-centric model. Generally, the producer initiates an idea, and then commissions a writer to draft both an outline and screenplay drafts. In order to facilitate both payment and a potential market for the project/series, the producer normally sets the project up with a national broadcaster after they have approved the outline. No director is considered at this point. Only after considerable drafts, during which the producer gives significant creative input, is a director even considered to be attached to the project. This process is not to denigrate the role of the director – but underlines the critical importance of the script(s), and the overall creative thrust of the project as derived by the partnership of the producer and writer (or writing team). "The director is of course vital once they come on board, but they don't guide and shape the creative material from the start", explains *The Queen* and *The Crown* TV and film producer Andy Harries. "It's the producer's responsibility."

Script editing

The role of the script editor is generally embraced within the Hollywood system. In the United Kingdom, script editors are often used, but they tend to be trained and employed only within the broadcast sector, and are normally working in this discipline as a route up the ladder to writing, producing or directing. Experienced script editors are not generally employed on the Continent for feature film work, although work through the MEDIA's ACE and EAVE programmes has lowered some of the resistance with positive effect. Programmes adopted by some emerging territories, such as the South African National Film and Video Foundation's screenwriting strategy, have championed the stepped approach and actively included the role of the script editor, with interesting results regarding the improvement of screenplay quality emerging from the Foundation's slate.

A strong script editor can quickly spot structural holes in a screenplay. Problems with a screenplay can be solved earlier with the help of an editor, saving both time and money later in the production and post-production process. "A script that is far too long and ends up being shot is a disaster", says producer Bernd Eichinger. "Of course you can shoot it, and cut it in the editing room, but in the case of a big, $30m film, you are cutting away $10m that you could have saved in the first place."

Professional script editors are not executives or freelancers who simply provide 'coverage'. The coverage, normally executed in the form of a generally standardized script report, is used by executives, producers and even directors to pre-select (or pass on) material that they may be interested in working on or taking to a further stage of investment. Strong, high-marked coverage may simply mean that a project has been brought to an executive or producer's attention. It does not necessarily mean that they have read the screenplay themselves.

The varying roles of the film producer

While the screenwriter is at the heart of the development process, the producer should be right there next to him or her, supporting and driving the process. Producers often initiate films, raise the money for rights to adapt ideas and material, hire the screenwriter(s) and during the process, constructively analyse and develop the script drafts in partnership with the writer(s). Producers rarely write or heavily re-write screenplays. Ideas, and in certain cases, editing or restructuring is one task; fully-fledged writing is quite another. One of the key jobs of a producer is to work out how to make his/her writer write better.

The film industry tends to divide producers into two vaguely defined camps: the 'creative' producer and the 'financial' producer. Few practitioners are uniquely talented in both disciplines. Theoretically, an effective producing combination is one where two people – one creatively skilled and one financially astute and capable – work together on developing and producing projects, and building a sustainable company. Other experienced producers build a team of varying talents around them that complement and enhance their operation. For example, Jeremy Thomas has built a team that includes a highly capable manager and financial operator in Peter Watson; an experienced creative development executive in the late Hercules Belville; and a leading sales executive in Tim Haslam, who managed Hanway, the sales arm of Thomas's film activities (before setting up Embankment, now a leading sales operation, in 2012). Whilst Thomas drives

the selection of ideas, projects, writers and directors, he is constantly in touch with these key executives, who, in turn, help shape his slate and future business. That said, Thomas tends to always develop with a director attached from the start of the development process – making the director the central filmmaker from the start.

The term 'executive producer' is often applied to the producer who takes a specific role in co-financing a feature. However, over the past decade the term has become much abused. Executive producer credits have been insisted upon in return for early development commitments, or early attachment without active responsibility for the filmmaking process. Credits are insisted upon for relatively small and straightforward contributions to a film's overall financial package. American independent films sometimes credit more than half a dozen executive producers or more, somehow denigrating the credit itself. Public funds and their executives can also be an issue. Heads of funds can elect to either take a credit or pass on a credit. Above all, lead film producers should know the details of the financial aspects of their project and not delegate ultimate financing responsibility to an executive producer.

The creative producer

One of the key functions of the creative producer is to develop a strong set of relations with talent. Whilst directors and actors are important, the writer is where the development process kicks into action. Producers normally build up a trust and understanding over a considerable period of time with writing talent. Whether it comes through story ideas, structural suggestions or an ability to help the writers improve their work, the producer needs to have the writer's respect and trust.

Creative producers read solicited, and, in many cases, unsolicited scripts, treatments and story outlines. These normally come to them either through writers, writer/directors, talent agents, contacts or friends. In addition, the producer will have his/her own ideas and sources. The creative producer develops relationships with publishers, and attempts to see advance book lists and upcoming proofs and work as soon as possible. It they think that a book has potential for a screenplay, an option may be paid to the author of that work to protect the right to adapt it for a film. Normally, that option is for a specific period, after which the option lapses and the screenplay rights revert to the author of the original work. Many producers take out a two-to-three-year option on a work, or option for less time but with automatic renewals. Options are normally renewed because the development process has demonstrated progress and the producer believes that the project can reach fruition.

The creative producer also develops strong relationships with writers, actors and directors (and agents and managers who represent such talent). Above all, it is their flair and competence when dealing with and attaching talent that helps them develop successfully. This area marks out the importance of the balance between the producer, the writer and the director (if the writer is not also the director). The skill of passing a project from a writer on to the appropriate director lies at the heart of the producer's role. Managing creative egos and sensibilities is a highly complex task, and the producer will often need to keep the writer and the director separate for a period of development, rather than expose a director's viewpoint too directly upon the writer. In addition, no writer wants to hear solely from a head of development or a script editor; he or she wants to have the attention of the producer and direct feedback where possible.

The financial producer

The 'financial' producer (who is sometimes credited as an executive producer) is the person responsible for bringing together the different elements of the film's budget. Like the creative producer they too are aware of the relative 'value' of the project. That means that they need to know how much the different 'elements', including the book or source material, the writer, the director, the cast and the genre if appropriate, are worth in the marketplace. The financial producer will have a strong understanding of previous performance of the aforesaid elements; and will have box office and sales figures on previous films, genres and performance around the world. All this information helps the producer build a convincing 'pitch' for the positioning of a film in the financing and distribution marketplace.

It is the financial producer who should know all the different international sales companies, key distributors in different territories, private equity and banking finance sources, public subsidy funds – both national and supranational – and key executives within the medium and larger film production/distribution companies around the world. They need to know how different institutions and business cultures operate, and, critically, which people make decisions within them. This will include not just chief executives, but assistants, script editors, development executives, marketing executives etc. All projects need support and champions to gather momentum, and a strong producer needs to build a case for a project.

A key element of this process is 'testing' in the marketplace. This process requires considerable contacts, and the ability to gauge the right time to launch a project. The objective is to determine whether the marketplace will support a project, or whether a screenplay and package do not add up. This is not to suggest that the market's determination is universally empirical or scientifically 'correct'. Many world-famous hit projects that went on to box office success were widely rejected at their early or packaged stages. Others that appeared to appeal can fall at the final financing stage due to inherent problems and weaknesses that only become apparent at the point that financiers and distributors are forced to become partners and make commitments in order for a film to enter production.

Financiers and distributors only tend to read once. Sending out incomplete, early drafts, or projects without crucial elements such as a director or key cast attached, wastes executives' time. A producer normally only has one bite of the cherry. Waiting until a screenplay is well developed, with strong attachments will normally pay considerable dividends.

References

[1] A. Macdonald, MSc class, Film Business Academy, Cass Business School, The City University, April 2008.

[2] A. Finney, *A New Dose of Reality: The State of European Cinema*. London: Cassel, 1996, p. 18.

[3] A. Finney, *Developing Feature Films in Europe: A Practical Guide*. London/Madrid: Routledge/Media Business School, 1996, p. 7.

[4] G. Pisano and A. Berkley Wagonfeld, 'Pacific coast studios', *Harvard Business Review*, 10 January 2006, pp. 7–8.

[5] S. Ferarrai, G. Cattani and C. Baden-Fuller, 'Building projects through collaborative networks: A study on the determinants of project-entrepreneurs' performance', Working Draft, 2008, p. 13.

[6] 'Federation of screenwriters Europe', Policy Paper, 2008, p. 4.

[7] A. Harries, in interview with A. Finney, *Circle Conference*, Abu Dhabi, 9 October 2009.

[8] A. Finney, *A Bag Full of Tricks*. Berlin: European Film Academy, 1994, p. 14.

[9] For further reading about key producer roles and choices, see A. Finney, A.L. Hadida (2019) *The King's Speech producer's dilemma (Case A) and The King's Speech distribution dilemma (Case B)*. Published by: Cambridge Judge Business School, University of Cambridge: See SAGE Business Cases 2020 Annual Collection.

4 Development

The writer and the agent

An interview with writer and executive producer Ashley Pharoah (*Life On Mars, Ashes to Ashes, Wild at Heart*)

Author

It would be good to know more about how you kicked off your writing career, after you attended the National Film and TV School in the 1980s?

Ashley

I did the screenwriting course at the film school, and my graduation film *Water's Edge* did very well. It won me a short film BAFTA nomination, got me an agent, had I had some early commissions: I thought "off we go, lovely life!" Then of course, a first-time screenwriter writing movies? They didn't get made. Three years passed, four years passed, and I thought "oh, shit". I'm back on the dole. I had a friend from film school who was directing the [TV soap] *EastEnders* at Elstree and he said, "look, you should give it a crack". I was such a snob about television, let alone soap operas. I thought "I couldn't do that". He said, "you can't even afford the bus fare to get here", which was a good point. I sent in my stuff. I got an interview, I got one episode. I knew I was towards the wrong end of my twenties by now, so I worked really hard on that episode. I'd never really watched *EastEnders*, but I made sure I watched everything I could and read everything I could. The episode went well, I had more episodes, I spent three years there, off and on. Then I got a bit anxious that it was too comfortable. I'd not started out wanting to be a soap writer, so I forced myself to leave that comfort zone and I ended up writing on shows like *Casualty*, where suddenly you go from being given the story on a soap, to *Casualty*, where you're given the regular characters, the serial stuff, and then you can bring your own episode stories. That's exciting.

Then I went from there to write the first season of *Silent Witness*, which, back in those days, was a massive step-up. I remember having an interview with the producer and I could see him thinking "you're a soap writer and I don't want a soap writer on my lovely new film", but there was a script editor there that was called Vicky Featherstone, (who now runs the Royal Court), a fabulously brilliant woman and she said, "I think you should give this guy a go". Then, as happens a lot in the television business, you start to make friendships and relationships and those people that are runners one week, it seems next year are running stations. Vicky went off to ITV, and she had an idea for a series about district nurses in Yorkshire, which she asked me to write. That turned into *Where the Heart Is*, which ran for 10 years.

DOI: 10.4324/9781003205753-5

Author

Dialling back, just talk a little bit about the creative craft skills and what you learned from writing soap formats and characters, especially in terms of scenes and flexibility and thinking your way round scripts that need to be produced at a price.

Ashley

Unlike any of the other writers on *EastEnders* at the time, I'd been to film school, which none of them had. They'd mostly come out of theatre. I think I had the instinct for it, if that isn't immodest, but I also had three or four years looking at movies with brilliant editing tutors and directors. So, I had all the theory and then I went to *EastEnders*, which is industrial storytelling; I had to unlearn some of my craft. The classic one for screenwriters is, "don't talk about it, show it", because it's a visual medium! I started on *EastEnders* and we had this sequence which I was given to write, where Arthur is learning to drive and he has a slight car crash and hits a bollard in the square. So, I wrote the scene and they went, "what are you doing?" I said, "It said he has to have a car crash-" and they said, "don't show it, talk about it". So, in the pub that evening, Arthur's like, "you know what, I just knocked the car into a bollard". So that was a pretty different pressure. Money is important, time is important. Then eventually when I left *EastEnders*, I had to unlearn some of that stuff and remember that film and television are essentially a visual medium. So, it's about cutting the cloth and learning your craft in the different spaces and assignments you end up with.

Author

One of the things that you're best known for is *Life on Mars*. Tell us the background to how *Life on Mars* was given birth to and why you think the series worked.

Ashley

Everyone now says, "What a brilliant idea … broadcasters must have knocked you over to get it". That is absolutely not true. I met two writers at *EastEnders*, way back on my first job, Matthew Graham and Tony Jordan. We got on very well, we worked together for a long time, stayed friends although we went our separate ways. Tony phoned me up and said, "I've met this guy, Stephen Garrett, who's got a very small indie called Kudos. I said, 'they make fishing programs, don't they?'" Now they're a big, big deal, but they weren't then, they'd done no drama. Tony said, "he wants us to come up with some long running series ideas which we'll pitch to broadcasters".

We thought: "Wouldn't it be funny if somehow a contemporary cop woke up in 1973". I remember being on school camp and every pub or shop you walked past had the David Bowie's *Life on Mars* song playing. We thought, "there's our pitch and our title". We pitched it to him, and Stephen thought we were mad because this is the time where television in the UK and Ireland and all of Europe was really social realism. It was before the *Doctor Who* reboots and there really wasn't high-concept television, certainly not after nine o'clock, it was alien. It was all about kitchen sink stuff. Anyway, we pitched everywhere … BBC1, which was a no, and ITV wouldn't even take the meeting as they thought the idea was so silly, and the same with Channel 4. So, eight years later, a guy called John Yorke, who is by now is head of drama at Channel 4, phones up: "have you still got that time, you know, cop thing". I said, "yeah, still got it". So, we dusted it down, he said, "yeah, I really like it". We rewrote it for Channel 4 and he pitched it to his boss, who read it and said: "I don't think so, John. This is career-threatening". John said, "well I'm your head of drama, you got me in here because you wanted what I'm passionate

about". So, they went to the head of Channel 4 and he said, "I'll read it over the weekend, and I'll give my views". In the morning he said, "John, I'm sorry, I think it's a bit silly". So John, bless him, pretty much handed his notice in because of this. He ended up at the BBC, and by now, eight years have passed and there's a younger set of execs in British broadcasting, including one called Jane Tranter, who also said: "Have you still got that thing that I read as a secretary?"

Then suddenly it got made. So, it took eight years to write one episode and then about three months to write the other seven. I remember seeing an early cut with a producer and I got nervous about the comedy in it, which can be quite broad. That got cut, until Jane Featherstone (sister of Vicky Featherstone), said, "let's let the boys to put the comedy back in. Let's see what we've got". Then suddenly, *Life on Mars*, as we know it, was there. This odd mix of a conventional cop show, with a sort of very high-concept serial arc, with weird bits of surrealism in it, with a brilliant needle drop soundtrack. Then I remember screening it to a bunch of TV journalists in Soho, thinking, "I'm not sure if it's going to go one way or the other", but they absolutely loved it. Then it became this phenomenon, really. I mean, of all the things I've written in my life, nothing has touched what happened when *Life on Mars* was broadcast.

Everyone in the Los Angeles film and television industry watched *Life on Mars*, and it was quite a radical show. It was remade in the US. It was a fantastic journey, but it wasn't a short journey. If I'm really honest with you, if it'd been me on my own, I think I would have given up.

Author

Talk us through relationship with Stephen [Garrett] over those eight years, given that he was obviously growing Kudos during that time. How supportive and confident was he that it was going to find a place, or did he wait until there was a reaction?

Ashley

I think he was clever, because he spotted Vicky Featherstone and got her into the company. So much of our business is about talent spotting. She had just produced something for the BBC called *Glasgow Kits*, which was good, but he saw something in her. She was always, and is, brilliant. She was the one who pushed it through and she was very hard on us, in the nicest possible way, as she didn't let us be lazy writers. She pushed us and pushed us. I think Matthew Graham wrote well over 50 drafts of that first episode.

She went, "Yeah, it's good, but it's not good enough". I'm not quite sure how she pulled it off because she loved writers. Sometimes you get producers who really would like to be writers, I think, and they use writers almost like a pen, like, "can you do it like this? Can you make it like this?" and you think, "yeah, but that's your version". She was always like, "I love it. Let's make it better. Let's make what you want better. Tell me what you want and let's find it". She was a phenomenal woman and brilliant at scripts. She was a huge part in its success.

Author

As a writer and originator, with obviously your friends and team, you saw money being made by remake rights being exploited through *Life on Mars*. Was that the start of you considering where you were going to sit in the industry outside of being a writer? I am thinking in terms of executive producing and looking at rights and exploitation as an IP creator?

Ashley

Massively so. There are two problems. One is creative and one is crudely financial. On *Life on Mars* we hadn't even been in the cutting room as writers, you know, producers and directors have seen it before us, even though we spent a decade of our lives making it. Then when we saw it, we thought, "well, that's not right". It was only because we were a bit more experienced by then that we kicked up a fuss, and if we hadn't done that, it would not have been as successful. So, we'd seen that first episode and we said, "Can we get in the cutting room?" and they we're like, "well…", and it's like "fuck it, frankly, it's ours". So, I could see that if you want to get more creative influence on your work, not power, I've never been interested in being the top of the pyramid, but to have some say in who's in it, how it looks, who directs it, the music … it seems fair that the person who created it might have a good opinion. That was the creative side of the shift.

On the financial side, we had very good, very fair deals with Kudos, but they were old-fashioned writing deals. So, we got our script fees and then we got a small part of the back end, which was very kind of them. Then we heard that the Americans were remaking it. ABC wanted to remake *Life on Mars* with Harvey Keitel as Gene Hunt. We were like, "Wow, how awesome is that?" God knows what the budget was for this ABC remake, it was very expensive. We got two grand each. When the Americans remade it, the first six or seven episodes were verbatim. Our lines, our character names. I went over there, as they did invite us to watch it be filmed in Manhattan. It was an extraordinary experience and the Americans often said, "God, so how big is your new house?", and when I told them we were getting nothing, they could not believe it. It just didn't compute to them. There was no bad feeling because we signed all those contracts in good faith, there was no skullduggery.

Author

It was just a big wake-up call.

Ashley

If you turn the clock back, not many British shows got remade anyway back in those days. Television was a very national business, and this was the start of things like *The Office* getting remade, but I don't think that British agents even thought about it as a thing. In the end, Matthew and I formed a company called Monastic, which was more like an intellectual rights company. We would have ideas, pitch to broadcasters, and if they were quite interested, we would then write spec scripts, go back to them and if they said, "We really like this", we would then go back to someone like Kudos and say, "Look, we're three quarters of the way to a green light, it hasn't cost you a penny in development, but we would like to make this with you, and we want a bigger slice of the cake at the end of it". The indies didn't really like it because that was their cake. But if they didn't like it, we didn't take them ideas. I think in the end, that's how *Ashes to Ashes* was made, the follow-up of *Life on Mars*, which was a Monastic-Kudos co-production. I like to think we brought a lot to the process, and that we weren't just pocketing the cheque.

Author

Do you agree that the relationship between the creative producer and the writer (or writers) remains the fulcrum of drama for television and now streaming, rather than it being a director-driven medium as per feature film?

Ashley

I think that's absolutely true, but it's gone a little bit too far now. So, when I started, the director was still big news on the set, it was their show. Now sometimes it's almost like the producers expect them just to put the building blocks together and "I'll do it in the edit", and I don't like that. I want them to come back to the table a bit.

Author

Something that happened very quickly around the same time as *Life on Mars*, which is what I call your high-class bread and butter work was *Wild at Heart*. Talk us through *Wild at Heart*, because to me that was also a really important experience, the creation of a lot of content on a regular basis to a huge audience, ultimately all around the world...

Ashley

A completely different piece to *Life on Mars*! You don't get any BAFTAs for making *Wild at Heart*, but you get an awful lot of people watching it. I had done an adaptation of *Tom Brown's School Days* for Company Pictures, and it had gone very well. George [Faber] and Charlie [Pattinson] got me in for a meeting, and they were very crafty because they knew I had an abiding love of Southern Africa. I've spent a bit of time there in my life and I really liked it. They wanted me to do an eight o'clock ITV show, and I said, "guys, I've done that with *Where the Heart Is*, so if I do another one, I'm never going to get out of that pigeonhole". They said, "yeah, but it's Africa".

At the same time, they were also making that amazing Channel 4 dysfunctional family show, *Shameless*. I'm thinking if you took an eight o'clock version of *Shameless*, like a slightly dysfunctional family, where the mum and dad had just got together, they've got different kids, with all of those tensions and he's a vet in Bristol and he has fat guinea pigs and dogs that have eaten pencils, but at vet school he was a star ... What if somehow that family ended up in Africa on a game farm. I thought, "sod it, I really like that idea". I pitched it back to them and they liked it. Then we went to ITV to pitch and it shows you how times have changed. The guy said, "no way would an ITV audience watch something set in Africa, they wouldn't be interested". He said, "Will it have Africans in it?" I said, "Well, it is set in Africa". Then I think he said, "Oh go on then, but don't make it shit". So, I wrote all of that first season, because again I knew that world a bit, and not many British writers would have known much about Southern Africa.

Company Pictures were very much one of the early Indies that loved getting writers into the middle of the shows and it ultimately made them very successful and very powerful. My deal with them was very generous, without my agent asking for anything. My deal came through and I was like, "shit", and I spent seven years making that show, partly because I love those guys and partly because the deal was phenomenal. So much so that when it happened again and the remake happened (with a dreadful version!), my deal was the same as the *Life on Mars* deal. However, Company Pictures paid me out of their own profit for that show. My agent was like, "I've never, ever, ever come across this. This is not in that contract. They don't have to give you a penny". It just shows you that it doesn't always have to be, "Yeah, but you signed that". So, I was very lucky, for six or seven years I had these two completely different shows being made at the same time. For the one, I got the critical praise and people talking about it on the radio, and on the other hand I've got 12, 14 million people watching on a Sunday.

Author

One of the problems right now is a lack of writers that producers and commissioning editors trust to deliver. There's a talent drain at the moment with a lot of very experienced writers booked up for two to three years. Any emerging indie is not necessarily being able to even develop the relationships with some tried and tested writers. It also indicates that people are hesitant taking a risk on emerging writing talent. How do you think new writers should deal with such challenges?

Ashley

The business has changed so much for writers. One of the biggest developments for British screenwriters is the constant show running, which didn't exist when I started out. Now, if you get a bunch of writers in the pub, that is what they'll talk about, show running, which in its most extreme form, you don't need a production company because you do everything. You exec it, you hire everybody, fire people and I'm starting to see it come in. People like Jed Mercurio want that sort of power and influence. The Williams brothers, who were very successful with Company Pictures, started their own company, so they don't work with anybody other than themselves. My friend Matthew started a company with another screenwriter, and they've got serious funding from America. So, that is another development. Very new young writers say, "I want to be a show runner". It's become a new aim.

Author

Can you talk about *The Living and the Dead* [2016]?

Ashley

I'm a huge Thomas Hardy fan, he's one of the reasons I'm a writer. Basically, my pitch back to the BBC was Thomas Hardy with ghosts. As I was writing, I thought about what ghosts are in the sense of an intensity of experience. The high concept spin, I suppose, was that halfway through the first episode, you're in a country graveyard and a character looks up at the sky and sees the trail of a jet plane, and they just carry on with the story. The very last image was this Victorian guy wakes up hearing a noise at night and gets the oil lamp out and comes out, and there's a woman with an iPad looking back at him. So, the concept was that ghosts bleed back and forth. BBC loved it, and I was so excited. It was almost like, if I've been put on earth to write a show this was it. Set in the region where I'm from, the region I love.

Then it became a disaster, partly because something happened between me and the executive at the BBC. It went from a lovely relationship to a very spiky one where she just took against the idea. She was like, "do it more like this" and I said, "no, this is what I pitched you". So suddenly the structure doesn't work when the writer and the creative producer aren't on the same page. It's muddy. Everyone gets sucked into it, 'cause everyone's thinking, "who am I listening to?" I thought it was me, she thought it was her. I had got writers trying to write episodes and everything was changing, it was really difficult. Then we started filming and she never once came on set, so there was a vacuum. I could see the actors and the crew looking at me like, "Are you the boss? Are you the person I ask if she wears a yellow dress or a red dress?"

In the end, the actual filming part I loved, because I got rid of all the politics and although the show and the script we were filming weren't really what I wanted, they were good enough, and I loved the actors and director. Then post started and we had the same battles again. It was so horrible. I was working seven-day weeks, working through the night, I was on my knees, I was so tired. I was being a shit dad. I remember one Sunday

with my wife sitting down and thinking "I don't think I want to do this anymore. I've had a fantastic career, maybe this is time…" Then I got together all my savings and pension and thought, maybe not. But yeah, a brutal time that left me very disenchanted and it took me a few years to pick myself up.

Author

The next big job is *Around the World in 80 Days*, which is what you are in post on now, correct?

Ashley

Whether by accident or in design, I'm almost a hired gun on it. I'm still an executive producer, although sometimes they forget I'm an EP. My job on that project was that I ran the writer's room, almost like Head Of Department (HOD) of scripts. Although I've fought all my career to have more say and influence, I've really enjoyed having a sit back and just being a writer. It was quite a difficult job to write. So, with all that past experience, I just concentrated on doing the best I possibly could. It's a brilliant book, but it's un-filmable. Its politics are like, "way-hey!", but it's a wonderful story. So, I made Phileas Fogg, who's played by David Tennant, a likeable idiot. An English colonialist, but he's a fool rather than a bad man. He's never really left London. So, the world to him is like, "wow". It was at the time that the whole Brexit thing was bleak, and I wanted to write something that wasn't about borders or nationalism. I wanted to show that it is a wonderful world we live in.

Slim Film & TV were taking it as a concept and a script to the BBC and ITV and Sky, but they couldn't get it away. I came in and did a sort of polish and by then, they had taken it to someone called the Alliance, which is a newish sort of affiliation of France Télévision, RAI and ZDF. They knew they couldn't compete with Netflix on their own, they couldn't fund shows for 3, 4, 5 million pounds an episode, but if they got together and put in a million, a million and a half, they could. So that's quite a clever idea. Suddenly for the first time in my career, I'm working for European broadcasters and we got David Tennant, which opens up the world; he's such a big television name. It's been really difficult with COVID and everything, but we made it. It is designed to be a one-off serial. So, after *The Living and the Dead*, my mojo is well and truly back and I love it.

Author

What are you working on now?

Ashley

I do most of my pitching on Zoom, like the rest of the world now, but I'm pitching to people I've never met. I'm pitching to Disney and there will be 10 faces, most of whom don't speak. It's quite hard, I'm used to a more social one-on-one pitch, but it does make you more disciplined. The classic pitch in my career is that you go to the commissioner and the last thing you talk about is the pitch. You talk about the journey and the weather and "how are your kids?", you know, "you're probably not interested, but I've got this idea…" That's how we pitched in this country, isn't it? In LA, they do not pitch like that and I've gotten my head kicked in a few times. They pitch like, "here's the thing. We start on…". I'm thinking, "oh my God, I can't pitch like that". But I think now, the idea has to be very robust. You've got to know your onions and you've got to be passionate. They absolutely smell the passion. It is business, but it's not really business, it's art, pitching.

I think people want to hear a man or woman who is really excited, "I'd love to see what they do". You've got to know your characters and you've got to know the basic journey of where it's going and how much it will cost. They'll ask questions about who you think will watch it. Is it able to be cast? Is it diverse? That's a massive thing now. It's hard to do straight period drama now. You'd have to have some spin on it, like *Bridgerton*.

Quite rightly, they just don't want more of the old telly. I think you have to be very aware of that stuff, but I guess in the end having said all that, it does come down to story. I've seen technology change in my career, you know, when I was at film school, we used to actually mark the numbers on the film, edge numbering, it was called. You'd literally cut things with a pair of scissors. But really, has anything changed from a writing point of view, producing point of view? You're still telling stories around the fire, I think. People want to be entertained and moved and made to laugh.

One last thing. It's really basic. It is a fantastic business. I go to work every day excited. Although there are tough times I have talked about, if I were starting out again, if I was 20 again, I would do this. It all changes but it all stays the same.

The agent's perspective

The mystery of storytelling, a TedX Talk by literary agent Julian Friedmann (November 2012, Ealing, London)

"I'm an agent and I'm going to try and talk to you from an agents' point of view. You may not realize it, but agents are in the business of rejection. We reject a lot of people all the time at my agency. We get about 6,000 submissions from writers every year and we probably do not take on more than six writers a year. We know that there are millions of people who want to write, who want to tell stories, but we also know that most of the time what they write isn't very good. In fact, it's extremely boring and I really want to try and demystify the process because it appears that storytelling is somewhat mysterious. There are many experts that disagree fundamentally on lots of things.

I think we need to start by looking at a really important question which is "Why is it so difficult?", and the answer is partly because you've got to remember the story is much more about the audience than it is about the characters or the plot, and it's much more about the audience than it is about the storyteller. I would even say that storytelling cannot be taught. I don't think it's a proper study for writers. I'm involved in setting up writing courses so I must admit that I also jump on that bandwagon, but I say this because I worked with writers for 40 years. I've been an editor, publisher, an agent, executive producer. I'm in awe of writers, I'm filled with admiration for them. It takes an incredible amount of courage to put your soul on paper and have people who are probably much less talented than you, certainly much less creative than you, trample all over it.

Agents are often derided. We have a bad press, which actually is fine, someone once said to me "you're a really good agent". I said, "don't tell people that, I want to be known as someone who's nasty". A good agent was once described to me as a marriage broker, and a bad one, as a pimp, and we are trying to develop long-term relationships, but it's difficult. There's the story about why in Hollywood scientists who at the cutting edge of research into the latest cures for cancer are now using agents rather

than rats, and there are five reasons for this. The first is that people in California are crazy, the second is the animal liberation movement are targeting scientists who are experimenting on rats, the third is there are now more agents in California than there are rats, fourth is you can't get emotionally involved with an agent, and finally there are some things that rats won't do.

I now want to talk about adultery because writers need to be unfaithful, and this is with due respect to anyone who's religious. For me the Holy Trinity in my life and my work is the writer, the characters and the audience. As a writer, you live with your characters for a long time, you nurture them, after all you create them, you have a kind of fidelity towards them, but your audience, you very rarely meet them. If you're going to be successful you will never meet more than a minute proportion of them. They probably have prejudices and tastes that completely differ from yours. You probably wouldn't want to know what their personal hygiene was like and basically, you're just there to thrill them, to turn them on, to titillate them, by doing so yourself, and then leave them. So, your primary relationship has got to be with your audience, not with your characters.

Now, if the proper study for writing is not right, what is it? I think it's human behaviour, it's why people behave the way they do, why they are so irrational, why they can do such outrageous and terrible things. Irrationality is really quite interesting. My mother always used to win arguments with me by saying "don't be rational about my neuroses", and there are some experts, some people who've written about screenwriting who I think are very good. The majority I think are not. Lajos Egri wrote a book called *The Art of Dramatic Writing*, and what's interesting is the subtitle – the subtitle is 'its basis in the creative understanding of human motivation', so that's what writers should be doing.

Now we know that millions of people want to write. Why? What is it that compels people to tell stories? George Orwell wrote a book, which is his probably as least well known but I think is possibly his best book, it's called *Why I Write*, and he describes why he writes but he also says he thinks it applies to the majority of writers, and there are four reasons he gives. The most important and comprehensive one is sheer egotism. The other reasons are immortality, getting back at people who put you down and trying to make the world a better place. Samuel Johnson would not have agreed with him, he is famous for having said "no man but a blockhead ever wrote but for money". He also said one of my favourite quotes about writing, when he was asked to read someone's manuscript – "Your work is both good and original. Unfortunately, the part that is good is not original and the part that is original is not good".

I believe that stories define us, not language. It's often said language is what defines us, but you know dolphins have language, whales have language, elephants have language, chimpanzees have language, but they don't, as far as we know, have stories … despite *Planet of the Apes*. Most of the books about screenwriting and most of the courses tell you there is no formula. Many of them also tell you you must write out of your own experience, which is one of the main reasons why most of the stories a lot of these people write are very boring, most of us have pretty boring lives.

Or is there a formula? Years ago, I was studying under Frank Daniel, a famous teacher. We asked him if, when in a preliterate society (in other words, before there was any writing), when the old wise men sat around the campfire telling moral tales to try and bind the clan together (given that they'd not read Syd Field or Robert McKee),

would they have used the three-act structure? Frank said the three-act structure is actually a function of how the human brain works, you plant a piece of information, it pays off, you have to have a beginning to get to the middle to get to the end. Sometimes it's said the British film industry doesn't work like that, it has a beginning, a *muddle* and an end.

Actually, Aristotle then described the formula, and he did that two and a half thousand years ago. Not only did it work then, it still works today. So actually, anyone who says there's no formula is wrong, there is. Aristotle did it in a way that makes it incredibly easy to remember. There's three words: Pity, Fear and Catharsis. He said you need to make the audience feel pity for a character. You do that usually by making the character go through some undeserved misfortune. What that does is it enables the audience to emotionally connect with the character, and once the writer has got that emotional connection between the audience and the character, the writer begins to have some control over the audience. You then put the character into a worse and worse and worse situation and because of the emotional connection, the identification, the audience feels fear. When you release the character from the jeopardy or whatever the situation they are in, the audience experiences a catharsis. Pity, fear, catharsis. Now the catharsis is actually the result, not of any intellectual activity, but of chemicals being released in the bloodstream, notably one called phenethylamine, otherwise known as PEA or the happiness drug. Now you can actually cause that release in your bloodstream by taking speed or ecstasy, if you want to be a bit more legal, by eating chocolate or having sex. So, we can try and save the British film industry by giving bars of chocolate to people who are going to see British films, they'll come out of there and tell their friends they had a really good time. But just so you can see this is not specific to two-and-a-half-thousand-year-old Greek, I found in the program notes of a series of Beethoven concerts given by Maurizio Pollini, this very interesting quote: "Beethoven's preference for happy endings is not by any means a tendency towards kitsch, but rather a musical style akin to Schiller's philosophy of suffering, struggle and overcoming." So, you can see the pattern; suffering, struggle and overcoming. Pity, fear, catharsis. Beginning, middle and end. It works, it's always worked and it always will work.

If you comprehend all this and you can do this in your writing, will you write better? No, probably not. You need more. You need to understand how audiences actually use stories, why we need stories, what we do with them. There's a really interesting example, for years people have known about these cave paintings that were done 25,000 years ago the famous caves in Lascaux, in southwest France. No one's ever really concluded what the paintings meant: paintings of animals with little drawings of stick people. Now if you know about the Maasai, when they go from being boys to men these kids have to go and live in the bush, they have a spear and they have to kill a lion. It's really dangerous and we know that they get very drunk, we know they do a lot of rhythmic dancing until they get into a kind of trance, and I think that those prehistoric caves were the earliest cinemas. I think that the hunters would go into the caves and they would look at the animals and they would imagine the fear that they would feel when they went out into the savannah or the bush to face bears, wild boars, mammoths, elephants and sabre-toothed tigers. They rehearsed their fear and I think that's what we use literature for, that's what we use theatre for, that's what we use cinema for. So if you now know that, you can think well what have I got to do to enable the audience to have experiences which they can then relate to themselves? Is that enough? Actually, it's not.

Particularly if you're working in film, you've got to understand that we in Europe have evolved a very different means of telling stories for cinema than the Americans did. We know that 80% of all box office in Europe goes to American movies, American movies travel far better than ours. Why? Well, they have bigger budgets, they can spend more money on development, they have bigger stars ... we can't really compete with that, that's a given, it's an uneven playing field. They also have very accessible characters and they also like sentimental happy endings. It's very common in the British press to see something saying, "great film, what a shame it was so sentimental".

Well, we can do it when we need to, we've done *Four Weddings and A Funeral, Trainspotting, Bend It Like Beckham, Billy Elliot, East is East*. They all did phenomenally well. So, the solutions are: you have to have accessible characters that the audience will emotionally engage with, you need upbeat endings if possible because we know statistically that they like it. Then there's the question of dialogue. American movies have only two-thirds the dialogue of European movies, and this is really important because it means their movies can communicate to audiences who don't have a high level of education, who aren't even literate. The other thing that American movies do is they tell their stories much more visually because they aren't using dialogue, so they think almost in storyboards.

This is important for a very simple, psychological reason. We believe what we see, we don't believe what we hear. In fact, a really clever script will sometimes have dialogue contradicting what you're seeing because it makes the audience wake up and instead of leaning back as a passive spectator, they will lean forward as an active participant in the process of watching your film. We can do that. The other thing we can do, but we don't, is shorter scenes. I was told by a company that does dubbing and subtitling that American movies on average have scenes half the length of European movies. It's a huge difference. Now if you have your scenes, you cut the beginning and the end of every scene out without taking out anything that's critical to the understanding of the film, you leave a gap and the audience will fill in that gap, and in doing so it makes them feel good. They are actively watching your film instead of passively watching it. It doesn't cost anything to cut out dialogue. It also gives the composer much more room to use music and as we know music is a much stronger way of connecting emotionally than words, and your job is to try and create that emotional connection.

Now, I started out by saying we're in the business of rejection. Diana Rigg edited a book once about the worst reviews ever given of theatre plays, called *No Turn Unstoned*. I think in a way we need to face the fact that there are going to be people who criticize what writers do, what creative people do, and writers have got to get rejected. All great writers have had lots of rejections, we know that. We could in fact do an entire TEDx on rejection, you know, a guy goes into his publishing company, big marble entrance hall, security guy says, "who've you come to see, Sir?", "I've come to see my editor, I've sent in my manuscript". Security guy looks on the computer screen and says, "well I'm afraid your editors not in but I'll reject it if you like". All that does is it tells you that you will be rejected by people who probably aren't as creative or as talented as you and that unfortunately also often includes agents.

To end, I want to [cite] the best rejection letter I've ever seen. It comes from, apparently, a Chinese economics journal and it was as a result of someone submitting an article.

We have read your manuscript with boundless delight. If we were to publish your paper, it would be impossible for us to publish any work of a lower standard. As it is unthinkable that in the next thousand years we shall see its equal, we are to our regret compelled to return your divine composition and to beg you a thousand times to overlook our short sight and timidity.

So, on behalf of agents everywhere, to writers, please forgive us for our short sight and timidity and if, while you're egotistically trying to get immortality, while you're trying to make the world a better place, while you're trying to get back at people who put you down, please don't forget you have to entertain us. You have to enable us to look at ourselves, because when we're looking up at the screen, we're not looking at the actors who are saying your wonderful lines, we're not looking at the characters you have so lavishly and lovingly created, we're certainly not looking at you, we're looking at ourselves, because only we are the storytellers and only we can give you immortality. Thank you."

5 Green lighting films

> There is no such thing as an independent producer. There are dependent pro-
> ducers. Dependent on distributors, financiers and bankers, and distribution
> channels that understand the market even less than the corporations that own
> the studios ... Perhaps even more than the studios, those with the controls over
> whether or not a movie gets made independent of the studios do so almost with
> less attention to the movie itself.
> (Bill Mechanic, president/CEO of Pandemonium LLC and former chair/
> CEO of Fox Filmed Entertainment, IFTA keynote, 2009)

An introduction to green lighting

The film industry uses the term 'green lighting' for the moment a financier or set of
financiers decide to move ahead, commit investment and place a film project into
production. In a perfect world, that moment normally happens at a formal meeting,
whose attendants in turn consider a set of criteria prior to taking a formal decision.
Such a process would seem to be a rational approach to managing risk–investment
decisions, often in the many millions. The reality is rather different, and the actual
process varies considerably from studios to mini-majors, and through to the myriad
of sources of finance that make up the typical independent film's structure. This chap-
ter explores some of the typical mistakes so often made in the independent system
through the case of the author's former company, Renaissance Films.

For a studio, most often responsible for 100 per cent of the budget (or at least 50
per cent through a split-rights deal), the decision will have taken place with all key
heads of departments, including worldwide territory managers, who will supply rev-
enue projections for their global regions. The one-stop shopping approach entailed
by the studio's ability to fully finance a film makes the green light process reasonably
straightforward, although there is still considerable resistance and second-guessing
from owners and powerful executives along the way. By contrast, independent films
are rarely triggered in such an orderly process, as their financing relies on a vari-
ety (sometimes a multitude) of sources of finance and investment. This complex web
makes the task of 'closing' a film's finance particularly challenging when working in
the independent sector.

Any green light decision requires information upon which a decision can be made.
Prior to investing or committing finance, financiers will demand full details of a pro-
ject's budget, cast, director, producer, finance plan, pre-sales, remaining sales estimates

DOI: 10.4324/9781003205753-6

(or distribution projections, territory by territory, if a studio) and estimated timing of delivery. If a recoupment order has been proposed by a producer, this too will form a critical part of the assumptions; but often financiers tend to use the exercise (colloquially referred to as 'running the numbers') in order to negotiate their recoupment position re other investors. This range of information is then placed into a spreadsheet (aka a 'control sheet') that relies predominantly on the sales estimates or territory projections, as these combined revenue streams are the key route to an investor/financier's being repaid.

Many independent sector green light decisions will include further hurdles that the management and the specific film project have to overcome before drawdown of investment is allowed. At times, a green light meeting's 'yes' decision may mean only a part of the film's finance is triggered, and the film's final move into principal photography is still dependent on other deals or green lights from other co-financing sources being closed or approved.

Many independently financed features crawl haphazardly through a vague green light stage, where, in the words of Stephen Woolley, one of the most experienced UK producers, 'the producer starts, and everyone else catches up'.

The practice of 'management by committee' and the wisdom of collective decision-making attract much criticism. The way current and previous studio heads, by contrast, refer to their jobs speaks volumes about the centralized power they exercise to make decisions. 'My job running a studio was to make money', explained Bill Mechanic, former chairman and CEO of Fox Filmed Entertainment:

> My goal was to make good movies. When I did my job well, I made good movies that made money. The key to making decisions that don't blow up in your face is to understand the aims of the film and the filmmakers.

The following in-depth case study examines some of the inherent problems, issues and consequences that arise when key green lighting decisions are made through a collective committee.

Case study: green lighting film productions at Renaissance Films

The call came in just as I was set to board a plane in Malaga Airport following a summer break:

> We need to call a green light committee meeting as soon as you are back. I think we're going to need to do this film *Morality Play*. We're under a lot of pressure from the Board to use the investors' money and get productions going.
>
> As my plane took off, I pondered the numerous issues and variables that would inevitably be raised and considered at the upcoming meeting. *Morality Play* (aka *The Reckoning*) was the third Renaissance film to be brought to the green light committee over the past year, but by far the most ambitious both in terms of production and budget.

Rules for how Renaissance Films placed films into production had been clearly mapped out in a business plan written by myself and my partner Stephen Evans the previous year. The green lighting rules had been discussed at length by the

management and the investor, Hermes, and they had been refined before the invest-
ment of £24.5m had been finalized. The investors and the management (also at risk
for a combined £500,000 in shares) had jointly recognized that the green light system
formed a critical part of the risk management of their investment decisions in movie
productions.

Renaissance's green light committee was comprised of four executive directors,
including the company's co-managing directors; the finance director and the director
of sales; and three non-executive directors, including the investor's representative and
the company's chairman. Four votes (a simple majority) in favour of a green light
decision would carry the day, as long as the film fulfilled *all* criteria within the rules.
The investor's representative had the power of 'veto' if the four executive directors
voted for a film, while the three non-executive directors voted against. The intention
was that the committee operated a 'checks and balances' system. It was assumed that
the existence of a veto would effectively guard against the management 'railroading'
it's film choices into production.

If a film that failed the criteria was to still receive a green light (albeit with one or
more of the rules effectively broken), all seven committee members would have to
vote in favour of going ahead. The rules as written out in the company's Articles of
Association covered the following points:

- A film under consideration had to present a package containing the following ele-
 ments: a script, budget, producer track record, director and two main cast actors.
 The package had to be satisfactory to the Committee. These documents needed to
 be made available at least ten days prior to the committee meeting.
- A reputable Completion Guarantor needed to have issued a letter of intent to
 bond the film's production and delivery at the budget level (less standard exclu-
 sions) submitted to the Committee.
- A minimum of 30 per cent of the film's total budget needed to be covered in either
 pre-sales to distributors, and/or co-financed by third-party investors. Such co-fi-
 nancing had to be in place prior to the green light decision.
- Satisfactory minimum sales projections from available territories indicating no
 less than a straight 100 per cent return on investment had to be provided by
 Renaissance's sales team.
- Any bank involved in cash-flowing a section of the finance, and/or 'gapping' up to
 25 per cent of the film's budget, had to be pre-approved by the Committee.
- The Committee could not commit more than 50 per cent of a film's total budget;
 nor approve an investment of more than $10m in any one single film production.

Previous green lighting decisions

- The two films previously green lit by the committee were *The Luzhin Defence* and
 Disco Pigs. *The Luzhin Defence* was a project already in advanced development
 when the new investment was secured. A 'go' project was deemed attractive by the
 investors. To their eyes, the film was a 'kick-start' to investment and production
 activity, and the chairman had agreed to 'shepherd' the film through the green
 lighting committee.
- In terms of the green light criteria, *Luzhin* was well positioned. The screenplay
 was adapted from a classic novella. The producers were 'in-house'. The director

and cast was deemed attractive enough for an $8.8m budget; and more than 30 per cent of the finance was originating from three co-production partners – France; The Netherlands; and Italy.

(The Netherlands was later replaced by Hungary following a dispute between Renaissance and the Dutch producer, but the film still qualified as an official co-production under the European Convention on Cinematic Co-productions, thereby not collapsing the complex structure of co-finance from the different territories.) These co-financing sources were not strictly 'pre-sales' to commercial distributors; but this point was conveniently glossed over. Film Finances, a reputable completion guarantor, had issued a letter of intent to bond the film; and Société Générale, with an experienced film finance arm, was lined up to discount and cash flow nearly 40 per cent of the film's financing. A UK sale and lease-back tax arrangement was in place for around 12 per cent of the film's budget. Sales projections showed acceptable minimum sales from around the world (excluding the United Kingdom, where Renaissance had secured a guaranteed theatrical distribution deal with a leading independent distributor, Entertainment Film Distributors, on an ongoing basis). However, no hard pre-sales had been achieved on the back of the script and package prior to the committee's decision to go ahead with the movie production. Renaissance was investing $4.4m of *The Luzhin Defence*'s $8.8m budget, thereby complementing the 50 per cent maximum investment rule under the green light rules.

Almost as soon as the film had been green lit; Renaissance secured a co-financing deal with Clear Blue Sky, a deep-pocketed US independent company. However, Clear Blue Sky, a development, production and finance company, had been attracted to the screenplay for *Luzhin* and admired the package. Critically, Clear Blue Sky was keen to do business with a company that could match its financial resources, rather than be tapped by third-party productions where it was not a full and equal production and finance partner. The deal stated that when deciding to proceed on a film investment, each party would put equal amounts of money into the production. Additional fees and commission were agreed which allowed Renaissance to charge for its sales and marketing services. Clear Blue Sky wanted the deal to include a joint investment in *Luzhin*, albeit that it was a retrospective arrangement. Renaissance's investment subsequently was offset a further 50 per cent, dropping from $4.4m to $2.2m.

Prior to completion of *The Luzhin Defence*, sales activity based on the package and a 12-minute promotional video, had proved the committee had little to worry about. A pre-sale was achieved to Japan for the $1m 'asking price'. This is the 'high' or 'Ask' sales estimate rather than the minimum 'Take'. The pre-sale was made during the MIFED film market in Milan (while the film was in post-production), and it helped to provide confidence within the Board that the film was on track.

Disco Pigs, the other film the green light committee had already approved, was a low-budget Irish production adapted from a theatre play. A promising first-time director was attached, alongside one of Ireland's most interesting and prolific film producers. The green light decision rested on the following criteria:

- The film was supported by Ireland's state subsidy body, the Irish Film Board, with an investment worth 25 per cent of the budget.
- A further 14 per cent was to be raised by the Irish tax deferral system, Section 481.

- This left Renaissance needing to put up around 61 per cent of the budget, 11 per cent more than its 50 per cent rule. All other criteria had been fulfilled, with the exception of pre-sales or investor finance covering more than 30 per cent of the budget. It was deemed by the committee that the combination of two sources of 'soft' financing was applicable to cover the 30 per cent rule. As the film was seen, in the words of the chairman, as a 'baby' project, *Disco Pigs* went ahead, backed unanimously by the green light committee, with Renaissance investing just under $2m of the $3m budget. Little notice was taken of the fact that the rules had effectively been sidelined in order to place the film into production.

Morality Play

Like *Luzhin, Morality Play* had been in lengthy gestation at Renaissance Films prior to the arrival of the Hermes £24.5m investment. A dark tale set in medieval Britain adapted from Barry Unsworth's admired novel, the script had gone through a number of drafts, and had been considered and rejected by a range of UK and European directors. That spring prior to the August green light meeting, a former photographer and second-time director, read the screenplay and responded positively to the material. Although his first film had not scored at the box office it had won some critical acclaim and he had discovered a new 'hot' UK actor. The film offered an insight into the director's ability to handle tough material and attract strong performances from his actors. When Renaissance showed interest in this director, the new actor in turn showed willingness to play the lead role in *Morality Play*.

During that year's Cannes Film Festival and market, Renaissance held a number of meetings with prospective co-production and finance partners for *Morality Play*. These included numerous potential German co-production partners and a German tax fund that showed keen interest in the project. However, no distributors showed any appetite for pre-buying the (then) $10m budgeted project. A meeting with Clear Blue Sky focused mainly on a different, US independent film that the companies ended up co-financing later that year. *Morality Play* was given scant attention by Clear Blue Sky.

Talks with a German tax fund partner had continued during the summer prior to the August green light meeting. Finney had travelled to Los Angeles in July in an effort to close a deal, but no commitment in writing had been issued by the tax vehicle's representative. Meanwhile, with no interested German co-producing partner, the lead producer looked to southern Spain as a region to shoot the film. A large and expensive set was to be built, with the ultimate intention to burn it down at the end of the shoot, as per the narrative in the screenplay. An experienced Spanish co-production partner was brought in, contributing the minimum 20 per cent under the Anglo-Spanish Bilateral Co-production Treaty rules. However, while the contribution on paper needed to be 20 per cent of the budget, the hard cash contribution from the Spanish partner was $800,000 – just 8 per cent of the $10m budget. It was also going to be cash-flowed by the co-producer against future distribution and TV deals rather than discounted and guaranteed by a bank.

A UK sale and leaseback partner was contracted, contributing a further 12 per cent of the budget. By the first week of August just 20 per cent of the $10m budget had been raised. Major territory distributors, including North American buyers, who had read the screenplay and held meetings with the Renaissance sales team

during Cannes, all, without exception, chose to wait rather than pre-buy rights in the movie. A number of them stressed their concern about the subject matter when compared to the relatively high budget. And no German tax deal had been secured by a banking advisor appointed by me to help address the shortfall of the project's finance plan.

The film's budget, following the appointment by the producer of a top director of photography and an ambitious production designer, had meanwhile swollen to $12m. Both heads of department had worked with the director on his previous film. 'I'm not interested in compromise', the director had indicated forcefully at a meeting with the production team and the executive producers. 'This is the film we're making and there's no point in going ahead unless we've got this budget'.

Meanwhile, the film had been formally presented to Clear Blue Sky under the co-financing deal they had already partnered on *Luzhin*. Despite a leading US independent actor joining the cast, Clear Blue Sky elected to pass on *Morality Play*. At this stage, one of the co-managing directors had chosen to place the new, rising actor on a 'pay-or-play' deal. Evans's intention was to stop a rival film 'stealing' the actor away that autumn and pushing *Morality Play* back into a shoot the following year. This meant that the relatively new actor would be paid his fee, even if film did not go ahead. In addition to the development and early unofficial pre-production costs, which by August amounted to some $300,000, Renaissance was going to be penalized a further $250,000 payable to the actor if the green light committee decided not to go ahead with the film. While the UK sale and lease-back deal was able to remain at 12 per cent of the new budget ($1.44m), the Spanish contribution in hard cash remained at $800,000, or 6.6 per cent of the budget.

The Finance Plan for *Morality Play*, as presented to the committee in August, is shown below:

Percentage

UK sale and leaseback contribution: 12 Spanish co-producer contribution: 6.6 *Renaissance Films: 81.4* Total: 100.

The green light meeting

I had only 24 hours from the moment my flight landed to the green light meeting. I had a series of meetings and conversations, including with one of the in-house producers of *Morality Play*, who cogently argued that a decision to go into formal pre-production was critical if the production was to hit its actors' and location dates. Deposits and crew contracts were being made on a daily basis. A delay or postponement of a decision would effectively have collapsed the film, an argument that was made forcefully by Evans and the finance director to me just before the meeting. I was also worried about the lack of pre-sales and indeed of real interest in the project from the independent distribution market. Indeed, I recalled how difficult the film had proved with regards to pre-sales and potential co-financiers only three months earlier at the Cannes Film Festival. However, my position was potentially compromised if I went up against my senior co-managing director in front of the green light committee. If I became the 'veto' vote from within the executive director management team, I was acutely aware that I might well be 'vetoed' out of the company all together.

The film value chain

The management decided to divide the presentation into two key parts. Part of the management team put forward the creative case for the film going ahead. This argument highlighted the cast, script, subject matter, production values and director's vision. Once this 'pitch' had been made, the second part of the presentation concentrated on the financials. The point was underlined that not doing the film was going to cost the company more than $800,000. Heads of departments had been placed on contracts that would have to be met; bookings would need to be cancelled with associated kill fees; the lead actor would have to be paid his full $250,000 fee; and Renaissance's historical costs would be effectively lost and ultimately written off. In addition to the financial hit, Evans stressed that a 'no' decision would cause considerable damage to Renaissance's reputation, a valid concern given the slow start the company had experienced post-Hermes. He fleshed out his concern by explaining that agents, talent and existing and potential partners would lose confidence in the company's ability to green light investment decisions. Renaissance, in his mind, needed to 'walk the walk, and not just talk the talk'.

The finance director presented the investment case for the film, but this part of the meeting was already under the shadow of the 'hit' that Renaissance would have to take if the green lighting committee was to say no to the film. Financing actually in place by this date totalled 18.6 per cent of the budget. No pre-sales had been achieved. This, in turn, meant that no bank had been approached to 'gap' a percentage of the budget against remaining available territories (as had been the case in *Luzhin*). All film finance banks demand a 'market test' in the form of hard pre-sales to significant territories before lending against remaining estimates. Of the film's negative cost, 81.4 per cent would need to be guaranteed by Renaissance if the decision was made to go ahead.

The minimum estimates from the international sales team amounted to around $7m, some $5m lower than the (then) negative cost of the film (excluding the value of the UK distribution rights). The estimates would not cover Renaissance's exposure of just under $9.76m. The argument, however, was once again put by the management to the committee that the difference between writing the film off and risking losing $2.76m on the downside of the minimum sales estimates (with the possible boost of a strong UK performance to help mitigate any losses) was a reasonable way to gauge the investment decision at hand. Much was made of the production fees, at around 8 per cent of the $12m budget that would also partly mitigate the risk.

I had recently returned from Los Angeles prior to my Spanish break, and unwisely stressed the likelihood of the company closing a German tax fund deal, which, in turn, would bring a co-financing partner worth 20 per cent of the film's overall budget. If such a deal was closed, it would bring a further $2.4m to the production, and Renaissance's contribution would effectively drop to $7.36m, still higher than the 50 per cent of a total budget green light rule and still below 100 per cent coverage on minimum sales estimates, but significantly more acceptable in the eyes of the committee.

Lastly, the director of sales presented what in view of hindsight was an optimistic view of the cast, script and his ability to close sales at MIFED as the film proceeded through production. This was despite a poor reception at Cannes and a straight 'pass' from nearly all the French and German independent distributors who had reviewed the project over the proceeding four months. Part of the problem facing the sales team at Cannes had been an incomplete package and the wrong script draft for distribution

to buyers, and I recall being warned by a very experienced German producer that we were making the film for far too much money.

Film Finances, a reputable completion guarantor, had issued a letter of intent to bond the production at the agreed budget of $12m. The guarantor had a strong relationship with Evans, and felt comfortable at this stage about bonding the production. However, Renaissance's production fees and historical costs were excluded, as is usual, from the overall delivery guarantee.

The green light committee had no Renaissance films that had completed their first full cycle of sales with which to compare the estimates and 'ultimate' results presented on the behalf of *Morality Play*. However, *The Luzhin Defence* had premiered at the Cannes film market in May that year. The film had sold to North America during Cannes, but for a $300,000 advance. The minimum estimate from the sales team prior to the film being green lit had been $1m.

The chairman asked the management what risks North America presented to the film's success. Evans explained that it was his intention to try to sell the film to a North American distributor as the film was shooting. 'They will take the film seriously once the cameras are rolling'. The minimum (Take) figure for North American value had been stated at $1.5m by the sales team. Hermes's Investor Representative had indicated during recent board meetings that the Investor was growing somewhat frustrated that the company was not using its financial resources to make more films. The company was well behind in its stated aim to produce or acquire four to five films per annum, as set out in the business plan.

During the green light meeting, which formally voted unanimously to green light *Morality Play*, the Investor concluded the meeting with the words: 'It's good to see the company is finally making films'.

But was it the right decision to green light the film?

Ramifications of the Renaissance green light decision

Morality Play, which was finally released as *The Reckoning*, underwent the following:

a) Further overspend: the final budget was $14.2m, and the additional $2.2m overspend was excluded by Film Finances at the point of closing the bond. Renaissance received no production or financing fees for the film.

b) No further partners: the German tax deal was never closed, in part due to the agents representing the tax fund falling out with their partner – something that only became clear in late August, two weeks after the green light decision had been made.

c) No further pre-sales were made until completion and screening to buyers in August 2001.

d) The Spanish deal was to remain stuck at $800,000 despite the budget overspend.

e) Final sales (ultimates) were significantly lower than the minimum sales estimates. On screening, Paramount Classics bought North America, Japan, Latin America, South Africa and the Middle East for $1.75m, but demanded a new music score, and significant edits and a two-day re-shoot. The additional 'cost' of the deal was around $130,000, which was to be split 50–50 between Renaissance and Paramount. Overall sales on the film remained at around $2.5m, compared to the low estimates of $7m, despite the North American multi-territory deal.

f) The film was rejected from all the major film festivals, including Toronto, Venice and Berlin. It premiered in Taormina, in Sicily, in the fall of 2002, some 12 months after completion. It premiered in North America at the Tribeca Film Festival a further 8 months later, and sunk at the box office. The UK theatrical release lasted two weeks.

g) The corporate impact of the film being green lit: Renaissance lost more than one-third of its available capital for film investment due to its decision to green light *The Reckoning*.

h) The green light rules were never properly revisited.

6 Sales and markets

> You bring me a picture like this and want money for it? You may as well put your hand in my pocket and steal it. It isn't commercial. Everyone in it dies...
> (Hollywood mogul Adolph Zucker, passing on *Broken Blossoms*)
>
> Sales companies need to be doing a whole lot more than merely 'selling' in today's market. We're in the business of screenplays, talent packaging, executive producing, financing, and weighing up the options between traditional, hybrid and streaming routes to the global content market.
> (Phil Hunt, founder and CEO, Bankside and Headgear)

The territorial picture

A film is a product that can potentially be exploited throughout the entire world in a range of media. Before examining the sales sector and specific functions of a sales company, it is important to consider the way that the film business refers to rights and footprints, as these heavily shape sales activity. 'Territory' as a definitive term has a variety of uses: it can apply to one country, but it can also be applied as a term of ownership or licensing footprint across a number of territories. For example, it can be applied to describe a range of rights, from worldwide, to a cluster of territories, to just one small country or even state or region within a country.

That territory 'footprint' has become even more important to clearly define as we have entered the world of fettered rights being fought over by competing online platforms. Increasingly, sales companies are having to work out bespoke strategies for how to maximize licensing rights for films that will fall between traditional territorial exploitation and territories that are picked up by a streaming platform.

World markets break down in the film business into five key sectors:

1. 'North America' – the USA (and normally Canada). When referred to together, the term 'domestic' is used to define 'North America';
2. Europe – dominated by the 'big five': the UK, Germany, France, Spain and Italy, and which can be further broken into Western Europe, and Eastern Europe;
3. South East Asia (often described as Asia/Pacific, driven by China, Japan and South Korea but Asia/Pacific will include Australia and New Zealand);
4. Latin America;
5. Others (Middle East, Israel, South Africa, Airlines etc.).

DOI: 10.4324/9781003205753-7

A further way the business considers the world market is to take the globe as its starting point, and then divide it into 'domestic' and 'foreign' (also known as 'international', which can be confusing). For example, sales operations and studios use 'foreign' (or 'international') to describe all territories outside North America (or 'domestic'). Alternatively, a typical 'territory' often applied in transactions is 'English Language' (or 'English-speaking'). This definition would normally include North America (including Canada), the UK (including Ireland), Australasia (including therefore New Zealand) and South Africa. English language or English speaking takes on the legal form of a 'footprint' territory by shared language definition.

The business breaks the term 'international' down further into subsections, and then typically allocates specific territories within each subsection heading. For example, Western Europe is divided into the 'big five', which include France, Germany, the UK, Spain and Italy; and the smaller Western European territories, which include the Benelux countries, Scandinavia (including Nordic territory Finland, but excluding Iceland), Iceland, Greece, Portugal and Switzerland.

Table 6.1 is familiar to international sales agents and the Studios' international distribution departments, including, crucially, their marketing departments. For example, the territories, and their groupings, dictate the kind of footprint a multi-territory deal might encompass, and what might be available outside co-producing and/or pre-sold territories for potential streaming platform deals. Or a marketing department may need to strategize an international roll-out, determining which key territories will be released when, and in what particular order. For any independent film business concentrating on the buying and selling of film rights, territories help break down complex sets of rights, their relative pricing, and assist in the organization and strategic priorities of an international sales or distribution entity.

The relevance of territories and their groupings has a wider impact than on just the sales and distribution markets. How territories are acquired, defined and exploited play a critical role for film financiers and film investors, risk managers and film producers. After all, if a film is able to be financed by a producer through the resources of its home territory alone, that film, theoretically, can subsequently go on to be distributed, marketed and exploited in every territory in the world.

The sales sector

The international film sales sector grew exponentially during the late 1970s and early 1980s with the advent of a new ancillary platform, video rental in the format of VHS tape, which famously beat out the technically superior rival Beta around 1975. As the video rental market matured during the 1980s, the ancillary revenues were so strong that 'video rights' were sometimes sold separately as a horizontal right across territories, or split out from vertical rights in specific territories. It was in part due to the considerable rise in prices and revenues that the concept of 'pre-sales' emerged, where a film's rights in different territories (or as one world territory) could be sold in advance of the film being produced and delivered. On the back of this system, the need for cash-flowing of contracts became critical, and hence the emergence of the specialized film banking sector that 'discounted' contracts and advanced finance for the making of film product. On delivery of the film, the bank lender would receive the balance of the distributor payment, and so the most dominant independent system of financing film product was born.

Table 6.1 World breakdowns of territories

Western Europe
 United Kingdom (including Ireland)
 France (including French-speaking Belgium and a range of African states)
 Germany (including Austria)
 Italy
 Spain

Smaller Western European territories
 Benelux countries (Holland, Flemish-speaking Belgium, Luxembourg)
 Scandinavia (Sweden, Denmark, Norway and Finland)
 Greece
 Portugal
 Switzerland
 Iceland

Eastern Europe
 Russia
 Poland
 Czech Republic
 Serbia/Croatia/Slovenia
 Hungary
 Bulgaria/Romania/Baltics

Latin America
 Argentina
 Mexico
 Brazil
 Colombia
 Chile
 Venezuela
 Peru/Ecuador/Bolivia
 Central America
 West Indies, Dominican Republic

South East Asia
 Japan
 South Korea
 Thailand
 Hong Kong
 Singapore
 The Philippines
 Malaysia
 Indonesia
 China
 Taiwan
 India

OTHERS
 Australasia (Australia and New Zealand)
 Africa
 South Africa (most other African territories are included specifically in French, Benelux and
 German contracts. A sales company/lawyer will know all the precedents)

Middle East
 Israel, Middle East
 Turkey
 Additional rights: Airlines, shipping etc.

Source: A. Finney/Renaissance Films

Research

The sales sector has a formal trade organization, the Independent Film Trade Association (IFTA), formerly known as the American Film Marketing Association (AFMA). IFTA actively promotes independent film and monitors market developments on behalf of its membership cohort, whose product ranges from mainstream commercial fare to niche specialist films. Collectively, IFTA members produce more than 500 independent films and significant levels of television production every year.

London has proven to be a leading centre for international sales companies outside Los Angeles, in part due to its global time-difference position but also to do with the critical mass of film business-savvy executives and established legal knowledge in the entertainment sector. However, for many years the UK sales sector was fragmented and dis-unified, with companies tending to be secretive and unhelpful to each other, despite their need for pooled information and critical mass as a lobbying body. That has fortunately changed since the advent of Film Export UK (FEUK), which has more than 30 active members and has greatly improved cross-fertilization, training, sharing of information and lobbying. *Research*

The specific activities within a sales company

Many players outside the sales sector remain unclear about the functions and strategic role of a sales company. The key functions can be broken down into five main areas of activity: acquisitions, sales, publicity and marketing, business affairs and technical delivery.

However, as entrepreneur Phil Hunt explains in the opening quote at this chapter's heading, the role has become much more demanding as the market has grown more sophisticated and competitive. Many sales companies are positioning themselves as close to the early stages of the value chain as possible. Some, including Protagonist for example, has moved actively into production and executive producing; while others are now engaged in animation and long-running streaming/TV series in a bid to widen their market access and impact. Unlike most non-A list producers, the leading international sales companies have close relationships with the major streaming platforms and have much better access and commercial knowledge of appetites and deal terms than the majority of production companies.

Acquisition of product

The key driver for a sales company is a flow of new films to sell. Acquisition executives or main sales staff in smaller companies will actively track projects and talented filmmakers for the company to pursue. A controlled Tracking Document is normally maintained, with new potential films, tracked films and older product still being monitored and listed with notes on script, director, talent and budget etc. When the company has established a relationship with a producer they nurture it and provide a conduit for information and feedback regarding development of the script and the talent package. Sales companies read scripts, treatments and other written submissions and provide coverage (reviews) and recommendations with specific regard to the commercial prospects of the package. They will be aware of the credits, reputations and career paths of filmmakers, actors, producers and financiers. They also screen completed

product – often at festivals, but also on 'screeners' (normally via Vimeo/online link rather than DVD today) and at private screenings – and report on their suitability for the company. A basic knowledge of budgeting and financing, as well of the production process, is useful for acquisition executives, but the most important role is developing a strong network of producers.

The sales department

Sales executives negotiate a licence with the distributor (the buyer) for one or more films in one or more territories, negotiating the terms of commercial exploitation in one or more vertical media (theatrical, DVD retail and rental, VOD, pay-TV, free-TV, airlines etc.) for a fixed licence period. These 'rights' are licensed in return for a consideration which is normally a share of revenue and usually involves an upfront advance against that share. Because the rights are normally licensed exclusively to only one distributor in a territory, a very strong film – either on package or on viewing – is normally the subject of major competition. Sales veteran Ralph Kamp explains that "selling a 'hot' film is actually fairly simple. The hard part is explaining to a number of unsuccessful distributors why their bids did not win, and how you can maintain good relations with unsuccessful bidders going forwards."

Identifying the 'optimum deal' requires a high degree of knowledge of the territory in question, about the bidding companies, their expertise, track record, credit rating, and their future plans. It also requires knowledge of the distributor's plans for marketing and releasing the film and how those fit with the specific market and product. This is always important particularly to the producer. Often the salesperson ensures that required approvals for the deal are obtained from producers and/or financiers and prepares a preliminary deal memo for the distributor to sign.

The critical role of the sales team is to compile sales 'estimates' – a set of numbers that estimate the value of a film in each territory in the world. Normally, numbers are run in two columns – an 'Ask' and a 'Take' set (sometimes referred to as 'High' and 'Low'). The 'Ask' numbers are ignored by financiers and, in particular, banks. Instead, lenders focus on the accuracy of the 'Take' or 'Low' figures, and will stress test them with a 'third column' of their own even more conservative values based on their detailed knowledge of the current market and pricing. In addition, estimates cover all territories available, while, in practice, many films fail to be sold to more than five to ten territories around the world. (Note: some sell to none outside their home market and/or co-producing territories. A strong result for a film's sales is more than fifteen to twenty territories, while a 100% full sell-out across the world is an optimum result (achieved by precious few, such as *The King's Speech* and *Parasite*).

Producers often depend on a set of estimates in order to attract and start negotiations with financiers and investors at the financing stage of a film. They act as a risk management tool for third-party financiers and investors. Sales agents understandably are torn between proving positive estimates upfront in the knowledge that they may be competing, whilst remaining realistic about the film and market value of the film in question. The reputation of the sales company almost exclusively comes down to its ability to meet the majority of its 'Take' estimates – as these are the currency they compete and trade in.

Marketing and publicity

The marketing department in a sales company is responsible not only for the image and positioning of each film on the company's slate, but also for branding the sales company corporately. The marketing department will read and report back on scripts, and on film packages. A member of the team will normally be present at the acquisitions meeting and monitor the tracking document.

As a film is prepared for the market prior to, or during, production, a concept poster is commissioned and designed, often by an outside agency. A promo, teaser or trailer is also commissioned. The marketing department is also involved in preparing information for the trade and press, in the form of B2B websites, press kits and materials that distributors can use for local markets. On-set 'unit' publicity is normally appointed by the producer, but the sales company will have a relationship with that person, ensuring that set photography and the production notes are of the required standard for worldwide delivery. Additional publicity responsibilities include the commissioning, preparing, editing and occasional writing of material for publication.

The preparation for markets (for example, Berlin, Cannes and the American Film Market), and festivals, in particular where films are being launched, is a major part of the marketing department's responsibilities. The booking of the appropriate office, technical equipment, poster hanging, screens for trailers and promos to run etc., are functions all too easily taken for granted by CEOs of sales companies and their producer clients.

Business affairs

Whether predominantly handled in-house by qualified lawyers, paralegals or experienced contract executives, or by external lawyers, business affairs is a pivotal function because the film sales business involves numerous documents and agreements that tend to lack consensus on 'standard terms and conditions'. This extends to definitions of media rights to be granted (e.g. new digital media) and territories granted (e.g. satellite footprints) even before hard commercial and financial points are reached.

The sales company's role in closing a film's financing, even if that company is not a direct investor, is tantamount to acting as the 'glue' that binds many different elements together. Producers come to depend on the estimates – and live in hope that serious pre-sales are possible to achieve. The producer also depends heavily on the numerous functions the sales company supplies in reaching distributors and the international marketplace. The financiers, in turn, depend on the sales company's reliability, experience and reputation to deliver; and for investors, the sales company is the entity they look to first for recoupment of their monies. Business affairs executives will be involved in many contract negotiations that involve a high degree of contention (not just triggered by the value of the deal). Among the transactions and relationships they will cover are: inter-party agreement (recoupment order, co-production agreements); acquisition (agreement to obtain rights in films from producers or financiers, e.g. sales agency agreements); sub-licences granting exploitation rights to distributors (sales); and what should be covered in negotiations on terms and conditions of use of copyright materials.

Technical and servicing

Until a film is ready to be fully delivered to a distributor, a sales company typically remains unpaid in commission or in repayment of its advance. With the exception of North America, and increasingly Germany, most distributors pay the balance of their advance on Notice of Acceptance of Delivery – but the role of delivery is critical for both producer and sales company, and their interests are fully aligned in this aspect of film production and finance. A technical department (or out-sourced company, which is the most usual method) is responsible for the physical materials necessary to exploit the film, including film and digital, video and audio, foreign language tracks, marketing elements and documentation. All this flows from obtaining the correct elements from the production. This includes preparing all the necessary paperwork and keeping accurate records. Because irreparable defects or omissions in these elements can terminate agreements, meticulous care is needed in their gathering, duplication, storage and shipping. Servicing executives develop in-depth technical knowledge of different (and proliferating) formats and interact with laboratories and distributors to ensure the timely and cost-effective provision of all necessary materials. They will manage supplier relationships in order to ensure that the company's time-sensitive communications are reliable, including material shipments, couriering of legal documentation, and delivery of marketing materials to trade shows and other events.

Sales strategy

An international sales company's strategic task is to build a slate, cement a brand, and attract a set of distributors that they can regularly sell films to in key territories around the world. They need to keep their product flow appropriate to the size, scale and demands of their particular area of the market. For example, certain boutique operations can survive by handling just four to six films or so a year. They do this by keeping overheads low and through steady relations with appropriate distributors who appreciate their taste and specialist skills. Other major sales companies handle up to 20–25 films a year, sometimes with different labels to differentiate product. The standard level of product carried by most medium-sized companies is at 10–15 films in play at different stages of development, financing and distribution at any given time.

Sales outfits need to market their companies to producers, talent and financiers, as these form their key sources of product. They do this by displaying their track record (in particular, recent and current product), circulating recent sales deals through the trade press, developing their profile in the market (sometimes by advertising, but normally through word of mouth), and promoting their own personal approach to the role. For example, a sales company that provides helpful script reports, strong financing support – in particular, excellent bank relationships, healthy distributor relationships and detailed territory-by-territory knowledge – is offering compelling reasons to producers and suppliers to bring product to them.

The producer's needs

From a producer's perspective, their relationship to the sales company *should* be very important. The producer needs to feel confident of the sales company's enthusiasm and dedication to the film in question, and that the film fits appropriately in the sales

company's slate. Sales companies can position a film and introduce it to appropriate distributors – hence their specialist contacts and track record with key 'types' of distributors is vital. A seller that tends to take on a wide range of films, and has a slate of say 20–25 films at any time, can place producers at a disadvantage. If the specific film in question does not spark interest quickly, the busy sales outfit will tend to move on to what is selling rather than work hard at additional angles.

Boutique, highly specialized outfits have the advantage of time and focus, and can work a film hard in terms of appropriate festivals and markets. However, they do not have the advantage of 'weight' – meaning the ability to trade off other successful films coming through their pipeline – in order to glean advantage with buyers, or, in particular, to force collection of unpaid monies. Ultimately, producers would do well to learn about the different range and styles of sales operations in detail, and to do considerable research on their history, track record and current slate before committing into a contract. There is considerably more to the business relationship than just the exchange of sales estimates in return for representation of product.

In addition to the role of the sales agent, there has also been a trend in the North American market for 'producers' reps' to take on the key strategic, negotiating and contracting role. John Pierson, experienced producer rep and author of *Mike, Spike Slackers and Dykes*, and John Sloss, of Sloss Law and founder of Cinetic, are two striking examples of such creatures. They offer experience of handling challenging indie product, and positioning it effectively in not just the right festivals, but specific slots and screening times. Experienced reps know all the studio, mini-major and independent buyers and, of course, the key streaming platform options – from CEOs to junior acquisition executives, and they have forensic knowledge of contracting terms, from payment structures to revenue shares all the way to TV costs. They can manage expectations on films that may not spark commercial interest, but when a film breaks out, their expertise is critical between a film not just picking up an impressive advance, but going on to benefit from a distribution plan across both North America and Foreign territories.

The business-to-business marketing stage

Once a sales company is up, running and armed with product, it will have two key marketing tasks. First, it needs to market its films to distributors at various different stages in the cycle (this work will also depend on, of course, the stage at which it acquired rights). Second, it will need to create a range of marketing materials that a distributor will have access to if they acquire rights to the film. Areas that require marketing attention include:

1. Book/synopsis/screenplay to distributors
2. Script, budget, talent, cast (the full package to distributors)
3. Clips from rough footage (to distributors, often at film markets)
4. Promos shown to distributors (often at film markets)
5. Concept posters (shown at film markets)
6. Website with clips, news and links
7. Trailers and release posters for international distributors
8. Teaser trailers, TV clips
9. Press notes (supplied by producer to sales company)

10. Still photography
11. Early press coverage, e.g. set visits
12. Press pack
13. Electronic Press Kit (EPK) and online materials
14. Festivals
15. Press junket/launch (mainly for large budget films)
16. Market screenings
17. Trade press: releasing of deals, information, photography
18. Order of release territories – often controlled by USA and/or the lead producing territory; or a streaming platform if they have picked up a major number of territories.

Many of the marketing tasks and roles above are specifically designed to help each territorial distributor understand, prepare and release the film in their own territory. To summarize, the marketing tasks include the development of concepts, creative tools and materials, event management (in particular, festivals and markets, see Chapter 7) and a plan for the film's roll-out across the world. The sales company's job is never to market directly to the audience, but it should always be thinking about the final intended audience at all stages that it is involved in handling a film.

Markets

There are currently three major film markets each year: Cannes (May), Berlin (February) and the American Film Market (AFM, November). These are key annual events that last from five main business days at the AFM to the two-week media hoopla of Cannes. They offer market platforms where producers, financiers, investors, sales companies, independent distributors, agents, producer reps, publicists and studios all meet to finance, promote, buy and sell films. Each has their own distinct character, and, of course, the two European markets are run alongside major film festivals.

Studios and a wide range of different kinds of independent distributors from around the world utilize the markets to 'track' upcoming films, to screen films, to buy product, and to help plan their future release strategies over the next 24 months or so. Leading market distributors will often send teams to cover Cannes, screening a broad selection of films that are not necessarily appropriate for their company. They screen and track in order to keep on top of directors and actors, and collect counter-programming information about rival acquisitions. This activity is also carried out at the major festivals, including Venice, Toronto, Sundance et al. (see Chapter 7).

Pre-market information, preparation and working out a market strategy are critical for both sellers and buyers. Sellers tend to focus on their latest product; and market premiere screenings, and hence prepare buyers accordingly. Given that many sales executives will hold 30-minute meetings with buyers around 15–20 times on each market day, they have a limited amount of time to get their key information across. For producers (and financiers), the experience can be frustrating, as their film is only one of a number that the company is handling during this intense period. Films that have already screened at previous markets tend to fall off the end of the sales pitch, a contentious issue between the filmmaker and the sales agent.

Buyers will want to read screenplays before the market has begun; and will draw up a shortlist of films they intend to compete for, or at least consider acquiring. For larger

budget films where, for example, distributors may need to pay significant advances for the rights to their territory, they will 'run numbers'. This will involve the compilation of a spreadsheet (aka a control sheet) with high, medium and low box office (and corresponding ancillary) estimates. Against these numbers will be a range of anticipated prints and advertising spends, and standard video and television sales costs. Overhead and interest will be added. The goal driving these calculations is the point at which the film will break even; which, in turn, allows the distributor to consider an appropriate level of minimum guarantee (Advance).

In addition to the major markets, more specialized and targeted events have emerged over the past 20 years. Rotterdam Film Festival holds the Cinemart, a market aimed at broadcasters, public funds and smaller, lower-budget feature filmmakers. The festival's programming is particularly strong in Asian cinema and includes a range of documentary as well as feature films. Cinemart holds a grid of meetings between producers and financiers, predominantly from the public fund and broadcasting sector. The structure and organization has been highly praised, providing producers from around the world with an opportunity to pitch and present. Pusan holds a market aimed at South East Asian feature film product in tandem with its international film festival. In 2007, Film London launched the Production Finance Market (October) to run alongside the London Film Festival. This highly focused market (which the author managed for Film London from 2007 to 2017) is aimed at attracting commercial financiers and new sources of money to meet established producers keen to finance single projects and slates of films and company expansion. An additional micro-budget event was also established to address the needs of emerging talent. Financiers have found the event to be of significant value as it offers them an opportunity to meet each other, and to exchange notes on deal structures, emerging markets and changing revenue formats and income streams.

Case study: *The Mother*

The following case study examines business-to-business marketing, sales and promotion prior to the consumer release. I was responsible for leading the sales campaign on the film and was an executive producer on the project.

The background

The Mother was an original screenplay written by Hanif Kureishi, which the author initially wrote for Stephen Frears to direct. The film never happened. Only when Duncan Heath at ICM put Stephen Evans, MD of Renaissance Films, and a list of filmmakers, including Kureishi, director Roger Michell and producer Kevin Loader, together, did the screenplay have an opportunity to be packaged and ultimately financed and produced. The writer–director–producer team was reunited, following their successful partnership on *The Buddha of Suburbia*, an adaptation of Kureishi's acclaimed novel.

The screenplay was a sharply drawn, family-focused drama with a significant twist: the 'mother' loses her elderly husband of many years during the first act, only to take up an affair with her daughter's errant boyfriend. By the third act the family – including the daughter – find out what's been happening behind closed doors. Renaissance

Films picked up the project in 2000, and then, with the support of ICM and Michell and Loader's Free Range Films, brought BBC Films in to be the lead financier on the £1.6m film. Renaissance Films retained the world sales rights outside the United Kingdom, which BBC Films controlled.

Despite the pedigree of the filmmaking package, *The Mother* was a testing read from a distributor's perspective. The film had an edgy and challenging perspective on families, sexuality and emotional trust. Michell – who had experienced commercial success with films ranging from *Notting Hill* to *Changing Lanes* – was determined not be lured into typically 'commercial' casting choices, opting for theatre and television veteran Anne Reid over other suggestions, such as Dame Judi Dench. The boyfriend attracted up-and-coming actor Daniel Craig, not yet known as James Bond; while other roles were filled by strong UK actors, including Stephen Mackintosh (*Lock Stock and Two Smoking Barrels*). However, none of the actors were of significant value to distributors.

Pre-selling The Mother

Renaissance and BBC Films were aware that for the film to work, it required a carefully staged marketing plan to distributors over a series of film markets that were to include Cannes 2002, the former MIFED (November 2002), and, ultimately, a first-half 2003 festival that would launch the film to the world market. At Cannes 2002, a simple, typographical concept poster with the title and the names of the filmmakers was designed in green, with deliberately no images run at that stage. BBC Films was credited as the financier, meaning that the film was, in the eyes of distributors, very likely to go into production.

When Sony Pictures Classics, run by Michael Barker and Tom Bernard, heard of the re-teaming of Kureishi, Michell and Loader, they showed considerable interest in the project. SPC had previously handled *The Buddha of Suburbia*. A screenplay was sent after Cannes 2002, to which Barker responded positively.

SPC was very keen to pre-buy the film for what Barker calls his 'standard' $300,000 advance. This sum was $200,000 lower than Renaissance's 'Take' sales estimate, but the sales company stressed to BBC Films that with North American distribution secured, a commitment that is very valuable to foreign independent buyers, the film would attract further cornerstone distributors prior to its completion. SPC was keen to build awareness of the film at an early stage, and set up a website for the film with quotes, images and information about the film and the filmmakers. Most importantly, the deal was able to be announced prior to the MIFED market in Milan, attracting considerable attention from specialist buyers.

By the time the Milan market took place, the film was being edited. Producer Kevin Loader and Renaissance convinced Michell to allow a couple of clips to be shown (lasting just a few minutes, with no grading and no music), including one of the sexually intimate scenes between Craig and Reid. Tele-Munchen came in with an offer for German-speaking rights of $220,000, just $30,000 lower than the 'take' price, which was accepted by Renaissance and BBC Films. A couple of smaller territories, including the Benelux countries, also pre-bought the film. Strategically, this meant that the film had some strong specialized commitments before any of those buyers had actually seen the completed film.

The festival challenge

The next step in terms of positioning was to find a launch pad for the film at a key festival in the first half of 2003. Despite the pedigree of the filmmaking team, *The Mother* was rejected by all sections of the Berlin Film Festival, to the surprise of the sales team and financiers. Renaissance's marketing team decided to try to convince the Cannes section, Director's Fortnight, to support the film. After deliberations, Director's Fortnight offered *The Mother* the opening film slot. All other Cannes slots had also rejected the film, so Director's Fortnight was the last slot for a premiere launch.

As soon as the film was accepted by Cannes, Renaissance organized a screening of the film in Paris. The strategy for sales companies when a film has a slot at Cannes is to find a French distribution partner prior to the festival. This allows press and festival marketing costs to be shared, but, most importantly, it enables the French distributor to organize and take best advantage of the attention a film attracts with the world press during the festival. The late Philippe Helman, MD of UGC PH, offered $125,000 for the film, and, once again, the deal was able to be announced prior to the festival premiere, further attracting buyer interest. During this period Michael Barker saw the film in New York, and rang me and gave me his blunt reaction: "Angus ... I've seen the movie ... it's spectacularly un-commercial."

The opening slot in Director's Fortnight was a good place for the film to be premiered. From a sales perspective, it allowed the film to be reviewed early and subsequently screened to buyers in the first half of the market. This, in turn, allowed for sales to be closed during the second half of the two-week festival. If a film screens very late in the festival, it can be hard to impossible for a sales company to take advantage of the market and close out un-sold territories.

The film was supported strongly by the makers and talent. Michell, Kureishi, Craig and Reid all came to Cannes for the premiere, and then dedicated two full days to give press, television and radio interviews. Kureishi, in particular, was popular, opining about American foreign policy mistakes during the festival press conference, and attracting significant press attention due to his literary fame as much as his film work. A modest party was held at Renaissance's garden offices, attended by more than 150 guests. Despite divided reviews, the film picked up good festival word of mouth, and a steady flow of specialized distributors visited Renaissance's offices over the first week of Cannes.

By the end of the market, a significant number of territories had been sold, including Italy (Lucky Red), Spain (Vertigo), Scandinavia (CCV), Australia and New Zealand (Dendy), most of Eastern Europe and South Korea (Dong Soong). BBC Films had also found a UK distribution partner in Momentum. It should be noted, however, that due to the tricky subject matter, the film failed to be sold to Japan, and South Korea was the only Asian territory to buy the film. Japanese male buyers explained that an affair between such an old woman with a young man would 'never happen in Japan'; while Japanese female buyers stated that such 'affairs of this nature do happen, but no one talks about them'.

What was notable was that no two distributors went head-to-head for the film during Cannes. The pattern of sales was exclusively governed by appropriate and committed independent distributors, which, in turn, meant that final sales figures were modest rather than strong for *The Mother*. The BBC later confirmed that they were "entirely happy" with the results. And on the final weekend of the Cannes Film Festival, the film went on to receive the Prix Europa, winning distribution support across the European Union from the MEDIA programme.

7 The festival circuit

> If I am lucky, something extraordinary will happen to me during this festival.
> I will see a film that will make my spine tingle with its greatness, and I will
> leave the theatre speechless. There is no better place on earth to see a movie
> than in the Palais des Festivals at Cannes, with its screen three times the size
> of an ordinary theatre screen, and its perfect sound system, and especially its
> audiences of four thousand people who care passionately about film.
>
> Critic Roger Ebert [1]

In my preparation for teaching and training in Denmark, Saudi Arabia and Ireland,
undertaken at the height of the pandemic during the spring and summer of 2021, I
realized how little time and thought I had given to the worldwide festival circuit and
the critical role the "movie merry-go-round" plays in connecting films to people and
sellers to buyers. This was despite taking the major festivals for granted for so many
years (I have attended the Cannes Film Festival 27 times, and Berlin 20 at the time of
writing). I was clearly more consumed by the job in hand each year than taking the
bird's-eye view of what the circuit means to the international film industry at large.
This chapter is aimed at putting amends to my 'worm's view" oversight, and is further
emboldened by an interview with the experienced Sandra Hebron, former artistic
director of the BFI International London Film Festival (see below).

The international film festival circuit and packed calendar (See Figure 7.1) plays
an essential role in the discovery and launching of independent films. Festivals offer
a platform to promote a film towards buyers, critics, entertainment and cultural
press and audiences; while so-called 'competitive' festivals add the marketing hook
of potential awards and the sizzle of ever more press coverage. Film festivals are one
of the few marketing and positioning platforms outside the studio release system that
the rest of the film business has on offer to make people aware of their film. They have
been around for nearly 100 years, with just the Second World War (1939–45) and the
Coronavirus pandemic (2020–ongoing) to interrupt their reach and flow.

The history behind the major festivals

The first international film festival was Italy's Venice, which was launched for largely
political reasons under the dubious cultural impulses of Benito Mussolini in the
1930s. The US, Great Britain and France were so offended by the cultural and artistic
status-seeking land grab, that they teamed together to back a Riviera-based festival in

DOI: 10.4324/9781003205753-8

The Intense Festival Calendar

January	February	May	July
• Sundance	• **Berlin**	• **Cannes**	• Karlovy Vary
• Rotterdam	• Tribeca	• Sydney	
	• SXSW	• Munich	
	• Cartegna	• Sarajevo	

August	September	October	November
• Locarno	• **Venice**	• London	• American
• Telluride	• San Sebastian	• Busan	Film Market
	• Toronto		(AFM)

Figure 7.1 The intense festival calendar

response: the result was Cannes. Unfortunately, the proposed year of launch – 1939 – was steamrollered by the onset of a worldwide war. The "Festival International du Film" managed to kick off in 1946 with support from the city's mayor and City Hall. Fittingly, the building selected to house the first screenings was the casino. A new building called "The Palais" was built in 1949 but the roof blew off that year. The festival picked up steam in the 1950s and by 1959 the Marche was launched, firmly cementing the link between films screened in the festival to audiences and the churning demand for a forum housing buyers and sellers. The industry was instantly keen to take advantage of Cannes's focussed destination, sunny timing and media frisson created by the annual magnet for movies, stars and coverage.

"What you have to understand is that the birth and expansion of major festivals was really about business: creating a market around the attraction of visitors, tourists, and filling hotels. That shifted quickly to feeding the world's press and the selling of 'space' – whether it's rooms and restaurants, or sides of walls for posters to be slapped up against", explains Ben Gibson, former director of the London Film School and the DFFB (the German Film and Television Academy Berlin) [2]. The inevitable expansion over decades, involving the addition of side bars, a larger Marche, and an increasing artistic reputation, lead to the city of Cannes becoming a destination for a host of business trade shows, from property, advertising, music to MIP-TV and MIPCOM – dedicated television trade shows held in the spring and autumn each year. The impact of Coronavirus has been acute: Cannes lost more than $1 billion of revenues during 2020–21 due to the pandemic, and whilst its authoritative recovery in the summer of 2021 augurs well for the future, the business model was severely impacted once the trade and crowds were forced to stay at home.

Not to be outdone, the "Western" Germans launched the Berlin Film Festival in 1951 as a "showcase of the free world" – very much a child of the Cold War (and perpetually cold in February). Social and political issues have never been far away from its programming ever since its launch. Today, in addition to 11 sections, there are four key industry elements to Berlin: the European Film Market, the Berlinale Co-Production Market, B-Talents and the World Cinema Fund. Dating has become critical to the flow and selection opportunities to each of the main three festivals (Berlin: February; Cannes: May and Venice: September – albeit the dating has been thrown into disarray more recently due to the disruption of Coronavirus).

Around these established events are other critical leading festivals, including Sundance and Rotterdam (January); South By South West (SXSW) (February); Karlovy Vary (July); San Sebastian and Toronto (September), London and Busan (October) and the non-festival American Film Market in November, that has failed to ever properly launch a fully-fledged festival to chime with its commercial footings. Beyond this table there are of course multiple further key festivals: the apocryphal saying is that on each day of the year, yet another film festival has an opening night.

FIAPF (Fédération Internationale des Associations de Producteurs de Films; English: International Federation of Film Producers' Associations) is an agency made up of 26 producer organizations in 23 countries around the world, and it has historically legislated how festivals can operate. The agency runs a film accreditation system and attempts to install values and standards across four 'tiered' festival events. These include:

- Competitive International Festivals (referred to as "A list" festivals)
- Competitive Specialized Festivals ("B list")
- Non-Competitive Festivals
- Documentary and Short Film Festivals

This all appears very organized and straightforward, but any attempts by varying sectors of the industry to control and dominate proceedings inevitably attracts chagrin and criticism. Firstly, talk to any key festival director and their senior staff, and their first complaint is that being a member of FIAPF is expensive. It's also expensive in terms of the amount of time they have to spend dealing with a highly bureaucratic process. Festivals like Toronto and Sundance have never been part of FIAPF, and former Sundance director Geoff Gilmore complained volubly about the unevenness and unfairness of the FIAPF accreditation system. While the 'A-list' festivals are events where films win awards and are able to utilize festival laurels on posters and marketing campaigns, non-competitive platforms and specialized festivals can have a significant impact on a film's arrival and performance.

Strategies needed to negotiate festival opportunities

The precise positioning of a film within a festival can make a considerable difference to its ability to maximize the exposure. The specific playing time of the product matters, not just for the film's programming time, but also the counter-programming. Many expert sales and marketing veterans like their films to be screened later if playing in competition at Cannes, for example. Experienced film marketeer John Durie [3] explains:

> If you play between the last Thursday and Saturday, when the festival is peaking, and the level of adrenaline is building, it will be much fresher in the minds of the jury. Unless your movie is absolutely stunning visually and is so strong it stays in the jury's minds, early screenings are at a disadvantage.

Part of the key is for producers to learn their way around the complex clutter of film calendar events described above – competitive, non-competitive, market-driven or press-driven – and maximize their chances of improving their film's profile or lifting

their film from post-completion obscurity. Experienced sales companies are the producer's ally in working through this challenge.

Exactly how a particular festival invite (and which section does the inviting) helps a film's overall sales and marketing strategy, in particular the event's timing and profile, are important questions for both a sales company and producer to ask before accepting. Many films, in particular US independent films that have not made the top American festival circuit such as Sundance, Toronto, New York, Tribeca etc., cannibalize their international festival opportunities by accepting the next US festival that invites them. This stops the film being able to be offered as a 'world premiere' to say, an interested European festival. Most top festivals are intensely competitive, and vie for the most promising, interesting and often the most controversial films every year.

The press is the critical element of the festival process, and all events need to be assessed in terms of industry attendance and foreign press presence. All festival directors design selections and schedules with both contingents in mind. The leading trade papers will review a film only once, normally when it appears at an event they are covering. Consequently, the producer's role is to try to ensure that coverage is appearing in the right place, and that the film is going to secure a review next to considerable competition from other films. Beyond the critics, it is essential to be able to bring the appropriate and most compelling talent to the festival table. Just as a studio junket delivers director and key stars for an entire day in a major European city, so too must an independent film try to ensure that it takes maximum advantage of the launch festival marketing window. Talent that can only make dates prior to the film's screenings leaves the press at a major disadvantage when interviews are scheduled. An experienced publicist is a must.

For new talent, in particular directors, a film's successful embrace from the circuit can require them to make upwards of 15–20 international trips to support their film. Normally actors attend the launch festival, but the director needs to stay with their film. This can mean an entire year or so being spent on the move, rather than working on their follow-up film.

The sales company needs to wield considerable strategic skill when weaving together complex festival-and-market events. When is the right time to launch a film in advanced development to the market? When is it right to attempt to close pre-sales? At what point should a film be held back from distributors (and offers) until fully completed and ready to be formally launched? Films that are completed and screening prior to the major festivals may have already been rejected by those festivals – something that many producers are not transparent about. Above all, teamwork between the producer, sales company and financiers is critical if the festival system is to prove effective for sales and marketing to triumph.

Moving forwards

Whist the entire festival circuit has been thrown into turmoil due to the 2020+ pandemic, what's been lost for emerging talent, including producers, directors and upcoming executives, is the social and networking aspect of physical, face-to-face events. The talent-magnet structure as we know it has been acutely disrupted. Whilst the wonders of online technology, in particular Zoom (laughingly referred to many by the end of 2021 as "Zoom Doom"), has enabled online access to meetings and content, it has been a challenge for even the most experienced players to maintain momentum. Smart

operators have embraced cross-promotion and partnerships, but much of that activity has emerged from established players already connected. For the new arrivals, the last two years plus has been a nightmare.

"Nothing will ever be the same", lamented Kim Magnusson [4], the Danish film producer and now Scandinavian distributor. "The future, whether we like it or not, is going to inevitably be a hybrid one of online and physical". On uttering those words, Magnusson proceeded to show the 2021 online group of producers he was talking to from Copenhagen a snapshot of the Cannes road intersection just before you reach the Palais on the first Friday of the festival. While the press and trades were pumping up the event and films on offer, the stark truth was about to be shared: That road just up from the Croisette would normally be a) blocked off; b) heavily policed to assist the festival traffic through; and c) heaving with a mass of bodies trying to pass both ways as fast as possible. The phone's photo showed just three blurred figures far in the background and an empty road lined by palm trees.

The festivals are definitely making a comeback, but clearly nothing is going to be the same from COVID onwards, whether we like it or not.

Sandra Hebron, former Artistic Director of the BFI London Film Festival and Head of Screen Arts at the NFTS, UK, was interviewed by the author at the Danish National Film School, Producing Course, March 2021.

Author

Can you start by sharing with us your entry to the industry and how things developed from there?

Sandra

When I started my career there was a huge amount of cinema being produced around the world that people were just not getting to see. I lived in a city [Sheffield, Yorkshire, UK] where there was a very good independent cinema with a brilliant, anarchic curator, Dave Godin. I was introduced to lots of amazing work through him and I realized I was much more interested in the intersection between film and audiences than I was in just simply making more films myself. I wanted to think about how to bring work to audiences, so I started off working in a three-screen independent arthouse cinema which also had a gallery and a bar and a publishing company, and I liked that mixed-arts environment.

Whilst I was there, I was involved in setting up a couple of specialist festivals: an American independent film festival and a Spanish language film festival, the latter of which I'm happy to say some 25 years later is still thriving. I loved working in a venue, but at that time I thought that festivals offered more scope for experiment. So I moved to work on the BFI London Film Festival, where I did a year as the Programmer of the festival, a few years as the Deputy Director and then I took over running that festival and also overseeing the BFI London Lesbian and Gay Film Festival (now BFI Flare). I ran those festivals for 8 years, but in total I worked on them for 14 years. But I'm a believer in cultural renewal, and I wanted that for the festivals and for myself, so I decided to leave that role and do something different.

I retrained as a psychotherapist whilst also working on a number of other film festivals. I joined the selection committee of the Rome festival for a few years and then I worked on two start-up festivals in East Asia. Now I run a Curating MA and the

historical and critical studies programme at the National Film and Television School in the UK, I'm also a programme consultant for the Pingyao International Film Festival, and I have a small Saturday psychotherapy practice. So, that is me essentially!

Author

Your insight into the range of different festivals on offer is of real interest to filmmakers. How would you advise they go about selecting the right event for them and their project?

Sandra

Whatever your reasons for engaging with a festival, it's worth thinking about some key characteristics that define an event's profile, scale and reach, and that will help you decide whether a particular festival is right for you. It's important to think about who the festival is for. Where are you aiming to target your address, if you like, because obviously festivals are for audiences and for filmmakers, but also for sales agents, distributors and other industry delegates, and of course the press. Then there are the various stakeholders, those organizations and individuals who put money in or have a vested interest. The degree to which a particular festival serves one or other of these groupings will have an impact on where you feel that your film might best sit. For instance, if you're coming from the producer position, are you looking for a major festival that has an international reach such as Cannes, Berlin etc., or for a festival that has a national reach? If you have a filmmaker who you're trying to increase visibility for in a particular territory, then it might be that a big international festival is not necessarily where you want to be, you might need something a little more strategic.

Then of course there are a plethora of regional film festivals. If you're premiering your film, you're probably not looking to do so at a regional festival, but if you just want to go to a festival, engage with audiences and have a good time, a regional festival might be a nice way to do that.

You should also think about whether you are aiming for a generalist or a specialist film festival, because if you're trying to get into a big generalist festival, the competition is enormous. Of course, if you've made a brilliant film, that's not a problem. But, in submitting a feature film for a big festival, you could be throwing your hat in with at least 5,000 other feature films for a festival that may only have 60 slots. It's important to understand just how competitive the environment is.

If you have a film that has specialist content or speaks to particular audiences, the festivals that appeal to those groups will move up your list of priorities. For instance, if you've got a film that has a queer sensibility, you may well gain much greater visibility from putting it in something like Outfest in San Francisco or BFI Flare, or any of the other major LGBTQ+ festivals, because if you premiere your film there, it's very likely that the best films will get some kind of trade reviews or critical response. Whereas, if you put your film in a festival such as Toronto where you're alongside 400 other films, if yours is quite a specialized film or quite a small film, it might well be overlooked. Bigger is not necessarily better and specialized and more tailored can give you greater visibility.

One of the things you may also want to think about is "what is my film screening alongside"? Whilst it's great to be a strong presence in a festival, being part of an otherwise lacklustre selection can diminish the quality of your film. You want to be alongside a lot of other really good films. Some people might feel that competitive festivals are an indication of quality and certainly competitive festivals are popular, but personally, I would look carefully at how meaningful any festival award will be. Does it have industry or audience recognition? If not, does the festival offer other incentives, such as a cash

award which could be attached to either your next project, or to the distribution of the film that you're representing? In general, it may be that a reputable non-competitive festival with a decent profile would be preferable to a low profile, competitive festival – it really is all about reputation and how and where you're positioning yourself.

Another criterion you will want to consider is whether the festival is primarily industry oriented, or audience focused, or a combination of the two. You'll probably want to premiere your film at a festival that at least has some industry presence. As producers, you want your filmmakers to be known, and I imagine you want to get your own name out there too. Public audiences are great fun, but they won't help you with that. The presence of other industry activity such as a co-production events or labs are also things to take into account. Festivals rely on a consistent flow of excellent films, so many festivals have initiatives of this kind to help support filmmaking. Production finance markets or labs give a festival direct access to projects in their early days, and you hope that when the projects come to fruition and they're amazing that the producers and the sales agents will then go "oh yeah, I developed my project at Rotterdam" or "I developed my project in London, of course I'm going to premiere the film there". The competitive cycle of festivals is competitive on both sides. For you as producers, getting your films into festivals is extremely competitive and the success rate is low. The proportion of films that get selected relative to the proportion that we view is absolutely tiny. At the same time, festivals are all competing with each other for the same small group of very strong films, so having industry activities are often a way of attempting to encourage filmmaker loyalty to a festival.

Author

Could you talk about the management challenges facing a film festival director?

Sandra

I'm a curator. So, everything that I do is driven by that, and the selection of the programme is the work that I love. This includes thinking about events, filmmaker presence, contexualising materials, education initiatives and so on. But alongside this are a host of other interrelated elements that are part of process. So, whilst you're deciding on what to show, you are also figuring out where you're going to show it, and this in turn is related to the audiences that you hope to reach. Venue selection and platform selection, with all their related negotiations, go hand in hand with the selection of the work. It goes without saying that all of this is preceded by a great deal of financial and business planning, which in turn is connected to the work of fundraising, sponsorship and revenue generation. Staffing is another key area, namely how many people and with what skills do you need to deliver the festival, and when should you recruit them? Even a large festival with a core permanent team will need to staff up and integrate and motivate a team of temporary staff, which often includes volunteers. Press, marketing and promotion are also crucial, and these may well have a year round aspect to them. As a festival director you are always thinking in a holistic way, because there are a lot of interdependencies.

Then there's the running of the event itself, which feels a lot like a production. Most festivals have something akin to daily call sheet, so that everyone knows their roles and responsibilities on an hour-by-hour basis. And once the festival is over, comes the wrap up and evaluation, where you would use a range of qualitative and quantitative measure to consider whether you achieved what you set out to do. Here you would be looking at things like the perceived quality of the program, attendance figures, whether or not you reached your target audiences, whether you hit your financial targets and so on.

Author

Could you talk about the challenge of curating, programming selection and how you organized your programming team in London?

Sandra

Well, it's important to say that my London experience was ten years ago, and things have changed a good deal since then. Essentially we had a very small team in-house curatorial team, just myself and the Festival Programmer, though we also encouraged other members of the festival team to contribute to the selection process. My role was to oversee the programme as a whole and to select some individual films within it, particularly the higher profile and gala titles, and – because it's a particular interest of mine – experimental cinema. The Festival Programmer had specialist knowledge of British cinema and documentary film, but he also, like me, had to watch and evaluate a broad range of work. I think that's very usual in festival curating that you have to be both a generalist and a specialist simultaneously. We worked with team of 12 or so freelance international correspondents, each of whom had their own specialisms: often in particular national cinemas or kinds of work, such as short films or animation or artists' film and video or archive restorations.

We didn't work on the basis of people having a quota, but some festivals do. For us it was a more discursive process: everybody would view and propose films which we would then discuss. In practice, from January onwards, people were either travelling to festivals or different territories to view, or calling in materials to view. In practical terms, a filmmaker or film company will either submit their film to a festival or the festival will approach them – there is a huge amount of research and tracking involved. For a size-able autumn festival like London, in January you would begin updating your database in earnest, adding in titles announced for Sundance, Rotterdam, Berlin etc. Typically, these key festivals also mark the start of viewing films. So, the person who selects for the Nordic countries would attend Gothenburg, I would go to Sundance and somebody else would go to Rotterdam. We'd all go to Berlin, and this would continue through the next six months or so. Alongside festivals, the national cinema promotion agencies are also important in connecting festival programmers with new films.

Conversations around desirable titles often begin early – often with a producer or sales agent rather than a distributor as many films won't have distributors attached if the festival is watching them early in their life cycle. Then if a local distributor acquires the film, they would of course become involved. As the viewing goes along, as festival director you have a certain idea about how many films you need to have invited by a certain time. You want to make sure that you don't get a whole glut of amazing films right at the last minute, and have no space in the programme for them, but nor do you want to invite too few films and find yourself with a last-minute scramble. In reality, I've never known this to happen – there are always more than enough good films.

Whilst you're selecting, you're also thinking about positioning, which section or strand a film might play in. Is this a gala title? Is this possibly an opening night title? If there is a distributor attached, there is usually a process of negotiation with them about whether a particular title is suitable for that festival, and how a film could be positioned. The studios in particular will often have their strategies mapped out far in advance of release, and this will often be at least partly determined by when films will be released in other territories. For studio titles, negotiations would of course include both the UK and US teams. In London, I was offered an Opening Night film in September for a festival due to start the following October, so 13 months in advance. That's how early conversations can start.

Aside from the formal programme advisors that are involved in selection, there are lots of informal contributors, such as critics who are likely to be viewing a lot of films in key festivals and they can give good tips. Also, festival directors and programmers are pretty good at talking to each other, indeed many of us are friends. So, I would always call my counterpart on the New Zealand International Film Festival to ask what I should be looking at from Australia and New Zealand, and I would talk to my friend who was running the San Francisco Film Festival and ask, "Which of the hundreds of US indie films and documentaries do you recommend?". This network of trusted colleagues is extremely valuable. It's reciprocal, so they would also ask me for my recommendations. It also serves another useful purpose. If, as a filmmaker you submit to a festival and you don't get in, it wouldn't be that unusual for a festival programmer to say to a colleague elsewhere, "actually, this film doesn't fit our remit, but you might want to take a look at it". Because festival programmers talk to each other, I'd recommend being gracious in your dealings with people. If someone turns your film down, don't write them a long, annoyed email pointing out how misguided they were to do that. Write them a short, polite email that says "I'm sorry that you didn't feel this was for you. But if you feel that there's another festival that our film may be suitable for, it would be helpful to know". Festival directors, programmers, sales agents, distributors, critics – we talk to each other all the time, it's a very intertwined network.

Author

Absolutely. Can you just explain about the challenge of talent handling, handling directors and actors and actresses in that heady environment?

Sandra

Well, given the restrictions on travel in the last year, we're all adapting and rethinking how we work with filmmakers and other talent. Essentially, the world of film festivals is incredibly hierarchical, and so is the handling of talent. With big name guests, a festival would always be partnering with a distributor, and splitting costs. For instance, if a star needs a private jet, there are very few festivals with budgets that could run to that. There's always a negotiation about who gets what. So, if I partner with a distributor and then they're bringing talent into do a junket or an awards screening, maybe the festival would get one day with the talent and the distributor would get two days, for instance.

Many festival films don't have distributors attached and so there is no one to share talent costs with. So, festivals would generally set aside funds to bring in filmmakers with no other means of support. In that case, filmmakers are more likely to fully engage with the festival. Festivals never have enough money to invite everyone, and there is a pecking order to who gets invited. In a non-specialized festival, directors and actors are clearly top of the list; writers are sometimes valued; producers are pretty low down the hierarchy because I'm afraid you have limited appeal to audiences and press unless you are a superstar producer or there is something particularly noteworthy about how you were able to get the film made.

Author

The producer's job actually is to also make sure that they are responsible for managing and helping manage the talent. In other words, it's really important that a producer is involved in any kind of festival commitment and has a strategy and does talk through things with the writer, the director in particular, and obviously the actors.

Sandra

Obviously as the producer you're already closer to the work than the sales agent or the distributor. You also know the filmmakers as people, so you will not only have a sense of which festivals might suit the film, but also which ones might suit the filmmaker. If you've got a very shy director, you perhaps you wouldn't want to throw them into a very full on, commercial, brash environment. You would want to send them somewhere where the film and they will be treated a bit more delicately. So, there is a question of sensibilities. Once accepted in a festival, unless you have a publicist or agent to do this for you, part of the producer's job is to clarify expectations and the practicalities of what will happen at your screening and any related events. On the – thankfully rare – occasions when filmmakers behave badly at festivals, it's usually because no one has given them enough information or the right information. Don't be scared to ask for the information that you need well in advance. But do also recognise that as you will be dealing with a very busy festival team, it may not always be forthcoming, or that things might change at the last minute. And yet everyone will survive!

Author

Can you address the question about the length of short films, and festival programming and what works best and worst? Many emerging filmmakers and newcomers are often confused about what to aim for.

Sandra

A good shorts programmer will be very capable of putting together films of all lengths to make up a composite program. There's a lot of talk about the difficult mid-length film – anything over 30 minutes but not feature length. Of course, there are ways of showing mid-length films, either by programming them together or with several shorter films, but if you're trying to work thematically for instance, this can be tricky. In general terms, for short films in particular, the number of films selected compared to the number viewed is tiny – often less than 5% are selected. So, whilst it's heartbreaking that something might be excluded on the basis of its running time, the reality is that in some festivals that does happen.

Author

How do you think the post-COVID-19 festival online and physical presence is going to play out? Will 'hybrid' events be the new format around the circuit?

Sandra

Festivals have been pondering the whole question of how to work online for many years. In London we were already exploring this in 2009, but although some festivals, like Sundance, were much quicker in embracing the online space, I think there has been a kind of collective fear. We knew about physical venues and bricks and mortar screenings, and we even knew about pop-up, inflatable screens and so on, but online? That was scary techy stuff that we mostly did not understand.

 Of course, the pandemic has accelerated a previously slow process, as getting to grips with virtual screenings became an urgent necessity. We've realized that it's actually not that complicated. We are much clearer on both the opportunities and constraints, and in particular the opening up of access that online enables. I think we'll see many festivals going forward with some sort of hybrid model.

In my experience during the last year, I've found that the industry-facing activities generally work effectively online. Certainly, market screenings and meetings have been functioning really well online, though I really do miss the conviviality of being able to hang out with people, catch up informally, hear their views. I have a worry that the hybridization might see a great separation between the industry activity and the public facing activity in a festival, which would be a shame as that symbiosis of industry and public activities together is one of the things that I think gives a festival its vibrancy. An online market might be functionally efficient, but one of the pleasures of a market and festival combined is that you actually get that sense of festivity, you get an idea of kind of celebration and scale, and you also get to see how your film plays with a public audience. So, I worry a bit about the separation, but I welcome the accessibility and the convenience of online – and as the industry become more environmentally aware, we will inevitably have to consider how necessary it is to move large numbers of people around the globe for film events.

References

[1] Roger Ebert, *Two Weeks in the Midday Sun: A Cannes Notebook*. Andrew and McMeel/ Universal Press, 1987.
[2] Ben Gibson, Speaking on the London Film School/Exeter University MA course: The International Film Business, *Berlin Film Festival*, 2017.
[3] John Durie, quoted in A. Finney, 'A Dose of Reality: The State of European Cinema', *EFA/Screen International*, 1993, p. 101.
[4] Kim Magnusson, Speaking on the MediaXchange Limelight Training Course to the Author and Participants, July 2021.

8 Film finance

> We should all make a killing in this business. There's so much money in the pot.
> (Irving Thalberg, production chief, MGM Studios)
>
> The film industry is a lousy place for the private investor. They might as well shove their money down a rat hole.
> (Jake Eberts, producer and former Managing Director, Goldcrest Films)

Introduction

The majority of independent films financed outside the Hollywood Studio system depend on a myriad of sources of finance and investment to enter film production. Industry texts and analysts talk about 'jigsaw puzzles' and often suggest that there are 'no rules' to independent financing of films. Beyond the fact that the film production business is prototypical – meaning that each film is essentially a "one-off" and therefore unique (even sequels) – there have evolved certain structures and risk-managed approaches that continue to underpin the independent film finance business. But just as no films are the same creatively, few independent films are ever financed in precisely the same way (or repeated) as regards to the specific detail of partners, financing, investment, recoupment, secondary rights, and net profit share positions.

This chapter looks at the key difference between finance and investment, and examines the range of sources of finance available in return for varying demands and recoupment positions (see Table 8.1). A more detailed film financing/investment case scenario follows in the next Chapter 8, where I explain in detail the process an investor goes through (one hopes) when making a decision on a larger independent project priced at $20m. For more detailed information on specialized forms of film funding, such as tax, see the sources and bibliography, as this chapter is designed to deal with general principles and practices rather than being a forensic 'how to' guide.

Finance versus investment

Building on the strategic recoupment issues raised in Chapter 2: The film value chain, which places film investment in an often-challenging place in terms of its respective recoupment (hence late) position in the exploitation chain, it is important to first distinguish between 'finance' and 'investment'. Many independent films rely on both

DOI: 10.4324/9781003205753-9

Table 8.1 Finance and investment sources for film

Within the value chain

Distributor – needs a strong film pipeline to be in business; has the power to book and market product. SVOD is the critical area of change in the independent business, and the key DVD revenue earner with historically high profit margins is over.

Streaming platform – acting also as a distributor for content, and is also hungry for product, but is not limited by scale and numbers given its predominantly subscription-driven business model, and has vastly different marketing costs if no theatrical window involved (see Chapter 15).

International sales – needs film supply, relevant packages and genres/types of content, turnover is important for revenue re costs and overheads, commission fees for profit. Well-financed sales companies can put up Minimum Guarantees (Advances) for rights as part of the financing package.

Broadcaster – needs to license films for schedule/eyeballs/audience, but film has taken a lower priority on Free TV scheduling over last decade in contrast to reality/live entertainment and sport. Public channels are driven by cultural and quota imperatives reasons, and political mandates rather than commercial imperatives.

Outside the value chain

Banks and first position lenders – to make fees and interest while taking security against all rights where possible. The aim is make significant fees and get money lent at high interest levels and then get it all back as soon as possible.

Private equity – wide range of incentives from pure speculative return to lower-risk positions discounting receivables, now replacing bank finance on occasions. If positioned as investment will share in net profits alongside producer and talent in perpetuity.

Angel investors – want upside and involvement and link to creative element and lifestyle. Tax-based investors – tax relief/deferment for individuals or companies.

Public funds/subsidy – talent and industry promotion, career support, political and cultural mandate.

Regional funds – inward investment, development of talent/local industry.

Post-production – barter/in-kind investment in return for taking on full post responsibilities

Product placement/sponsorship – normally organized by the producer as an enhancement

sources of cash towards their budgets, but it is often assumed that finance and investment are essentially similar tools. They are not: each form an element of cash contribution that is governed by different objectives and end goals.

Film 'finance' is normally accessed in the form of a loan towards a film (or, more rarely, a slate of films). It is provided in return for as high a position of security as possible. Finance is normally made available on the condition that there is a binding assignment of rights to the financier against all available assets of the film, enshrined typically within the special purpose vehicle (SPV) set up to make the filmed product. "I'm in the business of finding collateral for my money: if there's no collateral, then there's no deal", explains Phil Hunt, entrepreneur and head of Bankside film sales and financing outfit Headgear. "And I would never touch equity. It's just too high risk because there's no collateral and you are too far down the recoupment order."

Senior lenders like Headgear or standard bank loans are normally provided on the condition of their repayment being placed first in the recoupment agreement. The bank will consider accepting a collection agent's fee at say 1–1.5 per cent, agreed sales

and marketing costs of normally between $50,000 and $150,000, depending on the size of the film and the timing of the sales company's involvement, and a nominal fee towards the sales agent of typically 5 per cent, while the bank's loan is being paid out, after which the agent will 'catch up' on deferred fees in the recoupment order (aka 'waterfall' – see below).

Against these conditions, bank finance takes no ongoing position in the underlying rights of a film once repaid: e.g. the bank takes no net profit position. Once fully repaid, it releases its charge against the film, leaving the producer and investors relieved of their responsibilities to the financier. Net profits are then, if available post cash break-even, divided up on a typical 50–50 basis between the investors and producer if industry norms are used. Some investors drive a harder deal against the producer, demanding 60–70 per cent of net profits, but the standard remains a 50–50 split between producer/talent and investor.

Film investment – often referred to as 'equity' – is typically forced to sit behind film finance in the recoupment order. Film equity will normally recoup behind a bank, but prior to the producer receiving net profits. Equity can be cash, but it can also be placed into a film as 'in kind'. For example, a 'facility deal' whereby the investor provides facilities in return for certain sharing of rights to a film, would also be termed an equity deal. Many of these deals are a mix of equity and reduced cash paid by the producer to the facility house. Equity can also be an alternative to salaries, such as the producer's and director's fees (or part of), which may be deferred and recouped after all financiers and investors are 'out' (meaning fully repaid).

Equity investors will typically take an aggressive approach to 'soft' investors – including state public subsidy funders and broadcasters putting up equity in addition to licence fee payments. It is in their interest to recoup ahead of these investors, accelerating the speed of their repayment, but specific details always come down to negotiation and the final contracted agreement. Overall, independent film recoupment structures normally adhere to the rule of pro-rata, pari passu in relation to the total budget – meaning they recoup at the same time and share 50–50 on each euro/dollar paid into the 'pot'. The area that differs is the position of the co-producer and his/her financiers – as they recoup typically from their own territory and corresponding rights, and not the recoupment pot.

Rights-based financiers and licensors within the value chain: sellers, distributors, streamers and broadcasters

Agreements for the exploitation of licence rights across horizontal and vertical territories and media form a critical component of independent film income. For a sales company, an advance (minimum guarantee) may be paid in return for the acquisition of a territory. This may be foreign, or English-speaking, or world, which would include both foreign and domestic, but not the producing territory and co-producing territories, as these rights are unavailable for sales/distribution apart from possibly servicing duties by the sales agent on behalf of the producer.

Technically, a sales company putting up a cash advance becomes the 'international distributor' of the film, as it has bought and owns rights (and is subsequently licensing them to third-party distributors), rather than representing the film and taking on the role of 'agent' for the producer, who remains in ownership of the rights. Sales operations that have access to a line of credit (meaning their own source of finance to

acquire rights, which still has to be repaid on agreed terms) or their own capital will often put up significant funds in advance in order to become a co-financier of projects, in return for a territory of rights to sell. However, there are considerably more commercial terms at stake than just the sales aspect if an agent puts up an advance, including the term of the deal in order to exploit for a much longer time (or, in cases, perpetuity); an executive producer position on the film; a share in the back-end profits; and a greater creative say in the production and marketing campaign.

Until the point that a sales company's advance, sales and marketing costs along with associated commission is recouped, the sales company remains in a position of almost complete control over each deal done within its agreed territory, unless, of course, a bank is sitting in front of its advance. This situation rarely occurs as both the bank and the sales agent is looking to get up to the top of the recoupment order to protect their position.

Distributors agreeing to make a pre-sale for a specific territory normally are required to typically pay 20 per cent on signature of long form, and 80 per cent on delivery of the film. It is the 80 per cent that generally has to be discounted by a financier (e.g. a bank) in order to cash-flow the commitment and direct those monies towards the production budget. (90 per cent of the value of the 80 per cent remaining is the standard lending level subject to the credit status of the buyer.) Distributors tend to dislike having to sign a notice of assignment to a financier, which provides the bank ownership/ security over their rights until either, a) the distributor has fully paid the contracted price or, b) if the distributor goes out of business or fails to pay. In this instance, the rights revert to the bank to exploit in order to recoup its financial position.

Broadcasters committed to film activity tend to be organized around development/ acquisitions and production financing – typically at the 20–30 per cent level of a film's overall budget in return for licence rights and a tranche of equity – but they rarely, if ever, distribute theatrically themselves. Key European-based broadcasters such as BBC Films, Channel 4's Film Four, ARTE, ZDF and RAI Cinema play an important role in propping up the predominantly culturally driven EU film market and in supporting new, emerging talent. However, all are facing the white heat of the competitive streaming revolution, and in some cases are now working more effectively than ever to co-finance and co-produce together (see Chapter 4: Ashley Pharoah interview).

The streaming conundrum

In today's disrupted market, the 'advance' may well come from a streaming platform commissioning a film or long-running series/documentary and potentially either fully financing or co-producing/financing. This is not to be confused by the oft-used and misleading term "original", where very often a platform has acquired varying licence rights after the film has been produced and completed by unconnected third parties, whilst still using the moniker "original". If a commission is undertaken, then the producer and streamer will negotiate over the territory footprint, first and secondary rights, and so on. Of key importance is how the streaming platform's financing will work in practice. At the time of writing, Netflix was continuing to expect a producer to cash flow its contract, often in a quasi-mirroring of the traditional 'negative pick up' model, where the majority, if not all of the contract value was paid on delivery of the film and not before. That has left producers searching for banking and financing facilities to turn a contract into cash. Again, by 2020–21 Coutts Bank had established

a strong working relationship between a range of experienced producers and Netflix, willing to cash flow (discount) a significant number of Netflix financing deals for a significant amount of filmed content. When a larger producer is able to act as the 'Studio' and effectively cashflow its own production from its own resources, it places that producer in a much more powerful negotiating position re fees and secondary and future licensing rights – enabling a greater share of the upside – as long as they have also looked after their talent, in particular actors and their ever-hungry and vigilant talent representation: agents.

The market's precarious characteristics

The film business has been characterized as a high-risk investment. There are strong arguments and facts to support such a case. Sunk costs in product prior to income streams are very significant. There are major completion and final product delivery risks in film production; there are acquisition and marketing risks in film distribution; and there are performance risks (in cinema exhibition, DVD/VOD, Pay TV, Free TV etc). There are, of course, also performance risks re streaming launches: we just tend to read and hear a lot less about them as they dive into the digital abyss. Given the creative judgements required in development, production and distribution, and given also the complex task of meshing together complex creative talents, there are, in addition, significant management risks, including the risk of failing to secure sufficient viable product to cover overheads. Furthermore, the marketplace is hard to read: only a minority of developed projects are converted into production; not all productions achieve a scale of release commensurate with their production costs; and only a minority of those so released make money. Outsiders who know nothing about the creative decision-making process tend to fall at the first hurdle. To paraphrase William Goldman, 'nobody knows anything', but outsiders know considerably less.

Within the film value chain, income can be generated from budgets (e.g. fees paid to producers, executive producers, investors, financiers and talent), from revenue streams (e.g. after fees retained by cinemas exhibitors and film distributors and sales companies) and from profits (in the event that a film recoups its production cost). Various fee corridors are available within revenue streams, and profit definitions can favour one party over another. Too often, incoming investors, especially those who invest in the overhead and development expenditure of independent production companies, find that their investment is effectively 'first in-last out' money, in direct contrast to sophisticated financiers, who lend in a 'last in-first out' position.

The culture of the industry also has discouraged investors. Most links in the value chain appear to be ruled by creative teams driven by project vision, not enterprise vision, according to former The City University's Film Business Academy director Terry Ilott:

> The projects themselves are dependent upon unpredictable talents, mostly employed on a temporary, freelance basis. Although the industry has enjoyed rapid growth, there has not been appropriate concentration of ownership and the companies within it are mostly small and highly volatile. They tend to have weak financial skills and low creditworthiness. The industry has a shortage of entry points and career paths, and this favours the emergence of maverick creative and commercial entrepreneurs who can be both brilliant but often unreliable. Most independent enterprises are small, non-hierarchical and dependent upon enthusiastic as well as industrious employees. [1]

Risk management and alignment of interests

Film investors have often misread the market, misunderstood the risks, or simply missed the appropriate point of entry – for example, by investing in high-risk development and production. As such, their commercial performance has been dependent on project conversion and on deriving net profits from successful films from which to gain a return. An ongoing concern for investors in film is whether their interests are aligned with those of the studio, distributor, streamer and/or with the producers and co-financiers in the case of an independent film. Financiers have historically found it more straightforward to secure alignment through collateral and/or commissions, fees and interest charges. They have held the leverage to price risk relatively effectively; while often, investors have found it much harder to exercise leverage. Often, it has been the case that investors have fundamentally misunderstood the structure of the film business and its proximity to a 'market-failure model,' as opposed to a 'hit-driven' model, which sounds exciting but should really be for only the very brave and well informed.

As entrepreneur and finance specialist Mark Beilby points out, the wealthy individual or equity investor has tended to utilize a mixture of tax breaks and subsidies, and the balance of funding beyond their own stake has been made available through the pre-selling of rights, supported by a handful of banks and finance houses who discount those contracts or provide gap funding of between 10 and 20 per cent. Gap funding makes up a financing shortfall by providing a loan made against unsold/ remaining territories (outside pre-sales and co-producing territories), normally with a minimum of 200 per cent coverage required (e.g. that the total value of the remaining estimates are more than double the amount being lent) and at least two commercial pre-sales in place prior to closing the arrangement. This is designed as a market 'test' on the behalf of the bank or first position lender. In return, the bank will be in first recoupment position from all available revenues, and all income and sales contracts are assigned to the bank until its risk is recovered. 'Overall, it's a system that has invariably been an expensive and fragmented model, often sub-optimally executed with highly correlated risk for the equity investors aligned to a minimal potential upside in the majority of cases', suggests Beilby [2].

Traditional bank 'gap' has mutated into 'super-gap,' where instead of 10–15 per cent of the production loan being required to complete financing, the sum rises to around 25–35 per cent. Super gap, although predicated on the 'last in-first out' positioning, is really a form of high-risk capital investment and accordingly the fees and interest charged reflect that level of risk. When compared to gearing in the finance markets or even the standard house mortgage structure, the concept is not unusual: put down 20–30 per cent equity and borrow the remainder.

The film finance process: an introduction

How a film is financed box (summary)

Financing film productions is similar to traditional project finance. A special purpose entity raises financing to create assets (film rights) that will give rise to future cash flows. In the film industry, future cash flows are generated from two primary sources: (a) revenue from distribution (exploitation revenue from theatrical exhibition, home video, television, and other ancillary markets); and (b) government-sponsored tax incentives/rebates/

grants. A typical film capital structure includes several tranches of debt and equity, which have varying seniority or security over these cash flows, and different levels of risk.

Typical film capital structure

SENIOR LOANS: Loans secured by pre-sold distribution rights with a first priority lien over all exploitation revenues

MEZZANINE FUNDING: Funding with a second priority lien over all exploitation revenues

TAX SECURED LOANS: Loans secured by future tax subsidies/rebates

EQUITY: Unsecured, residual claims on exploitation revenues

Senior loans

A pre-sale agreement is a binding contract to purchase a film's distribution rights in a given territory for a pre-determined price upon completion and delivery of the film. Distributors will often commit to purchasing the territorial distribution rights of a film before it is completed, based upon the film's script, budget and talent.

However, because the purchase of the distribution rights is concluded when the film is completed and delivered to distributors, these commitments do not provide a film with capital for payment of production costs.

In order to monetize these commitments, producers will pledge these pre-sale contracts to a lender (a media bank) as security for borrowing. Loans that use pre-sale contracts as security are known as "senior loans", and have a first lien on all exploitation revenue for a given film. When the completed film is delivered, the distributors make their purchase payments under the pre-sale agreements directly to the lender.

In this instance, the lender is concerned with the financial strength of the distributor rather than that of the producer, because the lender is essentially factoring receivables. Because they essentially underwrite distributor guarantees, senior loans are primarily exposed to counter-party risk and have limited exposure to "distribution risk" (e.g. the risk that a film will attain/generate distribution revenue).

However, if a guaranteeing distributor defaulted on a pre-sale agreement, the senior loan would then depend on distribution revenue for repayment.

Mezzanine funding (aka "GAP" finance)

Mezzanine funding is provided either in the form of debt or equity that takes a second lien on the exploitation revenues of a film. It is often referred to as GAP funding. Unlike senior loans, mezzanine funding is typically repaid from revenue generated by the sale of territorial rights after the initial financing has been provided. Sales agents, who broker distribution deals, typically estimate the value of unsold territorial rights. In order to minimize the risk of mezzanine funding, funders typically require that the estimated value of the unsold rights exceed the loan amount by a sufficient margin. The ratio of the estimated value of unsold territorial rights to the amount funded is known as the "coverage ratio".

Tax incentives/subsidies/'soft" grants

In an attempt to promote their local film industries and create jobs, many local and national governments offer tax incentives to film productions. The specific mechanisms of these incentives vary across different jurisdictions. For example, some governments provide producers with a direct tax rebate (e.g. Canada), while other governments provide

indirect tax incentives by enabling producers to claim tax relief on any qualifying film expenditure (e.g. United Kingdom). However, in all cases, producers must adhere to strict governmental standards in order to qualify for these tax incentives. Qualification is only finally judged retrospectively, although in some cases (e.g. United Kingdom) preliminary approval can be obtained.

Accordingly, in most cases these tax incentives are only provided to producers upon completion of a film. It is possible to make interim applications in some cases during production based upon the actual production spend to the date of the application.

As a result, these incentives, like pre-sale contracts, do not provide upfront cash for production. In order to monetize these incentives, producers may use them as security for borrowing. The primary risk of funding that assumes incentives will be available is "certification risk" (e.g. the risk that a film fails to qualify for tax incentives). Tax-secured funders only face distribution risk in the case of a failure to qualify for tax incentives, in which case they typically rank subordinate to any senior loans in the film's capital structure and, in some cases where mezzanine funding has been provided by debt funding, subordinate also to the mezzanine finance.

Soft grant money is often provided by government-backed support bodies. Awards may be repayable but in a soft, late position; or they may be non-recoupable. Most funding bodies have separate development loans/grants, and production funding. Many also support their filmmakers with marketing and distribution support (e.g.: BFI).

Equity

Equity investors are residual claimants on the exploitation revenue of a film. Upfront equity financing provides producers with capital for production and allows producers to delay the sale of a larger portion of the distribution rights until the film is completed. As completed film rights are generally more valuable than pre-sold rights, equity can enable producers to attain more favourable pricing for territorial rights. However, as film equity is subordinated to all other financing, it involves significant performance and distribution risk. Even amongst equity investors there can be a separate ranking such that some investors are paid ahead of others.

Studio risk transference: hedge fund slate investment

There are numerous examples of throughout Hollywood's history of 'risk transference', 'exporting risk' and the dark art of using 'OPM' (Other People's Money). The studios, ever since their inception early in the last century, have consistently searched for external funding to mitigate in particular production cost exposure. From 2005 to 2008, hedge funds and other funds invested heavily in the production slates of the major studios. These funds, including Melrose Investors I ($300m for Paramount) and II, Legendary Pictures (Warner Bros), Marwyn (Entertainment One), Virtual Studios ($260m for Warner Bros), Titan Film Group ($230m for MGM and Lionsgate), Dune Entertainment ($725m for Fox) and the former Relativity Media (Gun Hill Road I and II, providing $1.3bn for Sony and Universal), have sought to avoid development and overhead risk and to gain from reduced distribution margins and accelerated break-even.

Certain funds also addressed the opportunity in the independent sector in the USA and Europe. Among these are Future Capital Partners/Aramid and Cold Spring

Pictures. Investment banks, including Goldman Sachs ($400m funding for Lionsgate Entertainment and owner of Alliance), Royal Bank of Scotland ($350m for New Line Cinema), Morgan Stanley ($150m for Paramount Vantage), Merrill Lynch ($1bn for Summit Entertainment), J.P. Morgan ($225m for Overture) and Goldman Sachs (funding for Canada's Motion Pictures, the UK's Momentum Pictures and Spain's Aurum), have also entered the independent arena. And at least two new funds have been set up to provide advisory as well as investment services: Continental Entertainment (formerly backed by CitiGroup, but now shut down) and Entertainment Advisors (backed with $200m from J.P. Morgan).

The hedge fund 'Hollywood era' stems back to 2004, when banks entered the business of film-related structured transactions. Wall Street hedge funds and private equity companies, swamped with capital and surrounded by the availability of cheap debt, began to think that they saw the potential for high returns from the film industry, at the time buoyant in part thanks to high DVD revenue growth aided by excellent ancillary margins. Combined data shows that the hedge fund industry had around $14bn under management by the end of 2006, and the structured film finance elements of that sum broke down as shown in Table 8.2.

It is estimated that more than $14bn of third-party money has accounted for about 30 per cent of the total negative cost of those slates (all film expenses, including financing costs, bond fees and contingency reserves, necessary to create filmed product).

Some commentators suggest that many of these investments have shown losses at the junior capital level (not senior debt), although there are some notable exceptions in the Studio structures, some of which have performed extremely well. Patrick Russo, a partner at the Los Angeles-based Salter Group, explained that it depends on the specific structure of each deal, and that the independent market in particular has been negatively impacted by multiple influences – including a varied approach, investor

Table 8.2 Structured film finance

Between 2004 and 2009 $14.2bn in capital was raised for 35 transactions. The market for structured film financing transactions peaked in 2007 and petered out after the 2008/09 financial crisis:

13 financings

US$4.4bn in total capital

Supporting both major studio and independent film product.

As the capital markets began to unravel in 2008, volume receded considerably:

4 financings

US$1.1bn in total capital, a 75% decline.

In 2009, one transaction closed – DreamWorks, which is more of a hybrid structure, rather than a pure slate structure.

Several structured finance vehicles are in the process of negotiating take-out ultimate facilities to provide for additional liquidity.

Several vehicles are in the market for independent producers, again these structures are hybrids.

Source: The Salter Group, 'Structured Film Finance', delivered by Patrick Russo at International Film Finance Workshop, Abu Dhabi Film Commission, 28 September 2009

oversights on strategy, green lighting, DVD bubble bursting, independent weakness at the theatrical point, and, crucially, 'a shakeout of oversupply of weak performing independent content' since 2004/2005. And that is a long time prior to the streaming wars and Coronavirus.

What drove the hedge players towards the film industry and in some cases over the edge? Hedge funds need to leverage their investments to achieve their target returns, so slate deals have typically included an element of equity (high risk), an element of mezzanine debt (less at risk) and an element of senior debt (relatively safe). By committing to the entire amount of a slate deal, keeping some of the senior debt itself, and selling the equity and mezzanine tranches to other institutions in the financial market, an arranging bank earns a significant fee for retaining a relatively small amount of debt. Commercial banks such as Dresdner, Société Générale and Deutsche were the main leaders of this pack. The structure was to place senior and mezzanine debt in first and second positions, while junior equity was way back in the recoupment order.

The Monte Carlo 'track' scenarios

The investment notion was predicated along the lines of performance projection rather than qualitative analysis. With the notable exception of Dune Capital (see Table 8.3), most deals were green lit on the back of the so-called Monte Carlo scenario.

Projections, it was argued, could objectively predict downside risk. While this is partially true, suggests Russo, it also shows a range of performance outcomes, while giving guidance to probabilities of loss, magnitude of loss, return characteristics etc. It is not a predictor of the future, but rather a guide to potential outcomes predicated on the probability that the borrower has enough capital to facilitate his plan and what level of confidence do they have in order to facilitate their plan as well as upside gains, on a given slate of 18 films or more over the life of the investment. Simulation methods model phenomena through analysing key data such as first three-day and first week box office performance, which trigger a set of attached assumptions about future revenue streams from all resulting ancillary media. Just as Wall Street and the City found that new, complex financing structures cannot anticipate changes in the marketplace – instead relying on historic numbers – so too does the Monte Carlo system. Data on drivers of film performance are in constant flux. External and intervening factors

Table 8.3 Dune Capital and Fox

- Dune Entertainment, an affiliate of Dune Capital Management, invested an initial $325m in 28 films at 20th Century Fox.
- Alignment with Fox Studios was undeniably strong. Dune principal Chip Seelig had a direct line to Rupert Murdoch. Seelig gave a speech in October 2006, where he said the two crucial features were agreement over the composition of the slate and Fox's market knowledge.
- But the important point is that *The Devil Wears Prada* and *Borat* were amongst the early releases. Their success defied the laws of probability.
- It could be argued that investors were really betting on the performance of Fox and its management team as opposed to specific analysis of the slate in question. Fox's annual margins had been between 16% and >24% since Bill Mechanic assumed the studio's reins in 1993 and nurtured the studio's current leadership before leaving in 2000.

Source: M. Beilby, International Film Finance Workshop, Abu Dhabi Film Commission, 28 September 2009

over time can trigger considerable differences between original data and its historical assumptions, and the actual release performance of a film within an overall slate deal. According to Beilby, the kinds of influences that alter assumptions include shifts in audience tastes, viewing trends, emerging technologies, competition from other media, and, of course, market competition among a crowded release schedule, affected by specific release timings and the success or otherwise of marketing campaigns.

But if one leaves aside the above variables, the key question is whether the Studios and hedge funds were every truly aligned? There is a law of built-in deficiency, whereby if one assumes that the co-financing of movies develops to the point where a studio and an outside investor really do become equal partners, then that is the point that the studio will work out that it does not need that partner anymore, and revert to financing its entire film slate without transferring risk to a third party. Of the early hedge fund slate deals, only the two Dune funds with Fox and Paramount Pictures' first Melrose 1 fund (which included *Mission Impossible III*) covered truly sequential slates. The Studios could not pick and choose, or designate 'opt-out' films. (However, some producers choose selective deals on the grounds that they think they can pick winners better than the studio.) But overall it can be argued that it was inevitable that some of the slate deals were weighted towards the studio, and the structured funders were wiped out. Examples to the contrary (see Table 8.4: Elliot Associates and Relativity Capital) are few and far between.

Looking forwards, the closure of tax loopholes, changes in fiscal policy and prospective losses on a number of slate funding deals, taken together with the current squeeze in credit markets, means that structured film finance is going to be hard to come by over the coming years. As a consequence, there is likely to be an even greater shortage of investment capital for both the independent and the studio sectors in the near future. On the other hand, some investors have learned from the recent period, and, in the words of Salter Group's Patrick Russo, the 'early stages of smart and new money are positioning to fill the market holes.'

Table 8.4 Elliot Associates and Relativity Capital

- Former company Relativity Capital, an investment partnership between Ryan Kavanaugh's Relativity Media and New York-based hedge fund Elliot Associates, signed a deal in February 2008 with Universal Pictures to co-finance a significant portion of Universal's slate.
- Under the deal, Relativity Media was to share in the attributable profits of 45 films through 2011, while Universal will be able to exclude up to two films a year for budget purposes. Relativity can reject up to three films per year.
- Relativity acts as the principal and will retain the mezzanine and equity. Under the deal, Relativity will co-finance approximately 75% of Universal's releases during the term. Relativity Capital underwrote the capital structure of the deal and did not use an outside bank.
- Elliot Associates has over $10bn in assets under management and, before its involvement in film finance, had a reputation for building value through prudence. Elliot's average return as a fund over time is 14 per cent. It has not delivered super-profits in good times but has delivered an above-average return in lean times.
- This underlines that smart, prudent investors are still prepared to invest in the film business.

Source: M. Beilby, International Film Finance Workshop, Abu Dhabi Film Commission, 28 September 2009

Film recoupment

The buzz phrase used in reference to film recoupment is the 'waterfall'. Film finance specialist Mike Kelly prefers to refer to the recoupment process as a 'dammed river'. 'If you stand under a waterfall then you will invariably get wet, whereas you can invest in a film and remain parched', Kelly observes:

> What actually happens is that film revenues flow down tributaries (including theatrical, home entertainment, ancillaries, merchandising etc.). If they reach the delta, after the dam operators have taken their share (collection agent costs, financing fees and interest, sale company's sales and marketing (s&m) and commissions, distributor's P&A, sales and distribution fees etc.) then the delta fills up and the producer(s) and investors are very happy people. Unfortunately reaching 'cash break even' as Table 8.5 "The leaking bucket" shows below) doesn't happen very often.

Table 8.5 The leaking bucket: the value chain's cost of recoupment model: an independent movie

Assumptions:
- i). US distribution is through major specialist arm
- ii). Foreign sold/handled by an international sales company
- iii). Back end is a 50–50 split between financiers and producer re net profits (after negative cost of the film has been repaid and all fees/costs have been paid out....)

	US side of exploitation	*Revenue flow*
Fee	US distributor: interest and overhead charge on advance (override): 10% minimum, can be as much as 18–20%.	
Fee/cost	TV sales (30–40% of income given to distributor).	
Fee/cost	DVD duplication and marketing costs (royalty to you of 15–20% unless you can achieve a better deal).	
Fee/cost	Prints and advertising costs against the theatrical release in all territories with interest and override.	
Fee	35% distribution commission against rental figure of between 40% and 50% income stream to distributor.	
	Foreign sales side of exploitation	
Fee	10–25% sales commission on all foreign territories, 5–10% against the US sale.	
Fee/cost	$150,000 minimum sales and marketing costs in foreign (but likely to be $200,000).	
Fee	1–1.5% collection agent on all revenues collected.	
	Individual distributor deals in 'foreign'	
Fee	Distributor: interest and overhead charge on advance (override): 10% minimum.	
Fee/cost	TV sales (30–40% of income given to distributor).	
Fee/cost	DVD duplication and marketing costs (royalty to you of 15–20% unless you can achieve a better deal).	
Fee/cost	Prints and advertising costs against the theatrical release in all territories, with interest and override.	
Fee	35% distribution commission against the rental figure of approximately 30–45% income stream, but as low as 25% in the United Kingdom.	

Source: Angus Finney (from a range of industry sources)

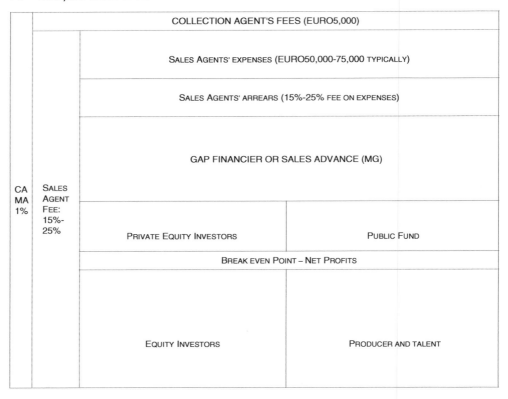

Figure 8.1 Film recoupment.

Figure 8.1 shows a classic recoupment chart, with details of why each player is drawn up in each position. A producer, financier or investor should be able to draw up such a chart from the information available in a legal recoupment order. The pictorial aspect of such a chart is of significant use – as it quickly highlights any conflict of position more obviously than when comparing written clauses in a legal draft.

Case study: the financial packaging of *Confessions of a Dangerous Mind*

Confessions of a Dangerous Mind started life as a Charlie Kaufmann original screenplay, commissioned by Los Angeles-based producer Andrew Lazar, who had an overhead and producing deal at Warner Bros. On delivery and reading of the second draft, Warner Bros' chief Alan Horn stated publicly that the studio would never make the film, as the material – about a game show host who (apparently) moonlighted as a CIA hit man – was deemed far too strong for the Warners' mainstream sensibility. By this stage of development, Warner Bros' had clocked up approximately $1.5m in development and overhead costs against the project.

Lazar, and his agent Cassian Elwes at William Morris, had shopped the unpackaged project (meaning that no director or cast was attached) to most of the other studios.

All of them passed, partly due to the unusual and challenging material, but also due to the producer's demands for a $5m fee (some $4m more than his last studio producer fee, technically called a 'quote').

Renaissance Films, based in the United Kingdom, was introduced to the screenplay by Elwes on a regular trip I undertook to Los Angeles at the same time as Bryan Singer (*The Usual Suspects*) became attached to direct. Renaissance, in need of significant international projects that would attract a higher level of buyer than they had previously had contact with, made an offer to finance the film. In order to bring Lazar to the table, Renaissance offered the producer a $2m producer fee, and a generous share of Renaissance's recoupment position as financier and world sales company.

The budget quoted by William Morris to Renaissance when it read the screenplay was $25m. Within a four-week period, the project's budget rose from $25m to $30m, in part due to Singer's ambition for the project, and attractive casting attachments, including George Clooney and Drew Barrymore. After considerable delays and a difficult negotiation (where Renaissance learned that Lazar was continuing to try to interest significant independent US players in the project), an 'option to finance' agreement was signed between Lazar and Renaissance, allowing Renaissance 120 days to put the film into principal photography. The contract stated that the production budget had to be no less than $30m.

The financial package

Renaissance proceeded to put together a financial package that involved the following elements:

Percentages of the $30m budget

A German tax fund at $6m inc. costs
Foreign pre-sales at $6m inc. discounts
Bank gap of $6m inc. costs (but dependent on equity that sat behind its gap or a North American pre-sale to close the film's finance)
North American pre-sale/partner or equity at $12m

The total raised in principle prior to re-approaching North America was $18m (60 per cent), although no distributor deals had been signed as all major foreign buyers wanted to know the North American distributor before committing. In addition, the option had not been signed prior to MiFED (the international film and multimedia market) that November, meaning that Renaissance had not been able to introduce the script and package to buyers at that stage.

North American deal

Miramax, one of the leading and most aggressive US independents at that time, responded to the project with enthusiasm, and made an offer of $9m (30 per cent) for North American rights in early January. This would have brought the total raised to $27m (plus financing costs), some $3m less than Renaissance's 'option to finance' agreement for a production budget of $30m with the producer.

What should Renaissance have done to close the film's financing?

1. Accept the offer and work with the producer and Miramax to bring the budget down.
2. As part of (1), attempt to get Warners to place its $1.5m development repayment into the recoupment order, rather than pay it within the cash budget.
3. Sell more foreign territories at a price level that still retained the bank gap level; see (1) above.
4. Find an equity partner prepared to sit behind the bank gap (e.g. the bank would come out in 'first position' from all revenues). Equity would be in 'second position' in the recoupment order.
5. Sell its' 'option to finance' on to Miramax and get out of the film.

What actually happened?

The producer refused point blank to bring the budget down when approached by Renaissance. Warner Bros' refused to defer their development costs. Any attempt by Renaissance to sell further foreign territories at a premium price would have depended on: i) closing and announcing the Miramax North American deal, and ii) securing the cast within the lower budget level. Neither proved possible.

Miramax changed its offer. It offered to split the film's financing 50–50, and it would recoup 100 per cent out of North America, and agree to go pari passu with Renaissance in 'foreign' after the bank was out. However, Miramax insisted on 50 per cent of the German tax benefit as part of its 50 per cent cash contribution. Renaissance did not have the financial resources to agree to and close this deal.

After the 50–50 deal collapsed, Miramax agreed to increase its offer from $9m to $11m for North American rights, placing the finance raised at $29m. However, it did not paper this deal, which left the offer worthless as weeks dragged on.

An actors' union strike (called by the Screen Actors Guild) was threatened during the autumn of these negotiations. Renaissance's option to finance (120 days) was under pressure, and the film was not going to be able to enter principal photography prior to the strike's dates. The film collapsed.

It turned out that Miramax's Harvey Weinstein wanted George Clooney to direct the film, not Bryan Singer. Miramax end up fully financing the picture. Clooney directs.

Renaissance was repaid all its costs, a premium, plus a $250,000 bonus if the film entered net profit. The company was also awarded one executive producer credit given to joint MD Stephen Evans.

Renaissance should not have got involved in such an ambitious, difficult, high-profile project. The financing was too complex for a company short of resources for a project of this scale despite the potential upside.

Once involved, Renaissance was correct to get out in return for costs when such an exit became available. The company was extremely fortunate to be given such an escape route.

9 Financing

The $20m investment exercise

> Half the films we backed did worse than we expected…and those that worked didn't make half as much as we had hoped!
> (Private equity investor in feature film projects, anon., London, 2021)
>
> You can't save your way to success….
> (CapCities CEO Tom Murphy) [1]

The challenge

Some years ago, I started working with a private investor, set to raise a considerable sum of equity from Middle Eastern sources. The investor was intrigued to learn more about how film financing and investments were structured in the international business. He asked me – as a potential manager of the fund – to address the following question:

> You are presented with five film packages, all priced at around $20 million budgets on average. How would you go about selecting which one to fund? Be as specific as possible. If our investment company and your company Larkhall was to finance, manage and executive produce this particular film, all or in part, how would the equity be structured? What and when would our investment be returned – if ever?

The task was so instructive, that I kept my notes and the paper I wrote for the investor. Building on that source material, this chapter sets out to review, as transparently as possible, the thought process and risk management considerations made by an investor/executive when considering project finance and the steps towards (or not) an investment commitment.

Step one

In order to select one of the five packages, I would go through the following process:

DOI: 10.4324/9781003205753-10

Project selection: the package[1]

When assessing a range of projects at the $20m stage, we would undertake the following steps to assess the five key elements of each film's package. These are the script, producer(s), director, budget and lead cast.

a) We (the investment team) would all read the **Script**. This is a critical creative and commercial barometer. It's possible to make a bad film from a good script, but impossible to make a great film from a poor script. We'd want to know the writer's background, and confirm if the writer will also be the director (see below). The script will dictate the film's genre (comedy, action thriller, sci-fi, horror etc.), originality, potential for a franchise, and overall potential market/audience and target key demographics around the world.

b) The identity and track record of the **Producer** (including producer team and production company as a whole) is a critical package component. The producer is the key manager of the project and the person (or persons) directly responsible for our investment – both in terms of expenditure and return on that investment. We would look for creative flair and taste, commercial instincts, talent management skills, strong links to actors and key heads of departments etc. We would check with completion bond companies on the track record of the producer to effectively deliver completed films, and with sales companies whom the producer has worked with previously. An analysis of completed films and performance and partners would be undertaken. We would ensure that the producer fully understood our deal terms, expectations and role as executive producer and investors. In most cases the producer and company will be known to the team at this level of budget and commitment.

c) **The Director:** We would find it impossible to make a financing/investing commitment without knowing whom the director is. We would check previous films (e.g. screen them), analyse performance, actors attracted to work with the attached director, sales companies and distributors who have handled their films etc. We would insist on meeting with the director, so that we can check how they present themselves, communicate their vision, talk about the film's aims, and how they might go down with actors etc. We will check with previous producers on how the director has behaved pre-production, on the set, during post-production, and throughout the marketing phase of previous films. We would almost certainly not finance or invest in a first time feature film director if a film was budgeted at $20m. We would pass on the project, but track it in case the director changed at a later stage.

d) **The Budget:** We would analyse the film's budget and the film's shooting schedule and get our own production manager consultant to do an analysis of the budget, schedule and script. Can the film be shot in the time scheduled? How complex is the shoot? How much is studio and how demanding re locations etc.? We would check for exclusions still to be added to the budget (including for example finance fees – our own and third parties) and completion bond fees. Further high-level questions include: is the budget accurate? Has it been padded? Do the above-the-line costs (script, rights, writer, director fee, lead cast fees) appear reasonable? Are the producer/production company fee(s) fair? Are the below-the-line costs – meaning the hard, physical costs of making the film – realistic and competitive?

A typical balance between above- and below-the-line costs for a $20m film would be somewhere around $7m above, $13m below. How does each of the films in question balance out?

Crucially, does the $20m budget offer value for money on the screen? And how does it sit when aligned with the script, producer, director and lead cast? E.g. is it coherent and robust?

e) **The lead cast:** Unlike lower budget independent films at the $1m–$5m range, a $20m film demands meaningful names (e.g. Colin Firth in *The King's Speech* – budget $13m; Bruce Willis in *Looper* – budget $32m; or an ensemble cast with great actors, such as *The Best Exotic Marigold Hotel*). Stars and/or high-quality names are required to attract film distributors, support marketing campaigns, and help launch the film to the public – both at cinemas and also through the exploitation chain, including Video-on-demand, DVD, Pay-TV, TV etc. We'd need to consider what options a streaming deal might offer, and how the genre and cast sit with Netflix, Amazon Prime etc. We would look at the quality and experience of the casting director, the ability of the script and director to attract the above level of talent, and the suitability of the actors regarding the genre and roles. We would also look carefully at the commercial terms of the lead actors to check that they are reasonable and professionally executed.

Step two: the finance plan

In addition to the **package** we would undertake a full examination of the **Finance Plan**, and where and how Larkhall's potential mix of loan finance and equity investment would fit within this plan, and how our investment would be recouped, and when. We would pay particular attention to the other financing parties in a plan, and their reputation, commercial terms etc.

The key elements of a finance plan which include:

- 'Soft' finance in place: we would examine the sources and levels of i) tax credits such as the UK producer credit – worth up to 20 per cent of a film's budget, ii) regional subsidies that are non-recoupable; national subsidies (government grants) that are non-recoupable, and iii) co-production territories, if they are structured as are non-recoupable partners – meaning the co-producer owns their territory and that they retain all revenues from their territory in perpetuity.
- 'Hard' investment (equity) in place, which will compete with Larkhall for a recoupment position and a share of net profit 'points' post cash-break-even. This may be in the form of other gap/equity players in which case we would probably move on to a different project as there may not be 'room' for us in the project. It may be the case that national funders require recoupment (and a premium) of their investment – as was the case when the UK Film Council was active – in which case we would need to negotiate on a case by case basis.
- Senior debt (either in place, or required to be financed): In connection to 'soft' finance, debt finance will be required to cash flow any tax credits and pre-sales to distributors. Larkhall will want to consider financing (loans) against these contracts, in addition to any gap/equity investment.

- The identity and reputation of the international sales company will be essential to Larkhall's decision-making process. The quality of the pre-sales and world sales estimates (e.g. remaining 'take' price value of the film outside territories already pre-sold or co-produced) will be vital. It is through the sales company's ability to create initial and ongoing revenues from contracting with distributors (and/or streaming platforms) that Larkhall's gap/equity investment will be repaid. Regardless of any pre-sales and/or estimates being available, we would raise the issue of a US pre-sale to a distributor/studio which would be an essential element when financing and investing in a $20m film. The only possible alternative is a Prints and Advertising partner in tandem with a US distributor, but such an option would require risk analysis and would be less preferable.
- Any alternative/additional financing in place, including sponsorship, product placement and post-production in-kind investment. We would check which were recoupable, and which were soft (e.g. non-recoupable).

Step three: moving to green light (or reasons for passing on some of the projects)

Passing criteria

Larkhall would have passed on four of the five projects in the $20m zone for the various/combination of following reasons:

- Poor/underwhelming script
- Un-commercial subject matter
- Difficult genre (e.g. dull drama, schlocky horror) and lack of a clear market
- Requirement for the Larkhall team to really appreciate the material and story: our gut feeling for the film
- First time or unreliable producer – track record failure
- First time or un-bankable director – track record failure
- Unconvincing director following face-to-face meeting
- Wrong budget for the material
- Sloppy, unreliable budget and schedule – with no response from producer
- Weak cast/lead actors or inappropriate actors
- No completion bond to guarantee delivery (and not addressed by producer)
- No sales company, or poor sales company and unreliable sales projections (estimates)
- No pre-sales in place to at least two key territories
- No bankable streaming deal in place in lieu of pre-sales/financing package
- No US pre-sale, or no acceptable alternative US distribution deal
- Unreliable third-party financiers/investors which damage the perception of the project in the marketplace
- Legal problems following due diligence: Chain of title or contract issues with script, underlying material, talent contracts etc.
- Excessive commercial terms offered to talent (producer, director, cast)
- Poor/unfair recoupment position indicated re back-end terms for Larkhall
- If a Streaming deal is on offer for world or a range of territories, does it make sense re our equity investment and Return on Investment?

- Does that Streaming deal reward the studio and producers, including Larkhall, with upside and share of secondary rights?
- Is the Streaming deal bankable? We would check with Coutts, currently one of the most active lenders against Netflix contracts, for example.
- Too small a share of profits (post cash-break-even) to warrant the risk of gap/equity investment
- Excessive sales fee and sales and marketing costs, pushing Larkhall too far away from cash-break-even and profits
- Finance plan does not add up properly and to close requires unacceptable "pre-pre-production" risk, meaning cash flowing prep before the film's finance is closed and cashflow is achieved
- Pre-sales contracted with distributors are below the 'take' or 'accept' prices estimated by the Sales Agent, undermining the projections
- Larkhall does not approve the quality of the Completion Bond
- Larkhall's commercial terms are refused and no agreement is reached
- Clearing bank, collection agent and collection agreement in place
- Full consultation rights on first festival and market launch
- Acceptable premier/first festival launch access
- Acceptable marketing plan from the streaming platform if we are going down that financing/distribution route
- Acceptable scenario projections (see below re our $20m scenario planning based on commercial assumptions)

Larkhall's commercial terms

To launch a competitive, aggressive investment vehicle in the international film market, and to build a library of rights and ongoing revenue streams, we feel that our loan and gap/equity investment model should be very attractive. Larkhall will not charge interest on its loans/investment. Instead, we will seek the following indicative terms:

- Executive producer credit(s) and fees (at approximately 2–3 per cent of total budget depending on the level and nature of our contribution). 3 per cent, for example, would be applicable if we were financing/investing more than 50 per cent of a film's budget, and if that budget was set between $1m and $15m ($300,000 on a $10m film). Between $15m–$25m we would be at 2–2.5 per cent depending on level of funds committed (2.5 per cent on a $20m film is a $500,000 fee).
- No interest payments on our advances or hidden charges
- Our legal fees of between $20k and $50k to be paid out of the budget, not picked up by Larkhall separately
- In return for significantly reduced fees and interest, our back-end terms will be very aggressive: We will seek between 20 and 50 financiers' net points (shared with an anticipated producers' share of net points at 50, out of which they pay talent, including writer, director and lead cast), depending on the level of financing and investment committed to the film, and third party equity
- We will examine franchise, prequel, sequel and re-make rights on all contracts with a view to first-look/option rights in partnership with the producer/production company
- If a streaming deal is on offer, we'd want to see how fees and share of secondary rights are 'papered' (described in legal, contractually binding terms)

Green light

Assuming that the package, finance plan and the commercial terms are acceptable, we would: a) consider the remaining sales estimates and build a 'third column' with our own conservative projections (taking into account the difficulty of the US market, and certain high value territories that often do not get sold, such as Japan and China). In addition we would prepare a set of worldwide box office and ancillary income projections, next to indicative collection statement payments showing gap/equity recoupment, followed by net profit participations (net of fees and costs). Loan finance (discounting of tax credits and pre-sale contracts) is separate from equity and in a 'higher' repayment position (see below) and considerably less risk attached as it's not related to performance risk.

Scenario projections

Larkhall would run three sets of performance assumptions on the $20m film

A. $30m worldwide box office (low)
B. $60m worldwide box office (medium)
C. $120m worldwide box office (high)

Timing of income streams will be modelled concurrently, including assumptions for the film's library value following the first exploitation term (normally five years) and thereafter.

We would need to explore a different model if the project is being commissioned by a streaming platform: Noting fees and share of secondary rights etc., as cited above.

The $20m finance plan (non-streaming commission)

The film selected is a UK–Australian co-production (official, bi-lateral) and the finance plan would be as follows:

1. Pre-sales at a significant level have been made by reputable sales company (e.g. Film Nation) and include: North America ($6m), UK ($2m) and Germany ($2m). $10m in pre-sales forms 50 per cent of the finance plan. Commission (5 per cent on pre-sales, 10 per cent thereafter) has been deferred and is only payable post-delivery of the film from the Collection Account. Whilst the advances will require each distributor to recoup, the pre-sales do not have to be recouped post-delivery from the Collection Account.

 Contribution: $10m pre-sales (Larkhall loan at 100 per cent of value less deposits of 20 per cent – $2m): **$8m loan**
2. The Australian co-production 25 per cent contribution ($5m) is comprised of National state funding, distribution advance, regional subsidy and a broadcaster licence deal. The $5m contribution is non-recoupable.

 Contribution: **$5m co-production finance** (Australia)
3. UK tax credit: The Larkhall will lend (and hence cash flow) the UK tax credit on the green lit $20m film. However, 75 per cent of the film's budget qualifies for the

credit, as the film has an Australian co-producer (25 per cent). $15m qualifying spend will require a $3m commitment. Timing of the tax credit loan will run from the first day of principal photography to full approval of DCMS: Conservative estimate of 9 months before repayment. The $3m is not part of the film's recoupment plan.

> Contribution: **$3m (Larkhall loan)**

4. Equity gap investment. In order to close the film's finance plan, Larkhall will provide $2m in first position (after Collection agent fee and agreed Sales and Marketing expenses and first festival launch, capped at $300k). Film Nation's 'take' sales estimates show a remaining worldwide value of $6m (mainly based on Latin America, Japan, France, Italy and Spain – all which will be sold either during production or after delivery), but allowing for significant coverage on the $2m investment.

> Contribution: **$2m gap equity (Larkhall investment)**

Summary

> $11m loan finance to production (Larkhall)
> $2m gap equity investment (Larkhall)
> $5m third-party finance (Australia)
> $2m pre-sale deposits (cash)
> TOTAL: $20m

3.2.3 The commercial assumptions behind collection

Performance assumptions have to be modelled both on i) subsequent sales income post-film launch, and ii) worldwide box office performance outside Australia/New Zealand (see Section 4).

Larkhall's return on Investment (ROI) has to be calculated with reference to the commercial terms of the deal achieved. In this $20m scenario the company has agreed:

- 2.5 per cent executive producer fee (to reflect the 75 per cent financing contribution): **$500,000 fee.** Payable on first day of principal photography.
- No interest or additional fees
- All Larkhall's legal costs within the budget
- 50 per cent of 100 per cent of net profits (e.g. financier's net at 50 points)

The CAMA would show:

> $5k collection agent fee (and 1 per cent CA corridor on all subsequent revenue streams)
> $300,000 sales and marketing costs/first festival launch
> $500,000 deferred sales commission to Film Nation (5 per cent)
> $2m gap equity re-paid to Larkhall (redeemed 9 months post-delivery)
> $200,000 deferred sales commission to Film Nation (10 per cent)

Cash break-even – net profits

NET PROFIT SPLIT

50–50 split between Larkhall and Producer thereon (allowing for 10 per cent sales commission and 1 per cent Collection Agent fee). The 50–50 split is therefore actually from 89 cents of each dollar recouped.

TIMING AND NON-RECOUPABLES

Assumptions:

Production: 8 weeks
Post-production: 16 weeks
Delivery: 2 weeks after post-production is completed
DCMS tax rebate repaid to Larkhall six weeks after Delivery
First festival/market launch to achieve further sales to distributors to take place within 4 months of Delivery approx.
Further 3 months to receive sales income into the Collection Agreement.
Final first cycle sales completed 12 months after First Festival launch.

Repayments

- UK tax credit repaid by DCMS in full within 8 months of first day of principal photography (Larkhall receives $3m)
- Loan finance for pre-sales repaid in full within 15 months of first day of principal photography (Larkhall receives $8m)
- Further sales income achieved: $5m (less 11 per cent commission = $500,000 and $50,000 to Film Nation and CA respectively). Gap equity is repaid in full within 15 months of first day of principal photography (Larkhall receives $2m gap equity investment in full).
- $2,450,000 is available in the Collection Account to be split 50–50 between Larkhall ($1,225,000) and Producer ($1,225,000)

Further sales

- 24 months after principal photography, Film Nation achieves a further $2m of sales (less 11 per cent commission: $220,000)
- $1,780,000 is available in the Collection Account to be split 50–50 between Larkhall ($890,000) and Producer ($890,000)

Interim assessment

24 months after first day of principal photography, Larkhall should have received all principal loans and gap equity repayments ($13,000,000).
Larkhall has received fees of $500,000.
Larkhall has received net profits (from further sales only) of $2,115,000.
Prior to any overages paid by distributors, Larkhall has received total income of
$2,615,000.

Overages

$30m
$60m
$120m

The above exercise would require some augmentation to take into account the changing options in today's marketplace; dominated by the rise and arrival of significant streaming platforms. (At the initial time of projecting, streamers in the late 2000s had not yet arrived, let alone opened their financing tool kits.) However, many of the risk and package assessment points remain the same: you can make a bad film from a great script, but it is nigh impossible to make a good film from a bad script (and package).

Note

1 Please see Appendix for industry glossary of roles and functions etc.

References

[1] Robert Iger, *The Ride of a Lifetime*, Bantam Press, 2019.

10 Risk management
The role of the completion guarantor

> When things go wrong on a production, the first thing you do is call the Completion Guarantor, give them everything you've got, and find out where things really are at...
>
> (New York-based producer, Anon.)

One of the most important and most frequently used tools for production risk management across film and small screen projects, is the completion guarantee. Also known as a completion bond, this is a legal undertaking by a guarantor (backed by a major insurer) that a film production, based on preapproved specifications, will be completed and delivered by a certain date in the financiers' contract with the producer. James Shirras, joint MD of Film Finances, UK, talks about his career, experience and advice with regards to production risk management and the role of the completion guarantor.

Author

James, what was your career starting point?

James

I practised as a solicitor in the City of London for several years. After a couple of years, I decided I wasn't particularly interested in working in a large office on financial commercial transactions where you don't get much interaction with the end product (or where the end product is really dull). I moved into the entertainment world and I joined a firm which practises in the field of theatre, film and television. I was there for nine years before I moved to join Film Finances, which actually is directly involved in the business of film financing, and I've been there ever since. So, I think I would say I'm a commercial lawyer who specializes in entertainment and entertainment finance, and then more specifically in the area of completion guarantees for film and television productions.

Author

Could you explain the history of completion bonding and how it came about in the industry?

DOI: 10.4324/9781003205753-11

James

The company that I am with, Film Finances, was founded in 1950 and has been active in the business ever since then. It was founded when a film producer who'd been very active in the 1930s, and a friend of his who was involved in the insurance business in the city of London, got together and discussed the problem that film producers were then facing, which was the banks were very reluctant to become involved in film financing. The reason for that was that there had been a number of large-scale business failures in the 1930s, particularly when producers had become heavily indebted. They'd borrowed a lot of money to make films and some of those films worked and some of them didn't, but specifically some of them cost far more than the producers intended they should when they began to make them. So, these two people in the late 1940s decided that's what they needed to be able to show the banks: that there was somebody willing to take the risk. If a certain amount of money had been allocated to the making of a film, that would be sufficient. It would remove the risk that a producer was going to borrow, say, £500,000 from a bank, spend it all and have no film to show for it. So, what the completion guarantee is designed to do is to promise the financier at the beginning of the process that the amount of money that's been made available for the process will be enough, and that whatever else happens (and all kinds of things do happen), what will not happen is that the producer goes back to the bank and asks for more money. Of course, there might be special reasons why they do that, but it won't be because they didn't have enough money to make the film in the first place. So that was the origin of the completion guarantee.

Film Finances was founded in February of 1950 and by the end of 1950, they'd already given completion guarantees on eight films. So there was clearly a need for it and it just grew from there during the 1950s, essentially in the United Kingdom, but thereafter in the rest of Europe, spreading to the United States in the 1970s, Canada and Australia from about 1980 and now many, many countries in the world. One or two places are resistant to completion guarantees, but Film Finances is pretty well known in most filmmaking countries.

Author

What underpins Film Finances' ability to have bonded such a high number of films and work so successfully in the business for 70 years plus?

James

We have expert staff, with a deep knowledge of the production and financing of films. From the very beginning, we've been backed by underwriters at Lloyd's of London, these days supplemented by other international large insurance companies, particularly Allianz. So, each completion guarantee that we issue is covered from the first dollar, up to the amount required, the budget and beyond. The largest budgets for which we have issued completion guarantees have been in excess of $200 million. We can provide unlimited amounts of completion guarantees up to that budget for a single production. So, in other words, to be clear about that, there's no overall limit on our reassurance capacity. The only limit is the per production capacity, and that is $200 million per production. Of course, most of the films we provide guarantees for have budgets that are lower than that. The lowest it is probably a million pounds or thereabouts.

Author

Could you define the term 'delivery risk'? In other words, what is your company actually bonding? What are you guaranteeing?

James

Well, you could divide that question into two sections. The first is that a film will be made, and so a producer has raised a million pounds to make a film and we will promise whoever's providing the million pounds that there will be a film. So, we will make sure that there is a film. That's the first risk addressed. The producer will have enough money to get to the end of the process and complete the film. The second part is that we have to promise that the film that the producer makes is the film that the people providing the money thought they were paying for. So, there is the second stage which we take care of, which is the stage when the film is delivered to the people who are buying it – distributors, essentially. So, we promise that the film that's delivered to the distributors will meet a specification which has been agreed at the outset. The producer delivers the film to the distributor and the distributor looks at it and says, "is this the film we agreed to buy?" If it's not, then that's where we step in again and have to sort out any problems. In 99/100, maybe 499/500 cases, the film is the film that's the distributor thinks that they have bought. In those cases where it's not, then we have to be there for the argument.

Author

Let's address the key elements that you analyse, including the script, the budget and the schedule.

James

We begin with the script, because the script tells us what we need to know about the project. It tells us what sort of a film it is, how many people are going to be involved, whether it involves people sitting around talking, or whether there are lots of action sequences and so on. It also gives us an idea of where the film will need to be made. Once we've read the script, we look at the shooting schedule to see how much time has been allowed to shoot that script. We will consider how many days there are in relation to how many pages of the script, and obviously we have certain expectations: different sorts of films have different expectations in terms of the amounts of time you'd expect, on average, a page to take to film. Then once we've got the hang of that, we look at the budget. Now, my colleagues who are experts in film production will always tell me that you can make a script for any amount of money. You can make a script for a hundred thousand pounds or a hundred million pounds, but clearly the film you make will be a different film depending on how much money you have. So, when we look at the budget, we will have formed a certain idea of what the script is going to need in terms of money in order to realize it. If there's an enormous divergence between our expectations, based on the script and the amount of money that we have available, then we'll have a discussion with the producers. That's fairly unusual, and usually there is a correspondence between the script, the schedule and the budget, which enables us to understand exactly what the producer has in mind and enables us to say "yes, in principle, this is something that we can guarantee".

However, clearly we do often see scripts which are written in a way that is unspecific. I mean, some scripts are impressionistic. So, you might have a scene set on the ocean with several hundreds of battleships approaching and you think, "well, what exactly is this going to mean?" Or there might be scenes set in medieval plains with many warriors approaching the camera and you think "well, how are they going to do this?" On the other hand, you might have scenes set with mountain backdrops and you think "well, if they really mean to do that, it is going to be difficult to do. Are they going to do that literally?" Or is it going to be done in some sophisticated way involving shooting the people,

having the dialogue in a studio and then imposing the background on them?" So, all of those things will come to our mind, but we will get an impression of how we think the producers intend to realize the script that they've submitted to us.

Author

How do you reach an arrangement with the producer and the financiers on what is called a 'strike price'?

James

The strike price is the amount of money that we have been told is available to make the film. So it could be anything. I mean, we provide completion guarantees for films that cost a million pounds and also those that cost a hundred million pounds. So the producer will have submitted a budget, which is a figure, let's say for the sake of argument, a million pounds. What we promise is that provided that money is available, then the film will be completed and it will be delivered to its distributors, and the distributors will accept it. So what the financier typically wants to know is how the money needs to be made available so that it can be satisfied that that conditions will have been met. Now, if you have a single financier providing a million pounds, that is really very easy. One question will be "How much has the producer spent already on this project?", because presumably that's money that the producer will want to repay him or herself. Once that has been dealt with, then there will be a balance of cash available and that will be the strike price. We will say, "As long as you make available a million pounds, of which £200,000 is going to repay the producer for the work it's done already, then the strike price will have been met and we will promise you that the film will be completed and delivered."

In most practical cases, it's more complicated than that because the money comes from a number of different places. Then the question arises as to whether each of the financiers can trust the others to provide the money that they have said they will provide. When financiers are distrustful of other financiers, they might well say to the others "we insist before we put our money up, that the other financiers put their money up first". They might want that money to be paid to the completion guarantor, because the completion guarantor can be trusted to hold the money to be spent on the film, and if the completion guarantor has received the money already, then the completion guarantor can say, "we can confirm that this amount of the strike price has already been made available". So that will be a complication or a sophistication of the strike price. The other area which needs to be addressed at the financing stage is the currency in which the expenditure on the film is going to be incurred. The strike price might need to be made available in different currencies. If you're making a film in two different countries, then you're likely to be spending significant amounts of money in two different currencies, but the financing for the film might not be provided in those currencies. So, there might be a disconnect between the financing and the spending, and that means that there has to be detailed work done on the numbers in order to make sure that the two sides match. There needs to be agreement between the completion guarantor and the financiers as to how the strike price is going to be met: the financiers look to the completion guarantor to confirm that the producers have made the arrangements necessary to ensure that they have the money that needs to be spent in the correct currencies in order to meet the budgeted expenditure of the film.

I explained how we will have looked at the script and the production schedule and the budget and said, "yes, in principle, we can provide a completion guarantee for this". That stage is followed by a more detailed examination of the script, the budget and the schedule, which will involve discussion with the producer and others normally carrying

on over a number of weeks, and that is entirely normal. During that time, the producers would also probably be speaking to financiers and we will also have direct discussions with financiers. So, all of that will take a number of weeks. During that time, we will come to understand exactly how the producer intends to address the issues that the production will present to him.

Author

Let's assume that we've got a green lit film and a strike price has been agreed and the bond is in place, and you're entering official pre-production, moving towards official principal photography. What do you expect to see from a producer and a production, and in particular some of the other key departments or roles, including the line producer and the production accountant?

James

We will discuss with the producers the identity of the heads of departments. Particularly of interest to us are the line producer, really the manager of the nuts-and-bolts day-to-day on the production. The production accountants are also very important to us because the reporting of the cost position is critical to our ability to do our job properly. But, of course, we are also interested in the creative heads of departments, that is the director of photography, costume designer, production designer and editor etc. It is very important that we know who they are. Because we've been around since 1950, and we've given completion guarantees on more than 8,000 films, we have comprehensive records going back all of that time. As I like to remind people, we know where all the bodies are buried. Everybody has a reputation as far as we're concerned, although we are very discreet about that.

We don't have a lot of preliminary contact with the director, but we do always have a conversation with the director before the film goes into production, because we need to make sure that what the producers are telling us about the film that they intend to make is consistent with what the director thinks he or she is going to do when they make the film. Of course, the director is important, but they shouldn't have too much contact with the completion guarantor. Once we've done all of that work with the producer and we've issued the completion guarantee, we then need to make sure that the producer does what s/he's told us s/he's going to do. In order to do that, we monitor the production closely. We will receive the daily call sheets, the daily progress reports, which tell us what has happened on the day. Which scenes were shot that day, how many people were on set, how many people had lunch, all of that stuff, what time you started work, what time production wrapped that day. So that's important and issuing progress reports is something that a production should do as a matter of clockwork without any difficulty every day.

Cost reports we expect weekly during the shooting period, issued shortly after the end of the week's shooting. Cost reports are sometimes less reliably produced by productions than progress reports. If we don't receive a cost report when it's due, that's usually something we worry about. It's very important to us that we get cost reports on time. If we don't, we will hound the producer until we've received them. Sometimes it happens that cost reports are not produced because producers have had difficulty closing their financing in an efficient manner and, as a consequence of that, the production's financial capacity, the production accountants and the producer's department have been distracted in trying to provide information required by financiers in order to get the financing closed. This is usually a bad thing, so there are good times to close the financing and bad times to close the financing. I think the best time to close the financing is probably a couple of weeks before you intend to start shooting. By then you should have worked out the

logistical details of how the film is going to be made: you will be familiar with the locations; you will have appointed all the heads of departments; you'll have cast the film; you will have spent some money, but you won't have started to spend the enormous amounts of money that will start to be spent once you start shooting. So that's the ideal time to close the financing.

Producers frequently have the ambition to close the financing before they start pre-production, a couple of months before they start shooting. This can be done, but it's more difficult for a completion guarantor to do this because there will be lots of questions that we would ideally like to have the answers to, that we will not at that stage have, because the producers have not yet done that part of their preparation. It doesn't usually happen because the financiers are not usually ready either at that stage, but if the film starts shooting and the financing hasn't closed, that's usually not a good thing. It can happen for various different reasons, but it's not usually a good thing because it means that the producers, instead of focusing on making the film, are focusing on dealing with the fact that they don't have the cash flow they would ideally like to have. They are talking to financiers and sorting out issues which are not to do with making the film, but to do with financing the film. In fact, we gave a completion guarantee on the film recently which finished shooting a couple of weeks ago, and the financing closed on Friday. This is not good because it means the producers have to go through all kinds of trouble to make short-term measures to find the money they need and to keep everybody happy when they're not being paid properly.

Author

Can you elucidate on the difference between a bond and different types of insurance that you'll expect to see in place when you agree to get on the hook and guarantee a film? There's quite a lot of misunderstandings, especially with emerging filmmakers and producers, of what insurances and what different types of insurance you need and how those sit next to the bond.

James

There's a fundamental difference. Insurance is what you buy to pay somebody else to assume the risk of an event happening over which you have absolutely no control. So, you buy insurance against your house burning down, you buy insurance against somebody driving into your car. If you have insurance, then you can make a claim on that insurance and it will cover the costs that have been incurred as a consequence, either of the fire or the accident or whatever. Film producers can obtain insurance for many things. For example, they can insure against the illness of the cast or key members of the crew. They can insure against a set burning down. They can insure against that camera equipment being faulty one day and the work being wasted. All of those things you can insure against. There might be conditions attached to that insurance, which you have to meet in order to make a valid claim on it, but essentially everything that's insured like that is outside the producer's control: they're things that you can't help.

A completion guarantee, a bond, on the other hand, covers those things that can't be insured specifically. It also extends to things that are within the producer's control. So, the producer will promise us that they will make the film in accordance with the script and the schedule and the budget, but if the producer decides that they are going to depart from those things, then there's nothing the financier can do about it. We, however, are in a position to do something about it. We can come and beat you over the head. We can tell you that you have not done what you told us we were going to do, and we will have certain remedies available to us because of that. So, the completion guarantee is a

hands-on thing, it's not insurance. The financial capacity comes from the insurance market, but it's completely different from insurance in that we are able to affect what happens and prevent there being problems, whereas insurance is because you can't prevent those problems.

Author

You talked about being an active component understandably as a risk manager, with the remedies that are available to you. What are the classic signals that things are going wrong, and, secondly, what remedies do you actually have to address such challenges?

James

The thing that worries us most is when a film is not getting through the script at the rate it needs in order to complete within its allocated number of days. The first warning signal will usually be a progress report. Obviously different pages of script are different and some necessarily are quicker to film than others. But if we had expected, for example, there to be three pages worth of filming, and there was in fact only one and a half, we would want to know why that was. So, at the end of that day, we would be speaking to the producers about why they had not managed to shoot as much material as they had intended to. Now they might have a very good explanation for it. It might be that, in fact, although it looks simple on the page, that scene was very complicated and they didn't mention it to us before, but in fact they always knew it was going to be difficult and so it's taken longer, but we shouldn't worry about it. They might say that, in which case we will be looking carefully to see what's happened on day two. But if, on the other hand, they didn't start filming until midday when they had their first call at eight o'clock, then that would be a different matter. We'd want to know why that was. Was it because somebody was late to the set and hadn't got up in time? Was it because the director just couldn't decide what s/he wanted to do until midday? So those things we would talk about.

Now, those are the things that are immediate warning signs that we can discuss with the producers. If, for example, it's a matter of not starting because people are not there, then you'd want to know what measures are in place to get people up in time and actually get them to work. If it's that the director is uncertain about how s/he wants to film the first scene, then that also is worrying. Is this a sign that the director is not properly prepared? Is there anything we can do about that? So those are the sorts of questions that would come up if not enough material had been shot on the first day. Now, of course, it might be that it was just a first day and that things were slow and that thereafter things picked up.

If the schedule is being adhered to then that would be something that we feel reasonably comfortable with. We'd look at it every day, but we would feel comfortable that things were back on track. Then we would look at the cost statement at the end of the first week, when things should have settled down. There should be a pattern of working and we would expect the costs to be in line with that. The film will have a contingency, broadly speaking 10% of the above- and below-line costs, which we will expect the production to spend. They will need to spend some of that money and it won't be a surprise if they have, but if at the end of the first week they've spent more than the proportional amount we would expect them to spend, then we'd look very carefully at why that was. Have they spent a lot of money on overtime? Have they needed to use many more vehicles than they expected in order to service the set? Are the location costs higher they budgeted for? All those sorts of things will be bad signs.

We would then start to talk to the producers about what they were going to do about it and we'd invite the producers to explain to us why this was not really a problem and

that it was all going to be fine in the longer term. We might or we might not believe them, depending on what they tell us. But I think at that stage, so long as there's not too much contingency usage, we'd probably not want to intervene too heavily because in general what we're doing is backing the producer and the director to make the film that they've told us they're going to make, so we don't want to interfere because that's not really what we're there for. The fact that we have the power to interfere is sufficient, and the producers will be aware that we have the power to interfere, but that we don't want to have to do that. So I think we would let it run for a couple of weeks, provided everything was fine and only if they were really getting through an awful lot of contingency or they were getting behind schedule ... if they're a couple of days behind schedule by the end of the second week, then that's a bad sign because it clearly indicates that they're not going to have enough days to finish the script as things stand and we'll be going into extra days and, of course, the extra days are expensive. Now they might plan to do that and they might persuade us that they have enough money to do that. But that's the conversation we would certainly be having with them. They might say to us "we know we're spending a bit more than we said we would, but it's all looking so absolutely wonderful and the director's doing such a fantastic job, that we really don't want to worry him at this time. We want him to do that because it's obviously going to be a masterpiece." At that point we would say "well, okay, we hear what you're saying, but you don't really have quite enough money to do that – are you planning to raise more money to enable him/her to do that? Are you planning to hand over some of your own fees in order to enable him to do that?" Those are the conversations that we might have if a producer was saying "we know we're spending more money, but it's going to be great".

Author

Actors obviously come in all sorts of shapes and sizes and perceived values. Can you explain how you handle an actor/actress who is an "essential element", if indeed you bond such a contract?

James

Okay. Well, there are lots of actors who, I think it's fair to say, by attaching their name to a project, enable the producer to get the film made. I'm always surprised by how few there are. But there are such actors and if you get one of those actors, then you will have a much, much better shot of getting your film made than if you don't have one of those actors. So, it's understandable that distributors will say, "this is a film we want to buy, we're going to distribute this at the UK and we'll pay a million pounds for it, but only if it's has X in it". Now, if a film has to have X in it in order for the distributors to want to buy it and to release it, then the producer has to make sure that X really is in it. So that means that not only does the producer have to insure that actor against an illness that might cause a delay, but it has to insure that actor to the extent that if the actor becomes ill or has an accident that prevents him from finishing filming his part in the film, that the film will be abandoned and the financiers will get their money back. In order to do that, the producer has to obtain what is called essential element insurance, which is essentially cast insurance with an additional dimension, which says that in the case of this individual, and sometimes it might be two different individuals on a single film, if either of them is unable to complete their part, then we accept the film would have to be abandoned and everybody would have to get their money back. In order to get essential element insurance, an actor will usually be required to take more invasive tests than would be the case if it was not required. So, there are certain unpleasant things that doctors might need to do which some actors don't like having done to them, which might mean there's

a tension between the producer saying, "I have to ensure you as an essential element" and the actor saying, "I don't want that test to be done on me, what are you going to do about it?" There are various ways in which that can be addressed, but that can be a tension. Of course, there are actors who have certain, should we say, predispositions and habits, which again they don't want to be subject to scrutiny of a too invasive kind by a doctor. But essential elements are a very, very important part of the financing of films, certainly at any serious budget level. So, there are issues that always have to be addressed by producers. Of course, if an actor is insured as an essential element, the completion guarantor agrees that that actor can't be replaced because the completion guarantor has to promise that the film as delivered will feature the performance of that actor.

Author

Can you explain in more detail how you might intervene when a film is particularly "stressed"?

James

Ultimately, we have the right to take over the production of the film. We can say to the producer "You're not doing a good job, go home. We're going to do this ourselves. We will appoint somebody else to do that." Now, we do that very, very infrequently because, clearly, we have persuaded ourselves before the film starts production that the producer is going to do a good job and that they can be relied on to do it. So, it's difficult for us to accept that in fact we were wrong about that. But it does sometimes happen. Now, if that's happening, then obviously we would need to appoint somebody else to replace the producer, and that will be disruptive generally for the director and the crew, unless they'd come to dislike the previous producer intensely or otherwise recognize it needs to happen.

So, there are some interim measures we can take before we do that. One thing we can do is to assume very direct control of the production spending. We can say to a production "We're not going to let you spend any money in excess of a very small amount without our direct approval. Each week when you were about to pay everybody and make your payments, send us a list of the payments you're going to make, and we will tell you what we will allow you to pay and what we won't." We are able to do that because we will, in any event, be controlling the cash flow from the financiers to the production, so we will say "unless you do that, then we're not going to let you have any money anyway, so just send us the list of payments you want to make and we'll go through that. We will confirm we're happy and if we're not in any case, we will tell you we're not." That discipline is very worthwhile because it means that before we are sent a list of payments to approve the production, they'll have been through that list themselves and think, "do we really believe that Film Finances are going to be persuaded that it's necessary to make these payments? Do they look rather excessive? Why do we still have so many carpenters on the set when we told them a week ago that all that was finished?" So all of that, we can still do that. If that's not sufficient, we might actually sign the cheques ourselves. Now that's actually (ironically) more difficult these days in the days of electronic banking than it used to be when you had a pile of pieces of paper to sign. It's even more difficult in the age of COVID, of course, but it can be done. We have sometimes sent somebody down to the production every week to authorize the electronic payments.

Then the next stage would be actually appointing another member of the crew to supervise things. Now that might be some sort of executive producer, somebody who everybody on the set knows has the authority of the completion guarantor, who is there ready to be our eyes and ears and just to make sure everybody behaves themselves and they

might or might not get involved in the hands-on management of the production. That will be the next thing we would do. Now, if that was not sufficient, then what would be likely to happen is that person would say to us "This is a completely dysfunctional set. The producer is causing all kinds of trouble. We really need to tell him not to be here anymore", and at that point, I think we would have taken over the production. Maybe not in a formal legal sense, but in a practical management sense, we would have taken over the production. That's happened very, very rarely.

Author

What are your risk management assessments when it comes to finally realizing that the director's out of control, unable perhaps to finish the film, yet you are reluctant to fire him or her?

James

Well, obviously there are projects where a producer will come to us with a fully worked-out script and idea of the budget, but without a director. That does happen, but it's fairly unusual. Most projects have a director attached who has become identified with the project. By the time it comes to us, the director might not have written it, but it's very much that director's project by that stage. So you can assume that the creative makeup of the entire team, the cast and the crew, has a relationship with the fact that the film has been directed by that individual. They're all working on a film by that director. But having said that, we are very reluctant to agree that a director is an essential element. Again, a distributor might be as attached to a director as they are to an actor as an essential element, but we always argue that in order to make sure that that director is able to complete the film they want to make, we have to reserve the right to get rid of them if they're in breach of contract. Financiers and distributors understand and accept that.

I think our experience with directors is that they are either known quantities, in which case if a project comes in with a particular director attached and the film is scheduled to allow four pages of script a day to be shot, and we can look back at our records of that director and see that on his previous five films, he's never shot more than two pages a day, then we'll want to know why that is, but still we will know where we are and we'll know what to expect. Of course, because we've done so many films, it will very often be a director with whom we have worked before. If it's a new director, who's new to us but is an experienced director, we will be able to find out from talking to other producers what we need to know about that director. The difficulties usually arise with directors who are doing it for the first time. Now, sometimes they are absolutely fantastic. We often see writers who have written three films and then want to direct the next one and they're often extremely good at it, but there are just the occasional one and two who really don't have much of a clue, and they're mainly the ones who don't know what they want. If you are indecisive, have the crew standing around waiting for the director to make his/her mind up about something, that is likely to result in an unhappy set, and that's the most likely circumstance in which we would think about talking to the producer about replacing the director. But in my many years of doing this, I can think of maybe three times that that's actually happened, as opposed to a director getting his/her act together and finding some way of working more efficiently. So it's very, very rare for a director to be replaced. It has happened more frequently, of course, at the editing stage where there's been a clash between what the principal financiers (often the studio) are expecting and what the director thinks the film is. So that's less unusual, but that's a different matter.

Author

Can you explain the challenges that you faced in terms of bonding productions with the arrival of COVID-19? What could and couldn't you do?

James

I think the difficulty was that when the pandemic brought the world to a standstill in March 2020, and a number of films that were in production had to stop shooting, the concern then was unrestricted transmission of the virus. It was assumed that all forms of contact, particularly physical contact, and then later discovered to be more to do with aerosol spreading and people breathing on each other, all of those things made it completely impossible for the close working which films involve, both for actors and for members of the crew. So, everything came into a standstill for a couple of months.

The other thing that happened was that it became impossible to obtain any sort of insurance for COVID-related risks. There are essentially two different sorts of COVID risks – one is that someone will actually contract the disease and be unable to work because of it, and the other is that the government will step in and prevent people from working, hence closing a production. There was no insurance for either of those risks (actually, there's still really no insurance for those things), but not withstanding that, within a few months, production resumed and COVID working practices were developed in Europe and some other territories, although the US was quite slow in this regard. Quite a high degree of sophistication was developed, which involves different groups on a production working in bubbles so that they knew that if they had tested negative for the disease, they would not be exposed to other people. There are all kinds of risks involved in this because crew members still often go home in the evening and they might come into contact with other people who are infected. So, it was by no means foolproof, but in general film productions were extremely disciplined and were able to find ways of working efficiently in a COVID[-safe], if not entirely safe, protected environment. An important part of this, of course, was very regular testing. So, if anybody did test positive, then the particular bubble they were in could isolate until they had all had negative tests, which satisfied everybody in that bubble that it was safe to carry on working.

Of course, it was more expensive because bubbling involves separation, more accommodation, and it involves more space and time. For example, if you have to sanitize a costume every day, then that's going to be an additional expense and it's going to take more time. All of those things took more time, but practices evolved and we began to see budgets which had an element in them for additional COVID costs. Now those additional elements have been really very significant. We are seeing a 10% additional allowance needed simply in order to address the COVID needs of a production. That's before you consider the disruption which would be caused if somebody actually contracted COVID. I think by the summer of 2020, that was well advanced in discussions and we saw the first productions resuming. Then the British government (and a similar thing happened in France and in Italy and in Ireland and in other countries around the world) was persuaded to provide what they called a 'restart scheme', which was in effect a plug in the gap which was caused by the withdrawal of COVID insurance. That has been very effective. It's been used in those countries where it's available by all film productions and there have been a number of claims on those government schemes, which would otherwise have been claims on insurance policies.

Of course, the completion guarantee also has an exclusion for COVID risks. It is taking much longer than I would have expected for these exclusions to be lifted – in fact, there is still little sign of that happening. The reason is obvious, with second and possibly third waves of the disease and the disease spreading in different parts of the world, it's

extremely difficult for insurers to quantify the likely scale of the risks they will be incurring. So it is understandable, and I'm sure that when products do become available they will, initially at least, be very, very expensive.

Author

When it comes to risk management in production and delivery, do you actively talk also to government representatives, as well as obviously commercial financiers and banks?

James

Yes, we absolutely have done so, particularly in the UK, Australia and Canada. Less so in Continental Europe where they tend to be slightly more suspicious of completion guarantees and bonds in any case. We have always worked with certain of the Hollywood studios who sometimes want to have a bond maybe because they want to maintain a distance from the filmmakers, or the film is being made in a part of the world that they're not familiar with. However, we have also worked with the streamers, so Netflix from the very beginning used bonds. They use them more selectively now because obviously they're more mature and they have a much more developed production department of their own to monitor things. Amazon we have worked with and, in fact, we recently did our first film with Apple Studios. So yes, very much so, and we are also involved at the moment with large-scale episodic television. We always have to some extent been, but at the moment we have a big European, multinational coproduction that we are providing a completion guarantee for, which is financed by large broadcasters in Germany, France and Italy, but with a bank loan covering the production cashflow, and that's something which I think will be happening more and more.

11 Co-production and co-financing

> All this talk of how difficult and expensive it is to co-produce is rubbish. The fact is, co-production simply has to be done. Forget whether it costs more. The point is that you won't have a movie unless you do it.
>
> (Cameron McCracken, CEO, Pathe Pictures)

The co-production approach to filmmaking

The strategic importance of partnerships when analysing the collaborative nature of filmmaking can never be overstated in the film business. Co-production (and co-financing) is an approach and strategy that has for historical reasons tended to be enshrined in the post-1960 European method of film financing and production. Film made as a co-production is any type of production that involves more than one producing party in the financing and production process – whether through official channels or unofficial. Co-productions may be made through a partnership, a joint venture or through varying types of co-operation, the most common of which fall under official co-production treaties. During the 1980s and 1990s, co-productions were particularly dominant across Europe, and still remain a vital strategy for continental territories as a means to harness additional finance and distribution potential beyond their national support systems.

Europe's filmmaking experience, in particular during the past three decades, demonstrated that while partners are clearly a necessity for financing many films, two key questions need to be asked: 'How much?' and 'In return for what?' At the crux of this equation lie issues of cultural specificity, national identity and creative integrity: how are these tenets upheld when placed next to a project's financing demands and various partners' different needs? We shall examine later in this chapter Europe's filmmakers' changing, increasingly positive relationship to their audience over the past 10 years. This development in turn suggests that filmmakers, and in particular, producers, have learnt how to mostly avoid the traps of 'Euro-puddings' made to appease each party. The combined skills of focusing on a compelling story and appropriate package alongside an increased ability to navigate the complex 'points' systems that have abounded during the 1980s and 1990s appear to have paid dividends. The evidence for such a statement will become clearer as this chapter develops.

There are two compelling economic drivers that relate directly to co-production: the hard costs of making and delivering a film; and the issue of recoupment of all costs. With notable exceptions, the North American territory has historically been viewed as the only territory in which a producer can recoup their costs from the

DOI: 10.4324/9781003205753-12

domestic territory.[1] Hence, in the independent filmmaking industry, there is a pressing need to find partners to raise money, spread risk, and ensure the widest possible distribution of the product. The received wisdom to date (prior to new distribution opportunities) is that the more theatrical the opportunities, even if of a modest scale, the better the potential returns from the film value chain. And the reason why an official co-production is selected is that it allows the film to take advantage of the fact that the production will be treated as a national film by each of the countries involved. This offers an incentive to each producer involved, as it maximizes the value of each national support commitment (e.g. national subsidy/support system) and other financing mechanisms in each territory.

When an independent producer/company enters a co-production it has to execute an official co-production contract which satisfies all the criteria the treaty intends to qualify under. This approach pre-supposes that the producers want to make an 'official' co-production. Any official co-production allows the film to become eligible for support systems under each territory's rules. This may appear to be straightforward, but some of the barriers facing recent efforts to streamline complex bilateral and multilateral agreements are that specific legal intricacies are different for many European territories. Consider in addition that key co-producing territories across the world outside Europe – notably Australia, New Zealand, South Africa, India, Canada, etc. – offer specific arrangements that understandably vary from territory to territory. It is at this point that support from national film bodies and experienced legal advice can help the producer(s) navigate difficult waters. For example, most national funds have experienced production and business affairs advisors; while specialized entertainment legal firms strive to draft documents that are wherever possible compatible, especially as there are certain headings a co-production has to hit.

Co-production – practical headlines

Key co-production questions to address

- Where do the underlying rights lie? E.g. Are they in an SPV? Who is it controlled by?
- Is it a bilateral or multilateral co-production?
- Who is the lead producer (producer deleague)?
- Are the financial percentages being raised from each partner realistic and within the bilateral or multilateral laws that govern the official co-production?
- Are the creative contributions in line approximately with the financial contributions? And are the qualifying nationals working within the framework of the treaty?
- Are the co-producers genuinely independent from each other, and not linked by a common management team?
- Are the general contractural terms agreed?

Applications – the typical three-step procedure:

- 'Provisional' co-production status – granted by the competent authorities on the grounds of an approved agreement between the co-producers.

The film value chain

The co-production goes ahead, with each producer backed by the National Film benefits in their respective territory.

On completion of the film, an audit confirms to the competent authorities that the film has adhered to the agreement and rules, and is subsequently granted official co-production status.

The co-financing and multilateral routes available

Financial, rather than strictly controlled creative, co-operation (aligned with points for different nationals etc.), addresses one of the key hitches that has historically blocked many co-productions: namely, reaching detailed agreements on casts, crews, scripts and other specifics. In the past decade a debate has taken place over whether a project is more likely to be accommodated through a 'co-financing' model than a strictly controlled 'co-production' model. Bilateral treaties invariably require that a producer's financial participation be matched by an equivalent artistic and technical participation.

Taking the above logic further, the European Convention on Cinematographic Co-productions (1992) was designed to allow the streamlining of co-productions to reflect more fully the economic realities of film production. Access to Europe's national funds and subsidy systems (both national and pan-European) became more readily available to a wider range of co-produced projects. The convention applies to co-productions where all the producers are nationals of states that have signed the convention. If not, then there must be at least three producers from three states who are providing at least 70 per cent of the production in order to still qualify.

The convention is specifically aimed at multilateral film productions, not television co-productions, and existing bilateral agreements have remained in place. The key difference is that the convention has acted as an enabling umbrella, which has effectively smoothed out the obstructive bilateral problems when a multilateral production can take over. Multilateral co-productions that qualify are able to access national funds in the same way as official bilateral co-productions. In practice, if no bilateral treaty is already in place, the convention may be applied as a bilateral agreement; or, if a bilateral treaty already exists, it will remain applicable. In addition, if the co-production is between producers from more than two states, the convention will apply and will override (where in conflict) any bilateral agreement between any of the states. The rules dictate that any qualifying producer cannot put in less than 10 per cent or more than 70 per cent (compared to the 20 per cent and 80 per cent figures under bilateral contributions).

The convention contains a general provision that each co-producer's technical and artistic contribution should approximately balance its financial contribution. Technically, between 10 per cent and 25 per cent can be purely financial, with no creative or technical input. However, for the film to pass the regulations there has to be a majority co-producer whose technical and artistic contribution satisfies the conditions for the film to be recognized as a national product under that producer's national state rules. Ironically, a 'majority' co-producer may actually amount to as little as a 30 per cent contribution.

A point system still applies. The co-produced work needs to qualify as a 'European cinematographic work'. The definition is reached by a points system, whereby a

production needs to score 15 out of 19 points to fully qualify. A breakdown of the system shows that, for example, a director is worth three points, an art director worth one point, and so on. Ironically, a lower score than 15 may still be able to pass, as long as the film 'reflects a European identity'. Each co-producer has to apply for approval from the relevant national authority in their state at least two months prior to principal photography.

Eurimages – the pan-European multilateral approach

Eurimages is the pan-European fund for European multilateral co-productions. It also provides support for documentary, cinema exhibition and distribution marketing, but the focus in this section in on the fund's production support. The fund was established in 1989 by the Council of Europe in Strasbourg and has no direct connection to the MEDIA programme, which is overseen by the European Commission.

Eurimages' member states pay an agreed sum into a central pool, which is then administered by a central selection team. The basic arrangement is in the form of an interest-free loan, repayable from producer's net receipts. A qualifying co-production must involve at least three independent producers from the fund's member states (two are allowed for a documentary, although the production must be aimed for a theatrical release) and be directed by a European filmmaker.

According to a report prepared for the Council of Europe Film Policy Forum by the European Audiovisual Observatory, titled 'The Circulation of European Co-productions and Entirely National Films in Europe, 2001–2007',[2] three main conclusions can potentially be drawn from the benefits of co-productions.

1. European co-productions travel better than their 100 per cent national counterparts, achieving a release in more than twice as many markets as national films.
2. European co-productions attract on average 2.7 times as many admissions as their national peers.
3. Non-national markets are more important for co-productions than for entirely national films in terms of admissions, with non-national admissions accounting for 41 per cent of total admissions to co-productions compared to 15 per cent in the case of entirely national films.

Originally, the majority co-producer could contribute up to 60 per cent of the budget, but this was adjusted to 70 per cent in 1994 to come into line with the European Convention on Cinematographic Co-production. The maximum Eurimages will lend any one co-production is 20 per cent of the budget or a cap of €5.5m. The minority co-producer participation must not be less than 10 per cent of the total production cost. Requests are deemed eligible if principal photography has not commenced, and will not have started before the end of the period of settlement of the application.

In practical terms, any application to Eurimages must have the full support from the film's respective national Eurimages representatives. They in turn must be fully informed of the budget, the creative and practical elements and all details of the partnership. The representatives are then in a position to answer queries when the respective project is discussed at quarterly board meetings; but also in a position to 'champion' the project within a funding structure that has become increasingly competitive over the past decade.

The international producer's approach to co-production, financing, sales and talent. In an interview with Philippe Bober, The European Co-Production Office, the author discusses a wide range of issues and challenges facing the maverick filmmaker and businessman.

Author

How did your career start off?

Philippe

I started the company when I was 23 years old in 1987. I had studied management before, which was absolutely useless for the rest of my life, more or less. I think maybe what was interesting is that I graduated when I was 22 and between 22 and 23, I did some internships and I understood some fundamentals. One internship I had was at Renée Gundelach, an executive producer who had been one of the managers of Wim Wenders' Road Movies. She had produced *Der Amerikanisce Freund*, which was the reason I approached her. At that time, she was executive producing and packaging art house movies. So, I worked six months in her office. She was advising on maybe 15 projects: working on budgets, financing plans, contracts and so on.

That was at a time when co-productions were very seldom and exotic. So, during these six months as an intern, I raised some finance in France for a project. I think the fundamental thing that I understood was what I did not want to do. So, thanks to the opportunity that I had to look at 15 projects and look at their financing plan and even the balance sheets of the companies and so on, all the stuff that you need to complete an application was in that office. I understood that there is something fundamentally wrong in the producer business [model], which is that since the 1970s and 1980s producers are actually paid from the budget and not from the revenues of the films. This has a lot of negative consequences. One is that producers are obliged to produce because they need to cover their overheads, which they do with their producers' fee and overheads. The second is that they cannot go over budget because otherwise they lose money. Then you have this machine that starts rolling where people are producing just because they need to pay the mortgage, which is the reason why I started the sales company before I started the production company.

There was an interim time during which I was packaging films. I was raising finance and the first feature film I worked on was *Europa* by Lars von Trier, whom I had approached after seeing *The Element of Crime*. I actually approached him with a project, and he said "well, I have a project", which was *Europa*. Then I started working with him and Peter Aalbæk Jensen and I raised the finance basically outside of Scandinavia, which was as a French co-production with UGC [actually a company owned by UGC]. There was a German co-production with a distributor, and I also arranged for the shooting to take place in Poland with, Krzysztof Zanussi's production company. We realised that in 1988, Germany was not looking like 1945 Germany, but Poland was! So we went to Poland and found all the locations that were needed. So, actually the first film that I sold was *Epidemic* and the first film that I co-produced was *The Kingdom*, for which I was also the sales agent. So, I built up the sales company, I would say until 1995 and then I started producing.

Author

What is it that attracted you to taking on the international sales role? Just explain the thinking, even more beyond your critique of production and producing.

Philippe

So when I was doing this internship, looking at the balance sheets, the budgets and so on, I realized that there is no way you can really put all your efforts into quality because the logic goes into putting the film in the can and then finishing on time and in budget. A sales agent has a completely different logic, because you have to sell your film and you're not going to sell a film that is mediocre. So, if you are a sales agent and you see that the film is not completely what it should be, and that it is running out of money and you have already paid a minimum guarantee, you're going to lose your minimum grantee unless you double it. That is a logic that does have an economical sense as a sales company. So if you have already paid 100,000 for a bad film, it's better to pay 200,000 and have a good film that you can sell so that you recoup your minimum guarantee. The other major difference is cashflow. Collection agents didn't exist at that time, so the sales agent is the first who gets paid and the producer is the last who gets paid. And that means that if you don't screw up in sales, you have a positive cashflow. You can have a relatively relaxed relationship with your bank. Well, as a producer, depending on the countries, you need to mortgage your house in order to cash flow your movie. That is actually the case in countries like Germany, or it was at that time: you could not cash-flow a movie unless you would give a personal guarantee. So, I made this decision in principle to start with sales in order to have the cashflow to make decisions that would not be compromises that I would need to make in order to pay the rent and pay the employees and so on.

Author

That assumes that you're developing, through your sales operation, pretty intimate and close relationships with a range of specialised distributors. In other words, your clients, the buyers. Just explain a little bit about how you did that in the 1990s. Please also explain how you used the festival and market circuit to develop those relationships with buyers.

Philippe

When I started in the business it was always just before doomsday. People were always saying "it's the end of art house". "It's the end of film". Blah, blah, blah. Interestingly enough, most of the people who tried a more commercial route are not in business any-more. Meanwhile, my company is quite solid, with tangible and non-tangible assets, a catalogue of a hundred films and the films that I produced are almost all something like modern classics. So, that means that they don't grow old. We are now, for instance, in the third exploitation of Roy Andersson's *Songs from the Second Floor*, which was in Cannes in 2001 and won the Jury Prize. Roy Andersson, being the first director with whom I worked after Lars Von Trier. I'm still selling these films now for the third time to the same people, while the films that were commercial in those years are gone. They did not acquire what the industry calls a 'shelf value'.

So, about the distribution companies, I think what has changed is that, in the beginning the market was much more mixed, so there were large distributors dis-tributing art house and small distributors trying to distribute American Indies that were supposed to be commercial and so on. I think that there was a concentration for commercial cinema, and that there was a natural selection for the rest of the market. I think that this is not a model that works anymore, so you have to choose to either be really commercial or really specialised. That is the major change. The distributors we are working with are indeed faithful. We have a relationship and they buy things

almost blind from us because they know it's going to be a strong auteur and they know that maybe they will make a little bit of money if not with this one, then with the next one. They also like the fact that because of the fact that I'm both a producer and the sales agent, the connection to the director is much shorter. So, I know the directors very, very, very well because I worked with them for 10 years or 20 years. So, I can book a trip of Ruben Östlund to China or Jessica Hausner ... I can do things that a sales agent normally cannot do. That of course, is very much appreciated by the distributors.

Author

Please talk about your ability to curate. One of the things I remember way back when we first met was that you explained that you would make sure you saw every film from the key festivals, even if you weren't able to see it physically at the festival. You would track very carefully all the filmmakers through the festival circuit year on year, and build up a detailed knowledge of the talent. Just talk about that strategy. And, secondly, how you then respond and track that talent in order to potentially work with them?

Philippe

I had another job. For two years I was the head programmer of the Sarajevo Film Festival when it started. After that, I had a very small section called 'New Currents' that had only seven films and short films. In order to curate that section, I indeed tried to watch everything. So, there was one year where I counted, and I had watched 600 films for that purpose. I can confess that I did not watch all of them from A to Z. In this context I have found *Autobiographical Scene Number 6882*, I think is the title, which is the short film Ruben Östlund made prior to *Involuntary*, and this is how we met. I did not see Roy Andersson's short films in this context, but I invited them ... I think I saw Jessica Hausner's graduation film in that context. Now I would have to think hard to give you more examples, but that was an excellent discipline for me for a period of some 15 years, because I developed a rather good overview of the industry.

From 2000 I became more sexy because I had two countries where I was co-producing and one sales company, which enabled me to approach basically whoever I chose. So whichever director in the world, there would be a way for me to either to put up my own money or to raise the money. And that became a very good synergy between my activities in the early 2000s.

Author

Can you talk about budgets and whether or not you feel that there's been more pressure on the specialised market in terms of budget levels? Or do you find that the work that you do, especially with a sales hat on not just a producer's, means you are seeing a fairly steady kind of level of pricing for these films, or has it changed? Is there more pressure now?

Philippe

As you can see looking at my filmography, I never believed in the middle of the road. There is absolutely no pressure for my company. Not at all. I can even say that things are getting better. But the companies that suffered or disappeared were the companies that did not have a clear line and that tried to be a commercial and do a little bit of children movies and some arthouse from Uzbekistan. I think these companies have disappeared or

are in the process of disappearing. What is going to be left is … I suppose we don't need to worry for Protagonist or for StudioCanal, and then you have the established French sales companies that are doing mostly arthouse. But also in France there is a support system which is going to help them survive COVID and other things.

I like to mention when I teach, Roy Andersson. I remember the last time I was in Venice, I took a water taxi with the director of a major festival. We were talking about Roy Andersson and about Ulrich Seidl and he could not believe it that Ulrich Seidl sells more tickets than a rather famous French director, who makes films that are much more expensive, and with stars. And that is maybe counter-intuitive, but not for me. I can see in my own statistics that Roy Andersson or Ulrich Seidl didn't sell many tickets, but every time a little bit more. There is an economy that makes sense. The films are also not particularly expensive. And as I said, they are classics. So, I'm selling them again and again, and again.

Author

Can we just define what is not particularly expensive?

Philippe

I think the most expensive film I have produced in 30 years was *The Square* at around Euros 5 million, produced together with Erik Hemmendorff. Now Erik and I are post-producing Ruben's next film, that is more expensive.

Author

How has the festival circuit altered in the last 18 months, because of COVID, and therefore events have had to change strategies? Obviously what we've had is a lot of online experience, a lot of online screenings, online social and business interaction. Do you think that we're going to go back to a much more physical setup or do you think we might be entering a period where there's a hybrid system, where the festivals have to use a certain amount of online and also physical interaction?

Philippe

I would say from the conversations I have with colleagues and distributors, that the general expectation is that normality will start in Berlin next year (2022). My personal job in the company is to deal with Cannes, Venice, Berlin, so I'm not so much in contact with the other festivals. I don't know what the plans are. But definitely these three festivals want to go back to normal and will go back to normal because they have a function in the industry.

Author

In terms of your producing and sales hat, how do you navigate the streaming platforms and the growth of streaming platforms?

Philippe

I don't have a clear opinion about this. In our company one of the top priorities this year is to understand what our own policy is going to be. At the moment I can say that it has had very little impact, both positive and negative. It is going to change, but at the moment, I can say that we have never sold a movie to Netflix directly and I sold

one movie to Amazon directly … but our local distributors did sell movies to Netflix or Amazon. And they made money. *Force Majeure* was sold to Netflix for a high figure by the US distributors, which is fantastic. Meanwhile, in large territories, like France, Germany or the UK, you can make deals with platforms for EURO100,000, which is a relevant amount that basically replaces television. So, I would say that this is indirectly positive. Money goes to the distributors, but of course if your client is making money, it's also good for you.

Author

How do you choose which projects to work on?

Philippe

This is a very interesting question and, of course, you're not the first person to ask it and I'm still always struggling to answer. The fact that I have this past as a festival pro-grammer is an excellent help to put things in perspective. Now I don't curate festivals anymore, I'm still on the board of the Sarajevo Film Festival, but my role is to drink with the guests, which I can do very well. If you look at the films that we represent, including those that are produced, I think that there are some similarities. The one is that they have a very researched form. The other is that actually most of the directors I work with, this I realised a posteriori, invented something. So they are not followers, they are followed. They also have something to say. A common denominator of the films is that what mat-ters is not the fact that you are entertained during the 90 minutes; it is that you think about it afterwards. But that is something that I can say a posteriori after having been asked this question a few times and thinking about it. For me the method, so to say, was to watch a lot of movies and to pick the directors I wanted to meet and then to have drinks with them and then maybe to read the script. So, in that order, because it's not necessarily in the script that you will understand if a director has something to say, it's in a bar.

12 Exhibition and the changing cinema experience

> I remember the happiest moment of my childhood. I was sitting in a dark movie theatre between my father and mother, eating an ice cream ... I felt the sounds from the screen wash over me, and I was overcome by the awesome rightness of things. Engulfed in that dark space I indulged in glorious private pleasures, yet I was not alone. I was protected but I was free. I felt my soul expand to fill the room.
>
> (Jon Boorstin, *The Hollywood Eye*, Harper Collins, 1990) [1]

> Please watch our movie [*Nomadland*] on the largest screen possible and one day, very very soon take everyone you know into a theatre, shoulder to shoulder in that dark space.
>
> (Frances McDormand, actress, at the Oscars, 2021)

Exhibition's role in the film value chain

In Neal Gabler's controversial book *An Empire of Their Own: How the Jews Invented Hollywood* [2], the film historian cites the Vaudeville experience as a key catalyst that propelled 'live entertainment' from floorboards to, ultimately, the moving picture business. That shared experience, collectively witnessed, together, under the one roof and within the dark, helped cross linguistic, social and cultural boundaries and paved the way to the importance of the exhibition sector as we know it today. It is still called 'theatrical', which to newcomers may seem a confusing term, but its roots go all the way back to the 'theatre' experience – a shared sanctuary for entertainment – that Gabler and other historians, commentators and creative practitioners such as the eloquent Jon Boorstin [2] have written so passionately about over the past century. That emotionally charged experience remains as critically defining of the moviegoing act as carried out through the visiting of theatres to watch films as it ever has been.

Historically, even in the peak years of the 1980s and 1990s, levels of cinemagoing attendance in the USA were well below the levels of the 1940s and 1950s. The abrupt drop in attendance during the 1950s and 1960s was deemed a result of competition from the arrival of new visual entertainment media – most notably television. By the 1980s and 1990s, cinema exhibitors also faced new challenges from video rentals, cable television and, ultimately, the sharper delivery tool of Digital Versatile Disc (DVD). Between 1980 and 1995 VCR-owning households in the USA had grown at an average yearly rate of nearly 30 per cent. Yet despite the proliferation of alternative

DOI: 10.4324/9781003205753-13

entertainment, including film at a later stage of the window sequence, the exhibition sector stood up to the onslaught with resilience. Whilst the building and proliferation of multiplex cinemas had an important role in the market, multiple-screened cinema theatres only go a limited way to explaining the retained strength of the theatrical market prior to the 2020 hiatus.

The COVID-19 hit

All that seeming resilience took an almighty hit at the start of 2020, when the Coronavirus pandemic started to fan out across the world. Cinemas were facing a nemesis: a highly infectious global disease, which in turn was to give rise to film and entertainment changing direction of destination, with both feet, firmly into the living room. The (yet further) explosion of online entertainment, led by Netflix and Amazon et al., led many to question whether cinemas could "ever win us back" [3], with commentators pondering "whether the rise of watching new releases at home may be irreversible". Day and date was becoming the battleground between the Hollywood studios and exhibitors (see Chapter 15), with audiences expecting long-delayed blockbusters to be available simultaneously on cinema screens and streaming.

But crucially, Generation Z and its younger sibling demographic moniker "Generation Alpha" are impacted in ways that may yet dent cinema's alluring pull. "The lives of teenagers have shifted so much that, while before, cinemas would be an escape from home and a large part of their social life, now their escape is in their bedrooms, plugged in and chatting, gaming, watching, creating, whatever. They are an age group used to being at home, who then find that the films made for them, like *Black Widow*, are on TV" [3]. Meanwhile, television and (certain) streaming shows are pulling out the stops and becoming both more cinematic and, crucially, emotionally powerful (think Kate Winslet in *Mare of Easttown*; Elizabeth Moss in *The Handmaid's Tale* and Anya Taylor-Joy in *The Queen's Gambit*).

At the time of writing, it was difficult to read quite how successful the world's cinemas (albeit with varying difficulties on a territory-by-territory basis raised by the pandemic) were in the summer of 2021 in making up for lost openings and hence revenues, let alone socially distanced seating. Variety offered a range of projections in the autumn of 2021 that pointed to a near-70% recovery of global box office, yet more than one-third of this recovery was thanks to China alone [4]. Ironically, according to specialist distributors, the long delays and absences of blockbusters had created more room for strong independent titles over some 20 months of the pandemic, but the overall trend was indicating that more than half the studio fare was going to be offered via VOD with just the most expensive and high-profile projects going exclusively theatrical. When Universal and AMC struck a US-only (for then) deal that marked a historic agreement to collapse the window of time films screen exclusively in theatres from 90 days to just 17, before becoming available on streaming services, much of the cinema industry collectively shuddered. "We do not see any business sense in this model", opined Cineworld's CEO [5].

Why we go to the cinema

Combined market studies have indicated that there are four major factors that determine whether moviegoers decide to go and see a movie: a) the quality of the film

itself; b) the location of the theatre; c) the starting time of the screening; and d) the overall quality of the cinema. Whilst developing technology assisted the cinemagoing experience, such as Dolby sound systems and for ardent moviegoers the size of the screen, research has not indicated that these developments made crucial differences in terms of exhibitors' performance. Neither has ticket price nor customer brand loyalty [6]. The most important factor was, and still is, the quality of the film that the audience selects to see. Therefore, all exhibitor companies place great emphasis on the selection of films that they license and book for screening. Just as a distributor has to take a commercial view on the 'package' – including the story, script, director, actors, budget (and genre) – so too does an exhibitor. In addition, an exhibitor has to consider the specific timing of the film in question. Is it the right weekend? What is the film competing with? Should the film be programmed for a holiday period, or a specific season? What the growth of multiplex cinemas in the 1990s allowed was for theatre operators to offer a wider selection of product and to reduce some of the pressure for picking 'hits' when licensing. On the other hand, certain operators played so safe that the new market was observed by some critics as 'flat' and regressive. When 20-screen multiplexes in New York City, for example, were playing the first *Batman* film on 19 of their screens in the film's first weekend, no wonder observers questioned the homogenizing effect of the multiple screen era.

Terms of trade

The standard arrangement between a distributor and an exhibitor is called a film licensing agreement. This governs what is called a 'film rental fee', which is paid by the theatre owner to the distributor in return for screening their film. Negotiations normally take place at least three months before a film opens (and in many cases earlier, especially in respect of tent pole studio fare). The structure of the film rental fee is normally governed by the greater of two amounts, which are calculated under the following formulas:

a) The gross receipts formula. The distributor will receive a specific percentage of box office receipts, with that percentage dropping over a period of time. For a new film, the percentage is normally 60–70 per cent in the first week; this figure then declines gradually to around 30 per cent after 4–7 weeks.
b) The adjusted gross receipts formula (also known as the 90/10 clause). This arrangement allows the distributor to receive 90 per cent of the box office receipts after a deduction for the cinema's expenses (aka the house allowance – which is negotiated on a distributor/exhibitor basis for each cinema in question).

From a film booker's perspective (working on behalf of the cinema or chain), their role will be to consider the different available titles being released in a specific week (or month/period), so that they can programme or counter-programme effectively. They will then set about negotiating a deal with their counterpart at the distribution company that addresses the following points:

• the film rental
• the number of screens
• the total seating capacity

- the number of show times (very important for long-running films)
- the duration of the overall run.

The most significant aspect is the film rental agreement. Of the two examples above, the adjusted gross receipts deal (b) is the most typical when dealing with studio/major distributors' product. The key to the 90/10 deal and its precise calculation is the specific theatre's pre-negotiated house allowance figure [7]. The exhibitor and the distributor examine a range of facts when it comes to their determining the house allowance. These include the quality of the theatre, the number of screens and the number of seats. The house allowance figure is then taken into account when calculating the final payment: e.g. it is subtracted from the films' 'gross' for the week and the remaining sum is multiplied by 90 per cent to calculate the 90/10 film rental owed to the distributor. If the 90/10 rental is larger than the film rental worked out through the 'floor' percentage for the same gross then the exhibitor will pay the 90/10 rental. If the floor percentage provides a larger film rental, then the exhibitor will pay through the floor calculation method. Table 12.1 provides a simple example of how the above formulas, when applied and compared in a specific week at one theatre, are calculated. The example assumes box office receipts of $12,000, a gross receipts percentage of 60 per cent and a house 'nut' of $5,000. (The 'nut' is the overhead – normally including payroll, rental on theatre property, maintenance, insurance, utilities, and standard advertising.)

In Table 12.1, the exhibitor would pay the distributor the greater of the calculated amounts, i.e. $7,200. It is important to note that there have typically been exceptions to the normal practice. In a process known as a 'settlement' the formal agreement was subject to a renegotiation if the set terms meant that the exhibitor would not make a reasonable profit on the deal. Normally, this kind of renegotiation would not take place unless an exhibitor had lost out to more than one film from the same studio. Exhibitors would also sometimes be required to pay a non-refundable advance rental fee in order to secure a film licence – normally a 'hot' film that the studio could use to negotiate such a hardline position.

When dealing with 'speciality' or independent films (even if produced or acquired by a studio's speciality division), exhibitors play a critical role in the exposure these films require if they are to work on the theatrical circuit. Exhibitors track the upcoming market through festivals, trade reviews, and business word of mouth, and will contact a distributor directly when they have found out about an interesting/appropriate title. Normally, the distributor will contact the exhibitor and arrange

Table 12.1 Cinema gross and adjusted gross deals

	Gross receipts	Adjusted gross receipts
Box office receipts	$12,000	$12,000
Gross receipts	60%	
House 'nut'/allowance		−$5,000
Subtotal	$7,200	$7,000
90% adjustment		−$700
Payment to distributor	$7,200	$6,300

Source: G. Verter and A.M. McGahan [6]

for them to screen a film and consider booking it in one or more of their theatres. A typical example of a US exhibitor booking a foreign language film involved minimum terms and a minimum playing time, and called for a split of 90/10 above the house nut. A minimum floor for the first week was set at 70 per cent, the second week at 60 per cent, the third at 50 per cent, the fourth at 40 per cent and all remaining weeks at 35 per cent.

The floor protects the distributor if the film does not work, while the 90/10 split also protects against the downside [7]. So, for example, a distributor may negotiate the following deal:

a) Minimum terms and minimum playing time.
b) Split of 90/10 above the house allowance, with minimum floor for first week at 70 per cent, second week at 60 per cent, third week at 50 per cent, fourth week at 40 per cent and all subsequent weeks at 35 per cent.
c) For example: theatre week one has $40,000 gross on a 90/10 deal, with a 60 per-cent floor and a house 'nut' of $5,000.
d) Start with $40,000 as the gross, subtract $5,000 (house 'nut'). Then split remaining $35,000 for the distributor.
e) How does that compare with the $60,000 'floor' figure? Sixty per cent of $40,000 is $24,000.
f) Since a new film rental of $31,000 (the distributor's share) is about 78 per cent of $40,000 or about 18 per cent higher than the floor, the 90/10 split will govern, with the theatre paying a higher percentage to the distributor than a straight 60 per cent gross.

Exhibition economics

Cinema owners have traditionally made most of their money from theatre admissions but also crucially from what the business terms 'concession' sales. Concessions include all drinks, sweets, popcorn and other foods sold on site. Specialized cinema owners have deliberately introduced licensed bars and higher-end food to cater for a different clientele. Making the moviegoing decision an "experience" and ensuring that service and premium supplies are available are increasingly important to a venue's business model and enduring success. Overall, theatre operation costs and film rentals are the main costs that have to be met. Remaining income is derived from theatre advertising (commercials shown prior to trailers), foyer games and the rental of theatres for business, group or special event meetings. These make up the miscellaneous income streamlines below.

Income

For a multiplex cinema (owned or leased), against the theatre gross of 100 per cent:

Percentage

Box office receipts 72 Concession sales 26.5 Miscellaneous (theatre ads etc.) 1.5

The above numbers are for a typical hypothetical 16-screen US multiplex as outlined by Redstone [8]. From the total theatrical gross, the largest cost to be deducted

is the film rental (i.e., the share of box office income that is to be returned to the distributor). The film rental is only calculated as a percentage of box office revenue and does not include other income streams.

Items that are listed after film rental include rent (if paid), payroll, cost of goods, utilities, taxes, licences, insurance, maintenance and repairs, payroll taxes and employment/social benefits, services and supplies, miscellaneous (such as travel and promotion), and advertising. Each item below is listed as percentages of 'total theatre gross'. Hence, 'theatre-level cash flow' is, according to Redstone, in effect, "multiplex revenue after all costs are deducted, When corporate overhead costs are then deducted, we achieve a 'net cash flow' or profit margin of 15 per cent before depreciation, taxes or debt servicing for his hypothetical model."

Costs

Against the theatre gross of 100 per cent:

> Film rental (to distributor) 35 Rent or cost of money 15 Payroll 12 Cost of goods 4.25 Utilities 3 Taxes, licences, insurance 2.5 Repairs, maintenance 2 Payroll tax and benefits 2 Supplies and services 2 Miscellaneous 1.5 Advertising 0.75 Theatre-level cash flow 20
> Less overhead 5 Net cash flow 15

Percentage

A typical profit level ranges from 15 to 45 per cent depending on whether the theatre/circuit is owned or leased. However, it is important to recognize that 'rental' figures vary considerably from territory to territory. For example, even strong independent distributors in the United Kingdom only get a 30 per cent rental figure from exhibitors. Some rental figures from smaller UK distributors are as low as 23–25 per cent. In the next section of this chapter and the case interview, we shall see how the economics of the above, standard approach, are already altering the way the exhibition sector is, and, crucially, where it will be operating over the coming decade.

Digitalizing the exhibition experience

There has been a generally held assumption that the digital age has brought huge changes to the movie industry's primary window – the release of films at the cinema. There are a multitude of factors in play, including the potential reinvention of content, alternative programming, the specific kinds of films that could become available, alternative and highly flexible, targeted programming, non-feature film material such as live performance and sports events, new ways of presenting film material and ground-breaking technical experience devices including 3-D viewing.

Broken down more categorically, the key element to focus on is the stage termed 'digital cinema'. This is the term used to describe distribution and projection of films in a digital format without the need for physical film prints. The system of 'virtual print fees' – where distributors paid for 'prints' to help support the costs spent by theatre owners to turnaround projectors to install digital screening equipment. The overall cost of such a conversion to nearly 40,000 cinemas worldwide has now been

pretty much paid off around the world. This advancement allows distributors considerable flexibility, and major cost savings – albeit these are eaten up by ever-rising marketing costs. At least one major barrier has been paid down. However, the cinema-owning business has been not less than luddite when it comes to allowing prints to be delivered through the cloud. For some old-fashioned reason, owners insist on a physical delivery system of DCPs (Digital Cinema Packages), rather than trusting a state-of-the-art, truly digital process. The technology not only exists, but has been around for nearly a decade. Instead, the theatre business remains entrenched, feeling reassured by physical DCPs – which are more expensive, most likely to suffer damage, and require large numbers of people in the supply chain to operate – in contrast to a simple cloud system. So much for the industry embracing change and advancement every step of the way.

Embracing real change

Writing in Bloomberg's Screentime newsletter, Lucas Shaw [9] boldly stated that "The pandemic didn't kill the movie business. It did expose its flaws. For years, studios and theatres have stifled efforts to change the moviegoing experience. They have maintained a status quo that has been good for the biggest studios and theatre chains, but bad for independents and consumers."

Like other sharp observers, charging higher prices for tickets (and relying on the next big Bond or Marvel offering; mixed in with the returning fad of 3D for a period) has stemmed the bleeding business model but has hidden inherent issues. But by holding its head just above water, Shaw explains that two "nettlesome" points have been obscured: "People are going to the theatre less often than ever before, and the average theatre is usually more than 70% empty" [9]. Despite the drop off, the theatrical film business hasn't changed its business model very dynamically to adapt to this new reality.

The pandemic, however, has changed some of the above recalcitrance to change. Studios have already forced theatres to accept that movies will be available online sooner than ever before, despite the howls of discontent recorded previously in this chapter. Shaw suggests some changes that "could make the movie business smarter – and the theatre experience better for those of us who love them":

Implement flexible pricing

"You pay the same price to see *Shang-Chi* on opening weekend as you do *Free Guy* in its fourth week. You also pay the same price to see a movie on Wednesday night as you do on Saturday night.

Few businesses ignore basic supply and demand to this degree. If more people want to see a new Marvel movie opening weekend than anything else, it should be more expensive. If more people go to see movies on weekends, those tickets should also be more expensive.

Raising prices comes with risk. If you charge too much for a new movie, people may not be able to go. But there are a lot of people who would pay $30 or $50 to see *The Eternals* on opening weekend. Anyone who hesitates to pay that price could wait for a week or two when the price be lower. And if the person doesn't want to pay the price at all, they can wait to watch it at home.

This cuts both ways. You might entice people to come to see more movies if they knew there was a deal. Why not offer older Marvel movies on Tuesdays for $6? Or have a Friday night special for date night? Two tickets for the price of one."

Experiment with programming

Watching a trailer for the new James Bond movie, the last with Daniel Craig, I was struck by a desire to revisit the previous installments. I can't be the only one. The Bond franchise is one of the most popular in movie history.

Why wouldn't theaters offer a new Daniel Craig Bond every week until the day that one opens? Surely there is as much demand for *Casino Royale* as *Malignant*.

This doesn't just apply to movies by the way. Movie theaters offer massive screens, and comfortable seats. They are a good place to watch video entertainment in many forms.

Why not use theaters to show more of what people want to see? Big football games. TV series finales. Live concerts. So many theaters are empty because they are playing movies most people didn't want to see in the first place for weeks longer than anyone has any interest. AMC just did a deal for NFL Sunday Ticket, so perhaps we are headed in this direction already.

Embrace streaming

The proliferating number of movies streaming at home could actually be a good thing for theaters. it enables them to offer more new product. If AMC took a new Netflix movie every week (with an exclusive window), it could replace some of the holes left by recent consolidation (and also solve some of Netflix's marketing and launch challenges concurrently).

Trying to stop people from consuming media the way they want to do it seldom works. The music industry didn't solve for piracy until Spotify offered a more convenient way to consume music online.

The moviegoing experience has to be meaningfully different from, or better than, the at-home experience. Otherwise there is no reason to leave your house and spend a lot of extra money" [9].

An interview with Andrew Woodyatt, Marketing/PR and development director at London's Rio Cinema, Dalston, London

The Rio Cinema is a Grade II-listed independent Art Deco cinema in east London. The listed building is a highly popular independent cinema located on Kingsland High Street in Dalston, with a history stretching back over 100 years. In 2017, the Rio launched its RioGeneration scheme to add a much-needed second screen in the unused basement space and restore the exterior and the spectacular night time lighting. The Rio hit its £125,000 fundraising target with support from the Mayor of London, local residents, Rio members and customers, and Screen Two opened on 29 December 2017. Further building work continues and the Ludski Bar opened May 2019 next to Screen Two in the basement, creating a welcoming space to hang out before or after the film, and as a space to hire for parties and screenings.

Author

The Rio in Dalston has been selling out pretty much all its post-COVID lockdown screenings (in the summer of 2020). Why is that?

Andrew

Because we have developed a built-in audience. Looking back, it's clear the old business model disappeared around 2010 when streaming started to kick off. Free TV and DVD started to drop away, making minimum guarantees harder to find/raise. The rug was pulled out of the indie film model. The most resilient UK specialist cinemas (ICA, Picture House, the Curzons, Everyman, Rio etc.) then got hit by COVID-19 and just about survived the reduced seating capacities but were probably losing money despite being busy.

Author

Can you explain more about your audience and how you've built such a loyalty?

Andrew

The challenge when running a cinema – "the best toy in the world!" – is to overcome insular thinking. The fabric of indie cinemas and successful distribution is all about social and community. Every time you have a film, you need to be thinking very clearly about who the audience is and how to get those bums on seats. How original is your marketing materials and partnerships? How can you increase sales? How can you create an 'event' (and in our case build a second screen…). There are fundamentals that you have to look at when running an indie cinema. So in our case, we needed to build a second screen, and worked out how to do that at the cheapest price (£80k). £40k–£50k was spend on kit. The seats were ripped out of an old, closed cinema (£1,000), so we applied a DIY ethos to the build. It allowed us to have an additional space for events etc. even though small compared to the 400-seater main screen.

Author

It would be helpful to understand more about the basic economics of running a theatre, in particular pricing.

Andrew

Ticket pricing is extremely sensitive: Students, teenagers are keen on low pricing. Middle-class ticket buyers are less sensitive. But if you're running an arthouse cinema, why penalize them? RIO is pretty low and tight on pricing. Take £10 ticket cost: There's £2 charged for VAT at 20 per cent; and a 50 per cent rental number to have to pay the distributor. That leaves £3 per ticket left to the RIO. Hence concessions (local beer, coffee, ice cream, popcorn etc.) are a critical factor and make up 30 per cent of our turnover. Local produce is essential – local audiences like that sense of supporting local businesses. And it's part of the experience and branding.

Author

Can you explain about your approach to programming?

Andrew

Genre is incredibly important when it comes to selling tickets. So are actors and the "likeability" of the title and the connection they have to a target audience. It's about 'triggers

to buy'. Ten per cent of our programming is Asian cinema each year. But *Parasite* (see case study below) was really hard to judge initially. How big was it going to be? How could we sell every seat? It is such a good film and has what we call the "playability" factor, but you have to make sure it all comes together at the right time. The UK was the last territory in the world to release, so there was some worry about piracy. (Middle-class people and students have no moral issue over pirating!, and some are patient will eventually find it online anyway, by any means.)

Author

How critical were the high-profile awards that Boon's film won that Awards season?

Andrew

Never underestimate the power of the Oscars and winning the Best Picture. In March 2020, despite the move to lockdown, we were incredibly busy – while April became harder competing with other films. The press also made a difference with a huge amount of ongoing support around the film.

Case study: "Parasite"

Parasite, **the South Korean Cannes- and Oscar-winning hit, turned heads around the world when it broke foreign language box office records just before the advent of the Coronavirus pandemic.**

The idea for *Parasite* – the only film to win both a Best Picture Oscar and the Palme D'Or for 65 years – was born in 2013, while the South Korean filmmaker Bong Joon-ho was working on *Snowpiercer*. An actor friend of Bong's from the theatre suggested that he write a play based on his work as a tutor to a wealthy Seoul family. The title was chosen as it provided a double meaning: "The story is about a poor family infiltrating and creeping into a rich house ... [but] you can say the rich family are also parasites in terms of labour: they can't even wash their dishes ... they leech off the poor family's labour" [10].

Following the completion of *Snowpiercer* (which later became a long-running series on Netflix), Bong wrote a 15-page treatment. His production assistant, Han JiWon, then turned in three different drafts of the screenplay. Post-*Okja* (2017), Bong returned to the screenplay and completed it. Described as a 'black comedy thriller' – an unusual mix of genres – the story had a number of sources of inspiration. References cited include *The Housemaid*, a 1960 "domestic gothic" South Korean film about a middle-class family thrown into turmoil on the arrival of an interloper in the shape of a domestic maid. Other references stemmed from a story about two 'live-in' maids in France, set in the 1930s, and titled *Christine and Lea Papin*, in which the eponymous two maids ultimately murdered their employers. Bong also drew on his personal experience, as he'd worked as a private tutor for a rich family in his twenties: "I thought how fun it would be if I could get all my friends to infiltrate the house, one by one..." What transpired was a heavily ironic tension between wealth disparity, rich versus poor, and an upstairs/downstairs situation

– what Bong described later as "a staircase movie". Boon saw the film and its main themes as a reflection of "late-stage capitalism", exploring the tensions that arise from inequality and social exclusion. However, its impact is further strengthened by its cultural specificity: the term "Hell Joseon" is a contemporary South Korean phrase used by young people since the mid-2010s to describe youth unemployment and their use of connections to get ahead for all parts of society: the rich, the middle class and the poor.

The extended shoot – 124 days of principal photography – kicked off in May 2018 and wrapped in September. Pre-production was particularly important in terms of the preparation and design of the film's main location. The Parks' house was a specially constructed set, with a ground floor and garden designed on an empty outdoor lot. The basement and first floor was also constructed on set: "It's like its own universe inside this film. Each character and team has spaces they take over that they can infiltrate, and also secret spaces that they don't know about", Boon explained. The home was aesthetically beautiful but also served as a stage for the precise needs of the camera, compositions and characters. It was built by an architect embedded within the actual story. Likewise, the Kims' ugly, downtrodden basement and back street was also built on set – which also enabled the entire set to be filmed as the apartment became severely flooded within the storyline. The sun and its precise position during daylight was a key factor when the design and angles of the house were set. The director of photography explained that he wanted "sophisticated indirect lighting and the warmth from tungsten light sources", whilst being clear about where the sun was at any point in the day for key scenes.

Despite the carefully curated original sets, the editor Yan Jin-Mo explained that there was very little 'coverage' shot; instead the editor would often stitch together different takes of the same shot. In addition to the colour version of the film, a black and white version was produced prior to the world premiere in Cannes 2019, which debuted in January 2020 at the Rotterdam International Film Festival, along with a limited release in certain territories. An IMAX version of *Parasite* was also created.

The financing and distribution strategy

The film was financed, sold internationally and distributed in South Korea by the territory's vertically integrated entertainment powerhouse, CJ Entertainment. Pre-sales were notable, and included North American rights going to Neon (AFM 2018); other rights included Germany (Koch), France (The Jokers) and Japan (Bitters End). The world premiere, in the Official Competition at Cannes 2019, where *Parasite* won the top prize, set up a South Korean launch on 30 May 2019, followed by Mad Man's roll-out in Australia by Madman, Russia in July and North America in October. Unfortunately, the film's release in China was cancelled for "technical reasons".

Neon, led by the ever-imaginative Tom Quinn, upped its cinema screenings from a classic limited platform start (3 theatres), then moving to 33, and then 129 to 620 in the sixth weekend, which it hold until a huge shift from 1060 to 2001 over the weekend of 14 February 2020 following the film's Oscar success, despite Home Video having already started. Hulu acquired US streaming rights, which kicked in April, and Amazon Prime started streaming the film internationally from 28 March 2020. The film had taken $20m by its tenth week in North America, but the Oscar

and the doubling of screens took it to $53.4m overall. In South Korea, the film reached 10 million people, grossing $71.3m and capturing the attention of one-fifth of the country's population.

In the UK, Curzon Artificial Eye bought the film on sight just before Cannes, and previewed the film relatively late – in early February 2020 – with a general release set for 7 February. While other rival distributors offered more than Curzon's MG, CJ Entertainment trusted Curzon. For example, previous strong performing *The Handmaiden* had seen Curzon pay overages to CJ, giving the sales arm confidence that they would receive in revenue streams if the film did perform in the UK. When the staff saw the film, they were astonished and excited. However, the company has no output deals with Pay-TV operators such as Sky. It was decided that an approach to Studio Canal, a significant mini-major with a Sky deal and more clout at booking cinemas, would be optimal. Studio Canal entered an agreement with Curzon, and both companies were to greatly benefit from the Friday 7 February opening, moving to the Oscar win three days later and some £12m UK box office from an expanded release that reached 600 cinemas and improved terms over the course of the film's life. "Winning was the greatest feeling ever", recalls Curzon's Jake Garriock, head of distribution strategy and group publicity. "We ended up spending £1.5m in prints and advertising, with sustained ads, and adjustments upwards each with, all approved by CJ Entertainment." Materials were accessed from Neon, with a trailer, posters and still photography all produced at a high-quality standard.

The film's UK success was, of course, due in part to word of mouth and click As Garriock explains, however, "some brilliant films simply cannot find an audience, while *Parasite* had a great premise, material and never underestimate the Best Picture Oscar". Boon and the filmmaking team also travelled extensively with the film, giving endless interviews and Q&As, and providing the oxygen for ongoing debates and interest around the film's themes as much as the actual playability of the movie. Some press members became obsessed: *The Guardian* ran articles every day for two weeks such was their fascination with the film; while *Parasite* achieved the highest ever screen average at the Rialto in Hackney, London.

All this was achieved on a film budged at $13m, which Deadline later calculated meant a net profit of approximately $46m to be shared between the talent and CJ Entertainment. Metacritic established that 52 compiled reviews gave it a 96/100 rating, and the film became the 45th-highest rated film of all time on the site. IndieWire ranked it first amongst 300 critics, while the Associated Press suggested that while the Academy had previously failed to recognise women filmmakers, this time it had acknowledged diversity. Whether that really opens the door for Hollywood to undergo a change and promise a more inclusive approach to foreign language films is highly debatable. What is clear is that major streaming companies are reassessing the power of world and international cinema as their tentacles stretch ever wider around the globe (see Chapters 16 (Streaming) and Chapter 17 (Netflix)).

At the time of writing, an HBO limited series is in active development with Bong heavily involved, which he explains will "explore the stories that happened in between the sequences of the film". Meanwhile, tourist attractions have been built around the set and the shooting locations, setting up a very ironic message as poor basement dwellers in this areas of the capital are now "monkeys in a zoo". The government has been forced to intervene and support 1500 low-income families in surrounding semi-basements to manage the messaging.

References

[1] Boorstin, J., *The Hollywood Eye*, New York: Harper Collins, 1990.

[2] Gabler, N., *An Empire of Their Own: How the Jews Invented Hollywood*, New York: Doubleday, 1988.

[3] Dean, J., *The Sunday Times*, 09/05/21.

[4] *Variety*, 14.09.21.

[5] Greidinger, M., *Film Take*, 10/10/20.

[6] Verter, E. and McGahan, A.M., *Coming Soon: A Theatre Near You*, Harvard Business School, 24/09/1998, p. 3.

[7] Squire, J.E., *The Movie Business Book*, 3rd edn. New York, Fireside, 2004, p. 394.

[8] Verter, E. and McGahan, A.M., *Coming Soon: A Theatre Near You*, Harvard Business School, 24/09/1998, pp. 386–400.

[9] Shaw, L. Bloomberg news letter Screentime, 'The Pandemic Gives the Movie Business a Chance to Reinvent Itself', 19/09/21.

[10] Ankers, A., 'Parasite: Bong Joon-ho Reveals the Meaning Behind the Title of the Oscar-Nominated Film', 23/04/21.

13 Production

Global challenges and change

What will become known as 'The Great Film Production Renaissance' has begun. Make no mistake, it's going to affect everyone.

(Richard Janes, *The Startup*) [1]

I *am* the producer ... I cook!

Walter White (Bryan Cranston), *Breaking Bad* series (2008–2013) [2]

During times of acute physical and psychological stress, and amid practical and financial challenges, the next logical stage of advancement is accelerated. New Phoenixes' rise from last year's (and decade's) ashes. Some companies and individuals fail to survive, while others are nimble and adaptable, shifting gears, and embracing innovation and change. New emerging players break rules, embrace the next, and establish a new order, and so the world moves on.

The film industry is no different to many other business sectors, as industry practitioner and analyst Richard Janes elegantly wrote at the start of the pandemic: "Reduced crew sizes, minimal extras, reduced international travel, restricted contact with key personnel, are the key dictates that are being passed down by studios, networks and insurance companies in an attempt to get productions back to work and minimize the risk of COVID-19 infections which could stall a production and inflict millions of dollars' worth of damages to a production. With these forced adjustments will come new norms and cost savings that will be hard to roll back when the all clear is given ..." [3].

Janes' analysis and articulation of the "future of film and TV" is so compelling (I was introduced to his writing by Paul Brett, the interview subject below, and subsequently shared with many), that I deem it worthy of significant 'airtime' in this chapter addressing production change. Janes correctly predicted in mid-2020 that we will see "a huge amount of projects vying for the limited sound stages that are available around the world. Sound stages where crews don't have to travel, the environment can be controlled, and economies of scale can be achieved through reduced unit moves etc."

The revolution is driven by digital technology, encompassing everything from game developers such as Epic creating 3D photo real visuals to Virtual and Augmented Reality, green screen and LED screen technology (*Jungle Book*, *The Mandalorian*) and a rapidly expanding world of 'virtual production'. The digital camera revolution took around 15 years to get established, but it's clear that this revolution has arrived

DOI: 10.4324/9781003205753-14

at a far greater speed than previous shifts: "There will be people that hold out and say it will never be as good – just as we saw with the movement from silent to talkies and most recently from film to digital. But this technological advancement will mean that, in the not-too-distant future, film crews heading out to multiple locations with big basecamps taking up street space and having to deal with the limitations of a real-world environment, will be a rarer occurrence on a shooting schedule and one that most likely be met with a groan from the crew who have got accustomed to all the benefits of a single place of work" [3].

Standing back from the exciting fray, and due to a number of factors that rely tangentially on Moore's Law,[1] it is highly likely that virtual technology-based filmmaking and associated digital developments will evolve and advance every two years or so. But the really interesting factor here is that filmmakers (rather than ads, promos, music videos, et al.) are making the running in these new, ever-changing production shifts. "It's not a big leap to see filmmakers lean into more of these VR environments. With a little bit of imagination, it's easy to see how 60–80% of all TV shows and movies we watch (especially outdoor scenes, large rooms, or vistas through windows) will, in the very near future, actually be billions of digital triangles ('Nanites', as the folks at Unreal/Epic Games calls them) that make up these 3D worlds, and the majority of all productions will be studio based or at the very least one location that could double up for many different environments … as more productions embrace these models, it will be the overall cost savings that will pave the way for this way of shooting to become the dominant way of making movies" [3].

For those keen to follow the new digitally-driven upgrades, changes and developments, the annual Future Of Film reports [4] are a very useful guide and insight. In the 2021 report, the authors concluded with the following prescient recommendations:

The future of film will be a place where:

1. Filmmaking will be strengthened through increased **interdisciplinarity** – creative teams will bring together **diverse** worldviews, perspectives and multidisciplinary skillsets.
2. An increasing diversity of storytellers will realize the **commercial and creative opportunities of exploiting IP across a variety of platforms** – by adopting a "story first, format second" approach.
3. A **diverse range of virtual assets**, from a range of organizations from cultural heritage institutions to commercial production entities, will travel fluidly across medium boundaries and communities of practice.
4. Audiences will become **centralized** in all aspects of the creative process, **all** audience-types and demographics will be considered, accounted for and **included**. **Accessible communications and assets** (such as audio description and subtitles) will be standard in all productions.
5. The use of **audience data** will be **creatively and ethically** exploited. Streaming platforms will provide greater transparency about the behaviour of their viewership.
6. **Filmmakers will prioritize issues of sustainability, reducing their carbon footprint through the effective adoption of greener technologies, working practices and strategies. The environmental advantages of virtual and remote production will be researched, quantified and made known.**
7. Under-represented groups will be **actively recruited** into productions and funders will commission projects that reflect a **wider range of stories.**

8. A wide range of **training and mentoring programmes** will be deployed for marginalized voices and groups by both public and commercial organizations. This will continue to be complemented by **individual action.**

9. Virtual Production workflows will be developed and made **openly available** to broaden its adoption by a wider range of projects and budget levels, building **larger and more diverse communities of practice.**

10. Virtual Production tools and techniques will continue to develop **genuinely collaborative** space which brings talent together across the creative process.

The major changes for production and film crew (below)

Sound Stages: By mid-2021, Netflix alone was known to have more than 200 studio deals in place for its production commitments around the world, and rising. The cost to build larger 20k square foot stages is high, but there will be a significant amount of video backdrop stages at the 3k–7.5k square foot in demand.

Camera Team: More time will now be spent in pre-production "in vertical worlds mapping out camera angles and testing lenses just as they will look in the final movie. The 'camera department' will be focused to shooting scenes with talent; while cut aways and establishing shots will be covered in post. VFX teams that typically have worked in post, will now work alongside the director and DP in preproduction, setting up the physical shoot in principal photography. Pick-ups and reshoots will become much more accessible and cost-effective: 'Load up the background and we're ready to go'." [4]

Location Departments: Scouts will continue to be essential but will be driven by photo capture of the most appropriate interiors and exteriors, not the wider issues around room size for camera and lighting, hotel availability, crew parking, proximity of other locations etc. Once locations are approved, "a team with come in with a 'photogrammetry tech' team and spend a day or two capturing mega scans of the location and all the items in the room. No big crew. No massive transportation team. That location, forevermore, captured on a hard drive" [4].

Props: The props department, according to Janes, will be split in two. One part will focus on the traditional hand props – things that actors have to touch. The other will focus on the digital props, armed with licences for all the dressing props they can drop into the environment via digital libraries. Prop masters will become IP owners in their own right, just as locations will be able to license their library material to third-party filmmakers.

Actors: All cast members will start to be scanned at the beginning of each production. The scans will be used as back up for additional shots and coverage. The rise of video backdrops (replacing green screen) will enable actors to engage and interface with their environment instead of reacting to imaginary, yet to be created characters and objects as per green screen. Background artists (aside from those close to view) will drop away as they will be digitized. CGI actors are some way off as viewers are drawn by other humans … for now.

Hair and Make Up: High Definition changed the demands made on hair and make-up artists; and now Virtual Reality is going to shift further gears. The workflow processes in post between reality and VR needs to be seamless, and according to Janes, there will be "much more scrutiny over their work … actors faces are captured in greater detail and in

close up for every setup so that models can be perfectly replicated for additional footage if needed" [4].

Costume: All clothing will be scanned for future use, and costume buyers and rental outfits (such as Angels of London) will digitally capture all their inventory and license it out around the world. However, traditional costume will remain critical for leading roles, although that too will be scanned. Details, differences, ageing and authenticity will still matter, so top costume designers will want to scan from a range of sources rather than replicate one costume in multitudes.

Product Placement: There will be costs involved in building 360-degree environments, but with libraries growing in shot inventory, costs will start to come down when compared to VFX budgets. This, in turn, will assist a further rise in product placement, where brands, tourism, famous sites etc. will all have an interest in scanning their locations and products and making them available either for free or a licence fee.

Interview with Paul Brett, production/studio entrepreneur with The Studio Group and Flying Tiger Entertainment

Author

Paul, please tell us about what you've been working on in terms of production and studio space and how your business is evolving?

Paul

The first third of my career has been in marketing and distribution, the second third in film finance (during which time Brett Executive Produced *The King's Speech*, among numerous productions), and now for my third and hopefully final act, we're focusing on physical production and physical studio space. Since 2016, it's occurred to me that there literally isn't a country on the planet that couldn't benefit from some form of studio space because all governments see it as the future; as a very positive way to train youngsters; a provider of employment and a way to be at the heart of an industry that's going to grow throughout the rest of this century. We're seeing a geometric rise in production, and I think that that's here to stay for quite some time.

Author

Whilst everyone's very aware of the rise of streaming and the desire for content, just explain about what you've noticed regarding the demand for studio space and who is exactly driving that, because it's not just streaming platforms?

Paul

No, it isn't, it is the usual players: the major studios are all doing it, but the demand for programming is insatiable and it is coming from every quadrant, every quarter in the world. The growth is astronomical and the studios are rationalizing resources, so there'll be more mergers coming in the near future. However, there will still be the rich and the poor. There will be those who've got bottomless pockets that they can buy facilities and buy programming and resources, and there'll be those who are struggling to piece it together. It was ever thus, as it has been for the history of the moving image. However, the demand for the traditional studio that we think of, such as the 007 stage

at Pinewood, isn't so great. There'll always be a need for big stages to do big shots and big effects with a severely controlled environment, which is the whole point of studios, but there's also going to be a real move towards smaller stages, which are much, much more technically proficient. Many of you will have seen *The Mandalorian* and be aware that that was filmed not on actual foreign planets or on alien spacecraft, but on stages where those images were pre-shot and projected on a backdrop on giant LED screens, similar to the televisions that we're watching at home. It has many advantages. One, that space is reduced and space is a premium because you're paying per square meter per day, in many cases. Two, you can reduce costs and time involved, which are the same thing in the film industry. So, you can advance your post-production a great deal. Thirdly, and most importantly in a way and least recognised, is that the actors are actually acting within an environment rather than to a tennis ball or in front of a blue screen. They are within the alien spacecraft or on a foreign planet or wherever, so they can give a greater performance.

Author

Can you put this in context? Let's take the UK, for example, and the activities that studios and Netflix have been up to in terms of making sure they secure shooting space for near future. Give us a sense of context of how long some of these leases and deals are being done for?

Paul

Everything changed four years ago when Netflix and Disney did two deals with the same group. Pinewood and Shepperton operate as one unit and the management there deals with Netflix for Shepperton and Pinewood for Disney over a 10-year lease. So, they have guaranteed access to stages and this effectively knocked everyone else out, although with negotiation around and with the familial nature of the studios, there has been some license given here. This is because the studios and the streamers regard space that's tried and tested, and where talent feel comfortable, at a premium. Talent is familiar with shooting in certain places, notably the UK, Ireland and Eastern Europe, as well as, of course, Hollywood. America has been relatively slow in taking advantage. They have the home advantage of America being the home of Hollywood and the home of the film industry as we Westerners understand it, but they haven't tended to take this up and ensure their future. This has allowed China, India, and others to rise up.

Author

Paul, whereabouts do you see the interesting new areas and new territories to look at in terms of expanding production capacity, and how do you match production build with talent pools and servicing?

Paul

It's the most important question there is, and one can be incredibly geographically specific. So, if we go back 50 years in the UK, there were two places to film and that was Hollywood and London. In London, we really referred to Pinewood and Shepperton, and that really has become the hub. So, the crew live around there, the epicentre being Beaconsfield, where I used to have an office, and the aspiration was to live there and commute a few miles to the office, to Pinewood or Shepperton. Now that still holds true, and we will see developments in Enfield and the growth of Elstree and other areas within the M25.

Now, the Mayor of London and the Prime Minister both agree that they'd like to see East London as a hub. So, there's been talk of Dagenham/Barking … so the whole of the East from the Thames estuary northwards will develop, and there will be studios sited in the south, around Guildford and the A3 and so on, all around the M25 orbital.

Any new studio facility in developing and emerging countries, by contrast, is going to want to have a film academy to train not only directors and cinematographers, but also grips and sparks and all the people that will be necessary in order to get films made and to build a television industry. This is a global requirement: You can build a studio literally anywhere as long as you build facilities to train the crew. You can fly everyone in, but you actually want have as much local crew as possible to reduce your costs and improve efficiency. I think that the known hubs, such as the UK, will continue to grow; Ireland will grow very strongly; Eastern Europe will grow very strongly and we'll see individual hubs appear in, for instance, in India. So, it won't just be Mumbai, but the industry in Chennai is going to grow, the industry in Bengal will grow and there's an incipient industry in Bangladesh, for instance, that will grow. You can apply this virtually anywhere. KFTV (Kemps directory) is a very useful source for learning where to film, where the best incentives are and the best facilities.

Author

What might interrupt the current rising level of demand? Is this huge production gold rush going to remain steady or is there going to be a certain amount of tailing-off?

Paul

I can't see the amount of audio-visual material ever diminishing because essentially, it's free. Everybody has access to a mobile phone and is able to literally record what they're looking at and post it and share it. The entry point is very, very low. When I started in the business you had an entry point that was quite high because you had to assemble a crew and produce things in a certain way. Then various new waves, most famously in France but elsewhere too, showed that you could capture the punk spirit. This is very much associated with the 50s, 60s and 70s of the last century, but this has grown. Yes, there'll be mergers and so forth, but as an example, we talk regularly with Comcast and they have 11 divisions that commission material, the most famous ones being Universal Studios, Focus Features, NBC, Peacock, Sky and so forth. So that's five of them, but in addition to that, they have divisions that oversee the production for other sources, including Netflix and Apple, who are their rivals in the streaming environment. So that's just one example, but when you add HBO/Warners/Discovery, that's another conglomerate, Disney/Pixar/Lucas, another. These vast corporations have a number of gatekeepers and commissioners who are looking to make and distribute material. So, it isn't true that the number of places you can go to get entertainment made is diminishing, it's just a question of it getting more complicated as to know where to go. Again, 30 years ago, one would just have in a little black book a few key names. The churn, the level of turnover of stuff famously at Netflix, is so great that it's very much an inside job to keep track of where to go to get the funding for projects. Always has been, always will be.

Author

If you're an emerging producer and you're working in the independent feature film sector, it's going to become harder and harder to be able to get the right level of appropriate space going forwards. We're talking about a very dominant top-down industry here, where you've got what I call 'super producers' servicing conglomerates who are basically

'monsters in need of a feed'. How does an emerging producer, or even an established smaller producer, navigate and negotiate in terms of space? What would you suggest?

Paul

Again, it's ever thus. It's who you know and how you operate. It's always been a mantra of mine: absolutely any project can be made. It doesn't matter how esoteric, how arthouse, how independent, how seemingly microscopic its audience is, as long as the budget is right. So, it's a question of taking your idea and making it as close to your vision and to make it as artfully, as truthfully and appealingly as you can and doing it on a very low budget. So, if you can maintain that, and those rules hold true, whether you're making your first low budget independent feature, or you're making a sequel in one of the biggest franchises of all time. You have to look at your audience and work out how they're going to watch it. Will it be in the cinema? Will it be on the television? Will it be on their computers, iPads, smartphones even? Judge and cut the cloth accordingly. It applies to sequels even more than it does to your independent feature, because your first feature, you're just getting it made. The late, great Nik Powell [former joint MD of Palace Pictures and head of the NFTS] said that the Hollywood studios would never green light a film unless they knew the release date and how it was being distributed. Was it a Christmas release? Was it a summer release? The British and other Europeans just wanted to get it made. When you had the money to get the cameras rolling, you'd shoot the film and then look at it in a screening room in Soho and go: "Ah, now how on earth are we going to get an audience?" That's when that process would start. Nowadays, you're having to think of your audience, and how you want your content to be watched. I really believe it's the most crucial thing for emerging talent: be resourceful about how you use space. For example, by using photographic galleries where people would do photo shoots and adapting that for purpose is going to be a real skillset to have. Being resourceful about your location shoots and flexibility will be key.

Author

Can you discuss virtual production and how you see advancements playing a role in the next 10 years of film production? Will it be the so-called cost saver that some people propagate?

Paul

There are two answers to that. Technology will grow. I'm old enough to remember black and white being 405 lines and then 625 came in for colour. Now you have 2K, 4K, 6K, 8K, and the technology and the clarity and the depth of field for these screens will continue to grow for the foreseeable future and the costs will be reduced. So again, you will cut your cloth accordingly. For instance, if you're shooting something that needs to be distributed by Netflix, you have to have a minimum of 4K. That's the acceptable level. That will change and that will go up fairly soon and you have to be able to meet that accordingly. So, therefore, if you're just hoping to shoot film and show it to your friends in a village hall, you could do that on the equivalent of a Super 8 or the video that's on your telephone. That will increase too.

As you start with your career, you will be using cheap facilities and will just try to just get the project made. That will improve and the resources that are available to you will grow. It's very difficult to see with a crystal ball how the technology will change beyond that other than a gradual growth in improvement of the finished image and a reduction of costs according to Moore's Law. So, it's a question of keeping your integrity intact,

but also looking and keeping an eye on the technical aspects of production so that you're aware of what you can do in order to make your finished film as valuable as possible and as high a quality as you want, because it's in your own best interest and your chances of getting it seen by as many people as possible, which is, after all, why we're in this business.

Author

One of the interesting models that some production companies developed, certainly in the 1990s and 2000s, was via the control of the means of production. Look at Zentropa in Denmark, who decided to buy up an old army camp, and then build a post-production facility house that allowed them to have quite a lot of control over not only their own productions, but to build a business model via post with third-party producers and productions. That was just one micro example of a production company learning how to grow by having access to a different part of the production value chain. Do you see that there are opportunities for entrepreneurs here in this space going forward, where people could start to raise money for developing facilities like this?

Paul

Precisely. Just as the rise of the camera and the rise of the digital economy allowed everyone to become an auteur, the demand for the facilities will allow everybody to become a studio chief, so that you can own the facility and make an income by letting it out and by facilitating other filmmakers. This could be where you'd find similar kindred spirits. This is a team game. You can't do anything on your own. You might get to build a team in order to make a film or a television program, but you could also use the same modus operandi building a team in order to produce the actual facility to make numerous films. It's rather like "you can feed a man for a day by giving him fish, or you can teach that person to fish and they can feed themselves for life". I would put it to you to do a business plan to build a facility so that multiple films, television series and streaming programs can be made out of one place, which would be the same as the business plan to produce a single feature film.

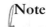

Note

1 Moore's Law dictates that gains from experience in production (for example) will double every two years or so.

References

[1] James, R., *The Startup*, 22/05/2020.
[2] Cranston, B. (Walter White), *Breaking Bad*, 2008–2013.
[3] James, R., *The Great Film Production Renaissance: Are You Ready?* 22/05/2020.
[4] Stolz, A., Atkinson, S. and Kennedy, H. W., *Future of Film Report*, 2021.

Part II
Users and the changing digital market

14 Users, changing behaviour and market knowledge

No picture can be considered a success unless it appeals to the matinee trade. When you've got a picture women want to see, the men will have to go along. But a woman can always keep a man away from a picture than only attracts him.

(Irving Thalberg)

The images come first, and with images, like music, the primary reaction is emotional...

(Richard Brooks, director, *In Cold Blood*)

Time, space and the marketplace

When examining the overall operating environment that media exists within, time and space are key defining factors. Together they are defined by the term 'marginal utility' in business school speak. Time is fixed, as there are only 24 hours a day available within which the public can select and consume product, or simply spend time doing an activity that does not involve the purchase of any product or monetary outlay. One of the economic variants that media analysts focus on is how cultures and economies vary from territory to territory, and within different sociological demographic groups. What do we do all day, and all night? Where are we? Where are our eyes focussed? Specifically, people and communities that spend relatively less time working in turn create more available leisure time. So it was no surprise that the Coronavirus pandemic witnessed a huge surge in online entertainment, from Netflix to ninja gamers. Higher levels of working hours, by contrast, are assumed to create less leisure time. By calculating the marginal utility of leisure versus marginal cost of foregone income from working, market analysts can take an initial step towards understanding media market parameters.

The next issue to consider is the heavy competition within the available leisure place. Films are launched into an intensely competitive marketplace. As a cost-per-unit, studio films, for example, are one of the most expensive media in the world to produce and to market to the audience.[1] And yet, of the 51 hours per week each American adult spends on leisure, movies and video take up less than 2 per cent of that time.

Building on the areas covered in Chapter 11 on exhibition, film destined for a theatrical release presents certain distinct challenges in itself. Unlike other consumer

DOI: 10.4324/9781003205753-16

products, which can be tested in limited markets and then refined and repositioned before full theatrical launch, films are not able to be relaunched (with certain extraordinary or outstanding back-catalogue exceptions).[2] In the USA and leading international territories, every weekend is an 'opening' weekend, with new pictures facing competition from existing ones and new rivals, allowing audiences a relatively wide choice of what they can choose to see on any given weekend, albeit limited by the homogeneity of Hollywood-style 'opening' fare.

Successful commercial results depend on a studio or major film's launch during this all-important opening weekend. By contrast, smaller independent films generally struggle to find appropriate screens and cinemas, and rely on critics, press coverage and, crucially, the key common success factor, word of mouth. For both sectors, the theatrical release affects all other revenue streams and ancillary markets.

What elements help attract a given audience to a film? Key motivators for the audience to buy a cinema ticket include:

- the awareness/visibility of the film
- the 'want to see'/level of desire/aspiration
- word of mouth (personal recommendation from peers)
- digital word of mouth (social networking, Internet forums/message boards and Twitter, for example).

The corresponding challenges presented to the industry include:

- an effort to meet end-user demand and appetite
- expanding and heightening the overall cinemagoing experience
- demand for detailed audience research, and trends in leisure time
- an upward pressure on film production and marketing costs.

Market research

- Given the above factors, market research is therefore of critical use to both studios and independent film distributors and producers. It can provide information on: a) the market before the film is released; and b) the outcome once an audience has seen the film.

Marketability

- This provides information about consumers that enables creative, advertising and marketing materials to be planned and executed to maximum effect. What and why is the audience attracted to (ultimately why would they buy a ticket)? How can this be optimized? How can the research be utilized to maximum effect?

Playability

- This concentrates on consumer feedback specifically focused on how a film satisfies (or otherwise) its audience, and the likelihood of broad word of mouth and playability that can be gauged through both initial test screenings but also in exit polls.

- The key methodological tools available include qualitative research and quantitative methods. Qualitative research can be used for early-stage concept/creative development work and to explore how best to position the film, as well as to get a deeper understanding of trends in the marketplace.

Quantitative research can provide information on how strong, effective and persuasive the materials may be. Materials in question normally include trailers, TV commercial adverts and posters. Other quantitative research will focus on competitive testing and tracking studies. One of the key tools that can be used to determine both playability and marketability are recruited audience screenings. The intention is to replicate as closely as possible the cinemagoer's typical experience. These screenings are deliberately held in regular cinemas at regular times of the day; in suburban or provincial locations – in an effort to avoid heavily urban audiences, which have a higher percentage of 'avids' and cinephiles. The market research aspect of the screening is not revealed until after the film.

Audiences are selected according to demographics, films seen and their interest in the film concept being presented to them. Examples of perceived target audiences may be fans of the main stars or cast, genre fans, older females, franchise followers, younger teens, highbrow audiences etc.

Test screenings normally fall into two key categories:

- Production screenings – sometimes a smaller audience, often more qualitative in nature, with more focus on the story, editing and elements that can still be refined.
- Marketing screenings – always a larger sample size (in other words conducted in large auditoriums) aimed at assessing overall appeal and across demographics, key strengths to build and focus on, and potential for word of mouth.
- A vital lead finding tops the market screening process: How does the film play to an audience of cinemagoers interested in seeing that sort of film? Once that is established, the next key finding is whether the film has the potential to break out beyond that audience into a broader audience. It will only achieve that wider result if word of mouth is likely to take place. What will people say about the film? How will they describe the film? Will they recommend it, and how strongly? Word of mouth is one of the most important market phenomena that cannot be bought, no matter how much money is spent on a film's budget or its marketing launch. Strong test screening results are not a guarantee of box office success – they simply serve as a guide to the 'playability' of the film. A large number of other factors are all brought to bear on how a film performs when it is released.
- Other market research tools include *opening weekend exit surveys*. These provide information on who went to see the movie; the audience's satisfaction and hence the film's potential for strong word of mouth; key media draws – what worked, what didn't; and how the film might play in later ancillary markets. Studios tend to use opening weekend exit surveys, combined with box office takings, to strategize their marketing and advertising strategy for the remaining length of the theatrical release, and to refine the DVD release.
- *Tracking* films prior to their release is a market research tool used extensively by the studios. Tracking occurs on an ongoing basis, with data and reports being sent out to studios/distributors at regular intervals throughout the week. This kind of information helps to establish the level of interest and awareness in a film about

to be released, in release or some weeks/months prior to its release. Tracking information helps studios and distributors to strategize their release dates; their advertising spend (aka 'media buys'), theatre bookings and overall allocation of marketing budget and spend.

Understanding cinema audiences and consumer behaviour

The blockbuster approach

Each year the Hollywood Studios release around five titles that are intended to become *event movies*. Event movies are also known in the business as *'tent-pole'* films, around which the studio's other pictures are slotted. They are high-budget films (now sometimes more than $200m in budget size), and are produced by studios with the intention of becoming mass-appeal vehicles with 360 per cent business models. They are supported by huge marketing spend and intense strategic planning.

Examples from the past decade include the following kinds of hit films or major franchises: *Lord of the Rings*, *Harry Potter*, a Pixar film, a Batman film, a Bond film, a Jerry Bruckheimer production etc. And Summit Entertainment's Twilight franchise proves that it is not just the big six that can create such commercial franchises. The studio's demographic target for event movies focuses initially on the 16–24-year-old market, and then it strategically attempts to broaden out to a wider audience. Parental Guidance and PG-13 films, for example, accounted for 85 per cent of the 2006 top 20 movies in the USA.[3] Today's market dictates that the anticipated box office needs to exceed $200m at the domestic box office in order to join this club – a considerable inflation on the equivalent $100m plus entry-ticket during the 1990s.

When we consider that of the $9.49bn taken at the US box office in 2006, that year's five leading movies grossed collectively $1.338bn (when some 607 films were released),[3] it is clear that the drive to achieve mega-hits is intense. The same pressure applies to the world market, which reached a box office all-time high in 2006 with $25.82bn. Just five films grossed collectively $2.237bn – almost 10 per cent of the worldwide total box office.[4]

The industry has applied the traditional 20/80 model (where 20 per cent of goods take 80 per cent of the market) to theatrical box office take. Known as 'Murphy's law', after the celebrated *Variety* statistical journalist Art Murphy, it states that 20 per cent of the films released in any given year take 80 per cent of the box office. However, given the above domestic and worldwide statistics, the trend has become polarized to the extreme.[5]

The independent approach

Bringing an independent film into the marketplace is now arguably a harder task than finding the finance and resources to produce and complete it. The traditional system for distributing independent films has been in a critical condition for the past decade; although certain industry professionals are confident that as traditional distribution paths have become more dangerous, promising new ones are opening up.

Peter Broderick, an independent film business consultant, argues:

> As the costs of marketing and distribution rose, studios increased their dominance over theatrical distribution. Distribution advances paid to distribute independent

films declined, along with the willingness of distributors to take risks on independent features without stars or other pre-sold elements. When such films found distribution, their fate was often determined by the size of the audience in their first weekend in the theatres. Unless a substantial crowd appeared, their theatrical life was usually short, undercutting their ancillary possibilities. While every year a handful of independent features succeed in distribution, these are aberrations that belie the fate of the hundreds of films that find little or no distribution.[6]

Independent moviegoing audiences present a host of different challenges compared to the Studio roll-out of tent-pole and larger budget film releases. The standard target audience for independent films is normally 30-plus, although students (18–25) present an important demographic for specialist films. University towns, for example, provide strong opportunities for target programming aimed at students. One of the best US examples includes Boston/Cambridge (with Boston University, MIT and Harvard within the catchment area).

The 30-plus audiences are generally harder to reach through advertising and marketing and, crucially, have considerably less leisure time available. Typical barriers to theatregoing for this age group include having young children, both partners working, one or both working later hours, the prohibitive cost of childcare etc. Unlike studio mainstream releases, independent films are not just competing with other leisure activities per se, but are competing against major lifestyle barriers to physically attending the cinema.

On the one hand the above barriers only go to serve the importance of market research, including production and marketing test screenings, even more strongly. On the other hand, many independent films are made at a fraction of the cost of studio tent-poles, leaving little funding available for this kind of test at the production stage.

Specialist independent distributors also tend to be working to a different economy of scale; hence their marketing research tends to be centred on festival screenings, inherited marketing information and materials from the sales company they acquired the film from, and their experience and gut instinct. Detailed market research is a luxury this sector rarely can afford.[7]

Segmentation analysis: how does the cinema industry (e.g. theatrical) deal with different audiences?

Classification exists in nearly all territories, and generally tends to rely on an age-related scheme, which awards film certification. The categories set by the British Board Film Classification (BBFC) in the United Kingdom, for example, are shown in Table 14.1.

The classification categories roughly translate to the following four audience groups:

- children (5–12 years old)
- family groups
- teenagers/young couples/students adults.

The above categories are broad, and the industry has attempted to define them more closely. The All Industry Marketing Committee, AIM,[8] has categorized audiences into two groups: by 'lifestyle' and by 'attitude' (Table 14.2).

Table 14.1 Classification ratings

U	Suitable for all children below 12
PG	Parental Guidance – some scenes need adult to be present
12 and 12a	Suitable for 12 years and older
15	Suitable for 15 years and older
18	Adults only
R18	Restricted to licensed cinemas and sex shops

Source: British Board Film Classification

Table 14.2 All-Industry Marketing Committee's categories for audiences

AIM's *lifestyle* categories include:
- teens (to 16 years of age)
- teens/singles/couples (to 25 years of age)
- young families
- older families.

AIM's *attitude* categories are:
- film enthusiasts/avids
- social ('if nothing else to do…')
- reluctant
- non-attenders.

Source: All-Industry Marketing Committee

The AIM is also concerned with the physical difference between urban and rural barriers to cinema attendance. Urban theatres tend to be within easy reach; offer a wide choice of films and screens, and offer a range of other entertainment activities either pre or post the film at close hand; but a trip will still demand a babysitter for a family with young children. Rurally located theatres require the audience to travel – normally by car – to reach the cinema; may not run a multiplex or multiple-screen cinema, therefore limiting choice; will need to provide or offer food nearby to help attract customers; and shares the baby sitting issue with urban screens.

Cinemas face a considerable challenge in expanding their audience base. Some of the tools they use include the effort, over the past decade, to make them places for social meetings and activity beyond just screening films; offering regulars family tickets, loyalty cards, and subscription schemes; and promoting lifestyle combinations such as attached clubs and restaurants.

Establishing a theatre's catchment area

One way of understanding the challenge facing cinema operators is to consider what a cinema manager or exhibition site developer needs to consider when building a site. The industry as a whole tends to focus on the success or otherwise of film product, but the physical and sociological culture surrounding where and how the audience sees films is vital to understanding the market as a whole.

The numbers of screens per person – known as 'screen supply' – is a key starting point for any exhibitor. Currently, there are nearly 19,000 people per screen in the

United Kingdom; down from 1995 when there were nearly 30,000 people per screen. When compared to the USA, which is supplied at approximately 7,500 people per screen, the United Kingdom has a strategically steady ratio, whereas the USA is significantly over-screened.

The planning of a cinema development involves estimating the catchment area that the new enterprise will serve, and from which it attracts customers. Associated issues include the drive time boundary (most people use cars outside major cities, and often inside urban areas); including travel radius; quality of roads, and utility and time of public transport.

The key factors to consider re strategy and position of a theatre include:

- scale of the cinema (10–20 screen multiplex? Two-screen independent?)
- scale and number of competitors
- quality and range of other leisure activities
- scale and quality of public transport services
- car parking facilities
- age and lifestyle profile of the target audience
- surrounding geography (are there many smaller villages/towns; or is the cinema really remote, e.g. in an isolated town not surrounded by population clusters)
- future town planning and upcoming changes in surrounding population need to be checked. All of the above requires research, projections and a clear screening strategy.

Demographic and lifestyle data (United Kingdom)

There are a range of sources where data are available. These include: local authorities; national statistics; commercial companies (Experian etc.); and CACI Ltd. CACI Ltd runs ACORN – a geo-demographic system that classifies neighbourhoods into descending subsections of statistics, including, for example, 6 categories, 17 groups, 54 types etc. Each category includes patterns of consumer, economic and lifestyle behaviour. Additional sources of information include Mintel, British Market Research Bureau (which works for the UK cinema advertising industry), the BFI, whose website has a wide range of information and research, and the Arts Council.

All the above information can be analysed and adapted to understand audience patterns, which in turn can be used strategically to establish a site and target audience for a cinema. There are certain limitations to the impact of this kind of demographic research. Individual films can vary widely re their attraction to different audience types. Specialist audiences have very different profiles when compared to multiplexers. They tend to have higher education qualifications and work in professional careers. Teen audiences rarely attend specialist film screenings.

Audience development

Much has been written about the importance of the cinemagoing experience: the size and scale of faces larger than life; spectacles that do not exist in real life but take extraordinary form on the big screen; the emotional, visual, listening senses all stimulated in a dark auditorium surrounded by other people. The 'shared experience' of the

cinema theatre has been likened to the telling of stories around camp fires way back before the days of mass media and global communication technology.

Two key elements will drive audience development. The first driver still relies on the quality of the product. But quality does not necessarily mean large, big budget films packed with stars; or the third or so film in a proven franchise that historically took huge numbers in its opening weekends but is now tired despite being previously tested. The 20/80 law dictates that many blockbuster films fail to recoup their overall production and marketing spend even at the end of their full ancillary run. Break-out specialist films, in particular those that cross over from a niche audience to a wider appeal, can be highly popular and profitable.

The second driver is the inexorable advance of technology. Digital distribution, digital sound, picture quality and general viewing conditions are under constant development. Given that the theatrical experience is entirely different to watching a film at home, developments to enhance the cinemagoing experience are critical to its sustainability. The selection process and physical commitment are different; and the power of being able to do other things at the same time as semi-watch a film – turn off, pause, and start again – are not part of the cinemagoing experience.

Mass broadband penetration is driving change throughout all media industries. In the entertainment sector, video-on-demand, downloading to own, net and cell phone marketing, blogging, video uploading etc., are all helping drive significant change. These new delivery and information platforms are, in turn, making new demands on audience research experts, as explored in the following chapters on streaming and Netflix.

Market access to China: Bridging The Dragon

> Working with the Chinese is like going into a drinking competition. They will challenge you to the last minute! You don't want to be the first to crash to the floor. You have to be sitting at the table until the end…
> Cristiano Bortone, producer, founder and CEO of Bridging The Dragon

Established in 2013, Bridging The Dragon has firmly established itself as the leading association supporting European and Chinese collaboration. With an array of powerful partners, including the Cannes and Berlin Film Markets, the highly active operation has held annual Project Labs, held a range of conferences and recently established a branch promoting the trade to China of European copyrights, remake rights etc. Any producer or executive keen to understand the constantly changing Chinese market could do no better than become close to Bridging The Dragon.

Founder Cristiano Bortone, an experienced film producer, director and dealmaker, began his close relationship with China back in 2008, when his film *Red Like The Sky* reached China and became one of the European films most appreciated by the local film community. He was invited to teach at the Beijing Film Academy and attend and talk about a range of mainland festivals and educational institutions, going on to establish his own production company Yiyi Pictures. As the Chinese film industry started its exponential rise and the market shifted gears, Bortone, together with a group of European film producers, saw an opportunity to establish a non-profit association aimed at filling the knowledge and networking gap between European and Chinese filmmakers. "Up until that point China had focused almost exclusively on Hollywood, thinking that that's

where the money is made. So there was huge potential and we could see a real development opportunity down the line, but also serious challenges", recalls Bortone.

The European challenge

The main challenge was how to "create a club, a circle of people given that what was missing was real knowledge exchange between European and Chinese filmmakers: Who are they? Are they reliable? Are they crooks? Many film professionals in China often had just one or two years of experience. So, my intuition was to create a place where everyone could eat, drink, and create plans, but under the scrutiny, due diligence and guidance of a professional association. We live in the age of the 'network' and Bridging The Dragon was designed to meet that need, igniting sparks and collaboration."

What Bortone had observed on the European side was the range of obstacles that faced individual producers and companies trying to engage and gain access to the giant Chinese market: "So many Europeans tried to create a key to the Chinese, but they were just scratching the surface." Meanwhile, European governments send national delegation after delegation, all keen to co-produce and gain access to the perception of new money. The problem, according to Bortone, was one of access and attention. Small individual territories were finding it hard to penetrate the sheer scale of the Chinese population and institutions. So, it made sense for a professional association to "act as an umbrella: leading, driving and unifying filmmakers' experiences, knowledge and building up a meaningful network". It also enabled the sharing of resources, stories and case studies – elements of tangible value to the Chinese members given the immaturity of their market and the cultural tendency to guard information rather than share with transparency. By contrast, Bortone felt that the best way to build a community was by being "very inclusive and building an economy around sharing. We don't want any walls."

The Project Lab strategy

By maximizing the association's Berlin base, and working closely with the Berlin Film Festival, Bridging The Dragon used the one of the highest-profile festivals to help attract and house its main strategic offering: The Sino-European Project Lab. Designed around the selection of eight projects from Europe and eight from China, the immersive workshop started by focusing on projects and filmmakers who offered the best chance for collaboration. The potential for successful co-production formed a key element of the selection criteria. However, rather than managing a prescriptive, points-driven selection process, Bortone favors a much more open style. "Europe and China are still at the pioneering phase of their relationship. The critical mass of production knowledge isn't big enough yet, so we need avoid building fences and be open minded about everything. So, we don't have budget or genre restrictions. We accept projects in animation, fiction, television, and sometimes even high-end documentaries. What's most important is the reality test: does this project have a real commercial potential to be made and reach the market? Or otherwise, can this project be a case study for the participants and express the dos and don'ts when trying to make a film with China? As a matter of fact, the Lab is becoming more and more an immersive think tank to help grow the deeper understanding of a specialized film community." Complementing the European–China Project Lab strategy, Bridging The Dragon has also developed a Sino-International offering, bringing together 25 international producers from all over the world to meet their Chinese counterparts during the Cannes Film Festival. Most recently, the association has also launched a Professional Talents operation, acting as an unofficial agent to promote the sales of European finished films, remake rights, services and even heads of departments to work on mainland productions and help up-skill Chinese crew and heads.

"We have had always constant requests from our Chinese members to acquire certain rights or expertise from the rich European landscape. Our cultural history is so rich and diversified. So, at some point we decided to structure this offer", explains Bortone. "Again we are not in competition with any existing entity such as agents or sales representatives. We rather help them navigate better in a complicated territory and get the best for their clients. In China there is a hyper-demand for story, services and quality talent, given the immaturity yet sudden growth of the market. It's also important to realize that working in China can be very expensive, as with growth comes inflation and an escalation of pricing. It is understandable that the Director of Photography off a recent big hit would become much more expensive on a next movie."

Bortone is also sensitive to the more recent downturn in the market, with mainland film producers and studios facing a financing crunch when funding projects and slates. The government's crackdown on celebrities, the increasing censorship and propaganda, the trade war with US and the effects of the COVID-19 pandemic, generated all together a perfect storm which is hitting the local entertainment market. However, he takes a longer-term view of the current market tensions: "China's 5,000 year history shows us that the country has constant cycles, a little bit like the two waves of the Yin and the Yang. In the last decade we've seen the overall market open up in an incredible way, with lots of freedom and the encouragement to make money. Now we are going into a downturn but we cannot forget that China still has a huge population which will be always looking for wonderful stories and curious of something diverse. I think that eventually the market will open up again. We still have a lot ahead of us in terms of merging our cultures and business."

The different business culture

Having worked for more than a decade closely with the Chinese, Bortone offers some interesting perspectives on the vastly differing cultures that have a direct impact on the way business is undertaken between the West and the mainland. "The key challenge is not language, although there's clearly a complex relationship between different cultures and their specific language. The real challenge is about character and the assumptions that come with that character. The Chinese culture is still deeply rooted in rural aspects, where somehow people make deals around a table, drinking rice wine, building trust thorough a personal bond. This is not cold and legalistic, in a way Anglo Saxon law is applied to business agreements and contracts."

"I am always fascinated by languages and how they express (or influence) the nature of a community. Take German, for example: it is logical, specific, almost scientific. English offers short, tight syntax which fits well with capitalism, business and fast deal making. On the other side, Chinese language is based on tens of thousands of pictograms. They hold a visual and poetic meaning. But the grammar through which they are assembled is very basic and therefore open to interpretation through an extremely complex set of cultural understandings. This has an impact on commercial or legal documents. The context of any agreement is often key, making formal communication often confusing and very different to our European straightforward approach. No wonder there is so much confusion!"

According to Bortone's view, in China an agreement is the start of a relationship. A contract is seen as part of an ongoing re-negotiation that often stops only at the conclusion of the business. But what is fascinating – for who can adjust to that – is that there is a strong cultural driver towards a search for a 'win–win' result. "This approach drives Europeans crazy. They see their Chinese counterparts as unreliable, but they miss the key point: the pond over there is so huge that they keep looking for better options even when you think it's all over. At the end of the day the Chinese are trying to find a way to get the best both parties can get."

References

[1] The average cost to make and market a major MPAA member company film was $100.3m in 2006. This includes $65.8m in negative costs and $34.5m in marketing costs. Source: MPAA Research and Statistics 2007/08. The MPAA has stopped giving out such information, perhaps guided by its studio membership and their desire to keep back competitive data from competitors, including now streaming platforms.

[2] A studio executive who has experimented actively on re-launching specific titles is Harvey Weinstein, former co-chair of The Weinstein Company and now in prison. Two notable examples include *Into the West* (1992) and *Confessions of a Dangerous Mind* (2004). However, it should be noted that the reasons behind such action may have been connected to keeping talent satisfied and beholden to Weinstein as much as any potential commercial gain.

[3] MPA, March 2007. Worldwide Market Research and Analysis. The top five films were: *Pirates of the Caribbean: Dead Man's Chest* ($423m); *Cars* ($244m); *X-Men: The Last Stand* ($234m); *Night at the Museum* ($219m); *The Da Vinci Code* ($218m).

[4] MPA/Variety April 2007. The top five films were: *Pirates of the Caribbean: Dead Man's Chest* ($642m); *The Da Vinci Code* ($540m); *Ice Age: The Meltdown* ($452m); *Casino Royale* ($339m); *Mission Impossible III* ($264m).

[5] For an in-depth analysis of global cinemagoing trends, see Charles Acland, *Screen Traffic, Movies, Multiplexes and Global Culture*, Durham, NC: Duke University Press, 2003. Acland examines the ways in which the post-1986 US commercial film business altered prevailing and audience conceptions of moviegoing. Specifically, Acland demonstrates how the film industry's reliance on ancillary media markets has cultivated a global landscape of cross-marketed media commodities and led to the development of what he calls the megaplex cinema – a space of 'total entertainment' which focuses on 'up scaling, comfort, courteousness, cleanliness ... and prestige'.

[6] P. Broderick, 'Maximising Distribution', *DGA Magazine*, January 2004. Broderick runs a Los Angeles-based consultancy and specializes in the independent production and distribution business. (Website: www.peterbroderick.com)

[7] For more detailed examination of the marketing and distribution issues facing independent film, see Chapter 15

[8] The All-Industry Marketing Committee was established in 1984.

15 Marketing
From traditional to digital

> Entertainment marketing doesn't get enough attention ... and digital marketing
> is where all the momentum is these days.
> (Andrew Wallenstein, President and Chief Media Analyst, VIP, Variety [1])
>
> Don't outspend your revenues, but don't underspend your potential.
> (Rob Friedman, co-chairman of Lionsgate Motion Picture Group)

The scope of feature film marketing

Historically, early films in the first part of the 20th century were driven by publicity generated around stars, normally while a film was being shot. The two key marketable elements were stars and the picture title, and every effort was made by the studios to get those names and titles into the press. Later, the long release patterns – sometimes months – of the 1960s and 1970s allowed film titles to build a following (via word of mouth) without the urgent pressures of a "make-or-break" opening weekend.

Towards the close of the 20th century, given the competitive pressures of the entertainment mass market discussed in the previous chapter, marketing started to present an all-encompassing and ever-present challenge at every stage, starting with a film's inception and all the way along its journey through the value chain towards finding (and building) an audience. Marketing in the film business has historically suffered from a tendency to be approached and viewed from a tightly drawn and narrow perspective, and looked down upon by the creative community at their peril. The standard, traditional assumption is that marketing stands for a set of elements created and executed by a department at a certain stage of a film's life – most often restricted to the theatrical release. That silo mentality is finally shifting, with huge time, energy and resources being spent on digital opportunities, social media and a growing understanding of films requiring "event management" skills to stand out from the ever-crowded entertainment market.

Whilst later sections of this chapter will focus on the strategies and tools specific to film product, many of the issues and techniques are relevant to wider business strategies. Issues of how to sell, place, brand and differentiate a product should start all the way back at the inception of an idea. These challenges might, for example, include the initiation of a company; the start of a brand; the impetus behind a filmmaking team; the placing of a product by a sales company into the international distribution market; and the positioning of all associated media materials and spend, not just at

DOI: 10.4324/9781003205753-17

the theatrical stage, but during the video/net download, pay-TV, free-TV and even library re-packaging stage. And certain films will demand associated merchandising and/or music spin-offs that all help create awareness of the product. In summary, marketing is a key and ever-present element of any strategy concerning the film exploitation process.

Defining the role of marketing

How can we best define marketing as it mainly relates to the film business? [1] Marketing offers a range of communication tools and strategies that connect product with buyers (aka distributors) and audiences. Each film is different, and hence each film requires a different specific marketing strategy. The initial starting point – such as a book, short story or newspaper article – can often offer or suggest a critical concept that can then be refined and built around. If a screenplay is based on an original idea rather than on source material, it may still have a key defining element that can be used as a marketing 'hook'.

The specific *genre* of a film – if it definitely fits into one – is a strong starting point. Concepts that communicate clearly and simply what a film is about – meaning the *type* of film the audience can expect to see – are enshrined in a key photographic image, a logline, a title, a poster, a teaser trailer, a trailer, and so on. Sometimes they are further reinforced by the association of a certain actor or actress promising a certain kind of experience: think Sandra Bullock in a female lead comedy in the 1990s/2000s; or Jason Statham in an action-thriller. But, most often, defining concepts are there to be found in the source material, but they can sometimes be in danger of being over-looked if the filmmaking process has typically become divided and disjointed between departments or different companies.

In particular, the film's director may well wrestle with the idea of his/her 'baby' being micro-analysed and boxed into a one-sentence log line, let alone a one-word genre descriptor. "But my film is far more complex ... there's more to it than that ... I don't feel comfortable with this one-dimensional, superficial approach", are all responses I have heard numerous times. This is before we've even got to the stills selection, the poster options ... and, god forbid, the trailer! It is the producer's job to help manage, steer and communicate the director towards drinking from the freshest well and understand that in the hands of first-class marketing talent, their film has the best chance of reaching their intended audience.

Each element of the creative package, including the director, the writer(s), the lead cast (and sometimes even departments such as photography or music), presents important marketing opportunities. Naturally, leading movie stars bring a different set of hooks, awareness (and pressures of expectation) in contrast to unknown leads – but the impact of festival and prize-giving awards and press 'discoveries' should offer significant opportunities to capitalize on.

Marketing plans and successful execution sometimes fail due to poor internal communication between the filmmaking team, financiers and distributor(s). It is essential for producers, executives and specialist marketers to agree on a plan, and organize meetings so that ideas are properly explored and examples are circulated in a timely manner. Communicating to a buyer further up the value chain or to the audience end user effectively requires excellent communication between the originators and exploiters of the product.

A marketing plan will be mapped out over a timeline, but its strategic utility is how effectively it gauges opportunities and entry points into targeted and specific areas of the overall market. These are known as 'platforms' (not to be confused with 'platform releases') and by breaking down the overall market into different segments, the shape and scope of a plan can become apparent, and weaknesses addressed before the wrong message or emphasis has jeopardized the film's value.

The player value chain

Conceptually, it is useful to consider the filmmaking process – all the way from inception to final delivery to an audience, as a 'chain' (in the same way that we use the film value chain to analyse the different stages of inception, production through to delivery and finally the audience). Each key player plays the role of a link in that chain. Key 'links' include the producer, the writer, the director, the financier(s), the sales company, the key distributors in major territories, the exhibitors controlling access to cinemas, and so forth. Between these links, facilitators, advisors and specialists all play a role. They include agents, lawyers, managers, accountants, designers and specialist marketers, publicists etc.

All of these players need to 'pitch' or 'sell' a product or their own services/skills at various stages in the film business process, whether it's the 'idea' for a story (producer to writer, or writer to producer), the project to a favoured director, the package to financiers, or a distributor screening a film to an exhibitor etc. What each player is really doing is marketing themselves and their product to each other. A weakness in the links – or, critically, a break in the chain – will mean that the product either stalls or ultimately fails.

Long before a film has to be presented to an audience it will have gone through a highly exacting process of being pitched from one sector of the business to another, in an effort to maintain momentum. The ability to 'pitch' an idea, material or an overall package forms one of the key roles and skills required in a film producer. However, the demand for strong presentational and intercommunication skills is high among all areas and sectors of the film business. Early mistakes and sloppy presentations lead to films normally never being financed and shot, let alone meeting their intended or otherwise audience.

Business-to-business marketing

Most industries operate on a number of different levels or platforms. The buying and selling of product is often done more than once during the process of bringing the final 'goods to market' and it is often referred to as 'business-to-business' activity. The film industry operates on a number of levels, all of which require different practitioners and customers to position themselves and 'pitch up to the next level'.

A simplified player value chain is outlined below, with notes on who markets to whom:

The screenwriter

First, a screenwriter markets themselves through the quality of their ideas, work and track record. Second, established writers have agents, who control access to talent and are responsible for shaping careers and finding appropriate work for their clients.

Write a treatment

Producers – in particular, creatively driven producers who generate their own ideas and material – are extremely important for writers to be championed by. Directors also play a role in the work and marketing of writers. Established directors may choose to work with a writer on a long-term, multi-project basis; or recommend a writer to other filmmakers. To operate effectively, a writer must be able to: a) write treatments/outlines as well as full screenplays; b) verbally communicate their views, concepts and work; and c) understand where their work is targeted in terms of the overall market.

The producer

Self-reliance is critical to a producer's market value. They need to be able to market themselves, generate their own ideas, have an ability to raise finance, attract talent (including writers, directors and actors), and be strong project managers. During their contact with the rest of the player value chain, they are constantly selling their ability to produce. Producers have allies – such as a lawyer (and sometimes agents, especially in Hollywood) – to guide and help them. That relationship is also an important part of a producer's positioning and marketing, as they will be judged by the quality of their advisors.

- Meet agents
- Meet lawyers

The director

If a director is also a writer (in particular, an 'auteur' voice) then they arguably will have the potential advantage of being more 'visible' to producers and other financiers. Their work and 'vision' is already partly committed once they have produced their own screenplay. Otherwise, a director's bank of work is important. Agents do play an important role in the Hollywood/English-language market sector. However, a director will have to sell themselves when they are: a) a first-timer; b) coming off a poor or mediocre film; c) changing direction or genre; d) trying to direct their own script for the first time; or e) working at a new budget level, in particular a higher one.

The distributor

An independent distributor faces two ways: towards producers, studios and sales agents in order to acquire product; and towards exhibitors, and all the ancillary distribution outlets in order to reach an audience/end user. Their brand, specialist knowledge and ability to market and book appropriate to their market are all noted by sellers, but often a distributor will have to stress their strengths and skills beyond just price in order to compete for hot product. Their relationship to exhibitors will depend on their strength in the market and their supply of upcoming product, but they will have nurtured and spent considerable energies on positioning and branding their operation. Above all, the distribution team's passion and commitment to the film in question will nearly always make the difference between a mediocre campaign and one that, more often than not, resonates with the intended core audience.

Film marketing to the theatrical audience

Much has been written by academics and by industry practitioners about the significant changes in the exhibition landscape, in particular in the USA, which, in turn, has

radically changed the way films are released over the past decade. For any producer and distributor, the following questions are important to consider:

- What kind of film are you launching? Can it be presented as a genre film? What is the target audience if it is a specialized film?
- Who's most likely to want to see it? (e.g. What is the demographic of the core audience?)
- How are you going to reach that demographic? (What kind of release is appropriate? Wide? Platform?)
- Is there a unique selling point (USP) hook (e.g. a major star in small film; a real-life story hook)?
- What tools are you going to use? What tools have you already got (normally via the shoot and the sales company) and are they still applicable?
- What tools are you going to create?
- What test screenings have been done?
- Are you holding marketing test screenings?
- What is the level of the marketing budget to be spent by the distributor? (see below)
- How did the exhibitors respond to the screening? What pattern of booking do you want, and what are you expecting in reality?
- What are the best release dates/programming/counter-programming issues?
- How are you going to handle the press?
- Do you need to think of ways to make your film critic-proof?

The above list is by no means exhaustive, but it provides an indication of the level of practical, strategic, creative and execution-dependent demands on the distributor as they launch a film to the theatrical audience. A key part of the planning for a theatrical release is the level of the marketing (what used to be called the prints and advertising budget: aka P&A). Each distributor puts together a P&A/marketing budget for the initial theatrical release of a film. It is this exposure, in addition to that from the press and by word of mouth generated by the release, that 'legitimizes' the film, and helps create further value down the value chain. A poorly planned P&A budget can lead to too many, or too few screens booked (and prints struck), not only damaging the strategy but wasting considerable financial resources. An advertising campaign that does not reach the specific film's target audience may not only waste considerable sums of money, but garner poor word of mouth through the wrong audience seeing the film in its first few days. A media spend (within the 'A' part of P&A) will need to be checked carefully. Too much emphasis on television spots may not be beneficial to a film's market – or no spend in this area may be equally damaging, depending on the product and the distributors' plans in terms of video and so on. Crucially, online marketing strategies and budgets are not dominating both the financial allocation of resources and the creative work rate (see below re digital marketing).

Screen International and *Variety* box office charts each week publish within their statistical information the number of screens each film is playing on and whether it has changed week-on-week. The important number is the film's screen-average in addition to its overall three-day or seven-day total. The screen average is an important indicator of a successful release. For large blockbusters, a screen average of around $4,000–$6,000 represents a strong showing for releases of more than 3,000 screens.

For small, independent fare, the number may be much higher per site over just one, two or double-figure numbers of screens. These averages can be up to more than $20,000 per screen and sometimes much more.

The best organized and experienced distributors have a detailed plan for the release of each of their films, informed by previous P&A campaigns, similar profiled product, and strong tools.

The poster

As with photographs in papers and in cinemas (windows etc.), the poster may be the first visual element a member of the public sees of the film being marketed. It is very important and presents an opportunity to place a film.

Great posters can reveal the 'feel' of a film, and guide the audience's expectation without trying to say or achieve too much. Some directors, such as Spanish auteur Pedro Almodóvar – whose company prepares his marketing material, capture their brand and work through colours. His posters are always distinctive, as are the stills selected for the press. Most Hollywood posters and US indie posters handed across to 'foreign' are unsuitable for many territories. But the photos delivered are also poor.

Key issues to consider when building a poster campaign include:

- Who is your key target audience, and is your image appropriate?
- Clear images, which are not trying to tell too much but are attention catching, work best if available or able to be created.
- A clear title is important, as the image must appear in much smaller ads in newspapers and be memorable and work for word of mouth/click.
- How good was the set photography, or do you have to start again or take prints from the negative?
- Colours are very important. They often run in keeping with the genre. Bright, loud colours denote comedy. Dark blue/black denote thriller and sometimes horror. Red can mean love/romance. These are not hard rules, but worth being aware of.
- Quotes – often very useful from festivals/early reviews.
- Updating: new quotes, prizes of 'biggest indie hit in UK this year' etc.
- A poster is always limited: it can only say so much.
- The trailer: this is a key tool designed and used to encourage an audience to 'want to see' a film. Very strong trailers can attract word of mouth even before a film's release. The trailer is a more targeted tool, and can be more powerful than a poster, given that it is using the film medium – images, sound, fast cutting, music, voice over, dialogue from the film (and sometimes deliberately not) etc. A good trailer can offer a powerful combination, and can be utterly off-putting if poorly executed.

There are three main trailer groups (in addition to a promo made by a sales company or producer for showing to buyers only). These include the theatrical trailer that normally runs from around 90 seconds up to 3 minutes; the teaser-trailer, that runs at around 1–1.5 minutes, and TV spots, which can be 5, 15 and sometimes 30 seconds. Crucially, all marketing campaigns today need to consider how all their materials play online, with testing and demos the norm (see below).

Key issues to consider when building a trailer campaign include:

- The positioning of the trailer – what other film(s) is it playing with? What type of cinemas, screens?
- Positioning of the TV spot/teaser – what programmes, what time, what audience demographic?
- What information is being communicated – Genre? Characters? Style? Narrative – but not whole story? Emotion – probably the most important?
- Holding attention – is the information conveyed in a compelling manner?
- Does it drag, feel long, and is it intelligible?
- Is it too fast to follow, too visual to the point of disengaging the audience?
- If two stars are the leads, are we clear who is the protagonist…?
- How large does the film feel? Is it a major blockbuster?
- How emotionally affecting and intimate does it feel, if that is appropriate?
- Is the music working? (And, crucially, has it been cleared?)
- How does the trailer test (e.g. with colleagues etc.)? And how and where will it play online via platforms and social media outlets?

Digital film marketing and the use of online opportunities

Just prior to *The Cluetrain Manifesto*'s publication in the spring of 1999, along came a micro-movie called *The Blair Witch Project*. *Cluetrain* [2] had argued that the future of the internet and therefore the majority of all future business was rooted in conversations. Top-down marketing was over. Two-way dialogue was the only way to go. *The Blair Witch Project*'s marketing campaign, however, managed to go far further than just a two-way, company-to-customer dynamic. Indeed, the impact of its pioneering viral campaign benchmarked the film much higher than either the filmmakers or its distributor Artisan Entertainment ever imagined when acquired at Sundance in January 1999 for $1.1m. Made for approximately $50,000 and grossing more than $100m at the US theatrical box office alone, the genuinely micro-budget shocker-horror film was the movie industry's first mainstream internet marketing success. It left the major studios' shoehorning of the internet as a secondary, supplementary marketing tool standing still in the water.

On 1 April 1999 Artisan relaunched *The Blair Witch Project* website with a host of new material, including material presented as out-takes from 'discovered' film footage, police reports, the 'back story' on missing film students, and a mythological history of the Blair Witch legend. Instead of premiering trailers on the TV or in theatres, Artisan trailered on the 'Ain't It Cool News' website, and send out *The Blair Witch Project* screensavers to more than 2,000 journalists.

Fiction and fact were deliberately mixed and blurred across the web campaign, which, in turn, spurred unofficial offspring websites, parodies and new narratives emanating from an ever-expanding fan base. Even the offended citizens of Burkittsville, Maryland, created a page to detract from the film's authenticity [sic], further fanning the flames of debate across usernet groups, online chatrooms and web boards. While Artisan spent around $1.5m on the Web promotion (from an overall campaign costing $20m), the viral spiralling was worth exponentially more than the cash injected [3].

The macro and the micro impact

The relationship between the internet and film from a marketing perspective can be viewed at a micro level, encompassing interactive media and its impact on audiences through social networking, widgets, applications, podcasting etc. (That's why Spotify is playing an increasingly key role in film experience and audio marketing campaigns and techniques [1: ibid.].)

The reflexive relationship – with multiple loops and feedbacks on offer – can also be analysed at a macro level, whereby film marketing encompasses a meeting point of social, economic, creative, technological and structural dynamics which reflect both the industry's changing architecture and its 'reflexive' relationship to the consumer – taking 'interactive' to its full level. In an MSc dissertation essay, Michael Franklin [4] usefully pointed to the numerous gaps in this field, including those between academic theory and hard research; and the surprising reluctance by both the studios and main-stream distributors to fully embrace the internet's potential both as a targeting tool and a wider 'space' to explore their relationships with audiences/consumers in full.

Before fully testing his thesis, Franklin sets out the landscape that governs new inter-active digital media, pointing out that the impact of the internet in film has been both as a marketing tool and a new mode of consumption. Peppers and Rogers argue that digital marketing represents a complete transformation of the marketing paradigm, from a 'one-to-many' broadcast relationship (controlled by gatekeepers), to limitless one-to-one relationships. Others (Deighton [6]) point out that marketing as a profes-sion, and the associated theories and science it draws upon, are heavily determined by the tools at its disposal. "The marketing toolkit is clearly experiencing massive inno-vation, suggesting the discipline is under pressure to reshape. The Internet's interactive abilities allow mass marketing concepts to become customized and responsive to the individual: promising a new marketing paradigm."

What makes online marketing so revolutionary? The key factors are its interac-tivity and its scalability. As Franklin declares, the Web is not simply a vehicle for adverts, nor just a step-up in 'addressable media'. The interactive multimedia platform offers opportunities for advertising, selling, service delivery, production, distribution and market research that are inseparable and complementary. Digital technology has reduced conversation costs to zero, providing limitless any-to-any communication that is a dramatic contrast to the historically dominant one-to-many broadcast model. … Any-to-any communication operates on a global scale and affords limitless possi-bility for both information and value transfer between consumers and businesses in any combination (Franklin, p. 24, ibid.).

But the additional factor that enhances the phenomenon is timing. The major online marketing draw is "being able to reach an audience, communicate with them, estab-lish a two-way relationship with them well before the film comes out", explains Rus-sell Scott, CEO of Jetset Studios [7], a leading US online marketing agency. "Online, there's an unprecedented chance for the filmmaker to reach an audience and let them interact with a brand that doesn't exist yet, well before one-sheets and any kind of trailer appears."

We know now that the producer/distributor can generate messages to the consumer, which in turn can provide feedback (both specific and generic), which in turn the producer can respond to. Hence, to borrow Soros's 'reflexive' theory about financial markets, a circular dynamic is in existence. Unlike financial circuits, the marketing

dynamic has a considerably more positive aspect in terms of fine-tuning the message and respecting the audience. Opportunities to foster relationships, build intimacy and loyalty, and, most importantly, construct consumer communities, which in turn may generate and build upon 'fan' bases, are far-flung from standardized 20th-century 'push' advertising techniques.

Much has been written about online marketing since the advent of *Blair Witch*'s marketing project. When a Web campaign becomes so hot that it 'buzzes', it can create news itself and self-perpetuate awareness, word of mouth and 'word of mouse' far beyond the core target fan base. But since *Blair Witch*, the explosion of YouTube, Twitter, SnapChat, Fortnite, TikTok and other platforms, costs have risen exponentially. If studios and mainstream distributors go the 'old' approach and simply buy out 'pages' in an effort to dominate headlines, they miss the "Brave New World" that connects content to customers in real time. As Andrew Wallenstein, in his forward to Variety's VIP Digital Marketing special edition [1], points out:

> Great creative is a must, of course, but there has to be a plan in place to make sure the right eyeballs are seeing your content. The old days of Madison Avenue's spray-and-paint approach have given way to a much more sophisticated strategy that slices and dices audiences into targetable segments. The secret sauce is that data digital platforms can deliver in real time, allowing the fine-tuning of marketing campaigns that are able to charge in response to how consumers are receiving them. Word of mouth isn't what it used to be. It's a brave new world of hashtags and programmatic buying, one that you can't afford not to understand.
>
> [1: ibid., p. 2]

The viral approach to marketing

'Viral marketing' and 'viral advertising' descriptions refer to marketing techniques that use pre-existing social networks to produce increases in brand or product awareness. Viral marketing achieves this through self-replication (not to be confused with the spread of computer and pathological viruses), where the effect is carried by an 'ideavirus' in which the medium of the virus *is* the product (Seth Godin, 'Unleashing the Ideavirus' [8]). Viral promotions may take the form of video clips, interactive flash games, advergames, images, or text messages etc. Viral marketing is a marketing phenomenon that facilitates and encourages people to pass along a marketing mes-sage voluntarily – hence mirroring the peer-to-peer recommendation system of word of mouth. However, Godin, and other commentators such as Wallenstein above, suggest that word of mouth dies out over a given period, whereas a successful 'ideavirus' can grow exponentially.

Why? 'Because something amplifies the recommendation to a far larger audience'. That could be TV or other forms of media (a good review in the *New York Times* that amplifies the message of one reviewer to many readers) or it could be the Web (a site like planetfeedback.com amplifies the message of the single user). Marketing research shows (generally) that a satisfied customer tells an average of three people about a product or service he/she likes, and more than ten people about a product or service which he/she did not like. Viral marketing is based on this natural human behaviour of sharing, disseminating and interacting.

The goal of digital marketeers interested in creating successful viral marketing programmes is to identify individuals with high social networking potential (SNP) and create viral messages that appeal to this segment of the population (e.g. demographic or core audience etc.) and offer a high probability of being passed along. The term is also sometimes used pejoratively to refer to stealth marketing campaigns – the use of varied kinds of astroturfing both online and offline to create the impression of spontaneous word of mouth enthusiasm. Of course, not all films lend themselves neatly to stealth-based campaigns, but the link between two-way traffic flow and user-generated content allows for a wide diaspora of ideas, gossip and 'buzz' to be disseminated.

And traditional marketing materials also have their role in this landscape. Teasers, trailers, artwork, stills, production notes, progress reports, exclusive interviews, talent snippets all play a role – but crucially in a way that allows the consumer and the emerging community to consume, control and/or adapt the material and concepts, bucking the traditional analogue 'push' strategy – typically a 'hard sell' tactic.

Observers have noted that 'virals' have their limitations and quantifying 'value' has altered: measurements of success used to tend towards the 'how many members became friends with the film's profile'; whereas the viral approach only really takes off when users distribute applications and generate and send on original content. For those interested in viral marketing beyond just film, David Meerman Scott [9] has written extensively and draws on a wide range of creative media and digital executive experience. Ultimately, any attempt to create a viral campaign needs a very clear, focused strategy, and to understand the odds: either it's right, or it would have been better not to try at all. Key elements to consider include the following:

Try to create or do something unexpected. This may sound obvious, but copycat campaigns or promotions that stick to hard-core selling do not work in this arena. 'Man bites dog' works. 'Dog bites man…'. Well. Exactly.

Create emotions – a reaction or at least a feeling. Strong ideas, extreme opinions accompanied by dedication, passion and commitment are important to generate. Extremes mean exactly that: love/hate, happy/furious, clever/stupid etc. Neutral does not work. Extreme emotive and emotional binary approaches have been proven to work best.

Sharing: create the opportunity to download and send on. Viral could be called 'sharing' – which, in turn, means making it easy to download content in easy formats and easily embedded in the content on their own sites; with simple links, and sites/networks that publish, and allow bookmarking to be added.

Avoid advertising or hard-sell promotions. Stories work far better than corporate messages or brands.

Once caught, get other people to make the sequel (or the prequel, or the spin-off).

Connect with your audience: allow comments and feedback. Include the negative or you will be found out to be manipulating the space.

Non-exclusivity: never restrict access. The studios and some of the leading streaming platforms could do with learning this one. Do not insist on registration; membership; to download additional/special software, to enter 'unlock' codes or demand anything to be done to get the right links [10].

Case study 1 : *The Best Exotic Marigold Hotel* – marketing the promise of an experience

Introduction

The Best Exotic Marigold Hotel (2012) enjoyed a typically challenging journey to cinema screens. Tenacious producing and Fox Searchlight's marketing and positioning of the film in the UK ensured a commercial hit far beyond the film's home territory. This case study examines the producer's role in the making of the film, and Fox Searchlight's UK marketing campaign that established the materials and strategy for a global success.

Graham Broadbent (*Seven Psychopaths, In Bruges, Three Billboards Outside Ebbing, Missouri*) is one the most successful UK film producers to emerge over the past two decades, but he's an advocate of producer partnerships as opposed to going it alone. Pete Czernin has worked with Broadbent for a decade, and they've enjoyed a strong run at Blueprint Pictures:

> *Pete's an old friend of mine, which is great. I think being a sole producer can be the loneliest of lonely jobs and the idea of someone just bearing the stress and weight of filmmaking is daunting. To have someone else to share the load is very important.*
>
> *The way we work is that we lead on our respective projects [mirroring Tim Bevan and Eric Fellner at Working Title, where Broadbent started as a runner] because I don't think it helps any of the creative team to have two producers around. They don't quite know why they have to talk with two people, so doubling up is not particularly useful. It might work for other people but for me it seems like a waste of resources. Directors generally want to talk to one person. Pete worked in LA for nine years in the Studios, so he has more studio experience both at Warners and Columbia. I've always been an independent producer, and I have much more financial knowledge on just how to put things together and what deals might work.*

In May 2007 Blueprint Pictures signed an option agreement with the novelist Deborah Moggach for *These Foolish Things*, the book on which the film is based (although the title was later altered). The deal came with a first draft of the script that Deborah Moggach had written. Moggach did one further draft, and then Broadbent brought in writer and friend Ol Parker to work on the screenplay. What the producers were really attracted to was the concept at the heart of the story: "The idea that you can"' outsource retirement', which seemed a really good concept. As a film idea it's one that you can discuss over a water cooler, over a coffee. It's an easy one and we ran with it", Broadbent explained.

By mid-May 2007 the film was set up with Pathé in the UK, who were keen to make the film happen. Parker wrote a couple of further drafts, and the producers talked to Kenneth Branagh about directing, given his reach and perceived status with older cast. A recce trip to India was made in 2008, but when the financial crash occurred later that year, Pathé, like a host of other entertainment companies, drew back and the film's progress fell apart. This was in spite of the producers bringing in US-based socially motivated financier Participant. They, in turn, introduced the project to the former sales powerhouse Summit Entertainment (now owned by

Lionsgate); according to Broadbent, however, the numbers didn't work and the film remained in limbo. By this stage, all the US mini-majors and specialist wings had also passed.

A few months later, the producers were sitting in then Fox Searchlight CEO Peter Rice's office in LA. A two-box set of *Cocoon* was sitting on Rice's DVD player. Broadbent asked: "Why are you watching that?" He was told that it was for a different audience; a remake for an older audience. "Don't do that", said Broadbent, "because we've got just the thing for you." It was at that point that Rice jumped onto the idea. A new title was added to ensure that the internal logs didn't show a previous pass, and the project was sent through to Fox Searchlight, who all loved it.

Meanwhile, Parker had been re-writing and tightening the screenplay considerably to keep the momentum going. Despite Fox Searchlight's enthusiasm, the producers were still facing considerable challenges. The first was an Indian shoot. "You can only shoot for about five or six months of the year", explained Broadbent.

It's very seasonal and any time from March through to September it's just impossible to shoot. It's just too hot or too wet. And the danger if you're a producer trying to put together an ensemble cast of well-known actors is that you keep missing the window. The script's not there, the director's not there, Judi Dench isn't there ... and we had about 18 months of missing availability windows, waiting for this and that, and running through different directors.

The film finally came together for a shoot starting in October 2010, after John Madden had signed on that summer.

We needed a director who would perform well and we had our cast: we had Judi Dench, Maggie Smith, Tom Wilkinson, Bill Nighy and it all just seemed to come together in a perfect storm, which is what happens occasionally. The best thing about that, on this particular project, is that often when you have a project and you're trying to make it and it takes a while to make it often just drifts off where it should be, its core. Something goes wrong so it turns into something else, it gets weaker and loses its concept or quality. But what actually happened on this film is that the best version of the film was made in the end.

Financing was unusually straightforward by this stage, with a $13m budget being split 50–50 between Fox Searchlight and Participant. The one potential stumbling block was the casting of the hotel owner's son, Sunny. The character was originally written quite a lot older but Searchlight was very keen, having been involved in *Slumdog Millionaire*, to bring Indian actor Dev Patel into the film. It was a suggestion that Broadbent in particular was initially resistant to.

"The lessons you always learn as a producer with a studio is just don't fight head to head. It rarely makes sense. You go through a process and that process is to all come to a conclusion together. So you offer yourself up, and say, 'look, he seems wrong to me, he's not what's written in the script, but I understand that you've got a different idea on this so let's meet him, test him and then see'. Because then you haven't looked challenging and difficult, which is a really easy position to take but it's not constructive and studios hate you for doing it. You never get to the right conclusion and if you do it it's really hard work getting there. Whereas if you just go all right, let's meet him and test him (and he tested brilliantly) ... then we re-wrote

the role for a younger character, and proved that Searchlight were absolutely right", explained Broadbent.

Shooting in India turned out to be "simple, fun and nice to do. We tied up with a company there called India Take One Productions". The company has serviced a number of UK and western productions, including *Slumdog Millionaire*.

We ended up taking very few crew out there, about 15 people I think, probably, from the UK, and the cast. We had a huge Indian crew, with lots of experience but you get an awful lot of people. On a film like this you might have 120 people on a UK or US shoot normally, with this sort of budget at $13m. And we had 350 people! And I'm looking at the unit list going who are all these people? What are they all doing?

And they were a terrific crew, and worked very well. John was fantastic with them, and the cast, and had a great time. He got into the spirit of India almost like a mirror of Tom Wilkinson's character in the story. No-one got paid very much compared to typical rates, including the cast, which is the Fox Searchlight way of doing things: if it's a success there's reward but they keep the budgets low going in. The shoot was relatively smooth ... then we came back and had a nice time in post, cutting happily away.

The first testing was in the US and UK within a couple of days of each other in the middle of the summer 2011.

What became clear was that the audience was really enjoying the movie. So the numbers were very high, the feeling was very high, and as a producer you've got that stage of, "hang on, the studio's really interested in this now".

Kate Gardiner, head of Fox Searchlight UK, had first seen the script at the beginning of 2009.

"The US office wanted to make sure that the UK office liked it because if we didn't think it would work then I guess they would have been a bit scared. But we all absolutely loved it. So often when you read a script you're like 'ok, I don't know who it's for ... I don't know what we'd do with it'. In this case it was just like 'ok, we get it'."

Fox Searchlight UK still had some concerns about the comedy and tone. Given that the distributor releases a number of Bollywood films in the UK, Gardiner decided to invite a couple of agencies they worked with to see the test screenings, because I'd already seen it and all the comedy around the Indian characters we found really funny but we needed to be really sure that it wasn't offensive. We had in our minds that the Bollywood audience was something worth targeting, so we got those guys in at the point where if they had said, "You know what? This is really not going to go down well", then it wasn't too late to make little tweaks. Actually they loved it as much as everyone else and thought the film was a really positive representation so that was a big relief.

Dating the film's release created serious debate

We had quite a lot of to-ing and fro-ing about dating because initially there was a thought of getting it out in the autumn, and qualifying for awards that year. But we felt that there was such a good opportunity to trailer over the award season, with *The Iron Lady* and all those films playing, along with the fact that this was a film that would need lots of time. Whilst we felt it would play really well it still needed to be released at a time where there weren't loads of other films coming in week after week, which allowed the film to hold its screens. So we eventually

dated 24 February, which was right at the end of the award season. Hence we had all those brilliant films to trailer on and then we had Mother's Day in our third weekend, which was always part of our strategy.

In the end, Broadbent and Madden thanked Fox for not entering the film into the awards season as a contestant, but instead as a benefactor of the period.

The UK date was brilliant. Straight after the BAFTA awards. And then the US was about two months later and that was a brilliant date as well because all the Academy films were out of the way, and you're going into summer when there was nothing else around, outside the Studio summer movies. They called it the early summer slot. They now call it the Marigold slot. We opened against *The Avengers*!

In terms of targeting, Gardiner was very clear whom Fox was trying to target:

We knew that pretty much everyone would enjoy it but in terms of positioning we wanted to clearly go after an older audience. The comps [comparative titles] we had were Madden's *Shakespeare in Love, Calendar Girls, Gosford Park, It's Complicated, Notes on a Scandal, Eat, Pray, Love, Mrs Brown, Mrs Hudson Presents, Made in Dagenham, The Importance of Being Earnest, Ladies in Lavender, Saving Grace, Tea With Mussolini* and *Keeping Mum*. These films ranged from £1.7m at the bottom end (*Made In Dagenham*) to £20.8m for *Shakespeare in Love*. So when we looked at the average, which is £7m, even that is a big number. And that average is massively skewed by *Shakespeare in Love* and *Calendar Girls*, which both did amazingly well.

We didn't expect it to reach the dizzy heights of *Calendar Girls* but you know we felt like £7m–£7.5m would be something to aim for. I must admit in terms of what we spent, it was more than normal for a £7.5m box office target, but that was because we were releasing the film as a launch for Fox's campaign throughout the rest of the world. A lot of the international markets were quite dubious, so they really needed to have a big hit in the UK to carry the confidence and momentum through.

Trailering followed suitable releases such as *The Iron Lady, The Artist, My Week With Marilyn, War Horse* and *The Descendants*.

We were able to hit our target audience over and over again ... and we had fun with the poster. We struggled for quite some time. It was a real challenge because you had all the characters that you wanted to get in, but you wanted to see their faces, so having seven little people was kind of pointless. You also wanted to get India across and the fact that it was fun. You didn't want it to look like *Eat, Pray, Love*. So we concentrated on the little things like Bill's raised eyebrow and Cecilia's smile that give it that feel-good warmth.

Older audiences (35+, but in this case 60+ was being targeted heavily) notoriously take a long time to catch up with film releases, buy tickets and make a commitment to going to the cinema. Although Searchlight released in the UK on 24 February, they ran their first TV ad from Boxing Day to New Year's Day. Gardiner explained that that period is one of the less expensive times in the year, so we got a lot for our money and it also meant that when we came on to tracking it was in a pretty good place. Mother's Day was also heavily targeted.

Gardiner stressed that the 'promise of an experience' is always key for any film campaign.

We bought a lot of outdoor space, and ended up going for bus sides, because we figured that our target audiences are out during the day when it's light. Many

of them are retired and they go to the shops in the daytime. The artwork was really warm and colourful and stood out in the cold so the posters came across almost like a holiday ad.

We worked with the Mail on Sunday and Classic FM amongst others, and we did a screening programme with them and the attendance rates were through the roof. There were people queuing round the block for these 'talker' screenings and the reaction was that they were the best we've ever seen for any film that we've screened like that. So that was something that I think played a big part in us actually managing to open it as well as we did".

Broadbent explained that the highly experienced cast, including Bill Nighy, Judi Dench, Maggie Smith and Tom Wilkinson, were all theatre actors.

"They'd all worked with each other, they all knew each other, and there was this great affection. As a producer on tight budgets, if you want to create a company you give people as nice a time as they can have at work. You want them all to be happy, to feel looked after and good about everything and I think it pays dividends later on in the marketing.

"The reviews were mixed", explained Gardiner. "We expected that because the film was too 'genuinely enjoyable' for some of our UK broadsheet critics. But there were plenty of people who loved it as well, so we did have some press formats that had reviews on. We ended up running about eight weeks of press advertising on this film because it was our key sort of sustaining medium. Everyone who attended our talker screenings was invited to enter a competition and go to a Facebook page to submit their reviews, with a holiday to India as the prize. We captured about 3,000 reviews and then we picked quotes, with the name, age and home town placed on our ads which led to a really nice mix. Broadbent thought, 'this was genius because we never got these quotes from the reviews. People of all ages were absolutely saying that you'll enjoy this movie'."

The film's box office pattern was extremely steady and consistent, taking just over £2.2m in its first week, and then consistently taking £2m approximately a week over a two-month stretch, and finally passing £20m. Advertising and clever, sustained promotion helped the film 'hold up', which, in turn, allowed traditional word of mouth and an older targeted audience to reach the cinemas during the theatrical release rather than waiting for ancillary options. Meanwhile, the film went on to surpass all ancillary estimates across DVD, VOD etc.

The UK materials served as the bedrock for Fox's rest of the world campaign, with the film going on to take $46.4m in North America, and $90.4m in foreign territories, including the outstanding UK performance.

Case Study 2: *The Safety of Objects*: managing the film distribution process [11]

The next case focuses on a North American film, *The Safety of Objects*, which was co-financed by Paul Allen's US film company, Clear Blue Sky and Renaissance Films on a 50–50 funding basis, with each company's managers acting as co-executive producers on the project. Writer-director Rose Troche had garnered considerable attention with her first feature, *Go Fish*, and her creative reputation and screen-play adaptation of A.M. Holmes' novel, *The Safety of Objects*, attracted strong A-list cast in the case of Glenn Close's attachment to the project. The two lead produc-ers working with Renaissance and Clear Blue Sky included New York-based award-winning Killer Films and UK-US-based InFilm. Prior to and during production, key distribution deals in foreign territories, including Spain, Italy, the UK, France and Benelux, were successfully pre-sold by the Renaissance. For a film budgeted at just over $8m, the pre-sales were worth nearly $2m, a significant financing component. However, a North American deal was not closed until the film was ready to be screened to US studios and distributors, leaving a question mark over the film's value in its most important territory.

The Toronto International Film Festival and US Distribution

The film was completed in summer 2001, and was selected for a world premiere at the Toronto International Film Festival that September. After the first screening (and despite the impact of the 9/11 World Trade Center bombings), an indepen-dent US distributor and cable operator IFC made an offer of $750,000 for North American rights. The offer included 'bumps', stating that on certain levels of theatri-cal performance, the financiers would receive additional advances against receipts, making the overall deal potentially worth as much as $1.5m.

The distribution contract stated that IFC would release the film theatrically within nine months of signature of the agreement. This clause was vital to the foreign distributors who had bought the film already, and who intended to wait until the US release of the film, before taking it out to cinemas in their respective territories. It was also important for the film not to be held back longer than this period, as press and talent start to suspect the film suffers from a "problem" or will be "difficult" to place and market. In many cases, lengthy delays lead to talent being unable to commit to supporting a film, both because of schedule and their "reputation" in the eyes of their agents, managers and press advisers.

Nine months passed. All the UK financier's foreign distributors grew increasingly anxious about the film's plans in North America, as IFC had still not given clear dates for the theatrical release. A conference call was set up between the producers, Clear Blue Sky, Renaissance and the US distributor, IFC.

During the conference call, held ten months after the signature of the agree-ment, IFC's chief executive explained that because the company's main shareholder owned a cinema that was under construction in downtown New York, he was under pressure to hold back the film for the theatre's opening premiere. IFC's plan was for the film's star, Glenn Close, to open the cinema, and attend the premiere. However, nothing had been agreed with the star or her agents and management. The con-struction was also bogged down, with only a vague estimate of a further six months before completion. The film was unlikely to open before April 2004.

The project management team was facing a critical dilemma. What should the partners do about the original foreign distributors, who had not accepted full delivery of the film (and hence held back 80 per cent of their minimum guarantees), as they were waiting for the North American release plan and opening in cinemas?

Should the film's financiers and producers tear up the US contract and find a new US distributor? Should they demand an earlier release plan, and insist that IFC abandon its cinema premiere? As a damage-limiting strategy, they could try to keep talent onside, be patient and not block foreign distributors from releasing the film prior to the US release. As a final resort, they discussed the pros and cons of taking IFC to court for breach of contract and material damages.

The Lessons Learned

What actually happened in this case demonstrates the extreme lack of controls both producers and financiers can bring to bear on the key stages of a film's exploitation process. At the point of the US deal being made at Toronto with IFC, the combined project management team clearly suffered from illusions of control. The 'availability' of an attractive offer dominated the positive response to the deal, to the exclusion of other pertinent information, such as IFC's real intentions regarding its release plan.

What transpired are the following facts:

> IFC released the film in autumn 2003, two years after it had bought the film. (The new cinema was still under construction and hence was not used for the release after all). The theatrical release was a failure. The film grossed $350,000 over three weeks, having been released on more than 250 screens in the first weekend, dropping to 180 screens in the second week and 90 by the third.

All agents and managers blocked the film's stars from supporting the film where possible. Crucially, Glenn Close did not give any interviews or attend any promotional screenings, despite having attended the Toronto launch previously. She was clearly and understandably upset with IFC's strategy. Due to the lengthy US release delay, the film's foreign distributors decided to release the film before IFC. The producers and financiers did not try to block them. Most released on very limited theatrical runs, and some went straight to a video/DVD release, missing out the cinema window.

The film's financiers received full payment of the $750,000 advance, and three years later overages (net profits) of approximately $150,000. The North American income streams were still significantly less than the original sales forecast value of $1.5m.

What could the financiers and producers have done to avoid the damaging delays and subsequent negative effect on the film's foreign distribution plans? Suing is not a realistic option, and can be described as irrational at best. As a project management solution tool, a wise producer would know they've failed even when starting to consider such an action. It would be fair, however, to argue that the financiers should have been much more focused and 'cognizant' about the outside release

date agreed with IFC from the start of the North American deal negotiations. It would have made the US distributor more committed and aware of the 'foreign release date' problem, and less likely to keep delaying. Strategically, the producers should have utilized the stars' agents and managers to put pressure on IFC and influence a change of mind. Conservatism appeared to rule the project managers' actions, as they failed to change their mind in light of the evidence of lengthy delay, which, in turn, was damaging the foreign value of the project.

On a wider level, and most critically, what the case underlines is the fragmented nature of the film value chain. The danger and negative impact of de-linkage between production and distribution in the independent, non-Hollywood Studio film business leaves project managers and their financiers vulnerable to third-party risk. Studios tend to control world rights to the films they produce and finance, and subsequently release their films on a 'day and date' basis. Their strategy is designed to protect themselves from territorial and political divisions to a large extent, and with good reason.

References

[1] The best text book available on the A–Z for film marketing is *Fiona Kerrigan's Film Marketing*. Routledge, 2009.

[2] www.cluetrain.org.

[3] For further reading on *The Blair Witch* project, see: Turner, P. Devil's *Advocate* (2014), Auteur and Blaze, M., *8 Days in the Woods: The Making of the Blair Witch Project* (2019), independently published (ISBN 110: 1697213499).

[4] M. Franklin, 'Does the Use of the Internet Represent a Paradigmatic Shift in Film Marketing', MSc dissertation, Cass Business School, The City University, London, August 2008.

[5] D. Peppers and M. Rogers, *The One to One Future*. London: Piatkus, 1993; *Enterprise One to One*. London: Piatkus, 1997.

[6] See Elberse, Deighton and Barwise; Peppers and Rogers; and Wietz and Wensley in Franklin's bibliography; and J. Deighton, E. Salama and M. Sorrell, 'Interactive Marketing: Perspectives', *Harvard Business Review*, November–December 1996, pp. 151–152.

[7] David Meerman Scott, *The New Rules of Viral Marketing – How Word of Mouse Spreads Your Ideas for Free*, e-book, 2008.

[8] Seth Godin, 'Unleashing the Ideavirus', www.ideavirus.com.

[9] Source: adapted from www.Baekdal.com, 23 November 2006 edition (web magazine).

[10] Movie Marketing Madness, www.moviemarketingmadness.com.

[11] Finney, A. PhD thesis (2014).

16 The streaming wars

> Nature does not hurry, yet everything is accomplished.
> (Lao Tzu, Chinese Taoist philosopher)
>
> The next three to five years will be a time of creativity and chaos, with many artistic highs and unprecedented amounts of money invested in scripted content.
> 'A Creative Explosion,' Nostradamus Report, 2020 [1]

Once upon a time, the script that the entertainment business followed was a simple, linear model subject to slow shifts over years and decades. World wars came and went but the show had to go on. Audiences paid for cinema tickets, and later – in the second half of the twentieth century – we learned to watch movies on television sets; followed by the arrival of video in the living room via a box connected by cable. The 'cable' linkup started to evolve into channels, sending ever more programmes into homes and living rooms, until by the turn of the 21st century 'choice' had become a heady plethora of multiple viewing options. Few of us saw that the rise and rise of the internet was set to change the entertainment world to a point where there is now no point of return; certainly not for the Hollywood Studios, who for years were fast asleep at the wheel. Blinded by corporate fear and greed, locked into organized silos, the all-powerful oligopoly was not built to see the future coming.

Some notable changes and shifts began in the 1990s: Hit series like *The Sopranos, Sex and The City*, and later *The Wire* on Home Box Office (HBO), a cable channel then fully owned by Time Warner, confirmed that viewers would pay more, and dedicate more time, to consume compelling, high-quality programming. HBO still relied on TV's version of 'windows' whereby weekly episodes were released sequentially: "It was a wholesale proposition, sold in a bundle of pay-TV channels" [2]. "The big bang", explained Barry Diller, chairman of IAC and founder of Fox Broadcasting, came in the in the mid-2000s with the arrival of Netflix, and soon after, Amazon Prime Video, the e-commerce 'online Goliath's' streaming service [2].

Instead of taking stock and shifting through the gears, the Hollywood Studios inexorably played the short-term game, deciding to sell (e.g. license) its vast library catalogues and locomotive hits to the new arrivistes. The fast-growing streamers piled on new customers on the back of *Friends* and *The Office* and a host of other shows and feature films, while HBO did deals with Amazon for quality long-running content such as *Six Feet Under*. Having won an ever-increasing foothold in the market, the streamers gradually started to produce their own programming, crucially in 2013

DOI: 10.4324/9781003205753-18

with Netflix's genuinely original [sic] *House of Cards*. The full first series was released all in one go, marking the dawn of the age of online "bingeing", albeit building on the DVD box set shift in behaviour of the earlier 2000s. The studios were feeding the new monsters a daily diet of high-end content, comatose by the ingrained 'silo mentality' of departmental competition – a problem that continues to exist for many of them today and beyond.

Rising costs and rising competition

Costs of production and marketing have risen over the past decade (and higher due to the ongoing pandemic); while the previous business model – based on control of access to and pricing of content via windows – has buckled and now snapped in half. The DVD exploitation model drove more than 60% of all distributors' revenues and an even higher rate of return on investment – a staggering share of profit margin. Large bundles of pay-TV channels generated margins of more than 50% and accounted for nearly 75% of profits at studio-owning conglomerates such as News Corporation, Disney, Viacom and Time Warner [2]. Movies' future revenue streams were long dictated by their opening box office numbers. That model is also buckling, as it bears little to no relevance to the Subscription On Demand model, where new customers and their abiding loyalty are the prizes to be won, not three days' takings at the cinema opening over a busy weekend.

There are three ways to make streaming pay. Companies can accumulate deep ranks of loyal subscribers across key territories and ultimately maximize their global footprint. They can jack up prices, or they can cut back spending on content (a primary cost) and marketing (a secondary and far less expensive drain than theatrical P&A). At the time of writing in late 2021, the competition was so intense that the ten leading Western-cum-global streaming platforms were fighting a war so intensely that no one was considering spending less on content, while Netflix was the only player to flex its pricing and subscription models. The (formidable) rest were in a pricing battle predicated on how many households would fork out for how many different services per month (and/or per year, as a growing trend of 'on-off' payments was already taking pace). The average is somewhere between 3 and 4 services monthly,[1] but where that leaves cable, currently being cord-cut to shreds, embattled public broadcasters and ad-driven commercial stations is now up in the air.

And what of those rising costs? According to Bloomberg Intelligence, the average cost of producing one single hour of scripted drama has now reached more than $6m, double the price just four years ago. The year before the pandemic outbreak (2019), banker UBS estimated that 16 leading firms, from Disney to Netflix et al., would spend more than $100bn on content: the same sum as the American oil industry invested in 2019.

How this is going to impact the 'face of content' going forwards is, ironically, likely to take some shape and form from the past: companies that can aggregate the various streaming options "in bundles with simple interfaces will reap rewards" [2]. That sounds rather like the historical cable channel approach to delivery. The viewing public would undoubtedly appreciate the Steve Jobs rule of thumb for the customer, paraphrased as: "Two clicks and you are there". But the multitude of offers, recommendations and variety of services – before you even get to the cluttered wall of content choices per platform – is more often than not leaving audiences perplexed

and overwhelmed. Not all streaming giants, naturally, have the same business models: Unlike the content-focused Netflix – now widening to online gaming – some are in the global mass-retail business (Amazon – offering its free shipping with Amazon Prime membership), while Apple is dedicated to hardware sales and online services.

What has shifted is the emphasis on creative talent, both in front and behind the camera and in the executive's office (or Zoom space). An ever-spinning wheel of executive shuffling has been taking place, with studios and Netflix in particular arming up with experienced executive TV programming talent, while dedicated studio feature film executives are being shifted out, and top foreign-language production companies are starting to see a new panoply of commissioning opportunities (see Chapter 17).

Meanwhile, A-list writers are booked for more than two years in advance according to the top literary agents, while commissioning editors remain wary of taking risks on emerging talent. While a bank of development piled up during the pandemic's worst months throughout 2020 and 2021, that will gradually be either commissioned or passed on, leaving the talent bottleneck as intractable as before the onslaught of COVID-19.

A different model

Trying to adapt the traditional film value chain to a streaming model is far from simple. Each streamer takes a different view and level of commitment to the early stages of development, packaging and financing. Netflix famously does not "do development", although the truth is more complex: It will depend on which territory and which commissioning editor you are dealing with, and whether the platform has actually bought your company in whole. More recently, the platform has shown willingness to commission screenplays around themes etc., most notably in the UK, according to leading producers happy to see new routes to market. Financing comes in different shapes and forms, so research is key for any producer considering their options. Overall, Figure 16.1 shows how the model generally looks as of writing in 2021. Of course it's subject to individual decision-making and protocols that are changing fast,

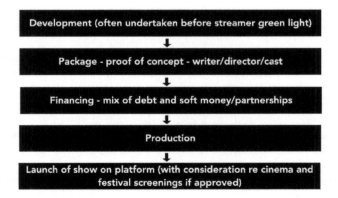

Development (often undertaken before streamer green light)
↓
Package - proof of concept - writer/director/cast
↓
Financing - mix of debt and soft money/partnerships
↓
Production
↓
Launch of show on platform (with consideration re cinema and festival screenings if approved)

Figure 16.1 The streaming value chain.

but the largest challenge for content-makers is to be able to conceive, develop and part-package projects at a level that can be pitched and presented to streamers at a level that opens their arms and cheque books.

More widely, the streaming wars have reshaped media well beyond the once-video-driven living room and stimulated (mostly) a huge surge of creative endeavour. The move towards on-demand and often fragmented consumption is making it harder for any one company (or even an oligopoly) to dominate world viewing habits. And, of course, not all are happy both inside and outside the world of content making. Writing in the *Financial Times*, Anna Nicolaou suggested that: "When *Game of Thrones* concluded in 2019, some media pundits postured that this was the end of an era, after shows such as *The Wire* and *Mad Men* had ushered in critical acclaim and cinematic quality for the small screen … whatever happened to the golden age of television?"

The streaming giants have no schedule to have to fill: "they can make as much TV as they want, throw it online, and see what happens. This means taking bets on hundreds of hours of programming that 'maybe nobody is watching' says Jonathan Taplin, an Oscar-nominated producer. 'The audience is fixed … you're not creating new people'." [3]. And so, a debate that will no doubt run and run, has been doing the rounds about 'quality'. It's notable that Richard Pleper, former HBO boss responsible for green lighting *Game of Thrones*, on leaving the firm, warned that, "More is not good. Only good is good."

The day and date conundrum

The fight over windows has long been on the front burner, with cinema owners and their lobbying arms desperate to hold the line and retain some kind of buffer between the theatrical and alternative routes to viewing of films. In July 2021, after the notorious *Black Widow* dropped almost 70 per cent at the box office following its record-breaking opening (albeit within the pandemic), the National Association of Theatre Owners (NATO) released a statement accusing Disney of cannibalising the film's box office takings by opting to make the film available to rent at the same time on Disney +. Meanwhile, Warner Bros. had already announced that it was releasing its entire 2021 slate on HBO Max at the same time as the movies hit the cinemas. Variety asked a pertinent question about such practices: "If releasing films concurrently on streaming is costing studios ticket sales at the box office, what's their incentive to keep losing money?" The answer lies in the business model that underpins streaming platforms. The streaming wars are not rooted – at least for now – in profitability: "For a significant movie, the best way to make the most money is to release the movie first theatrically with a window, establish the brand, and make a fair amount of money in movie theatres", argued NATO's Jonathan Fithian [4]. "That brand then carries forward into the later markets, where you can sell the movie on video-on-demand, as well as profit from rentals and television licensing. You make money at every step. But the streaming wars are being led by people who are not focused on profitability. They're focused on attracting subscribers because Wall Street has said to them 'we're going to jack your stock price if you get a lot of subscribers'."

"Maybe I'm old fashioned, but where does value and profitability come into play? If you're losing lots of money by taking movies straight to streaming services, how long does that last as a smart business model? How long are you comfortable losing

money while gaining subscribers? We know theatrical windows are good for business. Actors know that, filmmakers know that, talent agents know that, and any studio executive who has been in the business for a long time knows that too. But if the holy grail is streaming subscriptions, the whole idea of trying to make money on a product gets tossed out the window" [ibid.].

The challenge for traditional distributors

Speaking to the analyst and commentator Mike Gubbins, the experienced US distributor Tom Quinn, who launched indie operation Neon in 2017, explained that: "More than ever, cinema is where *movies* are watched, it's not just content … There's no such thing as 'virtual' cinema … it takes place in theatres. Parasite was a fine example…" [5]. Addressing the challenge facing independent distributors, Quinn stressed that, "It is imperative not to be sentimental or paralysed. We had to release new movies despite the closure of cinemas and grow an ultra VOD model." What Neon developed was a VOD model with "skin around the film. We wanted to avoid the digital abyss … just being online does not mean you are found." 'Skin' meant sharing revenues at a 50 per cent cut with partners. Neon built a network of 250 partners for *Spaceship Earth* to help extend the opportunities to other businesses: Stores, museums, bookshops, retail and newsagents all helped the title gain a wider reach and recognition – creating and finding a community. Neon achieved an eight-week turnaround on *Spaceship Earth* (compared to the typical 90 days), and satellite and cable all participated in addition to a range of VOD platforms. This example is "proof that the streaming model can be combined with the transactional model", Quinn pointed out, explaining that with the right strategy and paying attention to exactly what you're doing you can limit cannibalization. It's a challenge to place new types of films online, and it's too early to tell if COVID-19 has helped diversity (and nobody is helped by a lack of transparency in data, although smaller platforms are much more open), but ultimately "we have to find the best cinema we can find…" [ibid.].

Imitation as a form of flattery

Leaving the theatrical conundrum to one side, Netflix and other leading streaming platforms are also facing competition from more regional and local Over-the-Top streaming operations. The most successful route appears to be one whereby investing in original and local content can pay dividends. Propelled by the pandemic, there was a rise in the number of subscribers to online video services in Western Europe, who in 2020 overtook pay-TV customers for the first time. However, the dominant streaming providers are from the US. Out of the 140m+ video-on-demand subscriptions in Western Europe, nearly 90 per cent are with US services such as Netflix, Amazon Prime and Disney +, according to Ampere Analysis estimates. "While Hollywood used to sell films and TV series to European broadcasters, US streaming services now hoard their best content, building relationships directly with European consumers and muscling incumbents out of their way. Netflix is ramping up local productions such as *Dark* in Germany and *Lupin* in France (see Chapter 17: Netflix case study), using an estimated global content budget of $17bn in 2021 – almost eight times the BBC's TV spending, and 12 times that of ITV" [6].

A Nordic challenge

In Scandinavia, one Swedish-headquartered company is holding up rather well. Nordic Entertainment Group (Nent), armed with a modest $1.5 billion turnover compared with Netflix's $25 billion, is making a fist above many others across the European continent by holding its own. From a rising base of three million subscribers, Nent's Viaplay streaming service, which offers a mix of premium sport and original entertainment, stands second to Netflix in Sweden, Denmark, Finland and Norway, where Ampere estimates that the US service has about 4.2m customers. "When it comes to revenue from those markets, Nent says Viaplay – whose packages with sports are higher priced than Netflix – actually generates more than its US rival. Nent chief executive Anders Jensen: 'If you don't copy some [of Netflix] with pride, then you're making a mistake' [5]. Nent is leaving the big pay-TV conglomerates such as Sky TV or Vivendi's Canal+, alongside commercial broadcasters such as RTL, France's TF1, Mediaset of Italy, and the UK's ITV well behind. Jensen explained that most European rivals are "very conservative: On a scale of 1 to 10 – where 10 is full readiness to go head-to-head with the US giants – I think most are at, maybe, a strong two. That's the unfortunate reality of it" [5]. Nent was quicker than some in Europe to make the streaming switch, in large part because of its relative weakness. While its founder Jan Stenbeck pioneered Scandinavian commercial television in the late 1980s, by the time Jensen took over what was then called Modern Times Group in 2014, its television arm was lacklustre, the second- or third-ranked player in most markets. "The decision was more obvious to us", said Jensen. "If you have 99.9 per cent of your revenues coming from advertising, it takes a lot of guts to move to a low-priced subscription video-on-demand service. You will have to go through a lot of pain. It is not for everybody."

Through its Viasat pay-TV business, Nent also had established a pan-regional footprint and a reason to invest in a streaming platform that could easily stretch into new markets and languages. Like US media groups, it began to ramp up production of original drama shows such as *Alex* and *Veni Vidi Vici*, and held back some content from international sales. Venturing out of its home market – sometimes as a specialist Nordic drama service, as it planned to launch in the US in 2022 – Nent is aware that only subscriber scale will allow it to reap the benefits of a streaming model and sustainably defend its home turf. "We have to go international to be relevant in five, six, 10 years' time", Jensen explained, who is now planning on expanding the Viaplay service into 10 new territories, aiming for 10.5m subscribers in total by 2025, with 4.5m outside the Nordic region. Investors are behind the plan: the group's shares rose 50 per cent during 2020–21: "If you don't copy some [of Netflix] with pride, then you're making a mistake", concluded Jensen.

Local European operators have strong assets: a flow of new local, culturally specific programming, which is a key offering to bring viewers to their platforms, as explored in more detail in the next chapter. Meanwhile, the major US and Hollywood licensors are holding back their top programming to drive their own operations, making American shows and films scarcer. Mergers such as the Disney acquisition of Fox and the more recent May 2021 deal between Discovery and WarnerMedia mean, by example, even less pickings will be available in the future [7]. Production costs have risen, and are continuing to rise, thanks to the streaming wars and the Coronavirus pandemic. "Nent shows that you don't need a telecom operator behind you, you don't need a

US owner", said François Godard of Enders Analysis. "If you are single-minded on the transition, you can do something, even if you are in a small market, even if you don't have the money to create drama series at $10m an episode" [5]. Nent clearly indicates a strategy and a route forwards for those smaller, less armed streamers (and broadcasting incumbents); but they will require nerves of steel if they are not to slip into irrelevance and invisibility.

The war chests: a free-for-all spending spree?

The level of money being committed to fresh content was reaching new highs by the end of 2021, and there were no signs on the horizon that this was abating. Investors were and will continue to demand that the major players are consistently adding subscribers or monthly active customers in order to justify their enormous outlays on content and platform launches. As Variety noted [8],[2] "all the major conglomerates are pouring billions of dollars into original programming and forgoing sales in order to feed internal platforms". The below charts show where those levels of spend sat in 2021, and where they are projected to go by 2024 (Figures 16.2 and 16.3).

What's interesting in the above data trends is not just the growth of commitments in what is projected, but what is missing. What might happen if there is further consolidation, including major mergers and acquisitions? What if Netflix's model (see Chapter 17) does not continue to convince its shareholding base that a sale might be in their best interests? And what if viewing behaviour shifts away from its current trends

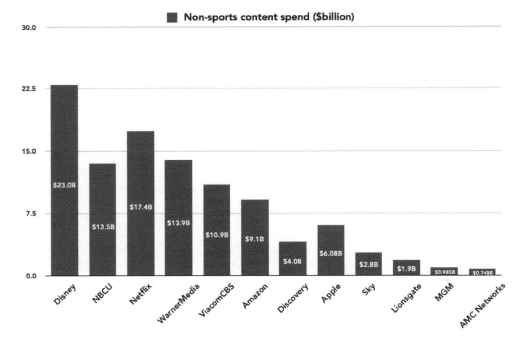

Figure 16.2 Estimated content spend 2021.

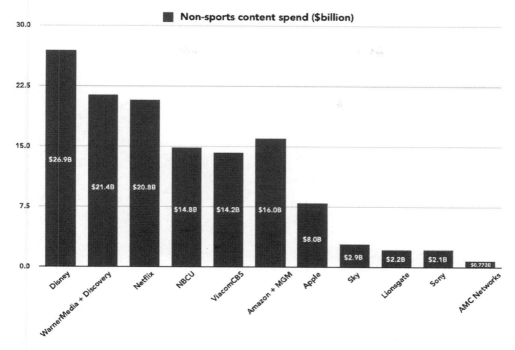

Estimated Content Spend of Major Media & Tech Players in 2024

■ Non-sports content spend ($billion)

Figure 16.3 Estimated content spend 2024.

and the programming and commissioning decisions become increasingly alienated from the audiences they intend to capture and keep? The below chart (Figure 16.4) capturing the most attractive features that audiences rate with regards to Video On Demand services, is enlightening.

For example, if 35 per cent of the respondents rate a VOD platform as offering the "shows they want to see", where does that place the remaining 65 per cent who are perhaps less certain of their intended menu? And binge-watching shows no sign of dropping off, coming in high at 34 per cent – but perhaps tipped by the timing of the research being in sync with the pandemic? No advertising ranks relatively high at 23 per cent, yet much of the future of online streaming is set to be driven by AVOD according to wide reams of reports and data across the media industry. And it's not just AVOD set to expand, but a range of sponsorship, corporate-backed material, branding and cross over and transferable elements from online platforms that will drive growth and customer interest. Meanwhile, online gaming is already going 'downstream' with subscription platform and virtual live experiences spanning out across the video game industry. Netflix turned heads in the summer of 2021 when it announced its appointment of former Electronic Arts executive Mike Verdu as vice president of game development. "We view gaming an another new content category for us, similar to our expansion into original films, animation and unscripted TV", confirmed co-CEO Reed Hastings in his July 2021 shareholder letter [ibid.], confirming that Netflix would not be charging additional fees or rates for access to its upcoming

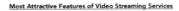

Most Attractive Features of Video Streaming Services

Q: Please select your top 3 reasons for watching SVOD (Subscription Video On-Demand)

Has the shows I want	35%
Binge-watching	34%
On-demand access	31%
No ads	23%
Keeps me entertained	21%
Original content	19%
None of the above (or not applicable)	18%
Ease of use	17%
Exclusive content	16%
Better than cable	15%
Low cost	13%
To pass the time	12%
Easy search	9%
To catch up on TV	8%
Popular programs	8%
Background noise	5%
It's like regular TV	4%
Live sports	3%
Other (please specify)	3%
Favourite service	2%
Channel surfing	2%
Right amount of ads	1%

Figure 16.4 Most attractive features.

online gaming content. Ten years after Netflix's move into original programming and clearly the platform feels it's time to spread its content wings ever further and higher.

Back to the future

Much of the future of the entertainment industries via online screens will be dictated by demand: namely, how customers around the world – whether we call them users, audiences, or indeed 'members', as per Hasting's description of Netflix's 222+ million customers worldwide – will behave and respond to limits on their time and purse. But clearly a range of content is going to be critical: armed with scale, quality and talent, the leaders of the pack will inevitably force other contenders out of the mainstream market. That does not mean that the game is over for smaller, niche players, as evidenced by Mike Gubbins' excellent 2020 report into the Evolution of a European VOD Sector [9].[3] However, alongside the attraction of choosing content on a streamed screen, next to how compelling that content is to the customer, a more subtle mix of local, authentic and resonant stories, and the way they are told and sold, will also be telling. Audiences, as the history of entertainment has borne out decade after decade, are notoriously fickle. They will vote with their fingers that press buttons, motivated in many more than one way.

In total, the above analysis provides a challenging matrix for any organization to attempt to get correct, and demands will shift inexorably over months and years. But what's clear is that the streaming wars have started, and yet they are far from over at the time of publication of this book. As the French novelist Gustave Flaubert stated

back in the 19th century, "The thought of the future torments us and the past is holding us back; that is why the present is slipping from our grasp" [10].

Notes

1 According to Kantar Media, 74.6% of US homes (nearly 96 million), had at least one video-streaming subscription by mid-2021: Variety, 07.21.21.
2 Variety (Weekly Ed.), "Growth Spurt Sputters", 07.12.21.
3 EUROVOD report, 2020.

References

[1] The Nordic Film Market report, revealed at the Goteborg Film Festival, 31/01/20.
[2] *The Economist: The Future of Entertainment*, 16/11/2019.
[3] Anna Nicolaou, FT, 19/04/20.
[4] Jonathan Fithian, Variety, 28/01/15.
[5] Tom Quinn as talking to Mike Gubbins, CEO of Sampomedia, for a UniFrance online series about changing sales and distribution models in September 2020.
[6] Alex Barker, 02/02/21.
[7] Economist, Monster of a merger, 22/05/21.
[8] Variety weekly edition, *Growth Spurt Sputter*, p. 15, 21/07/21.
[9] 'Evolution of a European VOD Sector; EUROVOD report', author Mike Gubbins, 2020.
[10] G. Flaubert, *Letters*, 1821–1880.

17 "Catch me if you can"
The rise and rise of Netflix

> Think big. Start small. Scale up fast.
>
> (Silicon Valley saying)
>
> One of the most important qualities of a good leader is optimism, a pragmatic enthusiasm for what can be achieved … Simply put, people are not motivated or energised by pessimists.
>
> (Bob Iger, former CEO and current Chair of Disney) [1]

The abdication of rules

In the introduction to Reed Hastings' recent book *No Rules Rules* [2], the Netflix founder and co-CEO tells an engaging story about his and co-founding partner Marc Randolph's visit to the $6 billion video rental giant Blockbusters Texas headquarters in 1999. At the time, Netflix was running a small startup that allowed the consumer to order DVDs on a website and receive them through the US post. "I was a nervous wreck … that year alone our losses out totalled $57 million", recalled Hastings. "We suggested that Blockbuster purchase Netflix, and then we would develop and run blockbuster.com as their online video rental arm." The Netflix executives named their acquisition price, at $50 million, but they were flatly declined.

Two years later, Netflix went public. By 2010 Blockbuster had gone bankrupt. Nine years later, just one Blockbuster video store remained open of the previous $6 billion mega-chain franchise. Ironically, while Netflix was sending DVDs out through the post, Blockbuster didn't have a single DVD on its store shelves during the first four years of Netflix's infancy. As Hastings points out:

> Blockbuster had been unable to adapt from DVD rental to streaming … we had one thing Blockbuster did not: a culture that valued people over process, emphasised innovation over efficiency, and had very few controls. Our culture, which focused on achieving top performance with talent density and leading employees with context, not control, has allowed us to continually grow and change as the world and our members' needs, have likewise morphed around us.

"Netflix is different. We have a culture where No Rules Rules" [3].

DOI: 10.4324/9781003205753-19

The breakthrough moment

It took 13 years of attrition and team building before Netflix's breakout moment arrived. In 2010 the company launched in Canada, its first new territory beyond the US starting point. Up to that point, the company had engineered a hybrid model, straddling DVD online orders and delivered by the post, with a gradual roll out of streaming. But Canada's launch was a 'go for gold' via a streaming-only service. That launch day, the team was busy doing demos, so they did not track the numbers. "That night we got them and found that the number of sign-ups were like ten times larger than we'd thought", said Hastings [4]. "That was just shocking and I remember thinking: 'Gosh, streaming works!' That was the beginning of our great global expansion." A year later the company launched into Latin America and the Caribbean, followed by the UK, Ireland and Scandinavia the following year and France, Germany, Austria, Belgium and Luxembourg by the autumn of 2014. Today, Netflix is available everywhere in the world, other than China, Syria, North Korea and Crimea. At the time of writing, the platform has 200+ million subscribers and is continuing to build on those numbers despite a slight tail-off following Western territories' slow recovery from the Coronavirus pandemic that shook the world back in March 2020.

Game changing does not even come close to what the company has achieved over the past decade. It burst onto the original programming circuit in 2013 with an initial slate that offered *House of Cards* and *Orange is the New Black*. As *New York Times* columnist David Carr wrote back in 2014, "Netflix is the necessary figure in what will come to be seen as the year that television staged a jailbreak. Netflix, which was supposed to lay waste to traditional media companies, may have saved them instead" [5].

The emphasis on research and development

Some readers of this book will remember the days of intense viewer downloading dissatisfaction, prompted by annoying buffering, time lags to access movies, and a general sense that the film and longer-running drama was a tech-lag arena, beaten out by streaming's (and user's) obsession with YouTube-style shorts, encapsulated by 'cats falling down toilets' video clips.

According to Neil Hunt, Netflix's then Chief Product Officer, the key to the platform's rapid growth was the company's investment in the quality of streaming and picture excellence [6]. To ensure picture quality, the company invested in a purpose-built content delivery network (CDN), Open Connect. This is basically a series of servers that house Netflix video. The company, in turn, offers these to Internet Service Providers (ISPs) either to connect with internet exchange points globally or to install directly within their own networks. "We can pick a choose which of several different versions of video and audio to request and deliver, in order to get the best picture that your particular internet connection is capable of", explained Hunt. "We spend a lot of time trading off how quickly and aggressively it shifts up to higher-quality levels, and how much buffer retain, so it never stops, never freezes and doesn't interrupt unless there's absolutely no alternative." Of course, overall progress in broadband speeds and width – albeit varying across different international footprints and territories – have also catapulted what Hastings likes to call "click and watch".

The second (and much-discussed across the industry) point of difference, at least by the mid-2010s, was the use of data: Netflix's development and use of algorithms.

The employment of such micro data is not just used for subscriber recommendations: today it's utilised across all sorts of programming and commissioning choices without allegedly getting in the way of risk-taking and exploration of concepts, genres and ideas [7]. What occurs in practice is that each title on Netflix is tagged and cross-referenced with a huge range of global viewing data, including, of course, what each viewer watched, but also, critically, how exactly they watched the said programme. How long did they last? Did they complete the show? Did they binge watch all 10 episodes? Did they fast-forward or rewatch segments of the programme? Did they repeat watch the entire film or series? Now the person themselves has become the target and resource, not just the wider and more opaque demographic target(s) and data. Crucially, the tyranny of the fixed schedule has been lifted: the rules of linear television where a programme's likelihood of being watched depended almost entirely on what went right before has ended.

Data are used for budget spending but also 'audience prediction' – involving multiple factors, including cast, director, genre, prequels, and prior screening information and figures are captured and analysed. Data mining also plays a critical role, where each individual's Netflix page(s) are designed to reflect their viewing tastes, trends and likes. Within that, more information has been structured to lead the customer around that first page, with top 10s per territory, top 10 pick lists, "popular on Netflix" lists, along with the rise of not just one-off documentaries, but documentary series' which have proved highly popular. Netflix also introduced new upcoming content so that viewers could see what to potentially look forward to (and, of course, thereby ensuring customer engagement and loyalty). Mining also uses a viewer's Netflix "doppelgänger" – a person who could be anywhere where the platform is available, who binges on *The Queen's Gambit*; watches *The Witcher*, but also views a David Attenborough documentary nature series. Netflix reviews the programmes that the "doppelgänger" has watched (while their similar viewer has not yet got to those programmes) and recommends them to the primary subscriber.

Commissioning and handling the creative process

Creative freedom and the danger of interference are potential negatives of which the Netflix culture and teams are acutely aware. Predictive data, if applied relentlessly and solely to commissioning models, could lead to a dangerously dull, homogenised range of so-called Netflix "originals". In counter to any suggestions that Netflix impacts on the creative process via application of algorithms, Hastings is on record as stating that the artists have full freedom: "We want the artists that Netflix commissions to have creative vision and not to assemble a bunch of sugar candy or car chases."

More recently, following his appointment as co-CEO in 2020, Ted Sarandos expanded on the ever-evolving commissioning process [8].

> If we were going to really realise this global vision that we had, [then] you have to be very careful about not bottlenecking decision-making. My role went from picking all the programming that used to be on Netflix to picking the people who pick the people who pick the people [who pick] what goes on Netflix.

Sarandos explained that you cannot scale an organisation if you have some "false sense that you have to have your fingerprint on everything that happens". He pointed

to the major drive into animation, at a level of some six features a year (which no Hollywood studio has ever done previously): "the only way you could do that is to have a really trusted team, who will make decisions and take them seriously and own them".

The Hastings approach to management and organisation

Back in 2009, Reed Hastings compiled a 125-PowerPoint slide deck, encapsulating his innovative management philosophy. It has been viewed more than 20m+ times since he posted it online more than 12 years ago. The deck also formed an essential basis for the book *No Rules Rules*, referenced at the start of this chapter [9].

Netflix's management has been built on the "rock-star principle" – a well-documented Santa Monica study that saw one performer out of nine more than 20 times faster at coding, 25 times faster at debugging and ten times faster than his colleagues at programme execution. "We focussed on having the top performers in the market, [but] I knew we didn't have the cash to lure them away in any numbers", explained Hastings [10]. "I found having a lean workforce has side advantages. Managing people takes a lot of effort. Managing mediocre performing employees is harder and more time consuming." Hastings added other notable exceptions to typical company rules: Holidays are allowed to be taken at any time at the discretion of the employee; and expenses do not have to be pre-approved as long as both decisions are "in the best interests of Netflix".

Management and staffing's liberal self-empowerment (under the self-editing rule of 'best for Netflix' of course) is only one part of the Netflix revolution. The most impressive is the company's ability to generate value for money from its employees. According to research by the *Economist* [11], 7,900 employees each generate $2.6m in annual revenues on average. That is nine times more than Disney. Each employee creates $26.5m in shareholder value, which is three times more than Google's management and foot soldiers manage. Clearly Hastings is on to something genuinely powerful.

The programming and curating challenge

Up until the pandemic, Netflix depended on just a few original shows to drive new subscriber growth, but as Figures 17.1 and 17.2 show, their own programming started to take hold. Nevertheless, the company appeared vulnerable to the future success of such mega-hits, which are statistically extremely hard to find select, commission and deliver. The company was – and still is – facing significant competition from the world's largest media companies, who are all chasing hit-driven material. In particular, Disney's library and control over some of the world's biggest franchises has had an impact on Netflix's subscription levels, especially when combined with undercutting subscription pricing. Analysts suggest that what is a stake in the overall streaming wars is winning the concept and application of "LTV – the Lifetime Value of the audience member" [12]. The studios have been forced to spend huge sums of money marketing blockbusters. Jones references *Spectre* (2015), the Bond movie that had a marketing budget of $245m: "They have to spend big as they do not have long lasting relationships with consumers … The current model does not allow for sharing of customer data between all units." However, streaming services allow you to establish a direct relationship with the consumer and you do not have to re-market per film. The LTV

Figure 17.1 Netflix stats.

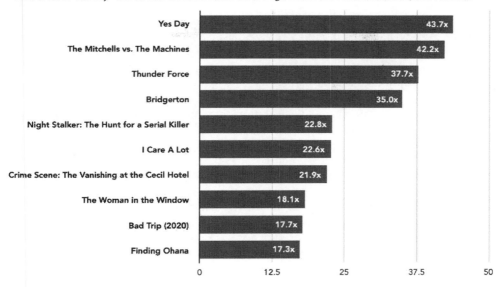

Top Netflix Titles in H1 2021

How to read: *"Yes Day" was viewed 43.7x more than the average Netflix title TVision measured, Jan.1-June.30*

Figure 17.2 Top Netflix titles H1 2021.

of a consumer allows for either linear or an upward curve (if price changes). Amazon Prime members spend average of $1,400/year on the platform, a value per customer much higher than Netflix; while Apple has music/computers/software to 'upsell' to streaming customers and Disney can rely on a 360 degree business model armed with long established merchandising, theme parks and a range of franchise-driven IP and entertainment brands etc.

The worldwide approach to local content

In 2020, Netflix made the radical decision to buy a very small police show called *Capitani*, made in Luxembourg by Samsa Films initially for RTL television. Set in a traditional Duchy village with Machiavellian priests, bossy bakers, gossipy grocers and tormented teenagers, the screenplay was written for local acting talent in mind as the talent pool for 'Luxembourgish'-speaking actors is … limited. *Capitani*'s outstanding viewing numbers helped the local show rise to join Netflix's top 10 among its 200 million plus subscribers in the Spring of 2021, according to FlixPatrol, a streamer rating service. "It's a huge, huge thing", explained *Capitani*'s producer, Claude Waringo, who has enjoyed a remarkably successful career across film with 120 features and prizes at Cannes and Venice. "Nobody really believed it was possible" [13].

By 2020, some ten years after its initial launch in Europe, Netflix had started to commission more than 60 per cent of its exclusive TV and feature programming beyond the English speaking market, according to Ampere Analysis. "We didn't really know if Netflix and Amazon and Disney would eat us up, the whole European system", explained Waringo. "We know that the streamers will totally change our world.

It's not easy to understand where it will go" [14]. According to Netflix, translated viewing of foreign language content has risen fourfold between 2017 and 2020. It's not just new so-called "original" content that has made the switch. Shows such as the Nordic *The Bridge* and *The Killing*, both ambitious hits across Scandinavia in their initial local runs, had a fresh global liberation once Netflix decided to take them on.

David Kosse, Netflix's very experienced London-based head of international, explained to the *Financial Times* [15] that his team are constantly reminding European and international content makers to

> be ambitious in your theme. Be ambitious in your production values. And we can give you a global audience … There's no reason an Italian movie can't have the scope and scale of an American one. There are crews there. The talent is there. What we're learning is that when you have the money, people go: 'Oh, it wasn't the Americanness I was attracted to, it was the scope and scale'.

Winning global audiences no longer starts with the mature and oft-times xenophobic North American marketplace. Winning local audiences and converting them into life-long customers is dictated by culturally specific content.

Netflix's specific commissioning behaviour is not always as encouraging as the above fresh wave of international content might suggest. Writing in later 2021, numerous territories reported that they cannot raise development cash from Netflix unless they already have a very mature, well-formed package, including screenplay in advanced draft (or one/two scripts for a longer TV series), trusted production company, sometimes the director(s) attached depending on the taste of the commissioning editor, and a host of visual supporting material. Engagement and development access appears to be on a case-by-case, territory-by-territory basis. Meanwhile, some of the commissioning editors from Netflix on the training circuit are banding around some of the most quasi-scientific decks on series development known to humankind. One such document was seen by the author in early 2021 and left him none the wiser. When shared with a top writer, they laughed and agreed that trying to commission by numbers never worked, and nothing's changed on that front. But what is it really like working with Netflix?

Working with Netflix

Finding out direct and reliable information about what it is like working with Netflix has been notoriously difficult for practitioners and researchers alike. However, both the referenced and anonymous sections of the MBI Broadcast Intelligence report [16] offer the most interesting and revealing insights, contained in an excellent research study into how producers and distributors find working with Netflix. When asked, "How does the deal making process compare to traditional players?" One producer explained:

> They had more aggressive business affairs demands. They were very hot on liabilities; someone did say to me when querying something, 'we want to know who we're going to sue'. The reality is that these are hard-edged negotiators but they are open to being negotiated against. They are firm but fair. They might duff you up, but they will respond in proportion if you stand up for yourself.

Another producer commented: "They are pleasant but tough negotiators; it's better than dealing with inept negotiators. They are getting tougher on money and a little bit more flexible on rights … less one size fits all."

A further respondent praised the model, celebrating the freedom in form on offer: "As you're liberated from a slot, you can give the story the length it wants. You're not tied. They are very good about letting the narratives have the length they require … that's one of the big pluses." However, one of the recurring themes across the industry is that Netflix does not fund development. "There wasn't really a development period. We had an idea, we took it to them … and once the deal was in place we were up and running. We didn't have an experience of them having to fund development. We developed it up to the point that they got involved." Received wisdom is that with outside talent that the company has actually bought into directly, Netflix will track interesting projects but not step in until a project has been developed to an advanced, finance-ready level. That puts considerable pressure on the production company to be well enough financed and organised to reach advanced development – including, for example, screenplay(s), treatment(s) and proof of concept visuals – before Netflix may move to make an offer. Inevitably such an approach enables well-established players to gain access, while emerging producers can find the process frustratingly alienating.

The biggest challenge facing Netflix outside its financial model – which has been improving steadily throughout the past three years (see below) – the challenge of positioning and marketing. The biggest issue is marketing, and MBI report's analysis of Marketing and Feedback reported:

> Netflix's marketing methods divide opinion. Some producers were impressed by Netflix's targeted approach through the use of their algorithm and tailored programme artwork. Others highlighted Netflix's over-reliance on an automated approach for reaching an audience as a weakness. A number of respondents felt Netflix did not spend enough on campaigns to market a specific show …

Netflix seemingly struggled with, or gave a lower priority to, content that was either very specialised or very local in these cases [of criticism]. Companies who had a great time creatively and were supported at a high level with budgeting and timely payments, nevertheless voiced concern over the launch period:

> One of the biggest disappointments was that after delivery, when they were not so impressive. That's when they started to rely on their algorithm – thinking that they can take it automatically to the right audience. They also fell into the trap of thinking that they could create the marketing materials and trailers in-house, whereas we know where all the good stuff is. On the PR side they were very uninspiring and unimpressive. Their marketing spend was also minute. Netflix is absolutely brilliant from a filmmaker's perspective but it breaks down when it gets to the release [17].

None of the producers indicated that they received any detailed performance feedback. Some respondents were told that Netflix was happy from a creative standpoint, but they received no viewing data concerning the show's performance, which would have enabled a more direct comparison to a traditional linear audience. What was clear was that recommissioning was the acid test of success.

Turning to relations and best practice with distributors, who are often acting as both sources of content, co-financiers and producers and aggregators, the general trend was positive: "Netflix's ability to move quickly is noted by a number of the distributors. Overall, the picture emerges is of a finely tuned and highly efficient content machine, staffed by seasoned TV industry executives." Leading global distributors, such as All3 Media International, were an early client, and did a major library deal in the US and the UK and were a key partner in the launch of Netflix's UK service. The company then moved into co-productions, including *Traitors*, *Collateral* and *Requiem*. Business then evolved to also include unscripted programming and formatting business. Scripts and talent tend to drive their appetite, according to Paul Corney, SVP global digital sales and co-productions at All3. "To confirm Netflix as partners is always pretty quick – they are very committed to the projects at an early stage ... [and] the fees Netflix were offering were very competitive."

For acquisitions, Netflix will sometimes acquire for a specific territory or group of termites and that's an audience-driven decision. According to Endemol Shine International's Cathy Payne, Chief Executive Officer:

> We have shows that they license for the UK, just because they do very well for them in that market, but they don't see an audience for them beyond there. On anything that's an original or co-production, yes they are [seeking] global rights.
>
> The one thing I would say in particular about Netflix is that they track everything. They know what you're up to and they track it through you, they'll track it through your producers, they want information on how to do that. The people I talk to at Netflix have always been very informed – they know writers, they know directors and you can talk that language.

According to Payne, there have been some surprises: "They passed on *Black Mirror* in the first stage, as did everybody else. I think it's interesting because they did pass on it many times. Then we sold it to the Audience Network in America for the first run and then somebody at Netflix said: "I might pick up a non-exclusive second window", and they put in on in the US, It did really well and they were really surprised. Then they picked it up for other territories. I think *Black Mirror* was one of those shows when it first came out – Charlie Brooker was way ahead of his time. People were really nervous about it. So that's done well for them." Ultimately, Netflix is now treated as another major player and its business as usual for leading distributors: "Demand drives the price. The market will pay what the market pays, and Netflix is no different."

Back to the future

Like it, love it, or hate it, Netflix has changed the course of the worldwide entertainment industry in the 21st Century. The sheer level of energy, focus and commitment enshrined from its leaders to lenders – as demonstrated by this case study in spades – is admirable and, for the majority, beyond reproach. As leading industry commentator and story practitioner Jeff Gomez has explained:

> "Global streaming platforms such as Netflix have embraced the necessity of making content that is more representative of its expansive customer base. This is

helping drive a more culturally decentralised film landscape and grow demand for a much wider range of story-perspectives."

However, there is much work still to be done. "The dominance of the global platforms also represent a bottleneck and not all types of stories are going to be accepted in these channels. How will independent storytellers reach their audience and build careers in this environment? Will a growing diversity of stories be matched by inclusive, ethical dialogue with audiences? And, perhaps most importantly of all, can film move to genuine sustainability?" [ibid.]. Hastings and Sarandos and their multitude of talent are no doubt pondering not just today's challenges, but how best to do the right thing for tomorrow as well.

References

[1] Iger, R., *The Ride of a Lifetime: Lessons in Creative Leadership from 15 Years as CEO of the Walt Disney company.* Bantam Press, 2019.
[2] R. Hastings and E. Meyer, *No Rules Rules.* London: WH Allen, 2020.
[3] Ibid. [2].
[4] Wired 02/15.
[5] Ibid. [4].
[6] Ibid. [4].
[7] Working with Netflix Broadcast Intelligence report 2019.
[8] Ted Sarandos, Variety, Art Streiber, 10/09/20.
[9] Ibid. [2].
[10] The Times *The Netflix CEO Reed Hastings on His Rules for Hiring the Best and Firing Them Quickly* 07/09/20.
[11] The Economist, 09/11/20.
[12] Richard James, *Hollywood's Broken System and the Three Letters That Will Save It,* 11/05/20.
[13] Financial Times: Foreign Affairs, 13/06/21.
[14] Ibid. [13].
[15] Ibid. [13] p. 34
[16] MBI Broadcast Intelligence Report, 2019.
[17] Ibid. [16].
[18] Gomez J. *Future of Film* Ibid

Netflix, Amazon, Disney
- They have cut those lines off from setting cultural trends
- Rogue films that people didn't know they needed

Through an all-xo vetting process
- It's too difficult to get in.

18 "Fandom land"
The Chinese star system

> Wealth and obscurity cannot equal poverty and fame.
>
> (Chinese Proverb)
>
> Even if you get countless fans for a while and your fan club is full, there is no way to develop steadily over the long term [without] constantly cultivating your own morality and character.
>
> (Keynote speech by Hu Zhifeng, Beijing Film Academy's vice president and deputy Communist Party secretary, September 2021)

China's rich cinematic history has, notably, been driven in large part due to the skills and depth of female actors. From the 1920s through to the Cultural Revolution, Chinese mainland stars tended not to travel beyond borders, but since the 1990s have spread in influence and popularity to Southeast Asia, Europe and the United States. This stage marks a period when the star system in contemporary China became established, with female stars most often matching male peers right up to the start of the Coronavirus pandemic of 2020–21. This chapter explores the background that has shaped Chinese acting talent, before examining the rise of celebrity, fame and fandom, and the People's Republic of China's (PRC's) redrawing of the 1.4 billion-strong territory's complex and fragile social contract at the start of the 2020s.

The star making routes to fame

There are numerous methods at hand to cultivate and manufacture stars in the fast-expanding Chinese entertainment marketplace. Some are educated through orthodox universities, while others are discovered and developed through China's own version of a talent agency system. A few break through to fame at a young age, and some have maximized their career growth through savvy use of the internet, social media, gossip and building fanzine bases (see below re "backlash"). The method of "school training" mainly refers to a group of universities, represented by the Beijing Film Academy and the Central Academy of Drama, which predominantly teach film and drama. This type of school has a more detailed division of film majors, with special performance majors, and this focus has greatly aided the development of actors at the early stages of their careers.

DOI: 10.4324/9781003205753-20

Some influential stars in China belong to those who have received orthodox performance training, including, for example, Gong Li, Zhang Ziyi, Tang Wei, Xia Yu etc. The list of accolades are extensive: Gong Li won the 49th Venice Film Festival Best Actress for *Story of Qiu Ju*, Zhang Ziyi won the 2006 Golden Globe Award and Academy Award for Best Actress nomination for *Memoirs of a Geisha*, Tang Wei won the 61st Cannes Film Festival Best New Actress for *Lust, Caution*, and Xia Yu won the 51st Venice Film Festival Best Actor for *Sunny Days*. However, due to China's special historical and political environment, the cultivation of talents in universities generally took shape only after 1980. As a result, most of the stars trained by this method are relatively young, and mostly seen after the 1990s.

The background to the agency training

Hong Kong developed and used the agency model in the 1970s and onwards as represented by TVB Hong Kong, which mainly deals with the TV business and also signs contracts and trains artists. A training class for TVB artists was set up in 1971 to train stars such as Chow Yun-fat, Andy Lau, Tony Leung, Stephen Chow and Donnie Yen [1]. After 2000, mainland China has cultivated more stars through this model, but the role of key filmmakers and executives cannot be underestimated. Those rising stars during this phase included Fan Bingbing, Yang Ying, and Zhao Liying. Fan Bingbing, by way of example, was born on 16 September 1981, in Qingdao, Shandong province. In 1996, she was admitted to Xiejin Film And Television Art Collge Of Shanghai Normal University. At university, she acted in the TV drama *Strong Woman*, directed by Liu Xuehua and was recommended to filmmaker Qiong Yao. In 1997, she took part in Qiong Yao's drama *Princess Pearl* and signed a contract with Qiong Yao's agency. In 2000, she signed a contract with Wang Jinghua Company. At the end of the year, Wang Jinghua became the general manager of Huayi Company, and Fan Bingbing also joined the company. Just six years later an entire Fan Bingbing Studio was established.

Zhao Liying's entry into the film and television industry was more a result of coincidence than strategic planning via any agency or studio. She did not graduate from an art college. Instead, she was chosen by director Feng Xiaogang for a commercial. In May 2006, she participated in the competition jointly sponsored by Yahoo, Zhe Jiang TV Station and Huayi Brothers, and became the leading figure in the Feng Xiaogang group through her personal performance and the support of voting netizens, thus officially entering the entertainment industry.

Agencies tend, therefore, to be somewhat reactive, and pick up talent after they've arrived rather than finding, discovering and building their early careers. However, there are also agency firms that will sign contracts for the secondary development and training of graduates from the Beijing Film Academy, the Central Drama Academy and other institutions. Under this mode, the cultivation of Hong Kong stars is slightly more mature and its influence is relatively broad. Quite how politics and the unrest between mainland China and a re-shaped Hong Kong will impact on the movement of actors and their ability to travel remains to be seen.

Child stars

Child stars have always been the focus of attention. Jackie Chan and Hong Jinbao are both child stars. Chan, for example, took Yu Zhanyuan as his "master" at the age of

6 and played Li Lihua's son in the film *Big and Small Huang Tianba* at the age of 8. Hong Jinbao is a famous senior brother of Hong Kong's *Seven Boys*. He starred in his first film, *Love Education*, when he was just 9 years old [2]. Many stars bring their children into the industry through film and television exposure and early experience. Teenage fame is beneficial to the actor's future growth, but it also has both advantages and disadvantages.

Not all child stars become stars simply because of an early start. Because of the special existence of Chinese martial arts, such as *Seven Boys, Chan Brothers*, martial arts competitions have also become the cradle of kung fu stars. After taking part in the martial arts competition, Li Lianjie went on to appear in the film *Shaolin Temple* [3]. At present, online variety shows and social networking software are very developed. China's online variety shows often follow South Korea's example and produce reality shows, such as Iqiyi's *Idol Trainees*, to cultivate new stars through the excavation of new talent.

(More recently, there has been a long arm of intervention from the PRC. In 2019, the State Administration of Press, Publication, Radio, Film and Television (SARFT) issued the "Regulations on The Administration of Programs for Minors" to prevent the publication of stories about celebrities' children. And then in September 2021, the National Radio and Television Administration also announced that children (including adults) of celebrities, are not allowed to participate in variety shows and reality shows.)

Star packaging and the issue of trust

Just as Hollywood has, to a large extent, industrialized acting talent, stars are seen by the Chinese entertainment industry as commodities. As analyst and historian Jiangyan Chen explains: "Use the actor's popularity and acting characteristics to win the bargained commodity value, and select stars from the masses that satisfy the seller's market to participate in the system of survival of the fittest" [4]. The challenge is how to package and develop a star and create an image that is accepted by the public. A key starting point is online exposure. "The so-called 'packaging' process reflects the values of a highly commercialized society. There are 'fixed patterns for some film stars, and that underlines the social contract between actor and audience'" [5]. It can be argued that a value chain model helps to form and create stars. A packaging economy and power system, driven by the audience's acceptance of a star's social value and status, reflects an interrelated, influential and bundled system.

However, China operates a very competitive market and certain components regularly experience re-correction for a range of reasons. In the case of the Chinese system, recent abuse of power has damaged some mainstream stars' image and status, and interfered with the audience's respect and loyalty. This, in turn, has led to acute pressure on the packaging model, in part due to the collapse of social values and issues of trust.

The 2018–19 international scandal surrounding top Chinese icon Fan Bingbing and her alleged tax issues is a clear example. The very public naming and shaming of the star led to fan groups attacking her on the internet, and spread to a general, wider distrust of privileged and super-rich talent. Typically, any public assault on a star's packaging image makes him/her vulnerable to losing market value and alienated from its inherent and/or intended audience. Subsequently, the economic status and social

power of the star is directly affected (see below: The Big Change). Commercial companies, including agencies, studios and leading producers, tend to develop individuals according to the highly controlled packaging model, and stars cannot (or at least are not expected to) have personal values. They must be strictly monitored and developed according to the image given by the agency and those that pull the strings.

Most of China's stars develop through work and exposure in film, television and music, while a few stars concentrate and specialize in a certain field:

> Whereas Maoist thought required artists to unite with the masses, directors now merge with the commercial production and distribution units. Filmmakers take over not only directing but also advertising and promotion, and their work expands far beyond the artefact screened in theatres [6].

The trend has been for actors to develop all-round artistic capabilities theoretically capable of taking on a range of filmmaking responsibilities (or not, as the case often has proven). For example, Hong Kong star Andy Lau is packaged as an actor, singer, film producer and has other multiple identities. However, stars following the Lau model tend to start with a single sector skill, such as acting or singing, and once established than they gradually develop across branches. Chinese actors are most likely to develop in the direction of directing and producing because of their performance skills and heightened status. Therefore, many stars in China have no industry distinction, and stars have become a somewhat generalized concept. As a result, the development of stars in a certain field is not particularly prominent. All-round artists have high popularity, but offer few outstanding work. However, stars who have only made achievements in the film field in China often develop into world-class stars, such as Jackie Chan, Jet Li and Maggie Cheung.

Stream boys and girls

In addition, 'stream boy' has become a key word in the packaging of Chinese stars in the early 21st century. The definition of stream boy cannot be found on Wikipedia, but if you search for "stream stars", you can find some answers on China's websites. It is related to the word "stream", and stream itself often refers to the click-through rate of websites. If a star has high economic value and has many fans, this is reflected in a high level of internet stream (or 'traffic' and 'hits'). Therefore, stream stars use internet language to describe stars with rising or high levels of fame and fandom. China's stream stars are often young with high "facial" values (meaning acceptably 'good-looking' visages), with a large amount of discussion on microblog topics and numerous fans. Boys are called 'stream boys', while girls are called 'stream girls'. For example, Li Yifeng, Wu Yifan, Tang Yan and Zheng Shuang all have grown their careers via such social media cultivation. The building and packaging of stream stars tend to be around the "all-round" artist theme, so these talents are often involved in films, TV plays, variety shows, song lists etc. They have a high reputation in mainland China, and some of them have influence in Hong Kong, Taiwan and even East Asia, but their influence outside mainland China is often limited, and they do not have the perceived "qualities" to become international stars. The lack of excellent, high-quality film content (e.g. material) is also viewed as a common block to the progression of this kind of star.

A different star system

China's entertainment industry has a developed agency system, but one not nearly as mature and sophisticated as the English-language system dominated by Hollywood, New York and London. Since the late 1990s, as the Chinese star system gradually evolved, so too has the agency system stepped up, mirroring the commercialization and opening of the market [7]. However, Chinese agencies have suffered from somewhat uneven and immature roots. As organizations, they have lacked a professional system for training and knowledge capture – key factors that make the Hollywood and London agency systems extremely powerful and influential. Most agents come into the role via entertainment journalism, media editing, acting, singing, and from the staff of advertising and entertainment companies. Initially, many were "nanny-type" managers in the early stage of development, before then moving towards intelligence gathering and specialization with the rapid development of the film industry. The challenges facing the agency system has blocked the development and professional management of stars, and all too often it is wholly focused on the Chinese market rather than capable of building international profile and value for clients.

> Nowadays, many star agents adopt a one-to-one agency mode in China, and some companies implement a 'project responsibility' system, that is, the agent of the company does not manage a certain actor specifically, but is responsible for the actor according to the project [8].

In short, there are two modes between Chinese agents and stars, one-to-one and one-to-many. In the one-to-one mode, agents bet all their capital and efforts on a star, thus maximizing their profits if they have picked a winner. The one-to-many model is most beneficial to agents and agency firms. In this way, the company's interests can be maximized, rather than those of the individual talent in question.

> At present, most entertainment groups with a certain production scale in China have set up star agencies to raise the attention and influence of film and television works through the creation and packaging of new people. With the help of the group's network, advertising, cinema, music and other businesses, the multi-dimensional value-added of star utility can be realized [9].

At present, China's major agency companies or film and television companies that set up agency departments, including Huayi Brothers Media Co. Ltd., Orange Sky Entertainment Group, Hairun Qianyi Performing Arts and Cultural Development Co. Ltd., Rongxinda Film and Television Art Co. Ltd. etc.

Stars and agents are have a reflexive relationship, with the aim of mutual benefits wherever possible. The management of stars by Chinese agents is not only in relation to casting and contracts, but also in the personal management of the talent in question.

> Yu Li, head of Beijing Dongwang Agency Company, said frankly that after the actors become famous, it is very difficult to control what kind of acting agency they took on. At that time, the cooperation between the two sides is entirely based on feelings [10].

Stars offer huge potential value for agents, hence making the relationship between supply and demand unbalanced and not always in the alignment of interest. Therefore, after becoming a star, many Chinese actors often choose to set up their own business, either by starting their own company or by finding relatives and friends to act as their own agents. However, self-interest rather than strategy still leaves the agency industry somewhat irregular and unprofessional. Although the "family workshop brokerage" mode is still relatively popular, it is arguably not the strongest strategy for long-term and overall industry development.

How stars grow from reality "idol" shows bears considerable influence on the underlying values and business models abounding in the "modern" Chinese system. For example, Hong Kong star Nicholas Tse has pointed out that cultivating a Korean 'idol' requires a complete and strict training system, which takes eight to nine years. The elimination rate is very high, and the commission company takes most of the income of the stars through ruthless exploitation of contracts and IP in the form of image rights. By stark contrast, the Chinese 'idol' model requires just nine months of training of talent for them to start to make money. "There is no patience and no time to cultivate emerging acting and performance talent, which is a root problem in the Chinese star system", explains one film and TV series producer unable to be named for this publication. "In fact, this element is a problem whereby stars and bound contractually to entertainment companies, driving up the company's valuation with the intentional of being listed on the market as soon as possible, in order to deliver crazy cash."

The "fan economy"

The so-called 'fan economy' is the downstream result and product of star packaging, and the blisteringly fast rise of the internet in China. Stars are shaped into 'ideal' people, corresponding to the number of people who pursue and buy into this projected ideal. And it's intense: it's not uncommon for fans to watch films by booking the whole film theatre. The fan economy is dictated and driven by modern fan culture, which – in part due to the reach and speed of the internet and social media – dissolves traditional Chinese film culture, something that has not gone unnoticed by the Chinese Communist Party. Therefore, there are a range of filmmakers who seize on the bright spots of the fan economy and specialize in making fans films, such as the *Tiny Times* series. This acceptance of the fan economy and its over-exaggerated recognition demonstrates that Chinese films and the surrounding industry are insecure about how best to obtain economic status and commercial identity (let alone artistic quality) in the current society.

Stubbornly superficial and often driven by incompetent actors who insist on writing, producing and directing (and hence controlling), these 'fan' films are a far cry from the sophisticated, craft-driven auteur-styled films that emerged to the world in the 1980s and 1990s through the international film festival circuit. However, it is often argued that the Chinese fan economy is ultimately a bi product of the internet. Fans exist as both producers and consumers of the internet economy. Alvin Tov Le pointed out that "the boundary between producer and consumer will gradually blur, and the two will merge into a whole, giving birth to a new production consumer ('Prosumer'), that is, the combination of producer and consumer" [11]. Hence it's not surprising that China's burst of online films, online dramas and online variety shows

in the past decade or so are often hugely popular and successful. Multiple formats also enable wider exploitation: a variety show *Where Is Dad Going?* can also be adapted into a film to be shown in cinemas and earn a good return on investment, thanks to the economic effects of "Internet Plus" fans.

Stars act as the driving force behind this economic model, so, to a certain extent, it is fans who make stars, and stars who give birth to fans. Stars sell themselves to their fans through conveyed emotions, images, words and deeds, and fans give back the value with money to stars in the most direct and concise way. Therefore, Chinese film scholar Jenkins believes that,

> fans' position in the media entertainment industry has changed greatly. First, the affective economics has increasingly attracted the attention of the media entertainment industry, trying to understand the emotional basis of consumer decisions as the driving force for viewing and purchasing decisions [12].

Fans' economy is also characterized by group behaviour. "The association of community with a being that is already known precludes the becoming of new and as-yet unthought ways of being" [13]. Sociologist Howard Rheingold put forward the concept of Virtual Community in 1993: meaning people who break through regional restrictions and communicate with each other, share information and knowledge, and form a special network of similar interests and emotional resonance connected through the Internet.

Fan economy can be equated with an 'emotional economy'. Cornaire Sandworth [14] pointed out that from the perspective of text consumption, fans are fixed, regular and offer an emotional input into a popular story and text. "Fans" can also be understood through fascination and infatuation, which are the behavioural characteristics of fans. In other words, fans' economy just reflects the emotional consumption of fixed and regular things or stars in text consumption. They appear in groups and form a group. Stars, as products, can also be shaped into brands, thus having a relatively fixed fan base. Therefore, stars become the projection of fans' interests, desires and even self, with functional and symbolic functions.

The big change

By the early summer of 2021, something was up. Amongst a range of orchestrated criticisms and attacks on big business, internet giants and, in particular, gaming and celebrity culture, Beijing banned social media platforms from publishing celebrity popularity ratings and began to regulate fan merchandise sales. Broadcasters playing fan-orientated shows were no longer allowed to charge fans for voting for their favourite idols (as stars had become to be known). The fan club page of one of China's most popular actresses, Zhao Wei, had been taken down. The so-called 'clean up' and tighter regulations included the office of the central cyberspace affairs commission (CAC) announcing a two-month operation aimed at "fan quan" (fan club culture) which was said to have harmed the mental health of children. The commission published a 10-point list that was aimed at rectifying "the chaos in the fan community", and they halt online activities that "cause fans to bully each other". In a further move, the CAC issued draft regulations for internet recommendation algorithms – in a bid to stop those that encourage users to spend large sums or in any way that might "disrupt public order".

The crackdown also targeted individual celebrities, with a focus on alleged financial misconduct, with actor Zheng Shuang, for example, being fined £33m for alleged tax evasion and banned from appearing on any shows. Meanwhile, Variety [15] reported that following the arrest of Kris Wu, the Chinese-Canadian pop icon, on alleged rape and sexual misconduct charges, cases were going viral – ironically dominating the rankings of top each and hostage topics on social media. Clearly, the government is making it clear that it can reach anyone. On the other hand, numerous commentators pointed out that such high-profile cases in favour of women victims was a first for the Chinese culture.

China's fan economy, worth north of $15 billion in 2020, fed by more than 20 million active avid fans on social media platform Weibo alone, spend cash on streaming music, merchandise and concerts [16]. Shares of Chinese entertainment companies have taken a huge hit given the political and social disruption. Huayi Brothers, for example, dropped 46 per cent over a year to mid-2021; Alibaba Pictures dropped 20%; iQiyi – known as China's Netflix, and broadcasters of the country's top idol competition – was down 50% and few saw them coming back given the depth and weight of the crackdown [17].

The Beijing Film Academy's role in leading the moral purge

The long arm of the PRC and "instructions" given out to rising talent continued apace throughout the autumn of 2021, as the power struggle to control fandom "chaos" continued. The Beijing Film Academy, which was founded in 1950 during the nascent years of the People's Republic, marks the only public film institution of higher learning directly created by the state and the party. "Even if you get countless fans for a while and your fan club is full, there is no way to develop steadily over the long term … [without] constantly cultivating our own morality and character", BFA vice president Hu Zhifeng stated to a cohort of more than 1,000 students in September 2021. "I hope that you will be … respected by the world instead of slipping down to the moral bottom, appearing superficially grand for a while before being cast aside" [18].

After the string of celebrity scandals noted in this chapter, Chinese officials have told young filmmakers entering China's top film school that their foremost task is to develop the "moral cultivation" and consider themselves as key "art workers" in adherence to President Xi Jinping's strident philosophy. Hu urged students to become "shining stars" of humble virtue rather than blazing then burnt-out "shooting stars", and to avoid creating the "ridiculed, substandard works" that he said currently plague the industry [19].

Only time will tell if the BFA's revised approach to how it trains onscreen talent will impact on the fans of tomorrow.

Case studies

Data 1 The case of "My Sunshine"

My Sunshine was first published in *Jinjiang Web* as an online novel, which was serialized from September 2003. By 2018, the total number of hits on *Jinjiang Web* exceeded 18 million, and seven different versions of books were published. Since its publication in 2005, it has gone through 108 sold-out and 52 reprints. In 2015, the

TV series *My Sunshine* was launched on *Jiangsu Satellite TV* and *Oriental Satellite TV* with an average audience rating of 1.234 and 0.953, respectively. During the broadcast of the TV series, the hit rate of the internet exceeded 5 billion, and 45 hot topics on microblog. It became the hottest TV series in 2015, and the TV series copyright was purchased by MBC TV station of South Korea. In the same year, the film version *My Sunshine* was released nationwide, with a box office of over $7.44 million on its first day, and a total box office of $52.7 million.

As a star product, *My Sunshine* has achieved various forms of media expression, from novels and TV plays to films, while its fans have been loyal followers in the 15-year brand consumption. The author of the novel, Gu Man, is a star writer and has a relatively fixed number of fans. The actors in TV plays and films are also popular young stars in China. The combination of star products and star actors has brought about the flexible transformation of *My Sunshine* among various media forms and has achieved the optimization of economic benefits with ease. Similar cases include the variety shows *Where's Dad Going?* and *Happy Mahua*.

Data 2 The case of Jingming Guo

Jingming Guo was born in 1983 in Sichuan, China. Since 2002, Jingming Guo has been engaged in the writing of online novels and became famous with the novel *Ice Fantasy*. Jingming Guo did not graduate from university, but he became one of the representative figures of the post-1980s writers in China. Jingming Guo ranked 92nd in the "2005 Celebrity List" published in the Chinese edition of *Forbes Magazine*. Jingming Guo's micro blog attracted more than 4 million fans. His novels have sold more than 3 million copies. Jingming Guo, who became famous, not only excelled in fiction, but also set foot in film. In 2013, Jingming Guo made his novel *Tiny Times* into a movie, earning $72.6 million box office. Subsequently, Jingming Guo filmed and released *Tiny Times 2*, *Tiny Times 3* and *Tiny Times 4* in 2013, 2014 and 2015, with a total box office of $44.2 million, $78.3 million and $72.8 million, respectively, with the box office often exceeding 100 million yuan on the first day [19]. Jingming Guo fans are mostly under the age of 18, with a male-female ratio of 2:8". "Among the more than 90,000 original microblog authors of *Tiny Times*, women account for more than 80%, and nearly half of them are microblog experts. It can be said that the young female audiences of *Tiny Times* are also a relatively active group in the new media such as microblogs. They actively participated in the watching, commenting, sharing, spreading and even debating of *Tiny Times*. They even created various microblogs related to *Tiny Times*, which are several times than other films [20].

Jingming Guo, as a star, became the core of his own work sales. His fans followed the stars and realized the benefits of different types of products driven by the stars themselves. The film series directed by Jingming Guo also selected different young stars as the main actors. Stars' overlap lead to fans' overlap, thus realizing revenue. Jingming Guo is not the only case. Similar cases include Han Han, Han Lu, Ying Yang and TFBOYS. These stars have become brand commodities, forming targeted fans' groups, and becoming the proof of the era of fans economy.

But not so fast. By 2021 the PCR's machine had banned Jingming Guo on the grounds of plagiarism, leaving the above success story in tatters overnight.

Case study

Case 1

Jackie Chan's International Image Building

Jackie Chan is the most successful Chinese movie star in the process of internationalization. With the uniqueness of Kung Fu comedy and the social effects caused by real Kung Fu, Jackie Chan has become another Chinese Kung Fu in the wake of Bruce Lee. Jackie Chan's internationalized development is not only accompanied by internationalized movies, but also brings up the internationalization of personal image and the internationalization of star influence, including public welfare activities, image endorsement and political behaviour. For example, Jackie Chan donated $145,000 to the medical research department of John Cu College of Australian National University. Jointly set up the Jackie Chan Scholarship with the Pan-Asian Chamber of Commerce to provide financial assistance to Asian Americans in high school. He was also an UNICEF Goodwill Ambassador and Singapore Anti-Drug Ambassador. He served as a member of The 12th National Committee of the Chinese People's Political Consultative Conference and vice-chairman of The China Film Association. "Famous politicians and stylists are entering each other's fields and keeping close ties with each other, because they all need resources from each other's fields" [21]. "Stars can represent people's opinions to some extent". "It can also influence people's behavior through personal reputation [22]". McDonald and Wasko also mentioned that "Hollywood, where the movie industry is mature, has a special star-making system that can create star influence in many ways. It is also mentioned that the commercial nature and cultural nature of stars are inseparable" [23].

Therefore, in Jackie Chan's international development, film works are only one aspect. Jackie Chan's international events are often created with positive energy or in line with the image needs of the Chinese government. This also enables Jackie Chan to have a certain living space under China's political discourse. However, in the process of international development, the aesthetic acceptance of international audiences is still the main factor. Therefore, Jackie Chan did not place too much emphasis on the sense of being a star, nor did he give full play to the influence of his personal image. Generally speaking, Jackie Chan's characters in international movies are mostly ordinary people ('everyman') who show weakness but have special skills. For example, in *Rush Hour*, Lee and Carter, as racially disadvantaged parties, successfully challenged two white FBI agents, who became universally sympathizers around the world [24]. At the same time, Jackie Chan's comedy style of Kung Fu has removed the cultural gap and made audiences around the world accept and embrace such a Chinese actor with pleasure, which is also an important tool for him to become (and remain) an international star.

Case 2

Tianlin Zhai Academic Scandal

The incident in Tianlin Zhai has caused a great uproar after the Chinese New Year in 2019. As a Chinese star who is not well known in the world, this book introduces him to discuss the maintenance of star image. Agency companies will set up their star images for development at home and abroad, according to different stars. For example, Jackie Chan in Case 1, his star image has always appeared in movies as a chivalrous Kung Fu fighter. Jackie Chan's real Kung Fu is also an important way to maintain his star image. Jackie Chan's real Kung Fu was not performed through movies, but was real. Therefore, Jackie Chan's star image can be regarded as unified both inside and outside the play. However, the star image of Tianlin Zhai is different from that of himself. Part of the agency companies pay attention to the unity of the image of the film and television works and the image of themselves when shaping the image of stars. Some agency companies have strengthened their differences. These two practices are both behaviours that conform to the market demand and can reflect the flexibility of China's star market at present. So, what is the star image of Tianlin Zhai?

Two points should be distinguished here. The first is the image of Tianlin Zhai in film and television works. Tianlin Zhai 's films are very few, and only four can be found. Among them, *The Crossing Part*, which directed by John Woo was the most famous, but Tianlin Zhai was only a guest star in this film. The roles played in other works were also difficult to coordinate their actor images. However, Tianlin Zhai has a large number of TV plays, most of which are positive roles; only a few of them are negative roles. In other words, Tianlin Zhai 's screen image has the following characteristics: decent people, good men, kind people, educated people, people who meet the needs of mainstream politics and the media. Therefore, the image created by Tianlin Zhai through TV plays is easily accepted by most Chinese audiences and media, and it is also a common way to create the role of Chinese stars. Secondly, it is the image-building beyond Tianlin Zhai's film and television works. In addition to his role, Tianlin Zhai released photos of doctor's admission, graduation, defense, public welfare activities and staying up late to write papers through various website channels such as microblogs and short videos. Or through media interviews to show his good results, through other celebrities' comments to confirm his image as a good student. Outside the screen, there is relatively scant negative news on him. On the whole, the image of the actors themselves is healthy and positive.

In China's film and television industry, there are many stars with outstanding academic scores and achievements. For example, Leehom Wang holds a bachelor's degree from Williams College and a double master's degree from Berkeley College of Music. Similarly, Aarif Rahman graduated from Imperial College London with a major in physics, Karen Joy Morris graduated from Royal Holloway, University of London and Kelly LIN Hsi-Lei graduated from the University of California, Irvine. However, few stars continue to emphasize their image as good students in order to capture more fans. Through various forms of media, Tianlin Zhai has continuously conveyed the image of "student bully" to the audience, stimulating the establishment of good student, and forming a relatively stable image of highly educated people outside the screen, which is regarded as a rare image shaping among many

stars in the entertainment circle, forming a special view and arousing the audience's pursuit.

The image of stars is based on the trust of the audience. "The actions of mass stars, because of their strong personal charm and symbolic significance, are more likely to be reported by mass media, thus arousing public attention to specific issues" [25]. For the image setting of Tianlin Zhai with high academic qualifications, the Chinese people choose to believe, accept and worship. Therefore, when the people found out that the star who is going to occupy the post-doctoral resources of Peking University has no important academic achievements and the only "scientific research articles" are copied from others, people are angry. The star image of a good student, which was painstakingly built up by the Tianlin Zhai agency company, collapsed.

The academic scandal of the star Tianlin Zhai actually differs from that of other stars. Tax evasion in Bingbing Fan and the sex scandal around Baihe Bai were both reported by entertainment reporters, paparazzi, thus creating scandals and a big stir in China. However, the academic scandal around Tianlin Zhai was actually exposed in the media interviews due to its lack of academic accomplishment, which was questioned by the people and implemented through the hands of the people.

Therefore, the maintenance of star image is not only the responsibility of the agency, but also the responsibility for stars. Maintaining the star image is a long-term process, in which the cost of manpower and material resources is the result of a team's work. Stars are the core of this team and the most shining part. The establishment and strengthening of off-screen images of stars should have a solid foundation. That is to say, stars themselves should have the innate conditions of this image setting. Chow Yun Fat, for example, also used swords on the screen, but he was never strengthened by the Kung Fu image outside the screen. The collapse of Tianlin Zhai's image as a "good student" is based entirely on the fact that he does not have the background and performance record required in the case of a truly 'good' student. An image set based on lies does not have endurance. However, his academic scandal directly affected the broadcasting of film and television works and the attitude of the previous censorship body SARFT. Therefore, it is clear that a star's positive image or negative image directly impacts on movies and TV works, as well as advertisements, fans' values and other surrounding areas.

Whether on-screen or off-screen, the setting of star image needs a relatively stable foundation. This foundation is rooted in the hearts of the audience, obtaining the cognition and resonance of the corresponding groups. In order to build a star image, Chinese agency companies have spared no efforts to ignore the trust needs of the audience. And between the star and the audience, the audience is actually helping the star to maintain its image. Therefore, when setting up and maintaining the star image, the agency company must consider the audience, who cab be regarded as one of the maintenance costs. Once the image of a star is set, it is conveyed to the audience by the star themselves through both on-screen and off-screen channels. The continuous recognition of the audience often determines the continuity of the star image. Once the audience link collapses, the maintenance of the original star image will no longer exist.

Perhaps that's exactly what the PRC has in mind as it continues apace with its war on "morality".

This chapter was contributed to by Chinese academic Lei Ding, associate professor, Jiangsu Open University, Master tutor, Nanjing Normal University, and a Visiting Scholar at University of Exeter (2018–2019).

References

[1] [EB/OL] https://zh.wikipedia.org/.
[2] [EB/OL] http://www.ifeng.com.
[3] Ibid. Wiki.
[4] Jiangyan Chen, Europe and America: Stars are Such Brokers [J], Broker 2005, p. 6.
[5] Ibid., Chen.
[6] Yomi Braester, Chinese Cinema in the Age of Advertisement: The Filmmaker as a Cultural Broker [J], *The China Quarterly*, No. 183.
[7] Xuan Zhang, Li Qi Talk about Brokers [J], Broker 2003.
[8] Yufeng Zhang, Interview with Lear Zang, Chairman of the Star Brokerage Company of America Paradise [J], Broker 2004, p. 12.
[9] Ruo Si, The Star Business of Brokerage [J], Contemporary Film 2012, p. 5.
[10] Jian Qi, Tiger and Cat Games [J], Broker 2005, p. 10.
[11] Xiong Xiong. From Fan Economy to Cross-brand Community Integration, Why does Netease Choose Such a Bureau? [EB/OL]. Sohu.com: http://www.sohu.com/a/207649052_124448.
[12] H. Jenkins. *Convergence Culture: Where Old and New Media Collide[M]*. New York and London: New York University, 2006, pp. 61–62, 62.
[13] Howard Rheingold. *The Virtual Community: Homesteading on the Electronic Frontier[J]*. Reading, MA: Addison-Wesley, 1993, p. 5.
[14] Variety, "Has China Met Its Real Harvey Weinstein Moment at Last?", p. 13, 18/08/21, Sandworth.
[15] Wikipedia [EB/OL].
[16] Zhi Hu.com [EB/OL].
[17] Sina.com [EB/OL].
[18] Variety, "Chinese Film Students Told That Morality Should be their Top Priority", 20/09/21 Rebecca Davis.
[19] Variety, ibid.
[20] D.M. West. *Celebrity Culture in America* [EB/OL]. www.insidepolitics.org/HedgehogReviewCelebrityPolitics.doc.
[21] L. Van Zoonen. 'Imagining the Fan Democracy [J]'. *European Journal of Communication* 19(1) (2004): 39–52.
[22] D. Schultz. 'Celebrity Politics in a Postmodern Era: The Case of Jesse Ventura [J]'. *Public Integrity* 4 (2001): 363–376.
[23] P. McDonald and J. Wasco. *Contemporary Hollywood Film Industry* [M]. Zhejiang University Press, 2014.
[24] Minha T. Peng. *The Asian Invasion of Hollywood (Multiculturalism)*, World Cinema, 2010, p. 1.
[25] D.S. Meyer, J. Gamson. 'The Challenge of Cultural Elites: Celebrities and Social Movements [J]'. *Sociological Inquiry* 65(2) (1995): 181–206.

19 "Winter is coming"
The *Game of Thrones* case study

> Every superior human being will instinctively aspire after a secret citadel where he [sic] is set free from the crowd, the many, the majority.
> Friedrich Nietzsche, *Man Alone With Himself* (1844–1900)
>
> Binge-watching is a night out, even when you spend the whole day in. It's a way of being.
> Clive James, TV critic [1]

Once in a rare while, an astonishingly "good" TV show comes along that blows through the world's entertainment landscape like a recurring hurricane. Not very often, but when such a series catches fire, exploding via word of mouth (and click) from season to season, it redefines what a really great show can mean to a global audience. *Game of Thrones*, which started development back in January 2007 when HBO acquired the TV rights to fantasy novelist George R.R. Martin's *A Song of Ice and Fire* series, was that kind of global game changer.

Martin's book series has sold more than 90 million copies worldwide and been translated into 45 different languages. Armed with the experienced duo of David Benioff and D.B. Weiss as the series executive producers – who effectively show ran the entire eight-part seasons packed with 73 episodes – along with Martin on board as a co-executive producer (albeit for a period), HBO pieced together Television 360, Grok! Studio (also known as Grok! Television), Generator Entertainment and Bighead Littlehead, to manage and produce one of the most demanding long-running series ever shot around the world. The long-running show was filmed in the UK (predominantly in Northern Ireland), Canada, Croatia, Iceland, Malta, Morocco and Spain. Ironically, the infamous pilot episode, 'Winter Is Coming' – which cost near to $10m – came in as a dud in its first version. Yet HBO boss Richard Peeper backed the courage of both his and the HBO team's convictions, re-commissioning 90 per cent of the pilot and the show had to go on.

The power of historical allusions

Martin's literary skills at building grand, sustainable themes are on display from page to screen, (as far as the books last and then subsequent scripts were forced to divert from the original material, see James K. Wight below). Martin builds a compelling medieval-like fantasy universe: colourful, complex, convoluted and packed with

DOI: 10.4324/9781003205753-21

conflict. *Game of Thrones* is steeped in themes such as pernicious power struggles, spectacular falls from grace, multiple murders, incest, insurrection, sexual deviations, defrocking, reincarnation (albeit in the same body aka Jon Snow) and, of course, blockbuster battles after battles. The world is littered with monsters ranging from dragons and giants to zombie-like 'white walkers' who can turn the dead into 'wights'. On reading Martin's books, the reader quickly becomes aware that each chapter is titled with a key character's name, ergo plot is emphatically character-driven despite the maze of action and events.

According to medieval historian Carolyne Barrington, "we learn about the world and its various customs, inhabitants, power plays, religions and cultures through a medievalist lens ... a journey that takes the reader through the 'world of imagination'" [2].

> Both the books and the show free their narratives through shifting points of view: the intricate plots follow the perspectives of particular characters, showing or narrating what happens to them and, in the books, telling us what they are thinking and feeling. In the show, such interior psychological processes become clear through the actor's expressions and through dialogue; characters need someone else to talk to in order to voice their feelings ... the characters who are granted Point Of View stays are often – and this is not coincidental – sympathetic and likeable. Indeed, we'd probably shudder to see the world through the eyes and mind of Joffrey.
>
> What we are never shown, however, is how the world looks from the position of the non-Westerosi characters; we neither hear their reflections on their own cultures nor do we share their views on Westeros, regarded with an outsiders' critical eye [3].

Warming to her grand themes, Barrington underlined the importance of *honour*: "bloodline is everything for the members of the Great Houses, and their relative standing is determined by the length of their history" [4]. Writing and analysing up to Season 5, she points out that the divergence between the unfolding show and the books, which didn't matter all that much until that point, has now become considerable. How right she was to notice the gradual divergence without knowing what that might mean for the show's final climax.

Other notable 'fanzine' historians, like the best-selling Oxford academic Tom Holland, have picked their brains over the "historical allusions". Holland draws a direct link to "that most famous of all historical epics: Shakespeare's cycle of history plays. Just as the rival houses of Lancaster and York feuded over the English crown in the [15th century] War of the Roses, so do the rival houses of Lannister and Stark feud over the Iron Throne in *Game of Thrones*" [5]

Unlike Tolkien, an Oxford professor with a profound knowledge of the medieval past, Martin portrays a world that owes less to the Middle Ages themselves than to how, in the 18th century, enlightenment philosophers came to imagine them: as a sump of blood and gore.

Holland, keen to draw more contemporary comparisons and influences, points out that parents "who had named their baby daughters Daenerys [were] appalled when, in the final series of Game of Thrones, she went berserk and deployed a dragon to

incinerate a city". The TV series has indeed had a profound influence on how history is imagined, but perhaps its profoundest influence will be on those historians who, in the decades and centuries to come, look to it for fascinating evidence of the ambivalences, the aspirations and the paradoxes that mark the early 21st century [6].

The critic's perspective

Clive James, one of the world's most perceptive and experienced TV critics of the past 50 years, wrote an extensive 'binge-worthy' review on *Game of Thrones* in the *New Yorker* magazine [7].

> I kept watching, even as I vowed to stop when the eggs hatched. What was the immediate appeal? Undoubtedly, it was the appeal of raw realism. Superficially bristling with every property of fantasy fiction up to and including cliff-crowning castles with pointed turrets, the show plunges you into a state where there is no state except the lawless interplay of violent power. The binding political symbol is brilliant: the Iron Throne, a chair of metal spikes that looks like hell to sit on (it was forged from molten swords by a dragon's breath, but skip that). It is instantly established that nobody in King's Landing or anywhere else in the Seven Kingdoms can relax for a minute – especially not the person on the Iron Throne....The whole thrust of the show is to give us a world in which the law has not yet formed, a Jurassic Park that has not yet given birth to its keepers … for popular art, for any level of art, this is a rare step toward the natural condition of the world. The rarity might be multiplied by the unusual profligacy of sacrificing a star, but even that expensive boldness has been not unfamiliar since Hitchcock pioneered it in *Psycho*; as he told Truffaut, the shock value of Janet Leigh's early departure in the shower scene depended on the audience's expectation that a headline name would stay alive. But Sean Bean, though he might be admired, has never counted among the much loved, and the shock value of his departure from *Game of Thrones* depended on the size of the investment that the creators had put into building up his part of the story until it looked like the armature of the whole deal. For them, it was a key play in a deliberate campaign to get their show beyond the reach of movie cliché, and even beyond the reach of show business itself. Show business usually depends on fulfilling our wishes. In King's Landing, however, our wishes might run out of luck.

James does not hold back on the creative and technical skills on show and praises the quality of the writing, which allows actors time and space to perform at an emotionally arresting level far beyond the already compelling and yet often sparse dialogue. For once, the audience is allowed to fill in the gaps.

Pricing an expansive universe

The first season's budget for *Game of Thrones* was estimated at $50–60 million, but the cast in particular were mostly young, unknown and had few agent-style "quotes" to inflate their acting rates. That all changed as the series grew in scale, size and sensational appeal to an ever-widening fan base. In 2014, several actors' contracts were

renegotiated to include a seventh season option, and by the final (eighth) season, five of the main cast were being paid $1 million per episode, some of the highest fees every paid to TV cast [8]. TV Guide reported Peter Dinklage (Tyrion Lannister) and Lena Headey (Cersei Lannister) were making $150,000 per episode as of Season Four. By Season Five they, Kit Harrington (Jon Snow) and Emilia Clarke (Daenerys Targaryen) were understood to be making around $300,000. By Season Seven, those frontrunners, including Nikolaj Coster-Waldau (Jamie Lannister), made at least $500,000 an episode. For the final season, they were paid about $1.2 million per show, according to Hollywood Reporter. (This figure is supported by Court documents from a lawsuit involving Coster-Waldau, when his ex-manager revealed that the actor was paid $1.06 million per episode [9].)

The scale of the numerous wars, battles and more modest jousting scenes, which in turn help kill off, incarcerate or maim key cast members on a regular basis, has not been depicted at this level of production value on the small screen in any previous series. For example, during the second season, the show received a 15 per cent budget increase for the climactic battle in 'Blackwater' (which had an overall $8 million budget). Between 2012 and 2015, the average budget per episode increased from $6 million to more than $8 million, while the sixth-season budget was over $10 million per episode, for a season total of over $100 million, a record for any series' production cost around the world. By the final season, the production budget per episode was estimated to be $15 million [10].

'Blackwater' was not a typical episode, so the creators went to HBO to ask for more money, they told GQ magazine. Benioff explained: "We had one really intense conference call with the HBO brass. It was awkward: they said, 'So, what are you guys talking about, an extra $500,000?' We said, 'Noooo…'. 'You guys need a million dollars?' 'Ummmm…'."

Weiss: "I think we asked for $2.5 million. We got $2 million-something. That's a lot of money in TV."

ThinkMoney analysed viewing figures, subscription costs and production costs & found that whilst the budgets of *Game of Thrones* steadily increased over eight seasons, due to the huge popularity of the show it went on to only cost HBO $2.37 a viewer per season. With a total show budget of $1.5 billion, the show has earned $3.1 billion through HBO subscriptions alone. All eight seasons, spanning 73 episodes and bringing together 566 characters, cost HBO a mere $30.90 per viewer, such was its global reach and popularity. By the time season eight arrived, the show had brought in an average of $88 million just for each episode from HBO subscriptions. No wonder Amazon boss Jeff Bezos told his team at Amazon Prime in 2017: "Bring me a *Game of Thrones*…".

How could HBO spend so much on this series?

- HBO was able to generate significantly more money via their shows than their premium cable competitors, Starz and Showtime, and effectively 'reinvest' in the ever-rising budgets matched with expanding audience figures.
- HBO typically banks half the subscription fee from new viewers; Showtime and other pay-cable networks tend to strike deals in which distributors pay a flat

licensing fee and then keep customer subscription income for themselves. This encourages providers to discount Showtime, which increases subscribers without necessarily earning the network more money in the short term.

- Unlike most networks, HBO owns, rather than licenses, almost all its shows (and therein lies the power of ownership of IP from the start of the development process). By contrast, Showtime owns approximately half its output (the recent breakout hit *Homeland* is produced by Fox). That makes programming costs more expensive, but it enables HBO to control and exploit all the underlying intellectual property (see below re spin-offs etc).
- HBO has complete control over decisions about syndication and DVDs. Not only does it bank the proceeds from DVD sales – Season One of *Game of Thrones* sold about 350,000 units in the first week it was available – it can also time the release date to maximize subscriptions [11].
- Licensing exploitation also brought money to the table as *Game of Thrones* rated as the most licensed show in HBO's history. Worldwide, HBO has handed out over 100 licenses for *GoT*-branded merchandise, the most out of any show in the network's history [9]. The array of themed goods are dazzling: There's *GoT*-branded beers, whiskeys, wines, cups, mugs, puzzles, models, board games, plushes, Funko pops, jewellery, video games, $50,000 pens, candles, blankets, make-up, bags, sneakers and cookbooks.

The rise of a global fanbase ... and a backlash in the making

The evidence pointing to the wider ripples and 360% business model around the fan followers appears, for a period, compelling:

- BBC News opined in 2013 that "the passion and the extreme devotion of fans" had created a phenomenon, unlike anything related to other popular TV series, manifesting itself in fan fiction [12].
- In America, "Arya" became the fastest-rising baby name for girls. According to a press release from the US Social Security Administration, the name jumped from 711 in 2011 to 413 in 2012 [13]. (Indeed, parents may have been somewhat happier as the series evolve about their choice of name, given that Arya went on to kill the Ice King, than had they chosen 'Daenerys'.)
- As of 2013, about 58 per cent of series viewers were male and 42 per cent female, and the average male viewer was 41 years old [14].
- Vulture.com cited Westeros.org and WinterIsComing.net (news and discussion forums), ToweroftheHand.com (which organizes communal readings of the novels) and Podcastoficeandfire.com as fan sites dedicated to the TV and novel series [15].

However, it's not just HBO and its quality brand that benefited financially from the series. The show's long arm has impacted directly on tourism, and has been particularly beneficial to Northern Ireland. Barclays has been appointed the new corporate banking partner for Northern Ireland's newest tourism attraction, Linen Mill Studios, after agreeing a £10m loan. Linen Mill Studios in Banbridge was one of the key locations

for the filming of *Game of Thrones*, which opened in the summer of 2021 as a tourism experience. The launch coincided with the 10th anniversary of the series. It's being developed under licence with WarnerMedia and has turned the 10,000-square-meter film studio into an interactive visitor attraction housing set pieces, props and costumes from the series. The attraction is expected to bring in 600,000 visitors a year and help generate around £400m of tourism revenue over a 10-year period for Northern Ireland, supporting almost 200 jobs [16].

The future: more fun and games

A worldwide hit of the magnitude of *Game of Thrones* was always going to provide, potentially, what the Chinese proverb calls a magic rice bowl: every time you eat, it instantly fills up again.

- HBO has signed a 5-year development deal with George R.R. Martin to work on spin-offs.
- The *House of the Dragon* prequel – which started production in Spring 2021 – was eyeing a 2022 debut. The 10-episode series takes place 300 years prior to *Game of Thrones*.
- Co-created by Martin and Condal, *House of the Dragon* stars Emma D'Arcy, Matt Smith, Olivia Cooke, Rhys Ifans, Steve Toussaint, Paddy Considine, Fabien Frankel, Eve Best and Sonoya Mizuno [17].
- *Tales of Dunk and Egg* – based on 'A Knight of the Seven Kingdoms' book, 90 years prior to 'A Song of Ice and Fire', is being planned.
- Other spin-offs include *10,000 Ships, 9 Voyages, Flea Bottom*, an animated series… [18].

The reigning king of mega-budget dramas, *Game of Thrones* has been so iconic and game-changing, with a scale and shooting schedule that more resembled that of a blockbuster feature film than an episodic series, that the series redefined what a successful, repeatable series could achieve. When it debuted, its price tag was in line with what HBO typically spent on dramas, at around $6 million or so per episode. However, as the show grew into a four-continent behemoth with multiple production units shooting at once, it also began to generate a multitude of healthy revenue streams for HBO. The merchandising lines and foreign sales have brought plenty of gold to the network, and it's been an effective branding flagship as the premium cabler transitioned into the nonlinear age with HBO Now [19]. The challenge for Discovery and HBO is how to tap the brand and build further to assist its streaming offer for HBO Max as it competes across the 2020s. Some industry observers have pondered whether anything like it will ever be made in the future. Since *Game of Thrones* first aired – landscape has changes drastically – streaming services creating a diverse but fractured landscape – "There's so much more content now than there was when *The Sopranos* or even *Breaking Bad* debuted", says Alan Sepinwall, author of *The Revolution Was Televised*, "and we all watch on different schedules. So, it's much harder for any show to become a water-cooler phenomenon in the Peak TV era. *Game of Thrones* may be the last of its kind" [20].

What happened in that last and final series eight, and how did the fans cope?

Generation Z blogger and creative entrepreneur James K. Wight (see Chapter 17), wrote a considered piece titled *Game of Thrones*: "You know nothing, HBO" [21]. Four days after the season 8 finale, that discussed the turmoil and disappointment felt by many fans of the show as series eight came to an end, and with it more than eight years of addiction up in flames.

James K. Wight on: *Game of Thrones*: "you know nothing, HBO" [ibid.]

"And now our watch has ended".

All of us have a connection to *Game of Thrones*. Either you were a fan of the books, you watched all eight seasons, or you simply got caught up in the drama of the outrage of its conclusion.

As a franchise, it "broke the wheel". It redefined fantasy tropes, death was unpredictable and consequential, characters were neither good nor bad, and we saw a fantasy series get a big budget behind it and dominate mainstream pop culture.

But the final season … that's where people lost their sh*t. I wanted to explore the fan response, and the online response to the fantastical finale of Westeros.

"When you play the game of thrones, you win or you die".

Cersei Lannister's immortal words of conquest certainly embodied HBO's attitude to their fantasy smash hit – a modern-day "go big or go home" approach. There was a lot riding on *Game of Thrones* as we saw different families and factions compete to rule Westeros. For fans, we had grown to live and love these characters and their story arcs – for EIGHT YEARS! That is a lot of time and emotional investment to sit through. But the finale's gone down in infamy. Now, we've seen fan backlash before. We saw it with *Doctor Who*, we saw it with *Fantastic Beasts: The Crimes of Grindelwald*, we saw it with *Captain Marvel*, and we saw A LOT with *Star Wars: The Last Jedi*. For *Game of Thrones*, the criticism levelled is directed *squarely* at the writers – to the point where fans "google bombed" the creators. If you type in "bad writers", D.B. Weiss and David Benioff – often referred to as "D&D" by the online community – would show up at the top of the results.

Of those criticisms levelled, the main ones are:

- Jon Snow's right to the throne is never addressed.
- Cersei goes from being ruthless to being scared, and has an unceremonious rock crush her.
- Jamie loses out on his redemption arc, goes back to his abusive brother–sister relationship, and contradicts his behaviour in earlier seasons.
- Tyrion goes from being incredibly smart to being incredibly dumb – putting people in a crypt when the Night King is bringing the dead back to life.
- The Night King's motivations are never revealed, nothing really about his connection with Bran, and he dies by having Arya just stabbing him.

- But the biggest one is Daenerys herself. She forgets about the Iron Fleet and has a heel-turn to villainy by burning down the whole of King's Landing – including innocent men, women, and children – with her suddenly super over-powered dragon.

If you go online, there are many more issues fans had. After eight years of getting to know these characters, seeing their humanity and their struggle, *this* was how it ended. It's a mess, and it *really* frustrated the fans. What's weird is that they could have easily expanded and developed all these plot points beyond their six-episode final series – and HBO was more-than-willing to give them more episodes. But the greater issue here is the response, the mishandling of the creator/fan relationship – and something that I think could have been better foreseen.

"The things we do for love".

A perfect quote to describe the modern fan. Whether it's *Doctor Who*, *Star Wars*, *Harry Potter*, or *Game of Thrones*, the audiences have changed. This isn't the passive consumer renting a B-movie video from a Blockbuster. Fans are now active, they have choice, and they want to invest their time and money into properties that will deliver.

There is now a petition with over one million signatures to 'Remake Game of Thrones Season 8 with Competent Writers' [22], those same writers who crafted the show to begin with. This sort of demand would have been unheard of even a few years ago. But now, it's an increasingly common occurrence – a *Last Jedi* approach to fandom. I'm very much opposed to petitions for this sort of thing myself. It reminds me of that Stephen King story: *Misery*, where an obsessed fan has her favourite author held captive to force them to write the story they wanted – it was strangely ahead of its time.

The big difference is in how we consume culture, and the role of multi-platform engagement. We can now tweet and circulate petitions if we don't like something. If there's a show that's great, memes and fans will make it their responsibility to make it go viral. If something fails to deliver, it risks getting lacerated in online reviews.

But this response seems to go *further* than just fan criticism – it's almost … capitalist. (Stay with me.)

In this new space of streaming and tweeting, the measurement of the success of a show isn't how much money it makes, but its social and cultural impact. Culture is the commodity, and it costs money. Fans have treated this show as an investment – investing time, money, and engagement in this series [23], placing our trust in the producers and writers at HBO. The petition isn't just "the ending sucked, and I hate it!" It's also about the eight years of investment. It's an investment HBO failed to deliver on. It *reads* like shareholders demanding the CEO get sacked and replaced with someone who knows what they're doing. We buy culture like we buy cars. You're promised an experience, you give your money and trust, and you feel let down if it doesn't deliver – this is what the response to *Game of Thrones* has amounted to. This has revealed something very important for producers: that they must now navigate a fine line between toxic fans demanding their own way, and an investor who's not seeing a return. In economic terms, the stock of *Game of Thrones* plummeted as soon as those bells rang.

"If you think this has a happy ending, it doesn't".

One of the things that franchises need is a Bible and a writer for that Bible.

> *Harry Potter* has J.K. Rowling,
> *Star Wars* has George Lucas,
> *Game of Thrones* had George R.R. Martin.

These writers were responsible for crafting the mythos surrounding their worlds, time-lines, histories, destinies, characters, religions, physics, everything. Their word is final, and it was something that fans and readers could deem "authentic".

A takeaway from the finale is the response 'at least we have the books'. In an age where streaming is the dominant medium – that's problematic.

Ideally, different mediums should reinforce each other. Perhaps the books could offer greater perspective or internal thoughts. What could be interesting is if Daenerys does eventually take over, we see more of her internal conflict and thought process behind destroying King's Landing.

But the television series has left the community in a state of shock and limbo. HBO's *Game of Thrones* is not the *true* story – it's now the books. They are at odds with each other.

One of the terms I've used in the past is 'Trickle-Down Transmedia'.

If you think back to the post-*Jaws* blockbuster boom from 1975 onwards, often you would have a film, then if that was successful you might get a sequel which was created more to capitalize off of the hit, and then you'd have outsourced video games, TV shows, or maybe an animated series.

This was the case with *Jurassic Park, Terminator, Ghostbusters, Alien, Star Wars* – just about anything that was big in the 80s and 90s.

With the film, home video, book, graphic novel, and video game markets being so disconnected, often the spin-offs weren't as good as the original was, simply created as a quick cash in.

I think it is this approach that turned people off transmedia for the longest time – that "it's popular, let's milk it for all it's worth!" mentality.

But we live in a platform-neutral world. We can watch TV shows, read books, and chat about TV shows and books *on the same device* – there *needs* to be a co-ordinated effort to make the most of this technology.

But it is the *Game of Thrones* spin-offs that I think are going to struggle more – as they don't tie directly into the story like *Endgame*, and a sequel series has just been ruled out given the response [24].

We have FOUR spin-offs coming from *Game of Thrones*, and it feels more reminiscent of that old transmedia mentality [25].

Of course, these spin-offs might be good, or they might be dangerously close to saturating their own market after an incredibly controversial finale … we'll have to wait and see, but I don't think anyone has an appetite for much more *Game of Thrones* – the stock's just gone through the floor!

It's a real business gamble, and it's telling that we already have HBO losing subscribers after this [26].

Game of Thrones proved just how valuable content and IP is for streaming services and highlighted the dangers of a network investing so much into a single vehicle.

Perhaps diversification is the key.

> ### *"I'm not going to stop the wheel. I'm going to break the wheel."*
>
> It's now such a shame that the series has yet to break the wheel when it comes to a long-term engagement strategy.
>
> As with *Star Wars* and *Fantastic Beasts* before, I fear there's only so much you can spin off a series. These franchises haven't evolved to meet the needs of the multi-platform consumer.
>
> If these franchises are investments, then some form of diversification is needed to survive – just as in a business. I believe that *Game of Thrones* could have minimized their damage through better co-ordination of its properties, and a long-term strategy for how it was going to manage these characters – again, it didn't help that the last two books hadn't yet been released.
>
> Unless storytelling changes are made, we will risk more cultural stock plummeting.
>
> For a television series *Game of Thrones* certainly "broke the wheel". But as a franchise, I fear it remains trapped in past.
>
> It is not enough to break the wheel if you can't replace it with something better.

References

[1] The *New Yorker* magazine, 11/04/2016.

[2] *The Medieval World of Game of Thrones, Winter is Coming*, Carolyne Barrington, I.B. Tauris, 2016, 2017, p. 9.

[3] Ibid., p. 8.

[4] Ibid., p. 15.

[5] *It's Not Just Sex and Dragons…*, Sunday Times, 23/05/2021.

[6] Ibid.

[7] NY Thrones of Blood, 11/04/2016.

[8] Wikipedia, Ref 12/13, Harpers Bazaar.

[9] *An Inside Look at the Finances Behind 'Game of Thrones'*, Work & Money, 03/05/19, Craig Donofrio.

[10] *Here's How Much It Costs to Produce One Episode of 'Game of Thrones'*, CNBC Make It, Emmie Martin, 14/04/19.

[11] *How Much Gold Is 'Game of Thrones' Worth?* Slate, June Thomas, 29/03/12.

[12] *The Best (and the Weirdest) of 'Game of Thrones' Fanfiction*, Salon, Molly Templeton, 16/06/13.

[13] *'Game of Thrones' Domination Is Nearly Complete 'Arya' Is the Fastest-Rising Name for Baby Girls*, Entertainment Weekly, Adam Carlson, 10/05/13.

[14] *Yes, Women Really Do Like 'Game of Thrones'*, Wired, Angela Watercutter, 06/03/13.

[15] *The 25 Most Devoted Fan Bases*, Vulture, 15/10/12.

[16] *Barclays in £10m Deal with NI's New 'Game of Thrones' Attraction*, Belfast Telegraph, Emma Deighan, 30/03/21.

[17] *'House of the Dragon': HBO Unveils First Official Photos of 'Game of Thrones' Prequel*, Deadline, Denise Petski, 05/05/21.

[18] *Every 'Game of Thrones' Spinoff in Development*, Variety, Antonio Ferme, 17/04/21.

[19] *TV Series Budgets Hit the Breaking Point as Costs Skyrocket in Peak TV Era*, Variety, Maureen Ryan & Cynthia Littleton, 26/09/17.

[20] *How 'Game of Thrones' Changed Television*, Financial Times, India Ross, 12/04/19.

[21] *'Game of Thrones': You Know Nothing HBO*, Transmedia Blueprint, James Wight, 23/05/19.

[22] *Remake Game of Thrones Season 8 with Competent Writers*, change.org.

[23] *Fans Are Ruining Game of Thrones – And Everything Else*, The New Republic, Jon Greenway, 21/05/19.

[24] *A 'Game of Thrones' Sequel Is Not an Option for HBO's Top Executive*, Hollywood Reporter, Lesley Goldberg, 21/05/19.

[25] *Four 'Game of Thrones' spinoffs Are in the Works. Yes, FOUR!* Digital Spy, Justin Harp, 04/05/17.

[26] *Tons of 'Game of Thrones' Fans Now Cancelling Their HBO Subscriptions*, We Got This Covered, Sam Plank, 20/05/19.

20 The "metaverse"

Generation Z and the Ticking Tok

> Every social media network gets the influencers it deserves...
> (Elaine Moore, *Financial Times*)
>
> What I discovered [in TikTok] was irresistible – an unruly playground populated by a generation whose modes of expression struck me as refreshingly honest and hilarious, a new way of imagining our online lives...
> (Sejla Rizvic, *The Walrus*)

Once upon a time, not so long ago, a 12-year-old boy called Ben created a set of 3,350 whales. They were made in the style of a common whale meme used in the video game Minecraft. Ben created the whales on a pixel art-website, and he was entrepreneurial enough to cash in: He went on to sell Non-Fungible Tokens (NFTs) and generate nearly £300,000. NFTs enable 'artwork' – and no doubt a range of images, items and icons all yet to come – to be tokenized into a digital certificate of ownership, which can then be traded just like stocks, shares and bitcoin et al. "I chose whales because in crypto-currency a whale is someone with 1,000 bitcoin", explained Ben [3]. "I could then say that everyone who owns a whale is a whale. I could craft that catchline...".

The wonderful controlling idea about the future is that we can all make it up as we go along. Today's reality can be constructed into an alternative 'next age', where we can make things cleaner, clearer and, in the eyes (and actions) of Silicon Valley, intrinsically more dominant and hence profitable. Welcome to the world of the 'metaverse'. The world of the metaverse, which is probably more aptly plural (aka "metaverses"), is derived from a 1992 science fiction novel titled *Snow Crash*, written by Neal Stephenson, in which software demons and human avatars inhabit a parallel three-dimensional universe. Some thirty years later, the term metaverse has now taken on a life of its own, yet of course online geeks and Silicon Valley leaders all have their own take on what it means. Generally speaking, it means "the next big thing in the digital world, a kind of internet 2.0" [4]. Citing Microsoft's Satya Nadella, we are introduced to an "enterprise metaverse", where a further 2 billion connected devices will be coming online each year up to 2023, and in which our physical infrastructure will be cloned with virtual representations of roads, parks, houses, factories, airports, galleries and pop festivals. According to Facebook's ubiquitous Mark Zuckerberg, we are heading towards a three-dimensional "embodied internet ... a holy grail of social interactions ... and the infinite office". All this in part depends on headgear: lenses that compress a supercomputer into micro-slim classes at a price point that

DOI: 10.4324/9781003205753-22

encourages global adoption. Hardware and pay systems are lagging well behind the visionaries, while the descending reputation of Facebook's brand and behaviour may further dent new takers over the coming decade.

The technology writer John Thornhill is more circumspect. He warns of a third vision of what the metaverse might look like, and it's much more disturbing. In an interview with sci-fi writer William Gibson in 2020, he was told by Gibson that the novelist was "mystified by fans who told him he had inspired them to pursue a career in tech while missing the point that many of his novels are dystopian. Ours would be the last generation to draw a distinction between online and offline worlds. Future generations would regard them as fully fungible." My advice to readers and students is to watch this evolving space carefully: it throws up a host of equally challenging and dangerous issues, from climate change (supercomputers will drain power faster than cars!), to ownership and privacy issues, all the way to our new 'worlds' being dominated by what Thornhill calls a "corporate land grab" [5].

The arrival of TikTok

And so, the new battle for eyeballs had begun. Halfway through 2021, TikTok, launched just four years previously, had shifted status to becoming a "social media juggernaut" [6], drawing hundreds of millions of users, predominantly in the age range of 12-to-24-year-olds. Clashing head-to-head with YouTube, both online offers announced in 2021 'Creator Funds' of $1 billion in an outsized bid to attract talent deemed capable of generating and keeping users' attention, and hence advancing advertising revenues and their expanding business model. These funds designed to attract creators and hence traffic and loyalty are charted in Table 20.1.

On further refection, what makes TikTok's modus operandi so intriguing is that the app is genuinely innovative in one fundamental aspect: TikTok has moved away from its rival social media platform drivers by opting to rely on the "interest graph"

Table 20.1 How creator funds stack up

Company	Size ($)	Date Announced	End Date	Requirements
Facebook	1 billion	July 2021	2022	Invitation-only to start
YouTube	100 million	May 2021	2022	Videos with high views or engagement
Square/Linktree	250,000	May 2021	TBD	Application
Pinterest	500,000	April 2021	Ongoing	Application
Clubhouse	5,000/ month to individuals*	March 2021	Ongoing	Application
Snapchat	Millions/month	November 2020	Ongoing	Videos with high views or engagement
TikTok	1 billion**	July 2020	Ongoing	Application and 100K+ videos in last 30 days

* Amount can vary by country
** TikTok started with a $200 million fund that will grow to $1 billion over 3 years in the U.S.
SOURCE: The Information reporting

as opposed to the "social graph" [7]. To those, like me, less initiated, this means that the app is based and driven by micro-signals between the user and the app. This individually specific micro-data is then run through TikTok's algorithm analysis, which, in turn, allows TikTok to tailor individually curated content specific to the user, as opposed to following a wider-based set of social group data. Individual-based digital mining includes how the specific user views content, how long a video is watched, and if and how it is shared; all achieved with a clean screen devoid of distracting ads and thumbnails ('Gen Z' abhors ads). TikTok, (as is Netflix to an extent), is watching and learning about its audience with a digital intensity and clarity far surpassing YouTube, Snapchat, Twitch and the rest.

What else is attracting Gen Z's hordes to flock? The TikTok toolkit is relatively easy and intuitive to use to generate videos, but it is supported by a stream of updated new tools and filters to meet the supply and demand of new content and smart generators of content. Place that next to YouTube, which in more than 17 years has failed to release any serious creation tools of note, and we can see why TikTok's ease of content creation is working in a virtuous circle.

What makes TikTok tic?

Researchers Richard Daft and Robert Lengel proffered a theory back in the 1980s, when online communication began to go global, that examined the variations in "richness" among different types of media. Writing for *The Walrus*, Toronto-based graphic designer Yazmin Butcher referenced their earlier pioneering work: "In this framework, in-person communication is generally considered the richest medium, while text-based forms of communication are comparatively 'lean'" [8]. Email, for example, can offer a large amount of information but without all those subtle distinctions possible during in-person communication, such as body language, eye contact and tone. "In contrast to platforms of the millennial internet, TikTok offers a 'media rich' environment in which users receive a great deal of auditory and visual information – like seeing one's facial cues and hearing the intonation and pacing in one another's voices."

Butcher explains that TikTok users don't need to follow any 'accounts' before they are served content: "Instead, a mysterious, uncannily accurate algorithm intuits the user's preferences and presents them in a so-called 'For You' page. Each video is 60 seconds or less and can touch on any possible subject. TikTok posits that the power of the algorithm is based on factors such as user engagement on previous videos; songs, captions and hashtags contained in those past videos; and users' location and language preferences.

"But what really makes TikTok unique … is the feeling of intimacy and immediacy between users", writes Butcher. "Unlike platforms that trade only in words and still images, TikTok shares a steady parade of faces and voices during what has been perhaps the loneliest year of the past century … TikTok provides an uncanny feeling of closeness and camaraderie, like a FaceTime call shared with millions of strangers. This intimacy may also be the reason for Gen Z's generational allegiance. Where millennials were cloaked in mostly faceless anonymity online (LiveJournal, Tumblr, Twitter) or highly curated photography (Facebook, Instagram), Gen Z's digital life is dominated by the near-constant production of images and videos of themselves (Snapchat, TikTok), creating a very different relationship between them, their peers, and the rest of the world."

The notion of established or pre-existing celebrities, stars and famous people driving the word of click have been left behind – for now – in the world of TikTok. Elaine Moore, the *Financial Times*' deputy Lex editor, writing in the Tech World column, put it well when opining: "Every social media network gets the influencers it deserves … TikTok remains as addictive as ever. Here, celebrity does not carry the same weight … TikTok's biggest stars are ordinary users who joined early" [9]. Referencing an earlier (2016) interview with Alex Zhu, co-founder of TikTok-like app Musically, and who later was appointed TikTok's CEO when its Chinese parent ByteDance bought his company, explained that social networks require early adopters to be young, creative digital natives with time on their hands. However, they need to attract this group by giving them a reason to leave existing popular platforms: "That reason was the possibility of becoming a star." Moore goes on to explain that the advantage of "building a stable of homegrown stars instead of parachuting in well-known names is loyalty".

Stars can be volatile and fickle. Snapchat took a massive nosedive, for example, when US reality TV star Kylie Jenner tweeted in 2018: "sooo does anyone else not open Snapchat anymore? Or is it just me … ugh this is so sad." Snapchat's parent company took a $1 billion hit in market cap in just one day. The lessons are severe: Big names can be capricious and add a huge layer of brand vulnerability within a flash of one tweet. So too, as creative entrepreneur James K. Wight points out in the interview below, can all social influencers as they are uncontrollable and ultimately, god forbid, human. They have a tendency to post statements and information before realizing the ramifications of their messaging.

What's up with YouTube?

YouTube is the second-biggest social media platform after Facebook, with two billion daily logged in users, and the second most visited website after its parent Google. The days of the site being driven by birthday party videos, sports clips and cats falling down toilets are long gone. The online operation now appears to behave more like a giant online cable channel, with multiple offerings, links, vast vaults of programming, user-generated content, and a range of user choices re ad-stacked 'free', 'fremium,' premium, pay per view etc. All users can access YouTube without needing to have an account, so the daily user levels are potentially much higher.

YouTube Features:

- Live streaming
- Video uploading up to 12 hours in length
- Premieres (where you can watch the film alongside your subscribers and comment live)
- Captioning (for accessibility & different languages) with a lot of options to manually amend the captions due to it not always being accurate.
- High Quality Playback
- HD, HQ and SQ
- In-app editing should errors be noticed after uploading

To monetize YouTube from a producer/content creator's perspective, the channel needs 1,000 subscribers and 4,000 watch hours in the past 12 months to enter into the

YouTube Partnership Programme. At this point money can be earned through Advertising Revenue, Channel Membership, Merch Shelf, Super chat/stickers and through YouTube Premium Revenue.

For YouTube, "a wider audience, however, means a larger chance for criticism. This applies across all social media platforms though, and is negated by the reach YouTube can achieve. Roughly 75 per cent of all adults use YouTube, with this being spread fairly evenly across the generations, in contrast with many other video streaming platforms where there is a steep decline at various generations", explains Naomi-Ruth Greatovex, of Social Media Consultancy. For those 56 and over there is still roughly 67 per cent of all adults who regularly access YouTube. YouTube is getting more and more accessible, with not only use via computers and mobile phones, but now most TV's come with the YouTube app already embedded. Alongside this YouTube can be accessed via Playstations, Wii, XBox, Apple TV, Roku Player and Nintendo Switch.

So where is TikTok going?

Circling back to TikTok, the globe's most downloaded app in 2020 (by the summer of 2021 TikTok had become the first app not owned by Facebook to cross the 3 billion download mark). "For context, there are 5.3 billion mobile phone users worldwide", notes highly recommended author and net analyst Chris Stokel-Walker [10].

> When people spend longer on TikTok they spend less time on its competitors, including Facebook and the Facebook-owned Instagram – which has tried to replicate TikTok's success with Instagram Reels. TikTok is the new Facebook … just as Facebook has shaped the internet, the ways we interact, and our approaches and attitudes to personal data for the past two decades, so TikTok has the potential to do the same for the next 20 years.
>
> Its videos were once no more than 15 or 60 seconds long. Now they can last up to three minutes. Until February [2021], TikTok was predominately a mobile app. Now you can watch videos through your web browser, or even your smart TV. It once had a single video format, then incorporated live streaming. It allows you to buy products through the app, and to tip your favourite creators. It has even started ripping off other apps' best features, an art pioneered by Facebook that ByteDance is taking to another level. TikTok Stories was announced [in August 2021]. But the biggest tell that TikTok is the new Facebook? A little-noticed policy shift in May [2021]: the release of the TikTok login kit. The tool set permits third-party app developers to allow users to log in to their apps using their TikTok account. In other words, TikTok is set to become a portal to the rest of the internet. Where we can now log in to Tinder, Spotify and hundreds of other apps and websites using our Facebook account, soon we could do the same with TikTok.
>
> [Ibid.]

Interview with 'Gen Z' creative entrepreneur James K. Wight, currently in development with four animated characters for a TikTok-first launch.

Author

Can you define what exactly what you see as Generation Z, and what specific factors are important in how these young people behave and what they watch and follow?

James

Gen Z is really tricky to classify because there are a number of factors which gave birth to it. The big one is first technology. They engage with YouTube, but they are both consumers and producers. They also crave a sense of authenticity and intimacy with the properties and content they consume. This is why YouTube influencers are such a big challenge and influencers in general are a challenge for platforms like Netflix. Why watch something which is thought out, scripted and potentially meaningful when you could watch a kid on YouTube, roughly your own age, do something reckless and impulsive? There are some interesting statistics out regarding how receptive Gen Z users are to marketing. They are actually the easiest demographic to sell to, because they offer influencer marketing, which other generations don't. Say you watch someone's regular TikTok videos (they don't need to be complex they can just be someone dancing), but you watch that enough times. Then when this person says they support whatever, or they love their Gucci dress etc, and that will have an impact on them.

There are issues with this though, because, as we're seeing, there are so many YouTube scandals: David Dobrick, James Charles, Jeffree Star, Shane Dawson, those are just the ones that come to mind. There is a huge risk with investing in them at the moment because they are just so volatile and unpredictable in ways which traditional marketing isn't. Just about every group involved had to politely pull out and say, "we will not work with this person". That's where animation has a role to play, as animated characters are controllable. Human influencers are not!

(handwritten note: Ah! Have to be anonymous)

Author

What role does politics play – or not – with Generation Z?

James

They are politically active, but there is a strange sort of groupthink mentality. I don't think this applies to Gen Z as a whole, but it's definitely the way which companies are trying to market to them. The concept of "woke" is something which originated with Gen Z and is impacting the industry. So you do get political lectures, you do get a more political emphasis. However, a good story needs to be universal. You can certainly take global elements, but consider, for example, *Alice in Wonderland*, *The Wizard of Oz* and *Spirited Away*, three different stories, three different cultures, three different centuries, but they are all fundamentally the same journey: a young girl in a mystical magical world, maturing and learning lessons. So, this is interesting because there's such an overt political element, also on behalf of producers and studios, to say "we're for a cause", "we're for a brand", "we have to release a statement on whatever political protest is going on in the world at the time". But when your cause is marketed and sold by huge retailers or studios, is it really counter-cultural? You can get big studios supporting what would have in the past been rebellious, civil rights movements, the Gloria Steinem approach to feminism, for example, the Martin Luther King civil rights movements. Those were trying to change the culture. But you also don't get like H&M releasing 'Black Lives Matter' t-shirts or you don't get Colin Kaepernick partnering with Nike, or you don't get Gillette

talking about men's issues and how they can 'be better'. You go on any of these commercials on YouTube and you will find a lot of dislikes. The Kendall Jenner one is probably the biggest example, by Pepsi. That was remarkably bad. It's basically, she goes to a protest and ends it with Pepsi. It's so superficial and this is why I think, especially moving forward and looking at the reception to politics now, people want something actually authentic that isn't necessarily political, but something which at least acknowledges it's a product and it's trying to sell it to you. I think one of the things we need to consider is to move away from the political discourse and prioritize storytelling.

Author

Can you explain how you are planning to build up an audience on TikTok first, and then roll out from there?

James

You can build a following on TikTok, ideally by building multiple followings across those character-driven platforms. That gives us a little bit of leverage when it comes to speaking to them. There's a lot that you can do with these sorts of short formats. So TikTok is really interesting because when you're creating a story, you usually think in terms of the three-act structure or a five-act structure of whatever, TikTok is very much the antithesis to that. It celebrates the normality and personality of what's being uploaded and that applies to both influencers and, of course, fictional characters as well. There is this tremendous level of depth which you can convey in TikTok videos. You've got 15 to 60 seconds, I think they extended it to three minutes, but again, these are like super, super-short snippets. It's not so much a case of this is our character and they're thrust into the unknown, rather, it's very much, this is our character, this is the normal world. There's actually a very good level of multi-platform analysis and storytelling you can do with that. It's a great way to establish a character's personality, likes and interests. You can tell if they're moody or quirky or what they're interested in, what books they like, what they like to talk about, how they dance. Again, it is just based on the algorithm. I mean, TikTok started off as a dancing app, for lack of a better term, that still does very well.

The other things to consider, of course, is breaking through the noise. There are hundreds of millions of TikTok videos being uploaded every day. How do we get that audience? Our own solution is animation. There've been various reports from TikTok confirming that they are the best platform for animators and animation in general. It gives creators a voice and it also is a great way to stand out from the countless young people doing videos of themselves. On the 'For you' page for TikTok, you flick through countless videos, you see lots of people talking directly to the camera or dancing. Then when you see animation, it really jumps out at you.

We are focusing on not one but four characters. We're focusing on a tent pole character first, the one we believe is going to be the most marketable initially. In the same way, of course, that Marvel started off with Iron Man, and then they could build stuff off of that. We're starting with our character called Mimi before, of course, we introduce the other characters, who's designed very much in a sort of TikTok vibe, she gives off that TikTok sort of feeling. Mimi takes lots of inspiration from the far east in terms of her design, her interests and her engagements. This is very important because even before we move on to other platforms in the long term, we can already create a sort of multi-profile community. On TikTok, each of the characters we've created are very unique, they've all got fundamentally different interests.

There are so many different avenues to explore within the same context, the same genre if you will, and you can very much bring them together. We're living in a 'post-genre'

media world. An example is in Marvel's *Wandavision*: a totally separate genre of sitcom, a parody sort of comedy. Loki is subverting a lot of genres, he's taken out of his timeline and is forced to work with a totally unique set of characters. This is really interesting and it's going to have ramifications in the long term with how we engage with characters. Perhaps the biggest one is *Fortnite* actually. Vastly different characters from different franchises, including the first ever virtual influencer, Guggimon, who has now moved over into video games, he's from Superplastic. This is really important because that suggests that audiences care more about characters which can appeal to them personally, and whose personality they can follow and engage with, rather than does this character fit the established universe which has been set up?

From a business perspective, having four profiles is better than having one. As they're all engaging with each other across profiles, you get what we call 'follower cross-pollination'. If one character shows up in another TikTok video just doing goofy stuff, or playing a game of chess and getting frustrated or whatever, something quirky and fun, there's so much potential you can have with introducing followers to other mediums. There's a thing called an 'influencer house'. This is where a group of influencers by their nature get together and live together, in a way in which bolsters all of their followings. It's a community which people can follow and engage with. We want to try and create the first UK-based virtual 'influencer house'.

We're at the super-early stages, but we believe that this plan has immense scope, especially because, unlike flesh and blood human influencers, many of whom are getting tainted by scandal in the past few years, this is also something brands really want to invest in as well. There's an element of control. You don't have to work with an actual person. You can engage with a virtual icon. What's really telling about this already, is that in China, virtual idols now make more money than real flesh-and-blood performers. Virtual icons have the ability to be fitted or moulded into whatever fantastical story you want. Again, we're already dealing with robot characters. We can have them go to space, we can have them travel through time, we can literally explore any possible concept with them, throw them out of their comfort zone, off from TikTok and into a horrifying real world, or all sorts of fantastical world scenarios. Traveling to parallel universes is a fun concept in fictional terms, you know, there's so much scope and potential and storytelling potential for that hero's journey, which you can't do with real life people.

So not only are we trying to just build a following, we're trying to tell a story, a multi-platform story where people can get to know the characters first on social media, and then as we move into video games, animation, film, whatever. Not only do they act as revenue streams, but they also act as a great way to further expand and develop the story. Of course, as we move on to other platforms, we anticipate a feedback loop where maybe people who aren't familiar with TikTok, but who are getting engaged in the video game community, can then follow the characters and engage with them online as well.

Author

Let's imagine, if we fast-forward, that your character development has worked, and you launch successfully with a level of following that feels concrete. What kind of numbers would you be looking for to be able to then start to look at other platforms? Just so that the basic reader would understand the model.

James

It's very difficult to say, because, of course, anything can go viral at any given time. But I would say, especially for our tent pole character, we want around 5 million followers on TikTok. It may seem like a big number, but it's not totally out of the question, because

again, if you look at the animation, which is already doing very well, type in 'Nobody Sausage' and they've recently reached 8 million followers. That's just off a dancing sausage doing goofy stuff. The question isn't so much about the numbers of followers, it's about whether it has the potential to expand and develop? I've seen some very goofy stuff get a big following and it's got absolutely zero scope or transferability. The important thing is we have more scope and transform.

Author

Please talk about transferability more as that's a very interesting concept to analyse and explore further.

James

Transferability, to my mind, comes from character-driven narratives and stories. Personality first, scenario second. Think of Iron Man. The first *Iron Man* movie is basically more of a *Transformers* movie than anything. It's down to earth, it feels grounded, but that gives you a good idea of a character, what they look like, what their abilities are, that they're charismatic, charming and a bit arrogant, but you can then take them into vastly unique and bizarre scenarios. By the time Tony Stark dies at the end of *Avengers: End Game*, he has been an antagonist in *Captain America: Civil War*, he's been a hero in the *Avengers* movies, he's been a time traveller, he's gone to space, he's done everything. That starts with personality first, if you start with personality first, you have immense transferability.

So that's why TikTok is so vital because it's a great way to establish personality. Even a fun-loving, quirky robot can be thrust into a dystopia in the distant future where everyone is gone. How are they going to react? How are they going to engage? Get a solid character and then you can throw them on the hero's journey into some horrifying or exciting scenario.

Author

We have talked about Gen Z, but what is the generation coming after them?

James

I should state that when we discuss generations, there's always a bit of flexibility with what years we're talking about, but so far from what I've seen, Generation Alpha is from 2010, to most likely 2025. The beginning of Generation Alpha are the people born at the start of the iPad, when the iPad was introduced. I think that's the best definition I've seen. They will be more immersed with screen usage than anything else. They are going to be total digital natives in a way that even Gen Z wasn't.

Author

I have a little boy who is 11 years old, he's my youngest son, Xavier, and you have just described him completely.

James

He will know more about how to work an iPad than you will. This is very important because that means that they're going to have a totally different level of socialization. They'll view influencers more as friends, they'll be far more familiar with YouTubers. Their icons won't be celebrities, they will be YouTubers and virtual characters. There was

a fascinating TikTok statistic recently which was conducted amongst TikTok users of Gen Z and 30 per cent of them say their screen time has actually decreased from streaming media and videos in general, because of the app. This is really interesting because it perfectly coincides with another statistic, which is Gen Z, and this will be even more the case for Generation Alpha. I suspect, [they] view social media as a form of entertainment. It's not about socializing. It's about entertainment. You can put your wacky, quirky personality on that for the world to fall in love with and engage with. This is important because it's going to impact the entertainment industry as a whole. It's already impacted music, but film and television and video games will not be far behind. Video games will probably be the next one, because of just how much engagement it gets on YouTube.

Generation Alpha will be able to totally immerse themselves in virtual, social environments. They will be able to engage on a global level. They'll be following and commenting, liking and subscribing to all of their favourite people. Friendship groups will be online, and I suspect that's going to be more and more the case for Generation Alpha and beyond. I guess Generation Beta would be logically next, and the only thing I would predict for that generation (they'll be 2025–2040) is a total virtual reality immersion, total augmented reality immersion. You would be able to have theoretical glasses and engage with the virtual world and the real world simultaneously. Going to a virtual concert will seem just as natural as going to a regular concert. That's where we're headed supposedly, and that's where you can tell really great stories and that's what we're trying to do.

Author

Why is it that we can tell great stories? What are those elements that lead towards that opportunity?

James

So unlike film as we know it, where you're separated by a screen and you're watching a character's journey, this will be where you can actually engage and follow a character more in real time. I'm not saying you would necessarily engage with that character one-on-one, in theory you could, but the way I see it is almost following fictional characters, like you would a celebrities, or real life influencers…

Author

This reminds me of Charles Dickens writing chapters of his books, which people would read every week in a printed version rather than in full form…

James

If you look at the Sherlock fan base of the late 1800s, they would religiously follow the stories [chapter by chapter]. Fundamentally, the storytelling medium hasn't changed, and in a way the way we engage with it won't either. You're seeing the rise of 'V-tubers'. You're seeing people able to express themselves more with creativity and art, in the same way that the characters in *Ready Player One* can choose their appearance, choose their story, go on their own adventures. I think that level of creative freedom for expression is going to become more and more apparent. An early example of this is already *Fortnite*, where you can choose how you want to look out of nearly a million 'skins', I believe. You can choose what your character is designed to appear as, and, again, there's so much innovation going on. We're already looking at things like virtual fashion, virtual clothes, virtual commodities, virtual houses, virtual real estate. It's extraordinary.

In a world where you can just have video games and global worldwide launches all digitally, or you can have, again, digital engagement for movies, you can have premium passes … thinking globally from the very beginning, I think is going to become essential for creatives and producers in the future. I think that's very important and TikTok is great because it does give you that global audience. As we grow, we will also be able to access the statistics to see who's watching us in what countries and where and why. The challenge is going to be how we integrate into other media, especially new media.

References

[1] Elaine Moore, *The Financial Times* (21/02/21).
[2] Everybody Hates Millennials, *Gen Z and the TikTok Generation Wars*, The Walrus (9/02/21).
[3] *The Guardian* (28/08/21).
[4] John Thornhill, *What Meta Verse Will We Choose to Live In?* FT (27/08/21).
[5] John Thornhill, *What Meta Verse Will We Choose to Live In?* FT (27/08/21).
[6] Mark Sweeney (18/06/21).
[7] St, Danny Fortson (18/07/21).
[8] Everybody Hates Millennials, *Gen Z and the TikTok Generation Wars*, The Walrus (9/02/21).
[9] Elaine Moore, *The Financial Times* (21/02/21).
[10] Chris Stokel-Walker, *The Guardian* (16/08/21)

Part III

Business, leadership and management strategies

21 The legal masterclass

> You know you're in serious trouble when a counter-party files a case for default. The key is to always aim to avoid that situation. And that's where really great entertainment lawyers enter the picture...
> (A Los Angeles-based film investment executive, anon)

Why legal advice is critical

Team building for all content makers includes a range of advisors, accountants, consultants and, crucially, legal representation in the entertainment business. Working with lawyers can be both extremely valuable but also at times deeply frustrating. The best lawyers are those that always put their client first, and therefore always have their client's interests before their own. The issue is not just a case of excellent legal advice and experience. Some of the best technical lawyers across the entertainment business happen to be the most damaging to deal making when they behave aggressively and lead with their ego.

Most importantly, lawyers are there to advise, provide counsel, and to 'paper' deals. This means drawing up contracts (or responding to the opposite/corresponding sides' paperwork) and then providing comments and advice on those contracts during the negotiation process. What less experienced producers sometimes do not realize is that they are the 'principals' in any negotiation, and the lawyer are advisors. A lawyer does not set the commercial terms of any agreement: only the principals can do that. Neither can a lawyer sign off and agree a deal unless specifically agreed by a 'power of attorney' letter in place.

Back in the 1990s I interviewed entrepreneur Richard Branson about his early friendship and business partnership with the late Nik Powell, the former film producer and joint MD of Palace Pictures (*The Egos Have Landed: The Rise and Fall of Palace Pictures*, 1996). Among the most salient words Branson uttered was: "Never, ever try to save money on legal advice. It will always cost you."

DOI: 10.4324/9781003205753-24

In this masterclass, the author talks with Abigail Payne, an entertainment lawyer and partner with Harbottle & Lewis

Author

Can we address the importance of 'chain of title' and the role that that plays from the very beginning of the development process?

Abigail Payne

Chain of title agreements are probably the most complicated and time-consuming agreements that a producer has to negotiate in connection with a production. And unfortunately they come right at the beginning, before the producer has raised any funds. It's unfortunate timing-wise but producers do need perfect chain of title before going into production, otherwise I promise it will come back to haunt them later. In order to minimize the outlay in legal fees at the outset, I often suggest that producers enter into a "shopping agreement" with the writer or book author instead of a full-blown writer agreement or option agreement. Shopping agreements are very simple and cost-effective, and work especially well for TV productions where the producer will know quite quickly (within say six months) whether a broadcaster or streamer is interested in developing the project. If there's a treatment or a book that a producer really wants to develop, but they can't afford to pay script fees or option fees or the legal fees for a lengthy negotiation, a very short and simple shopping agreement solves this problem. It normally gives the producer (often for no payment) between six to twelve months of exclusivity to "shop" the property around to potential development financiers or broadcasters. Once the producer secures third-party development finance, they can then negotiate the terms of the long-form agreement with the writer or the author. It enables producers to avoid getting into the complicated negotiation of terms and the payment of scriptwriting or option fees until they know whether anybody's actually interested in developing the project and they have the backing of third-party development finance.

Of course, the shopping agreement approach works better for TV than for traditional independent film, because in TV, there are very few entities to approach for finance, for example the terrestrial broadcasters, Sky and the streamers. If none of these are interested in the book, the producer will know pretty quickly and probably won't proceed with the project. With a traditional independent theatrical film, it can take much longer to know whether or not the film is viable. There is less development finance available for independent theatrical films and these tend to be developed on promises and favours until there's a full-blown script ready for packaging. So, shopping agreements do not work quite so well for films, because it can be difficult to raise development finance within the six months or year required. If you think it's unlikely that you're going to be seeking third-party development finance, then you just have to bite the bullet and do the negotiation upfront right at the beginning and try and negotiate as low option fees or script fees as you can. Agents can often be flexible, so long as it's not a best-selling author or very established screenplay writer that you're negotiating with!

Author

Can you talk us through how a book option typically works?

Abigail

At a very basic level (because book options can get quite complicated), an option fee is payable upfront. The first option fee is normally 10 per cent of the purchase price, but there's great flexibility on that, depending on what the producer can negotiate with the agent. The option fee pays for an exclusive period in which the producer is allowed to commission and develop a screenplay based on the book, and attach a director, cast and financing and get into principal photography. Option periods are normally structured with an 18-month initial option period, followed by a renewal period of 18 months and a second renewal period of 12 months. The first option fee tends to be applicable against the purchase price, meaning that it will be deducted from the purchase price. The other two option fees tend to be in addition to the purchase price, and are not applicable. It's advisable to obtain option periods of at least three years in total, especially for theatrical productions, where the development process can be very lengthy.

In order to exercise the option, the producer must pay the purchase price on or prior to the first day of filming. The traditional purchase price for independent films is about 2 per cent or 2.5 per cent of the "net" production budget. The calculation of what "net" means here is important because it makes a big difference financially to the budget. "Net" production budget means the full production budget, excluding indirect costs, which are items such as the contingency (because you don't know at the outset whether you'll spend it), financing costs such as bank arrangement fees, bank interest and bank legal fees, completion guarantor fees and insurance costs. I often try and deduct all legal and audit fees too, as these are really part of the financing. Depending on the financing structure and the level of financing costs, these deductions could add up to around 15–20 per cent of the full budget. This means that a purchase price of 2–2.5% is only calculated on around 80–85 per cent of the full budget.

Option agreements normally contain a ceiling and a floor on the purchase price. Producers should try to avoid a floor wherever possible as they won't know at the outset what the final budget is going to be. On traditional UK independent films, I often see floors on the purchase price of around £35,000–£50,000. On the other hand, the ceiling is there to protect the producer if an "A"-list actor is suddenly attached, which could vastly increase the budget. So, on traditional UK independent films, a cap is normally inserted of around £175,000–£200,000. The problem now is that in the current world of streamers, budgets are increasing. Previously in the industry, producers would be confident that their budget for a film was going to be somewhere between £2 million and £5 million, because there was no other way of financing the film at a higher budget, unless it was financed through the studio system in the US, which was incredibly rare or had a US pre-sale, which was also rare. Whereas now, it is increasingly common for budgets to end up being much higher than expected. So, it's become a bit more complex, with producers saying, "okay, if the budget is above £20 million, then the cap will be 'X'. If it's below £20 million, it will be "Y".'

Author

Can you talk about what I call 'casual agreements', in particular between producers and writers of original material? I am thinking of problems which arise between so-called 'friends' and how handshakes and napkin-written 'agreements' can end in tears...

Abigail

Yes, I'd be happy to do so. There are two common mistakes producers make. The first is where a producer is almost "co-writing" with a friend who is a writer, and so they're both contributing to the script, they have a good relationship, and then all of a sudden, things go wrong between them. They've never documented anything, and the screenplay is heavily mixed up between the two of them, so that no-one can recall who contributed what. In this scenario both individuals would jointly own the script and neither can exploit it without the other's consent. But if both individuals have fallen out, negotiation is difficult. The producer is often heartbroken, because they've been working on this project forever but the writer just keeps saying no to any offer. There's not much the producer can do in this situation unless the writer agrees terms and assigns the rights over. So, it's always good to have terms agreed upfront, especially when working with a friend!

The second example is where the screenplay is at a very advanced stage and a director is attached. The director starts working on the screenplay and may work on it for many months, giving the writer detailed notes over several drafts and even contributing to a 'director's polish'. But if something goes wrong in the relationship with the director, because you can't agree deal terms or you fall out creatively, or one of the financiers requires that a different director be attached, then there is a real problem. The producer then has a screenplay which is ready for production but which has lots of contributions from the director which the producer doesn't own, because the copyright was never assigned over. The result is a mess and the producer is then obliged to go back to a very old draft of the screenplay which existed prior to the director coming on board, which may be many months or even years old. So when a director is attached, it's really important for producers to negotiate a short-form director's attachment agreement covering the director's development services and containing an assignment of copyright – and this should be signed before the director starts contributing to the script.

Author

Can you just talk a little bit about turnaround clauses and how they operate in practice?

Abigail

Turnaround clauses in book options are different from turnaround clauses in screenplay commissioning agreements. With book options, a turnaround situation is very rare. The more common situation is that the option simply lapses

at the end of the option period and the author walks away. A turnaround situation, on the other hand, will only occur where the option period runs out, the author refuses to extend the option period and principal photography is still some months away, so that the producer is obliged to exercise the option and pay the purchase price in order to keep the rights, even though filming hasn't started. A turnaround clause in a book option will normally say that if filming doesn't start within five years of payment of the purchase price, the author can then license the book to other producers provided the purchase price is repaid to the original producer from the budget of the turnaround film on the first day of filming. The author is not normally required to repay all of the producer's development costs on top of the exercise price.

A screenplay turnaround clause works slightly differently. Where a script is being commissioned and script fees are paid and there is an assignment of rights to the producer (as opposed to an option structure), there is normally a clause stating that if filming fails to commence within a certain time limit (say three to five years from delivery of the last writing step), the writer can re-acquire the rights in the script which were assigned to the producer under the agreement. However, the producer or development financier normally requires that not only all the script fees are repaid, but all other development costs as well, including casting directors' fees, recce costs, line producer fees, director attachment fee, and book option fees etc. Some development financiers require that a premium of 10–25 per cent is repayable by the writer on top of all the development costs, to compensate the original development financier for advancing risky development monies.

Author

The important thing to get across is that chain of title isn't just a concept, it's a bundle of documents that are going to be checked by any party, whether they're in sales, distribution, financing, streaming, whoever they are. It's normally the very first thing that a third party will ask to see from a producer. That often is where the problem starts.

Abigail

Correct. The most complicated scenario is where the project has had several previous lives, meaning that it's been developed by one or two US studios and is now in turnaround from both or has had several different writers or production companies. Sometimes there can be 20 or more agreements that form part of the historic chain of title.

Author

Can we just move now onto production agreements? I'm thinking here of how a producer organizes themselves when it comes to dealing with a lot of different heads of departments. Most heads of departments, certainly in Ireland and the UK, have an agent or a manager. There will be a negotiation no doubt about the weekly fee or salary that they're expecting over on a production, and I'm just

interested in how much help your production lawyer can give you on that side of closing a film. In other words, getting all the production agreements nailed down.

Abigail

Our involvement in the day-to-day agreements for the heads of department and other general production agreements will depend on the size of the production budget. My firm [Harbottle & Lewis] often acts on large US studio productions where we spend a great deal of time advising in detail on the production agreements such as heads of department agreements and facilities house and location agreements because these agreements are very valuable on big budget films, so can often be complex.

On lower-budget UK or European films we tend to have less involvement in these types of agreements and instead issue the production company with a 'production pack of templates', which the line producer or production manager then simply completes with dates, names, fees etc. These packs contain a large number of templates, such as cast agreements and special stipulations, various different types of crew agreement (for example PAYE or loan-out), a location agreement, prop release and many others. If the agents of the cast or heads of department occasionally require amendments, then we do advise on the drafting of those amendments, but I tend to find that the lower budget the film is, the fewer changes are requested by agents to these templates. On these lower-budget types of films, we don't tend to get involved in the negotiation of the fees for the crew. This is normally handled directly by the line producer.

Author

Obviously, there's a big difference between streaming, broadcast and independent films in terms of the concept and application of net profit points and share of net. I am interested in hearing from you about the importance of nailing down the appropriate points that you'd expect to give a screenwriter, a director, and what's left for the producers, having shared with the talent, including obviously the lead actors? How would you normally see that typical group divided?

Abigail

Net profits are in a state of flux at the moment and things are changing rapidly in this area due to the rapid entry of streamers into the marketplace, which don't account for ongoing revenues. Let's start with a typical independent film financed, for instance, by BBC Films or Film4, a sales agent, pre-sales, tax credit[s], and an equity deal from a post-production house, for example. That's the typical financing structure that's been around for years and existed before the current world of streamers. On these types of film, the equity investors tend to take 50 per cent of the net profits, leaving the production company with 50 per cent. The 50 per cent share that the production company retains is called the 'producer's share'. Talent net profits are normally expressed as a percentage of the producer's share of net. Writers tend to be offered 2–3 per cent of the

producer's share of net. Directors tend to be offered a little more – say 3–5 per cent of producer's net. The net profit shared offere to cast varies widely depending on how "A"-list they are. If they're not "A"-list, their share is often quite small – say 1–2 per cent of producer's net, or even lower. If they're "A"-list, it can be much larger and "A"-list actors are often entitled to box office and award bonuses and large deferred fees on top of their net profit shares.

I said earlier that net profits are in a state of flux. This is because where a film is being fully financed by a streamer, the streamer will commonly "buy out" any ongoing revenues by paying a lump sum premium called a "buy out" premium. So increasingly, it is this one-off premium which is deemed to be "producer's net profits" and which is shared with the talent according to the percentages set out above.

Author

Can we address typical financing agreements? Let's start with the kind of things that you might look for from a sales agency agreement. I'm thinking here the kind of things that you need to watch out for, in terms of the license term of the territory, the typical kind of fees that a sales agent might charge, the sales and marketing costs and first festival costs being capped … Can we run through some of those key commercial terms that you'd expect to see from a typical sales agency agreement?

Abigail

Well, with the sales agent, it depends on whether or not they're putting up a sales advance. A sales advance works as follows: the sales agent will look at what they think they can sell the film for throughout the world in all the different territories. If they feel they might get, say, three million dollars of sales, they might put up a sales advance of, say, one million dollars. Typically, however, sales agents do not put up advances. Often they just produce what are called "sales estimates", which is a list of estimated sale prices in each of the territories which the producer then uses to attract investors. If sales agents do put up an advance, their commission tends to be a lot higher – the starting point is often around 20–25 per cent. Where there is no sales advance, typically, a sales agent will charge a sales commission of about 15 per cent of gross worldwide receipts, although the commission on the US sale tends to be a bit lower, say 7.5 per cent or 10 per cent [sometimes shared 50/50 with the US talent agency representing the lead actor, as that agency often jointly negotiates the US sale in tandem with the sales agent].

A sales agent will be granted the rights for a fixed term, which can be anything from 15 years to 25 years. Some sales agents even take the rights in perpetuity, especially where they are putting up a serious sales advance.

The sales and marketing expenses incurred by the sales agent will depend on the budget of the film, but for a typical independent British film, the cap on these is normally about £100,000–£150,000, although I've noticed this has been reduced to closer to £50,000–£75,000 in the past five years or so. Any expenses above this cap will require the producer's approval.

Sales agents tend to produce two different sales estimates called the high [or 'Ask'] prices, and then a more realistic scenario estimate, which is called a low [or 'Take'] prices. The producer will have approval of any sales made by the sales agent which are below the minimum sales estimates. However, if the sales agent is providing an advance, then it won't allow the producer an approval right. In this scenario the sales agent will have complete control over what sales they make, so that they have the best chance of recouping their sales advance.

Author

'Take' prices are the only estimates that any bank or financier will look at. They're not interested in the highs, they're interested in what they think the currency of the sales company is, and whether or not they actually have a track record of hitting a consistent level of 'take' prices or above. One of the things that I experienced when I was putting different international films together was the importance of the bank – the bank who's lending senior debt. In other words, cash flowing, perhaps the UK tax credit or Section 481, and often doing a certain amount of such as discounting pre-sales, and in certain cases, which is less likely now, a percentage of gap finance. It always struck me that when we were negotiating, especially on a complex jigsaw puzzle-kind of financing, where there are different entities together, that actually the producer needs to pay a lot of attention to the bank in order to close a film.

Abigail

A massive amount of attention! The reason banking contracts are so complex is that banks are in the business of zero risk. Banks normally issue a lengthy condition precedent checklist, which could have some 50 or 60 items on it, which all need to be concluded and delivered to the bank before the producer can draw down on the bank loan. Absolutely everything has to be in place for draw down. When banks lend against multiple pre-sales, it can become very complex, as the bank will require that a separate notice of assignment is negotiated with each pre-sale distributor. A 'Notice of Assignment' is a cast-iron guarantee from the local distributor that it will pay the minimum guarantee (MG) when the film is delivered (with "delivery" being defined in accordance with the completion bond's definition of "delivery"). The notice of assignment stops the distributor terminating the distribution agreement for alleged breach – for example, if there's a problem with the chain of title, or the film is not first-class quality and is less commercial than anticipated. The bank will insist that the completion bond is in place and on risk, and for the completion bond to be in place, all the cast have to have had their medicals. If a cast member is an essential element, then there has to be separate essential elements insurance in place, so that if the cast member is ill or injured, then the film can be abandoned, and the bank is repaid via the insurance. Each condition precedent involves a raft of separate paperwork.

Author

It doesn't change much when you might have an entity that is fulfilling the same functions as the bank, but is effectively acting as a financier, a lender.

Abigail

Correct. The lead financier is always very rigorous to make sure that their collateral is fireproof. In the rarer circumstances where the financier is a private individual who's investing for the fun of it, or sometimes a government body, then the paperwork can be a little more flexible, but only a little!

Author

What's also interesting, when you were talking about the importance of the notice of assignment to any distributors who pre-bought the film, the other key point that's important is to make sure that pre-buying distributors pay their deposits. That can rest on both the producer and the sales agent, or even, in certain cases, the international distributor, to have to lean very heavily, with a time crunch on getting money out of distributors. They tend to be surprised and say: "But I'm not part of the financing of the film." The response is "Yes, you are. You do need to pay that deposit now or the film won't start."

Abigail

Yes, the collection of pre-sale deposits just before financial closing can be very stressful – especially when filming has begun and we urgently need to close the financing to meet the first cast and crew payroll. There can often be a delay of a couple of days in closing simply because the signatory at a distributor in a distant territory is away on holiday, not realizing the time pressure! The other common problem with pre-sale deposits is that, at the last minute, somebody suddenly realizes that withholding tax is deductible on the deposit. So, right on the day of closing you end up with less financing than you were expecting. Or the currency exchange rate suddenly plummets, so the deposits, once converted to Sterling, are worth a lot less than you were expecting. Of course, the bank will say, "well, there's now a hole in our collateral, so we can't close". Then there can be a further delay while everybody argues over whose fees are going to be deferred in order to plug that gap. So, it's often deposits and exchange rate differentials that hold up closing.

Author

There's one agreement that I just wanted you to talk us through: the inter-party agreement and when and why it's required?

Abigail

The inter-party agreement is the one agreement that joins all the financiers together. The most important provision in the inter-party agreement is the financial undertaking from all the financiers to each other that they will continue to fund the film in accordance with the cash flow schedule, come what may. Unless the completion bond abandons production and repays the financiers, or the financiers all agree to stop funding in a force majeure situation, then all the financiers have to keep funding. Otherwise one of them could simply claim breach by the producer of its financing agreement and stop funding, leaving a large hole in the

production financing. The other main reason to have an inter-party agreement is because different financing entities take separate security, so you end up with several security agreements on one film. It's important to regulate the order of priority of that security. A security agreement is very much like a mortgage on a house. If you have two competing mortgages, one of them has to take priority if there's a sale. The priority of security normally follows the recoupment schedule, so that the bank's security is in first position, the mezzanine (or gap) financier's security is in second position and the equity funder's security is in third position, with the completion bond in fourth position. Sometimes security is prioritized according to territories, so that if an investor is investing only against the sales estimate for the US and is recouping in first position from US revenues, then that investor will have first priority security in the US.

The inter-party agreement also attaches the final budget, cash flow schedule and credits schedule. The credits schedule contains all the various credits and logos of the financiers and their executive producers and there is often quite a bit of negotiation between the financiers as to the form of their various credits (for example, "X presents" or "in association with X") and whose credit appears first.

The inter-party agreement also regulates the relationship between the sales agent and the financiers, giving the financiers numerous pages of approval rights over sales and over other decisions of the sales agent. It also sets out the priority of the approval rights, meaning the rotation of these. The bank tends to be deemed the approver until it is fully paid out, so only the bank can approve what the sales agent does or doesn't do until the bank is fully recouped. Then the approval rights pass to the financier, which recoups next in priority, and this normally follows down the recoupment order. The producer has to cede its original approval rights under the sales agency agreement to the financiers. Once all financiers are fully recouped, the producer gets their approval rights back, by which time it's probably too late to make a difference!

The inter-party agreement also covers who gets to determine the final cut of the film, and there is often a "final cut panel" made up of the various financiers.

Author

Can you talk us through your sort of hands-on experience of dealing with equity investors and how they might behave?

Abigail

Equity investors tend to be individuals, and sometimes they are new to the film industry. They are often friends of the director or producer, or they like the particular subject matter of the film. You could call them investor 'angels'. Equity investors recoup behind the bank, and behind what's called 'mezzanine' finance [aka 'gap']. They're the last financier to recoup. Equity investors do not charge an arrangement fee or interest in the way that a bank will. Instead, they are entitled to a premium of around 20 per cent of their investment. The premium is recouped alongside their investment, so that in total they are entitled to recoup 120 per cent of their original investment. Equity investors are normally also

entitled to a pot between them of 50 per cent of the net profits, which is often referred to as the financier's share of the net profits. Banks don't tend to be net profit participants. So equity investors have much more potential upside than the lead financier if the film performs really well, but their risk is much greater if it doesn't perform well, as they recoup in last position.

Author

Who is the producer's best friend during this period of closing finance? Who is the best person to stay closest to?

Abigail

The production lawyer, of course! I often speak to producers 10 times a day during the closing process, which can be a very stressful time for producers – it's important for them to have a good team who come up with innovative solutions to the problems that invariably arise.

Lawyer aside though, the producer's best friend has to be the lead financier. If the film is being financed by a fund rather than a bank then the person who you really need on your side is the person running that fund. If there's a bit of money missing due to an exchange rate differential or something goes wrong at the last minute, it's a case of trying to persuade the lead financier that they should help you for the benefit of the film and the benefit of everyone. If you have a really good relationship with the lead financier fund, they will often bail you out with a bit more cash. A bank will struggle to do this because they have to go back to a credit committee, get more approvals, and tend not to be as flexible as a fund.

The other best friends, of course, are the UK broadcasters and government bodies and their equivalents on the continent in Europe. These entities can be very helpful and flexible, because their primary remit is less the making of money, and more the supporting and nurturing [of the] talent in the British film industry.

Author

Where would a streaming platform differ in terms of what they're looking for?

Abigail

Well, there are really two different scenarios. It depends on whether the streamer is commissioning and fully financing the production of the film, or whether the film has been produced with private finance and then later sold to a streamer at Cannes or Berlin, when the streamer will often take the world, or the world outside the UK. In the latter case, the deal will look rather like a normal distribution deal, as it's really a pick-up. However, if a streamer commissions and fully finances the film, it will act much more like a studio, and will expect to take a lot more rights – for example, all subsequent production rights, video game rights, even stage rights, publishing rights and so on. Often a commissioned film will need to be produced through the streamer's own production vehicle, just like a studio. So, the production company would be owned by the streamer, and the

producer is more of a 'producer for hire' in this sense. The copyright and other intellectual property is then owned by the streamer, not the producer's company.

Author

Can you explain the role that the collection account plays, especially when it comes to closing the film's financing, but also the collection account management agreement [CAMA] in terms of what function it plays for the producer and the financiers and all the talent involved?

Abigail

A collection agent is an independent revenue collection specialist which is based in a tax-efficient country for withholding tax purposes – normally Hungary or the Netherlands. The most commonly used collection agents on UK productions are Fintage House and Freeway. The collection agent collects and administers the revenues from the exploitation of the film. In order to protect themselves against the insolvency risk of sales agents and to have transparency of accounting, financiers insist that a neutral expert administers the revenues. When local distributors buy a film they pay their MG directly to the collection agent rather than to the sales agent. The collection agent then accounts to all the participants according to an agreed recoupment schedule which sets out the recoupment priority of all the participants. The producer, the film's financiers, the completion bond, and the sales agent all negotiate and sign a collection agreement with the collection agent, that sets out in great detail how accounting is administered, for example when participants are to be sent statements, their audit rights etc, and, most importantly, the recoupment schedule for the film. A typical recoupment schedule would be as follows: collection agent fees and expenses come off first, then the sales agent's sales commission and marketing expenses come out next, then guild residuals, then the bank or lead financier is repaid, then the mezzanine or gap financier, then the equity financiers are repaid, often with a premium of, say, 20 per cent, then deferred fees are paid out and then if you're very lucky you hit net profits. This is all set out clearly in a recoupment schedule which is attached to the collection agreement.

Reference

Angus Finney, *The Egos Have Landed: The Rise and Fall of Palace Pictures*, Heinemann, 1996.

22 Project management and cognitive bias

> Some very rich men in Hollywood were bearded, but most of the assistants and vice-presidents who wanted to look like rich producers with beards only looked like those assholes with licence plates frames that say ... MY OTHER CAR IS A PORSCHE. The bearded producers were only copying the bearded directors. The bearded directors were all copying Francis Ford Coppola...
>
> (Screenwriter and novelist Michael Tolkin) [1]
>
> One man (sic) can never have too much power. If my life has a meaning, that's the meaning.
>
> Max Shreck (Christopher Walken), *Batman Returns*, Warner Bros, 1992

Back in the 2010s, I decided to try my hand at starting and completing a "PhD by prior publication". I had published a body of books, reports and some papers on the international film industry. (I did not have a beard, nor a car, let alone a Porsche.) However, when reflecting about the lessons from failure that did for Renaissance Films in the 2000s (a key focus in the 2010 edition of this book), it seemed to me that one of the big problems we face in the film business lay rooted in "cognitive bias", which to us mere mortals means: "How We Lie To Ourselves".

The following chapter, complemented by an interview with the South African-born filmmaker Zaheer Goodman-Byat, has been adapted from that thesis, and for some it may make uncomfortable reading. Look away now.

The industry setting and context

This chapter defines the film entrepreneur – which in this case is the producer – and their relationship to cognitive bias. Like the long-suffering alcoholic, unable to cope with the craving for booze once started, and perpetually obsessed with the next drink and spree rather than living in the now, the producer is forced to confront and navigate an array of potential pitfalls that can send the toughest back to the bottom of the trenches.

The producer is seen as the lead project manager [2], but they will need to work alongside their key 'collaborative relationships'[3], including talent, financiers, sales companies and distributors/platforms. 'Project entrepreneur', when used as an academic description that reduces the manager to a sole individual, is not consistently accurate within the film industry context, as 'producer partnerships,' 'teams',

DOI: 10.4324/9781003205753-25

'collaborative relationships' and 'networks' play critical roles in the film industry's project management architecture.

Project management takes place in the film industry through the framework of the film value chain model, as I have established in Chapter 2. Therefore, it is helpful to further examine and define the model as it forms a key framework for the producer's mental model, 'habits' and 'conventional wisdoms', and arguably shapes the environment within which local decision-making occurs. Producers are acutely aware (or at least they should be) of the need to maintain momentum, and shift their projects from development to a package, through attracting financing and into production, and from delivery to distribution, and finally reach an audience.

Table 22.1 Film value chain model (non-Hollywood model, by activity)

Element	Players	Support
Consumer	First-time product is seen by end user, and where true value can be assessed and realized. Time and money have been sunk at high level before this final contact with the consumer marketplace.	Media spend, press and publicity, social networking + traditional marketing tools
Exploitation – traditional theatrical/ ancillary; platform/ streaming	Exhibition/cinema release, DVD sales/rental, VHS, Sales/rental, pay-tv, Video on demand, Internet, Download, Free-TV, Syndication Library rights: on-going exploitation opportunities for producer, financier; distributor's licence window. Remake, prequel, sequel rights + library sales	Marketing by territory (distributor and separately by exhibitor)
Sales/acquisition to distributor/ platform	International sales agent; producer's rep; producer, Marketing and selling distribution rights and in return receiving commission.	Marketing by sales agent and international markets
Production: Pre-production/ Shoot – 'principal photography'/ Post production	Production company/producer, director, cast, crew, studio locations, labs, support services, post production, supervision, facilities. (Director, producer and financiers normally involved in final cut and sign-off of product)	Marketing use of PR on shoot, still photography
Financing	Producer(s); Production company; package (including the script, director, cast, national and international pre-sales (if available), sales estimates, co-production, co-finance. Funds/partners, national subsidy finance, national broadcaster. Finance, equity, bank, gap finance, tax financing. Executive, Associate and Co-producers. Talent agent, talent manager, lawyers. Completion Bond. Insurance.	Lawyers, talent agents, managers
Packaging (Preparation of budget, attachment of director; actors)	Concept, idea, underlying material producer (creative), Writer, development executive, script editor, development fvinancier, agent, director (as developer with writer or as writer/ director). Private equity rare at this stage.	Regional and national subsidy support and/or broadcaster support.
Development (Producer-driven, writer(s), writer/ director	–	–

Source: Finney, A. (PhD Thesis 2014)

The independent (i.e. non-Hollywood Studio) film value chain (see Table 22.1) includes a sequential 'model' to help identify each stage a project manager needs to navigate in order for a project to reach the market.

Project management

To further understand project management in the film industry, it is helpful to start at the stage that the basic elements of how films are set up and managed. My participant observer data and ethnographic-orientated experience has shaped my findings on how films can be effectively managed and navigate the value chain. The project manager will need to inspire and manage all key collaborators 'inside' the project team [9]. They will also need to deal with the uncertain [11, 15] 'outside' relationships and generally unpredictable [1] contextual environment. Contrary to industries where conventional forms of exchange dominate, film industry project entrepreneurs typically face two further key challenges: the interruption of project-based relationships by shorter or longer latent time periods, and the subjectively-viewed 'uniqueness and novelty' of a particular project (Manning and Sydow, 2011) [59].

We then turn our attention to first-hand experience; to the things that go awry, and lessons that one can potentially glean from the experience if mindful of the importance of a reflective approach. Lessons form elements of the professional 'knowledge-based learning' and the 'knowledge capture' process (Mintzberg et al. 2009) [13], and ideally should assist both existing and emerging practitioners, and guide project managers from avoiding similar traps and pitfalls in the future. Knowledge-based resources (Miller and Shamsie, 1996) [5] play a key role often underestimated or taken for granted by practitioners. "Knowledge-based resources often take the form of particular skills: technical, creative, and collaborative ... [some] may have the collaborative or integrative skills that help experts to work and learn together very effectively" [ibid., p. 522]. For that to take place within the film project management environment, 'habits' [2] will need to be challenged and broken down, and 'conventional wisdoms' empirically challenged, as Catmull emphatically states (see Chapter 28). Further analysis of how and why 'learning' [6] does not take place within the film industry to a significant and tangible extent is explored in this chapter.

Project management in the film industry

Project management is a central pillar within the film business: each film is a project in itself. Professionals even refer to films as "projects" per se on a daily basis [6, 7]. The key project manager, from start to completion, is the film producer. The producer's role and responsibilities are wide-ranging and cover 12 key areas (see Table 22.2), which rely on a high degree of self-organization, local decision-making, networks and collaborative relationships [3, 4]:

There is considerable evidence that there exists a difference between what is supposed to happen in effective project management in the film industry, and what often happens in reality [6]. The paradox of managing projects in the film industry is that practitioners need to master the principles of how projects are supposed to be managed to make films that capture value, but to be effective they must also learn to acknowledge and cope with the failure of these very principles and build on them.

What do we know about how to manage projects in the film industry?

Table 22.2 Learning from sharks: lessons on managing projects in the independent film industry

The producer's project management role: responsibilities throughout the film value chain
1. The production company's entire slate of projects
2. The project's inception, research and development
3. Creative development and attachments (to achieve a script and "package")
4. The package required includes the building of 5 key elements: a) script, b) producer, c) director, d) budget, e) leading cast
5. Collaborating with financing parties and execution of contracts
6. Building a team of additional executives (executive producers, co-producers, associate producers etc.)
7. Drawing on third-party resources, including lawyers, agents, accountants
8. Budget, locations, schedule, logistics etc.
9. Production crew and extras
10. Post-production and delivery of the film to distributor
11. Distribution and marketing plan
12. Film launch followed by long-tail monitoring.

Source: Finney, A. (2008)

Managing film projects as a process

1. In principle, managing the film project should start and end with the film producer. Every decision the producer makes (or avoids) will impact on the way each level of a project advances. Managing the creative development process means the concept, story and screenplay, which all begin early in the project management process. This critical stage of the management process can be compared with the design and laying of a foundation for a tall building. If it's slightly out at the start, the rest will collapse later.

2. The ambitious producer is, by definition, also a dealmaker and collaborator. An experienced producer knows the number of projects he or she is able to manage successfully. From the perspective of a hands-on film producer (who is dedicated to the making of films rather than acting in a more removed 'executive' capacity), he or she will only be able to make one feature film a year. More might impact on the effectiveness of their 'project management'. A top Hollywood producer making blockbusters (films of budgets in excess of $100m, but now normally more than $200m+ excluding prints and advertising release costs) can normally manage one film every two years or so due to the sheer scale and demands of each project.

3. A producer is, by definition, in the business of multi-tasking; but their focus is on three key areas when managing a film project: development, production and distribution. At the development stage, an established producer would be reading (and, where appropriate, optioning) a range of books, plays and other source material for adaptation, considering original film treatment outlines, commissioning scripts, reading original screenplays and packaging more advanced films. These activities form the R&D element of their business. So while overseeing the physical production process on any given film project, a producer should be concurrently developing a slate of projects at varying stages of advancement.

4. As films come closer to achieving financing and entering the production stage, the producer needs to identify and attach value to the project. For example, attaching "elements" such as a director, cast etc., enables financiers and distributors are better able to assess the project's market potential and intended audience. That same producer is also responsible for securing distribution for the film. This is a challenge that they should be considering from the early stage of a project's conception. Alongside the distribution stage is the marketing and commercial exploitation of each completed film through a series of windows (albeit now collapsing [18, 19]), while the detailed management is delegated to third-party distributors and/or studios around the world. The distributors, in turn, deal with exhibitors, aggregators, sub-distributors and ancillaries etc. [7].

5. The producer is a pivotal figure in the production process, but they work alongside the executive producer (s) and/or operate with co-lead producing partners. The 'executive producer' is responsible for raising part or all of the finance, but is expected to complement and assist the producer's day-to-day management of each film project. Most executive producers manage larger companies than the sole producer with an active slate of 10 or 15 films on an annual basis. They are therefore expected to oversee each project, with specific focus on financing and exploitation. While financing entails raising funds to cover the costs of production and marketing, exploitation focuses on maximizing revenues from all release and distribution formats and platforms: cinema release, Video-On-Demand, Pay-per-view, Pay-TV, Free-TV etc.

6. Producers must also negotiate and liaise with international or local distributors and/or streaming platforms, often through the services of a sales agent. These sales agents, of which there are around 300+ across the world but predominantly situated in LA, NY, London and Paris, are responsible for selling films to each territory around the world, whereas local distributors take charge of releasing films in a specific territory. Distributors normally see the product at a later stage and therefore have a different perspective to that of the producer. They will at times play the role of executive producers, helping to finance films. For the most part, however, their overriding imperative is to manage the film release process in their respective territories, or around the world if a studio has acquired the product.

7. Within each film project, a range of additional practitioners plays a role. They divide into four key sectors: a) creative, including writers, directors and actors; b) the crew who make the film; c) third-party financiers, including banks, investors, sales companies, broadcasters, distributors; and d) 'services', including lawyers, accountants and agents. Some exist inside the film value chain while others are outside the chain, highlighting the fragmented nature of the non-Hollywood industry in question. To help guide the reader through the inside/outside players (see Table 22.3).

Knowledge and the challenge of learning through projects

Translating expertise into control whenever possible is inherently desirable from a project entrepreneur's perspective. No producer is expected to be a leading expert in all the above areas. Their respective project management skills, however, will dictate which areas they control and lead directly; and which they delegate, including what appropriate teams and levels of responsibility are given down the line. It is sometimes

Table 22.3 Insiders and outsiders in the film industry

Film industry insiders
Producer/writer/director/executive producer/co-producer
Sales agent, studio/distributor/streaming platform
Festivals and markets

Film industry outsiders
Lawyer(s)
Accountant
Financier/investor
Agent/manager
Public funding body
Aggregator

Source: Finney, A. (PhD Thesis, 2014)

said that a great producer hires people who, in each case, know more than they do. Each area is extremely demanding. A producer who is inexperienced in certain areas will fail if he or she does not delegate effectively; a producer who cannot co-ordinate executives and representatives and drive timelines will be unable to achieve financing and/or production completion.

A producer who can complete the creative package and finance for a film, but has not considered the market for distribution and exploitation will fail to recoup (meaning recover the negative cost of the project and then share in net profit revenue streams). In summary, producers need to know a huge amount about: a) themselves and other people's behaviour; and b) effective, specialized project management, if they are to succeed [6, 7].

Knowledge of what may happen, often optimistically mapped [13] by the film producer in the style of a 'pre-mortem' (Makridakis, 1990) [1] analysis, including the use of such tools including a film's finance plan, forecasted value in all territories (aka 'sales estimates') around the world, or a casting wish list, is not the equivalent to understanding, controlling and conquering the project management process. Such pre-mortems [1] and map-making may provide the project manager with a sense of project momentum and sense of control. They also play a role in often providing financiers with a false sense of comfort. Based on my own practitioner experience, much can change very quickly to make such planning redundant, and forecasting ultimately misleading and empirically wrong [7].

There are few industries where project leaders and managers have as little genuine control over results and 'capturing value' as the film industry [11], and yet they operate on a basis underpinned by the 'illusion of control' [37]. This inherent threat applies even more so to film producers working outside the Hollywood system, and in particular now that the international market has been so explosively disrupted by the arrival of highly competitive streaming platforms. Ultimately, the typical way that film producers learn to deal with the gap between knowledge of how the process is supposed to unfold, and control over this process, is on the job: dealing with crises and rising to the challenges. Indeed, project management in the film industry is often akin to 'crisis management' rather than an orderly progression through the value chain, from development, packaging and financing, then on to production, post-production and to delivery, and finally to festivals, markets and an audience [7].

The knowledge that emerges from learning to manage this gap is heavily based and dependent on individual experiences, hearsay and tacit assumptions. It is therefore idiosyncratic and ambiguous to measure accurately in as far as most filmmakers are fortunate (or unfortunate) enough to directly experience only a limited number of crises over one professional lifetime. But the lessons that filmmakers acquire from these incidents are at times tacitly gleaned but more often ignored by the wider community, [4] including other filmmakers, talent, production organizations, financiers, agents, lawyers, public bodies and competitive groups. There is a marked tension between recognizing how competing project entrepreneurs operate in this uncertain market space. Few wish to acknowledge how little control each of them actually has over the highly demanding process whatever they may optimistically hope for [6, 7].

Many projects that I have gleaned through the interpretation of my research material can be usefully analysed through the 'objective' School of Cognitive Strategy (including themes such as the 'illusion of control', 'escalating commitment', 'narrow framing', 'single outcome calculation', 'optimism' and 'blind spots', et al.) [1, 13]. In light of the broad range of cited film-related research, it is hard to discover project managers and organizations that appear to display the ability to 'switch gears' at a cognitive level [2]. There are, however, lessons and tangible evidence that are readily available through project management activity, which appear to be repeatedly ignored by film industry peers and rarely tapped in education and training. Some film industry research suggests that existing training techniques are of little value to practitioners and their ability to capture value going forwards (Lampel et al.) [8], but my research suggests that by highlighting biases and challenging industry norms and assumptions, a new, fresh cognitive awareness is capable of being captured. I am not alone, given the recent enlightening contribution from Pixar's Ed Catmull to the body of literature [16]. The registering of such heightened levels of awareness about cognitive bias and mental models supports the importance and relevance of these lessons and their wider implications for film, creative industries and beyond.

There exists a perplexing gap between what is supposed to happen and what actually takes place in film project management. Cognitive strategy, as my thesis evidences, can help explain why that gap is so prevalent in film project management, and what we can learn from the way that individuals and companies have overcome that gap and captured both repeated success and valuable insights into creative management, leadership and knowledge capture.

Interview with South African-born filmmaker Zaheer Goodman-Byat, currently working as a producer and entrepreneur in Los Angeles, USA.

Author

Please tell us about how you started in the entertainment business?

Zaheer Goodman-Byat

My earliest days in the business was as child actor. As a 12-year-old, I started acting in TV commercials and theatre productions and had directed my first play

professionally by the time I was 16. Then I didn't want to do that, and I thought I needed to do something more serious, so I then pursued a very serious career in finance and banking. 10 years later, I realized I was very unhappy, and I wanted to get back to do my first love, which was the entertainment business. The way it happened was that I literally walked into my best friend's house for dinner on New Year's Eve. He was a very established commercials producer, and I said "hey, Gareth, let's make a movie", and he said "what?", and I said, "let's make a movie", and he said "okay". Three months later we were shooting something. The only thing I can say about how I got started was I just wanted to do it and I refused to accept anything else. I think that's the key. You just do it.

I mean, it's so interesting now, right? These phones, the camera and its abilities and the offline edit and online that you can do on the Macbook Pro that I'm speaking to you on now. In order of magnitude it's all more sophisticated and advanced than it was 15 years ago. For anybody who wants to make something, the only limitation right now is their willingness to actually do it.

Author

Interesting. You know, this reminds me of a great statement from Mike Figgis, the well-known British filmmaker. He makes a similar point in a fine book called *Digital Filmmaking* (Faber). He said he has been frustrated throughout his career by young and emerging filmmakers who never start. They talk a lot, but they don't start.

Zaheer

Yes. I was privileged to attend a workshop with Anthony Minghella at the height of his career. He was delivering a directing workshop and there were maybe 30 of us. He started by getting introductions from everybody: "Who here is a director? Put your hand up", and in a room of about 30 people, two people put their hands up. He said "The rest of you, this is a workshop for directors, so if you're not a director, what are you doing here? Why did you come? Are you a director or are you not a director? Who decides whether you're a director or not? It's you, you decide. Until you've decided, you're not it. So just make a decision and do it." He was just extraordinary. His ability with actors was amazing. He had six actors who had prepped three scenes between two of them, and he directed the actors through the scene. So, you watched him at work, crafting the scene with different actors and how he was able to be incredibly direct with people without being insulting or offensive. I think that was the biggest thing I took away. His precision with giving very direct feedback that was true and accurate, but that was not offensive and where you understood it was all about the work. There was one actress in particular that was very resistant to the feedback. Anthony just got to a point with her where he was like, "You're the actor, I'm the director. I make the movie, it's my movie. This is my scene. You're in it, but this is my scene. If this was an audition and you don't do what I tell you and you're more interested in arguing with me than you are in exploring the scene, you're not going to get the job."

Author

A high level of straightforward communication and a certain level of emotional confidence. Those are great qualities for a director.

Zaheer

Super important. I think the hardest thing that I've experienced in this business, and particularly starting, was getting direct feedback from people where they tell you honestly why they're saying no. It's really interesting some of the things I've learned along the way. People say no for a host of different reasons and in my case, I've found a lot of the no's have nothing to do with my project and more to do with what's happening with the people I'm talking to. So, I had this one very interesting experience with Endgame, and they were shutting down. They were winding up their business and they were super interested in a project. We were very far down the road with them financing it and at the last minute they didn't pull through. They gave me some super weird feedback on the script that I didn't understand and went like, "Oh, we're not going any further." I was like, what just happened? I do not understand these notes, but it's like, well, they've said no and there's nothing I can do about it. Then 12 months later I found out that all the staff were getting fired and they were shutting down, and instead of anybody just being honest and saying, "Hey, we can't go forward with this because the company's not profitable and we are shutting the company down", they just gave super weird feedback. I think the worst thing that could have happened at the time was if I'd taken that feedback seriously.

Author

When did you get to the stage where you started to explore and grow, because you were getting better feedback?

Zaheer

If you take one thing from this, it is to hold onto the contacts that will read whatever you send them quickly and give you a fast no. Put those people at the top of your call list for the next project, because those people are serious, right? The fact that they've looked at it, given you a clear answer and moved on is great. It means that when you contact them again, they'll look at it and give you a clear answer. The worst kind of people are the ones that go, "Wow, your project's really interesting. We might be interested if you attach Angelina Jolie to this role." I remember this was a turning point moment for me with a "C"-list distributor at the Cannes Film Festival, who said exactly those words to me: "If you get Charlize Theron in this role, we'd definitely be interested." I looked him in the eye and I said, "If I had Charlize Theron in this role, I would not be talking to you." Right? That is feedback that's absolutely no use to you because you're never going to get Charlize Theron and then you're never going to be dealing with these guys, because if you did get Charlize Theron and you have that access, you'd be at a whole different level.

Author

Can you discuss your approach to writers and how to handle notes?

Zaheer

I have my particular approach to notes, and I think it's because I came from a writing background and I wrote a lot at the beginning of my career. I still write a fair amount. My approach to notes is this: Usually there's one or two things that are wrong in the script that are major problems. What the notes tend to do is focus on a lot of nit-picky details. You can polish a turd, but at the end of the day, it's still a turd. I think too many notes actually move things backwards. The magic is finding the note that's the real note. What's really wrong with this? Why is the person giving me these notes? What does this mean? Does it mean my lead character is not clear enough, doesn't have a clear enough objective, is not going on a big enough arc, is not believable? What's the real note that's making people respond in this way? The key to that is that you just can't be defensive about your work. For me, this came from a lot of making things and then sitting in a room with an audience and watching the response and going "Oh, that's how they reacted. Why did they react like that?" So, the privilege of notes is you're watching somebody's response as they articulate why they responded, but a lot of the time, those readers don't know why they're responding. So, our jobs as people who read notes is to listen to *why* they're saying, not *what* they're saying. Some note-givers are really good at articulating their *why*, and then you can test it for yourself.

Author

When you and I first met in 2008, a number of people in the room in Johannesburg stated: "I'm a writer, producer, director." You've had experience now over navigating and strategizing your career and working out where you put the emphasis at different stages. How do you navigate those steps and choices?

Zaheer

Yeah, that's a really interesting one. I think at the beginning, I really wanted to be a director, and I wrote a lot. Writing for me is the primary creative material. Everything else is secondary. Writing is the only real creative job. Directing is not a core creative competence, because the director is building on the writer's work. I think for people who want to be directors, it's really important to distinguish between, am I a writer-director, that I want to own all of the creative because I have something to say and I have a point I want to make. I have something I want to explore and communicate. The pinnacle of that kind of writer-director at this moment in time is Christopher Nolan. He is the only real "A"-list director right now who's making original work, that's not based on some existing IP, exploring his own ideas with $250/300 million budgets. Also, James Cameron with *Avatar*, but now *Avatar* is a proven piece of IP, and so even with James Cameron and *Avatar*, it's not necessarily the same thing. So, for that kind of "I want to be a writer-director", it's about "What is it that I want to explore

creatively? What is what's bothering me or what am I so interested in that I want to put in this much effort?" I think to make a feature film and even maybe at a budget level we're talking about for this, we're talking under $5 million, "Do I want to put three years, five years, seven years of my life into exploring one idea? Do I care that much about that idea?" That's a real consideration for somebody who wants to be a writer-director.

For me, working now primarily as a producer, I get to exercise all of those muscles together. I have the power to shape the stories that I want to tell, in the sense that I pick the material. That's the story I want to tell. For me, I found that picking the material allows me more creative freedom than directing, because as the producer, I get to pick the material, and I get to shape the development process. I also think a subtlety of making feature films or TV, is that people don't really get is the power the producer has in choosing the heads of departments. The movie is going to look the way the production designer and the DP make it look, and how the movie looks is the joint decision between the producer and director over who to hire in those key roles. It is a far bigger consideration artistically than what the director thinks that decision is, because what it becomes in the end is a collaboration between the director and the production designer, but you're hiring those people based on their tastes and their aesthetic and network.

So, as a producer, I'm looking at those creatives and their body of work and seeing "Do they have the taste and the style and the individual style that I want to bring to this project?" Those are much bigger decisions than, you know, approving them the look book or the references, because all of those things are derivative. I think the biggest freedom I get from being a producer is I get to decide what to work on and because I hustle, I get to make things happen and I have a very thick skin. My key issue when I'm trying to get something made, is to get the 'quick no'. Obviously, I'm looking for yes, but I want the 'quick no', I don't want to die hanging on for 'maybes'.

Author

Just talk us through your relationship with the editor and how that works between you and the director.

Zaheer

The editor is where all the storytelling magic happens. The editor is the person that ultimately sets the pace, the tone and the feel of the piece, way more than the director. The editor has enormous storytelling power. The edit is my favourite part, because in the edit, you can make it something completely different. You can change a film profoundly in the edit. It's a very complex working relationship and editors are usually not very communicative people; they don't use a lot of words. They're really interesting. It's very hard to see what an editor's work is because you watch a finished piece, and you don't know what choices were the editor's, what choices are the director's, what choices are the DP's and what choices are the actors. You just don't know. I mean, when there's a shot in the movie, did the editor have 22 good takes to choose from? Or was there one good take? Or were there no good takes, and the editor has managed to communicate

something by piecing together some bad takes in a really interesting way that gives it its tone?

So, for me, the key qualities I'm looking for in an editor are creativity, a voice and a unique point of view. But the biggest thing I personally am looking for is: do they get the piece, independent of the director? Does that editor want to tell this story? Does editor have something to say? If they don't have something to say, then it's just someone pushing keys around, making choices they don't really understand, and it's a disaster. To have someone in their job that doesn't understand the piece, that doesn't have a feel for it, that's on the fence about the message, about the ability of the director, about the quality of the script … is the worst and is equivalent to having someone who took the job for their break. Always look at the body of work. That speaks more than any words any person will say, and even if there isn't a deep body of work creatively to look at it's just like, "What has this person done? Did they shoot a short by themselves? What's their work ethic? How do they collaborate with people? What's their taste? What are their favourite films? What's their sensibility?" Look deep into the background and say, "What's this person going to bring and where are they going to take it?"

Author

Do you think some of the directors that you've worked with haven't quite understood some of the things that you're talking about?

Zaheer

You know, I've had: "this first-time filmmaker really doesn't have a clue what they are doing", so I step in and finish the film with the editor, because I chose the editor and we finished the film, then the film looks great and wins prizes. "Oh, thank God, thank you because I really didn't know what I was doing", says the director later. I've also had a director locking me out of the edit room and refusing to show me anything for 16 weeks because it was his movie, and that was his contract under the Directors' Guild of America (DGA) agreement. Then we get to the end of that period, and we're saying: "Okay, cool, this is not where it needs to be and this is what we're going to do now", and him going, "Well, you have to find the budget. Give me another four weeks." It's like "I told you, you're not getting another four weeks because it's not in the budget. I can't reopen the financing and I can't go to the 15 financiers and raise another four weeks, even though it sounds like a stupid amount of money. I told you that and you wouldn't listen, so now I'm just going to do in the two weeks that I've got left, what I need to do."

Author

Thank you. Can you talk a little bit about your move from South Africa to the US. How are things in terms of the culture in LA in comparison to where you've come from in South Africa?

Zaheer

There are multiple different industries, right? There's the LA-centred English language entertainment world. The big ones are LA, India, just kind of doing its own thing, and then South Korea, which is kind of doing its own thing. Meanwhile everybody's trying to sell to China. Everybody's trying to get this big international distribution, but the stuff that's centred in LA is the stuff that really travels, and Europe has organized itself into all these complex treaties with all this complex state funding that you can access to make cultural content, to preserve local industries and local jobs. I had become very entangled in all of that and had access to government money and was trying to piece the South African money with the German money or French money or Canadian money or UK money, and piece together these movies that met all these different criteria so that we can put the funding together.

My real awakening moment was being at the Berlin Film Festival, sitting with a group of producers having a conversation, not about any of the projects we were making. It was dinner, and we were just talking about the movies that we loved. I was sitting at a table with all Europeans, and me. The conversation was in English and the movies everybody was referencing were the movies I grew up with and they were all in English. My 'a-ha' moment was ... English was my first language; I don't really speak any other language. This culture, the semi-American culture ... then this culture I grew up with, this third culture where my parents are Indian and I grew up in South Africa and I was raised Muslim, and the films we're talking about are in that world where we all speak English now, and we had this weird mix of culture, and I had this moment where it was like, "Wait, why am I trying to do things that are in France or in Germany, when I know nothing about this?" I know nothing about the literary background of France or the literary background in Germany, I can't reference their novels and I can't reference their movies or their TV because I just don't know it, but in the English-speaking world, in the UK and in America, I know all the major works. I know the major works of cinema, I know the major novels, I know the major poets, and this is my world. This is what I really know, and everybody's trying to get international distribution and trying to make English-speaking films and like, why am I trying to do this in Europe and not in the US when this is my first language and culturally I'm at home? It took me probably a year to pivot, but overnight I dropped everything that had European connections and started focusing on things that were individual to me, original to me, that Americans and American financiers would be interested in, American audiences would be interested in. Yeah, that's how that pivot came to be.

Author

Can you talk about the agency system in Hollywood and how you handle that? Because it's something that is always rather perplexing when you're outside looking in?

Zaheer

You need thick skin. I was having trouble with an agent and a casting [process] and I had lunch with a close friend of mine, who is Ridley Scott's main producer. I was telling him about my woes, and he just laughed. He was like, "I'm trying to get this B-list TV actor into a Ridley Scott movie in the lead role, and I'm having the exact same trouble with the agent." So, my first kind of reassurance to you is it's not you, it's them, and the thing about the agencies is if they don't know you and they don't know who you are, they're very suspicious. Why? Because there are a lot of people who are doing a lot of bad things, like really not cool things and those agents' job is to protect their clients.

This is such a closed system, but it also has a staggering amount of money going through that system. The agent and agencies' job is to gatekeep against outsiders. So, I've found the best path is to make friends and the easiest people to make friends with are the assistants. The assistants are underpaid, overworked, and desperate to find the next big break. So, I think that a really great strategy is, whatever talent you're trying to attach to your project, to understand who the decision-making agent is, and then find that person's assistant. You can find that by just asking questions, they're pretty transparent. Once you get that assistant on the phone, you have to sell that assistant on who you are and why your movie's interesting and important. You really have to pitch the assistant and make them believe that what they're going to do by getting involved with your project and backing your project is breaking new talent. The number one asset you have is that the agency has no insight into where you live and who the talented people are and the person you represent, whether it's yourself, your writer or your actor, your star could be the next big thing. So, what you have is, "I'm bringing you something fresh, I'm bringing you something you don't know", and do a really good job of selling that rather than begging.

References

[1] Tolkin, M. (1986) *The Player*. London: Faber & Faber.

[2] Finney, A. (2014) *Project Management and the Film Industry Value Chain: The Impact of Cognitive Biases on Value Creation and Learning.* City University London, PhD Thesis.

[3] Manning, S. and Sydow, J. (2011) 'Projects, Paths, and Practices: Sustaining and Leveraging Project-Based Relationships', *Industrial and Corporate Change*, vol. 20, no. 5, pp. 1369–1402.

[4] Miller, D. and Shamsie, J. (1996) 'The Resource-Based View of the Firm in Two Environments: The Hollywood Film Studios from 1936 to 1965'. *Academy of Management Journal*, June 1996, 519–543. Also appeared as 'Competitive Advantage, Hollywood Style' (Research Translation). *Academy of Management Executive*, February 1997, 116–118. Also published in Corporate Strategy, eds. A.A. Maritan & M.A. Peteraf. Edward Elgar Publishing, 2011.

[5] Catmul, E. (2014) *Creativity Inc. Overcoming the Unseen Forces That Stand in the Way of True Inspiration.* Bantam Press (Random House imprint).

[6] Finney, A. (2008) 'Long Range Planning', *Learning From Sharks: Lessons on Managing Projects in the Independent Film*, Vol. 41, No 1.

[7] Makridakis, S. (1990) *Forecasting, Planning and Strategy for the 21st Century*. New York: The Free Press.

[8] Lampel, J., Shamsie, J. and Lant, T.K. (Eds.) (2006) *The Business of Culture: Strategic Perspectives on Entertainment and Media*. London: LEA.

23 Business strategy

Business planning for film enterprises

Whether you are in the film business or any business, the fact is that at least nine out of ten new business ventures fail. Most new businesses fail not due to poor business plans, but because their owners are underprepared for the business they have chosen to be in. This chapter departs from film-specific material and explores the key business demands required to run an operation effectively. And prior to the formal technicalities that follow, all self-described independent 'film' producers should be asking themselves whether a 'film-only' strategy is seriously sustainable in the current and future entertainment landscape?

Many entrants and even experienced businesspeople shy away from writing a business plan. Excuses run from 'not enough time' to 'we all know that the business plan is far from what actually happens…' to a basic lack of understanding about what a business plan can achieve for your company going forwards. There are some key questions that have to be answered when embarking on the discipline of a plan:

1. Can I make money investing my time, energy and cash in this business (what's the risk versus reward)?
2. Do I like and understand the business I am investing my time and money in?
3. Do I trust the people with whom I am investing?

The areas a business plan forces you to address are: a) fundraising, if required; or initial sunk costs and cash flow management if you are not looking to raise third-party capital; b) a road map, which acts as a benchmark to your subsequent progress; and c) a document that promotes accountability and, ultimately, if enshrined in a Shareholders' Agreement, a legally binding document that dictates key business parameters of practice.

Taking the arguments further, a business plan allows both yourself and your team and potential investors to test your concept properly. Ultimately, any investors are interested in one key ultimatum that bests all others: how much cash does your idea generate, and how fast does it flow? Next to those cash flows, both an entrepreneur

DOI: 10.4324/9781003205753-26

and/or an investor will look at the costs – both sunk and running overheads –, the revenue being generated and the timing of those revenue returns.

The utility of capital in business

Before we explore business planning further, it is important to examine typical uses of capital, as applied to any business, rather than just film. There are two main sources of capital for a limited company: share capital and loan capital. Share capital is normally raised by selling shares in a company to investors who wish to own a piece of that company. The shareholders are the owners of the company, though they do not normally take part in the day-to-day management of the business. Shareholders receive rewards from their investment in two different ways: a) they may receive regular dividends, if the company is profitable, and directors can afford and decide to pay out dividends; and b) they may benefit from a gain in the value of their shares.

Loan capital is provided by organizations and individuals who lend money to businesses in return for the payment of interest, and often a premium. Loan interest is payable whether the company is in profit or loss, while dividends are only payable at the election of the directors.

Capital is employed in two key areas: fixed assets and current assets. Any expenditure on fixed assets is termed capital expenditure and consists of expenditure on items, which the business will retain and utilize in the business for a number of years. Examples of fixed (or sometimes called 'non-current') assets are buildings, land and office equipment.

Fixed assets normally lose value over time, either because they become redundant or wear out. The term 'depreciation' is used to describe the accounting process for this loss of value, which is estimated on an ongoing basis by accountants. Intangible fixed (non-current) assets – which are particularly important in film – include assets such as acquired licences. These also, over a period of time, reduce to a zero value, as the licence period expires. The 'using up' of the value acquired in the buying of such rights is termed 'amortization'.

Current assets are those assets that are constantly changing. They usually consist of stock, debtors (receivables) and cash balances. Stock is items held for ultimate sale to a customer. Items of an inventory on which work has started but which are not ready for sale are called a work in progress. Debtors (or receivables) are amounts owed to the business by customers who have been granted time to pay for goods or services sold to them. Given that there is always a possibility that certain customers may not pay, accounts must contain a provision for debts that may ultimately not be met.

Creditors (also termed accounts payable or payables) are the suppliers who have provided credit to the business for goods and services supplied, but who have not yet been paid. They, therefore, are a further source of finance, and can often help to provide a 'financial buffer' to allow a business to obtain resources and begin to process or sell them before any cash is spent. If a business turns over very fast, it may even be able to sell goods or services, collect payment, all prior to any creditor demands payment.

Working capital, which is usually referred to as 'net current assets', is the term granted to part of the capital invested in a business that is continually moving. This is essentially the capital, which is working to generate cash for the business: raw material is obtained on credit and converted into finished goods, which are sold to

customers on credit. When the customers pay, the cash can be used to pay creditors, who then supply further raw materials to be invested in the working capital cycle.

The term given to creditors and other types of short-term debts such as short-term loans, bank overdrafts etc., is 'short-term liabilities'. These creditors provide a buffer for current assets and so help to reduce the level of money necessary for working capital. When current liabilities exceed current assets, the working capital is a negative figure – and is referred to as 'net current liabilities'.

Once a business has started to generate profits, there is a further source of finance available to it: reserves or accumulated retained profits. Directors may decide to pay out or distribute profits as dividends to the shareholders. However, if they decide not to, or to withhold some of the profit, then this profit can continue to act as an important source of finance for the business – also called 'retained earnings'. Such access to additional finance can help acquisitions of new companies, diversification or rapid expansion in existing activities.

The relative proportion of loan capital to share capital in a business is referred to as the 'level of gearing' (or leverage) in the business. If a business has a large level of loan capital (shown on the balance sheet under non-current liabilities) compared to share capital, then it is viewed as highly geared or highly leveraged. By contrast, if a business has a small amount of loan capital compared to share capital, then it is low-geared or has low leverage. If revenues start to fall and a company is highly geared, then managers will need to move very fast to ensure there is enough cash in the company to continue to trade. Shareholders are also directly affected by changes in revenue in a highly geared company. If profits fall, then earnings per share will reduce faster in a more highly geared company; if profits rise, then they will grow faster.

Business plan approaches

It may appear simplistic to ask a range of questions at the onset of any business plan, but a careful analysis of 'who?', 'what?', 'when?', 'why?', 'where?', with, in addition, 'how?' and 'how much?' goes a long way to producing general background notes before starting to compile and flesh out the template of a business plan.

The 'who' is important because investors, speculators and financiers tend to follow people who demonstrate experience, education, a track record and the ability to communicate their business concept with exceptional skill and simplicity. The 'what' (and the 'why') is normally the concept that enshrines a business and, most importantly, the investment opportunity; the 'when' describes not only the inception but also the timing of anticipated investment and exit; and the 'where' explains if the business is a national, pan-territorial or global business, and under what legal and regulatory environment/territory it is going to trade.

A business plan is an intersection of:

a) everything inside the business (costs, product, services, people); and
b) everything outside the business (competition, market trends, political/regulation changes and forces, technology development etc).

Most inexperienced managers/entrepreneurs looking for investment spend too long on their own business and do not pay enough attention or provide enough analysis on

the overall market they are seeking to exploit. The ability to describe your product or service in relation to the wider market and the industry or kind of business it exists within is nearly always underestimated.

Essential business plan elements

A well-organized business plan will normally incorporate the following sections (business strategy, marketing strategy and financials), and within each section will be included the following main headings:

The business strategy

- opportunity
- organization and operations
- legal structure
- business model
- operating procedures
- management
- board (as far as it has been structured)
- personnel
- risk management
- strengths and weaknesses
- core competencies and challenges
- track record and historical data on past performance
- location of business
- product offering – meaning the investment offering
- records and insurance.

The difference between a start-up company that cannot show previous trading records, growth and competence and a company re-financing or looking to expand is significant. Many equity and venture capital investors are wary of start-ups, especially in the film business. They are aware of the previously analysed issues surrounding the sensitivity of timing of creating cash flows and the problems often associated with no additional income streams from existing ancillary rights (e.g. library exploitation). The risk management section is particularly important to include in a film production, sales or distribution plan, as it goes to the heart of an investor's understandable concerns about security and management and operational controls.

The marketing strategy

- industry and market trends
- target market(s)
- strategy to exploit target market(s)
- distribution of product
- key customers/buyers, and secondary customers/buyers
- competition
- relationships
- branding

- advertising
- pricing.

This section is where you analyse the wider market and the 'positioning' of your business in relation to the overall business you are entering or re-financing within. Rival or similar companies are important to research. Even private companies have to submit accounts that are available on request and can provide illuminating trading evidence.

The financials

- use of funds
- start-up budget (one-time deal costs, including advisor fees)
- income statement (profit and loss account)
- cash-flow statement
- balance sheet
- cash-flow forecast
- profit and loss forecast
- sales revenue forecast
- capital spending plan
- budget
- break-even analysis
- sensitivity testing (if appropriate in initial business plan offering).

Assumptions

All of the above data projections rely on a set of assumptions. In the film business, for example, the assumptions would include size of budgets, number of films, size of projected fees, level of commissions, sales and marketing budgets, (prints and advertising (P&A) budgets, size of minimum guarantees paid, timing of product flow etc. The assumptions would also need to take into account expansion of the company and its rising cost base (management and staff costs, overhead etc.). The assumptions will be analysed intently by any investor or prospective manager looking for an interest in the proposal.

Time period run-out

Most prospective investors expect to see a five-year plan. While some investors may then ask you to run a longer plan, all are aware that estimating performance after the five-year point becomes a decreasingly accurate exercise. Those investors looking for a faster exit than five years will still expect to see a five-year plan submitted.

The key three financial statements

Each business has to prepare three financial statements for its annual accounts. As such, these statements also have to be prepared for any business plan submission. They are:

- the profit and loss account (income statement)
- the balance sheet
- the cash-flow statement.

The *profit and loss account* is a financial statement that shows the profit or loss earned by the business in a particular accounting period. The sales turnover is shown at the top of the statement, from which is deducted only those costs which have been incurred in achieving that turnover.

Hence, expenditure that has been incurred but which relates to a future accounting period (e.g. pre-payment) must not be included in the costs to be matched against the revenue. It also means that any expenditure which has not yet been paid for but for which a liability was incurred in the accounting period (known as an accrual) should be charged against the revenue, even though the cash has not yet left the business. An income statement, in summary, tells you if you are making money.

The *balance sheet* is a statement that shows the financial position of a business at the end of the accounting period. It tends to be referred to as a 'snapshot' of the business on this particular day or moment. The balance sheet is made up of two parts, the totals of which will always be equal. One part shows where the money was invested at the date of the balance sheet; for example, how much was invested in fixed assets and how much in working capital (current assets less current liabilities). The other part demonstrates the sources from which the capital was obtained to finance these assets. The two parts (use of finance/sources of finance) have to balance. While other presentations are sometimes used, ultimately the balance sheet shows what assets the business owns, and what it owes (e.g. liabilities) at the year end. When interpreting a balance sheet, it is important to remember that a balance sheet only shows the position of the business on one particular day. This may be entirely different on another day, and not representative of the typical trading position of the business overall. But the balance sheet does tell you what the business is worth at the end of the period.

The *cash-flow statement* shows where the money in the business has come from, how it is used and where it goes. A good way of looking at what a cash-flow statement can tell you is: 'where did the money move?' The importance of the cash flow in managing a company on a day-to-day basis is critical. The cash-flow statement shows you the amount of cash available for the business (including, for example, sales revenues, interest income, any sales of long-term assets, liabilities, such as loans, which are still cash into the business, equity drawdowns (owner investments, venture capital etc.)); the cash that leaves the business (including, for example, start-up costs, inventory purchases/rights); controllable expenses (advertising, packaging etc.); fixed expenses (rent, utilities, insurance); long-term purchase assets; liabilities (e.g. paying back loans); and owner equity (money taken out by you or investors). With this information, a manager will have a sense of the moving target of cash required to run the company.

Capital expenditure and revenue (operating) expenditure

Revenue (operating) expenditure is that which is incurred on the day-to-day running expenses of the business. For example, it would include rates, rent, salaries, electricity, phones etc. Revenue expenditure is also referred to as operating expenditure. Capital

expenditure is that which is incurred by the purchasing of or adding to the value of fixed (non-current) assets. It is important to remember that it is only the revenue (operating) expenditure that is charged in total against revenue for the period (allowing for accruals and pre-payments).

Capital expenditure is not charged against revenue in the profit and loss account as it is incurred, otherwise those accounting periods in which a fixed (non-current) asset happens to be purchased will show a comparatively low profit. Also, subsequent accounting periods that benefit from the use of a fixed asset will not receive any charge in the profit and loss account, because the whole charge was made in the year of purchase.

To get over this problem, the accountant makes a charge of depreciation (or amortization in the case of an intangible fixed asset such as software or a film distribution library) in the income statement of each accounting period that benefits from the use of the asset. In this way the original cost of the asset, less any projected final value, is shared out as fairly as possible over its life.

Gross profit is the difference between the sales turnover and the cost of the goods or services that were actually sold. Administrative and other operating expenses are then deducted from the gross profit to arrive at the operating profit, which is the profit before interest and taxation.

Once the net interest costs and taxation costs have been deducted from the operating profit, any remaining profit is available for appropriation by the directors. If any dividend is to be paid it will be deducted from this figure and the remaining balance will be transferred to reserves.

Sensitive areas

Investors pay particular attention to the *overhead* of any company they are looking to become involved with. The management and staff salaries will be analysed very carefully, as will the fixed and running costs. Management looking to take too much out of the business in salary, while also expecting to share (normally through shareholdings) in the upside of any success and profits, will normally be negotiated into a compromise that focuses their reward being primarily tied to the overall success of the business rather than them being heavily remunerated through a contracted position.

Common mistakes in assumptions, in particular in film business plans, include the underestimation of costs and income streams, and a slower product flow than anticipated. By contrast, overall cash generation and timing are overestimated. Optimism is normally counteracted by sensitivity testing, whereby an investor re-runs a business plan's financials, but adjusts the timing of key product and/or the success of 'hits', in an effort to gain a more realistic picture of what might happen when a business is slower or less successful than the one being estimated in the pitch document. It is a worthwhile exercise for the entrepreneur/manager to also run out sensitivity tests prior to key meetings with investors, in an effort to be prepared and have answers for major fluxes in fortune, and some idea of how they would attempt to counteract such difficulties.

All business plans are best served by a clear statement of the offering (and projected internal rate of return on behalf of an investment, known as the IRR) at the front of the document. This normally is clearly stated within an executive summary,

which essentially provides the 'highlights' of the plan, and should run between one and two pages long.

Other typical omissions include the prospective exits available to investors. Does the entrepreneur/manager anticipate a private sale, an initial public offering (IPO), a trade sale? Lastly, a health warning is required for any plan going out to investors, and an FSA registration for those going out to more than 49 sophisticated investors.

24 Entrepreneurs and investors in the film industry

> From deep caverns he will come who will make all the peoples of the world toil and sweat, with great trouble, labour, and anxiety, so that they may have his help.
>
> (Leonardo Da Vinci, of gold and the money made from it)

Film investor definitions

We have already established central issues around the economics of the independent film business that make it a high-risk business, based on a 'failure' model; albeit it is often pitched as a 'hit-driven' business. Unlike the stocks and shares of the FTSE 100, for example, the returns on which can be approximated and modelled, the returns to investors in individual films – in particular, independent films without one world distributor – are wildly difficult to predict. Overall, there is a fractional minority – beyond Pareto's 80:20 power law – that actually return financial benefits. That stated, film investment and film culture – with associated artistic, national and supranational creative voices – cannot be shackled together at the heel.

Ironically, mega-hit potential within a very high-risk business is not an automatic problem for investors. The risk of holding alternative assets in the form of a portfolio of perceived 'risky' investments is smaller than the sum of the risks of holding each investment individually. This enshrines the principle of diversification and portfolio management. The problem lies in the fact that, at present, the gatekeepers who control distribution and are closest to the top of the income stream are the most cash-rich centres for investment: they essentially act as portfolio managers. Smaller, fragmented entities – such as development and production companies in the independent film market – do not offer the same spread of risk and are too far away from the key cash flows of the business.

Film industry investments are viewed in the commercial sector as 'alternative' investments. Investors are seeking 'uncorrelated assets' which, in theory, reduce the risk inherent in traditional, lower margin portfolios. However, film-interested investors arrive from a range of sources, including:

- private equity (hard to find);
- angels (more common in the film production business);
- venture capital funds (starting to become more interested in film, but tend to be specialized rather than highly 'spread' investment vehicles);

DOI: 10.4324/9781003205753-27

- hedge fund managers (who have recently experimented again in Hollywood);
- tax-orientated investors (normally not at risk, although often state and regional rules state they need to be seen as at-risk investors to qualify);
- highly successful entrepreneurs that utilize cash and assets from previous businesses' success and strive to build up portfolios and both invest and start up new business strands.

Definitions of entrepreneurship in the film industry

Before breaking down the opportunities that the film business presents to an entrepreneur, it is useful to assess the generic qualities an entrepreneur requires if they are going to launch their own business operation.

The personality profile of an entrepreneur tends to follow a pattern and include character traits that an individual will tend to demonstrate, such as: being results-driven and often impatient; a strong need to achieve, and highly goal-motivated; competitive, but able to learn from mistakes; a strong sense of self-responsibility, and a belief that they can control their own destiny; the capacity to choose and build a management team and delegate day-to-day operations where appropriate; a calculated risk-taker; an open mind towards innovation and new concepts; a talent at spotting opportunities and gaps in a market; a creative as well as a business mind, with the ability to trust their own instincts; an acceptance of uncertainty and financial insecurity; and, finally, the ability to either move on from or fold an operation and start again. Critically, many entrepreneurs do not make strong day-to-day managers of companies. That is neither their area of skill nor their motivating goal in business.

Entrepreneurs tend to be instinctive businesspeople who can identify a concept and raise money from investors or a bank or use their own money to launch that concept and test it against a market. Their starting point is normally the combination of a concept and an opportunity or perceived gap in a market. The typical tools they utilize include the ability to spot an idea and opening; the skill of pitching an idea in person; the ability to put together a business plan (see later in this chapter); and the ability to build a team and select managers that can implement his/her vision.

Interestingly, some of the most instinctively talented entrepreneurs in the independent film business have steered away from film development and production. Those business-minded producers who have built assets and integrated companies have normally emerged as significant filmmakers in their own right or as teams which embrace writers, directors and producers, alongside sales arms and local distribution operations or output deals. The trend has been that entrepreneurs have tended to focus on the international sales, distribution, fundraising or the newly changing world of exhibition, rather than development and production.

Management of film businesses

The challenge of raising money, managing investors and selling a business at the optimum time, while also carrying out the day-to-day job of managing a business, is demanding. Most truly talented entrepreneurs set up a business based on a potentially profitable business model, grow and develop it, and then attempt to sell it at a perceived maximum moment. Then they start again with a new concept and/or a new company, and not necessarily in the same sector.

Managing a film company, whatever specific sector in the business, demands the physical daily presence of that person where possible. This can create problems in some sectors – such as sales and distribution, where managers are part of the sales or buying process and are forced to be absent from offices; or where producers have to be on set. Of course, strong delegation skills help a business run smoothly while an MD is away, but the day-to-day process can be interrupted if a manager is constantly away.

Other key roles of a manager include their ability to put the assumptions of a business plan into action, to hire and fire staff and to report to a board and/or owner. There is a tendency in the film business for managers who also own their business to fall into 'owner-drivers': part-entrepreneur, part-manager, and often compromised in their daily decision-making by also having to protect their shares and ownership.

Barriers and challenges to different types of film businesses

The production company

Barriers to entry are very low: a film producer does not have to pass any professional exams or belong to a union in order to be in business. Indeed, they can print their name on a card and below it the words 'film producer' and set about their business. However, without underlying rights in potential projects, most producers need to raise seed money to get started. Why? Because a producer has to be in development, with scripts and packages, prior to being able to potentially create income via being in production.

It is interesting to look at the development/production business from an instinctive entrepreneur's point of view. The first point an entrepreneur might raise is: How long am I going to be in development before I start making money? Answer: almost certainly longer than any business plan projection might claim, as most newcomers are extremely optimistic. The next set of issues is the repayment of sunk costs (plus overheads) and the ability to reach the stage where a fee income is payable.

A producer is only rewarded via three main streams:

- repayment and possible premium of development money being repaid on first day of principal photography;
- a production fee (if not forced to defer or part-defer);
- net profits shared normally on a 50–50 basis with the financier(s), of which the producer has to take care of the talent (writer, director, cast), which normally amounts to 20 of the 50 points. Rarely does a producer negotiate box office kickers/bumps from excellent performance.

In light of the above streams, we should reconsider the risk attached to any initial seed money. Most entrants achieve a low level of development project conversions, and many are forced to part-defer or defer production fees. There is no collateral (e.g. library rights), no guarantee of product flow and no guarantee of fee levels. The likelihood that a film achieves break-even now needs to be added into the mix. Cash break-even is the moment when the revenues of a film, following the deduction of fees and expenses incurred in distribution and the payment of gross participations to talent, equal the costs of production, including the overhead contributions and costs of finance. At that point, the film is able to repay its costs 100 per cent.

Following the break-even point being reached, all additional revenues, after the deduction of any additional cost of sales, contribute to profits. Until break-even, a film is a loss-making investment from the perspective of the producer/financier. As performance tails off, the film's generation of revenues will tend to lag behind the accumulating cost of the capital used to produce and distribute it.

The importance of the break-even point is that once it has occurred, given the marginal costs of distribution and exploitation being so low and the pricing of film at the consumer level being more or less fixed (i.e. volume can increase but prices do not drop), a film, once it has achieved break-even, will tend to generate increasing profits.

The sales company

Just as we examined the investment opportunities and issues in a production company, we now look at a sales company from a similar perspective. Unlike a producer/production company, where the overhead can be kept tight and the costs rise and contract depending on the level of actual production activity (and associated fees and contracted staff via a production), a sales company has certain fixed overhead and operating costs that are more difficult to organize in a flexible manner.

The fact is that there is a significant level of outlay of cash made by a sales company prior to any fees/commissions from product sales. They include:

- overheads – which vary from boutique operations with around 4 staff to major companies handling up to 30 films a year, with staff of 15 or more;
- materials, including poster, promotional material, trailer etc.;
- attendance at major markets, including Cannes, the American Film Market (AFM), Berlin;
- attendance at launch festivals, and launch costs for each film;
- advances/minimum guarantees if the company is financed to enable it to put up investment in return for rights.

The standard level of 'sales and marketing' costs normally allowed by a producer/financier has been around $150,000 over the past decade. But that figure has dropped to somewhere between $50,000 and $75,000 in most cases today. However, with the erosion of the value of the dollar, most companies either budget in euros or insist on a sterling minimum of £50,000, or $75,000 if they can get producers and financiers to accept. This is outside the cost of the first festival launch, which, in some high-profile festival cases, can cost as much as the overall sales and marketing budget.

Hence, without a library of rights that can assist in annual turnover via television sales and reissue business, entry can be hard to justify given the 2–3-year turnaround prior to real income streams. The main issue is that although the sales company is higher up the revenue stream, it has considerable outlays prior to receiving repayment on its own sunk costs, let alone commission on final delivery of the film to distributors. And a smart entrepreneur will also raise the question of payment on delivery. Despite contract obligations, what forces a distributor to always accept delivery of a film? Cases have occurred when a distributor has decided that the final delivery of the film is not the screenplay on which they pre-bought the film. This tends to happen when the film itself is disappointing. What

happens when the distributor goes out of business during the period between signature and delivery? The sales company has to find a new distributor and cancel the existing contract.

Making a business plan for a sales company is a more predictable exercise than for a production company. However, given the above variables and time-sensitivities, it still requires considerable collateral and underlying rights to help pin its business into a structure that ultimately becomes an attractive investment.

The distributor

Moving to the next level of the value chain, it is instructive to see the issue of risk, financial outlay and returns when examining an independent distributor's business plan. Despite being higher up the revenue chain, distribution is not a business for the strictly risk-averse investor. To be in business, an independent distributor has to compete with peers and, in certain cases, mini-major and major distributors. A distributor needs to address the following issues:

- the need for a high level of outlay prior to income/fees from product;
- start-up costs (sunk);
- overheads;
- market and festival attendance;
- cost of advances/minimum guarantees;
- cost of prints and advertising (marketing material);
- booking of cinemas and collections.

The relationships that matter to the entrepreneur

The key relationships that the entrepreneur needs to develop and maintain include:

- Other like-minded, smart, rising talents with ideas. The best entrepreneurs take notice and include other talent rather than remain threatened and closeted. This way they build an idea, a team and/or a partnership.
- Advisors: strong entrepreneurs will seek out the best lawyers and accountants. They assume that business-minded lawyers and accountants are business-savvy re fundraising, and they need reputation and advice when putting together investment proposals.
- The great and good: investors like solid, experienced people on board. It is a price the entrepreneur pays for taking the investment. They are likely to pay attention to connected people, including executive producers able to support the team and productions going forwards.
- Bankers: most only join up once the money has been raised. A bank that is in from the start is a far better partner, even if they simply lend you a limited overdraft.
- Interesting and relevant managers will be crucial to the founding entrepreneur to bring on board.
- Sounding boards: people who have experience – in particular, in the specific area you are targeting.
- The opportunity: what makes the proposition compelling has to be at the start, middle and end of the business plan that is being proposed.

The entrepreneur facing the investor (or manager)

What key questions is the entrepreneur being asked by an investor or potential manager? A manager is included in this assessment, as they too are often asked to make an investment in return for shares in an operation. Key issues that an investor will ask include:

- Why is the business opportunity compelling, and is it achievable with the resources being proposed – in particular, the management?
- What is the rate of return? This is calculated as an IRR (internal rate of return on the investment per annum pre-tax). If the IRR is too low (say, below 15–20 per cent per annum depending on going interest rates), then most investors simply walk away from the business plan and do not take a meeting.
- What are the risk factors? Top entrepreneurs focus heavily on risk management in an effort to counteract risk factors that will inevitably be raised or assumed by any potential investor.
- What is the growth potential?
- What is the exit, and how realistic are the different opportunities?
- Are the assumptions made in terms of income, timing and profitability realistic? What happens when they are tested?
- What is the additional X-factor upside that could take the investment into super-profits? This is particularly important in film investments.

The entrepreneur and the management team

Any entrepreneur will have put a team together consisting of:

a) a possible partner;
b) investors;
c) managers.

The senior managers and partner will be expected to put up what is called 'pain money' – for example, cash for shares (a share of the business ownership). Alternatively, managers will be given share options, at a price that should enable them to cash them up at a later date at a profit, but hence only at the point that the company has been successful. As the management does not pay upfront, it has less control over a manager leaving if the company has failed and the share prices are low. In the balance, the notion of manager/owners (rather than option holders) is more powerful in terms of key tests, including loyalty, tying management in, building success and being paid on a full exit.

The principle of 'pain money' is vital to the investor, and is seen as a commitment test. If managers are forced to come up with a token payment upfront, they will – theoretically – care more about the company and their decisions than if they just draw a salary with no initial investment. For entrepreneurs, it is obvious, and most do not expect to take any money out of the business until it has reached considerable success and profits. For managers, it sorts out the weak from the strongly committed.

The standard deal is around 20 per cent of the company, split out between a management team, and the remaining 80 per cent held by investors if a start-up.

Sometimes an 'escalator' (which means that, depending on the IRR, the management can earn back their shares and many more) can be applied to ultimately give the management a much bigger slice of the company. The ultimate new shareholding balance will depend on how well they perform.

Selling up and how to cope with failure

The exit is all-important to an investor and to an entrepreneur. What are the typical options for film companies in the industry?

- a trade sale;
- private sale of shares to new investors (hard to find);
- going public (alternative investment market – most likely in the UK) – hard to achieve;
- a management buy-out.

What are the key issues from an entrepreneur's perspective?

- write an action plan to keep a sale on track;
- choose top advisors;
- delegate to other managers while the sale is on;
- clean up the accounts and deal with any black holes/long-term debts;
- draw up a list of possible companies/investors;
- decide how involved you are going to be post the deal; this normally is a deal breaker, and will often require 'handcuffs' that force a manager/entrepreneur to still remain involved in some way;
- you only have one chance, so plan well ahead; never underestimate the time it will take to find the right buyer and the right price;
- always, in the film business, recognize that less of more may be better than remaining small: keep an open mind.

Issues around the notion and fact of failure

Never use the word failure with an entrepreneur. They do not get the concept. The fact that it is an integral part of business is not the point – it is just that the entrepreneur's way of business life and psychology is to never give up and accept defeat.

How do entrepreneurs overcome a major problem, setback or closing down of a company?

- acknowledge it fast;
- act on it fast;
- take insolvency advice early;
- look after staff on a close-down/exit;
- move on fast but not so quickly as to repeat the mistakes;
- acknowledge what were mistakes, and be honest about which were yours and which were beyond your control;
- remember it is only business.

Wisdom on how to proceed:

- Most deals go wrong at the start; a fact prevalent in the film business.
- Projections always override historical track record. Always put history first. Do not exaggerate. Or make promises you cannot keep.
- Try to put realistic milestones going forwards.
- Venture capitalists can be attracted to experienced boards but actually back the wrong non-executive team for a film company.
- It is important to overcome reluctance to change management when a company needs to turn around or alter direction fast.
- Finance directors are most often replaced in the first year.
- CEOs are the next most replaced in the first year.
- Do not see the deal as an end point in itself: you are back at the starting line in nearly all respects.
- Spend time with investors pre the deal, get to know them.
- See the bigger picture and the market you are operating within as clearly as possible. This is very hard when you are struggling to close a deal to continue film business professionally.
- Relations with your investors are critical – if they understand the film business you are in less than 1 per cent of the entertainment investment market. They will understand setbacks and wider market problems and be more patient.

Case study: Renaissance Films – from gold to dust

Stage one – the new investment

I met former City of London stockbroker and film producer Stephen Evans in 1991 while working as an editor at *Screen International*. You don't forget meeting Stephen Evans easily – such is his skill at netting a wide range of contacts, associates, potential financiers and friends at the drop of a hat. By this stage in Renaissance Films' history, Evans had become a highly respected UK film producer, having received 11 Academy Award nominations, including two Oscar wins, after his illustrious change of career. His successful catalogue included Kenneth Branagh's *Much Ado about Nothing, Henry V* and *Peter's Friends*, along with Nicholas Hytner's *The Madness of King George* and Iain Softley's *Wings of the Dove*.

However, by 1998 Evans had become somewhat bogged down, by his own admission, in development hell. He was finding it hard to raise finance for his slate of films at Renaissance, including an ambitious adaptation of George Eliot's *Daniel Deronda*. The financial and consumer markets were undergoing significant change in the late 1990s, which, in turn, demonstrated less appetite for Evans' refined literary-driven taste. Undaunted, he embarked on a new business plan. Evans, having spotted my work with Andrew Macdonald and Duncan Kenworthy on their successful Lottery submission for DNA Films, quickly hired me to assist in raising private capital, specifically to write an extensive business plan and co-present the company to potential City investors.

At this stage, the business model that Renaissance was following still resembled a traditional independent production company, but with no private financing available. Evans wanted to raise around £15m, which would be used to push his slate of films into production with third-party advanced development and equity investment. I felt that we needed to get closer to revenue streams to have a serious chance of raising finance, especially from a wary City, and argued that a UK distribution output deal and an in-house sales company would improve the pitch. To prove my point, I ran out his previous films' performance, but added the new sales commissions that would have been returned to the company had the new model been in place. Evans agreed to the new model, and a rather different plan took shape.

By July 1999, £24.5m was raised for a new Renaissance Films Ltd. company. It had taken just under a year to achieve, and involved:

- A tightly drawn, focused 28-page business plan, including basic business model, management team, board, projected internal rate of return (IRR) and financials.
- An extended 212-page plan with track record, scenarios and sensitivity testing.
- The holding of around 45 meetings, with 44 rejections despite some genuine interest and engagement with potential sources of finance/investment.
- The building of a management team, in particular a sales team.
- Putting a board together with an experienced, albeit ageing City and legal team.
- Bringing lawyers Olswang and accountants Deloitte together on the deal.
- Cash-flowing Renaissance while closing the deal.
- Raising £500,000 from the six-strong executive management, required as 'hurt' money next to the investment.

Hermes Pension Fund Management, acting on behalf of the Post Office Workers' Pension and BT Pension, made the £24.5m investment. Evans had a very good contact at Hermes, the late Alastair Ross Goobey, who in turn handed over the business plan to two Hermes investment directors. When the deal was closed finally in the summer of 2000, the company was financed through the following structures: £4.5m of equity; £500,000 of directors' investment monies (together making up £999,999 of share capital and £4m of working capital and two loans from Hermes for £10m each – with 10 per cent per annum and 15 per cent per annum fees) that could be drawn down under specific criteria. The additional £500,000 was raised and invested by the management team, which settled the issue of management 'hurt' money so often required by investors as they appreciate management having some 'skin in the game', meaning something to lose if things go wrong. In return, a 'ratchet' system was imposed, where the more successful the company became, the more the management's shares would be worth. In order to raise capital, Evans and I had developed the structure of the company, adding not only financing, but also a sales and marketing department, re-drawing the company along a vertically integrated model. An output deal for all future films was made with Entertainment Film Distributors in the UK. It was extremely unlikely that the pitch to raise finance would have succeeded had the business plan remained focused on development and production finance only. The company's staff rose from 6 to 22, and the monthly 'burn rate' shot up to approximately £60,000 a month, despite no immediate surge

in productions or acquisitions. In terms of film production and acquisition/sales, the company was expected to generate two productions a year, and four acquisitions (two with finance through a sales advance, and one third-party pick-up). The building of a library of some 50 films was anticipated after five years or so, although Evans was careful not to model a string of annual 'hit' films in the scenarios laid out in the business plan and the pitch for investment/finance.

> Business Model: The arrival of a vertically integrated film company with financing available, UK distribution guaranteed and international distribution opportunities through an in-house team.

Stage two: tensions in the model and the management team

Despite access to finance and an experienced staff, the company encountered major problems from the outset. The international market was in decline, with pressure on budgets and decisions dictated by buyers rather than sellers. Pricing films was a much tougher challenge in contrast to a decade earlier. Following a significant loss on a major commitment (see case study on *The Reckoning* in Chapter 5), the sales team was terminated. It appeared that either I would follow them or I would have to take over responsibility for sales and distribution. Senior staff clashed, with a major division opening up between development/production and sales/marketing. The Renaissance board was only able to agree on four film investments between 1999 and 2002. A \$3m slate of film scripts and rights was developed, but the majority was written off or going nowhere fast. Some \$34m had been placed in four films, with Renaissance committing more than \$22m, with little to no return on investment. By early 2002, Renaissance had no access to further monies (bar £300,000 kept back by Hermes from the £20m of loan facilities that had been put into place). The company's only future revenues were receipts from investments to date and new business generated through third-party product (i.e. with no equity investment from the company).

By the summer of 2002, investor relations had become understandably strained. Hermes had a number of choices, but after consideration the investor supported a business plan offered by me, as I had taken over the sales operation in 2001. My model was to focus on sales and marketing of third-party product, films that had been produced and developed elsewhere. The staff and overhead would be drastically reduced. Hermes still kept their £300,000. Evans left the company in July 2002, and the majority of the initial investment was written off. Hermes left a £2m charge against the company; took their last remaining £300,000; and reduced the board to four (from eight). The overhead was reduced by 50 per cent. In return, the finance director and I controlled 20 per cent of the company.

> Business Model: Vertical model erodes. Management changes and finance is exhausted.

Stage three: changing strategy

In order to address the problems experienced between 1999 and 2002, I proposed that the company should halt in-house production, cut back development and concentrate on sales and marketing. Major films owned by the company (Terry Gilliam's *Good Omens*, Neil LaBute's *Vapor*) still failed to go into production. The sunk costs in those two projects alone, totalling more than $1m, reflected in part the price of doing business at this level of the film industry; but they also demonstrate how hard it is for UK-based film companies to step up to a higher scale of budget and packaging. In response to the mandate to change direction, I cut back overhead even further, and focused on third-party product (films not controlled and owned by Renaissance) to sell into the market.

Starting with Roger Michell's *The Mother*, fully financed by BBC Films (as discussed in Chapter 6) the company started to claw back some sales activity and rebuild its lost reputation. But the slate of films needed to grow from around four to ten a year to make the cash flow and profitability work. In spring 2004 Hermes lost patience and either wanted to close the company or get out. They were mindful of the damaging impact on PR if the failure went public, and saw little point in remaining involved given that the investment was underwater to such an extent that from their perspective it represented a 'toxic' tax write-off rather than a going concern.

The company changed ownership in May 2004, when I bought out the company from Hermes. A charge by Hermes of £2m was lifted when this transaction was completed. The sum paid to Hermes in cash was £75,000. This left around £75,000 of working capital in the company, and I bought 100 per cent of the shares. At that stage, I had agreed a deal with the Royal Bank of Scotland to cash flow sales and marketing costs Critically, however, I had not closed that deal at the point of completing the management buyout. In addition, producers and filmmakers took some time to identify Renaissance as a sales agent. They had been used to dealing with the company as a production entity, and then production and financing company from 1999 to 2002. Competitors in the sales area were well established and had clear brands. It was going to take about 18 months for Renaissance to start to become fully recognized in the international sales arena.

From 2002, the key areas of trading were in:

- Film license rights – the acquisition of rights to feature films, and the licensing of those rights to third-party distributors around the world.
- A very limited amount of film development expenditure, through the development and packaging of existing intellectual property rights.

From May 2003, business did improve, with the company achieving world sales of more than $13m, with $8m posted from May 2004 onwards. Of these sales, crucially, some $6m had been achieved through pre-selling rights – making Renaissance an active co-financier in five films on its slate. By this stage, the company had finally stopped receiving unsolicited Shakespeare adaptations and period drama submissions.

> ## Summary: Change of ownership

Stage four: failure

Despite a growing slate of films, the Royal Bank of Scotland credit facility, worth more than $1m to the company's cash flow, failed to be approved. I had to either sell shares or find a new bank. Time ran out, and the company was forced into administration in July 2005 with creditor debts of £1m. Why couldn't the company find a buyer?

One of the key problems in dealing with investors was the company's very poor track record between 1999 and 2003, before the sales side of the business started to slowly improve. Accounts during this period showed huge losses – major write-downs and the escalating collapse of 'ultimate' valuations, making the company's trading record very unattractive.

Despite the sales performance starting to expand and improve, the company was under-capitalized and was vulnerable to any blip in sales activity or a cluster of films requiring servicing prior to any income being available to cover such costs.

The other issue was the need to attract new films, something achieved but at a price. Sales commissions were pushed down to 7.5–10 per cent on key films by producers and financiers, and time was wasted on non-performing third-party pick-ups that barely covered their sales and marketing expenses.

In a volatile and difficult market for independent films, the Cannes market in May 2005 proved a significant setback for the company's fortunes. Previous markets over the past two years had regularly provided sales in the region of $2m. At Cannes 2005, despite the largest and most interesting slate of films in the company's history, Renaissance struggled to get past $700,000. This was not the fault of one major film, or the senior staff, although certain films did not attract the level of attention or interest that the company had predicted. Overall, the sales estimates placed on the film slate were a long way from being met.

The company's problems were, in part, a reflection of the difficulties of the marketplace and the precarious nature of Renaissance's funding since the Hermes investment failure and my MBO a year previous.

The company entered formal administration in July 2005.

25 Business models 2.0

> Whether you are a writer, agent, producer, broadcaster or distributor you will need to re-evaluate your business model to adapt to the changing landscape. You need to do something about it now. The pace of change is accelerating, as is the economic impact on your business.
>
> (Patrick McKenna, CEO, Ingenious Media)
>
> The trick is not to look for new landscapes, but to look with new eyes…
>
> (Marcel Proust)

New media business models

Business models are one of the internet's most discussed and debated elements. The new environment they operate in, however, leaves them often as one of the least understood aspects of the web. Traditional 'old-style' entertainment business models are being forced to change or die, and yet, in the words of Professor Michael Rappa, there is very little clear-cut evidence of what this means precisely in the current 'transitional' stage.

Before examining the implications arising from the shift from 'old' to 'new' media, it is key to set out: a) how the overall media environment has been changing; and b) given the changing universe, what a 'business model' actually means. Of course, in its simplest form, it means a way of doing business that throws off cash. The associated model should demonstrate how those revenues are generated by marking where that business is positioned in the value chain. As we will see later, however, the value chain itself is being significantly restructured through the radical nature of the internet and associated change.

This chapter examines both the changing media environment and the challenge of new business models. It looks at which sectors are most likely to succeed in adapting, but, most importantly, views the entire new landscape with fresh eyes that throw up a myriad of opportunities. A conceptual starting point, thanks to the new geography of the internet, is to move away from the notion of 'consumers' and usher in the term 'users'. (Consumer assumes a direct commodity transaction, while the internet is governed by a wider predominantly 'free' space.)

Methods of investment are also being forced to change due in part to the changing dynamics of the changing economy. It is this author's view that old-style 'invest and exit' strategies over set periods of time are coming unhinged. On the one hand,

DOI: 10.4324/9781003205753-28

sources of seed and growth capital have been drying up; on the other hand, new entrepreneurs have been quick to use the internet to create new models from a 'bottom-up', garage-business starting point. The old 'five years and out' exit model has been recently criticized by Warren Buffett and others. The argument goes that venture capitalists are overly attracted to 'concepts' and assume an 80–90 per cent failure rate on all start-ups. The venture capitalist is seen as a commodity rather than a partner.

One answer to the breakdown is that emerging entrepreneurs are honing their skills at embracing new net models, while keeping their overheads as low as possible. Once sales and hence cash flows are up, profit starts to look realistic rather than towards the back-end of a five-year plan. Through new and adapted business modelling, combined with efforts to solve the tension between commodities and gifts in the digitally networked environment, film and other media industries are starting to navigate a socially and commercially profitable nexus.

The changing scene

The overall media environment, which includes film, television, music, games and user-generated content, is under considerable and increasing pressure with many competitors for people's time, attention, money and loyalty. The production and distribution of audio-visual content, in particular, has been affected in the past decade by:

- technological change, including a considerable increase in bandwidth specifically within Western Europe and North America, but also many first- and second-world regions across the globe;
- audience fragmentation and migration;
- an increase in multi-tasking skills and multi-absorption of varying media simultaneously;
- a rise in social networking and associated user-generated content and collaboration;
- a rise in multi-channel, interactive broadcasting;
- an increase in populist, interactive programming involving the public as lead players and contestants;
- a change in payment/billing mechanisms;
- a rise in the public's ability to produce and distribute (often cost-free) their own creative endeavours, including music, words, photographs and video;
- an increase in file sharing and an associated increase in piracy;
- interchangeability between mediums, with decreasing and less clear boundaries between online networks, short films, recorded music, photos etc.

In a highly focused and incumbent-critical report by the British Screen Advisory Council's (BSAC) Blue Skies Group, the effect of the above changes has not largely been driven by "old style broadcasters and filmmakers but by a range of new companies meeting consumer demands in ways the old systems did not". The supply-led to demand-led business trend is changing the exclusivity of existing suppliers and gatekeepers. And while broadcasters and filmmakers have habitually referred to 'choice', what they usually mean is a choice of content. Films and programmes tend to be prototypical – one-offs that demonstrate little indication of future success. Hence the entertainment industries have downplayed retail management and failed to deliver customer service to a level that competitive high-street brands have aimed to perfect.

Control over distribution is now being forced to give way to retail branding and servicing power. BSAC's Blue Skies Group goes further, arguing that 'share of mind' is the concept that captures the reality of the new market, replacing the conventional concepts of share of time and share of voice. "Owners of mind have the power to decide what, when and how to pay attention to what is on offer. Producers and distributors have to maximize their share of mind, and monetize it." In conclusion (and I refer to the ensuing debate later in this chapter), the BSAC group suggested two key trends to note and benchmark:

> *A New Ecology:* The new ecology consists of TV, film and video, the music industry, Internet Service Providers (ISPs like Orange, BT and Virgin), investors, computers, games and other sectors in puzzling and often-volatile relationships. The new ecology is systemic in that it is not possible to isolate one niche from another. In order to make sense of what is happening, industry and regulators have to understand the new relationships, both of content and cash, between producers, distributors, users and re-users, as we have tried to do. There is a real danger that by focussing on preservation, it will be impossible to relish the new. Attack is often the best form of defence and always better than accepting failure.
>
> *Winners and Losers:* All organizations have to work out how to establish a foothold in the new landscape. Revenues will be cannibalized as traditional business revenues begin to fail. We believe organizations that have a secure revenue base (e.g. the BBC) and newcomers that have no revenue base to cannibalize (e.g. Google) are the best-placed.

Developing business models

Given the scale of challenge, it is important to note that despite the impact of the internet, to date the successful monetization of new models has not emerged quickly. Part of the problem may lie in oversimplistic (and optimistic) business modelling or models that are built on the wrong set of assumptions and goals. Many entrepreneurs start the wrong way round. A useful, in-depth definition was posted in an essay in the *Harvard Business Review* in December 2008. The authors recommend that one should start by developing a strong 'customer value proposition (CVP)'. Many companies begin with a product idea and a business model, and then go in search of a market. Success, according to the authors, comes from figuring out how to satisfy a real customer who needs to get a real job done – and not just what and how much is sold but, more precisely, 'how' it is sold. The next step is to construct a profit formula that allows you to deliver value to your company. You need to decide what resources and processes you will need. A CVP without a profit formula is useless, 'as many dotcom start-ups found out'. The authors' advice is to start with a goal for total profits and work back from there. If you are an incumbent, then the last step is to compare the new model to the current one you are employing. This will determine whether it can be implemented with the existing organization or needs to be set up as a new separate unit.

By placing the customer first, and the profit formula, resources and processes behind him/her, the authors stressed that market knowledge and product expertise still gives incumbents insight and competitive advantages when trying to go 'new'. The challenge, however, is how to 'tap into expertise without importing the old-rules mind set'.

Today's media incumbents are having considerable difficulty changing their own predispositions, assumptions and entrenched mindsets. Media companies creating, licensing and distributing IPRs have tended to rely on relatively complex business models, traditionally based on a mixture of advertising, subscription, licence fee (e.g. Free TV), pay-per-view, sponsorship and sub-licensing etc. None of these models necessarily placed the CVP in poll position. And now the 'traditional' models are starting to either struggle or go bankrupt. In the United Kingdom alone, witness the BBC fighting to retain the licence fee, while ITV's advertising-dependent business model is collapsing and Channel 4 fights for its right to survive.

The internet itself, and associated business models, is not immune to the challenge of monetization. *The Economist* summed up the business model challenge facing the World Wide Web itself, stating in an article titled "The end of the free lunch – again", that

> Internet companies are again laying off following the last bubble of 2001, scaling back, shutting down or trying to sell themselves to deep-pocketed industry giants or talking of charging for their content or services. [MySpace and YouTube managed to sell to News Corp and Google before the cooling of the market.] The idea that you can give things away online, and hope that advertising revenue will somehow materialise later on, undoubtedly appeals to users, who enjoy free services as a result. But there is no business logic to it, too. The nature of the Internet means that the barrier to entry for new companies is very low – indeed, thanks to technological improvements, it is even lower in the Web 2.0 era than it was in the dotcom era. The Internet also allows companies to exploit network effects to attract and retain users very quickly and cheaply. So it is not surprising that rival search engines, social networks or video-sharing sites give their services away in order to attract users, and put the difficult question of how to make money to one side. If you worry too much about a revenue model early on, you risk being left behind. Ultimately, though, every business needs revenues – and advertising, it transpires, is not going to provide enough.

So if it is not 'advertising', the multi-billion-dollar question is what is it, and how is it to be achieved? A central element to the challenge is that the fundamental shift is in 'user' behaviour, brought about by 'socializing' technology and deregulation, not the mechanics of the digital technology itself. The only clear winner to emerge from the digital age so far is indeed the 'user': he/she has an ever-expanding choice of what is now available anytime and anywhere, and at an even lower cost – including a plethora of 'free' if you include pirated and user-generated content etc. Consumers are diverse and have as wide a set of behaviours, tastes and attitudes as those of producers or business-to-business buyers. Traditional models have chased the Pareto 80:20 principle – the larger the audience, the more justification for higher ad rates or retaining licence fees etc. And gatekeepers controlled distribution and had the consumer in a stranglehold. But today and tomorrow the internet allows people to operate either by themselves or in smaller groups or in focused fan-based flocks, rather than gravitating axiomatically to mass audience levels.

In the BSAC seminar on "Future Trends: Life and Death Post 2012", the Blue Skies Working Group pointed to the four Basic Demands (as do a host of academics and

commentators): Everybody wants to choose what they want to watch, when they want it, how they want to watch it and how they want to pay for it:

> That might be a one-off cash payment, a subscription payment, a payment to rent, view or keep, or it might be free. It might be paid for by advertising if the consumer is happy to have advertising around content. We're talking about consumers who want to buy and use a film or television programme in pretty much the same way as they can go onto Amazon, click and have books delivered within 24 hours. It's really as simple as that. And as we all know *the industry is so set up that that is a long way from being provided...* Broadcasters, filmmakers and entertainment companies often talk about choice but they usually mean a choice of content. Consumers are more ambitious and want choice in each of the Basic Demands.

What is impressive about BSAC's Blue Skies' fearless analysis is that as a practitioner group, it leaves most trade and industry bodies way behind in critical thinking. Ironically, it has been academic and journalistic work, research and non-film practitioners who have offered fresh thinking and added to the critical debate about the Internet and new business models.

The long tail model and debate

There are new suggested guidelines that govern present and future business in this new multi-window of commercial opportunity. One of the more extrapolated theories on how to exploit rights was coined by journalist Chris Anderson, editor of *Wired*, when his initial article (2004) and subsequent book (2006) drew on research and analysis of several companies in the entertainment sector. The argument put forward went as follows: commercialization on the internet is not a marginal market; instead, it is an emerging market with ongoing built-in increasing value. The commercial argument is rooted in three main observations: 1) the internet draws together a fragmented and dispersed audience which, when consolidated as a whole, makes up a very significant market; 2) the costs and limitations of physical distribution are eliminated and product consumption becomes more personalized and in tune with the demands of the net-generation; and 3) the 80:20 Pareto principle (20 per cent of products account for 80 per cent of sales) no longer dominates. Popularity is no longer the main or only driver of market value; relatively unknown or minority interest products can be found and bought with ease. Their availability and acquisition by fragmented users form a key part of the new virtual economy.

Anderson went on to outline three rules that oversee his new business model concept, all focused on the user's leading role and individuality: 1) 'make everything available' – meaning the availability of a wide range of titles; 2) 'cut price in half, now lower it' – which enshrines competitive pricing in contrast to other distribution channels; and 3) 'help me find it' – which relates to branding, retail action and personalized consumption. "The companies that will prosper", Anderson declared, "are those that switch out of the lowest-common-denominator mode and figure out how to address niches."

This statement and his accompanying work were directly attacked by Anita Elberse, an associate professor of business administration at Harvard Business School. Her own conducted research indicated the opposite to Anderson's conclusions. While acknowledging that the internet allowed for

more obscure products being made available for purchase every day, the tail is likely to be extremely flat and populated by titles that are mostly a diversion for consumers whose appetite for true blockbusters continues to grow. It is therefore highly disputable that much money can be made in the tail. In sales of both videos and recorded music – in many ways the perfect products to test the long-tail theory – we see that hits are and probably will remain dominant. That is the reality that should inform retailers as they struggle to offer their customers a satisfying assortment cost-efficiently. And it's the unavoidable challenge to producers. The companies that will prosper are the ones most capable of capitalizing on individual best sellers.

Anderson patiently batted back Elberse's curve ball in an ensuing blogging exchange, but the key point was that Elberse was taking the side of the 80:20 rule and supporting the notion that powerful incumbents have most to gain ultimately from the new global dissemination game the internet throws up.

The 360-degree approach and integrated opportunities

While there are key inherent dangers lurking in the bipolar positioning discussed in this chapter (where both sides may be well off the future mark), there are also positive areas of potential advancement. Specifically, barriers to entry for smaller and independent companies are lowering; and opportunities for creative talent to develop with less sunk-cost risks associated with physical production are promising. The arrival of a new, increasingly efficient market that is responding to the needs of new users provides for new commercial opportunities, which, in turn, also offer potential cross-media synergies for the entertainment industry and last, but not least, the scope for interaction with other markets linked to core product and able to be exploited and disseminated simultaneously across new platforms and accessed (and even paid for) by a myriad of user-friendly systems.

Ultimately, the adoption of a more holistic approach towards exploitation and multi-platform promotion will be essential if the cost of new content is to be successfully amortized. Hardly new (the studios have been operating it for decades) is the much discussed '360-degree' model. In the 'future is now' multi-channel world, where the user has infinite choice, creative businesses need to compete not just against rival product and other entertainment providers, but with other non-media businesses competing for the user's 'share of mind'. This requires early consideration and assessment of all potential forms of exploitation, adaptation and promotion of film in particular, if the changing value chain is to be conquered.

Vertically integrated and multi-channel exploitation remains vital to commercial development. New product and projects have the potential to be positioned and accessed through a multiplicity of revenue channels. This strategy does, of course, require a certain level of knowledge of the market for each opportunity, but it is also possible to acquire this through a series of partnerships or joint ventures. The integrated approach adopted in such examples can create a virtuous circle as each strand of exploitation promotes and reinforces each other.

The new way forward

"No matter how grand our request to become global entertainment giants or pioneers of revolutionary technologies, we cannot forget that it is the story that lies at

the root of every successful form of entertainment." When Peter Guber, film producer, chairman of Mandalay and former chair of Sony Pictures Entertainment, pronounced those words some 15 years ago, this author had no real notion of the enormity of user changes that were to be brought about through the internet. Nevertheless, content for the film business specifically remains 'king', while scale and 'reach' remains 'queen', to use the words of Terry Ilott. The creation of compelling, distinctive, emotionally alluring and moving content carries a premium that transcends all existing and future delivery systems. The informational networking ecology of the internet serves to promote and expand outstanding content, not bury it.

Leading creative organizations lead because they produce outstanding content. The challenge producers and creative organizations now face is how best to deliver that around the 360-degree clock, across as many different channels, outlets and platforms as possible, and how best to find that blend between commoditizing and gifting. But without strands of significant monetizing, the creative economy will dry up.

26 The challenge of creative management

> The view that good ideas are rarer and more valuable than good people is rooted in a misconception of creativity.
>
> (Ed Catmull, co-founder of Pixar and the president of Pixar and Disney Animation Studios)
>
> Historically we've been blinded by the genius of Shakespeare, but forget the fact that he was also a brilliant entrepreneur...
>
> (Marc Boothe, managing director, B3 Media)

Creative careers

Building a creative career in any artistic arena is a challenge; building a successful progression of work that grows to more than the sum of its parts in the film industry is tantamount to climbing Everest. You may think you are getting somewhere, and your goal appears closer, but all too quickly a setback pushes (and sometimes crashes) you back down again. Antagonizing peaks all too often lead to larger troughs, and many – understandably – fail to stick to the climb.

So how do creative, talented people stay the course? Retaining focus, confidence and a sense of direction all appear to be traits that are highly individual and idiosyncratic, but to enjoy the freedom to exercise talent requires dedicated and intuitive colleagues, dynamic teamwork and, essential to any filmmaker, strong creative management. These rules are not directed at directors only – for there is a multitude of creative talent that the industry itself all too often takes for granted and who rarely shine in the public limelight thanks to the hierarchical obsession with the cult of the 'director' in particular. Filmmaking is collaborative and requires reservoirs of creative talent to make ideas reach audiences in an effective manner.

There lies a potential contradiction in the notion of 'managing creativity', but the meeting of business and art is what draws people to work and remain engaged in the movie business. This chapter looks at why creativity is absolutely central to film companies; from where generic sources of creativity emerge; ways that creativity is either obstructed or encouraged; and how the building of a creative environment, nearly always with the assistance of teams, can impact on how artists feel about their work and its associated value to both them and the wider world.

Without creativity – which in business frames of reference results in the creation of intellectual property rights – film companies and media business entities would have

DOI: 10.4324/9781003205753-29

nothing with which to trade. Creativity is the axis around which all other filmmaking activity revolves. Far from being limited to ideas, creativity, to list just some of the most obvious areas of application, is required for writing, editing, pitching, producing, shooting, lighting, designing, editing, selling and marketing. Many creative talents are required on both a business-to-business basis (e.g. the positioning and selling of a film to a distributor/buyer) and for the task of designing a campaign to reach the end-user – the audience. This is how money is made, and how companies grow and thrive – through a churn of product, successful placement in the market and openness to reinvention. Without successfully harnessing creativity, companies and their managers have nowhere to go in the moving-picture industry.

Film organizations are heavily dependent on intellectual property to generate income. The key entrepreneurial equation is how to turn the creation of intellectual property rights into value, which in turn demonstrates how interdependent the artist and the manager/producer are when it comes to creating such a complex product as a movie. The variety and complexity of this 'business ecosystem' starts not necessarily with the broad 'market' per se, with all its rivalry and competition, but within a tighter vortex that throws up subtle contradictions and insecurities. Companies are dependent on creative people – and the more talented they are, the easier it is for them to leave and take up work elsewhere. So from a manager's perspective, the aim is to work out how to find them, motivate them, get them working to the best of their ability and retain their loyalty so that they do not leave.

Sources of creativity

Sources of creativity in the film development process, listed in a simplified, utilitarian way, gradually brings us to the key umbrella that helps link intrinsic creativity with productivity: the team. However, different 'feeders' supply core initial starting points, hence the order suggested below:

1. the book/adapted to a screenplay
2. the original idea/treatment/screenplay
3. the writer
4. the writer/director
5. the producer
6. the director
7. third-party sources
8. the team.

Sources of inspiration imply ownership. But, given the inherent complexity of the film value chain, and the difficulties of moving ideas through development, into production, and to the market, creative talent that inspires ideas axiomatically finds itself in the hands of managers if they are to realize their ideas into reality. This leads creative filmmakers into a trap: 'Most clever people don't like to be led. This creates problems for leaders.' This statement, cited by Peter Bloore (a Senior Lecturer in Creativity at the University of East Anglia) in his lecture on Managing Creative People, opens up the psychological issues at stake when management encounters creative people. Referencing Goffee and Jones's article 'Managing Clever/Creative People – Herding

Cats?' (2007), Bloore lists seven key factors that summarize clever/creative people's characteristics:

1. They know their worth and have tacit skills – knowledge that cannot be transferred independent of its holder – rather than skills that can be easily codified.
2. They are organizationally savvy and will seek the company context in which their interests are most generously funded.
3. They ignore corporate hierarchy. They care about intellectual status, not job titles, so you cannot lure them with promotions.
4. They expect instant access to top management and if they don't get it they may think that their work isn't being taken seriously.
5. They are well connected and are usually plugged into highly developed knowledge networks – who they know is often as important as what they know. This increases their value to the organization but also makes them more of a flight risk.
6. Creative people have a low boredom threshold and will leave if you don't inspire them with your organisation's purpose.
7. They won't thank you even when you lead them well. They don't like to feel that they are being led.

Obstructing creativity

Encouraging the imagination is much harder than killing it. Typical ways to block or stifle creativity include:

1. Inability to listen and ignoring people's input. Managers who quickly override creative people actively disable them. Listening is a required skill if creatives are to flourish.
2. Alienating team members by allowing dominant, inexperienced (or unconnected) personalities to control the creative process.
3. The failure to provide accurate and timely information (especially when well-informed creative people have a habit of finding out). Sloppy work and late feedback kills confidence in creatives.
4. Not providing a forum for open debate and blue-sky thinking. Defensive, controlling behaviour does not inspire creatives.
5. Failing to read and consider the written work in full (e.g. producer or commissioning editor reading notes/coverage but not the screenplay). Inability to physically read is probably one of the biggest demotivators for a writer or writer/director.
6. A lack of discipline for agreeing, recording and acting on decisions. A critical path is quietly appreciated by creatives, even if they verbally push against being actively controlled.
7. Instantly negative opening statements: 'We don't normally ... it can't be done this way...'; 'That's not the way we work...'.
8. Setting up unrealistic timelines and deadlines that lead to unnecessary disappointment. There is enough rejection in the creative filmmaking mix without generating it unnecessarily.
9. Inefficiency over practical details: not covering/repaying expenses; paying late; general thoughtlessness for the person in question.
10. Stalling development and progress through lack of finance.

What attracts creative people?

Financial reward alone is not what drives creative people. Ownership, recognition, appreciation and responsibility tend to be more important and persuasive drivers than simply being paid large sums of money. 'They don't want to feel bought – they want to feel valued.' That is not to suggest that financial reward is unimportant; but it tends not to be the primary motivating factor. There is an alignment of varying factors and influences that bear weight when motivating creative people. Attractants include: the people/peer group (e.g. a producer's track record); the challenge of the project/task; the chance and source of funding to see their ideas/vision realized; your vision; the external and internal environments; and the organizational culture.

Specifically, if management is to actively encourage creativity – especially in a team environment – it can choose to focus on the following actions: notice creativity; reward it (not necessarily in terms of money – it may be about working flexibility re hours, or shared ownership/credits etc.); request it but do not demand it; delegate it; and build up both individual and team ownership. 'One of the key tasks of a leader is to understand the problem space and help people define it and then work within it to solve the problem', explains Stibbe. Although directly referencing games rather than films, Stibbe also recommends managers to use the abstraction and objectivity of a 'partial outsider' to help put creative issues in context and help the team match the right solutions to the right problems and avoid false trails.

Creative team management from a film producer's perspective

Conventional 'business teams' tend to have clear objectives, roles and positions of hierarchical power, which are established at the onset of a project. These roles and the overall format tend not to alter much during the lifecycle of the project. However, as Bloore points out, business team theory and creative team theory provide us with an interesting way of viewing the film development process. If we take it as given that a 'team' is whenever more than one person works together in a planned way towards a single purpose, that accurately describes what happens in film development. Whilst acknowledging that it is not fashionable to think of film development as a team activity, Bloore goes on to suggest that the film development process involves a creative team that grows and shrinks regularly: 'As it does so, the balance of power and control also shifts within the team. … This is one of the many reasons why the film development process is more complex and potentially chaotic than "conventional" creative teams.'

So, from the producer's perspective, they normally maintain long-term relationships with more than one writer – certainly more than a director does. The producer also has to generate intellectual property – in this process created by the raw material of new screenplays or sources such as novels, plays etc., to adapt. Directors, especially those established and successful, are often offered completed screenplays to work on.

The producer's task is to balance the writer and, initially, their relationship with the development team. However, the writer will want to have a primary, one-to-one relationship where available and possible with the producer. They will not want to take notes, feedback and direction from development staff on an ongoing basis. If the writer is not working already with a director (or is not a writer/director), the producer will have to be careful about the way the writer is introduced to the director. Directors select material but are also chosen due to commercial demands, most likely

to do with the commercial imperative of financing a film on the back of an established and appropriate track record. The producer's director selection may not fit with the writer's view; an immediate point of creative conflict. Or the director may not be sympathetic and diplomatic about voicing creative input. And ultimately the director will be responsible for 'delivering' the film, not the writer, whose job has typically been phased out by the stage that the film is in front of the cameras. (Of course writers are often needed to re-write on set, and some directors are creatively open and inclusive in their treatment of writers rather than exclusive.)

The role of 'growth mindset'

The key to successful creative management of writers and directors is the ability to develop trust, and long-lasting bonds and achieve outstanding work together. In response to such leadership, writers and directors are engaged on a more regular and constructive basis, and slates of work emerge rather than ad hoc, one-off experiences. For such positive relationships to take place, it can be argued that the role of the 'growth mindset' plays a central role in the creative stages of production. Writing in her final MBA essay at Cambridge University's Judge Business School, producer Sonia Guggenheim developed "a model of optimal leadership approaches that foster creativity" with creative talent, consistent with the elements of growth mindset [The role of growth mindset in the early creative stages of production, based on interviews with six leading UK film producers, Sonia Guggenheim, University of Cambridge, Judge Business School, 2021 – yet to be published]. Guggenheim posits through key elements (see Table 26.1) that guide the process:

Table 26.1 Expertise and organisational skill

Growth mindset	Producer's roles	Creatives need
Expertise and organisational skill		
Strive to learn and gain expertise	Expertise in storytelling, and practical and financial matters of filmmaking	Informed, constructive feedback from producer
Have accurate view of skills and work to fill gaps in knowledge	Know their limitations and the limitations of the work. Able to evaluate ideas and identify flaws early on	External perspective to judge their ideas and identify the work's limitations
Value work process. Promote hard work and self-betterment	Allow time for creativity and trial and error processes	Process of idea generation: trials and errors
Take charge of the process that brings success	Draft clear goals and structure the creative stage, manage the transition from idea generation to idea implementation	Clear sets of goals and guidance in the transition from the idea-generation stage to idea-implementation stage
Provision for the autonomy of creative		
Welcome new challenges and embrace mistakes as learning opportunities	Welcomes inchoate ideas and mistakes. Nurture the development of those ideas	Guidance and support through the process of idea generation
Collaborate and listen. Don't feel threatened by divergent thinking	Be a resource of imaginative, intellectual and emotional support for creatives. Listen, give constructive feedback in a thoughtful way	Constructive, thoughtful feedback and creative control

Table 26.1 (Continued)

Growth mindset	Producer's roles	Creatives need
Believe people can become good through hard work. Believe in people's learning abilities. Inspire and promote the development of talent	Trust creatives. Give them autonomy. Be honest and financially transparent	Autonomy, responsibility and accountability
Establishment of a culture of trust		
Allow mistakes and learning	Create a safe, supportive space to build trust	Safety to seek support and feedback, and to share ideas
Emphasise learning and accept risks	Protect new ideas from early criticism. Approach risks with optimism	Experimentation with and tolerance of the risks and mistakes inherent in exploration
Help the development of others. Value improvements, passion, and learning	Establish psychological safety in teams through fostering and exemplifying a standard of consistent mutual respect	Perception that all other members are non-threatening, open to risk-taking, and eager to exchange new ideas
Engage with mistakes	Perform post-mortems, bring people together and discuss mistakes	Unthreatening discussions to learn from mistakes and setbacks

Source: Guggenheim, S. [Ibid.]

(a) Development of expertise and organisational skills
(b) Provision for the autonomy of creatives
(c) Establishment of a culture of trust, allowing for mistakes and learning
(d) Inclusion within a strategic network.

Take-aways from leading producers [Ibid.]

"The similarities in the producers' approaches were quite striking. On the basis of our interviews, we can identify the following commonly cited principles of operation as essential to creativity in production:

- Don't lose sight of the big picture. To quote Graham Broadbent: 'Ask: Where is true north?' To cite David Heyman: 'Be aware that you need to tell the difference between 'the forest and the trees'.
- Learn, learn, learn and develop your expertise. Know the limitations of your understanding and cultivate humility.
- Trust the artists, give them autonomy and responsibility. But share clear goals and establish a culture of commonly shared values.
- Be honest but be mindful: empathy and trust are key.
- Dare to fail. Be curious. Trust the process, trust others, trust yourself.

Guggenheim's conclusions are as follows, adding considerable value to existing research and literature on the subject of creative management:

The film industry has been built on the concept of innate talent. Individuals with 'talent' are traded as commodities during the development stage of a film in order to secure funding and mitigate financial risks. In this environment, it is challenging for leaders to build a growth-mindset culture, as filmmaking's costs and unpredictability engender fear of risks, spawn risk mitigation strategies and micromanagement of creatives, and generate conflicts between business and art. These tensions too-often thwart creativity and compromise artistic and financial outcomes. A growth-mindset culture offers a remedy, inspiring creativity by way of its emphasis on collective and individual trial-and-error processes, resilience, personal development and mutual respect.

Our examination of research about creativity and risk mitigation strategies leads us to the conclusion that the producer should foster and guard creativity during the earliest stage of filmmaking – the development stage with writer and director – and that this can best be accomplished by establishing a growth mindset culture. In that culture, the generation of creative ideas is promoted when producers themselves pursue learning and strive for expertise; when they give writers and directors both autonomy and responsibility; when they establish a culture of trust that allows for mistakes and learning; and when they follow an optimal network strategy, with both core and peripheral support.

Creative management case study 1: Neil LaBute's *Vapor* [8]

Taking an American piece of material and attached talent, and seeing what can occur when a European-based company commits to developing and financing that package, can illuminate the creative, cultural and financial hazards that are associated with ambitious cross-border investments in the film business. However, such ambitious projects that have high-value elements either attached or potentially likely to join such a project, often form part of the price of doing business in the higher end of the independent film business. Projects that can potentially drive a company's perception and reputation forwards are hard to come by, and entry comes at a premium. The following case study demonstrates many of the above issues.

The development package

Pretty Pictures, a Los Angeles-based production company run by producer Gail Mutrux (*Rain Man, Quiz Show*), approached Renaissance Films in 2001 to finance the development of a Neil LaBute project. The novella, written by a new writer Amanda Fillapachi, is about a young wannabe actress in New York, who meets and falls for a strange scientist who ostensibly makes clouds for a living. They embark on a highly charged and challenged affair, while the story takes on fantasy-like Pygmalion aspects as the lead actress is re-shaped, literally, by her admiring scientist. In other words, *Vapor* is an off-beat, truly 'independent' project, not cut out for in-house Hollywood Studio development, but potentially original enough to attract high-end talent given the status of the director and producer committed to developing the material.

The project came to light thanks to a vigilant acquisitions executive working at Renaissance during that time. Sarah Sulick had found out about the book and the attachments, and pitched it internally to Renaissance's co-managing directors, who were interested in pursuing the project.

After initial discussions, the agreement between Renaissance and Pretty Pictures stated that Neil LaBute (*In The Company of Men, Nurse Betty*) would adapt the novella, and direct the film. Pretty Pictures was to produce, and Renaissance was committed to financing, controlling world rights, and executive producing. The dates of writing commencement (two drafts and a polish) were initially left vague, as LaBute had some 'prior commitments', but Mutrux assured Renaissance that she would be able to get the writer/director to focus on the screenplay once his latest film, *Possession*, an A.S. Byatt adaptation, was completed.

During a meeting between Renaissance, Mutrux and LaBute, prior to signature of the three-way development deal, Renaissance stressed that some of the more extreme elements of the story needed to be handled carefully if the script was not to alienate both the potential cast and, ultimately, the project's intended audience. Renaissance internally debated whether it should consider including the right to appoint a third-party writer to the project as an insurance for timely delivery and a greater level of creative control – with LaBute writing a 'director's draft' rather than two full drafts and a polish, but nothing was decided upon. Renaissance decided, instead, to rely on a delivery date for the first draft (February 2002) in the long-form development contract, which allowed LaBute more than six months from signature to deliver.

At this stage, a Los Angeles-based company, Catch 22, approached Renaissance about sharing the development costs 50–50, with a view to co-financing the project. Renaissance decided that this partnership would help offset the upfront risks of development, and a verbal agreement was established, but not papered (e.g. legally drawn up) in a timely manner. (Later, Catch 22 fell away as the company closed prior to any formal legal contract being in place, leaving Renaissance picking up the tab for the full development and pre-pre-production costs.)

Writing delays

The first draft of *Vapor* was delayed by 12 months (script delivery ended up being in February 2003) due to LaBute directing a new movie of one of his plays (*The Shape of Things*), a Working Title project that was not mentioned when the development deal was agreed. Although the first draft was potentially strong, it needed significant rewriting. Specifically, the writing in the more extreme and emotional scenes in the script required attention. Most problematic was that the first 40 pages read like a zestful and light romantic comedy, whereas the following 80 read like a noir psycho-thriller. To be specific, the male lead literally throws the female lead into a cage with a view to 'improving' and training her around page 48 of the screenplay, shortly followed by the character using an ice dart gun to control his muse: definitely edgy material.

Market pressure on the development process

After notes and a meeting with Renaissance, LaBute made some minor revisions. Renaissance, however, was under time pressure to package the film (i.e. attach key cast and agree a budget) prior to the imminent film market at Cannes. Why? Because that was where the film had its best chance to be financed, and because Renaissance was hoping that the project's launch into the marketplace would also lift the company's overall status and reputation with international distributors.

The one draft plus revisions version of *Vapor* was sent out by the Creative Artists Agency (CAA), acting on the behalf of Renaissance, to cast. After a 10-week period, Ralph Fiennes and Sandra Bullock committed to play the leads. The director assumed that now that key talent was attached, the script was in shape and required no major additional work.

Renaissance's sales team argued that the draft suffered from mixed-genre confusion, and was not yet in shape for key distributors to read. By this time sole managing director Finney pointed out that the script needed to be sent to North American and foreign distributors at least three weeks prior to the commencement of Cannes. Otherwise, the script would not be read, the project would not be considered and no crucial pre-sales and financing partners would be closed. In turn, the talent would move on to other projects.

What should Renaissance do?

1. Put project on hold, and request a new draft from LaBute as per his contract?
2. Put project on hold, and appoint a writer agreed by LaBute to make the changes in tone etc., that Renaissance feels are crucial to the project working?
3. Request further work from LaBute on the screenplay right up to the eve of the market, and then deliver that draft to primed US and foreign distributors in the hope that they will read promptly given the attachments?
4. Allow the existing draft to go out three weeks prior to the market, and bring LaBute to Cannes to talk face-to-face with distributors about his vision for the film? Renaissance could then use a North American partner attracted to the project to bring pressure on the screenplay once they become partners.

What actually happened?

The script went out three weeks ahead of Cannes, and LaBute attended. However, whilst the project was taken very seriously, the script was not widely liked, mainly due to the mixed-genre problem.

What should have happened?

a) Renaissance should have included and exercised the option to appoint a third-party writer in the original development contract. This might have avoided some of the delays and hence subsequent time pressures on Renaissance to finance the film so soon after first draft script delivery.
b) Renaissance should have placed the project on hold rather than take a screenplay that was not ready to be read by distributors to the market, a mistake I was personally responsible for making as I was too keen to have new projects to attract distributors…
c) The writer and producer could then have had more time to work on a fully reworked draft. If the script worked, new talent would have committed.

The packaging stage

After the previously mentioned false development starts, Renaissance decided that *Vapor* still held certain strong attractions re creative packaging. 'Creative packaging'

refers to the writer, director and cast (potential or attached) that make up most of the key elements when planning a production. First, the writer was also the director. Second, the writer/director had a cast already in mind when the book was optioned and the screenplay commissioned.

The initial cast

The pitch from LaBute and Mutrux was that LaBute was intending to write the part for Rene Zellweger, who had played the title lead in LaBute's *Nurse Betty*. Mutrux had a strong relationship with Ralph Fiennes (to whom she spoke on the phone regularly) thanks to their work on *Quiz Show*. Renaissance considered the cast combination commercially appealing – possibly to the tune of around \$15–20m re a prospective budget. And Fiennes was extremely keen to work with Zellweger.

Shortlisting

When the screenplay was deemed ready to go out to cast, CAA, who represented Zellweger (and Renaissance), gave the project to her agent and management on an exclusive basis. No time limit was set initially, as the director, producer, agent and Renaissance all expected Zellweger to read promptly. She was aware of the project, and LaBute had spoken to her on the phone about the role and the concept. Zellweger had the script the first week of March 2003. Concurrently, she had been nominated for a Best Actress Oscar for her role in *Chicago*. Despite repeated calls from Mutrux, LaBute and Renaissance, CAA and Zellweger's management continued to ask for 'more time'. What became clear was that Zellweger was not going to make a decision about her next role until she knew if she had won the Oscar. CAA rang the producer six weeks after the initial submission, and told Mutrux that Zellweger 'was passing'.

Renaissance had just four weeks prior to the Cannes market to package *Vapor* to a level that would attract pre-sales and an American financing partner. A shortlist was drawn up, with Cameron Diaz at the top. It became clear quickly, however, that Diaz was not available. ICM's CEO Jeff Berg rang Renaissance suggesting Julia Roberts, but by that stage (three weeks prior to Cannes), CAA had got LaBute to focus on Sandra Bullock, also a CAA client. Bullock read the script within four days. Bullock has a very close relationship with Warners, including a production company with her sister that operated on the studio lot. Bullock was scheduled to play the lead in *Miss Congeniality 2* for Warners, but the shoot was not starting until January 2004 – leaving a gap that autumn for the actress to potentially fit in *Vapor*.

Suitability

LaBute met Bullock, who liked the screenplay and her character very much. She spoke to Fiennes about their prospective partnership, and that seemed to go well. Renaissance had little time to consider whether Bullock was the right commercial fit for the project – as the creative elements (writer/director, producer, existing cast) appeared convinced. So too was CAA, as the agency was mindful of the timing issues re getting the project out to distributors prior to the Cannes market.

Cannes

A letter from CAA, with the draft and cast attachments confirmed, was sent out ten days prior to the Cannes market. John Ptak, the lead agent representing the project, put a budget price of $25m on the film in his letter. (This number was an issue for Renaissance's sales head, as she was concerned that it was placing the project at a higher level than the material could justify, despite the cast attachments.) Renaissance managed to get an announcement about *Vapor*, with Bullock and Fiennes attached, onto the front page of *Screen International*'s first daily magazine of the market. Everything seemed on be on track.

The distributors' reaction

Vapor is a particularly demanding screenplay. Most key territory buyers did read the screenplay prior to attending Cannes. But many were confused, as they understood Bullock's casting up to page 48 of the script, but at the point that Fiennes' character 'forces her into a cage', many became confused about genre and casting suitability. With the exception of two key distributors, Renaissance failed to make any pre-sales at Cannes.

Post-Cannes, what should Renaissance do?

1. Re-cast Bullock, and relaunch the film later that year at MIFED?
2. Stick with the casting, and try to close a Warners' North American deal and a deal with Icon (an international distributor that operated in the United Kingdom and Australasia) for the United Kingdom/Australia/New Zealand with existing cast?
3. Go back to Zellweger, when she did not win the Best Actress Oscar?

What actually happened?

Renaissance tried to close Warners and Icon, and also tried to pre-sell during the summer of 2003 by visiting distributors in Spain, Germany and France face-to-face, but to no avail.

What should have happened?

Renaissance should have kept control over the project much more tightly at the point that Zellweger 'passed'. Instead of being rushed into a creative decision chosen by the creatives, the financier should have been cautious and patient. As an international sales company, it should have been aware of the dangerous juxtaposition that Bullock's casting represented: 'Light, comedic actress in dangerous, indie movie from auteur ...'. It should have said no to Bullock prior to her coming on board.

The financing stage

It is relevant now we come to examine the budget issues and finance that had to be raised, to recall that Mutrux and LaBute had worked previously on *Nurse Betty* ($32m) and *Possession* ($30m). These budget levels provided the executive producer

with an indication of the director's potential 'value' in the independent market-place, but more attention should have been paid to their performance (in the case of *Nurse Betty*, as *Possession* had not been released at this time) and possible over-pricing in hindsight. This aspect is about managing talent and producer's expectations next to realistic limitations, rather than falling into the trap of telling them what they want to hear.

Cast

By May 2003 the two leads attached to *Vapor* were Sandra Bullock and Ralph Fiennes. However, despite the high level of casting for an independent film, Renaissance had indicated to Mutrux that no more than $20–22m was likely to be available to *Vapor* from the marketplace due to the challenging material and LaBute's recent track record.

The budget

Renaissance asked Pretty Pictures to deliver a production budget on the draft that distributors read at Cannes 2003. The first production budget submitted totalled $33m without financing costs. In Renaissance's opinion, this budget was at least $10m too high. Renaissance decided to fix on what they thought was a realistic figure for distributors and financiers, and to re-work the script, schedule and budget while the financing was being raised. A figure of $25m was arrived at, including financing costs (e.g. cost of banking gap, loans, interest, and financing fees etc.).

Finance plan(s)

Renaissance had two potential plans for raising the finance for *Vapor*, based on the need to raise $25m. Both first required a North American deal, which could be announced and promote the film to the attention of key foreign buyers. These financial components would, potentially, be the cornerstone financing of the film:

1. North American deal (plus Australasia and South Africa) with Paramount Pictures (33.3 per cent of budget), German tax fund (20 per cent), further foreign pre-sales (30 per cent) and bank 'gap' against remaining sales estimates (17–22 per cent), requiring 200 per cent coverage.
2. North American deal at $5m (20 per cent), further foreign pre-sales at 40 per cent (including the United Kingdom/Australasia; Germany; France and Italy); German 'super' tax fund (30 per cent), and bank gap against remaining sales estimates (10 per cent), requiring 200 per cent coverage.

Finance plan 1 – Paramount

This plan stemmed from a first look deal Renaissance had secured with Paramount Pictures in 2001. The agreement was to cover projects owned and submitted by Renaissance, whereby on presentation of script, director, budget and two lead actors, Paramount would have the option to co-finance 33.3 per cent of the film's budget. The studio would take North America, Australasia and South Africa (the territory). Paramount considered *Vapor* carefully, and their head of business affairs, Bill Bernstein,

co-ordinated the financial assessment. However, despite the numbers looking promising, the studio did not feel that Neil LaBute was a director they wanted to work with given his art house and literary credentials. The studio passed two days prior to the start of the Cannes market.

Finance plan 2 – Warners

Sandra Bullock had a production company on the Warners' lot, and the actress was signed up to do *Miss Congeniality 2* for the studio starting winter 2003. When it became clear to Renaissance that all other studios and US independent buyers were passing on *Vapor* during the market, Renaissance asked the producer to call the office of Warners' CEO Alan Horn and request their support. Horn responded with an offer of $5m (later upped to $5.5m), but the deal was not agreed until the second to last day of Cannes. All major foreign distributors had left the market by then. The Warners' deal was also not agreed in any detail, limiting its use as an announcement.

Renaissance set about trying to close the Warners' deal in May/June, and that summer made in-person visits to key distributors in Germany, Italy, France, Spain and Japan. Nearly all distributors slowly passed, based on a) script, b) director, c) Bullock's casting. Any still keen were later put off when the project was moved from Warners to WIP (Warners Independent Pictures, the newly created specialist distribution platform), with its vastly reduced theatrical opening. In addition, WIP's head Mark Gill was not keen to inherit the project. He called Icon, who were keen to pre-buy United Kingdom and Australasia, and explained that WIP was not going to do the movie. Finance plan 2 was dead.

Finance plan 3 – equity

When it became clear that no North American deal was going to work, Renaissance then tried to find equity for the film, and to bring the budget down. The producer and director worked hard to bring the film down to $21m, and relocated the film to Toronto to cut New York City shoot costs, and pick up Canadian benefits. However, as the budget dropped, so too did the percentage commitments of some of the cornerstone financing, including the German 'super tax' plan. The plan now looked as follows:

Budget:
German tax: Canadian benefits: Pre-sales:
Bank gap: Equity required:
 $22.5m including financing
 $6.75m (30 per cent)
 $2.25m (10 per cent)
 $3.4m (mainly medium and minor territories, including the Benelux countries, Eastern
 Europe/CIS, Middle East, Israel etc.) (15 per cent approx...)
 $3.4m (15 per cent) – in first position re recoupment $6.75m

Renaissance attended Toronto in September 2003 with a view to trying to close the above financial package. It was under pressure to get the production into principal photography, and was starting to spend money on pre-production to keep the cast.

What happened next?

1. More than six potential equity partners requested in-depth meetings. Most focused on the strength of the cast, and why the project had not managed to close significant pre-sale territories.
2. All equity players focused on the bank gap being repaid prior to their equity being recouped.
3. No equity players decided to come into the project.
4. The German 'super' tax fund dropped its offer from 30 per cent to 20 per cent.

What should have happened?

1. Renaissance should have never spent monies beyond development and certain pre-production items such as the budget and location work.
2. Renaissance should have been much more concerned about the mismatch of Sandra Bullock in a project that was mixed genre – and far from a standard romantic comedy. This is in no way a criticism of the actress, but a realization post-distributor testing.
3. Once there was no North American distributor for the film, *Vapor* should have been closed down. Equity partners were unlikely to come to the table by that stage.
4. When the first budget at $33m was submitted, Renaissance should have confronted both the producer and writer/director much more specifically about the financing challenge and the need for a) script work and b) a reduced budget that correlated to the complexity of the material.

Underestimating uncertainty: the search for a studio deal for Terry Gilliam's *Good Omens*

Introduction

The purpose of this case study is to analyse a range of issues that arise from an in-depth examination of a larger-scale ($60m), European-based movie project as it navigates the initial, critical film value chain links. It examines the development, packaging and financing stages of an ambitious project. As a direct result of this selected focus, the case covers: a) project management behaviour; b) creative and talent management challenges; c) commercial and 'market value' obstacles when managing projects aimed at the bigger budget market yet sub-blockbuster pricing; d) the financing strategy required to finance ambitious, larger non-Hollywood Studio films; and e) the problem of 'closing' the financing on a complex project.

Good Omens, adapted from the Terry Pratchett and Neil Gaiman novel, was co-written and to be directed by Terry Gilliam, and was intended to star Robin Williams, Johnny Depp and Kirsten Dunst. The film's failure to be green lit was mainly due to no US studio deal being achieved prior to production, but that factor requires further analysis and investigation rather than being taken at face value. The project management process was materially damaged by director's behaviour and reputation for being 'difficult', alongside a level of entrepreneurial 'producer competition' rather than project management cooperation. It was not helped by the fact that I was inexperienced at trying to package and launch a major $60m+ film in the international marketplace.

The initial 'pitch'

It was a typical producer-financier lunch meeting in Milan in early November 1999, at a traditional Italian eating-house just outside the grey gates of the MIFED film market, that the first pitch to Renaissance for *Good Omens* took place. Marc and Peter Samuelson, the experienced English-born producers who traversed the Atlantic, with Peter based in Los Angeles and Marc operating out of London, left their most ambitious project until last on their development slate hit list. The two managing directors of Renaissance Films (myself and Stephen Evans) had raised some $40m earlier that year from a single source of capital, Hermes Pension Fund Management, and I was immediately interested in the ambitious project. Investing equity in larger budget films was not part of the Renaissance business plan. Developing potentially commercial projects and then financing them from third parties, and putting those projects through Renaissance's international sales operation, however, was a strategy that appeared worthy of exploring.

Co-written by Terry Pratchett and Neil Gaiman, *Good Omens* is a sprawling, multi-character novel woven around a 'reconstructed' Apocalypse. The book's central characters, Crowley – a slick, cunning earth 'devil' – and Aziraphale – a confused, emotionally erratic yet bookish 'angel' – represent the timeless notions of good and evil through their characters. Except they've been drinking friends for more than 400 years, and have jointly decided that the world is far too good a place to abolish and that the Apocalypse need to be aborted. That means they have to find the Antichrist – in the form of a 'normal' 11-year-old boy called Adam living in a quintessential English village – very quickly if the Four Horsemen of the Apocalypse and the final reckoning are to be halted and the world (and their drinking and friendship) can continue without threat. The story is distinctive, original, and thrives off heady elements of anarchy and morality in equal doses.

The Samuelson brothers had optioned the lengthy book some years previously, but had found it hard to tap the right director. Despite Warner Brothers controlling the project for a period, no script had been commissioned. Warner Bros. had made it clear that the material would need to be set in North America rather than the UK if they were to even consider financing the project.

What made the Samuelsons' pitch ride above the typical market hawking was the scale of ambition and, in particular, the director they had potentially secured. Terry Gilliam had expressed a genuine interest in co-writing and directing *Good Omens*, but only if the film was to be developed, financed and predominantly shot in Europe. His writing partner, Tony Grisoni (co-writer with Gilliam of *Fear And Loathing in Las Vegas*), was also keen to have a go at jointly adapting the novel. "What Terry wants is to make this film in England. He's not interested in setting the story in America and having a Hollywood Studio controlling every aspect. He's been through all that before. This time he wants to finish each day and go to bed in his home in North London", explained producer Samuelson.

Back in Milan, the Samuelson brothers indicated to me that the film would cost around about $25m to produce, a number that seemed 'conservative' in terms of the ambition of the project but also low enough to convince Renaissance that the pitch was worth considering. At the end of the lunch, it was agreed that the Samuelson brothers would set up a meeting for Renaissance with Gilliam, Grisoni, and Marc. When I returned to London, I took Evans through the pitch, and we agreed that

hearing Gilliam's take on a Pratchett novel was an experience not to be missed. Sure enough, in late November, Gilliam performed a an imaginative, energetic and high-octane pitch – supported by a more cautious and less gregarious Grisoni – who patiently explained that the book was going to be difficult to shape into a workable screenplay and may take significant time to conquer. The discussion skipped quickly over what sections and elements of the book would need to be pruned or cut; instead it was lifted by Gilliam's infectious humour derived from the material and his own peculiar vision.

By now, privately, the Samuelsons had indicated to Renaissance that the budget was more likely to be around $40m, nearly double the initial $25m mentioned in the original discussion in Milan. Work on the screenplay was not going to start for some while, as Gilliam was busy setting up his 'passion' project, *Don Quixote*, with a view to shooting the film in Spain the following year. But Evans and I were not put off, especially after being seduced by Gilliam's luminous performance and their 'optimism' over working with a significant director. It was decided that Sophie Jansen, the Deputy Development executive at Renaissance, should be the 'point person' on the project. She was to strike up a strong relationship with Grisoni, which was to prove important during the coming months. Renaissance's two MDs, Evans and myself, were to be attached as Executive Producers, in light of their financial commitment, ownership of the forthcoming script, and intention to work with the Samuelson brothers to package and finance the project. All seemed set to go forwards.

The development deal

Developing *Good Omens* was going to be financially demanding. An escalating commitment axiomatically arose from the first development deal signing onwards. Specifically, a stepped development deal was agreed in principle, with co-writers Gilliam and Grisoni being guaranteed a total of £360,000 to deliver two screenplay drafts and a polish. The initial payment was £30,000 to each writer on commencement of the first draft; £60,000 each on delivery of the first draft, £60,000 on delivery of the second draft, and £30,000 each for the polish. Once that polish was completed, each further polish was to cost an additional £40,000.

The book option deal was as follows:

> 1st 18 months 14/11/97–15/5/99 $25,000 on account of purchase price (at this point the book was optioned by the Samuelson brothers)
> 2nd 18 months 16/5/99–15/11/2000 $25,000 50 per cent on account (and here Renaissance took over)
> 3rd 18 months 16/11/2000–15/5/2002 $25,000 not on account (RFL paid)
> 4th 12 months 16/5/2002–15/5/2003 $50,000 not on account

The purchase price (that is the sum to be paid on first day of principal photography – and effectively 'exercises' the option): 2.5 per cent of budget, floor of $250,000, and a ceiling of $400,000 and 5 per cent of 100 per cent of net profits.

Jenne Casarotto, a very experienced London-based talent agent, who had represented Gilliam for some years (among other clients, including Stephen Frears, Neil Jordan, Nick Hornby etc.), had stressed to Renaissance that the overall commitment, whilst "appreciated" from a UK company, was "far less than a Hollywood Studio would have been prepared to pay to develop the project". The implication was that

Renaissance was 'getting it cheap', and that she would have been asking for more than $1m in writing fees (around £700,000 in 2000) if a Hollywood studio was paying the development costs. The one exception to the supposed 'cut price' was the costly further polish fees. She stated that it was an attempt to stop her client (and later Grisoni was added to her client list) being stuck in 'perpetual development hell' and to force the producers to focus on getting the film into production rather than going round in circles. Ironically, writing work did not start on *Good Omens* for nearly one year after the agreement was completed, thanks to Gilliam's unfortunate experience on *Don Quixote* (recorded in detail in the documentary *Lost In La Mancha*).

In addition to the cost of commissioning the screenplay, Renaissance picked up all the Samuelson brothers' historical costs, totalling around £110,000; and agreed to fund the ensuing book option payment schedule (see above). The overall commitment from Renaissance was more than £500,000 by the time all the contracts had been tied up. What was not included or set out in the development negotiations was the 'implicit' understanding that Renaissance was to be 'on the hook' for all further development and pre-production costs right up to first day of principal photography. In other words, Renaissance had unwittingly become the equivalent to a Hollywood Studio in the process of setting up *Good Omens*, with associated cost and control implications that had not been considered in full (or in detail by the team) by Renaissance Films and in particular myself. The implications were potentially considerable.

Competing interests: project management behaviour in relation to the different *Good Omens* producers within the value chain

Within a matter of days of the verbally agreed development deal, a new element was added to the project management composition, although one that had been very clearly planned by the Gilliam camp in advance of the project set up. Jenne Casarotto told Evans that Gilliam was concerned about the Samuelson brothers' producing the film as sole lead producers. Gilliam's *Twelve Monkeys*, which had starred Bruce Willis, Brad Pitt and Madeleine Stowe, had been produced by an A-list Hollywood studio producer, Charles Roven (later to go on to produce *Scooby Doo* and the later *Batman* franchise among other Hollywood Studio blockbusters). Gilliam was insisting that Roven was to be brought into the film as the lead producer, according to Casarotto. She also stressed that all parties would need Roven's script and Hollywood studio-driven access and packaging skills if the project was to be developed successfully to the point that project's budget was raised and the film was to be Green Lit.

A meeting was finally held at the Samuelsons' lawyers, Olswang, in early 2000. The intention was to map out how the project in principle would be financed; how much each party's fees would be per their respective work and financing, and how, by now lead project manager, Roven would work with the Samuelson brothers and Renaissance Films. Was Renaissance Films cognisant that the deal on offer meant that the company was being set up to become a replacement entity for a Hollywood Studio: bearing sunk cost and cash flowing commitments

An in-depth three-way agreement between the parties was going to be required. (In addition, a separate producer deal between US producer Charles Roven and the Samuelson brothers was also going to have to be documented – something that took a very lengthy amount of time and caused considerable divisions between the two producing parties.) What should have been a collaborative relationship throughout the producer

team, and a strong resource, was now a potential liability that would impact on future decision-making.

Before the meeting had really started, Roven asked bluntly whom Renaissance's distribution partners were in order to guarantee at least 40 per cent of the production's finance. The question exposed the fledgling sales operation Renaissance had added to its development and production interests when closing its deal with Hermes. The sales arm had no experience of pre-selling a film at a $40m budget level. Roven, in turn, explained how he had financed the $29m *Twelve Monkeys* (to be ultimately delivered at around $32m) through four key distribution partners, which included UGC PH (France), Toho Towa (Japan), Concorde (Germany), and Lauren (Spain). The deal was split 25 per cent four ways, and had effectively left North America 'open' for a sale at a later point. As a result, in part, to the budget being controlled when compared to the challenging material – and fronted by A-list stars – *Twelve Monkeys* had made considerable profits for the investor-distributors and producers. "Angus, here's the thing. I receive a seven figure cheque every year thanks to the financial structure of that film", Roven explained later. *Twelve Monkeys* had gone on to take more than $160m worldwide during its theatrical release and far more from video and DVD revenue streams.

While some of Roven's *Twelve Monkeys* partners had either moved on or been changed (with Helkon replacing Concorde, and UGC PH looking unlikely to be involved in a larger budgeted Gilliam film), his experience and relationships far outweighed Renaissance's. Roven stated that he could bring Germany and Japan to the *Good Omens* table. Renaissance had nothing to match this. With the exception of an output deal with Entertainment Film Distributors, where no advance was paid in return for a modest 25 per cent distribution fee and a strong share of the ancillary income, Renaissance had no long-standing foreign distributor relationships. On the other hand, given that Renaissance was stumping up the entire development and pre-production risk, the company's managers felt that they should have a fair shot at trying to presell and sell-and-service the majority of the sales on the film and be paid commission accordingly. A deal was later agreed that gave Roven/Samuelson a 5 per cent commission on key foreign territories (defined as France, Germany, Spain, Italy, Australasia and Japan) if they made the deal, and 5 per cent to Renaissance if in turn they closed the territory. It was agreed that Renaissance would handle the remaining Rest of the World for a 10 per cent commission.

No commission was due to be paid until the negative cost of the film had been met, so in practice all commissions were to be deferred and would only be paid out if: a) sales and finance came to more than the negative cost prior on first day of principal photography; or b) placed in a recoupment agreement once the financing had been raised. The deal also allowed Roven's company the opportunity to control and exploit music-publishing rights in return for a share of royalties. That left North America to be dealt with.

'Controlling' the tipping point: North America

On a projected budget of $60m, the project management team and development financiers knew that a North American advance for distribution rights was going to be critical to the project's move into physical production. Roven, as was to be expected, had a 'deal' with a Major Studio. He had recently moved away from Warner Bros.,

and had set up a deal at MGM. The terms of the financing and distribution terms with MGM were undisclosed, and were vaguely understood by Renaissance to be negotiated on a film-by-film basis. The 'deal', in standard Hollywood practice, did however outline Roven's producing fees and profit position. Roven, rather than insisting that MGM had an automatic first look at *Good Omens*, openly acknowledged that he did not own the project. Therefore, it was agreed that whichever party brought a North American deal to the table was to be entitled to a further 5 per cent fee post the full negative cost of the film being raised.

Thanks to Evans' relationship with Ruth Vitale, then President of Paramount Classics, Renaissance had been approached by Paramount Studios to work more closely on its slate financing. The MDs were invited to a meeting with Paramount President Sherry Lansing and Production chief John Goldwyn during the summer of 2000. Following the 'get-to-know-you' meeting, I picked up the baton, and started to close a first look deal with Paramount Studios through Bill Bernstein's Business Affairs office, supported by my Director of Finance Anne Sheehan. (The deal was not to cover any submissions to Paramount Classics, the specialist arm of the studio.) The agreement was to cover projects owned and submitted by Renaissance, whereby on presentation of script, director, budget and two lead actors, Paramount would have the option to co-finance a third of the film's budget. The studio would take North America, Australasia and South Africa (The Territory), and charge a 25 per cent distribution fee across all income streams (e.g. theatrical, video, ancillaries and television). The deal's structure was particularly attractive in terms of potential video and DVD income from Renaissance's perspective. The studio would fund the P&A, to be determined on a film-by-film basis, which was to be recouped off the top. Post full recoupment from the Territory, Paramount was to take a 2/3–1/3 split from overages; and keep the Territory in perpetuity. Three rejections in a row by Paramount would lead to the deal being cancelled at Renaissance's election.

Paramount's original intention had been to have an option over English-speaking territories, but Renaissance had successfully kept the UK out of the deal, hence protecting its output deal with Entertainment Film Distributors in the UK. On paper, the deal looked fair. In reality, what it represented was "an agreement to agree" rather than any significant commitment from Paramount towards co-financing Renaissance's larger, more commercial projects. And Renaissance was at risk for all development, overhead and pre-production costs.

Roven was gracious about the Paramount deal, and was pleased that *Good Omens* was to have two potential North American backers, rather than just MGM. However, before any realistic approach could be made to any studios, financiers and international distributors, the screenplay, budget, locations and star attachments needed to be in place. A 'package' needed to be constructed, which was to require considerable project management, time and money over the coming months.

Screenplay development

The first draft of *Good Omens* came in at more than 170 pages long. It also was delivered in the late autumn of 2000, many months later than anticipated thanks to Gilliam's commitment to *Don Quixote* and subsequent (and understandable) depression following that film's collapse. Delivery would have been even later had it not been for Grisoni's working methods and dedication to the project. The writer had devised

a workable structure with Gilliam, and was able to get a number of pages down, send them to Gilliam, get his notes and comments, rewrite, and then move on to the next section. Once a draft was in place, both of them then reviewed, discussed and refined the screenplay. 'Let me be clear. Terry doesn't actually write anything, but he's right there all the way through the process,' explained Grisoni.

In addition to the length, each page was extremely dense, packed with action, images and detailed effects and touches. (Some months later a senior Fox executive, Tony Safford, explained to me at Cannes that whilst he: "loved the script, every page read like it was costing a million dollars".) While the story's structure was starting to take shape, the multiple characters and density made the read slow and confusing. And whenever the devil and angel were not in the action, the story tended to drag. As Janson pointed out in her notes on the draft, "we miss Crowley and Aziraphale when they aren't on the page, as they are the heart and action of the story".

A development meeting was held, where Renaissance made it clear that the script needed to come down to no more than 120 pages. In Gilliam's directors' contract, it was stated that the film would be no longer than 120 minutes; and that financiers/ producers would have final cut. (The standard industry estimate is that a script page matches around one minute of completed film.) Gilliam paid scant lip service to the length, and was already arguing about favourite scenes and characters that he did not want to lose in the new draft. Grisoni tried to reason with the director during that meeting, recognising that the project was fenced in by practical realities. Extensive notes from Janson were passed on to the writers, suggesting specific cuts and character removals and reductions, many of which Grisoni appreciated. A new draft was embarked upon.

Early concept marketing

When the first draft of *Good Omens* arrived at Renaissance, it was read by the sales and marketing team. Despite the screenplay's length, the company's executives could all see the rich commercial potential. It was agreed with the producers that Renaissance could design a 'concept poster', which would include the name of the project, director, writers and producers. A concept poster makes distributors aware of a project's existence, and acquisition executives start to 'track' its progress and note the imminent arrival of a screenplay to read and provide 'coverage' for their senior management. In the case of *Good Omens*, the book's jacket cover was adapted and a large fiery red poster was designed with gothic black lettering. It was placed within the Renaissance offices at the American Film Market in February 2001 as a way of introducing the project to the market. It was also agreed between the parties that the first draft, under no circumstances, should be circulated to 'buyers' (e.g. distributors and studios) at this stage. Renaissance and the producers were aware of the damage often done in the marketplace when early screenplay drafts, which require considerably more work, are released and read before they are ready. And re-reading screenplays is an unpopular task within the film-buying community.

Between the American Film Market and Cannes 2001, Renaissance made some significant changes in staffing. I took over the international sales team. The shift in senior management made the producers understandably wary of whether Renaissance had the experience and clout to raise significant foreign pre-sales on the film.

Screenplay drafts and the casting process

The second draft materialised some five months after the arrival of the first. More than 30 pages had been cut, with the length now at 137 pages. Whilst decisions had been made about certain scenes to omit, the screenplay was still packed with a wide range of characters, and still 'challenging' to read through without having to go back and check on names and places etc. Roven, however, felt that it had improved considerably, and began to work more closely on the script. He also appreciated Janson's notes, many of which he agreed with. Crowley (the devil) and Aziraphale (the angel) were now much more central and present within the structure. But Renaissance and the producers all agreed that one of the characters (Shadwell, a witch finder) needed to either be cut completely or edited back, as he cluttered the third act; while the role of witch (Anathema Device) needed clarifying and more characterisation. A polish was embarked upon, with the intention that the script would be considerably reduced. A draft needed to ready for casting and distributor-financiers if the project was not to lose momentum. However, what occurred was a 'dance' of a few pages coming out, and certain scenes that Gilliam was keen on, going back in. 'What the experience made me realise was how important it is, when script editing, to make your points really clearly about cuts right from the start,' explained Janson later. 'I should have been stronger'. In fairness, Renaissance's co-MDs should have been more verbal and aggressive if this situation was to have been resolved. The project management team was clearly in fear of falling out with the director.

Gilliam had always been clear that he wanted Johnny Depp to play Crowley. He had become close to the actor during their work on the film *Fear and Loathing In Las Vegas*, and Depp had been a lead character in *Don Quixote*. He had subsequently witnessed the film's collapse at first hand. Unfortunately, the producers and Renaissance were mindful that in 2001, Depp was unable to 'open' a movie. His credits over the previous three years ranged between lower budget independent films to large budget-but-mediocre results. The producers drew up alternative lists, that included George Clooney (who read and liked the script but was too busy to commit); Brad Pitt (with whom Gilliam had fallen out with following a quote in a book regarding *Twelve Monkeys*); Mel Gibson (who was more focused on his own directing career, with The *Passion Of The Christ* on the horizon); and Eddie Murphy. Will Smith was added to Murphy's name on the list, and a debate between the North American and the UK partners about whether it was politically offensive to cast a black person as a devil ensued. The US producer was against; the European project managers didn't see the problem. Neither black star took up the role anyway. *Good Omens*' Crowley role kept coming back to Depp, in part because Gilliam had not personally pushed the script with any other of the above A list stars.

Aziraphale, the angel role, was more straightforward, at least to start with. Robin Williams had worked with Gilliam on *The Fisher King*, and had been pencilled in by the director from day one. Unfortunately, Williams was also going through a difficult period re his relationship to box office performance (although his issues with drugs and depression were unknown to the myself and the producers at this time). Renaissance had hoped that an A list Crowley would solve the problem, but that wasn't forthcoming. The third key role was Anathema, the witch. While Renaissance and the producers felt the role might be able to attract a star such as Cameron Diaz, Gilliam was keen on Kirsten Dunst, who showed great potential to become an A list star, but

had not reached her *Superman* status back in 2001. He met with the actress in Los Angeles, and she was keen to be attached.

A fluctuating budget and rising costs

By now, Renaissance had commissioned a budget. A schedule – essential for any realistic budget to be compiled – was drawn up by the experienced line-producer David Brown. After a number of meetings with Gilliam, Brown produced the first full budget for *Good Omens*. It came in at $93m. $10m was reserved for the two lead roles, at $5m each (fee levels that were nominal rather than established with the actors' agents as agreed); $15m was earmarked for CGI and special effects; and the overall shoot period was to last 18 weeks. The physical and technical demands of the complex and lengthy screenplay were the most important factors re the new 'near-blockbuster' budget. Renaissance was extremely worried at the level of this budget, and the schedule informing it was based on a script that had not been nailed down, making it an unreliable number.

In reaction, Renaissance and the producers focused once again on the screenplay. The new polish brought the screenplay down by a further six pages. Every cut, however, was becoming a personal fight with Gilliam – even when Roven stepped in to take up the cause. Ultimately, the polish removed Shadwell, the witch finder, from the third act. The screenplay was sent out to a shortlist of buyers, including MGM and Paramount. However, rather than commission a new schedule and budget, the producers and Renaissance told Gilliam that they could raise a maximum of $60m for this film, and that he would have to work within that parameter. Whilst the budget, through considerable skill on the part of Brown, was reduced downwards, at no point was a full, completed schedule and budget completed to fit the nominal $60m cap.

Part of the problem facing the project was that different elements required for a film of this size were not coming together at the same time. The script was still not at 120 pages; the cast was unofficially attached to the project rather than formally signed up; and despite different budgets being compiled around a) a UK shoot; b) a UK and Isle of Man shoot; c) an Australian shoot; d) a German shoot; e) an Eastern European shoot; Gilliam was clear that he wanted the UK only. This was communicated only after a trip to Studio Babelsberg in Berlin, and after Marc Samuelson and David Brown did a research trip to the Isle of Man. The Isle of Man was very clearly not to the directors' satisfaction. Considerable sums of money were now being spent in addition to Renaissance's development costs. For example, all Roven's travel costs, phone bills, trips to London etc., were being charged back to Renaissance. (Renaissance even had an invoice for $25 from Roven's office many months later when meeting me in LA at the Four Seasons hotel for breakfast, where he offered to clear in cash … Roven said to forget it, "but I'm really glad my guys are right on the case".) Heads of departments and a casting director were being approached and attached. Gilliam and Brown were working out of Radical Media's Soho offices – given gratis thanks to Gilliam and the director's work with the company. But the offices and momentum gave the producers and director the feeling that the film was about to happen.

Certain heads were not working out. Production Designer Assheton Gorton, for example, could never 'get' the Apocalypse as a concept let alone design it, was working in a very dated way though nobody would really come out and say it. Overall, from

one executive assistant's perspective, all the people who were brought in at this unofficial prep stage were half-hearted about it because the film wasn't cast or financed and they therefore didn't throw themselves into it.

Pre-selling *Good Omens*

Despite interest in the project from major foreign distributors, it became clear to me from my experience at Cannes 2001 that for a project of this size, foreign distributors would only believe that it was financed and worth stepping up for once a North American studio was attached. Roven agreed with him that a North American deal was essential if the film was to proceed. He too was mindful of his ability to bring his foreign partners to the table without the US secured. The finance plan for *Good Omens* was still vague at this point. The general strategy was as follows: If 25–33 per cent of the finance could be raised from North America, it was presumed that five major foreign territories could be pre-sold. Say, France, Italy, Germany, Japan and Australasia – bringing in by Renaissance's estimate around 40 per cent of the budget (or $25m, see below). In addition, if the film were to shoot in the UK a tax deal would be done, bringing in a further 8 per cent approximately. On the back of this level of pre-sales, a bank gap would be made to work if there was enough value in the remaining territories to provide 200 per cent coverage on the gap loan. So the plan looked in theory like this:

i) There was some debate over the amount possible to raise in the UK through tax deals. This figure was reached on the conservative assumption of any break allowable to a film of more than £15m. A more aggressive deal may have been possible, but for the purposes of the finance plan, this was the figure assumed.
ii) Territories left included: Spain, Scandinavia, Russia/Eastern Europe, Latin America, South Korea, and South East Asia.

The two MDs and Roven went out to Paramount and MGM respectively at the same time. Renaissance had developed a relationship with a senior Paramount production executive, who in turn pressured Rob Friedman, Executive Vice President of Marketing and Distribution, to consider the project under the terms of the Renaissance-Paramount deal. Friedman did not like the script. In particular, he did not like the ending, which he found offensive (Adam's young friends are killed in a variety of gory ways when the Four Horsemen of the Apocalypse arrive on earth). "You can't do that to children on a big screen", explained Friedman. "Definitely not on a project costing this much".

"Would you meet Terry and tell him that?" I asked Friedman.

"Yes, but only on the grounds that Paramount is not making this movie at this point. I don't want a misunderstanding where we fall out with Terry", said Friedman.

Over at MGM, Roven engaged the studio's head of production in the project. A new budget was requested that bore a resemblance to the $60m pitch, but before that was drawn up, MGM's president Alex Yemenidjian took a view on the project. 'Unfortunately, it's just not his kind of thing. He doesn't get it,' explained Roven. 'They're passing'.

Most other studios had politely 'passed' – always with the proviso that they would 'love to see the film when completed' – but Evans had a strong relationship with Fox

chief Tom Rothman. The two had become friends while Rothman was head of production at Samuel Goldwyn, and *Much Ado About Nothing* was one of the successful fruits of their work together. Evans managed to get Rothman and his partner, Jim Giannopoulos, to read the screenplay and take a meeting with Gilliam, Roven, Evans and myself. The meeting took place a few weeks after 9/11 – an event that Roven viewed as a world political watershed. 'The world will never be the same again,' Roven stated darkly. The Europeans working on *Good Omens* took a much more relaxed view. Surely there couldn't be a connection between the World Trade Center bombings and *Good Omens*, so we all thought.

The pitch seemed to be going well in Rothman's airy office on the Fox lot. Forty minutes into the meeting, Gilliam took out a large artists' pad. As he flipped each page, Rothman and Giannopoulos took an increasing interest in the wild and scary images, beautifully drawn by Gilliam's hand. Then the page turned again: an image that none of the producers has seen loomed off the page. Two huge towers, close to each other, with angels flying from one, while devils and evil beings scampered around the other, filled the room. Rothman suppressed a gasp, and appeared to pale as he sunk back in his chair. Fox were going to pass. No North American deal was available to *Good Omens* in the autumn of 2001. Shortly after the Fox meeting, Evans and I met with Roven at his offices on Sunset Boulevard. Roven was unequivocal: "Guys, we're finished. My advice is that you absolutely have to close this film down. We're dead."

Lessons from a painful post-mortem

This case study demonstrates a perplexing level of multiple 'blind spots' and 'escalating commitment' concerns [Ibid., Finney 2014]. As an in-depth case study, *Good Omens* serves to highlight how different environments and cultures also impact on cognitive bias, and how so-called 'collaborative relationships' can cause damage when they compete rather than a team's strategic framework and actions to critical third parties, such as Hollywood studios. Renaissance failed to recognise the Hollywood negative 'correlation' between a 'difficult' and wilful director next to committing upfront financial resources to acquiring, developing, producing and selling the film to worldwide distributors. Creative management skills were clearly lacking given the way the producers and Renaissance – led by me – handled the project management process right across the film value chain: the team failed to drive the development process and achieve a screenplay running at the right length and story structure; was pushed (once again) into setting the wrong level of budget, failed to work coherently with its US production counterpart and misread the value of the film's commercial elements next to the perplexing creative material.

Managing high-profile Hollywood talent (from a UK-based perspective) highlights both the danger of 'selective perception', but also in this instance also raises the temptation to underestimate uncertainty. The project management team, led by myself, felt significant pressure to keep the talent happy and on track, and made overt efforts to reduce anxiety – while continuing to underestimate future uncertainty. Despite the perceived value of the talent elements, the case proves that if a package has weak links (in this case the screenplay, director's attitude and wrong production team), the project will fail to navigate the early value chain and move into production.

References

[1] M. Stibbe, www.Stibbe.net/Writing/Games_Industry/Managing_Creativity.htm.

[2] M. Iansiti and R. Levien, 'Strategy as Ecology', *Harvard Business Review*, 82(3), 2004, pp. 68–78, cited in H. Mintzberg, B. Ahlstrand and J. Lampel, *Strategy Safari*, London: Prentice Hall, 2nd edn, 2009, p. 127.

[3] P. Bloore, 'The Creative Producer: Leading and Managing Creative People', University of East Anglia, Lecture Notes 2008, delivered for the South West Screen Producer Training Cohort in March 2008.

[4] R. Goffee and G. Jones, 'Leading Clever People', *Harvard Business Review*, 85(3), 2007, pp. 72–79.

[5] T. Amabile, *The Social Psychology of Creativity*, New York: Springer-Verlag, 1983, p. 91.

[6] M. Stibbe, www.Stibbe.net/Writing/Games_Industry/Managing_Creativity.htm.

[7] For example, Bloore (P. Bloore, op. cit.) cites as a case study the company Sixteen Films, where director Ken Loach and producer Rebecca O'Brien work with long-term collaborator and writer Paul Laverty on an equal footing; indeed, he has a position in their company. The director and producer (along with long-standing script consultant Roger Smith) spend long periods of time with Laverty during the development period. The key motivator and contributor to success is not necessarily the amount spent on Laverty's fees, but the amount of time spent with him as the writer. Bloore points out that it is vital to maintain trust and regular channels of communication within the creative triangle of the writer, director and producer, in order to develop and preserve the central vision of the project.

[8] Note: Both case studies are adapted for A. Finney's PhD Thesis (2014).

27 "To infinity and beyond"

The Pixar case study

Not everyone can become a great artist, but a great artist can come from anywhere.

(*Ratatouille*)

I never look back darling. It distracts from the now.

(Edna "E" Mode, *The Incredibles*)

Over the past thirty years, much has changed in the world of filmmaking. Indeed, in recent years that rate of change has been accelerating. The rapid advances in digital production and delivery technology, the advent and impact of social media, and changing population demographics across the 'global North' and 'global South' have been significant factors for film and content production companies, as has the rise of the Chinese home market and South East Asian exportable content. Managing the speed of change is a constant challenge for project managers and leaders. A gap has consistently been cited by film-industry research between cognitive bias and its impact on project management [1].

Over the same thirty-year period in question, there is one globally significant creative company that has successfully managed change, harnessed digital technology to its enduring advantage, and built a creative powerhouse that has consistently captured cultural, critical and commercial value. That same company has even managed to retain its creative core and brand, despite being swallowed up by the Walt Disney Company in 2006. Few film brands can claim universal recognition on a global scale. Connected to Hollywood, yet physically situated apart, and concurrently responsible for leading the Disney's animation turnaround (*Tangled, Frozen etc.*) during the mid-2010s, Pixar Animation Studios demands attention and analysis.

Frozen overtook *Toy Story 3* as the largest grossing animation film in history, passing $1.2bn worldwide in May 2014. It should be noted that at that time Ed Catmull was president of Disney Animation and John Lasseter was co-founder head (before resigning in 2018 after an internal investigation into his physical behaviour with staff).[1] Sitting alongside the extensive empirical proof of Pixar's commercial and creative successes, lies a central link to the high level of cognitive awareness within Pixar's management team that is raised at the heart of my PhD thesis awarded in late 2014. A series of critical questions are raised, including: how can project managers 'see' effectively in order to capture value and learn? And how can they best continuously apply that learning? How can their leadership and understanding of cognitive bias

DOI: 10.4324/9781003205753-30

impact on the project management process and the overall culture of an organisation? How can managers think actively and progressively about the challenge of what is 'obscured from view' [2] when managing projects and leading creative organisations? And can we find evidence that Pixar's leadership team's way of thinking and acting on the above challenges has creative a positive, reflexive relationship to the company's project management's skills and consistent capture of value?

In Catmull's seminal book *Creativity Inc.* (2014) [2], the Pixar co-founder and president brings together his previous published work, including articles in the *Harvard Business Review*, and curates his observations and lessons learned over the past three decades. His work delves deeply into the key factors that he considers helped build, shape and ultimately sustain Pixar Animation Studio's creative culture. Catmull's transparent approach to cognitive bias and his extensive citing of actions and tools that have helped overcome cognitive challenges are evidenced in detail. Catmull's self-described 'candour' [2] has also served to 'override hierarchy', manage both upwards and downwards, and minimalize the potentially toxic influence of Pixar owner Steve Jobs. This behaviour was also critical in identifying the cognitive 'limits of perception' in people, projects, managers, and indeed in his challenging of his own leadership powers. The results, mapped over the last nearly 40 years at the time of this book's publication, provide us with a positive insight into mental models and cognitive bias.

The Pixar leadership has developed cognitive techniques to deal with and solve a range of crisis management issues. Catmull openly acknowledges the danger presented by 'collective wisdoms' and a range of biases [2]. Here we can finally cite a sustained, evidenced methodology backed up by tangible and continuing results. Catmull offers both findings and solutions that directly address and consistently help to overcome the negative impact of cognitive bias. The evidence exists at a significant level, suggesting that the Cognitive School of Strategy (alongside other connected schools, including Entrepreneur and Learning, for example), should consider his work in relation to their future research.

Learning from failure

Success was not immediate. The value of looking back as well as forwards is that we are reminded of what in fact went wrong for Pixar in its first decade (from 1986 to 1996), and what moments and problems might have brought the company to a halt, and why, Catmull explains, for example, how 'production managers', who play a key part of the animation production process, had been alienated during the making of Pixar's first computer-animated film *Toy Story*. Despite his mantra that Pixar operated a level playing field, the creative artists and technical staff had little respect for production managers and their tendencies to 'over-controlling' and 'micromanagement' [3]. On further enquiry, Catmull discovered that the production managers did not want to work on Pixar's next movie, *A Bug's Life*, presenting the leader with a potential resource (and management reputation) crisis. In spite of the success of *Toy Story*, Catmull was astonished to discover in his post-mortem that the 'good stuff was hiding the bad stuff':

> I realised that this was something I needed to look out for: when downsides coexist with upsides, as they often do, people are reluctant to explore what's bugging

them, for fear of being labelled complainers. I also realized that this kind of thing, if left unaddressed, could fester and destroy Pixar. For me, this discovery was bracing. Being on the lookout for problems, I realized, was not the same as seeing problems. [4]

Production managers are people who keep track of the endless details that ensure a movie is delivered on time and on budget. They monitor the progress of the crew; they keep track of thousands of shots; they evaluate how resources are being used ... they do something essential for a company ... They manage people and safeguard the process [5]. The threat of damage and failure had triggered Catmull to think about the problem and respond to it. He subsequently brought the company together and explained that "anyone should be able to talk to anyone else, at any level, at any time, without fear of reprimand". It was to become one of Pixar's three defining principles (see below).

Pixar's enduring success appears to be rooted in the company's creative management philosophy. Another early example of this 'reflective' leadership style emerged following a story crisis during the making of *Toy Story*. To solve the crisis, a group of 'problem solvers' emerged organically, and together the five members worked to dissect scenes that were falling flat and analysed the emotional beats of the movie. The organic team-approach had no decision-making power over the film's producer and director. They existed to support, rather than to super-manage the project's leaders. The story support group was to develop into Pixar's 'Braintrust', and it was to have a significant impact on both Pixar's (and later Disney's) approach to screenplay development and storytelling. (Catmull also ensured that the Pixar's then-owner Steve Jobs agreed to not be part of the Braintrust team, demonstrating his ability to manage upwards and protect his team) [6].

The *Toy Story 2* crisis

One of the clearest examples of "learning from failure" emerged during the company's experience of making *Toy Story 2*, initially assumed by Disney to be a straight-to-DVD title rather than a theatrical release, an assumption the Pixar team were determined to alter. Although the film on release finally became a critical and commercial success, it was also a "defining moment" for Pixar in its first phase of filmmaking. "It taught us an important lesson about the primacy of people over ideas: If you give a good idea to a mediocre team, they will screw it up; if you give a mediocre idea to a great team, they will either fix it or throw it away and come up with something that works", explained Catmull [7].

> *Toy Story 2* also taught us another important lesson: There has to be one quality bar for every film we produce. Everyone working at the studio at the time made tremendous personal sacrifices to fix *Toy Story 2*. We shut down all the other productions. We asked crew to work inhumane hours, and lots of people suffered from repetitive strain injuries. But by rejecting mediocrity at great pain and personal sacrifice, we made a loud statement as a community that it was unacceptable to produce some good films and some mediocre films ... everything we touch needs to be excellent.

The necessity of failure and the learning process

The evidence underlines Pixar's leadership 'consistency', applied principles and its decision-making process, demonstrating a clear thinking modus operandi at all times, and not just when managers consider that its projects are underwater and that the Pixar brand may therefore be threatened. Such behaviour and decision-making processes supports the Greek academic Makridakis's suggested solutions to bias [1], although the Braintrust process, for example, centres around support to enable project managers to reach the right decision themselves and not to override them. Catmull has explained that the existence of "failure isn't a necessary evil. In fact, it isn't evil at all. It is a necessary consequence of doing something new" [2].

> Candour could not be more crucial to our creative process. Why? Because early on, all of our movies suck. That's a blunt assessment, I know, but I choose that phrasing because saying it in a softer way fails to convey how bad the first versions really are. I'm not trying to be modest or self-effacing. Pixar films are not good at first, and our job is to make them so – to go, as I say, 'from suck to not-suck' [2].

A flexible, rather than controlling approach to talent

However, Pixar has also demonstrated considerable flexibility in its harnessing of talent and the return of that talent to the hub. It openly acknowledges the footloose and freelance nature of film industry project-driven landscape. Director Andrew Stanton (*Toy Story, Finding Nemo, WALL-E*) has returned to the company after some years working elsewhere, demonstrating Pixar's interest in regeneration and capturing outside experience, which, in turn, is subsequently encouraged to return to the fold.

Failure was also threatening the Disney dream factory after a long list of mediocre titles up to *Frozen*. The evidence exists to demonstrate that Disney Animation (*Frozen, Tangled*), after a tough couple of initial years, has been resurgent post-2006. On its release by Disney, *Frozen* was hailed both with rave critical reviews and record-breaking box office, in much the same way as Pixar's films have regularly been received.

Although the studio's competition has been doing well in a burgeoning animation space, it still took rivals such as Dreamworks Animation to release two movies a year to hit the same revenue numbers that Pixar does with one. By the end of 2019, the company had taken gross revenues of more than $14 billon at the global box office, leaving aside all ancillary returns from DVDs, VOD, television, and merchandising (the original *Cars* movie took more than $5bn alone from merchandising). Some six years on from this thesis case study, and Pixar had produced 24 feature films, with 15 films ranking in the 50 highest-grossing animated films of all time.

Despite criticisms of doing too many sequels, their present slate (2014 onwards) appears to signal a return to originals (outside of *Finding Dory*, the sequel to *Finding Nemo*): in the summer of 2015 the studio released the Pete Docter-helmed *Inside Out*, set largely inside the head of a young girl. This was followed in the same year by the well-received *The Good Dinosaur*, based on an alternate take on history in which dinosaurs had not become extinct.

Shifting to more recent films, one stands out in its high level of creative risk-taking. Pete Docter's *Soul* is an emotionally demanding tale about jazz musician and African

American Joe, a middle-aged New Yorker who considers his true purpose in life when he is confronted with death and decides to mentor a yet-to-be born soul. *Soul* was the first Pixar film to have a black protagonist, and the first that did not premier in a cinema theatre. "It's a heartbreaker", Docter said "It's a movie we made specifically to be on the big screen, so it felt tragic". Instead of a theatre, the film went into the fast-expanding Disney Plus subscription juggernaut. At that time, Pixar had a further eight films in advanced development/early prep, "like planes waiting on the runway. If ours stops, everyone else has to wait" [8].Docter, who, as well as directing, has been the Chief Creative Officer of the Disney-owned company since the departure of Lasseter in 2018. Underlining the critical role of people and the way Pixar listens to its diverse talent, Docter pointed out:

> We have all these new voices and perspectives of people who have never directed before, and that's going to bring a lot more diversity and surprise to the films we're making. My job is to make sure that everything we do is as good as it possibly can be ... It's a really cool blend of old-school folks who've made a couple of these and a bunch of new people who don't know what they don't know ... I've learned to shut up for a little while, let them explore it, and see what it leads to [8].

Pixar's 'vision' and leadership principles

Pixar's way of 'seeing' individuals, teams, projects and its' management's deliberate linkage between technology and creativity are significant for the Cognitive School of Strategy. Pixar has undertaken and implemented a cognitive-driven, visionary theory and set of tools that have managed and led a 'people-driven' organisation business to global effect and impact.

Putting well-considered mantras into successful action is the gold dust of managers. "Clear values, constant communication, routine post-mortems and the regular injection of outsiders who will challenge the status quo aren't enough. Strong leadership is also essential – to make sure that people don't pay lip service to the values, tune out the communications, game the processes, and automatically discount newcomer's observations and suggestions" [9]. Catmull stands behind the belief that the creative power in a film has to reside with the film's creative leadership. He argues that whilst this may seem obvious, it is not true of many companies in the movie industry: "We believe that creative vision propelling each movie comes from one or two people and not from either corporate executives or a development department. To emphasise that the creative vision is what matters most, we say that we are 'filmmaker led'. There are really two leaders: the director and the producer. They form a strong partnership. They not only strive to make a great movie but also operate within time, budget and people constraints" [9]

The organization's operating principles are intriguing, and far-reaching. The three key Pixar principles, with commentary from Catmull below each mantra, are:

1. Everyone must have the freedom to communicate with anyone.
 This means recognising that the decision-making hierarchy and communication structure are two different things. Members of any department should be able to approach anyone in any department to solve problems without having to go

through the "proper channels". It also means that managers need to learn that they don't always have to be the first to know about something going on in their realm, and it's OK to walk into a meeting and be surprised. The impulse to tightly control the process is understandable given the complex nature of moviemaking, but problems are almost by definition unforeseen. The most efficient way to deal with numerous problems is to trust people to work out the difficulties directly with each other without having to check for permission'.

2. It must be safe for everyone to offer ideas.

 We're constantly showing works in progress internally. We try to stagger who goes to which viewing to ensure that there are always fresh eyes, and everyone in the company, regardless of discipline or position, gets to go at some point. We make a concerted effort to make it safe to criticise by inviting everyone attending these showings to e-mail notes to creative leaders that detail what they liked and didn't like and explain why.

3. We must stay close to innovations happening in the academic community.

 We strongly encourage our technical artists to publish their research and participate in industry conferences. Publishing may give away ideas, but it keeps us connected with the academic community. This connection is worth far more than any ideas we may have revealed: It helps us attract exceptional talent and reinforces the belief throughout the company that people are more important than ideas. We try to break down the walls between disciplines in other ways as well. One is a collection of in-house courses we offer, which we call Pixar University. It is responsible for training and cross-training people as they develop in their careers. [9]

The first two principles are rooted in Catmull's lessons learnt, but they are straightforward to comprehend as objectives. The skill displayed by the leadership is to make sure that the above actions and associated values become an enduring part of the company culture and not 'gamed' out of the processes. The third is more taxing for managers of film companies who tend to fight problems and challenges on a daily basis, 'putting out fires' in the guise of crisis management clearly investigated throughout the case site.

Life-long learning: mantras and action that is believable

Catmull explicitly values education and learning. Pixar runs a collection of in-house courses, which the company calls 'Pixar University'. It is responsible for training and cross-training people as they develop in their careers. But it also offers an array of optional classes – many of which Catmull has taken – that provide people from different disciplines the opportunity to mix and appreciate what everyone does. And ultimately, in addition to the fusing of technology with art, Pixar is placing learning at the centre of its own talent development pool.

There is a confidence and positivity to the Pixar model, but it is the management that took the lead and set (and has continued to re-set) the tone and core values for the company. Most importantly, the Pixar creative environment enshrines a "team democracy" approach. Attributes encompassing and also going beyond the Pixar model for a creative environment include the following consolidated check list of principles, values and actions:

The Pixar values and principles checklist:

A) General themes:
- A building/office that encourages people to meet, exchange information, and share facilities. No rabbit warrens or sectioned-off offices in gated silos.
- The management's and filmmaker's embodiment of a shared ownership and vision
- "Give a mediocre idea to a great team and they will either fix it or offer you something better." Brilliant people and teams are more important than good project ideas.
- Managing upwards successfully: Steve Jobs was subtly encouraged not to have an office and daily presence at the building. Post the acquisition by Disney the management team pushed to keep Pixar's own brand, identity and culture while encouraging Disney to develop its own.
- People are more important than ideas and form the lifeblood of a film studios' creativity and ability to capture value; therefore, embrace their brilliance rather than being threatened by them.
- Management has enabled those with less experience to have a voice, while promoting mutual respect. Inspiration comes from everywhere.
- Enjoyment and fun remain central to the culture. They promote team-shared experience, communication, confidence, morale and a sense of living in the moment.
- The ability of all managers to hire people who are better than they are.
- No employment contracts have ever been issued at the company. However, sharing of the upside for everyone, and a trust that people believe in the organisation, has helped shape the spirit and tone of the culture. Bonuses are handed out personally by the management, not paid on-line.
- The stimulation of a culture of innovation, including experiments, and pooling technology development, creative development and production management.
- A "No Hero" culture pervades the company. Art and technology are equal.
- The belief in the power of never-ending education at a broad, yet central level: this is enshrined in the promotion of Pixar University.
- Clear creative goals: "We're not going for realistic here ... we're going for believable."
- The constant desire to balance commercial demands and creativity.

B) Pixar: Cognitive-orientated actions and themes
- An ability to learn from mistakes has been fostered – promoted by tolerance and positive introspection.
- Post-mortems: regular and committed feedback that works as long as the filmmakers are listening and continue to command the respect of their team
- The acknowledgement and acceptance that failure is part of the journey that defines project management. Failure is built in to the culture as a tool for learning and improving (unless the director loses the faith of the film's crew).
- Outsiders and contrarians are encouraged into the project management process, not excluded or merely tolerated.
- The setting up of forums and communication/exchange of views rituals that are respected by all attendees.

- Considered, constant and timely feedback is a backbone to the project management experience and is not allowed to slip or simply paid lip-service to.
- Leadership that recognises the need to see beyond the immediate, the superficial, and to continue to listen to people at all levels of the organization.
- Leadership needs to exercise candour, while finding out the reasons why others regularly are not open and honest on an ongoing basis in a work environment.
- Self-assessment tools must be developed that seek to discover what is real.
- Sharing problems and embracing uncertainty and change is essential. 'Messaging' in an effort to downplay challenges and crises makes people less trusting of leaders.
- First, conclusions are typically wrong, and successful outcomes do not mean that the process was right all along or all the time.
- Preventing errors does not mean a manager has fixed everything, and the cost of prevention may well be more damaging than fixing them.
- Uncovering what is unseen and understanding its nature is central to successful leadership and project management.
- Share and show early work and encourage ongoing feedback. Defensive, secretive habits stop people being able to solve the problems.
- Imposing limits is important in project management because it will tend to encourage and stimulate a creative response. Discomfort and extreme problems can help find solutions and make people think differently.

Is it because of animation?

On reflection and following more than four decades of outstanding and consistent achievements, the question has been raised with me by classes (most notably, MBA students at Judge Business School, Cambridge University), about whether the production of animation, as opposed to live action, has a role to play in the enduring creative and commercial story of Pixar's success. It's an intriguing challenge, but one that instinctively I would answer by reverting to the script, the script, the script. Pixar understands story first, centre and last in the hugely demanding process of making compelling, emotionally authentic films. Animation is a creatively complex and highly technical means to an end: helping tell a great story that plays well to children, teens and adults alike – yet allowing each of them to take something different away from the experience.

Awards box [10]

The studio has earned 23 Academy Awards, 10 Golden Globe Awards, and 11 Grammy Awards, along with numerous other awards and acknowledgments. Many of Pixar's films have been nominated for the Academy Award for Best Animated Feature, since its inauguration in 2001, with eleven winners: *Finding Nemo* (2003), *The Incredibles* (2004), *Ratatouille* (2007), *WALL-E* (2008), *Up* (2009), *Toy Story 3* (2010), *Brave* (2012), *Inside Out* (2015), *Coco* (2017), *Toy Story 4* (2019), and *Soul* (2020); the four nominated without winning are *Monsters, Inc.* (2001), *Cars* (2006), *Incredibles 2* (2018), and *Onward* (2020). *Up* and *Toy Story 3* were also nominated for the more competitive and inclusive Academy Award for Best Picture.

Note

1 See Bob Iger's *A Ride of a Lifetime* (2019) for a clear explanation of what happened with Lasseter's departure from Pixar and Disney.

References

[1] Finney, A., PhD Thesis (2014). See also Makridakis, S. *Forecasting, Planning and Strategy for the 21st Century*. New York: The Free Press, 1990.

[2] Catmull, E., with Wallace, A. *Creativity, Inc.: Overcoming the Unseen Forces That Stand In The Way of True Inspiration*. New York; Bantam, London: Random House, 2014.

[3] Catmull, E., with Wallace, A. *Creativity, Inc.: Overcoming the Unseen Forces That Stand In The Way of True Inspiration*. New York; Bantam, London: Random House, p. 62, 2014.

[4] Catmull, E., with Wallace, A. *Creativity, Inc.: Overcoming the Unseen Forces That Stand In The Way of True Inspiration*. New York; Bantam, London: Random House, p. 63, 2014.

[5] Catmull, E., with Wallace, A. *Creativity, Inc.: Overcoming the Unseen Forces That Stand In The Way of True Inspiration*. New York; Bantam, London: Random House, p. 61, 2014.

[6] Catmull, E., with Wallace, A. *Creativity, Inc.: Overcoming the Unseen Forces That Stand In The Way of True Inspiration*. New York; Bantam, London: Random House, pp. 63–64, 2014.

[7] Catmull, E., with Wallace, A. *Creativity, Inc.: Overcoming the Unseen Forces That Stand In The Way of True Inspiration*. New York; Bantam, London: Random House, p. 60, 2014.

[8] Financial Times, Pixar's Bright Spark, 19/12/20, p. 12.

[9] Catmull, Ed, How Pixar Fosters Collective Creativity. *Harvard Business Review*, September 2008.

[10] Wikipedia, *Pixar Animation Studios*.

28 The entrepreneur

Interview with Simon Franks, Redbus Group

> In business, many people can have a great idea, do something well and make money once. Sometimes you just have the right idea at the right time. But good business people have something innate and that allows them to make money again and again. Curiosity is what allows you to be a serial entrepreneur, and your understanding of cycles means you know there's always a time to be a seller and always a time to be a buyer.
>
> (Simon Franks, founder and chairman of Redbus Group)

Simon Franks sold his first business at the tender age of 11. During chilly winter lunch-breaks at his North London school children were forced to play outside. Franks set up a business selling chicken soup. Aided by a teacher who would bring him boiling water, he would fill cuppa soups and sell them at a hefty margin. A busy trade ensued, to the point of such success that a group of other kids bought the 'business' from him. Some 20 years later, Franks sold 51 per cent of Redbus Distribution, first to Helkon for $23m, and then the same company again four years later, to Lionsgate for $35m in cash plus $7m of stock. This case study, from an interview with the author, examines Franks' entrepreneurial ride with Redbus Film Distribution.

Simon Franks has a thing about playing games. He likes the self-discipline because he knows deep down he is not really a very disciplined human being. Left to his own devices or nature for that matter, and he will fail to do the things he needs to do on time and on schedule. Wasting time in his book is a negative: life is short, and why feel the guilt that goes with laziness?

> One of the first things you find out about setting up business is that no one calls you back because you're not relevant yet to their livelihood. I understand that. They don't need you. They don't see how you can help them along their journey, so your phone doesn't ring. When you call people they often don't take your call and you get into this funk: get out of bed, get showered, get changed, walk into my office (i.e. the spare bedroom), remove the laundry that my girlfriend has dumped there the night before, and go right through the list of things to do. I'd do all those things and it'd be ten past ten and I'm finished. You have to be very careful what you do next, between ten past ten and six o'clock, whenever it is you finish, as it's critical to the success of your business. I had a time between 2.30 and 4.30 which was sacrosanct. It was the time when I played soccer on my Playstation. By doing this I didn't feel I was wasting time but instead enjoying a scheduled break.

DOI: 10.4324/9781003205753-31

Many of my friends would laugh and say 'he doesn't have a job, he just sits at home playing Playstation', and to an extent they were right, but there was a method to that madness. And I remember thinking that I would know when the business was getting off the ground because I would have to make appointments in my Playstation time. And that was a very significant moment, some six-to-nine months in. I actually realized that there was no purpose anymore to that game time.

Franks had always told himself that he would go to work in the City purely to make money. He came from 'quite a modest background', and he was committed to starting up his own business once he had made some seed money. He worked in the City on a five-year plan, after which he had paid off his mortgage and had around £200,000 spare to invest.

It's a lot of money for a 26 year old but it's not millions. And with that I looked around and I thought, 'What business should I turn my attentions to? What are the parameters for me?' One was: it has to be something interesting. And secondly, it had to be a serious challenge. The odds needed to be stacked against me. For in those situations the risk–reward equation is often positive and you are most able to leverage your efforts and skill. I like those kinds of situations...

Switching from a production fund to a distribution plan

One of the first people Simon Franks met in the film business was a UK producer, Richard Holmes, who had just completed a film called *Shooting Fish*. "The project seems to be going great and yet I'm not making any money", Holmes complained to Franks. "The distributors are making all the money." Franks listened carefully and, given how smart he thought the producer was, decided to ditch his plans to raise a production fund, convincing himself that "distribution is the business I'm interested in".

Shifting focus from a production fund to distribution allowed Franks to get higher up the film business revenue stream. But he was still perplexed by the specific vagaries of the film business.

Even in distribution it can be very scary – besides the cost of acquiring the rights to films, you have to cover a large overhead. In essence the overhead represents the cost of the group of resources – people ready to take finished product A and put it into the shops, effectively. In other consumer-focused businesses you see your design, you see your prototype, you push a button and in two months' time you're selling it. You know what you're going to be getting, you know when you're going to be getting it and you know what your marketplace is. But you don't know those things when you acquire the rights to a new film. Often you're going to have a terrible film come through which means not only have you lost money in what you've bought, but your resource is waiting around because they have nothing to do. Why? Because the product's not good enough and you're not going to release it. Though sometimes you have to accept that it's bad and then flog the dead horse anyway.

So what I said when I entered the business was two things: One, the kind of people who in the past had been running film businesses in the UK were people who wanted to be in the creative part of the industry. Now, although film is my passion – I see many films every week and have thousands of DVDs, a cinema in my home etc. – this had nothing to do with me being in the film business. What we looked for, firstly, was to avoid the wrong people in the wrong place who couldn't be unemotional and have perspective. The second thing was that people thought film was utterly random, and so serious UK business people shunned it. No one had really sat down and said, okay, can you model films? Can you build a process in a risk-adjusted way as you can do in other businesses? And so I built a very complicated spreadsheet which tried to model returns. We used to model things by budget sizes, by very developed strictly defined genres and certain actors that had certain values that were revenue drivers. Very often the revenue drivers were not what would make a film a theatrical success. Some films are more likely to do well theatrically but they don't do so well on DVD and they don't do well on TV and hence, through that matrix, you come through to a few types of films that are lower risk. That's what we focused on. Our model showed the best risk–reward situations to be in horror and then teen comedy. The third was British indie films, but I'm talking for the general international markets, and that's where we focused. Because if you work on the presumption that most films that we were going to acquire were going to be poor, then I'd rather have a poor horror film than a poor drama, because you'll make zero from a poor drama. TV and DVD sales for poor dramas are so low that they are meaningless financially.

For Franks, it was the buoyant video market that attracted him as a revenue stream that threw off enough cash to potentially 'manage' some of the inherent risks.

The only people I could see making money were doing so thanks to the video market. And I started to think, there's a lot of money in this business if you do it right. In the City I was an arbitrageur, doing debt restructuring and working out the relative values between X and Y. So when I started to look at film rights I wondered why no one valued them like music rights? So the first thing I did was to go to all these independent producers and buy their rights. But as it turned out, instead of going to say, ten producers and having ten films each, each UK producer's got one film and they can't sell you that because they've given away all the rights in making the film, so I'm thinking: "Hell, this is going to take me years to get ten films together just buying rights."

Distribution's business model attracted Franks. The portfolio approach – allowing for around 12–15 films a year to be exploited – in contrast to one or two a year via production, was much more attractive.

Not because I thought distribution was necessarily better than production but I do prefer to have a portfolio approach. If you're good at organizational administration – which I think is what I excel at – you can have a disciplined business, keep costs low compared to competitors and be very tight. That way, even in an average year, you can make money.

The early acquisition strategy

According to Franks, picking up product was a lot easier in the early to mid-1990s than it is today.

> In my day there were no big alliances but now many of the big product sellers are aligned and not selling their products to third parties. Lionsgate's product is gone, they were one of the biggest providers, Summit's product has gone, they were another of the biggest providers, the Miramax product has gone, the New Line Deal has gone … There's almost no product around, so when something does come around the price rate is astronomical, because everyone needs it. Unless you're one of the distributors aligned with one of those product providers, you are in trouble.

The first Redbus UK acquisition was *The Tichborne Claimant*. A large screening was held with many distributors attending, and the UK asking price was a multiple of millions at the start of the process. Franks worked the producer over, bringing the numbers down, but it remained seven figures. Then his partner, Zygi Kamasa, got involved in the process.

> I remember Zygi going to see him, when we were first talking about starting up and the producer said: "Look, I'll be honest with you, I've had some knocks, obviously, I'll do the UK, on its own, for one and a half million." Zygi's response was a simple: "How can we afford that, it's so much for this kind of film?" A year went by, and the company was established by this stage. A call came in from the producer, explaining that he's 'desperate to do a deal for half a million'. Zygi, who was a brilliant negotiator, probably the best I've ever met, and I went to see him. He just sat there very quietly and I was shocked when Zygi got it down to single digits. Zygi was looking at me, and I was trying not to giggle, as I get very embarrassed in these situations. He bought our first film for seven grand…

The first thing the producer asked was whether Redbus was going to release the film theatrically? "Absolutely", said Franks, who explained that "Martin Sorrell unknowingly had ('sort of') financed Redbus because WPP had provided them with a large credit line for advertising spend." Franks had £100,000–£200,000 in the bank.

> If any of those early films had failed we'd have been out of business pretty quickly and wouldn't have been able to pay them back I guess. But it didn't and you know what, they must have made a good profit out of us over the years. Last year we spent over twelve million pounds with them. Fortunately their faith in us has been repaid, thank god. The producer didn't really ask detailed questions, so we guaranteed a theatrical release, but of course we could do that on one screen. In the end we did it on just under 20 screens.

Redbus released *The Tichborne Claimant*, and it grossed a very modest £150,000 at the UK box office. Redbus, on the back of a very strong period story and decent cast – perfect for TV, cut an impressive trailer. So when the BBC offered around £70,000 for it, they said "Great, we'll come back to you". Then a call came in from the office of

the chief executive of Channel 4 asking if the film were still available, and that a buyer at Channel 4 will be in touch. "So this is great fun, an introduction to someone we didn't even know, saying that they had to have the film!", Franks explained that they had a deal with the BBC.

'Is it signed?' No, but 'we're a young company, so it's not our place to be pissing people off'. 'Well let me tell you the situation: the chief executive of Channel 4 was out last night and he and his wife went to see your film, which they've fallen in love with and he has to have it. He's promised his wife'.

Channel 4 offered £120,000 for the film.

So what could Redbus do? Bid the two channels up? Go with the BBC, who had been decent in the first place? Take the higher offer? Franks and Kamasa went back to the BBC and told them exactly what had happened. The BBC took some time to think about it, then came back and said: "If you promise to sign here, then we'll match what Channel 4 has offered." Franks is sure that Channel 4 would have paid more if given the chance, but

now that we were in profit on our first film … we dealt with Channel 4, and sat down with them, and explained exactly why we couldn't sell to them. We wish we could but it would be wrong. And you know what? The head of film said, "I want you to know that a) I didn't really want the film anyway, and b) I really respect you for coming to see us and being honest about it."

As a result of Redbus' experience on *The Tichborne Claimant*, the executives got to know all the TV buyers and they got on well. Franks even took to making it his policy to sit next to the BBC's chief film buyer, Steve Jenkins.

He's got an encyclopedic knowledge of film. And whether I enjoy the film or don't enjoy the film he's the biggest buyer of films in the country; all the other distributors were chatting to each other but instead Zygi and I were gauging his view and reaction to the film we had just seen.

Aggression also played its role in Redbus' rise. *Cabin Fever* was being repped by William Morris agent Cassian Elwes in 2001 at the Toronto Film Festival. Kamasa caught an early flight home, but Franks decided to stay on, intrigued following Redbus' hit film *Jeepers Creepers*.

I moved my flight to the last one possible, but I could still only see 15 minutes. He caught Cassian on his way out: "You know what? It's not bad … it's not bad … what do you want for it?" And he said, "Well, to be honest I was looking for x, y, z." I knew it was made for next to nothing, around $400,000 dollars. I paid $100,000 dollars for UK rights, which was more like a typical straight to video fee. So we signed a deal on the back of a napkin, there and then. Subsequently, the producers tried to get out of the deal (not Elwes). … We've still got the napkin in the safe, with the *Cabin Fever* deal on it. Thank god. It was a huge hit, and we made millions from it. From that point onwards, if I stayed in a film screening, people thought I must hate the movie!

Redbus focused on going to festivals and picking completed films. "Because we didn't have money to lose many times over, and I found it much scarier to pick scripts – finished films was a good way to go at the beginning", explained Franks. "Eventually, as we became bigger, that became impossible. All the really good projects have gone at script stage. And many of the films we did subsequently were acquired at script stage."

The challenge of cash flow

Cash flow management is critical in any business and is a nightmare if you are not on top of it. Especially in the film business. Even the most exceptionally bright people don't seem to be able to understand cash: it's the lifeblood of any business. A good starting point is to take your existing assumptions on cash flow and push all income back by six months and bring up all the bills three months earlier. And then you still should probably halve what you've got. For example, it was a shock to me when the BBC told me "by the way", on *The Tichborne Claimant*, "here's your deal for £120k", and I'm like "in the money", … then they explained: "We're paying you in three-and-a-half years' time". I'm like, "What are you talking about three-and-a-half-years' time, pay the money now. You can't pay in three-and-a half-years' time!" Answer: "We pay when we play."

> No one told me that. I went into distribution knowing nothing about the business. Obviously I tried to bluff it but it caught me out massively. Within a year and a half of us trading, by late 2000, we were technically trading 'off the top'. Now, we did nothing wrong by that because as long as you can explain that you had good reason to believe you'd be fine then that is acceptable. But drawing the line can be complex. There were times when we sat down and discussed whether we could make it. The fact was that we would have gone bust, profitable, which is just crazy. We were owed a fortune yet no one would lend to us. We had proper money by year two, you know, £300k to £400k owed to us by broadcasters, blue chip solid guarantees and Barclays offered us a total facility of £200k and no overdraft on top of that. Then overnight they took the overdraft away around the time of the dotcom bubble.

Franks went to three friends and borrowed £50,000 from each to remain in business. It did not take him long to find Coutts

> not because I was posh, but because their media division is incredibly supportive if they believe in the management of a company. We went from having a £200 grand facility to zero, and then thanks to Coutts to having a £3 million overdraft. And that was the difference between survival and failure.

Franks explained that drawing down on a facility can be a very demanding process. Coutts would use projected estimate on video revenues; so while that would create a positive for the drawdown level, the overall level would be reduced by any committed expenditure for acquisitions.

> It was a tricky thing, especially if the seller was looking for letters of credit [LCs], which is what almost everyone uses in the business. LCs are basically cash,

I mean, you can convince yourself that they are not, but they effectively block up your credit lines. Finance is the heart of any business, and I spent a huge amount of my time managing our cash flow and focusing on planning on when we could do things and we couldn't do things ... and sometimes a film's release would have to be moved.

However, Redbus struck gold not just once, but three times over two key years in 2001 and 2002.

We were very lucky. Over these two incredible years our total investment in terms of advances was around $2.3m in three hit films, and those films probably did $100m in total revenues: *Bend It Like Beckham, Jeepers Creepers* and *The Gift*.

It was the video business, which was huge for all three, which created serious cash inside Redbus. "And that's when everything changes."

Marketing and handling the United Kingdom's exhibition circuit

Dealing with the exhibitors in the United Kingdom as an independent is extremely challenging. As Franks sees it,

cinemas favour Hollywood Studios in their terms of trade and that's just a fact. These very low, basic rentals (Redbus received around 26–28 per cent of each box office ticket) and then very high hit targets, basically means that the good deals go to all the big studios that have all the huge hit potential. I think only once in our history in 12 years we made money at the theatrical stage of a film's life. Independents don't have special terms because we don't have films that excite in advance as much as big-budget studio fare.

In terms of expanding the Redbus brand and clout in the market, Franks was given a golden opportunity at the time PolyGram Filmed Entertainment's UK distribution operation was effectively closed down in 2000 when Universal acquired the company. With the necessary financing, and its first success in the bag, Franks went after Chris Bailey and Carla Smith and their 14-strong distribution and marketing team. It took nine months for Bailey to join up, and the condition was that Redbus had to hire every single person in PolyGram's UK distribution outfit, apart from the top executives, who were moving on. Franks recalls that it was

like, uh, okay, a) I'm still working out of my apartment at the moment, b) I have £200 grand in the bank and your combined wage bill is definitely more than that, so how am I going to finance this? This is what I was thinking in my head, but I told Chris 'done', and I told myself, they are the best marketing team out there, always have been the best, and this is a chance in a lifetime, so go for it. And I did.

The promise of hiring such a large team without knowing necessarily he could afford their contracted periods did worry Franks.

At our company we have a paid ethical advisor, who is someone who is a lay person who specializes in religion, ethics and all this stuff, and it's to him we said, "In this situation can we hire these people? Do I have to declare our financial situation?" If I did declare I didn't have the money they wouldn't have come, and he said that if any of them were in a situation whereby they were turning something else down by coming to us they should be allowed to go, but if they weren't (none of them had anything lined up), then it was okay. And so we said to Chris: "You need to tell everybody that we only want people that have no other current job offers."

Firstly, marketing is about the right people. Secondly, if you are going to be an independent distributor, spend less money buying films and more money marketing them, which is what we did. At the time that was quite novel, although everyone thinks that way now. And with what I believed to be the best marketers in the business we were now ready to take on the market.

The German deal that closed and then opened again

Rebus was finding business extremely tough during its first two years. "We were suffering real cash flow trouble. Not that we weren't profitable, but cash flow-wise we were basically on the edge", recalled Franks.

> I bumped into this guy called Werner Koenig who immediately I loved, and who ran a company called Helkon Media. The German distribution company was basically the same type as my business, except he'd floated it, somehow, and it was suddenly worth $500 million, you know? $500 million on the Neue Market bubble! Helkon only had double our revenues. It was pathetic … but those were the times.

Koenig told Franks: "I've always wanted to have a UK distributor, so why don't I buy your company." To which an astonished Franks replied: "But I've just met you! I'm not selling you my fucking company …" Franks and Koenig went out a few times and they hit it off.

> I really liked him; he was a great character, like a film star in many ways: he was full of charisma and dynamism. He was one of very few people I'd be happily subservient to: Werner was the real deal. Anyone who didn't get him, I didn't get either.

A year later, Franks was at nearing 'death's door' with the business, unable to pay his bills despite strong performances. Franks called Koenig and said: "You know what, maybe I will sell you the business."

The two met at the Four Seasons in Berlin and instead of getting on with a deal, Koenig insisted that they had a two-hour massage. Then they sat down.

> Although I owned the majority of the shares, Zygi and I had talked everything through. We'd agreed that if we could get $3 or $4 million we'd take it, as it would have got us out whole and made a profit for those who had supported us in the

beginning. (We also wanted a big earn out over time going forwards, as we felt that we were on the verge of an exponential growth in profitability if not cash generation.)

Look, you know what? I really like you Simon. I want to be in business with you. I'll make you an offer, I won't negotiate, you take it or you leave it. If you don't take it I'm walking out'. And I start thinking between three or four, please be four, be five even, go on. … He went: "Sixteen million dollars."

Our balance sheet was less than two. And we were 2 years old. Inside I'm dancing with the angels, but externally I went very quiet. Then I said: "No. You know what? Your business is at best double the size of mine and you are worth according to the stock market $500 million dollars and yet you think we're only worth sixteen? That's an insult. Don't treat me that way." I got up to leave. And he grabbed my arm, and said "Alright, how much?" I said "23 – but only for half." "Done." And that was it, 51 per cent was now owned by Helkon.

A year later Werner Koenig died in a skiing accident before the last tranche of the deal was paid. By then $16m had been paid, but Helkon was unraveling.

They were in a hell of a mess. Unfortunately there was a couple of Germans who were Werner's partners who had been with him since the beginning. They basically didn't trust any of us and wouldn't let us do what we wanted to do to try and save the thing.

Although by then Helkon's financial problems were north of $250 million. Redbus was never paid the last $7 million.

In this interim year, Franks became very disillusioned with the film business. His company had become owned by a foreign company now bankrupt, and the key person who had done the deal was now dead. And whilst $16 million received seemed a lot, the reality was that the majority was used to pay off debt and guarantees and to buy out other shareholders, and once Helkon was in administration, the entire freedom of Redbus to operate became almost completely frozen. "I need to do something else", thought Franks, so he started buying other companies – mostly distressed media businesses that needed restructuring but had potential cash flows and, ultimately, value. Most of the money from Helkon was reinvested rather than spent. Franks still drove the same car; lived in the same apartment; and, although wealthy by now, he reinvested considerable sums rather than go 'crazy'.

Two years later, Redbus got the UK distributor back thanks to a small, hidden-away clause in the original contract enabling Redbus to wrest control in the event of a Helkon liquidation. Under these circumstances, Redbus could be bought back at a substantial discount to the acquisition price. During the protracted and frustrating process, in particular dealing with administrators, and insolvency practitioners, and all the banks that deal with loans that are in distress or in default, Franks learnt a great deal about the process. Instead of obsessing about the distribution company, he took the opportunity to set up the Redbus Group as a business, specializing in picking up distressed companies, which remains its main activity today.

What was learned from the Helkon deal?

I would say to any owner do not sell 51 per cent of your business to anybody. Unless the quoted price is crazy, in which case take it but know that 51 per cent is

a bad number to sell because you got a lot to lose still but you don't have any control. The interim period was very horrible because I was dealing with this German accountancy in Hamburg, and they didn't get me, they didn't get the business, it was very difficult.

Having repurchased the company, Franks – who owned 80 per cent of the company – and his minority partner Kamasa decided to sell to Lionsgate in October 2005. The deal was reported by Lionsgate at $35m plus debt. According to Franks, however, the debt was quite substantial – "many millions which was owed to us plus cash drain, and we were a cash positive company so in total it was a lot of money. And we'd only bought it back at single digit millions from Helkon."

The deal came at the right time, explained Franks. The video market was flattening, the risk re P&A was higher than ever, and Redbus was witnessing a consolidation in the UK distribution market. Bigger players, larger pockets and higher barriers to entry all played their part in the decision to sell. And if Redbus had turned the offer down, Lionsgate may have bought a rival, making life more uncomfortable and leaving no option but to go back and reconsider the offer.

In summary, Franks did two very personal things on closing the Lionsgate deal. He established a charity foundation, the Franks Family Foundation. And he put aside more than $1m to be shared out between some 20 staff, even though there was no contractual need to make any bonus payments.

> I expect paid staff to work their bollocks off and treat my money, the company's money, like their own money. We don't like wasting things. When we went through a downturn, we didn't make any people redundant. Thank god, but almost everyone else did. And you know why we didn't have to? Because we keep things tight so that we can afford to keep people, but they don't see that in the good times, they think you are being tight with them. When we sold the company, I paid a special non-contractual bonus, which was in total over a million. Remember they didn't even work for me now. They worked for Lionsgate by this point, so it wasn't even as a motivational thing. But it was the right thing to do and I'm proud that we did it. The Redbus Film Distribution team was always a pleasure to work with. To be honest the thing I miss most about the business is spending time with them. Without the like of Carla Smith, Chris Bailey or Guy Avshalom, Redbus would not have been the successful company it was. I consider the time I had working with them and their teams a pleasure and a privilege for me.

Redbus distribution titles (all media unless stated)

Like Minds (2006) – distributor (2005) (UK) (theatrical)
The Best Man (2006) – distributor (2005) (UK)
The Contract (2006) – distributor (2006) (USA) (theatrical)
An American Haunting (2005) – distributor (2006) (UK)
Diameter of the Bomb (2005) – distributor (2005) (UK) (theatrical)
Revolver (2005) – distributor (2005) (UK)
Good Night, and Good Luck (2005) – distributor (2006) (UK) (theatrical)
Mortuary (2005) – distributor (2005) (UK) (theatrical)
Edison (2005) – distributor (2005) (UK)

Gypo (2005) – distributor (2005) (UK)
The All Together (2005) – distributor (2006) (UK)
Enron: The Smartest Guys in the Room (2005) – distributor (2005) (UK)
Hard Candy (2005) – distributor (2006) (UK)
Rize (2005) – distributor (2005) (UK)
Taking 5 (2005) – distributor (2006) (UK) (theatrical)
Zemanovaload (2005) – distributor (2005) (UK) (DVD)
Man about Dog (2004) – distributor (2004) (UK) (theatrical)
It's All Gone Pete Tong (2004) – distributor (2005) (UK) (theatrical)
Oyster Farmer (2004) – distributor (2006) (UK) (theatrical)
Madhouse (2004) – distributor (2004) (UK)
Ha-Ushpizin (2004) – distributor (2005) (UK)
School for Seduction (2004) – distributor (2004) (UK)
Tooth (2004) – distributor (UK)
Walk on Water (2004) – distributor (2005) (UK)
We Don't Live Here Anymore (2004) – distributor (2004) (UK)
Touch of Pink (2004) – distributor (2004) (UK)
Grand Theft Parsons (2003) – distributor (UK)
Open Water (2003) – distributor (UK)
The Republic of Love (2003) – distributor (2003–) (UK)
Emile (2003) – distributor (2003–) (UK)
11:14 (2003) – distributor (2005) (UK)
The Hunted (2003) – distributor (2003–) (UK)
Live Forever (2003) – distributor (UK)
House of the Dead (2003) – distributor (2004) (UK)
Monsieur N. (2003) – distributor (UK)
Levity (2003) – distributor (2004) (UK)
Asonot Shel Nina, Ha (2003) – distributor (2005) (UK)
Bollywood Queen (2002) – distributor (UK)
Cabin Fever (2002) – distributor (UK)
White Oleander (2002) – distributor (2003–) (UK)
Welcome to Collinwood (2002) – distributor (UK)
Stark Raving Mad (2002) – distributor (2003) (UK)
Spider (2002) – distributor (UK)
Ash Wednesday (2002) – distributor (UK)
Riders (2002) – distributor (2003–) (UK)
Bend It Like Beckham (2002) – distributor (2003–) (UK)
The Mothman Prophecies (2002) – distributor (2003–) (UK)
A Walk to Remember (2002) – distributor (2003–) (UK)
Repli-Kate (2002) – distributor (2004) (UK)
Jeepers Creepers (2001) – distributor (UK)
Chica de Río (2001) – distributor (UK)
Sidewalks of New York (2001) – distributor (UK)
The Gift (2000) – distributor (2001) (UK) (theatrical)
Dead Babies (2000) – distributor (UK)
Nasty Neighbours (2000) – distributor (UK)
State and Main (2000) – distributor (2001) (UK) (theatrical)
Maybe Baby (2000) – distributor (UK)

Under Suspicion (2000) – distributor (UK)
Being Considered (2000) – distributor (UK)
Gun Shy (2000) – distributor (UK)
What's Cooking? (2000) – distributor (UK)
Play It to the Bone (1999) – distributor (UK)
One Day in September (1999) – distributor (2000) (UK)
Strange Planet (1999) – distributor (UK)
The Big Kahuna (1999) – distributor (UK)
The Rage: Carrie 2 (1999) – distributor
The Tichborne Claimant (1998) – distributor (UK)
Abre los ojos (1997) – distributor (UK)

29 Case study
Squid Game's fame

> Debt... that peculiar nexus where money, narrative or story, and religious belief intersect, often with explosive force.
>
> Novellist Margaret Atwood

Hanging by thick ropes from the ceiling of a sports hall, a large translucent sack starts to fill up with bundles of bank notes. A sea of faces look upwards greedily, mesmerised by the cash-filled vision. Every one of the green-and-white track-suited participants suffers from chronic personal debt; and each is about to play the game of their lives, literally. The stakes are extreme: each player will die if they lose, screw up or even come a worthy second in the hit fantasy series called *Squid Game*, today a household name. 456 players, drawn from various social backgrounds but all facing chronic financial pressures, play a set of children's games for the chance to win the Won 45.6bn ($38 million) prize. There is only one winner, with 455 players set to die on the way. The title stems from a Korean game played by children, including the creator, writer and director Hwang Dong-hyuk, who is on record as having been "very talented" at it when playing as a child in the 1970s in a poor Seoul suburb: "It was the most physically aggressive childhood game I played in neighbourhood alleys as a kid, which is why I also loved it the most" [2].

A hit of all hits?

By October 2021, the truly "Original" South Korean nine-part series, commissioned and financed by Netflix and green lit in 2019, had smashed all the platform's streaming records following its 17 September, 2021 worldwide release. After five weeks, the audience figures passed 142 million, with more than 2 billion viewing minutes clocked up. On further examination, however, the truly astonishing numbers were not just 'on' Netflix's platform, but what was happening elsewhere on social media. According to The Publish Press and other reports, there had been some 42 billion views of the Squid Games hashtag and associated memes on TikTok, and a growth from 400,000 to 19.1 million Instagram followers on actress Ho Yeon Jung's account within a month of the show's launch. All of the other Korean leading actors in the show experienced similarly astonishing spikes in traffic. Jeff Bezos's obsession with selling shoes – except in this instance sales via a Netflix show rather than Amazon Prime – was rewarded with a 7,800 per cent spurt in sales of slip-on White Vans (worn by contestants in the show), which had kicked in by the end of October 2021. Duolingo also reported a surge in users learning Korean [3]. Netflix paid $21.4 million for the nine-episode

DOI: 10.4324/9781003205753-32

series (at approximately $2.37 m an episode, compared to average, escalating costs by 2021 of $6 m per hour). According to a Bloomberg report leaked by a soon-to-be fired Netflix staffer by mid-October, *Squid Game* was set to deliver more than 40 times that modest sunk cost, valuing the series at more than $891 m thanks to its "impact value." That proprietary metric is a measure of a title's economic contribution to Netflix based on subscriber viewing, with inputs from new customer predictions and retained customer loyalty.

Inspiration from debt and despair

When he first came up with the concept *Squid Game* creator Hwang Dong-hyuk struggled to get attention and backing from the Korean market. By 2008 he was personally broke, having failed to get his film script at that time off the ground. He spent hours in manga cafés reading survival books, including *Battle Royale*, *Liar Game* and *Gambling Apocalypse: Kaiji*. Art imitated real life all too clearly to the creator: Hwang wondered about his ability to join a survival game to win money and raise himself and his family out of debt. It was that drastic concept that inspired him to write a screenplay, but potential financiers stated that the concept was too strange, grotesque and hard to understand. The local market passed on the project emphatically.

The series' inception came long before the Oscar-winning South Korean film *Parasite* stormed the worldwide market in 2019–2020 (See Case Study, Chapter 12) which arguably helped explore and establish a near-universal appetite for searing critical exposures of wealth and poverty extremes through an imaginative narrative. "I wanted to write a story that was an allegory or fable about modern capitalist society, something that depicts an extreme competition, somewhat like the extreme competition of life. But I wanted to use the kind of characters we've all met in real life," explained Hwang [4]. One of the differentiating factors that has greatly helped the show's success with audiences worldwide is the viewer's ability to identify with the characters. They are drawn in a deeply humanistic way, yet are also readily recognisable as authentic characters from a wide range of walks of life.

However, digging deep took its toll on the filmmaker: "It was physically, mentally and emotionally draining. [Hwang lost numerous teeth during the shoot as a result of acute stress.] I kept having new ideas and revising the episodes as we were filming so the amount of work multiplied." The concept behind *Squid Game* was also influenced around Hwang's personal background, with him having grown up with a single mother in a deprived area of Seoul. It was also, and perhaps more strongly, under the shadow of the 2009 global financial bombshell that struck Korean badly.

> I was very financially straitened because my mother retired from the company she was working for. There was a film I was working on but we failed to get finance. So I couldn't work for about a year. We had to take out loans – my mother, myself and my grandmother. I read *Battle Royal* and *Liar Game* and other survival game comics. I related to the people in them, who were desperate for money and success. That was a low point in my life. If there was a survival game like these in reality, I wondered, would I join it to make money for my family? I realised that, since I was a filmmaker, I could put my own touch to these kinds of stories so I started on the script [5].

What Hwang was tapping into was the personal debt crisis in Korea: a socio-political crisis of extremes, where an underclass are often living in rooms "slightly larger than coffins, struggling to meet debtor interest rates of 17% plus", according to a Guardian podcast on *Squid Games* and Korean culture and society [6]. Every 12 minutes, a South Korean is declared bankrupt, in an economy where 25% of the population are small business owners, and $1.55 trillion of household debt keeps the lid firmly closed on any upward mobility [7].

The dark side of children's toys and games

During the first episode's initial 'game', a version of 'blind man's bluff' is played out. The 456 contestants can only shift forwards to the safety line when the face of an outsized mechanical doll is turned away from them. Anyone moving or caught out is gunned down by dehumanised guards. The protagonist is a deeply flawed divorcee, gambling addict and struggling chauffeur, Seong Gi-hun (cast and played deliberately against type by Lee Jung-jae in contrast to his typically more 'heroic' roles), who survives by forming alliances with other players, including his childhood friend Cho Sang-woo (Park Hae-soo), a white-collar criminal. Inclusivity with "the North" is achieved with the introduction of Kiang Sae-byeok (Jung Ho-Yeon), a North Korean defector who is trying to pay for a broker who can rescue her parents across the border and buy a house for them. "The show is motivated by a simple idea," Hwang points out. "We are fighting for our lives… my dream was to create something that would resonate globally. We are living in a Squid Game world now" [8].

Production and filming of the series ran from June to October 2020, including a month shut down due to COVID-19. While the South Korean Netflix team felt positive that the show could be a hit in its home territory, Netflix carefully curated the production with a firm eye on the international audience. Visuals and a highly original and striking production design ensued, using primary and stand out colours in part – but also pink and mint green hues that resembled colour patinas used by South Korean schools during the 1970s and 80s, and now world-famous costumes and shoes, but geared to create a fantasy world that helps to suspend the audience's disbelief. Some of the games were further simplified in order to avoid possible issues with the language barrier and sub-titling. (For the record, Koreans are not impressed by the subtitles and feel that a significant range of nuances and meanings are lost in the limitations of the English language in particular! [9]) The maze of corridors, tunnels and stairways were building on ant colony designs and the four-dimensional drawings of the artist M.C. Escher, famous for his never-ending staircase sketch.

Branding and marketing in a time of COVID-19

Whilst marketing of the series was complicated thanks to the restrictions of COVID-19 regulations, there were some fun and intriguing efforts to build awareness utilising the set and key figures. A replica of the giant doll in "Red Light, Green Light" was built in the Philippines and exhibited at Ortigas Avenue in Quezon City in September 2021; while a larger set replica was built at Itaewon Station in Seoul, but shut down promptly due to COVID-19 quarantine regulations. Paris witnessed the opening of a *Squid Game* pop-up store on October 2nd and 3rd 2021, at which a visitor could win a free one-month Netflix subscription if they managed to get the right shape

from the Dalton in 90 seconds. (Contestants who failed kept their lives.) But the best, most inclusive initiative was launched in the Netherlands, where Netflix hosted its own Squid Game, where people could play Red Light, Green Light in Rotterdam and Maastricht. Staff were dressed as guards and a replica of the giant doll dominated proceedings. Winners won Squid Game memorabilia and the event attracted hundreds of people. Already Netflix Asia has reported that the company is now looking at a potential video game adaptation of the series.

The show's extraordinary success has helped confirm Netflix's strategy over the past five years or so of reaching out to different territories around the world for new content rather than centralising all of its decisions in Los Angeles. Whilst senior Netflix executives are quick to point out, candidly, that the platform did not anticipate the worldwide reception at the heady level achieved, the Korean team was confident that they had a local hit, and that it had the right ingredients to at least strike across the South East Asian markets. And the hit series could also be cited as a prompt for changed behaviour within the commissioning platform: the company announced that it would in future release information more frequently and shift its main publicly reported metric to hours viewed, rather than the number of accounts that watched a title for at least two minutes [10]. Further data showed that Netflix users streamed more than 1.4 billion hours of *Squid Game* over the first 23-day period since its release [ibid.]. What is unclear is how Netflix's ownership of the underlying IP translates into micro-revenue streams from social media hits around the world, while of course placing it in prime position to commission a potentially enduring franchise, albeit subject to *Squid Game* creator Hwang Dong-hyuk' future availability. The show's infamous success and profitability has also raised the thorny issue, so close to Hollywood hearts and minds, about profit participation. "I'm not that rich," Hwang confirmed. "But … I have enough to put food on the table. And it's not like Netflix is paying me a bonus. Netflix paid me according to the original contract" [11].

Back in late 2021, Hwang was lobbying Netflix to screen three movies he had made over the past decade. And he was considering how to write and make a sequel, most likely after his next feature. "It's possible that I have to do season two to become as rich as Squid Game's winner."

References

[1] Wikipedia, p. 8/27.
[2] Ibid.
[3] Duke, Simon, *Sunday Times* Business Section 21/10/21.
[4] Brzeski, Patrick, *Hollywood Reporter*, 13/10/21.
[5] Ibid, *Hollywood Reporter*.
[6] *The Guardian* Podcast, "The Korean debt crisis that inspired Squid Game's dark dystopia", 21 October 2021.
[7] Ibid.
[8] *The Guardian*, Jeffries, Stuart, Interview, 26 October 2021.
[9] Ibid, *The Guardian* Podcast.
[10] *Variety*, 19 October 2021: "Global Squid Game mania lifts Netflix quarter".
[11] *The Guardian*, 26 October 2021, ibid.

30 Conclusions

> We belong in a time in which culture is in danger of being destroyed by the means of culture.
>
> Frederich Nietzsche (1844–1900)

When the great German philosopher of the nineteenth century wrote those perplexing words, Nietzsche could not have entertained any foresight of the cinema theatres of the twentieth century to come, let alone the smart TV box set, digital cameras, online streaming platforms and ubiquitous smartphones that we carry in our pockets today. And yet his words are as prescient today as they were many decades past. "The means justify the ends", as the old saying has it. Those 'ends' and how they reach and are consumed by us in today's global entertainment world are in a state of flux and up for grabs.

It is instructive to have reflected widely and in depth on some of the challenges facing the independent film and content business beyond Hollywood in this book. To my thinking, it is vital to underline how important it is for students and practitioners to understand where we have come from, and why we're in the situation we are today. While Hollywood and the leading streaming platforms slug it out for market domination (or at least survival), it's also important to wonder about the tyranny of what I would describe as yet more of the same: a daily diet of content that is all too easily accessible and digestible, but leaves us craving for more. Part of the problem is our addictive natures [1] – that heady emotional rush demanding ever more. As David Chase, the creator of the seminal series *The Sopranos* puts it succinctly: "I worry about entertaining ourselves into oblivion" [2].

Lurking just out of sight is that perplexing paradox at the heart of the pact that Hollywood filmmakers made long ago with their intended mass audiences: "For reasons of greed, ego and simple curiosity they try to give everyone what they'd like to see themselves" [3]. Whether the new titans of the entertainment world can somehow jump through this hoop and help create a more sustaining, democratic world of content remains to be seen.

In the opening section of this book, I analysed a connecting theme: that the independent film sector suffers from a range of strategic and economic shortcomings that fail to resolve the vertical and horizontal challenges required to build a sustainable business model. My stated view is that the film value chain is vertically 'dis-intermediated'. This already fragmented model is now facing acute pressure from the winds of change. Whilst it was always a demanding and protracted effort to get past the last problematic link in the chain and onto the next, we are now witnessing a 'dependent' business model rather than anything resembling healthy 'independence'. Those

DOI: 10.4324/9781003205753-33

fragmented links have all been carried out at a considerable distance from the final market destination – the user or, my more favoured word, the audience. Only the fittest of the fit are deemed to be allowed detailed data and feedback from the online behemoths; the rest are outside the loop or glean their information from watered-down top ten charts and the (albeit often-excellent) trade magazines and industry websites, et al.

The academic failure

Given my dual academic experience next to practitioner work over the past years, including teaching and studying at Cambridge University, City University, Exeter University and the London Film School etc. I have been driven to observe the considerable divide that exists between academic research and healthy, relevant teaching and training methods, and on to the practitioner's role and experience across the film market. Frankly, much of what is published in the academic spectrum is poorly informed, relies heavily on quantitative research rather than qualitative work, and is designed and written in such a way that it bears little to no relevance to the industry and the very pressing strategic, leadership and creative challenges it faces today.

Furthermore, academic form appears to insist that research papers and texts are back-scratching exercises in mutual citation and scripted in a language and syntax that few mortals can join up. I struggle to comprehend much of what has been written to date (with notable exceptions), so those of you out there are not alone. More effort is required to build a new architecture that links academia's research and insights and the practitioner's world of experience, much in the way that Pixar, for example, fuses the two sides into one productive whole.

It now still remains to be seen whether the rising demand in content (and therefore expansive production levels) will translate into being a saviour for the independent film and content business, or whether the majority of that sector's talent will have to get in line. 'A' listers, ranging from acting, directing, writing and producing, are dominating the "deal" headlines every day in my daily newsfeed from Variety. The evidence points to Pareto's power law still being very much in fashion: 20 per cent of the players are dominating 80 per cent of the global market. So where does that leave the reader (if they are still reading after 150,000 words) in terms of the three-legged chair of which I drew a metaphorical picture in Chapter 1: The Winds of Change?

The three-legged chair

That film, scripted content, documentary and animated filmmaking requires vast vaults of creativity is a crucial given, yet it cannot be demanded or commissioned and controlled at will. Creative leadership, as enshrined for example by Ed Catmull's Pixar, Bob Iger's Disney, Richard Pleper's HBO (all of whom have moved sideways of late) and some of the leading producers, writers and directors around the world, has never been required so urgently as today. Can creative management be taught, studied and learned? Yes, I believe it can, if the students of today and tomorrow grasp its essential role and nature in the order of creative content and filmmaking.

Technology, ever-shifting and moving, also requires a full commitment to sustainability, inclusion, diversity and an embrace of innovation [4]. Some, like literary agent Julian Friedmann, argue that screenwriting cannot be taught and that the vast

numbers of publications on the market about how to write a script are effectively useless. Only human experience, some talent and the honest desire to write for an audience first and foremost in mind will help you 'Pass Go'. But the world is also facing an acute shortage of production skills, ranging from physical, practical craft skills to experts in real-time technology, virtual production, and best use of LED stages. And all content makers appear to be hard-pressed to find space today, as the demand for studios abound.

Too much development out there has to be self-taught and self-upskilled on the job. The rush, pressure and stress of physical production has not abated as a result of advances in technology. Unions, as I write, are at war with their paymasters – stressed, massively overworked and feeling unappreciated. I sometimes wonder (very idealistically from my writer's armchair this autumnal morning) whether the industrial filming machine should be reminded that "Nature does not hurry yet everything is accomplished" [5].

For creative and technical advancements to move forward in unison and have resonant impact, true leadership is required. "Content", as I was reminded by my mentor Terry Ilott, "may be 'King' but reach is 'Queen'". By reach, I don't just mean rising subscribers, bigger box office and shooting films in space (yes, that's just been announced by the Russians, proud to have beaten Tom Cruise in the new race to be the first to shoot a live film in outer space, but skip that). Reach most vitally means touching, emoting, moving and enlightening us, as, above all, stories help us to understand and make sense of the world we live in.

And, above all else, the story will always go on.

References

[1] *Silence in the Age of Noise*, Erling Kagge, Viking Press, 2017.
[2] Financial Times, 19.09.21.
[3] Boorstin, J. *The Hollywood Eye*, Harper Collins, 1990, p. 213.
[4] Future of Film report.
[5] Chinese philosopher Lao Tzu.

Appendix 1
The international sales agents

When training and teaching, one of the most common questions I receive from emerging filmmakers is: "Who are the main sales agents and distributors out there? How do I find the right one?"

It is critical to find the right partner who can provide energy, passion and taste, alongside cutting-edge market knowledge. Gauging the appetite, reputation and communication skills within any sales company you decide to work with is key to the success of your project, and potentially your career. This decision is not just about the numbers (estimates), but also about the positioning, marketing and festival relations that they can offer. Above all, the sales agent is representing you, your talent, the project, and is deeply responsible for key stages in your project's journey as it traverses the entertainment value chain. Below is a far from comprehensive list of leading and relevant companies as a starting reference point.

UK

Altitude

Will Clark set up Altitude more than 10 years ago with money he made from the sale of Optimum Releasing to Studio Canal. Does UK distribution, international sales, and can make significant advances for titles. Tends not to handle foreign language, and understands genre very well.

- The company's vertically integrated structure also includes Altitude Film Sales, run by Mike Runagall, who formerly served as SVP International Sales at Pathé[1]
- Altitude Film Distribution's first release was the Oscar-winning documentary *20 Feet from Stardom* (2014) (dir. Morgan Neville, budget $1 million)
- 2015 released Ira Sachs' *Love Is Strange*, Asif Kapadia's biopic film *Amy* (about Amy Winehouse – budget $3.4 million), thriller *Spooks: The Greater Good* (Bharat Nalluri – budget $1.1 million) & sci-fi film *Narcopolis* (Justin Trefgarne).
- Altitude Film Distribution acquired distribution rights in the UK & Ireland to Barry Jenkins' Oscar-winning film *Moonlight* (2016)[2] (budget $1.5 million, box office $65.3 million)
- Altitude partnered with British Academy Award-winning film director Kevin Macdonald on the Whitney Houston documentary, *Whitney* (2018)
- Altitude Film Sales has closed a selection of international territory deals on *JFK: Revisited: Through the Looking Glass*, Oliver Stone's new doc re-examining the

assassination of John F. Kennedy 30 years after the release of Stone's thriller *JFK* – screened a sales promo at the pre-Cannes screenings event and film is set to have world premiere at Cannes on 12 July 2021.[3]

- Sam Worthington to star in thriller *Transfusion* (Matt Nable's directorial debut). Altitude has added it to its slate with international sales launching at the Cannes Market.[4]

Bankside

Established in 2007 by entrepreneur Phil Hunt, Bankside is a leading independent sales agency and linked (yet separate) to financing arm, Headgear. Not strong on foreign-language titles, but excellent on US and UK and English-language fare – both specialised and more mainstream.

- Writer Darren Le Gallo making his directing debut with *Sam & Kate*, a family dramedy starring Dustin Hoffman & Sissy Spacek. Bankside films is financing alongside Volition Media Partners and will handle foreign sales, taking it to Cannes 2021.[5]
- Emilia Clarke to star in love story *Let Me Count the Ways* (dir. Björn Runge) Bankside is teaming with Damian Jones of DJ Films (*Goodbye Christopher Robin*) on the production – full developed in-house at sales outfit Bankside.[6]
- Brianna Hildebrand & Lana Condor star in *Girls Night* by Marianna Palka * 'BlacKkKlansman' producer Shaun Redick – Bankside launches at Cannes.[7]
- Other known distribution credits: *I See You* (2019) (dir. Adam Randall, Starring Helen Hunt, budget $5 million), *Cargo* (2017) (dir. Ben Howling & Yolanda Ramke, starring Martin Freeman), *Belle* (2013) (dir. Amma Asante, starring Gugu Mbatha-Raw, Matthew Goode, budget $10.9 million).[8]

Cornerstone Films

Set up by Alison Thompson and Mark Gooder – a fine pedigree of executives – the company is more than just about making sales: it offers executive producer, packager, development financing services and significant global experience.

- Launched 2015, sales offices in London & LA as well as co-producing with Europe's X-Filme and Beta Cinema & Australasian partners The Reset Collective in Sydney
- June 2021: Emma Thompson in *Good Luck to You, Leo Grande* – Cornerstone to show footage at Cannes Market (dir. Sophie Hyde, prod. Adrian Politowski alongside Debbie Gray) – handling international sales & distribution[9]
- *The Tank*, Cornerstone launching sales at Cannes 2021 (dir. Scott Walker, creature survival horror film)[10]
- Letitia Wright & Josh O'Connor Drama *Aisha* – Cornerstone acquires worldwide sales rights (writer & dir. Frank Berry)
- *Whina* (2021) starring Rena Owen – budget: $1.2 million[11]
- Other distribution/sales credits: *The Dry* (2020) (dir. Robert Connolly, starring Eric Bana), *Hampstead* (2017) (dir. Joel Hopkins, starring. Brendan Gleeson & Diane Keaton), *Dream Horse* (2020) (dir. Euros Lyn, starring Toni Collette).[12]

Dogwoof sales

Anna Goodas is one of the leading specialists at theatrically-driven documentaries. Outstanding reputation and library after 15 years of game-changing activity in the documentary sector.

- Integrates production, sales & UK distribution
- Has released 28 Oscar-nominated documentaries, 4 wins & 3 BAFTA winners
- Notably: Oscar & BAFTA-winning *Free Solo* about US rock climber Alex Honnold (UK highest-grossing doc of 2018) (dir. & prod. Elizabeth Chai Vasarhelyi & Jimmy Chin, box office $29.3 million)[13]
- Recent releases: *Collective* (2021) – double Oscar nom. & BAFTA nom., dir. & prod. Alexander Nanau; *The Mole Agent* (2021) – Oscar nom., dir. Maite Alberdi, prod. Marcela Santibañez
- Dogwoof's TDog production investment fund has five features and two series currently in production; the fund is focused on feature docs, docu-series, and remake rights, gearing up the company towards vertical integration.
- Cannes 2021 line-up: *The Story of Film: A New Generation* (dir. Mark Cousins), *The Kids* (dir. Eddie Martin), *New Promo: River* (dir. Jennifer Peedom), *Captains of Zaatari* (dir. Ali El Arabi), *Sabaya* (dir. Hogir Hirori), *Ailey* (dir. Jamila Wignot)[14]
- Tribeca 2021: *The Kids* (dir. Eddie Martin), *The Lost Leonardo* (dir. Andreas Koefoed)

HanWay films

- UK-based international sales company specializing in theatrical feature films, established 1998 by leading international producer Jeremy Thomas
- Offers full-service solutions: arranging financing, sales, marketing & distribution from all films from Recorded Picture Company, along with projects from third-party producers.
- HanWay the Collections division has library of over 350 films available to license across the world – inc. films by Bernardo Bertolucci, David Cronenberg, Stephen Fears, Jean Luc Godard, Derek Jarman, Takeshi Kitano, Steve McQueen, Takashi Miike, Philip Noyce, Sarah Polley, Sally Potter, Lone Scherfig, Julien Temple and Wim Wenders.[15]
- Founder Jeremy Thomas is the subject of Mark Cousins' documentary *The Storms of Jeremy Thomas*[16]
- 2015 – MD Schumacher claims – was the most successful year from HanWay to date with critically acclaimed releases *Carol, Brooklyn* and *Anomalisa*.
- Other distribution/sales credits: *Only Lovers Left Alive* (2013) (dir. Jim Jarmusch, starring Tilda Swinton & Tom Hiddleston, budget $7 million), *Minamata* (2020) (dir. Andre Levitas, starring Johnny Depp), *The Burnt Orange Heresy* (2019) (dir. Giuseppe Capotondi, starring Claes Bang, Mick Jagger).[17]

SC Films International (Simon Crowe)

- SC Films is an international sales, distribution, finance & production company founded by Simon Crowe & Matthew Joynes (financier)

- Provides minimum guarantees, equity & bank GAP for producers
- Recently launched a large innovation bond offering on the Frankfurt Stock Exchange with a view to invest in qualifying film, TV, games and technology (as it intersects film TV and games projects).[18]
- UK Distribution: Blue Finch Films set up in 2018 by Joynes, Crowe & Mike Chapman – A UK & Ireland distribution company focussing on acclaimed commercial & festival driven titles.[19]
- November 2020 – acquired worldwide rights to sci-fi animation *Absolute Denial* ahead of American Film Market & intends to submit to festivals in 2021. Also on the SC Films slate are projects *Stonerunner, Marmaduke, Dragonkeeper* and *My Father's Secrets*.[20]
- Other distribution/sales credits in animation: *Gnome Alone* (2017) (dir. Peter Lepeniotis), *Marmaduke* (2021) (dir. Mark A.Z. Dippé, Matt Philip Whelan)[21]

Protagonist Pictures

The leading specialist label in the UK to take auteurs to the international market. Handle foreign-language titles on occasion. Protagonist has a fine reputation and very is good at positioning content worldwide. Has announced a restructuring and further commitment to production in mid-2021.

- International sales, finance and production company led by Dave Bishop
- In June 2021, Protagonist teamed up with Germany's production company Augenschein to co-represent worldwide rights on select English-language films.[22]
- In June 2021, Protagonist launched world sales on romantic comedy *Fado!*, starring Emily Watson and Richard E. Grant, dir. Jason Wingard.[23]
- *Censor* (2021), British horror, prod. Helen Jones, dir. Prano Bailey-Bond, starring Niamh Algar. Grossed $87k, released on VOD in June.
- *Blithe Spirit* (2020), British comedy, prod. Nick Moorcroft, dir. Edward Hall. Starring Dan Stevens, Leslie Mann, Isla Fisher and Judi Dench. Grossed $890k
- May 2021, Protagonist to launch sales of Tribeca competition title *Blind Ambition* documentary that follows Zimbabwean refugees who entered the world of competitive wine tasting.[24]

Westend films

- London-based production, financing and international sales company for feature films and TV, and capable of making significant minimum guarantees (advances), marking it out as one of the best-armed international sales agents in the marketplace.[25]
- Westend's library includes Oscar-nominated titles such as *The Breadwinner* (2017), *Albert Nobbs* (2011), *Song of the Sea* (2014), *Footnote* (2011) and *The Invisible Woman* (2013)[26]
- Recently created the brand 'WeLove'. Aimed at female audiences, it focuses on developing female-focused content and promoting female talent.[27]
- *Rams* (2020) Australian comedy-drama, dir. Jeremy Sims, starring Sam Neill, Michael Caton and Miranda Richardson. Grossed $4.3m
- *The Breadwinner* (2017), animated drama, dir. Nora Twomey, starring Saara Chaudry. Grossed $4.4m

North America

Film Nation

Led by Glenn Basner and now very well backed as a vertically integrated production-sales powerhouse, Film Nation (FN) is the leading specialist and cross-over US sales company that really understands the world film market. Great taste, and a fine roster of directors over more than a decade since opening large with *The King's Speech*, and a wider, experienced team with the ability to produce, finance, package as well as sell content worldwide.

- Founded in 2008, FN focuses on the distribution, production and financing of premium content.
- Announced in early 2019, the launch of its UK-based television production joint venture with Nordic Entertainment Group (NENT) – platform broadened with investments in podcasts, theatre and digital/short form content[28]
- Production and sales titles have gained more than 45 Oscar nominations and 8 wins.
- *Promising Young Woman* (2020), prod. Margot Robbie & Tom Ackerly, dir. Emerald Fennell, starring Carey Mulligan, Bo Burnham, Alison Brie. Grossed $16.3 million worldwide.
- *Late Night* (2019), prod. Mindy Kaling, dir. Nisha Ganatra, starring Emma Thompson, Mindy Kaling. Budget $9.5 million, grossed $22.4 million
- *The Big Sick* (2017), prod. Judd Apatow, Barry Mendel, dir. Michael Showalter, starring Kumail Nanjiani, Zoe Kazan. Budget $5 million, grossed $56.4 million.
- *Arrival* (2016), prod. Shawn Levy, Dan Levine, Aaron Ryder, David Linde. Dir. Denis Villeneuve, starring Amy Adams, Jeremy Renner, Forest Whitaker. Budget $47 million, grossed $203 million.
- *The King's Speech* (2010), prod Iain Canning, Emile Sherman Gareth Unwin, dir. Tom Hooper, starring Colin Firth, Geoffrey Rush. Budget $15 million, Grossed $430 million.

XYZ

- An agency that offers sales, financing and packaging and is excellent at genre. Has strong relations with Netflix, Amazon Prime, Shudder etc. Therefore it can offer streaming financing and licensing opportunities at a level unmatched by many other sales agents, either in the US or internationally. Strongest in the North American market.
- Founded in 2008, best known for *The Raid* franchise, 2017 Sundance Winner *I Don't Feel At Home In This World Anymore* and *Mandy*.[29]
- In June 2021, XYZ opened a domestic distribution wing, focusing on releasing independent genre films around the world, complementing the company's production, sales and financing operations.[30]
- In 2019, XYZ expanded into management, working with filmmakers across the globe. It also secured a film fund with ambitions of financing over a dozen films in the next few years.[31]
- *Stowaway* (2021), dir. Joe Penna, starring Anna Kendrick. Distributed by Netflix outside Canada

- *The Prodigy* (2019), prod. Tripp Vinson, dir. Nicholas McCarthy, starring Taylor Schilling. Budget $6 million, grossed $21.1 million

France

EuropaCorp

Built by Luc Besson, EuropaCorp is essentially a studio, with development, production, sales and distribution. It has created and sold some of Europe's largest 'blockbuster' franchises (*Taxi*, for example), and yet has also worked with strong auteurs. One problem is the energy and attention that Luc Besson himself demands from the company, leaving little oxygen for other projects and talent on occasion.

- Known for its expertise in the production of English-language films – developed and produced the *Taken* trilogy and the *Transporter* series[32]
- International sales recent titles: *Little White Lies 2* (2019) (dir. Guillaume Canet, starring Marion Cotillard), *Kursk* (2018) (dir. Thomas Vinterberg, starring Léa Seydoux and Colin Firth), *Valerian and the City of a Thousand Planets* (2017) (dir. Luc Besson, starring Cara Delevigne and Dane DeHaan).[33]
- 2020 – junior lender Vine gave EuropaCorp a new credit line of $100 million to bring the company back on track and develop/produce new slate of films – two English-language and one French-language film per year[34]
- Besson is currently under scrutiny for sexual assault allegations from 2018

SND Groupe M6

Essentially a TV company that has expanded into sales and is best known for exporting French comedies and genre fare.

- SND is the distribution and production arm of the leading French media company Groupe M6 – home to France's most popular TV network
- SND releases 15–20 films theatrically/year
- Sold films such as *Paris Manhattan* (2012) (dir. Sophie Lellouche, starring Alice Taglioni, budget $5.3 million), *The Tall Man* (2012) (dir. Pascal Laugier, starring Jessica Biel, budget $18.2 million), *The Love Punch* (2013) (dir. Joel Hopkins, starring Emma Thompson & Pierce Brosnan), as well as titles from the Classic catalogue, SNC, including *La Belle et La Bête* (1946), *The Swimming Pool* (1969) & *Le Gendarme de Saint Tropez*[35]
- Recent releases 2021: *Délicieux* (2021) (dir. Éric Besnard, starring Grégory Gadebois, Isabelle Carré), *A Friendly Tale* (2020) (dir. Daniel Cohen, starring Bérénice Bejo, Vincent Cassel), *Appearances* (2020) (dir. Marc Fitoussi, starring Karin Viard, Benjamin Biolay)

Kinology

A mainstream commercial sales company exporting French content. Very strong sales reputation amongst larger buyers around the world.

- A Paris-based world sales and co-production company representing innovative European feature films starring international talents such as Deniz Gamze Ergüven's *Mustang* (2015) (budget: $1.3 million), Harmony Korine's *Spring Breakers* (2012), David Cronenberg's *Cosmopolis* (2012), Michel Gondry's *The We and the I* (2012), Ana Lily Amirpour's *A Girl Walks Home Alone At Night* (2014), and Rodrigo Cortés's *Buried* (2010). In 2016–2017, Kinology fully produced the US$25M heist action lingo *Overdrive* (2017) (dir. Antonio Negret, starring Scott Eastwood and Ana de Armas).[36]
- Recent titles: *Annette* (2021) (dir. Leos Carax, starring Adam Driver and Marion Cotillard, budget $15.5 million), *How I Became a Super Hero* (2020) (dir. Douglas Attal, starring Pio Marmai and Vimala Pons, budget $15 million), *Changeland* (2019) (dir. Seth Green, starring Macaulay Culkin)[37]

Playtime Group

A specialist, classy agent, working with auteurs such as Francois Ozon that offer cross-over potential.

- Paris-based hybrid finance, venture investment and international sales company, active since 1997
- Recent successes: *Son of Saul* (2016 Oscar Winner) (dir. László Nemes, starring Géza Röhrig, budget €1.5 million); *120 BPM* (Grand Prix, Cannes 2018) (dir. Robin Campillo, starring Nahuel Pérez Biscayart, budget $6.2 million) *By the Grace of God* (Silver Bear, Berlin 2019) (dir. François Ozon, starring Melvil Poupaud, $6.8 million)
- Working with directors such as Céline Sciamma, Jacques Audiard, François Ozon, Robin Campillo, Naomi Kawase, Rithy Panh, Bertrand Bonello, László Nemes, Claire Denis, Raoul Peck, Olivier Assayas.
- As well as the Paris office – the Playtime Group included three specialized sales/financing companies: Films Boutique in Berlin, Be For Films in Brussels & Film Constellation in London/LA
- Recent sales credits include: *Good Night Mommy* (2021), *Guest of Honour* (dir. Atom Egoyan, 2019), *Sunset* (László Nemes, 2018)
- Recently set up a TV financing arm for international series[38]

France/Germany

Wild Bunch

Wild Bunch has private backing, a major library, and is a significant world cinema player. Most importantly, it offers good relations with the leading festivals. However, very busy and overcrowded (the company normally has more than 15–20 titles in sections of the Cannes Festival every year...).

- Wild Bunch AG is a German film distribution and international sales company – the name Wild Bunch comes from the French company Wild Bunch S.A. created in 2002, which became a subsidiary of Wild Bunch AG in 2015.
- Has distributed and sold films such as *Land of the Dead* (2005), *Southland Tales* (2006), *Cassandra's Dream* (2007), *Vicky Cristina Barcelona* (2008), *Che* (2008), *Whatever Works* (2009), *The King's Speech* (2010) and *The Artist* (2011)

- Wild Bunch is also the international seller of Studio Ghibli's works[39]
- Currently manages a library of over 2500 titles[40]
- Currently handling an international sales catalogue of 450 titles[41]
- Wild Bunch Launches New Animation Sales Company with French Firm Gebeka – Annecy[42]
- Recent sales credits: *The Ice Road* (2021) (dir. Johnathan Hensleigh, starring Liam Neeson), *Oxygen* (2021) (dir. Alexandre Aja, starring Melanie Laurent), *The Informer* (2019) (dir. Andrea Di Stefano, starring Joel Kinnaman and Ana de Armas)[43]

Germany

The Match Factory

- Founded 2006 by Michael Weber with his Pandora Film partners Reinhard Brundig & Karl Baumgartner – described as a world sales company based in Cologne, 'bringing arthouse cinema to the international market'. MVBI bought the company in 2022.
- Awards: Jasmila Zbanic's *Grbavica* (Golden Bear, Berlinale 2006); Bahman Ghobadi (San Sebastian 2006, second Golden Shell Award); Fatih Akin's *The Edge of Heaven* (Prix Du Scenario, Cannes 2007); Ari Folman's *Waltz with Bashir* (Golden Globe for Best Foreign Language Film and Oscar-nominated for Best Foreign Language Film 2009).
- Represent classics of the X-Filme library, the entire library of Aki Kaurismäki, as well as selected titles of Jim Jarmusch (*Night on Earth, Permanent Vacation, Dead Man, Down by Law, Stranger than Paradise, Coffee and Cigarettes* and *Mystery Train*).[44]
- Heading into Cannes 2021 with 14 titles in selection – biggest assortment of features to date: including Competition titles *Memoria*, from Thai helmer Apichatpong Weerasethakul, Ryusuke Hamaguchi's *Drive My Car* and Nanni Moretti's *Three Floors* (The Match Factory is co-repping North American rights with ICM on the latter two titles).
- "The role of the sales agent has changed massively over the last 10 to 15 years", Weber says. "We are much more involved with projects much earlier on than when we first started out. We go deeper when it comes to setting them up internationally but also, we find co-production partners and sometimes even producers for the projects."[45]

Denmark

REinvent Studios

- Represent SF Studios' content on the international market. SF Studios, established in 1919, is one of the world's oldest film companies. Today, SF studios is the leading film studio in the Nordic region with HQ in Stockholm, Oslo, Helsinki and London.
- SF has streaming service SF Anytime – is part of the leading Nordic media company Bonnier.
- YESA packaging, sales and finance studio based in Copenhagen.
- Has extensive knowledge of original trends and sales opportunities on both the Scandinavian and the international market.[46]

- HBO Nordic acquired A.J. Annila's international political thriller *Peacemaker* from REinvent International Sales. REinvent had previously sold the show to North America (Topic), Latin America (AMC Networks International Latin America), Spain and Portugal (AMC Southern Europe), Benelux (Lumiere) and CIS (Russian Report). Aurø, the company's MD, expects more sales to follow.
- REinvent recently launched REinvent Chills, a new genre arm focused on films and TB series spanning thriller, horror and suspense. First slate includes *Leave* by Alex Herron, *Watching* by Peter Ahlén, *Spirit of Fear* by Pål Øie & *Possession* by Henrik M. Dahlsbakken. All films are distributed by SF Studios in the Nordics.
- Shooting starting August 2021 – internationally acclaimed & award-winning Swedish director Björn Runge (*The Wife*) will direct SF Studios' upcoming adaptation *Burn All My Letters* (starring Bill Skarsgård, Asta Kamma August and Gustav Lindh). SF Studios will distribute the film in the Nordics and REinvent will handle international sales.[47]

Notes

1 http://www.altitudefilment.com/about
2 https://variety.com/2016/film/global/moonlight-altitude-uk-ireland-1201911437/
3 https://deadline.com/2021/07/oliver-stones-jfk-revisited-doc-sells-altitude-cannes-1234786230/
4 https://deadline.com/2021/06/sam-worthington-transfusion-movie-altitude-cannes-market-1234777004/
5 https://deadline.com/2021/06/dustin-hoffman-sissy-spacek-darren-le-gallos-sam-kate-cannes-market-1234773004/
6 https://www.bankside-films.com/updates/emilia-clarke-to-star-in-love-story-let-me-count-the-ways-for-the-wife-director-bankside-damian-jones
7 https://www.bankside-films.com/updates/brianna-hildebrand-lana-condor-head-for-comedy-girls-night-from-marianna-palka-blackkklansman-producer-bankside-launches-cannes
8 https://www.imdb.com/search/title/?companies=co0196210
9 https://variety.com/2021/film/global/emma-thompson-good-luck-to-you-leo-grande-1234996947/
10 https://deadline.com/2021/06/scott-walker-creature-feature-the-tank-cannes-1234768567/
11 https://www.hollywoodreporter.com/movies/movie-news/berlin-film-festival-market-2021-whina-rena-owen-4136815/
12 https://www.imdb.com/search/title/?companies=co0001526
13 https://dogwoofsales.com/about
14 https://dogwoofsales.com/canneslineup
15 https://www.hanwayfilms.com/about
16 https://variety.com/2021/film/global/jeremy-thomas-cannes-1235015673/
17 https://www.imdb.com/search/title/?companies=co0133023
18 https://scfilmsinternational.com/sc-fund/
19 https://scfilmsinternational.com/uk-distribution/
20 https://deadline.com/2020/11/sc-films-international-boards-animated-sci-fi-film-absolute-denial-afm-1234608245/
21 https://www.imdb.com/search/title/?companies=co0665351
22 https://deadline.com/2021/06/sophie-lowe-louisa-krause-dive-movie-protagonist-augenschein-cannes-1234775475/

23 https://www.kftv.com/news/2021/06/18/protagonist-pictures-romantic-comedy-fado-to-shoot-in-portugal-and-the-uk

24 https://www.screendaily.com/news/protagonist-to-launch-sales-of-tribeca-competition-title-blind-ambition-exclusive/5159686.article

25 https://westendfilms.com/company-profile

26 https://westendfilms.com/company-profile

27 https://westendfilms.com/welove

28 www.filmnation.com/about

29 https://xyzfilms.com/company/

30 https://deadline.com/2021/06/xyz-films-distribution-hires-former-neon-coo-1234778591/

31 https://xyzfilms.com/company

32 https://www.hollywoodreporter.com/business/business-news/luc-bessons-europacorp-reports-strong-419600/

33 https://cineuropa.org/en/intsale/8979/

34 https://variety.com/2020/film/global/luc-besson-europacorp-restructuring-deal-finalized-vine-alternative-investments-1203518982/

35 https://www.thefilmcatalogue.com/companies/snd-groupe-m6

36 https://cinando.com/en/Company/kinology_10605/Detail

37 https://www.imdb.com/search/title/?companies=co0238491

38 https://playtime.group/about

39 https://deadline.com/2020/01/netflix-adding-studio-ghibli-animated-features-1202835389/

40 http://wildbunch.eu/company/

41 https://www.wildbunch.biz/about-us/

42 https://deadline.com/2021/06/studio-ghibli-wild-bunch-netflix-deal-gebeka-new-company-1234776975/

43 https://www.google.co.uk/search?q=the+informer&sxsrf=ALeKk00h3nXO4dXd4S680L748ecsAxvRmQ%3A1626449826265&ei=oqfxYLC1D4nekgW0t6K4CA&gs_ssp=eJzj4tVP1zc0TDPKyC7LTYo3YPTiKclIVcjMS8svyk0tAgCGRgmY&oq=the+infor&gs_lcp=Cgdnd3Mtd2l6EAEYADIICC4QsQMQkwIyAggAMgIIADIHCC4QhwIQF-DICCAAyAggAMgIIADICCAAyAggAMggILhDHARCvAToECCMQJzoECC4QJzoECC4QQzoKCC4QsQMQgwEQQzoECAAQQzoICC4QsQMQgwE6AgguOgUILh-CxAzoHCC4QsQMQQzoICAAQsQMQgwE6BQgAELEDSgQIQRgAUJf3Alia_gJg_oYDaABwAngAgAFxiAGJBpIBAzkuMZgBAKABAaoBB2d3cy13aXrAAQE&sclient=gws-wiz#cobssid=s

44 https://www.the-match-factory.com/about-us.html

45 https://deadline.com/2021/07/the-match-factory-michael-weber-thania-dimitrakopoulou-streamers-international-disruptors-1234792219/

46 https://reinvent.dk/about/

47 https://reinvent.dk/news/bjorn-runge-to-direct-sf-studios-new-film-adaption/

Appendix 2
International TV distributors

Fremantle Media

- Production and distribution company, part of RTL Group – leader across broadcast, content and digital
- Website boasts: 480 new shows, 12,000 hours of new content and 25 billion YouTube views per year
- Distribution: operate in 23 countries, reaching audiences in 180 countries. Alongside new content, also have one of the world's largest catalogues, totalling more than 40,000 hours.
- Content: known for talent competitions: *Idols, Got Talent, The X Factor* and game shows *Family Feud, The Price is Right* etc.
- Move towards HETV Drama – Fremantle Media CEO Cecil Frot-Coutaz 2017 – they diversified with a "scripted strategy"
- 2018 helped parent company RTL book record profits, bolstered by 8.5 per cent to $174 million for its full year financials[1]
- Series such as HBO's *The Young Pope*, Starz' *American Gods* and *Deutschland '83, Beecham House, Charité, Picnic at Hanging Rock, The Rain*
- Fremantle Media Enterprises (distribution division)

All3 Media

- Formed 2003 by Steve Morrison (former ITV Head of Programming), David Liddiment & Jules Burns (former Operations MD at Granada)
- 40 production companies based in the UK, the USA, Germany (All3Media Deutschland), the Netherlands (IDTV) and NZ (South Pacific Pictures)
- All3Media's distribution business, All3Media International exploits programme rights – offices in London, New York and Singapore
- All3 Media International – 15,000+ hours of content, 200+ territories
- Scripted content UK: *Midsomer Murders, Fleabag, The Missing, It's a Sin, Liar*
- Non-scripted: *Gogglebox, Gordon Ramsay's 24 Hours to Hell and Back, The Dog House*
- 2021: Synchronicity Films (*The Cry, Only You*) signed exclusive 'first look' deal with All3Media International for all upcoming scripted TV projects – Synchronicity more access to development financing options
- COVID-19: Maartje Horchner, exec. VP All3Media International – whilst there has been a "lack of physical markets" they have arguably spent more time virtually

with "broadcaster clients", "onscreen talent have been ... available to support with interviews for client launches".[2]

- March 2021: All3Media in late-stage discussions to buy NENT Studios UK (formerly DRG) – producer of *The Cry*. NENT unscripted shows: *Don't Tell the Bride, Catch Phrase* – All3Media would gain AVOD rights on its 13,500-hour library[3]

Banijay

- Produce and distribute – 120 prod. Companies across 22 territories – catalogue of 95,000 hours of content
- Founded 2008 by Stéphane Courbit
- Expansion – purchased Zodiak Media in 2016
- Endemol Shine Group in 2020 (upscaled territories 16 to 22, $2.2 billion deal) – put Banijay Rights in control of 88,000 hours of content, including *Big Brother & Masterchef*[4]
- Content: *Big Brother, Survivor, Deal or No Deal, Masterchef*
- Scripted content: *Wallander, Peaky Blinders, Black Mirror*

BBC Studios

BBC Studios Divisional Structure and Lines of Business

Performance by operating segment

	Sales (£ million)		EBITDA (£ million)	
	2019/20	2018/19	**2019/20**	2018/19
Production & Distribution	**1,059**	1,047	**75**	81
Branded Services	**385**	161	**111**	71
Eliminations	**(56)**	(19)	**(5)**	7
Total	**1,388**	1,189	**181**	159

- Formed April 2018 merging the BBC production arm with the distribution arm (BBC Worldwide). BBC Worldwide renamed as BBC Studios Distribution Ltd.
- The two divisions worked closely together on *Strictly Come Dancing* and *Blue Planet II* – echoing trend for vertical integration (like ITV, Banijay and Fremantle Media)[5]
- BBC Studios has 22 markets globally, 6 production bases in UK, production bases and partnerships in 9 other countries. Creating around 2,500 hours of content a year, BBC Studios has revenue of around £1.4 billion.[6]
- BBC Studios Production was the UK's most commissioned creator of new content in 2019.
- In 2019, BBC was the most-used UK media organization, used by 41 million people daily in the UK – reaching 91 per cent of UK adults and 81 per cent of children on average per week.
- Between 2019 and 2010, BBC also entered into new long-term partnerships with HBO Max in the USA, Yandex in Russia, and ZDF in Germany, in addition to an extended partnership with Discovery.
- In 2019, investments in programming increased 19 per cent from 2018 to 2019,[7] and the BBC adaptation of *His Dark Materials* was the biggest launch of any new series (reaching an average viewership of 11.4 million people). Similarly, the following productions also reached record viewers: The *Gavin and Stacey Christmas Special* (18.5 million viewers), *Line of Duty* series (13.2 million viewers), *Seven Worlds, One Planet* (9 million viewers per episode and more than 180 million views in China on the Tencent platform).[8] Only 20 per cent of the funding for *Seven Worlds, One Planet* came from the licence fee, with the remainder provided by the co-producers, BBC Studios Distribution and UK tax credits. It was filmed in over 40 countries and was the first BBC natural history programme to receive the full Albert certification of sustainability (a certification denoting sustainable production)[9]
- The success of BBC Studio programming can be seen in the recognition received, including over 700 commissions won since its launch three years ago. In the past year (2019–2020), BBC Studios won 77 new commissions, as well as 73 awards and 202 nominations.[10]
- BBC Studios took control of seven of UKTV's channels, as well as UKTV Play in June 2019 (BBC had previously been a shareholder in UKTV since 1997).
- The strength of BBC Studios, including the smooth implementation of the UKTV acquisition and merger, is demonstrated by its increased earnings: BBC Studios had 14 per cent growth in earnings before interest, tax, depreciation and amortisation (EBITDA) from £159 million in 2018–2019 to £181 million in 2019–2020, and BBC StudioWorks a 33 per cent increase in EBITDA (from £6 million to £8 million).[11]
- 2018 BBC Worldwide invested a 51 per cent stake in Sin Gentle Films Ltd. – *Any Human Heart, Whitechapel*
- February 2021 Showcase included: *This is Going to Hurt* (based on the best-selling memoir), *Earthshot: How to Save Our Planet* (Silverback Films in conjunction with Prince William's global environmental prize), *Top Gear Series 30*[12]
- Programming by BBC StudioWorks includes: (i) chat shows (i.e. *the Graham Norton Show* for BBC One, *The Apprentice: You're Fired* for BBC Two, *The Jonathan Ross Show* for ITV and *The Great British Bake Off: An Extra Slice* for

Channel 4); (ii) game shows (*Pointless* for BBC One, *The Chase* for ITV, *Don't Hate the Playaz* for ITV2 and *A League of Their Own* for Sky One); (iii) comedy shows (*Have I Got News For You* and *Mock the Week* for BBC One, *Celebrity Juice* for ITV2 and *The Russell Howard Hour* for Sky One); (iv) continuing drama (*EastEnders* for BBC One); and (v) live broadcasts (e.g. *Strictly Come Dancing* and *Children in Need* for BBC One, *Peston* for ITV and *The Last Leg* for Channel 4)

Entertainment One

- Canadian production and distribution company – serves as subsidiary of US toy manufacturer Hasbro (since December 2019)
- 2013: made deal with AMC Networks to handle international distribution of its original scripted productions e.g. *Halt and Catch Fire, Hell on Wheels* and *The Walking Dead*[13] … Deal ended in 2019 when AMC expanded their distribution business. However eOne will continue to distribute existing series as well as *The Walking Dead* and *Fear the Walking Dead*[14]
- February 2021: eOne to cut film & TV staff by 10 per cent following pandemic
- Upbeat about film and TV prospects and said it will invest "between $675 million and $750 million on content across scripted and unscripted live action, animated TV and film in 2021, up from $439 million last year".[15]
- Studio's film and TV highlights in recent years: *1917, Spotlight* and small screen productions/licensing deals for *Hell on Wheels, Fear The Walking Dead, The Rookie, Halt And Catch Fire, Designated Survivor*
- Steve Bertram, president Film & TV, attributed cutbacks to "shift in Film & TV business towards greater control & creative stewardship" over content, due to the changes in the "traditional studio model" and "creation of original content"
- October 2020: eOne winding down German theatrical operation – will no longer acquire films to directly distribute theatrically due to competition in the pricey market[16]

ITV Studios Global Entertainment

- 45,000 hours of content
- Known until 2020 as ITV Studios Global Entertainment
- TV library: *Prime Suspect, Agatha Christie's Poirot, Bodyguard*
- Independent productions distributed by ITV: *Ancient Egyptians, The Story Of Us, Seconds From Disaster*
- 2019 ITV Studios major distribution restructure – split into three pillars: Creative Network, Global Entertainment & Global Distribution[17]
- Creative Network: leverage business's unscripted format labels in major format export countries – all formats IP feeding into the division
- Global Entertainment – focus on international format sales (unscripted), licensing unscripted formats
- Global Distribution: drama & finished tape-focussed, HETV drama financing & co-production – oversees *World On Fire, Noughts & Crosses* and *Romulus*

- Global Entertainment represents catalogues of Talpa Media, Twofour, Armoza Formats, ELK. Home to hit shows: *The Voice, Love Island, The Chase, I'm a Celebrity Get Me Out Of Here, Come Dine With Me*[18]

Sony Pictures Television

- US TV production and distribution studio founded 2002 – successor to Columbia TriStar Television, Screen Gems & Pioneer Telefilms.
- Is a division of Sony Entertainment's Sony Pictures Entertainment
- Is one of the television industry's leading content providers (SPT produces, distributes and carries programmes worldwide in every genre and for every platform).
- In addition to Sony Pictures Entertainment library – own and distribute shows from Tandem Productions, ELP Communications, TeleVentures, Four D Productions etc.
- SPT owns production or distribution rights for many long-running comedies and dramas, including: *Seinfeld, Community, Breaking Bad, The Blacklist, Bewitched, Shark Tank, Jeopardy!, Wheel of Fortune*, NBC's *Days of our Lives*, and CBS's *The Young the Restless*.
- 2020 – hosted its own LA Screening Portal in April and dropped out of Mipcom (along with BBC Studios, eOne, Fremantle and ITV Studios)
- February 2021: Sony Picture Home Entertainment and Lionsgate announce agreement in which Sony will handle distribution services for Lionsgate physical home entertainment releases in the USA and Canada[19]
- Current popular content by Sony Pictures Television include: *The Blacklist* (streamed on NBC), *The Crown* (streamed on Netflix), *Call Your Mother* (streamed on CBS All Access and ABC), *Cobra Kai* (streamed on YouTube Premium and Netflix), *The Good Doctor* (streamed on ABC), *Better Call Saul* (streamed on AMC), *Breaking Bad* (streamed on AMC),
- Channels owned and operated by SPT include Sony Channel, Game Show Network (launched December 1994), Sony Entertainment Television (launched September 1995), AXN (launched June 1997), Animax (launched May 1998), Sony Movie Channel (known as Sony Movies in Ireland, and launched October 2010), GetTV (launched February 2014), Sony Movies Action (launched 19 January 2012), Cine Sony Television (launched August 2012), and Viasat 3 and Viasat 6.
- In the past decade, SPT has acquired a number of other companies, including Film 1 (March 2015), CSC Media (May 2015), Funimation (July 2017), and Silvergate Media (December 2019). SPT now operates 21 wholly-owned or joint venture production companies in 12 countries.
- In addition to producing its own content, SPT also picks up third-party content for distribution. *Dragons' Den* – a local Japanese production from Nippon TV which SPT then picked up and developed as a global franchise – is one prime example of this.

Cineflix

- In partnership with Participant
- Catalogue of over 5,000 hours of content[20]
- Cineflix Rights is the UK's largest independent TV content distributor – content to over 500 broadcasters and platforms
- Smaller outfit – team on 30 staff overseeing shows, e.g. Apple's *Tehran* & ITV/Netflix series *Marcella*
- March 2021 Tim Mutimer, Banijay Rights' exec. VP was made the new CEO of Cineflix Rights.[21]

Passion Distribution

- Specialising in unscripted content
- Founded in 2008 and became part of Tinopolis Group in 2012 – integrated catalogue of *Robot Wars, Worst Driver, An Idiot Abroad, Big Fat Gypsy Weddings* and *Paradise Hotel*
- International hit shows: *RuPaul's Drag Race, Dynamo, Magician Impossible* etc.[22]

TVF International

- Leading independent factual distributor in the UK
- Strong presence on international festival circuit, attending major markets and events[23]
- Created *The World This Week* – award-winning current affairs show on Channel 4

Distributors – the new producers?

eOne Television International president Stuart Baxter – international shows are now more expensive to make and broadcasters in individual markets are paying less towards them – distributors now taking on more "financial risk" and thus require more influence over the shows[24]

International market events

Rise of distributor showcases

- NATPE in Miami (Jan); Series Mania in Lille (March); MipTV in Cannes (April); the LA Screenings (May); Serie Series in France (June); Discop in Africa (July); the Edinburgh TV Festival (August); Le Rendez-vous in Biarritz (September); Mipcom (October); AFM in Santa Monica (November) & Asia TV Forum (December)

The National Association of Television Program Executives (NATPE)

- The largest US-based global content association
- Established 1963 – professional association of TV executives, networking activities and events
- Initially created to resolve challenges as result of Prime Time Access Rule

- 2010 rebranded as NATPE Content First, pursuing new media and tech speakers as well as TV members
- The Educational Foundation founded 1978 promote educational activities – seminars, grants etc. to help students prepare for a future in TV
- Launched a streaming event September 2020 – NATPE Streaming Plus conference to facilitate conversation for the streaming industry – top execs from FOX, Pluto, Tubi, Univision & More
- NATPE attracted 400 exhibiting companies, and its dominant position indicates that there is "no room for big additional markets" in the US according to J.P. Bommel. Growth comes from targeting specific comminates or locales

The London TV screenings

- London-based international distributors = All3Media International, Banijay Rights, Entertainment One Fremantle & ITV Studios showcase latest and unscripted fare (virtual in 2021 but plans to return physically in 2022)
- Jens Richer CEO of Fremantle International says it allows "distributors to kick off their slates at the top of the year" & Stuart Baxter, eOne's president of international distribution. Says "essential event" presents opportunity to connect with clients in the first quarter
- eOne: major US shows *Designated Survivor, The Rookie, Deputy* – 2021: *The Newsreader, Cruel Summer*
- ITV new dramas: *Harry Palmer: The Ipcress File, Grace, I'm a Celebrity*
- Fremantle: showcase *Anna*, SA crime thriller *Reyka, Cargo*
- Banijay Rights newly combined 88,000-hour catalogue

MipTV (Marché International des Programmes de Télévision. Founded 1963 and based in Cannes (April)

- 2020 attending companies – All2Media, NBCU, Lionsgate and Sony
- 2021 scheduled online – 'Digital MIPTV' – create an online profile, browse and request meetings, join & rate meeting partners (-digital pass fee 250 euros)
- Struggled to adapt to changes in international TV – rise of streaming services and increasing importance of local production
- Also faced new competition from London Screenings – All3Media, Fremantle, ITV Studios, MGM and Sony present new shows to buyers and TV festivals e.g. Series Mania in Lille & TV sidebar of Germany's Berlin Film Festival.

Mipcom – Marché International des Programmes de Communication

- Founded 1985, based in Cannes
- days of networking, screenings and conferences set to go ahead in person (October 2021)
- 250 high-level speakers from around the world
- 13,500 participants, 4,700 buyers and commissioners, 240 investors, 2,330 distribution and production firms
- https://www.mipcom.com/en-gb/what-is-mipcom/attending-participants.html

No. of Buyers & Commissioner by genre

No. of Buyers & Commissioner by type

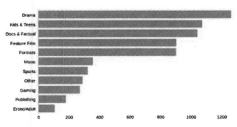

No. of Production Companies by genre

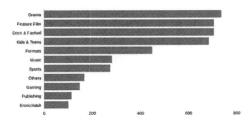

No. of Distribution Companies by genre

LA screenings

- Moved virtually in 2020 in May & September
- Set to take place virtually in May 2021 – co-organised by Prensario & NATPE
- 4,000+ participants, 1,500+ buyers, 125+ countries, 50+ exhibiting companies

MipTV vs Mipcom

- Both MipTV & Mipcom run by organiser Reed Miden – used to be 'joined at the hip' but now operate separately (rather than having to book a space at both events, as Mipcom is more popular among US networks e.g. Disney fits schedule better after new programmes are presented to LA Screenings in May)
- 2020 top TV distributors such as Fremantle, ITV Studios and Banijay pulled out of MipTV after separation

The rise of London screenings

- The latest blow to MipTV has been the increasing profile of the UK Screenings in February, a week-long series of events from distributors, including eOne, ITV Studios, All3Media, Lionsgate, ViacomCBS, Warner Bros, Banijay Rights and NBC Universal.
- Recent years more focussed on May's LA Screenings and October's Mipcom market
- Since 2016, the London events have grown in stature, piggybacking on BBC Studios' BBC Showcase in Liverpool, which brings in hundreds of international buyers (700 acquisition execs) from all over the world.
- International boom and move away from using US content to fill schedules – local events assume greater importance and arguably even makes LA Screenings in May less vital (for UK).

- Greg Johnson, ITV Studios executive VP of sales and distribution, says that London Screenings are important, as "a by-product of the U.S. studios clawing back content for their platforms is that our long standing linear broadcast partners and their catch up VOD services are even hungrier for content"
- TV is simultaneously becoming more local and more international

C21 London

- Content London plans to return as a real-life event between 29 November and 2 December 2021, bringing the global drama, factual, formats and kids' communities back together
- The two-venue event will host the market-leading International Drama Summit, Formats & Factual Forum (previously the Unscripted Entertainment Summit) and Kids Content Futures.

Other smaller market events...

- NATPE Budapest
- MipCancun
- Real Screen Summit
- Discop Abidjan
- Discop Johannesburg
- ATF
- New Europe Market

Notes

1 https://deadline.com/2018/03/fremantlemedias-high-end-drama-push-helps-bolster-parent-group-rtl-1202313299/
2 https://www.c21media.net/all3media-international-embraces-the-new-normal/
3 https://variety.com/2021/tv/global/all3media-nent-studios-uk-drg-1234939805/
4 https://deadline.com/2020/07/banijay-rights-will-inhale-endemol-shine-international-1202995581/
5 https://deadline.com/2017/11/bbc-merge-bbc-worldwide-bbc-studios-into-1-9bn-company-1202216337/
6 https://variety.com/2019/tv/global/paul-dempsey-to-lead-bbc-studios-global-distribution-business-1203289206/
7 http://downloads.bbc.co.uk/aboutthebbc/reports/annualreport/2019-20.pdf#page=46
8 http://downloads.bbc.co.uk/aboutthebbc/reports/annualreport/2019-20.pdf#page=13
9 http://downloads.bbc.co.uk/aboutthebbc/reports/annualreport/2019-20.pdf#page=55
10 http://downloads.bbc.co.uk/aboutthebbc/reports/annualreport/2019-20.pdf#page=46
11 http://downloads.bbc.co.uk/aboutthebbc/reports/annualreport/2019-20.pdf#page=46
12 https://www.bbc.co.uk/mediacentre/bbcstudios/2021/bbc-studios-reveals-agenda-for-showcase-2021
13 https://deadline.com/2013/09/eone-amc-networks-ink-multi-year-international-output-deal-for-scripted-series-578772/
14 https://deadline.com/2019/05/eone-amc-deal-1202619751/
15 https://deadline.com/2021/02/entertainment-one-to-cut-film-tv-staff-by-10-read-the-memo-1234690503/

16 https://deadline.com/2020/10/entertainment-one-winding-down-german-theatrical-operation-1234601745/

17 https://tbivision.com/2019/10/01/itv-studios-kickstarts-major-distribution-restructure-as-talpas-john-de-mol-exits/

18 https://tbivision.com/2020/07/10/itv-studios-global-entertainment-names-dan-exec-arjan-pomper-as-coo/

19 https://www.prnewswire.com/news-releases/sony-pictures-and-lionsgate-team-up-on-new-multi-year-physical-home-entertainment-distribution-agreement-301236580.html

20 https://cineflix.com/about-us/

21 https://deadline.com/2021/03/banijay-rights-tim-mutimer-ceo-cineflix-rights-1234718128/

22 https://www.passiondistribution.com/about/

23 https://tvfinternational.com/about-us/

24 https://tbivision.com/2018/10/24/distributors-the-new-producers/

Glossary

AVOD advertising-based video on demand AVOD is free to consumers. However, much like commercial broadcast television, consumers need to sit through advertisements. AVOD is applied by Dailymotion, YouTube and 4OD.

Above-the-line Usually refers to the key cast, director, writer and producer of a project. These are considered above-the-line costs in a film's budget.

Adjusted gross receipts formula The same deal as in the gross receipts formula, but with costs taken off the top. Normally used to refer to gross receipts less all distribution costs through the exploitation chain.

Admissions Term detailing the audience numbers of a film through its theatrical release in cinemas.

Advance A term used to describe a sum of money paid to licence or acquire rights to a film. An advance may be paid prior to a film's production, during production, on completion and delivery, or after its completion. Also referred to as a 'minimum guarantee'.

Acquisition The licensing of a film's distribution rights with a view to exploiting those rights and creating revenue streams in the process. Normally undertaken by sales companies, distributors and studios, and buyers of library rights, etc.

Ancillary markets Generally meant to describe any markets outside of the film industry's original one of theatrical exploitation in cinemas. This is usually home video or television, but includes airlines and shipping, etc.

Ancillary rights Film rights beyond the theatrical release, including but not limited to DVD, VOD, Pay TV, Free TV.

Angel investors Individuals who invest in projects on a one-off basis rather than as part of an overall strategy, and have low overheads and tend to trust their own judgement and instincts on an investment.

Approvals Rights normally exercised by a financier over a range of critical elements when agreeing to finance/invest in a film, including over the script, budget, director, producer, key lead actors, heads of departments, etc.

Assumptions A key component of a business plan, particularly as it is one of the most contentious. Assumptions are dependent on the managers'/entrepreneurs' commercial estimates (at their simplest) of costs versus income, next to timelines. Assumptions are the strategic a priori positions the business managers take on the different variables necessary for the running of the business, such as budgets, numbers, level of commissions, projected fees, P&A budgets, etc.

'Avids' Denotes a type of audience member that is a regular filmgoer compared to the rest of the population.

Award Kickers Pre-agreed bonus payments made by the distributor to the producer/financiers if a film wins Oscar nominations, Oscar awards or a range of cited academy awards and festival prizes.

Back-end The profits generated by a film after all costs have been repaid and said film reaches the cash break-even point. However back-end is sometimes also defined more broadly as a participation in the revenues generated by the distribution of a film, and in the case of certain talent this may come before the film itself reaches break-even.

Balance sheet A financial statement that lists the assets, liabilities and ownership equity of a business. It is meant to provide a snapshot of a business at a specific point in time, usually the end of the year.

Below-the-line Usually refers to the direct costs of a production, and cast and crew hired once the pre-production stage is underway.

Block booking The practice, now illegal, of selling a group of films to an exhibitor as a 'block' or single unit. It was prevalent among studios until outlawed by the *United States v Paramount Pictures* Supreme Court decision of 1948.

Board A team including executive directors and non-executive directors, plus company secretary that oversee a company's operation. Executive directors run the company on a day-to-day basis. Non-executive directors attend board meetings and advise on the overall strategy of the company.

Box office The gross income generated by cinema ticket sales collected by the exhibitor.

Box office bumps Pre-agreed bonus payments triggered by a film reaching certain milestones at the box office. The bonus may be calculated against US box office, international gross exhibition receipts, or worldwide gross receipts.

B2B: Business-to-Business Transactions, contracts and exchange of services and/or goods between one industry sector's chain to the next, normally within the value system of a sector. For example, film sales-to-film distributor; film producer-to-online platform, etc.

B2C: Business-to-Consumer Transaction, contracts and exchange of services and/or goods between an industry sector's chain to the user/customer/audience. For example, cinema to ticket buyer; online platform to subscriber, etc.

Business model The strategic framework that outlines how an idea/company/partnership can generate money. A business will use such a model to potentially create value in the marketplace.

Business plan A plan of the cash flow, returns, costs and sources of revenue for a business, often expanded to cover a projected five years of lifetime for the business. Will include an executive summary, business opportunity and model, exit strategy for investors, market analysis, management team, organizational structure, assumptions and financials, etc.

Buzz A marketing measure designed to represent the amount of discussion and public interest an upcoming film is generating, mainly by tracking internet outlets such as blogs.

Cash flow A term used to refer to the movement of cash within a business. It is a particularly useful concept in determining the liquidity of a business and whether it can meet overheads and debtors.

Cash-flow statement A financial statement meant to show how the company will manage incoming revenues into the business as related to its outgoing costs. This is often done on a year-by-year basis or weekly in more detailed cash-flow plans. The cash-flow statement should reveal the point at which the company will be most in the red throughout the operation of its business, a key component in deciding the amount of capital the business will need to operate.

Catchment area The radius around a cinema from which an exhibitor can expect to draw an audience, taking into account drive times, competitors and location.

Chain of title The documentation that establishes the producer's ownership of the rights in the script and original source material (e.g. novel), and which entitles the producer to produce, market and exploit the film. This set of documents usually includes the scriptwriters' agreements, development agreements with funding agencies and options or rights assignments. In some cases, the set comprises many documents, especially where a project has been in development over a long period of time, or where the script has been adapted from other sources, or where a number of writers have contributed to the script.

Classification The practice of assigning different age ratings to movies in order to denote the intended audience for a given film and keep younger audiences from watching mature content. In the USA, this is governed by the MPA and was originally a pre-emptive measure to avoid censorship from government.

Closing A term used to describe the final documentation for a film's production being fully completed, which in turn triggers cash flow to the production.

CNC Centre National de la Cinematographie, the main government body administering France's film industry regulations and practices, as well as funds intended to support said industry.

Completion guarantee Also known as a completion bond, this is a legal undertaking by a guarantor that a film production, based on pre-approved specifications, will be completed and delivered by a certain date in the financiers' contract with the producer. The Completion guarantee is not an insurance bond. The guarantor commits to finding the best way for a project to reach completion, or for the film's financial partners to agree to a 'strike price', the amount needed to cover remaining costs, after which the film will be completed and delivered by a certain date by the producer.

Concept poster A poster meant for business-to-business marketing conveying the idea and 'feel' of a project in order to raise funds, before it goes into production.

Concession sales Sales at cinemas that do not come directly from selling film tickets, such as drinks, sweets and popcorn.

Co-production Films that involve more than one party in the production process, through co-operation as a joint venture or partnership. Most typically, the term is used to describe a film that is made under an officially sanctioned co-production treaty, enabling two or more territorial producers to access their own sources of finance (subsidy, broadcasters, distribution advances, etc.) and enable them under the treaty to co-finance and co-produce under agreed percentages pertaining to finance contribution, cast and crew, national spend and cultural points.

Co-producer. Co-producer is an industry term that describes a producer who teams with another producer/production company to make a film. Normally, a co-producer works with a lead producer through a joint venture or partnership.

Counter-programming The practice of releasing a film with a target audience different from that of another major release that weekend, usually during a spot in the calendar that is in high demand.

Coverage A document that analyses a screenplay on behalf of a production company and recommends 'passing' on the property or considering it for investment or at least further development. Some coverage documents have detailed script notes sometimes used by producers in the development process.

Cross-collateralization A method by which companies that have bought rights licences can 'cross' these separate rights in their accounting so that the gains in one offset the losses in another. For example, a distributor that has the rights to a film in both France and Italy, and makes money in one territory and losses in another, can use the gains in one to offset the losses in another before handing overages to a producer or sales agent.

DCP A Digital Cinema Package (DPC) is a collection of digital files used to store and convey digital cinema (DC) audio, image and data streams.

DCPs (also) digital platform companies such as Amazon, Apple, Facebook, Google and Netflix.

Day and date release Describes the simultaneous theatrical release of a film across a range of territories. Also used to describe a release strategy for a film in which a title is released simultaneously in its theatrical and home entertainment formats, with no 'windows' system.

Delivery The contractually agreed point at which a distributor acknowledges full technical receipt of a film (creative, legal and technical), normally delivered via a producer/sales agent, and begins its task of releasing and marketing the film. If a producer or sales company gives a distributor 'notice of availability' then the film is fully completed and is ready to be delivered to the distributor.

Development The stage and process that turns source material (an idea, a novel, an article, a play, etc.) into a film package/project ready to go into production. Putting together the package, including script, budget, director and cast, is usually the main responsibility of the lead producer of a film. In development, an original idea is developed from a screenplay, or rights to an existing property are acquired (such as a novel). Writers are contracted to develop a screenplay, often over a series of drafts. Script editors are also often utilized by the producer to support the creative development process. A budget and a schedule are created as essential tools to plan and implement the production of a film. Key personnel are decided on, most importantly the cast, as they will form an essential marketing element of the film when the project reaches the marketplace. In the studio business model, the development work is at times undertaken by a development executive. Most often, however, it is carried out by an outside producer/production company who pitches the project to the studio for financing or who has an on-the-lot deal where the producer's overhead and a sum of development money is covered. In return, the studio has control over the rights and a "first look" at material before rivals can see or consider it for production. If the full creative and commercial package put together by the producer with support from the studio is approved, it will be deemed "green-lit" and placed into production. In the independent business model, the producer will need to build a package in order to attract financing for a film. Development is often a process that takes at least a year, but can often continue for multiple years. Film producers and established production companies

build up a network of creative contacts, including agents, writers, directors and actors, etc. that enable them to develop and package films for financing and distribution. This demanding and complex process lies at the heart of the producer role. It is widely seen as the critical building block of the filmmaking process, and one normally driven by the producer.

Digital inter-positive A digital copy of a film before a 35mm film print is struck for theatrical exhibition. It is considered more flexible to edit than the old film inter-positives.

Digital rights management (DRM) An umbrella term that refers to any technology intended to protect digital content from piracy or unlawful access.

Direct-to-Consumer (D2C) Monetising via advertisements or subscriptions.

Distributor A distributor of a film is any company that acquires the license to exploit a film title's rights for an agreed territory. The territory can range from one country, multiple countries to the entire world (e.g. Hollywood Studios). Distributors are therefore the final intermediary between a producer and the exhibitor that will show the film on its screens.

Domestic A key geographical sector of the film market that usually refers to the United States (and also commonly Canada). Together, they are referred to as 'North America'. Its economic power and large audiences makes it a key territory in film contracts, although a hard one to break into outside the Hollywood majors. Confusion arises when other territories are referred to as domestic, so that UK producers and distributors would consider that to be their 'domestic market'.

DVD Or 'digital versatile disc'. This is a format for storing images and sound that uses an optical disc to store larger amounts of data than the similar CD-ROM. Almost effectively redundant in the market today due to online streaming of content and cloud storage of filmed data.

Electronic press kit The digital/video tape version of all marketing materials, often included in a CD-ROM or DVD. Will include interviews with director, stars, etc., and key sound bites cut for out-takes on TV, etc.

Elements The key components of a film's package: director, producer, cast stars, script, budget, etc. The term is also used to describe key elements of a marketing campaign, usually referring to stars, notable crew, genre or other outstanding features. When describing key talent, they are sometimes referred to contractually as 'essential elements' which has considerable impact on contracts.

Entrepreneur An individual who is initiator, owner and leader of a business venture and therefore often has a large stake in seeing it succeed. Normally, they step to one side and appoint day-to-day managers once a new venture is launched. Also refers to an angel investor whose primary source of wealth was through leading businesses in this manner.

Equity In the film industry, a term that describes film investment (not loan finance) that, in return for investment, controls a portion of a film property normally through control of revenue streams. Equity is normally recouped after all senior debt and gap finance has recouped. Equity will often negotiate a premium to be paid in addition to its principal, prior to a film reaching cash break-even. Equity investors have a different relationship to the producer in contrast to lenders/financiers, as they act as partners/investors who share an alignment of interest, in contrast to financiers, who are normally 'last in, first out' in the recoupment waterfall or who have offered mezzanine/gap finance rather than equity investment.

Eurimages The pan-European fund for multilateral co-productions. To qualify projects have to be signatory members of Eurimages, the only major European territory not currently a signatory being the United Kingdom. Founded by the Council of Europe (and not the European Union), it is based in Strasbourg. Eurimages also provides distribution support in addition to production funding.

Exhibition The stage of the film value chain where films are exhibited at cinemas, often referred to as 'theatrical'. Exhibition is generally considered a retail business, different in terms of commercial forces from the rest of the film value chain.

Exit For an investment, the point at which an investor's capital invested is returned and he exits the business. Often described as five years in most business plans, but some investors look for much faster exits, such as (typically hedge funds). A subject of much strategic debate post the financial crisis.

Facility deal A deal where an investor provides facilities in exchange (or part) for copyright ownerships in a film, usually referring to post-production houses lending a production their services for free or a cut rate in exchange for an equity position.

Film copyright The copyright created by the making of a filmed production. Copyrighted elements included in the film may comprise the soundtrack, costumes or characters. These rights are exploited by their licensing to third parties.

Film franchise A term relating to the intellectual property involving the characters, settings and trademarks of an original film. This is built by creating a series of films and promoting its characters, settings and trademarks through advertising and merchandising. Film franchises thus often cross over to other forms of media and different types of products.

Film licensing agreement Term referring to the standard agreement between a distributor and exhibitor, detailing the film rental fee, the split of gross box office takings that the exhibitor will pass on to the distributor, after taxes.

Film value chain This term applies to the chain of processes, including the key creative and financial steps that are undertaken through conception to completion of a film product. Ultimately, each step theoretically adds 'value' to a film product, enabling completion and ultimately its delivery to an end-user. (See Porter, M. In Bibliography)

Finance Film finance is the term that defines loans towards a production or slate of productions provided against as high a position of security as possible. Film finance may be able to negotiate some back-end financiers' share of net profit, but it has no interest in the underlying rights of a film once its loan and cost of the deal has been repaid.

First Dollar Gross Deal A participation based on Adjusted Gross Receipts, calculated by deducting the 'off the tops' in the first place, so that a First Dollar Gross is a percentage of 'Adjusted Gross Receipts'. ('Off-the-tops' refer to specific deductions taken from Gross Receipts in calculating Adjusted Gross Receipts, namely checking, collection, currency conversion, trade dues, taxes and Residuals.) A true First Dollar Gross Deal does not deduct Prints & Advertising costs or distribution fees before calculation of the revenue share and direct payment to the benefactor.

Floor The maximum share of the gross box office paid by the exhibitor to the distributor, after taxes.

Foreign, or international Considered to be defining any territories outside North America. An 'international' sales agent, then, is a company whose business model is predicated on handling rights outside North America.

Four wall deal A deal made with an exhibitor in which a screen is completely rented out by the distributor, so that all receipts go straight to that party. The exhibitor only charges a small administration cost. Rare, unless a distributor is trying to show the film in a minimum number of screens to qualify it as a theatrical picture.

Free TV A television business model that is 'free', as the main source of revenue is from advertising or arguably public licence fee, rather than directly from viewers paying commercial subscriptions or pay-per-view fees.

GATT The General Agreement on Trade and Tariffs, signed in 1993, which left out film and television audio-visual productions due to the inability of the USA and Europe to come to a satisfying agreement on whether film should be treated as a cultural or commercial product.

Genre The 'type' of narrative or thematic convention followed by a motion picture, e.g. horror, thriller, romantic comedy, action-adventure, Sci-Fi. Drama is often cited as a genre, but is not strictly speaking a type of narrative convention. Often a key component in a film's marketing strategy, and is used extensively by online platforms, etc. today to position content.

Greenlight The point at which a film or movie is given the go ahead by its financiers/ investors to begin drawing cash flow from the production account and start the production process. Often a green light decision will be based on a combination of budget; pre-sales; sales estimates; agreed recoupment order – with a range of possible outcomes via projections made available to those taking the green light decision. For example, one would expect a 'high', 'medium' and 'low' set of projections to be prepared and considered prior to a decision being taken.

Gross box office The amount of takings (usually expressed in dollars) a film makes during its theatrical run, including taxes. This is also before cinemas have taken their share and/or costs, leaving a 'rental figure' that is paid to the distributor.

Gross receipts formula An arrangement between distributor and exhibitor where the distributor receives a specific percentage of box office receipts for a film, with the percentage dropping over time as the exhibitor keeps holding on to the movie.

Hollywood Once a specific geographic location where all of California's current five studios are based, the term now loosely refers to the Los Angeles-based film community and the studio system.

Home entertainment Also known as ancillary rights (see above), this term is becoming outdated due to digital technology and multiple devices beyond the TV screen and VCR, in particular Video On Demand (VOD). Traditionally, it has referred to video, DVD and television.

Home video A film or other media that is rented or bought in order to be used privately at home. The term 'video' was originally meant to describe the mode of delivery, the VHS or Betamax tape, but now most commonly refers to DVD. The term has been uncomfortably adapted to include 'video-on-demand', which applies to the availability of films via the internet.

Horizontal An approach of looking at the exploitation of film rights across independent territories where those rights may be exploited separately from other geographically defined territories or apply to entire footprints, such as Universe, World, etc.

House nut Also called the 'house allowance'. The basic costs of running screenings for a film, which the exhibitor takes out of the gross box office take for that film.

In-kind Payment to a production that is based on goods and services provided, rather than cash which the producer can draw from an account.

Intellectual property rights Intellectual property (or IP) refers to creative work (of the mind), which can be treated as an asset or physical property. Intellectual property rights fall into four main areas: copyright, trademarks, design rights and patents.

Intangible asset An intangible asset is an asset that lacks physical substance. Examples are patents, copyright, franchises, goodwill, trademarks, and trade names, as well as software. This is in contrast to physical assets and financial assets.

Internal rate of return Most commonly referred to as IRR, the annualized effective compounded rate of an investment, the return that an investment returns to its investor each year from said investment, as described by a percentage of the original.

Investment Film investment is money invested in a film with a view to being recouped behind finance in the recoupment order, but taking a share in the back-end of the film's profits in perpetuity.

IPR Intellectual Property Rights (IPR) is a legal definition of property rights over the creations of the mind. The creative industries primarily revolve around the exploitation of intellectual property rights.

Library of rights A collection of rights to productions that have gone through their first cycle of exploitation (meaning all 'first-run' windows, from cinema to Free TV), owned by a company in the film business in order to cash flow future productions or leverage to raise money and expand on further investments.

Loan capital Money raised for a business through the acquisition of a loan, to be repaid at a later date together with interest accrued.

Logline The description of a project in either one or a few short lines, often as an introduction to a treatment or script when presented to financiers or distributors.

Manager An executive director, appointed by a board to run a company on a day-to-day basis. Many have a stake in the company, through either shares or share options.

Market screenings Screenings are often set up by sales agents at a market in order to show a film, portions of a film, rushes or promos to distributors and thus secure a deal. Screenings can be restricted to distributors of certain territories or specific distributors within a territory. Most market screenings still take place at the Cannes, Berlin and the American Film Market, but they have also shifted to using online methods of screening films to buyers over the past five years, such as Vimeo.

Metaverse(s) The word "Metaverse" is made up of the prefix "meta" and the stem "verse"; the term is used to describe the concept of a future iteration of the internet, made up of shared, 3D virtual spaces linked into a perceived virtual universe.

Minimum guarantee Also termed an 'Advance', this is an advance payment to the producers of a film by rights-based financiers in exchange for the rights to a territory or territories. Minimum guarantees are usually based on expected receipts from the exploitation of rights in those territories.

MPAA (or MPA) The Motion Picture Association of America, the body founded in 1922 to represent the business interests of the six major studios.

Multi-Channel Network(s) (MCN) A multi-channel network (MCN) is an organization that works with video platforms to offer assistance to a channel owner in areas such as product, programming, funding, cross-promotion, partner management, digital rights management, monetization/sales, and/or audience development in exchange for a percentage of the ad revenue from the channel.

Multiplex A physical complex (building) comprising multiple screens, generally ten or more. The multiplex concept began in the United States in the 1970s and 1980s, with the development of larger malls and big box stores like Walmart. Some multiplexes, such as the Kinepolis in Brussels, have as many as 20 screens.

Net profits Returns after taxes, exhibitor's cut, distributor's expenses and fee, collection agents' fees and royalty, sales agents' expenses and royalties, and the production budget and costs of financing have been taken off. Given all these parties to be paid beforehand, reaching break-even point and profitability is a challenging task in the film business.

New media A catch-all term, now very outdated given that much of this media has existed for a number of years. It is meant to define new forms of delivery of media, such as video-on-demand, Internet Protocol television (IPTV), mobile/cell phone film downloads streaming, the cloud and digital projection.

Off-balance sheet financing A form of funding that avoids placing an owner's equity, liabilities or assets on the company's balance sheet. Generally, this is achieved by placing these items in some other company's balance sheet.

On-the-lot deal A deal where a production company has offices on the lot of a studio and usually has its development costs and annual overheads paid by said studio.

Opening weekend The first weekend of release (normally counted over three days of takings, including Friday) in theatrical exhibition of a film production, usually in its domestic market by also worldwide given day and date releasing patterns today. Thought to be the most important determinant of a film's eventual success at the box office, although this tends to apply to studio and larger budget pictures rather than specialized product.

Overhead The direct cost of running a business, be it office space rental, office materials, travels, etc. For example, for a sales agent these would be the main office, costs of paying staff, travelling to festivals and markets, and creating initial promotional materials. Some of that overhead is offset by sales and marketing budgets, which allow the sales company to effectively reclaim marketing costs to an agreed level, and apportion main market overheads against its slate of films.

Over the top (or OTT) An acronym or term that refers to material that's distributed directly to viewers over the Internet. OTT is a subset of VOD (Video On Demand) which also includes cable and satellite services. The increasing move towards OTT content simultaneously frees consumers from cables, geographic restrictions and broadcast schedules, and fundamentally changes the way video is monetised and consumed.

P&A budget The budget a distributor will use to release a film at theatres, referring to 'prints and advertising', i.e. the cost of new prints and the advertising needed to support the release of those prints. The 'prints' part of the formula might become outdated with the introduction of digital distribution.

Package A collection of the essential elements of a film, usually including the screenplay, producer, director, budget and lead cast.

Packaging Often this term is used in reference to talent agents, who put together a 'package' in order to raise finance and distribution for a project. It can also be used to describe multiple titles being packaged together, mainly for sale to a distributor or in home entertainment.

Pari passu A Latin phrase meaning 'in equal step', referring to a recoupment order where investors recoup equal to all other investors.

Pay-TV A television business model that is based on a subscription service and/or pay-per-view. Usually offered by cable and satellite channels.

Peer-to-peer (P2P) A system of networking computers so that the resources of the whole network can be pooled together, usually for the purposes of file sharing. Unlike client–server networks, a central server or host is not needed.

Pitch The strategy and presentation used to sell a project or idea to financiers, sales companies and distributors. Actually, each part of the player value chain finds itself pitching to each other (e.g. distributor to exhibitor, sales to distributor, sales to financier, producer to sales, etc.).

Platform A segment of the audience to which the film will initially be targeted and from which it can ideally be launched to pick up wider audiences. Ultimately, the aim is to widen to become a 'cross-over' hit.

Playability A film marketing term meant to determine how much a movie will satisfy its core audience, and the chance of repeat viewings from that audience.

Points A term used when referring to the percentages of net profits allotted to each investor and, separately, the producer of the film. A typical split for an independent film would be 50 points shared by financiers/investors (with equity financiers taking a larger share, and financiers normally taking much less) and 50 points shared by the producer, out of which they will award (normally negotiated prior to signature of contracts) 'talent' meaning writer(s), director and lead cast points to be paid from their share of net. Points can also be awarded for services rendered, as is sometimes done for line producers, executive producers and heads of departments (HODs).

Pre-production The stage of filmmaking where preparation for the shooting period begins, generally meant to be funded by cash flow from the production account but often drawdown comes very late in independent film productions. During this period, a full team is put together, and salaries are paid to the production staff to begin prepping their work.

Pre-sales Sales made to distributors (or a studio) worldwide/internationally/per territory prior to the film beginning production and/or prior to delivery, therefore contributing to the budget and immediate recoupment of said film. However, true pre-sales are made prior to production and are achieved by the producer and/or sales company, and become part of the closing of the finance.

Print A copy of a filmed production meant for theatrical exhibition developed from the dupe negative, developed from the inter-positive print, itself developed from the original film negative.

Private Internet Media Gateway (PIMG) A media gateway is a translation device or service that converts media streams between disparate telecommunications technologies. Media streaming functions are also located in the media gateway.

Producer A film producer is the 'project manager' of the process of creating a feature film or TV show/documentary. He or she is usually the first person involved in a project and the last person to follow it through to completion. The producer initiates, co-ordinates, supervises and controls matters such as fundraising, hiring key personnel and arranging for distributors. The producer is involved throughout all phases of the filmmaking process from development to completion of a project.

Production Divided normally into three different but sequential stages: pre-production, principal photography and post-production. When implemented and completed, the stages enable the physical creation of a film for exploitation.

Production screening A preview screening of a film that is not near completion and will probably be missing visual effects, soundtrack or an editing polish. These screenings attempt to gauge an audience's reactions to specific aspects of a film that could be improved before the film's edit is locked.

Profit and loss account A financial statement that describes how the company will transform revenue into net income, by showing the sources of revenue and the costs that will have to be taken out for the business to be operational.

Pro-rata Money recouped in proportion to money invested in a film project, i.e. if an investor has put up half the budget of a film, the pro rata share would be 50 per cent.

Quota protection Protecting a local market by imposing quotas that limit the number of films foreign to that market that are allowed to be screened in it.

R&D Research and development, an upfront initial investment normally described as sunk costs in order to research possible innovations and practices necessary for the success of the business.

Recoupment position The placement of each party's repayment from the film's revenue flows (aka 'waterfall'), whether a financier (loan) or an investor (equity). Normally, the Collection Agent Management Agreement (CAMA) is the final arbitrator, meaning the legal document that dictates the precise amount and timing of funds paid out to each party. If the film is a studio movie, then the 'waterfall' is contained within the Distributor Agreement. The recoupment order dictates at which stage an investor in a film begins to see a return for their investment, as relative to the persons interested in the film.

Release pattern Denotes the number of screens or prints, the date, seasonal period and cities chosen for the release of a film. Screenings at a large number of cities across the country are described as 'wide releases', whereas targeting specific screens and cities for a larger expansions are 'platform releases'.

Rental Industry slang for film rental fee, the distributor's share of the gross box office, after taxes and the exhibitor takes its own share and house 'nut' basic cast of overheads. This number is quite wide, and can range from low 20s to a 50–50 share.

Right of authorship A feature of European continental law that considers the author of a work to be its first owner. This is in contrast to Anglo-Saxon law, where the producer holds this position.

Rights-based financiers Financiers that exist within the film value chain and whose business model is essentially based on the acquisition of these rights. Examples would be distributors and broadcasters.

Run A film's run is the amount of weeks said film keeps showing at the theatres.

Sale and leaseback A now-obsolete tax arrangement under Sections 42 and 48 of UK law in which the producer sold the film to an investor with taxable profits sufficient to utilize the tax relief – typically a film partnership of individuals with higher rate tax liability – and leased the film back over 15 years. Most of the sale price is placed on deposit to secure the repayment instalments, with the remainder the producer's net benefit. Copyright and exploitation rights then returned to the producer.

Sales agent/company A sales agent is appointed to represent a producer/financier to sell/license a film to distributors internationally. If the company buys rights rather than just representing a film it is technically an 'international distributor'.

Sales agents are often credited in the independent market as executive producers, as their potential ability to close pre-sales to distributors and provide accurate/reliable 'estimates' of each territory's value (see below) are key to financing films even if the said company is typically not putting up an advance for rights.

Sales estimates A document detailing what the sales agent expects to receive from distributors in each territory for a given title. These are often broken down into two columns, the 'Ask', what the sales agent hopes to get, and the 'Take', the least the sales agent is ready to accept for a given title until after the film is delivered and screened, at which point prices may be subject to change.

Screen average The average earned by a film at each screen during a run at the cinemas. This is an important indicator of a film's success beyond its gross numbers, and highly relevant to specialized pictures' benchmarking of success.

Script editor As with many publishing editors, a role meant for an experienced script reader, which encompasses pointing out structural and stylistic problems within a screenplay and focusses on the story.

Scriptment Popularized by James Cameron, a longer version of a treatment, of about 20 to 40 pages, including dialogue and more detailed descriptions of each scene.

Sensitivity testing The process of testing the assumptions contained within a business plan given research into its specific market, or variation of the timings, hits and failures projected.

Share capital Money raised through selling a stake in a business, done by the selling of shares that represent a stake that an investor holds.

Slate deal An investment strategy, usually made by a producer or sales agent, to deliver a certain number of films over a specified time period, committing to more than the usual one single project. However, the best slate investment/financing deals are cross-collateralized, meaning the loss-making films are balanced by the successful ones. Achieving such a 'crossed' deal with one studio or leading distributor is extremely difficult. Achieving an 'uncrossed' deal as a producer is equally hard, as distributors will typically seek to cross all territories to protect their minimum guarantee (MG) and marketing spend etc.

Slate/portfolio management In film, a strategy used to spread the risk of a singular investment by spreading that investment across many projects. Studios commit to this strategy by releasing around 20–40 films a year, not being overly exposed to failure by any single one.

Spec script A script written not for a fee, but with the hope of it being sold to a studio or production company.

Special purpose vehicle (SPV) Also known as a 'special purpose entity'. This is a legal entity created for the purpose of holding, funding and exploiting a project. In film, this is often a limited company or partnership set up to handle all the accounts and place all intellectual property rights for one specific project in one legal entity. It is normally wound up within three to five years after the completion of the production.

Split rights The practice of companies coming together to acquire a totality of rights, which are then split among the different parties. For example, two studios could fund the totality of a film's budget, then split the revenues these rights create horizontally, having one handle domestic distribution and the other international (aka foreign). Rights can also be split vertically, having, for example, one company handle theatrical distribution and the other home entertainment rights. Studio rights are normally fully cross-collateralized.

Still photography Photographs taken throughout a production in order to give an idea of concept and atmosphere and to be used as key marketing tools. A key component of a film's marketing campaign, and one often neglected by independent producers.

Studio One of the major five vertically integrated companies, based in Los Angeles, which dominate the global film market: Disney (now incorporating Fox), Sony, Universal, Paramount and Warner Brothers. Membership tends to consolidate competing outsiders: for example, Metro Goldwyn Mayer was acquired by Sony in 2005, and more recently in 2021 by Amazon thanks to its vast library of IP. Other previous potential contenders, including DreamWorks and PolyGram, have found entry to the oligopoly impossible to surmount. The studios are defined by their ability to distribute films worldwide and therefore having the ability to fund the entirety of the budget of a film and control the creation of all rights from development onwards. The studios have large film and television libraries that allow them to take higher risks due to the resulting steady income streams and operate 360-degree business models that are considerably wider than just feature film exploitation. Studios are considered primarily distribution entities, yet have only recently entered the "Streaming Wars" after seeing the rise of Netflix and Amazon Prime, for example.

Subscription Video on Demand (SVOD) Similar to traditional Pay TV packages, SVOD allows consumers to access an entire catalogue of content for a flat rate, typically paid monthly. Major services operating SVOD include Netflix, Amazon Prime Video, Hulu, Apple, HBO Max, Sky (plus its subsidiary Now TV), and Disney+, etc.

TVOD transactional video on demand TVOD is the opposite of subscription video, since in this case consumers purchase content on a pay-per-view basis. There are two sub-categories, known as electronic sell-through (EST), where you pay once to gain permanent access to a piece of content; and download to rent (DTR), where customers access a piece of content for a limited time for a smaller fee. Examples of TVOD services include: Apple's iTunes, Sky Box Office and Amazon's video store.

Sunk costs Costs committed to a project (or company) that are non-recoverable and are therefore 'sunk' into the production (or company).

Tagline A slogan, often placed prominently in the poster for a film and related marketing materials, meant to encapsulate the film's 'feel' or 'hook' to an audience quickly and directly.

Tax fund investors Investors who leverage tax regulation in order raise investment funds and to seek returns.

Tax funding Film financing agencies based around government tax credits for film projects.

Teaser trailer A trailer considerably less long than a usual trailer (a trailer is normally around 90–120 seconds, and a teaser maybe 15–30 seconds) and made up of a series of images from the film with no narrative line, teasing the elements of the full-length trailer.

Tent pole films Films of a large budget (generally US$100m and up, but rising each year) that are traditionally released in the summer and meant to play with a wide range of audience demographics, both domestically and internationally.

Territory A contractually defined geographical area where a set of film rights may be individually exploited. Note that territories as contractually defined usually, but not always, relate to how they are defined politically. For example, the United Kingdom and Ireland, Australia and New Zealand, are often considered one territory in contracts, even if they are separate political entities. The French Territory often includes its overseas colonies, as do a number of larger territories, including Germany for example, that includes Austria and German speaking parts of Africa for example.

Theatrical Usually the first stage of exploitation of a film, that of a theatrical showing in cinemas. Also known as the 'exhibition' window.

Track record The financial performance of the films released by a company or with the talent and critical review in question. Awards play a key role in track record in addition to performance.

Tracking Activity normally undertaken by sales agents, distributors and financiers to identify promising films yet to go into production. Analysis of the package, including script, producer's track record, director, budget and lead cast (and all previous quotes re pricing), is undertaken and assessed before a commitment is made to the project by the above players.

Trade press Magazines and dailies that purely focus on covering the film and entertainment industries, and do so usually with a business-to-business perspective. Significant titles include *Variety, The Hollywood Reporter, Deadline* and *Screen International*. It is now a simple task to receive an online headline story service from such a trade title. Notable online sources of trade information and analysis has exploded in the past decade, ranging, for example, from Stephen Follows' excellent film blog, to 'Film Take' – a mine of information about specifically online business trends and developments.

Trailer Initially placed at the end of another film's showing (hence 'trailer'), but now, of course, shown before the main presentation, these short advertisements for a film seek to convey to an audience in a few minutes (no more than 2 normally) the plot and essential elements, and highlights stars/performances if in the film.

Treatment A long-form summary of the intended screenplay's plot. This rarely ever includes dialogue and set pieces, which are normally written in the full work later.

Underlying rights The bundle of rights in the copyright of the script acquired by the producer through the chain of title and which includes all or some of the right to make and license film rights based on the script, the ancillary rights and the right to sequels, spin-offs or remakes.

Venture capital A type of private equity provided to early-stage companies with a high potential for growth, with a view to earn back the investment through an Initial Public Offering (IPO), a trade sale and sometimes a management buyout.

Vertical An approach of looking at the exploitation of film rights up and down the different stages of such exploitation, starting with theatrical, then home video rental and sales/VOD (see below), television, etc.

Vertical integration The strategy is for a company to hold as much of the processes of the film value chain within their organization in order to minimize overhead costs and maximize profits. Studios are vertically integrated companies that control everything from development to distribution, alongside licensing and theme park activities for example.

Video-on-Demand (VOD) Fast replacing DVD, Video-on-Demand is the term used for the distribution and circulation of digital film rights across the internet and now available on multiple devices, either on an exclusive or non-exclusive basis, accessible via a variety of pay systems. Typical VOD platforms include Netflix and Amazon Prime.

Waterfall A term that is used to describe a range of repayment and profit-sharing orders in which different creditors/investors receive interest and principal payments/revenue streams at different stages of recoupment.

Windows The different chronological stages at which a film is exploited, starting with theatrical, then home video, Pay TV and Free TV, etc.

World Or, more precisely, 'world rights', when all countries are bundled into one territory. Licensing world rights essentially means giving a licence to exploit a film in all known territories across the world.

Bibliography

The author's prior publications

The author's published works include five books, one academic case study, two industry reports, one academic chapter and one academic journal paper, all sole authored, with the exception of *The International Film Business* (2015, 2nd ed.) credited as 'by Angus Finney, with Eugenio Triana'. Finney, A. (2010, 2014) *The International Film Business – A Market Guide Beyond Hollywood*, Abingdon, New York: Routledge. [Second Edition published 2015].

Finney, A.L. Hadida (2019) 'The King's Speech Producer's Dilemma (Case A) and The King's Speech Distribution Dilemma (Case B)', Published by: Cambridge Judge Business School, University of Cambridge: See SAGE Business Cases 2020 Annual Collection.

Finney, A. (2014a) *Brave New World: A Study of Producer–Distributor Relations*, Cardiff and London: Film Agency Wales/Creative Skillset.

Finney, A. (2014b) 'Value Chain Restructuring in the Film Industry: The Case of the Independent Feature Film Sector' (Chapter 1), from: Wikstrom, P. and DeFellippi, R., Cheltenham, UK, Edward Elgar Publishing.

Finney, A. (2008) 'Learning from Sharks: Lessons on Managing Projects in the Independent Film Industry', *Long Range Planning* 41(1), February.

Finney, A. (1996a) *The State of European Cinema: A New Dose of Reality*, London: Cassell.

Finney, A. (1996b) *The Egos Have Landed: The Rise and Fall of Palace Pictures*, London: Heinemann.

Finney, A. (1996c) *Developing Feature Films in Europe – A Practical Guide*, London: Routledge.

Finney, A. (1993) *A Dose of Reality: The State of European Cinema*, Berlin, London: European Film Academy/Screen International/Vistas Verlag.

Note: For a summary of academic articles relating to the film industry, please see Allegre L. Hadida's excellent comprehensive literature review of empirical studies of motion picture performance published from 1977 to 2006 ('Motion Picture Performance: A Review and Research Agenda', *International Journal of Management Reviews*, Volume 10, Issue 3, 2008).

Adler, T. (2004) *The Producers*, London: Methuen Drama.

Amit, R. and Zott, C. (2001) 'Value Creation in E-business', *Strategic Management Journal*, 22: 493–520.

Anderson, C. (2006) *The Long Tail: Why the Future of Business is Selling Less of More*, New York: Hyperion.

Anderson, H. (2011) 'Measuring Social Media', Measurement Matters blog. Available at http://blog.forthmetrics.com/2011/06/02/measuring-social-media.

Aris, A. and Bughin, J. (2006) *Managing Media Companies: Harnessing Creative Value*, Chichester: John Wiley.

Auletta, K. (2009) *Googled: The End of the World As We Know It*, London: Virgin.

Barnes, S. J. (2002) 'The Mobile Commerce Value Chain: Analysis and Future Developments', *International Journal of Information Management*, 22(2).

Bart, P. (1990) *Fade Out*, London: Simon & Schuster.

Bazalgette, P. (2005) *Billion Dollar Game: How Three Men Risked It All and Changed the Face of Television*, London: Time Warner Books.

Biggart, N. and Beamish, T. (2003) 'The Economic Sociology of Conventions: Habit, Custom, Practice, and Routine in Market Order', *Annual Review of Sociology* 29: 443–64.

Bilton, C. (2006) *Management and Creativity: From Creative Industries to Creative Management*, London: Wiley-Blackwell.

Biskind, P. (1998) *Easy Riders, Raging Bulls*, New York: Simon & Schuster.

Biskind, P. (2004) *Down and Dirty Pictures*, New York: Simon & Schuster.

Bloore, P. (2009) *Re-defining the Independent Film Value Chain*, London: UK Film Council. Available at: http://www.ukfilmcouncil.org.uk/12384.

Bloore, P. (2013) *The Screenplay Business: Managing Creativity and Script Development in the Film Industry*, Abingdon/New York: Routledge.

Booker, C. (2004) *The Seven Basic Plots: Why We Tell Stories*, London/New York: Bloomsbury.

Boorman, J. (1985) *Money Into Light*, London: Faber & Faber.

Boorstin, J. (1990) *The Hollywood Eye*, London: HarperCollins.

Catmull, E., with Wallace, A., (2014) *Creativity, Inc. Overcoming the Unseen Forces That Stand in the Way of True Inspiration*, New York: Bantam; London: Random House.

Catmull, Ed (2008), 'How Pixar Fosters Collective Creativity', *Harvard Business Review*, September.

Cave, R.E. (2000) *Creative Industries: Contracts between Art and Commerce*, Cambridge, MA: Harvard University Press.

Chapman, E. (2005) 'Models for Sustainable Cinema', Chapman Logic blog. Available at: http://www.chapmanlogic.com/blog/pdfs/Models_For_Sustainable_Cinema_eli_chapman_IIFF.pdf.

Collins, J. (2001) *Good to Great*, New York: Harper Collins.

Collins, J. (2005) *Built to Last*, London: Random House Business Books.

Corman, R. (1990) *How I Made 100 Movies in Hollywood and Never Lost A Dime*, London: Random Century Group.

Cunningham, S. and Silver, J. (2013) *Screen Distribution and the New King Kongs of the Oneline World*, Palgrave Pivot series, Basingstoke: Palgrave Macmillan.

Currah, A. (2007) 'Managing Creativity: The Tensions between Commodities and Gifts in a Digital Networked Environment', *Economy and Society* 36(3): 467–94.

Dale, M. (1997) *The Movie Game: The Film Business in Britain, Europe and America*, London: Cassell.

Daniels, B., Leedy, D., and Sills, S.D. (2006) *Movie Money: Understanding Hollywood's (Creative) Accounting Practices* (2nd ed.), Los Angeles: Oilman-James.

Davenport, J. (2006) 'UK Film Companies: Project-based Organisations Lacking Entrepreneurship and Innovativeness?', Vol. 15, No. 3, pp. 250–257, *Creativity and Innovation Management*, London: Blackwell Publishing.

De Vany, A. (2004) *Hollywood Economics: How extreme uncertainty shapes the film industry*, Abingdon, Oxon: Routledge.

Duhaime, I. M., and Schwenk, C. R. (1985) 'Conjectures on Cognitive Simplification in Acquisition and Divestment Decision Making', *Academy of Management Review* 10(2): 257–295.

Durie, J., Pham, A. and Watson, N. (ed.) (1993) *The Film Marketing Handbook: A Practical Guide to Marketing Strategies for Independent Films*, London: Media Business School.

Eberts, J. and Ilott, T. (1990) *My Indecision is Final: The Rise and Fall of Goldcrest Films*, London: Faber & Faber.

Egri, L., ed (2004) *The Art of Dramatic Writing: Its Basis in the Creative Interpretation of Human Motives*, New York: Touchstone/Simon & Schuster.

Elberse, A. (2008) 'Should You Invest in the Long Tail?', *Harvard Business Review*, July–August.

Elberse, A. and Eliashberg, J. (2003) 'Demand and Supply Dynamics for Sequentially Released Products in International Markets: The Case of Motion Pictures', *Marketing Science* 22(3): 329–54.

Eliashberg, J. and Sawhney, M.S. (1994) 'Modeling Goes to Hollywood: Predicting Individual Differences in Movie Enjoyment', *Management Science* 40(9): 1151–73.

Eliashberg, J. and Shugan, S.M. (1997) 'Film Critics: Influencers or Predictors?' *Journal of Marketing* 61 (April): 68–78.

Eliashberg, J., Elberse, A. and Leenders, M. (2006) 'The Motion Picture Industry: Critical Issues in Practice, Current Research, and New Research Directions', *Marketing Science* 25(6), November–December.

Epstein, E.J. (2005) *The Big Picture: The New Logic of Money and Power in Hollywood*, New York: Random House.

Evans, P. and Wurster, T.S. (2000) *Blown to Bits: How the New Economics of Information Transforms Strategy*, Boston, MA: Harvard Business School Press.

Ferriani, S., Gattani, G. and Baden-Fuller, C. (2009) 'The Relational Antecedents of Project-Entrepreneurship: Network Centrality, Team Composition and Project Performance', *Research Policy* 38: 1545–1558.

Fjeldstad, O., Snow, C., Miles, R. and Lettl, C. (2012) 'The Architecture of Collaboration', *Strategic Management Journal* 33: 734–750.

Figgis, M. (2007) *Digital Filmmaking*, London: Faber & Faber.

Gabler, N. (1988) *An Empire of Their Own: How the Jews Invented Hollywood*, New York: Doubleday.

Gereffi, F., Humphrey, J., Kaplinsky, R. and Sturgeon, T. (eds) (2001) 'Globalisation, Value Chains and Development', *IDS Bulletin Special Issue: The Value of Value Chains* 32(3): 41–6.

Goldman, W. (1983) *Adventures in the Screen Trade*, New York: Warners.

Gubbins, M. (2012) *Digital Revolution: The Active Audience*, Cine Regio Report. Published online at http://www.cine-regio.org/dyn/files/pdf.

Gubbins, M. (2014) *Audience in the Mind*, SampoMedia Report. Retrieved at: http://cineregio.org/dyn/files/pdf.

Gubbins, M. (2020) *Evolution of a European VOD Sector*. EUROVOD Report.

Hadida, A. and Paris, T. (2013) 'Managerial Cognition and the Value Chain in the Digital Music Industry', *Technological Forecasting and Social Change* 83: 84–97.

Hark, I.R. (2001) *Exhibition: The Film Reader*, London: Routledge.

Henry, J. (2001) *Creative Management*, London: Sage Publications.

Hastings, R. and Meyer, E. (2020) *No Rules Rules: Netflix and the Culture of Reinvention*, London: W.H. Allen.

Hilderbrand, L. (2010) 'The Art of Distribution: Video On Demand', *Film Quarterly* 64(2).

Ilott, T. (2009) '50 Theses on Film'. Unpublished paper.

Iger, B. (2019) *The Ride of a Lifetime: Lessons in Creative Leadership from 15 Years as CEO of the Walt Disney Company*, London: Bantam Press.

Ilott, T. and Puttnam, D. (1996) *Budgets and Markets: A Study of the Budgeting of European Films*, London: Routledge.

Introna, L.D., Moore, H. and Cushman, M. (1999) *The Virtual Organisation – Technical or Social Innovation? Lessons from the Industry*, London School of Economics, Department of Information Systems, http://www.lse.ac.uk/management/documents/isig-wp/ISIG-WP-72.PDF.

Isaacson, W. (2011), *Steve Jobs*, Little, Brown: London.

Iordanova, D. and Cunningham, S. (eds) (2012) *Digital Disruption: Cinema Moves On-Line*, St Andrews: St Andrews Film Studies.

Jackel, A. (2003) *European Film Industries*, London: British Film Institute.

Jancovich, M. (2008) *The Place of the Audience: Cultural Geographies of Film Consumption*, London: British Film Institute.

Johnson, M.W., Christensen, C. M. and Kagermann, H. (2008) 'Reinventing Your Business Model', *Harvard Business Review*, December.

Kahneman, D. and Lovallo, D. (1993) 'Timid Choices and Bold Forecasts: A Cognitive Perspective on Risk-Taking', *Management Science* 39(1): 17–31.

Kaplan, S. (2011) 'Research in Cognition and Strategy: Reflections on Two Decades of Progress and a Look to the Future', *Journal of Management Studies* 48: 665–695.

Kaplinsky, R. and Morris, M. (2001), *A Handbook for Value Chain Research*, IDRC, http://www.prism.uct.ac.za/papers/vchnov01.pdf.

Kent, N. (1991) *Naked Hollywood: Money and Power in the Movies Today*, London: St Martin's Press.

Knapp, S. and Sherman, B.L. (1986) 'Motion Picture Attendance: A Market Segmentation Approach', in B.A. Austin (ed.), *Current Research in Film: Audiences, Economics, and Law* (Vol. 2), Norwood, NJ: Ablex, pp. 35–46.

Kokas, A. (2017) *Hollywood Made in China*, Los Angeles: University of California Press.

Kula, S. (2002) *Appraising Moving Images: Assessing the Archival and Monetary Value of Film and Video Records*, Lanham, MD: Scarecrow Press.

Küng, Lucy (2008) *Strategic Management in the Media: Theory to Practice*, London: Sage Publications.

Lampel, J. and Shamsie, J. (2000) 'Critical Push: Strategies for Creating Momentum in the Motion Picture Industry', *Journal of Management* 26(2): 233–57.

Lampel, J., Shamsie, J. and Lant, T.K. (eds) (2006) *The Business of Culture: Strategic Perspectives on Entertainment and Media*, Hillsdale, NJ: Lawrence Erlbaum Associates.

Larrington, C. (2016) *Winter Is Coming: The Medieval World of Game of Thrones*, London/New York: I.B. Tauris.

Litvak, M. (1986) *Reel Power*, Los Angeles, CA: Silman-James.

Lovallo, D. and Kahneman, D. (2003) 'Delusions of Success: How Optimism Undermines Executives' Decisions', *Harvard Business Review* 81: 56–63.

Louis, M. and Sutton, R. (1991) 'Switching Cognitive Gears: From Habits of Mind to Active Thinking', *Human Relations* 44: 55–75.

Makridakis, S. (1990) *Forecasting, Planning and Strategy for the 21st Century*, New York: The Free Press.

Makridakis, S., Hogarth, R. and Gaba, A. (2009) 'Forecasting and Uncertainty in the Economic and Business World', *International Journal of Forecasting* 25: 794–812.

Makridakis, S. and Taleb, N. (2009) 'Decision Making and Planning Under Low Levels of Predictability', *International Journal of Forecasting* 25: 716–733.

Makridakis, S. (1996) 'Forecasting: Its Role and Value for Planning and Strategy'. *International Journal of Forecasting* 12(4): 513–537.

McPhillips, S. and Merlo, O. (2008) 'Media Convergence and the Evolving Media Business Model: An Overview and Strategic Opportunities', *The Marketing Review* 8(3): 237–53.

Miller, D. (1999) 'Strategic Responses to the Three Kinds of Uncertainty: Product Line Simplicity at the Hollywood Film Studios', *Journal of Management*, 25(1): 97.

Miller, D. and Shamsie, J. (2001) 'Learning Across the Life Cycle: Experimentation and Performance Among the Hollywood Studio Heads', *Strategic Management Journal* 22: 725–45.

Miller, D. and Shamsie, J. (1996) 'The Resource-Based View of the Firm in Two Environments: The Hollywood Film Studios from 1936 to 1965'. *Academy of Management Journal*, June 1996, 519–543. Also appeared as 'Competitive Advantage, Hollywood Style' (Research Translation). *Academy of Management Executive*, February 1997, 116–118. Also published in *Corporate Strategy*, eds. A.A. Maritan & M.A. Peteraf. Edward Elgar Publishing, Cheltenham, UK, 2011.

Mintzberg, H., Ahlstrand, B. and Lampel, J. (2008) *Strategy Safari* (2nd edn), London: Prentice Hall.

Mol, J.M., Wijnberg, M. and Carroll, C. (2005) 'Value Chain Envy: Explaining New Entry and Vertical Integration in Popular Music', *Journal of Management Studies* 42 (March).

Moore, S.M. (2007) *The Biz: The Basic Business, Legal and Financial Aspects of the Film Industry*, Los Angeles, CA: Silman-James.

Mosul, C. (ed.) (2005) *A Concise Handbook of Movie Industry Economics*, New York: Cambridge University Press.

Neumann, P. and Appelgren, C. (2007) *The Fine Art of Co-Producing*, Copenhagen: Neumann Publishing/Danish Film Institute.

Okri, B. (2015) *The Mystery Feast: Thoughts on Storytelling*, West Sussex, UK: Clairview Books.

Olsberg SPI (2012) 'Building Sustainable Film Business: The Challenges for Industry and Government', Independent Research Report, sponsored by Film I Väst, PACT and the Swedish Film Institute, July. Retrieved at: http://www.o-spi.co.uk/wp-content/uploads/2013/09/Building-Sustainable-Film-Businesses.pdf.

Olsberg, J.(2020) *Global Screen Production – The Impact of Film and TV Production on Economic Recovery from COVID-19*: A Study by OlsbergSPI, 25/06/2020.

Stolz, F., Atkinson, A. and Kennedy, H. (2021) Future of Film Report, University of Nottingham, UK.

Pardo, A. (ed.) (2002) *The Audiovisual Management Handbook*, Madrid: Media Business School.

Pautz, M. (2002) 'The Decline in Average Weekly Cinema Attendance: 1930–2000', *Issue in Political Economy*, vol. 1.

Porac, J. F., Thomas, H. Baden-Fuller, C. (1989) 'Competitive Groups as Cognitive Communities: The Case of Scottish Knitwear Manufacturers', *Journal of Management Studies*.

Porter, M. E. (1985) *Competitive Advantage: Creating and Sustaining Superior Performance*, New York: Free Press/Macmillan.

Porter, M. E. (2001) 'Strategy and the Internet', *Harvard Business Review*, March, pp. 63–78, p. 74.

Purkayastha, D. (2006) 'Pixar's "Incredible" Culture', *ICMR Center for Management Research*.

Rappa, M. (2008) 'Managing the Digital Enterprise: Business Models On The Web', 1 January. Available at: http://digitalenterprise.org/models.html.

Rayport, J.F. and Sviokla, J.J. (1996) 'Exploiting the Virtual Value Chain', *The McKinsey Quarterly* 1.

Rimscha, M. (2009) 'Managing Risk in Motion Picture Project Development', *Journal of Media Business Studies 2009* 6: 75–101.

Schatz, T. (1988) *The Genius of the System: Hollywood Filmmaking in the Studio Era*, New York: Metropolitan.

Schumpeter, J. (1961) 'The Theory of Economic Development: An Inquiry Into Profits, Capital', in *Credit, Interest, and the Business Cycle*, Oxford: Oxford University Press.

Scott Berg, A. (1989) *Goldwyn: A Biography*, London: Hamish Hamilton.

Silber, L. (1999) *Career Management for the Creative Person*, New York: Three Rivers Press.

Simon, H.A. (1947) *Administrative Behaviour*, New York: Macmillan.

Squire, J.E. (2004) *The Movie Business Book* (3rd edn), New York: Fireside.

Sweeney, J. (2007) *Successful Business Models for Filmmakers*, Bloomington, IN: AuthorHouse.

Tapscott, D. and Williams, A.D. (2006) *Wikinomics: How Mass Collaboration Changes Everything*, London: Atlantic.

Tversky, A., and Kahneman, D. (1974) 'Judgements Under Uncertainty: Heuristics and Biases', *Science* (1851124–1131).

Tolkin, M. (1988) *The Player*, London: Faber & Faber.

Torr, G. (2008) *Managing Creative People: Lessons in Leadership for the Ideas Economy*, Chichester: Wiley.

Vickery, G. and Hawkins, R. (2008) *Remaking the Movies: Digital Content and the Revolution of the Film and Video Industries*, Paris: OECD Publishing.

Vogel, H. (2007) *Entertainment Industry Economics: A Guide for Financial Analysis*, Cambridge, UK: Cambridge University Press.

Waller, G.A. (ed.) (2001) *Moviegoing in America: A Sourcebook in the History of Film Exhibition*, Oxford: Wiley-Blackwell.

Wasko, J. (2003) *How Hollywood Works*, London: Sage Publications.

Wasko, J. and McDonald, P. (1982) *Movies and Money: Financing the American Film Industry*, London: Sage Publications.

Wasko, J. and McDonald, P. (2008) *The Contemporary Hollywood Film Industry*, London: Blackwell Publishing.

Wu, T. (2010) *The Master Switch: The Rise and Fall of Information Empires*, New York: Vintage.

Yorke, J. (2014) *Into The Woods: How Stories Work and Why We Tell Them*, London: Penguin.

Index

Page numbers in **bold** indicate tables, page numbers in *italic* indicate figures.

Printed in Great Britain
by Amazon

31063795R00225